THE
INTELLECTUAL
DEVOTIONAL

BIOGRAPHIES

Revive Your Mind,
Complete Your Education,
and Acquaint Yourself
with the
World's Greatest Personalities

✦ ✦ ✦

DAVID S. KIDDER & NOAH D. OPPENHEIM

RODALE

© 2010 by TID Volumes, LLC

Book design by Anthony Serge, principal designer;
initial interior creative by Nelson Kunkel, The Ingredient
For image credits, see page 375.

Library of Congress Cataloging-in-Publication Data

Kidder, David S.
 The intellectual devotional biographies : revive your mind, complete your
education, and acquaint yourself with the world's greatest personalities / David S.
Kidder & Noah D. Oppenheim.
 p. cm.
 ISBN-13 978–1–60529–950–1 hardcover
 ISBN-10 1–60529–950–2 hardcover
 1. Biography. 2. Devotional calendars. I. Oppenheim, Noah D. II. Title.
CT104.K54 2010
242'.2—dc22 2010008517

Distributed to the trade by Macmillan
2 4 6 8 10 9 7 5 3 1 hardcover

For Leigh Haber and Joy Tutela,
whose belief and brilliance made this book series a reality

Contributing Editors

Alan Wirzbicki

James Downs

Introduction

This is the final volume of *The Intellectual Devotional*, a series we hope has made learning about a wide variety of subjects, from modern culture to American history to health, more accessible and entertaining for our thousands of readers. We've chosen to conclude the series with a collection of short biographies, offering intimate portraits of some of the world's most fascinating people, past and present.

Why end the series with biography? Throughout history, our world has been shaped by extraordinary personalities. The rise and fall of empires, the birth and evolution of religious communities, the expression of artistic genius, the advance of scientific discovery—it's all been driven by exceptional individuals. What makes those individuals different from you and me? You hold the answers in your hands. In this volume, you'll discover the fascinating stories of people who have made their mark on history, whether through high achievement, inspired thinking, or downright treachery.

The 365 entries are divided into the following categories:

LEADERS

Charismatic figures who mobilized the masses

PHILOSOPHERS

Deep thinkers who saw the world in new lights and helped others do the same

INNOVATORS

The original thinkers behind mankind's greatest advances

VILLAINS

Those who were vilified by their contemporaries or in history's judgment

AUTHORS AND ARTISTS

Creative spirits who expanded the boundaries of the human imagination

REBELS AND REFORMERS

Iconoclasts who overturned the existing social order, for better and worse

PREACHERS AND PROPHETS

Spiritual visionaries who redefined our conception of a higher power

Khufu

The ancient Egyptian pharaoh Khufu (c. 2609–c. 2566 BC) envisioned his tomb as a towering limestone monument to his own greatness. The great pyramid in the desert, he hoped, would not only protect his soul during its journey to the afterlife, but also ensure that the world would never forget his twenty-three-year reign.

Sure enough, the world hasn't forgotten. Khufu's name is forever linked with the enormous Great Pyramid of Giza, which it took an army of laborers nearly the pharaoh's entire lifetime to complete. The pyramid, one of the Seven Wonders of the Ancient World, was the tallest man-made structure on Earth when it was completed—and it would remain so for the next 3,000 years.

Aside from his enthusiasm for pyramids, however, little is known about Khufu. He was the son of King Sneferu and the second member of ancient Egypt's Fourth Dynasty. He became pharaoh while still in his twenties, following Sneferu's death. Khufu may have conducted some military expeditions to Nubia, south of Egypt, and Libya, to the west.

The religious significance of the pyramids is thought to stem from Egyptians' beliefs about the afterlife. They considered pharaohs to be living gods whose entry into heaven after their deaths on Earth was eased by pyramids.

Khufu's Great Pyramid was the first and largest such structure built at Giza. The pharaoh also built several smaller tombs for his wives and relatives, and two of his successors built their pyramids nearby. Most of the limestone used in the pyramids was quarried nearby, floated down the Nile on rafts, and then dragged up a massive ramp in enormous, three-ton blocks to the construction site. Other components were imported from as far away as Lebanon.

After his death at about age fifty, Khufu was mummified and buried in a tomb deep within the pyramid. Although the exterior layer of stonework casing was plundered over the millennia, the Great Pyramid remains largely intact, just as the pharaoh intended.

ADDITIONAL FACTS

1. *The Great Pyramid is made of roughly 2.3 million limestone blocks, some weighing as much as fifteen tons. The whole structure weighs about 6 million tons.*

2. *Khufu's full name was Khnum-Khufwy, meaning "Khnum, protect me." Khnum was the ancient Egyptian god of the Nile River, which was the lifeblood of Egyptian agriculture and commerce.*

3. *The Great Sphinx, a huge statue of a half-man, half-lion figure that stands near the Great Pyramid, is thought to have been constructed by Khufu's son, the pharaoh Khafra (c. 2558–2532 BC).*

✦✦✦

Thales of Miletus

In 585 BC, a scientist and philosopher in the Greek city of Miletus offered a bold prediction: On May 28 of that year, he said, there would be a total eclipse of the sun.

Such predictions, based on previous astronomical observations, were virtually unheard of in the ancient world. Few people in the Greek world believed that celestial events like eclipses could be foreseen; instead, they ascribed them to all-powerful gods. But the Miletian scientist, Thales (620–546 BC), stood by his claim that human reason alone could be used to predict nature.

And indeed, on that day, a swath of what's now Turkey was cast into total darkness, just as Thales had prophesied. The eclipse terrified the Miletians, vindicated Thales—and, arguably, set in motion the history of Western science.

Prior to Thales, most Greeks considered religion and nature inseparable. Events like earthquakes and eclipses, they believed, happened when angry gods wanted to send a message to mankind. Greek mythology abounded with stories of the deities directly intervening on Earth.

By correctly predicting an eclipse, however, Thales profoundly altered the Greeks' understanding of nature and of the value of knowledge. He also created the concept of philosophy—derived from the Greek words for "love of wisdom"—to describe those who sought to use reason to understand the world.

Thales was a trader and olive oil producer who had traveled to Egypt, where Miletus had a trading outpost, and to the Near East. He may also have traveled to Babylon, where he could have learned the Babylonian astronomical concepts that enabled him to predict the eclipse.

When he returned to Miletus, Thales founded a school of philosophy that would train several important Greek thinkers, including Anaximander (c. 610–c. 546 BC) and Anaximenes (585–525 BC). In addition to his scientific and philosophical work, Thales was a military advisor to several kings and played a role in preserving Miletian independence after the Persians defeated neighboring Lydia.

His death came suddenly at about age sixty—he supposedly dropped dead while watching a gymnastics performance.

ADDITIONAL FACTS

1. *Thales believed that the world was made of water and that all forms of matter had started as water.*

2. *The site of ancient Miletus is now the city of Milet, Turkey.*

3. *According to one story, Thales once traveled to Egypt to study Egyptian geometry. He supposedly dazzled his hosts by correctly calculating the height of a pyramid based on the length of its shadow.*

◆◆◆

Imhotep

Many histories of medicine designate the ancient Greek doctor Hippocrates (c. 460–c. 375 BC) the father of medicine. But more than 2,000 years before his birth, an Egyptian architect and priest, Imhotep, devised treatments for dozens of illnesses ranging from tuberculosis to toothaches to arthritis.

Indeed, Imhotep, who lived in Egypt in about 2650 BC, is believed to have been the first doctor whose name is known to history. A top official for the pharaoh Djoser, Imhotep documented hundreds of diseases and was such an expert healer that he was venerated as a god for thousands of years after his death.

As the pharaoh's architect, Imhotep also designed and built the first Egyptian pyramid, a 200-foot-tall, terraced structure that served as Djoser's burial site. One of the first large-scale buildings ever constructed, the step pyramid still stands just south of modern Cairo.

Imhotep was born a commoner, but he was elevated to high priest of the temple at Heliopolis, the Egyptian religious capital. He was later promoted to vizier, or chancellor, to the pharaoh—the king's most powerful advisor.

Imhotep's medical treatises, believed to have been inscribed on papyrus scrolls, are thought to have been among the first attempts to separate medically sound healing practices from superstition, and they would be passed on and recopied for generations after Imhotep's death. He offered cures for hundreds of diseases; for instance, the Egyptians believed wounds could be treated with honey, celery helped alleviate rheumatism, and aloe could soothe skin conditions. Some of the cures have been confirmed by modern researchers, including his recommendation to use the acacia plant to relieve cold symptoms.

In the centuries after his death, Imhotep came to be worshipped for his healing powers, and he was formally recognized as a god in the Egyptian pantheon in 525 BC.

ADDITIONAL FACTS

1. *Imhotep achieved new fame in 1932 when he served as the loose inspiration for the 1932 horror movie* The Mummy, *which starred Boris Karloff (1887–1969) as "Im-ho-tep," who returns from the dead to search for his long-lost love. The movie was remade in 1999, with Arnold Vosloo (1962–) as the high priest.*

2. *Imhotep's name means "The One Who Comes in Peace" in ancient Egyptian.*

3. *The step pyramid designed by Imhotep served as the model for the bigger and better-known Great Pyramid at Giza, which was constructed about 100 years later as the tomb of the pharaoh Khufu (c. 2609–c. 2566 BC). That pyramid was the tallest man-made structure in the world for almost 4,000 years, until it was surpassed by medieval European cathedrals.*

◆◆◆

Amenpanufer

An audacious thief who ransacked the tombs of Egyptian pharaohs, Amenpanufer was caught in about 1111 BC. Tomb robbing was considered a particularly serious offense in ancient Egyptian society, and Amenpanufer's arrest, torture, and confession constitute one of the first recorded criminal trials. The proceedings have also offered historians a vivid illustration of the waning power of the Egyptian government, which by Amenpanufer's lifetime was no longer able to protect the sacred tombs of its kings.

According to the trial records, Amenpanufer was a mason who worked in the quarries near Thebes. Along with a gang of about seven accomplices, he broke into several tombs in the Valley of the Kings, where most Egyptian pharaohs were buried, and stole gold and jewels buried with the royal mummies.

Although raiding tombs was a capital offense, the culprits in Amenpanufer's gang were hardly the only tomb robbers of the era. Many of the artisans and craftsmen employed at the Valley of the Kings dabbled in theft, especially after the incumbent pharaoh, Ramses IX, was unable to pay their salaries. Amenpanufer said he "fell into the habit" of robbing tombs years before his arrest.

Many of the authorities, apparently, were happy to look the other way. At his trial, Amenpanufer disclosed that he had been caught breaking into a tomb once before, but had bribed a local official to release him. The looter was caught again only when the pharaoh established a royal commission to investigate the robberies.

The specific tomb Amenpanufer confessed to violating belonged to King Sobekemsaf II, who had ruled some 500 years earlier. The thief was tortured before confessing and giving a detailed description of his break-ins. The records were found on scrolls of papyrus in the nineteenth century.

Amenpanufer's fate is unknown. The Egyptians considered grave robbing an offense against the gods, however, and punishment was usually severe. Whatever happened to him was sufficiently gruesome that it was still remembered thirty years later, when another man accused of robbing tombs said, "I saw the punishment which was inflicted on the thieves. . . . Is it then likely that I should seek such a death?"

ADDITIONAL FACTS

1. *The tomb of the pharaoh who had Amenpanufer executed, Ramses IX, was itself robbed in ancient times. His mummy was found intact in 1881, however, and is now stored at a Cairo museum.*

2. *Tomb robberies had become so common that authorities in Egypt gave up trying to guard the hundreds of burial sites scattered around Thebes. Instead, they moved the mummies to a few centrally located caches and guarded those. The first—and only—mostly intact, original tomb was Tutankhamen's, located in 1922 in the Valley of the Kings.*

3. *Mummification was intended to keep bodies intact for the afterlife. Kings, important clergy, and even cats were mummified in ancient Egypt. The practice began to die out after 1000 BC because of the time and expense involved.*

◆◆◆

Homer

According to ancient Greek historians, Homer lived in about 800 BC and composed two of the most influential texts in Western literature, *The Iliad* and *The Odyssey*. The two long poems both tell stories related to the victory of Sparta and its allies in the Trojan War, a major turning point in Greek history.

However, many modern scholars doubt that a poet named Homer ever existed. *The Iliad* and *The Odyssey* may instead have evolved from centuries of oral tradition; alternatively, Homer may have been a real person who compiled and refined the traditional epics into their present form. In either case, the existence of the blind poet of legend may never be proved or disproved definitively.

The influence of the two poems, however, is indisputable. Considered the first works of Western literature, *The Iliad* and *The Odyssey* have inspired writers, poets, and artists for three millennia, from Virgil (70–19 BC) to James Joyce (1882–1941) to Ralph Ellison (1914–1994).

According to Greek mythology, the Trojan War began after Paris, the prince of Troy, kidnapped Helen, the wife of Sparta's king. The enraged king, Menelaus, assembled a giant force to attack Troy and retrieve his wife. The army included the warrior Achilles and Odysseus, the king of Ithaca. Menelaus besieged Troy for ten years before finally conquering the city.

The Iliad, which scholars believe was written first, tells the story of Achilles and the final year of the siege. *The Odyssey,* picking up where *The Iliad* ends, relates the long, dangerous journey of Odysseus back to Ithaca and his faithful wife, Penelope.

In addition to the two epics, several shorter hymns are traditionally attributed to Homer. As with *The Odyssey* and *The Iliad*, however, the true authorship of the poems remains a mystery.

ADDITIONAL FACTS

1. *The plot of* The Odyssey *has been used as the basis for numerous books, plays, and movies, ranging from James Joyce's* Ulysses *(1922) to the Coen Brothers' film* O Brother, Where Art Thou? *(2000). The Iliad has also been a popular source of inspiration for works ranging from Shakespeare's* Troilus and Cressida *(1602) to the 2004 movie* Troy, *which starred Brad Pitt (1963–) as Achilles.*

2. *The word* odyssey *is often used to describe a particularly long and involved journey, while* Homeric *refers to heroic or consequential actions.*

3. *The first English translations of* The Odyssey *and* The Iliad *were completed by George Chapman (c. 1559–1634) and remained the most influential versions of Homer for centuries. Many other well-known poets and scholars have tackled the task of translating the epics, including British poet Alexander Pope (1688–1744), American journalist William Cullen Bryant (1794–1878), and Princeton professor Robert Fagles (1933–2008).*

◆◆◆

Moses

One of the central figures of the Old Testament, Moses was the leader of the Israelites who, according to the Bible, freed his people from the Egyptian pharaoh. Moses later delivered the Ten Commandments to the Hebrews, and he is recognized as the lawgiver of many faiths—including Judaism, Christianity, and Islam—for the Mosaic code, which forms the ethical basis of each.

Few of the details of the biblical account of Moses's life can be verified historically, and some—he supposedly lived for 120 years—seem improbable. If Moses existed, he is thought to have lived sometime between 1200 and 1500 BC, in areas that are now in Egypt and Jordan. The time period in which he lived may have coincided with the rule of the Egyptian pharaoh Ramses II (c. 1303–1213 BC).

The Book of Exodus provides a sketch of Moses's origins. At about the time that Moses was born, according to the Bible, the pharaoh ordered the killing of every newborn male Hebrew child. Rather than complying, Moses's mother, Jochebed, placed her infant son in a reed basket in the Nile, where he was discovered by one of the pharaoh's daughters. He was adopted by the princess and raised as an Egyptian, but fled after killing one of the pharaoh's slave drivers.

Rejoining the Hebrews, he was ordered by God to free his people. According to Exodus, he returned to Egypt along with his brother, Aaron, to present his famous demand to the monarch: "Let my people go." When the pharaoh refused, God unleashed the Ten Plagues of Egypt—locusts, hail, the deaths of all firstborn sons, etc.—which finally forced the king to relent. Moses then led the Hebrews across the Red Sea, back in the direction of their ancestral homeland.

En route, he stopped at Mount Horeb, where God gave him the Ten Commandments. However, God became angry with Moses for his impatience and punished him by refusing to allow him to enter the Promised Land. Just before the Hebrews finally returned to Israel, Moses died on the top of Mt. Pisgah.

ADDITIONAL FACTS

1. *Moses is one of the lawgivers whose sculptures are included in the US Supreme Court Building in Washington, DC. Also featured are the Babylonian emperor Hammurabi, the English legal scholar William Blackstone (1723–1780), and other legal luminaries.*

2. *Actor Charlton Heston (1923–2008) played Moses in* The Ten Commandments, *a 1956 Bible epic directed by Cecil B. DeMille (1881–1959). Moses has also been portrayed by Mel Brooks (1926–), Val Kilmer (1959–), and Burt Lancaster (1913–1994), among many others.*

3. *The Ten Plagues of Egypt are commemorated by the Jewish holiday of Passover—so called because the calamities passed over the Hebrews and afflicted only their Egyptian tormentors.*

◆◆◆

Akhenaton

One of the most notable religious reformers of the ancient world, the Egyptian pharaoh Akhenaton attempted to reshape his country's religious traditions in a radical effort to stamp out old beliefs in favor of a new religion organized around a single sun god, Aton.

Akhenaton, who ascended to the Egyptian throne in about 1350 BC, was the son of the pharaoh Amenhotep III, who had ruled Egypt for about thirty-seven years. The young king was originally named Amenhotep IV, but changed his name after creating the new religion in the fourth year of his rule.

Prior to Akhenaton, Egyptians had worshipped a centuries-old pantheon of gods, including Osiris, the god of fertility, and Horus, the god of war. After rejecting the older gods, Akhenaton banned the worship of the traditional deities and ordered the destruction of many old temples.

Although Akhenaton seems to have been sincerely devoted to his new creed, the monarch's new religion also had important political implications. By removing the Egyptian priesthood from its traditional role as interlocutors between men and the gods and declaring that he alone could communicate with Aton, the king weakened the clergy's power and strengthened his own authority. To consolidate his rule, he even built an entirely new city in the desert, Akhetaten, and moved the Egyptian capital there from its old home in Thebes.

However, the general population never fully embraced Atonism during the king's seventeen-year reign. After the pharaoh's death, the child pharaoh Tutankhaten bowed to pressure from the priesthood to restore the old gods and move the capital back to Thebes. Within a few years, the Egyptians had rejected Atenism completely and moved to obliterate all vestiges of the iconoclastic pharaoh.

However, Akhenaton is considered an innovator, and the religion he created is often viewed as an intellectual ancestor of the monotheistic faiths.

ADDITIONAL FACTS

1. *Akhenaton wished to be portrayed in artworks as having a short torso and long arms, neck, and head. This unusual representation has led some modern scholars to suggest that Akhenaton may have suffered from a rare genetic malady called Marfan syndrome.*

2. *The new capital city's name, Akhetaton, meant "Horizon of Aton."*

3. *After abandoning Atonism, the boy king Tutankhaten also abandoned his name, which meant "Living Image of Aton." In its place he adopted the name by which he is now more widely known: Tutankhamen.*

◆◆◆

Nebuchadrezzar II

In the Bible, Nebuchadrezzar II (c. 630–c. 561 BC) was portrayed as a tyrannical king who conquered Jerusalem, destroyed the first temple, and forced the Jews into exile in Babylon. The Book of Jeremiah describes the devastation in stark metaphors.

> Nebuchadrezzar, the king of Babylon hath devoured me, he hath crushed me, he hath made me an empty vessel, he hath swallowed me up like a dragon, he hath filled his belly with my delicates, he hath cast me out.

One of the principal villains of the Old Testament, Nebuchadrezzar earned the animosity of the Jews by defeating the Judaean king Jehoiakim in 598 BC and then attempting to erase Judaism by kidnapping thousands of Israelites and deporting them to his capital city—a period of time in biblical history that would become known as the Babylonian Captivity.

In secular history, however, the portrait of Nebuchadrezzar is more nuanced. In addition to his military conquests, which stretched from Egypt to modern-day Turkey, the king is thought to have built the Hanging Gardens of Babylon, a massive feat of engineering that was one of the Seven Wonders of the Ancient World. The landmark, possibly constructed as a gift to Nebuchadrezzar's wife, was a series of terraced gardens connected by an artificial irrigation system. Although the gardens were later destroyed in an earthquake and no trace of them remains, they were thought to be located south of modern-day Baghdad.

The biblical narrative suggests that Nebuchadrezzar went insane near the end of his life. He was "driven from men, and did eat grass as oxen, and his body was wet with the dew of heaven, till his hairs were grown like eagles' feathers, and his nails like birds' claws." He died in about 561 BC.

ADDITIONAL FACTS

1. *According to legend, Nebuchadrezzar built the Hanging Gardens because his wife, a Median princess, was homesick for the gardens and forests of her native country.*

2. *In the 1999 film* The Matrix, *the aircraft piloted by Morpheus—played by Laurence Fishburne (1961–)—is called* The Nebuchadnezzar, *an alternate spelling of the king's name.*

3. *The name Nebuchadrezzar comes from the Akkadian words* Nabu-kudurri-usur, *meaning "Nebo, watch over my heir." Although once widespread in the Middle East, Akkadian had disappeared by AD 1.*

✦✦✦

Heraclitus

One of the key disputes that divided ancient Greek philosophers was the question of the elements. Some philosophers, such as Thales (620–546 BC), believed that water was the fundamental substance of the universe. Others, led by Anaximenes (585–525 BC), argued for air.

As for Heraclitus (c. 540–c. 480 BC), a wealthy aristocrat from the city of Ephesus whose writings burned with hostility toward his fellow citizens, he held with fire. Heraclitus posited that fire was the basic building block of nature from which all other substances were derived.

Little is known about the life of Heraclitus. But the surviving fragments of his works show a deep contempt for other Greeks, and especially for his neighbors in Ephesus, a prosperous city on the coast of present-day Turkey. (In one text, he recommended that the citizens "would do well to hang themselves, every grown man of them.")

Heraclitus believed that the dispute over the makeup of the universe carried important philosophical implications. Because the world was made up of fire, Heraclitus theorized, it was constantly changing. This idea—that the world was in constant flux—was one of the most important tenets in his philosophy.

The world, he wrote, "is now, and ever shall be an ever-living Fire, with measures kindling and measures going out." Amid the constant transformation, Heraclitus wrote, there were few constants—an idea that put him in opposition to other Greek philosophers who sought to define eternal truths. Because he believed that change was inevitable and constant, he argued that people could not be trusted to manage their own lives and should be forcibly led in the right direction by authoritarian measures. "Asses would rather have straw than gold" and needed to be prodded to act in their own best interests, he wrote.

After spending his last years eating herbs and grass and avoiding human contact, Heraclitus died at about age sixty. But his writings continued to challenge later philosophers, including Plato (c. 429–347 BC), who tried to disprove some of Heraclitus's theories.

As for the elements, the Greeks eventually concluded that the universe was made up of four elements—earth, air, fire, and water. This view would prevail for centuries, until the development of modern chemistry.

ADDITIONAL FACTS

1. *Ephesus was the home of the Temple of Artemis, one of the Seven Wonders of the Ancient World, which was completed in roughly 550 BC. The city is now known as Efes, Turkey.*

2. *The philosopher is sometimes known as Heraclitus the Obscure because of the supposed difficulty of his writing style.*

3. *Heraclitus was a critic of the ancient Greek poet Homer, once writing that Homer should have been beaten for writing* The Odyssey *and* The Iliad.

◆ ◆ ◆

Pythagoras

All things are numbers.
—**Pythagoras**

Pythagoras (c. 580–c. 500 BC) was the founder of an ancient Greek religious cult whose members believed that the study of math and science would bring them closer to God. In the course of their religious devotions, his tight-knit community of disciples developed several of the basic precepts of math and geometry, including the famous Pythagorean theorem, earning their teacher a reputation as one of the fathers of mathematics.

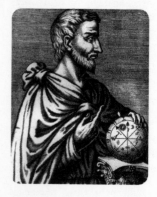

Born on the island of Samos, off the coast of Turkey, Pythagoras moved to the southern Italian city of Croton at about age forty. After founding the Pythagorean sect, he moved with his followers to Metapontum, another city in Greek-speaking southern Italy.

Belief in reincarnation was the central tenet of the Pythagorean religion. Pythagoras taught that the soul was indestructible, but that people needed to follow certain rules to ensure the best possible reincarnations after their physical deaths. Among the rules adopted by his followers: no wearing shoes in the temple, no touching white roosters, put the right shoe on first, and always abstain from eating beans.

Pythagoras also believed that the study of mathematics was a religious duty. Pythagorean mathematicians were able to prove the famous theorem $a^2 + b^2 = c^2$—the square of the hypotenuse of a right triangle is always equal to the sum of the squares of the other two sides. Pythagoreans also introduced the concepts of irrational numbers (numbers that can't be expressed as fractions) and the square root.

Little of Pythagoras's life is known, but dozens of improbable myths—that he had the ability to write on the moon, that he could travel through time—arose after the philosopher-mathematician's death. His followers continued to flourish for several hundred years before dwindling away.

ADDITIONAL FACTS

1. *To become a Pythagorean, it was believed that would-be disciples had to remain silent for five years as a way of demonstrating their self-control.*

2. *According to one myth about Pythagoras, his thigh was made of gold. He was also supposedly capable of being in two places at the same time.*

3. *In addition to avoiding beans, Pythagoras purportedly told his followers not to eat sea anemones, plough-oxen, or the heart of any animal.*

◆◆◆

Jezebel

A villain of the Old Testament, Jezebel was a Phoenician queen whose name has become synonymous with wicked women. In the biblical account, she repeatedly tried to coerce the Israelites into worshipping her god, Baal, and then had the prophets of Israel murdered when they refused.

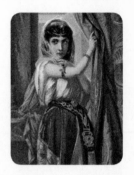

Jezebel's story is related in two books of the Old Testament, 1 Kings and 2 Kings. Whether she was an actual person—and whether she deserves her dastardly reputation—is the subject of scholarly debate. If real, she would have lived in the ninth century BC.

Described in the Bible as the daughter of a king, Jezebel was married to King Ahab, the ruler of the northern Israelites. Another unpopular figure in the Old Testament, Ahab was one of a string of bad rulers whose sins had incurred God's wrath. Indeed, in the words of the King James Bible, "Ahab did more to provoke the Lord God of Israel to anger than all the kings of Israel that were before him."

At Jezebel's urging, Ahab allowed the worship of the Phoenician god Baal. She also urged Ahab to give the temples of Baal financial support and supposedly used unspecified sexual temptations to attract new worshippers. After Ahab's death, her sons, Ahaziah and Jehoram, took over the kingdom while their mother continued her pro-Baal activities.

Baal was widely worshipped across the Mediterranean, and it is likely that the story in the Bible is a roughly accurate description of ancient religious strife in the Middle East. A seal that may have belonged to Jezebel was unearthed in the early 1960s, although many scholars have dismissed theories that it had any connection to the biblical figure.

Jezebel's demise, according to the Bible, came after Jehu was commissioned by God to "smite the house of Ahab" and end the "whoredoms" and "witchcrafts" of Jezebel. After killing Jehoram, Jehu cornered Jezebel at her palace. Knowing she was about to be killed, she put on her makeup (hence the term "painted Jezebel") and confronted him. He ordered her thrown out of a window, where her body was torn apart by dogs—ensuring, in the Old Testament's charming description, that "the carcass of Jezebel shall be as dung upon the face of the field."

ADDITIONAL FACTS

1. *A jezebel is also a type of Asian butterfly. Males of the species are pale, while females are vividly colorful.*

2. *Jezebel means "Where is His Highness?" in Phoenician.*

3. *The term* Jezebel, *once used as a pejorative, has been adopted by feminist groups, women's magazines, and even a lingerie line.*

✦✦✦

Sappho of Lesbos

The namesake of the word *lesbian,* Sappho of Lesbos (c. 630–c. 570 BC) was an ancient Greek poet and teacher. Although very few of her love poems have survived into modern times, she was immensely popular in the ancient world and exerted a major influence on later Greek and Roman poets.

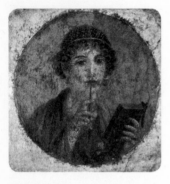

Indeed, her reputation was such that centuries after her death, Plato (c. 429–347 BC) called Sappho the "tenth muse"—comparing her to the celebrated nine goddesses of arts and literature in Greek mythology. She was "violet haired, pure, honey-smiling Sappho," according to another ancient admirer.

More recently, fragments of several of Sappho's lyric poems have been rediscovered, and she has been reclaimed as one of the earliest writers in Western history on homosexual themes. Several recent translations of Sappho's work have been published, novels have been written about her life, and her home island has become a magnet for lesbian tourists.

Sappho lived most of her life on Lesbos, an island in the Aegean Sea, although some historical evidence suggests she was briefly exiled to Sicily. She was probably a member of the island's elite, had at least two brothers, and may have given birth to a daughter named Cleis.

Filled with love, eroticism, jealousy, and longing, Sappho's poems were mostly directed at women, though several were addressed to men. In one characteristically vivid poem, she describes her jealous reaction upon seeing a woman she desires with a man: " . . . cold sweat holds me and shaking / grips me all, greener than grass."

After her death, Sappho's poetry was organized into nine books and read by Ovid (43 BC–c. AD 17), Catullus (c. 84–c. 54 BC), and other classic poets. Much of it was destroyed during the Middle Ages, when many Greek classics were lost; only one of her poems, "Hymn to Aphrodite," still exists in complete form.

ADDITIONAL FACTS

1. *According to the* Oxford English Dictionary, *the term* lesbian *entered usage as a synonym for* homosexual woman *in the nineteenth century. The use of* gay *as a synonym for* homosexual man *may have originated as early as the nineteenth century as well.*

2. *In total, only about 1,000 lines of Sappho's poetry still survive, much of it on tiny scraps of papyrus.*

3. *In 2008, three residents of Lesbos asked a court in Greece to prevent gay and lesbian groups from using the word* lesbian, *contending that it unfairly stereotyped the island's inhabitants. The suit was dismissed.*

✦✦✦

Solon

One of the fabled Seven Wise Men of ancient Greece, Solon (c. 658–560 BC) was a statesman and military leader whose reforms of the Athenian system of government led to the world's first democracy.

Born into an aristocratic family, Solon first achieved fame as a general after he led a successful campaign against Megara, a rival city-state, for control of the island of Salamis. According to the ancient historian Plutarch (c. 46–c. 120 BC), Solon was elected lawgiver in 594 BC.

The system of government in place when Solon took office was largely the legacy of a previous lawgiver, Draco. Famously strict, Draco's laws called for the death penalty for even minor offenses such as idleness or stealing fruit from an orchard.

Solon revised the laws and made punishments less severe for almost all crimes. He also set out to reform the city's system of government by transferring more political power from the nobility to the people. His goal was to restore *eunomia*—good order—to the city by making all Athenians feel as if they had a stake in its governance. He made it legal for any citizen to bring a lawsuit, opened juries to all, and created a representative body, the Council of the Four Hundred, an ancestor of democratic assemblies.

After his two-year term expired, Solon left Athens and spent ten years traveling across the Mediterranean. (He ostensibly left so that Athenians could not pester him with requests to repeal his laws.) When he returned to Athens near the end of his life, however, he was disgusted to discover that many of his reforms had been abandoned.

Although they lasted only a few years, Solon's reforms served as the first step in the democratization of the Greek constitutional system. In 507 BC, long after Solon's death, an Athenian nobleman named Cleisthenes (c. 570–c. 508 BC) took power in the city and installed a democratic government based on Solon's laws, leading to an unprecedented flourishing of the city's culture, philosophy, and military power.

ADDITIONAL FACTS

1. *According to the ancient historian Diogenes Laërtius, Solon was a distant relative of the Greek philosopher Plato (c. 429–347 BC), who lived about two centuries later.*

2. *Solon was also a poet, and he published verse in support of his constitutional reforms. They are among the earliest poems in Greek literature.*

3. *Both Solon and his predecessor, Draco, inspired words in the English language. A* solon *is a wise lawmaker, while* draconian *refers to laws or penalties that are particularly harsh.*

♦♦♦

Jeremiah

One of the major prophets of the Old Testament, Jeremiah (c. 627–c. 586 BC) is also one of the relatively few figures of the Hebrew Bible who can be matched to historical events. The son of a Jewish priest named Hilkiah, he was born in a village near Jerusalem in c. 650 BC, preached in what is now northern Israel, and probably died in Egypt sometime after c. 570 BC.

Jeremiah's lifetime coincided with one of the greatest calamities in ancient Jewish history, the destruction of Jerusalem in 586 BC and the subsequent period known as the Babylonian Exile, when the Israelites were forcibly deported to Babylon. The exile of the Jews from their homeland to present-day Iraq lasted about fifty years and would form a pivotal chapter in the religion's history.

To Jeremiah, the conquest was nothing less than divine punishment for the nation's collective sins. For years prior to the exile, he had warned that the nation was incurring God's wrath by permitting social injustices and lax observance of religious laws. Many Jews, he charged, had even resumed worshipping other gods, such as Ishtar and Baal, thus breaking their monotheistic traditions.

Jeremiah's preaching, recorded in the Old Testament's book of Jeremiah, was fiery and often vivid in its language. If the Jews didn't clean up their acts, he had warned, God would have his revenge.

> Then will I cause to cease from the cities of Judah, and from the streets of Jerusalem, the voice of mirth, and the voice of gladness, the voice of the bridegroom, and the voice of the bride: for the land shall be desolate.

Jeremiah's constant warnings did not make him popular among his fellow Israelites, either. During the Babylonian invasion, he was imprisoned in a cistern for attempted desertion. Ironically, it was the Babylonians who allowed him to go free. The invaders treated him with respect and even allowed him to stay with the "remnant" of the population of Judah that remained in Jerusalem instead of joining the other Jews in exile.

After the invasion, Jeremiah continued to preach, telling the Jews that if they rededicated themselves to their religion, God would forgive them. By some accounts, he was stoned to death by fellow Israelites who were tired of his harangues.

ADDITIONAL FACTS

1. *The word* jeremiad *is now used to describe a sermon meant to warn listeners of the consequences of their actions.*

2. *Jeremiah was not a bullfrog, as a hit song by the rock band Three Dog Night asserted. But according to the Bible, he did have some mighty fine wine: In one passage, God instructs Jeremiah to bring wine to the Rechabites, a small sect that abstained from alcohol, and to tempt them to drink it. However, the Rechabites obeyed their rules and refused, which God then used as an example of how the Jews ought to obey their own laws.*

3. *In addition to the book of Jeremiah, the prophet is sometimes credited with writing 1 Kings, 2 Kings, and Lamentations.*

✦✦✦

Cyrus the Great

Cyrus the Great (c. 600–529 BC) conquered large portions of present-day Turkey, Iran, and Iraq and founded the Persian Empire, a vast kingdom that became one of the ancient world's great powers. He also appears in the Bible as the king who freed the Jews from captivity in Babylon and allowed them to return to Jerusalem—an event that is thought to have taken place in about 539 BC.

After the death of his father in 552 BC, Cyrus became the ruler of a small kingdom, Persis, from which he launched a series of invasions. He conquered several neighboring states, including the Median Empire and the Lydian Empire. In one famous episode, Cyrus captured the legendarily wealthy Lydian king Croesus (595–c. 547 BC) and prepared to burn him alive before an omen convinced him to let the deposed king live.

In 539 BC, Cyrus entered the biblical narrative when he attacked the Babylonian Empire. The Jews had been deported to Babylon fifty years earlier, and after taking control of Babylon, Cyrus granted them permission to return to their homeland.

The conquest of Babylonia was Cyrus's last major territorial acquisition. In a span of less than twenty years, he had assembled an empire that stretched from the Bosporus Strait in the west to the Himalayas in the east. Within his domain, Cyrus was notable for allowing a high degree of religious tolerance.

Cyrus died in about 530 BC and was buried in his capital city of Pasargadae, in present-day Iran. The dynasty he established would fight several wars against the Greek city-states before it was eventually conquered by Alexander the Great (356–323 BC) in 330 BC.

ADDITIONAL FACTS

1. *A historical book based on the life of Cyrus that was written centuries after his death,* Cyropaedia, *was one of the favorite books of Thomas Jefferson (1743–1826).*

2. *Cyrus appears in three books of the Old Testament: Ezra, Isaiah, and Daniel. His liberation of the Jews was purportedly foretold by the prophet Daniel.*

3. *The leader of the Branch Davidian cult, David Koresh (1959–1993), believed that he was a modern reincarnation of Cyrus and renamed himself after the Hebrew word for the king's name,* Koresh. *Koresh and many of his followers were killed during a government raid on their compound in 1993.*

◆◆◆

Zeno of Elea

Why didn't the chicken cross the road? According to the ancient philosopher and logician Zeno of Elea (c. 495–c. 430 BC), the bird simply found it impossible to get to the other side.

Here's why: To cross the road, the chicken first has to strut to the halfway mark. That's easy enough. But then, logically, the bird has to fly, hop, or flutter half the remaining distance to reach the three-quarters point. After that, it has to cover half the remaining distance. No matter how far the chicken goes, it still has half of an ever-smaller remaining distance to travel. Therefore, Zeno concluded, nothing can ever really get anywhere.

The scenario is the most famous of Zeno's paradoxes, a set of logical riddles that have perplexed and infuriated philosophers for 2,000 years. The paradoxes are the most famous legacy of the Greek-speaking logician, who taught at a famous philosophy school in southern Italy.

Like the above dichotomy paradox, several of Zeno's other paradoxes were also "arguments against motion." One, the story of Achilles and the tortoise, asks whether a fast runner can ever catch up with a slowly moving tortoise that has a head start. The runner first has to reach the tortoise's starting point. But because the tortoise will have crawled to a second location by then, the runner still needs to keep moving. By the time the runner reaches the tortoise's second position, the tortoise will again have moved. No matter how speedy he is, the runner can never catch up.

Of course, as Zeno knew, runners do catch up with and pass slower objects. And sometimes, the chicken really does cross the road. The provocative question Zeno raised in his paradoxes is—*how?*

Little is known about Zeno's life. His influence, however, was great. By challenging his students to ponder the underlying dynamics of motion, Zeno inspired thinkers who would make major discoveries in mathematics and physics.

Zeno came to a violent end when he was implicated in a plot to kill a local tyrant. Under torture, the philosopher refused to name his coconspirators, instead biting off the ear of his torturer—first halfway, then all the way—before he was executed.

ADDITIONAL FACTS

1. *Zeno was born in the southern Italian town of Elea, which is now known as Velia. At the time, the area was under the control of the Ionian Greeks.*

2. *Another of Zeno's famous riddles, the "arrow paradox," questions whether an arrow can ever actually move. The scenario asks, If every object that occupies a single space is at rest, and if any object when in motion occupies a space at any particular moment, then how can an arrow move at all?*

3. *Rudimentary calculus, which was developed in the Greek world after Zeno's death, provided solutions to some of Zeno's paradoxes. Others have been "solved" by rejecting the philosopher's fundamental premises. For example, the arrow paradox presupposes that the arrow is "at rest" at a given moment, but that is not a condition that is ever actually met, since Earth is in constant motion.*

✦✦✦

Hippocrates

Do no harm.
—**Hippocrates**

Hailed as the father of medicine and the first physician, Hippocrates (c. 460–c. 375 BC) was a pioneer in the scientific study of the human body and the first to document many diseases. He is best known today for the Hippocratic oath, the vow taken by many new doctors that serves as the ethical foundation of the medical profession.

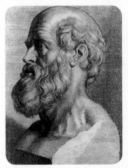

Hippocrates was born on the Greek island of Kos, just off the coast of modern-day Turkey. His father and grandfather were both doctors, and Hippocrates received his medical training at the island's *asklepieion,* or healing temple.

In ancient Greece, diseases were interpreted as divine punishments, and treatment often involved prayer and sacrifices to the gods. But Hippocrates believed that diseases had natural causes and could be cured by changes in diet or with medicine.

After founding a medical school on Kos, Hippocrates traveled throughout the Greek islands, earning a reputation as a healer. He is also believed to have written the *Corpus Hippocraticum,* a compilation of medical treatises that included the Hippocratic oath.

The oath required doctors to respect the privacy of their patients, prescribe the proper medicines, avoid sexual entanglements with patients, and share their learning with other doctors. The creed, and the professionalization of the practice of medicine it entailed, remains perhaps the Greek doctor's greatest legacy.

Like those of many other ancient Greek thinkers, Hippocrates' biography was compiled long after his death, and few details about his life are known with any certainty. But according to some sources, he lived to be about 100 and died in the Greek city of Larissa.

ADDITIONAL FACTS

1. *Several diseases and disorders are named for Hippocrates, including Hippocratic face, the gaunt facial appearance that Hippocrates first observed to often precede death.*

2. *Most doctors today take a modified version of the Hippocratic oath that omits several obsolete sections found in the original. For instance, the classic version of the oath prohibited doctors from performing surgery with a knife.*

3. *While versions of the Hippocratic oath remain in use today, most of the actual medical theories devised by the Greek doctor have been rejected by modern medicine. For instance, Hippocrates believed the body was governed by four "humors"—blood, black bile, yellow bile, and phlegm—an idea that is now rejected.*

✦✦✦

Coriolanus

Gaius Martius Coriolanus was a Roman general who won a major victory against the Volscians, but then joined the city's enemies because he resented the lack of appreciation shown by his countrymen. His betrayal earned him a starring role in *Coriolanus,* a tragedy by William Shakespeare (1564–1616) about the legendary general and traitor.

Although he is described by the Roman historians Plutarch (c. 46–c. 120) and Livy (c. 59 BC–AD 17), it is not known with certainty whether Coriolanus was an actual historical figure; Shakespeare, who based his play on Plutarch, took many liberties with even that account.

In Plutarch's telling, Coriolanus was a member of the patrician, or aristocratic, caste in ancient Rome. His father died when he was young, and the boy was raised by his mother, the inspiration for the character Volumnia in Shakespeare. He joined the Roman army and fought in wars against the city's exiled Tarquin kings.

The Volscians were a tribe who lived southwest of Rome and fought several wars with the Romans. Coriolanus was given his name in recognition of his bravery during the siege of Corioli, the most important Volscian city, in 493 BC.

After the battle, he returned to Rome and, in debates over Rome's political future, emerged as an enemy of the commoners (the plebeians) and an opponent of democratic rule. Coriolanus believed he was entitled to deference because of his military success, but he was eventually banished from the city by his opponents. In exile, he joined with his former enemies, the Volscians, and moved to their capital at Antium. The Volscians turned on him, however, and he was murdered after refusing to attack Rome.

Although he merits only a footnote in Roman history, the Shakespeare play has ensured the general an enduring place in Western culture. (He is even mentioned in the musical *Kiss Me, Kate* (1948): "If she says your behavior is heinous / Kick her right in the Coriolanus.") His story is also sometimes cited as a parable of a military officer who feels he has been denied recognition and influence after war.

ADDITIONAL FACTS

1. *Actors Laurence Olivier (1907–1989), Richard Burton (1925–1984), and Morgan Freeman (1937–) have portrayed Coriolanus. According to* Variety, *Ralph Fiennes (1962–) will direct and star in a Hollywood adaptation of the play in 2010.*

2. *The city of Antium is now known as Anzio. It was the site of a major Allied landing in 1944, during World War II.*

3. *Ludwig van Beethoven (1770–1827) wrote an orchestral piece about Coriolanus, the* Coriolan Overture, *in 1807. The general is also the subject of a Bertolt Brecht (1898–1956) play,* Coriolan (1952), *which was based on the Shakespeare play.*

+++

Aeschylus

He who learns must suffer.
—Aeschylus, in *Agamemnon*

The founder of tragedy, Aeschylus (c. 525–c. 455 BC) is one of the earliest play-wrights whose work has survived into modern times. Written at the dawn of democratic Athens, Aeschylus's plays are both the starting point of Western drama and a window into the culture of the ancient Greeks.

Born in Attica, the region that surrounds Athens, Aeschylus served in the Athenian army and fought at the Battle of Marathon in 490 BC and again at the Battle of Salamis in 480 BC. The two victories, both against the Persian Empire, preserved the independence of Athens and provided the historical basis for Aeschylus's oldest surviving play, *The Persians* (472 BC).

The play is somewhat unusual in that Aeschylus attempts to tell the story of the war from the Persian perspective, rather than from the standpoint of the victorious Greeks. It takes place in Susa, the Persian capital, and portrays the Persian defeat as a tragedy caused by the hubris, or pride, of King Xerxes (519–465 BC). Xerxes, in Aeschylus's depiction, had incurred the wrath of the gods by building a bridge across the Hellespont, an action that led to his defeat.

The Oresteia, a trilogy of plays about Agamemnon, a legendary king of Argos, dates to about 458 BC. Like *The Persians,* the three tragedies revolve around fatal flaws in their heroes that eventually bring about their ruin. *The Oresteia* also introduced several famous characters in Western literature, including Cassandra, who had the gift of prophecy but was doomed to be ignored or disbelieved. Aeschylus's tragedies established many of the conventions of Greek drama and would have a major influence on later Greek playwrights such as Sophocles (c. 496–406 BC) and Euripides (c. 484–406 BC).

Little else is known about Aeschylus's life. He won a number of theatrical contests in Athens, and the total number of plays he wrote is estimated at more than ninety, but only seven remain in existence. He died while visiting the island of Sicily, where, according to legend, a bird dropped a tortoise on his head, killing him.

ADDITIONAL FACTS

1. *A play thought to have been written by Aeschylus,* Prometheus Bound, *was the inspiration for the epic poem* Prometheus Unbound *(1820) by English Romantic poet Percy Bysshe Shelley (1792–1822).*

2. *In ancient Athens, no violence could be performed onstage. As a result, the copious violence in Aeschylus's plays all takes place offstage and is left to the viewer's imagination.*

3. *Many of Aeschylus's plays debuted at the Theater of Dionysius in Athens. The ruins of the theater, which held about 17,000 spectators, are located on the south side of the Acropolis.*

❖❖❖

Lucius Junius Brutus

The semilegendary founder of the Roman Republic, Lucius Junius Brutus overthrew the last king of Rome. After driving the monarch into exile, he put power in Rome into the hands of the Senate, the representative institution that would govern the city and its growing empire for the next five centuries.

The Roman Republic, in turn, would serve as a model for the authors of the United States Constitution. Inspired by ancient Rome, delegates to the Constitutional Convention in 1787 named the upper house of the legislature the Senate.

According to Roman histories, however, the founder of the republic was far from an idealist. The revolt against the king of Rome began as a personal vendetta after one of the king's sons raped one of Brutus's relatives. The rape of Lucretia by Sextus Tarquinius was one of the most famous scandals in ancient Rome, as well as a turning point in the city's history.

The Tarquins, an Etruscan noble family, had ruled Rome since shortly after its founding in 753 BC. At the time of Brutus, the throne was held by Lucius Tarquinius Superbus, or Tarquin the Proud. Tarquin had seized power by murdering his own father-in-law, Servius Tullius, in the first of many killings during his rule.

Brutus, a distant relative of the Tarquins, was originally an ally. But in about 509 BC, while away at war, he heard about the rape of Lucretia and rushed back to Rome. Believing that the family name had been dishonored, Lucretia committed suicide; Brutus supposedly grabbed the bloody dagger from her hand and vowed to overthrow the king.

After driving out the king, Brutus repulsed several attempts by the Tarquins to recapture Rome. According to legend, Brutus even executed his own two sons, Titus and Tiberius, after they joined a plot to restore the monarchy. He forced Roman citizens to take an oath never to accept a king; opposition to monarchy would later become a central part of the political self-identity of many Romans.

The death of Brutus, according to the Roman historian Titus Livius (c. 59 BC–AD 17), also known as Livy, occurred during a battle when he and one of the ex-king's sons, Arruns Tarquinius, killed one another in one-on-one combat.

ADDITIONAL FACTS

1. *According to Roman lore, Brutus passed his loathing of the monarchy on to his descendants. One of them was Marcus Junius Brutus (85–42 BC), one of the assassins of Julius Caesar (100–44 BC), who hoped to prevent Caesar from crowning himself king.*

2. *Lucretia figures in several of Shakespeare's plays and is the main character in* The Rape of Lucrece, *a narrative poem published in 1594.*

3. *The name Senate, originally denoting a gathering of Roman noblemen, is derived from the Latin word* senex—*meaning "old man." The Roman Senate remained in existence for more than a millennium but disbanded in the sixth century, after the collapse of the Roman Empire.*

✦✦✦

Zoroaster

For more than 2,000 years, Zoroastrianism was the dominant religion of large swaths of modern-day Iran and India. The faith's founder and namesake was a poet and prophet named Zoroaster, or Zarathustra, who lived in Persia in roughly the seventh century BC.

Although his teachings have had a profound impact on Asian culture and world religion, few historical details of Zoroaster's life are known, and even the century of his birth is disputed. It is believed that he was born in about 628 BC in central Asia, probably in what is now Iran, and trained as a priest at a local temple.

In mythology, Zoroaster is depicted as a religious visionary who struggled for acceptance before he ultimately prevailed. He supposedly left home against his parents' wishes at age twenty and spent ten years in a spiritual quest that culminated in a vision of what he called the "good religion." He then spent another ten years seeking converts, with little success, until he cured the sick horse of a Bactrian king, who then embraced Zoroastrianism. Many years later, when he was seventy-seven, Zoroaster was murdered under mysterious circumstances.

After his death, Zoroaster's teachings spread quickly through Asia and became the major faith of the Persian Empire. Zoroastrians worship Ahura Mazda, the supreme being and ultimate judge of souls, and believe in an afterlife in which the good people are separated from the evil. With its emphasis on a single god and a final judgment at the end of time, Zoroastrianism presaged many Jewish and Christian beliefs. It also bears many similarities to Eastern religions, including Hinduism and Buddhism.

After Islamic conquests of Persia in the seventh century AD, the center of Zoroastrianism shifted to western India. The number of practicing Zoroastrians plummeted during the twentieth century, and there are believed to be fewer than 200,000 adherents remaining worldwide, mostly in India and Iran.

ADDITIONAL FACTS

1. *Zoroastrians do not proselytize or accept converts, practices that have contributed to their steadily declining numbers.*

2. *Famous contemporary Zoroastrians include Zubin Mehta (1936–), the former conductor of the New York Philharmonic orchestra.*

3. *The German philosopher Friedrich Nietzsche (1844–1900) published a book called* Also sprach Zarathustra *in 1885 that argued against many of Zoroaster's teachings on morality. The book inspired composer Richard Strauss (1864–1949) to write a tone poem of the same name; that composition, in turn, was used as the theme to the 1968 movie* 2001: A Space Odyssey.

✦✦✦

Pericles

One of the most influential leaders of Athens during its golden age, Pericles (c. 495–429 BC) was a general and politician who helped transform the city-state into both a military power and a center of art and philosophy. His role in the city's success was so great that the period of prosperity from about 460 to 429 BC is sometimes called the Age of Pericles.

Pericles was "the first man of his time at Athens, ablest alike in counsel and in action," wrote the Greek historian Thucydides (c. 460–c. 404 BC).

Both of Pericles' parents came from aristocratic Athenian families, and he received an extensive education in music, rhetoric, and philosophy. He grew up during a period when Athens repulsed several attacks from Persia.

Pericles became involved in politics in 461 BC, when he helped organize a vote in the city's democratic assembly to strip the nobles of their remaining power. After the vote, Pericles emerged as one of the most powerful figures in the city. His major opponent, Cimon (510–450 BC), was ostracized later that year, clearing the way for Pericles to rule Athens unopposed for most of the next three decades.

In office, Pericles was known as a champion of the common man and a defender of democratic government. His Funeral Oration, delivered at a service for Athenian soldiers killed in war, is one of the most famous defenses of democracy ever written.

> It is true that we are called a democracy, for the administration is in the hands of the many and not of the few. But while there exists equal justice to all and alike in their private disputes, the claim of excellence is also recognized; and when a citizen is in any way distinguished, he is preferred to the public service, not as a matter of privilege, but as the reward of merit.

Within Athens itself, Pericles also built the Acropolis, opened theaters, and sponsored playwrights such as Aeschylus (c. 525–c. 455 BC) and Euripides (c. 484–406 BC). The sculptor Phidias (c. 490–c. 430 BC), who carved the marble figures on the Acropolis, was a friend and political ally of Pericles.

Pericles died in 429 BC, in the midst of the war with Sparta. His death, and the eventual Athenian defeat in the war, ended the city's golden age.

ADDITIONAL FACTS

1. *Pericles was a friend of Aeschylus and sponsored the first performance of the latter's historical play* The Persians *(472 BC), which recounts the aftermath of the Athenian victory at Salamis.*

2. *The term* Periclean Age *is sometimes used to denote the golden age of a country or industry. For instance, in 2005, one* Time *magazine movie reviewer referred to the 1930s and 1940s as the "Periclean Age of Celluloid" in an article about the movie industry.*

3. *The Parthenon was dedicated to Athena, the Greek goddess of battle and of the city of Athens. It took fifteen years to build and used 20,000 tons of marble. The structure later served as a Christian church and an Islamic mosque before it was protected as a historical site in the nineteenth century.*

◆◆◆

Socrates

The unexamined life is not worth living.
—Socrates

The master teacher of ancient Athens, Socrates (c. 470–399 BC) mentored a generation of Greek philosophers and is remembered today as one of history's most influential thinkers. A political gadfly and intellectual provocateur, he clashed repeatedly with his fellow Athenians about politics, morals, and ethics, challenging them to justify their most cherished beliefs.

The teacher's constant dissent, however, eventually caught up with him: At age seventy-one, the great philosopher was arrested for insulting the city's leadership, prosecuted in one of history's most famous trials, and finally forced to commit suicide by drinking the poison hemlock.

Oddly for a philosopher of such influence, Socrates never wrote anything. Instead, his reputation was established by a former student, Plato (c. 429–347 BC). Indeed, details of Socrates' life are so sketchy that historians refer to the cloud of unverifiable stories surrounding the philosopher as the *Socratic problem.*

Socrates lived in Athens during a period that encompassed both its golden age under Pericles (c. 495–429 BC) and its decline. He fought in several wars for the city but avoided politics and was suspicious of the city's democratic system of governance.

In person, Socrates had a striking appearance and a unique teaching style. He dressed in shabby clothes, grew his hair long, and apparently had no paying job. Students in Athens sought out Socrates for lessons, for which he refused to charge fees. He developed the *Socratic method,* a method of teaching that involved relentless questioning of the underlying values and assumptions of his students. Instead of drilling students on information, he would simply ask probing questions that helped his pupils explore the nuances and contradictions of religion and politics.

By the end of the fifth century BC, Athens faced mounting woes because of military setbacks and a short-lived coup against the city's democracy. The city's leaders, tired of Socrates and his incessant questions—and perhaps seeking a scapegoat—arrested the philosopher on charges of corrupting the city's youth and condemned him to death. Although he was given the choice to flee into exile, Socrates was convinced that no philosopher should fear death, and he voluntarily drank the hemlock.

ADDITIONAL FACTS

1. *Socrates was played by Tony Steedman (1927–2001) in* Bill and Ted's Excellent Adventure *(1989).*

2. *The hemlock that Socrates drank at his execution is unrelated to the hemlock tree, an evergreen native to North America and Asia that is not poisonous.*

3. *Impetuous to the end, Socrates was asked after his conviction what punishment he thought would be appropriate for his crime. He answered that he should be given a pension from the city to thank him for having exposed the ignorance of its leaders.*

Aristarchus

Long before Copernicus, the Greek astronomer and mathematician Aristarchus (c. 310–c. 230 BC) theorized that the earth revolves around the sun. But his findings were rejected by most other Greeks and then largely forgotten until his vindication almost 2,000 years later.

Aristarchus was born on Samos, a Greek isle near the coast of modern-day Turkey that was also the birthplace of the mathematician and religious leader Pythagoras (c. 580–c. 500 BC). Some of Aristarchus's ideas are thought to have been influenced by related beliefs of the Pythagoreans, who were still influential in the Greek world for centuries after their founder's death.

After leaving Samos, Aristarchus settled in Alexandria. He became a student of Strato of Lampsacus (c. 335–c. 269 BC), who had been one of Aristotle's disciples in Athens. Aristotle, along with most other Greeks of the time, believed that the earth was the unmoving center of the universe, a view that Aristarchus was almost certainly taught.

The only surviving work by Aristarchus is *On the Sizes and Distances of the Sun and Moon.* In the treatise, Aristarchus tried to calculate the sizes of the two celestial bodies and their distances from the earth. Although his estimates were way off, he correctly realized that the sun was far larger than the earth.

That discovery apparently led him to question whether the comparatively tiny earth could really be the center of the universe. Unfortunately, all of Aristarchus's later writings are lost, but the Greek engineer Archimedes (c. 287–c. 212 BC) recorded that Aristarchus eventually proposed a new model of the universe that put the sun at the center. Aristarchus also surmised—correctly—that the stars were celestial objects like the sun and were located at far greater distances from the earth than most ancients assumed. He also theorized that the movement of the stars in the sky was actually caused by Earth's spinning on its axis, another view that proved correct.

The heliocentric model, however, was ignored or ridiculed by most Greeks—including Archimedes. Nearly four centuries later, the astronomer Ptolemy (c. 100–170) published the geocentric *Almagest,* which would be the dominant astronomy text in the Western world through the Middle Ages. Not until Nicolaus Copernicus (1473–1543) published *De revolutionibus orbium coelestium libri VI* in 1543 would another scientist finally confirm Aristarchus's bold conclusion.

ADDITIONAL FACTS

1. *One of the most prominent craters on the moon was named in the Greek astronomer's honor. The Aristarchus crater is relatively young—the impact that created it occurred about 450 million years ago—and is often visible to the naked eye from Earth.*

2. *According to the ancient historian Plutarch (c. 46–c. 120), a critic of Aristarchus's named Cleanthes (c. 330–c. 230 BC) suggested bringing charges of impiety against the astronomer because his heliocentric model removed the earth from the central role.*

3. *Aristarchus performed all of his observations without a telescope, resulting in many errors.*

◆◆◆

Aristides

The politician Aristides the Just (530–468 BC) earned an impeccable reputation in ancient Athens. He refused to take bribes, steal public money, or grant favors to his friends. He was a successful general at the Battle of Marathon in 490 BC, but never sought personal glory for his victories. One contemporary called him the "worthiest" man of Athens.

Aristides.

Indeed, so morally upright was Aristides that he was widely detested by his fellow citizens, and in 482 BC they voted to expel him from the city. "I don't even know the fellow," said one Athenian who voted in favor of expulsion, "but I am tired of hearing him everywhere called 'The Just.'"

The banishment of Aristides, however, would soon come to be regretted. Two years after his expulsion, Greece was invaded again by the Persians, who defeated the Greeks at the Battle of Thermopylae and seemed poised to overrun the whole region. Humbled, the citizens of Athens were forced to beg Aristides to return from exile to organize the city's defense.

Along with Themistocles (c. 524–460 BC)—an Athenian politician who had led the campaign to expel Aristides just two years before—Aristides took charge of the alliance of Greek city-states formed to fight the Persians. They defeated the Persian navy at the Battle of Salamis in 480 BC and then the army at the Battle of Plataea the next year. The victory at Plataea effectively ended the Persian invasion.

When the Greek alliance began to break down after the war, Aristides led the diplomatic effort to ensure that Athens, not Sparta, would emerge as the leading Greek city. Able to win the trust of other cities because of his reputation for integrity, Aristides was one of the architects of the Delian League, a confederacy led by Athens that was formed in 478 BC.

Little is known about the rest of Aristides' life. He returned to politics and, according to Plutarch (c. 46–c. 120), died in poverty—a consequence of his refusal to enrich himself through politics.

ADDITIONAL FACTS

1. *According to Plutarch, the animosity between Aristides and Themistocles was personal in origin. Both had fallen in love with the same boy, Stesilaus.*

2. *Aristides held the rank of strategos, or general, during the war with Persia. The title is the source of the English word* strategy.

3. *The Delian League was named for Delos, an island where the confederacy stored its treasury and met annually to discuss policy. Although originally an alliance of equals, the league eventually became a de facto Athenian empire, culminating in 454 BC in the seizure of the treasury, which was used to help construct the Parthenon.*

✦✦✦

Sophocles

Sophocles (c. 496–406 BC) was an Athenian playwright and author of some of the most popular tragedies of the Greek stage. He is thought to have written more than 100 plays, although only a handful survive. Along with Euripides (c. 484–406 BC) and Aeschylus (c. 525–c. 455 BC), whom he knew and competed with, Sophocles is considered one of the greatest dramatists of ancient Greece.

Perhaps the two most influential plays written by Sophocles were *Oedipus the King,* about the legendary Theban king Oedipus, and *Antigone,* about the king's daughter. Although inspired by Aeschylus, Sophocles introduced more sophisticated styles of staging and character development into plays, making him the most often performed of the Greek tragedians today.

Sophocles was born in a small town in Attica and experienced the Athenian war against Persia as a child. His lifetime—Sophocles died at age ninety—spanned the entire period of Athenian ascendancy, from the victory over the Persians that established Athens as a superpower to the city's downfall in the Peloponnesian War eighty years later.

Early in his career, Sophocles was heavily influenced by Aeschylus. But he challenged the master at the Dionysia, an annual theater competition in Athens, and defeated him in 468 BC. His victory over Aeschylus was the first of many that established him as the city's preeminent playwright.

In *Oedipus the King,* Oedipus is the son of the king and queen of Thebes. He had been abandoned as an infant after an oracle informed his parents that their son would grow up to murder his father and marry his mother. Many years later, Oedipus, unaware of his lineage, kills the king in a dispute and then marries the king's widow—not knowing that she is his mother. (A man who wants to have sex with his mother is said to have an Oedipal complex—though in the play, Oedipus blinds himself and leaves Thebes in shame after discovering what he has done.)

Sophocles was also involved in Athenian politics and served as a *strategos,* or general, in the city's military. An old man by the time the Peloponnesian War began, he helped organize the defense of his city against Sparta and died just before the war ended in catastrophic defeat for Athens.

ADDITIONAL FACTS

1. *Only 7 of the roughly 123 plays that Sophocles wrote have been preserved:* Ajax, Antigone, Electra, Oedipus at Colonus, Oedipus the King, Philoctetes, *and* Trachinian Women.

2. *Many famous phrases and sayings originated in Sophocles' works, including "nobody likes the man who brings bad news," from* Antigone; *"time eases all things," from* Oedipus the King; *and "stranger in a strange country," from* Oedipus at Colonus.

3. *Sophocles himself appeared in many of his early plays, but he was forced to give up acting because of his weak voice.*

✦✦✦

Mattathias

The Jewish holiday of Hanukkah dates to the second century BC and celebrates the success of a revolt sparked by a priest named Mattathias the Hasmonean that reestablished Jewish control of the Temple of Jerusalem. After their revolt, the Jewish victors were able to light the temple for eight days with only one day's worth of oil, a miracle commemorated each year with the lighting of the menorah.

In 167 BC, the year the revolt began, Jerusalem was part of the Greek-speaking Seleucid Empire. Many Jews had adopted Greek customs and even worshipped Greek gods, a trend that led to strife within the Jewish community. That year, the Seleucid leader, Antiochus IV (c. 215–164 BC), added to the tension by issuing an edict that forbade several Jewish religious practices, including circumcision and keeping the Sabbath.

According to accounts in the Bible, Mattathias was a priest at the Temple, the religious center of ancient Judaism, who was incensed by the religious persecution in Jerusalem. "Why was I born to see this, the ruin of my people, the ruin of the holy city?" he asked, according to biblical accounts. He instigated the revolt by killing a Jew who was preparing to worship a Greek god, and he also killed one of the Seleucid officers who had been sent to enforce Antiochus's new edicts. After killing the men, Mattathias issued his rallying cry: "Let every one who is zealous for the law and supports the covenant come out with me!"

The revolt would last about seven years, but Mattathias did not live to see the eventual Jewish victory. He died in about 166 BC. His sons carried on the cause, however: They drove out the Seleucids, rededicated the Temple, and in 160 BC founded the Maccabean dynasty, which ruled an independent Jewish state until 63 BC.

ADDITIONAL FACTS

1. *The Temple of Jerusalem was destroyed by the Romans in AD 70. The famous Western Wall in Jerusalem is the only remaining vestige of the temple site.*

2. *Maccabee comes from the Hebrew word for "hammer"; Mattathias's family took the name because its members were said to strike their enemies like a hammer.*

3. *Mattathias was born in Modin, a city halfway between Jerusalem and what is now Tel Aviv. He was buried in a tomb there after his death, but all traces of the ancient city have been lost.*

✦✦✦

Lao-Tzu

Whether or not Lao-Tzu, the legendary founder of Taoism, was an actual person is the subject of continuing debate among historians. According to legend, the great sage lived in China in about the sixth century BC and wrote the *Tao Te Ching,* a towering, far-ranging treatise on free will, human nature, and ethics that formed the basis of one of Asia's major religious traditions.

Virtually nothing is known about Lao-Tzu's life—if indeed he existed—and this void has been filled with any number of improbable legends. According to one, he already had a full beard when he emerged from his mother's womb, a sign of his great wisdom. Another myth says he lived for 996 years. At some point, he is believed to have worked as an archivist for a Chinese emperor in the present-day city of Luoyang, where he penned his first philosophical writings.

The *Tao-te Ching*—written, according to another legend, in a single night—is an eighty-one-chapter guide to philosophy and ethics that describes the nature of the universe (*Tao,* meaning "path") and the importance of personal morals (*te,* meaning "virtue"). Lao-Tzu's moral code stressed the value of reflection, nonviolence, and passive acceptance of nature. "Be content with what you have; rejoice in the way things are," one passage reads. "When you realize there is nothing lacking, the whole world belongs to you."

One of the best-known concepts of Taoism is the idea of duality. According to Lao-Tzu, nature is full of polar opposites—feminine and masculine, light and dark, life and death—that often seem to be in direct conflict with each other. Lao-Tzu taught that by understanding the hidden links between such pairs, it is possible to achieve a deeper understanding of the universe. Indeed, in many cases one could not exist without the other. The concept is famously symbolized by the yin ("earth") and yang ("heaven") symbol; while the two seem opposites, in fact there can be no heaven without earth and no earth without heaven.

According to tradition, as an old man Lao-Tzu lived as a hermit and died in obscurity. His writings, however, were widely embraced, and copies of the *Tao Te Ching* have been unearthed in ancient Chinese tombs. Taoism remains one of the major religious forces in contemporary China.

ADDITIONAL FACTS

1. *In modern-day China, Taoism is one of the five "official" religions permitted by the ruling Communist Party, along with Buddhism, Catholicism, Islam, and Protestantism.*

2. *The Tao-te Ching was relatively unique among ancient religious texts for its equality between men and women: Lao-Tzu used the feminine* she *to refer to the most important qualities of existence, such as life and creativity, in order to challenge the otherwise patriarchal focus on men.*

3. *Chapter Forty-Seven of the Tao-te Ching provided the lyrics to the 1968 Beatles song "The Inner Light," with music arranged by guitarist George Harrison (1943–2001).*

✦✦✦

Alexander the Great

In the words of one ancient historian, Alexander the Great (356–323 BC) "never engaged with any enemy whom he did not conquer, besieged no city that he did not take, and invaded no nation that he did not subjugate." His conquests, from Egypt to India, encompassed virtually the whole world known to the Greeks—a remarkable accomplishment given that Alexander only lived to age thirty-three.

Alexander's military victories also spread Greek customs and the Greek language throughout the Mediterranean, making it the lingua franca of the entire region. His heirs ruled parts of Alexander's empire for the next 300 years, until they were, in turn, conquered by the Romans.

Born in the northern Greek kingdom of Macedonia, Alexander was the son of King Philip II of Macedon and one of his wives, Olympias. As a young man, Alexander was tutored by the philosopher Aristotle (384–322 BC), who instilled a love of science, literature, and philosophy in the young prince. Alexander was also renowned for his skill as a horseman; his horse, Bucephalus was one of the most famous animals of antiquity.

In 336 BC, Philip was assassinated and Alexander, at age twenty, inherited the throne. Within a few years, he had established Macedonia as the dominant power in Greece, subjugating ancient city-states such as Athens and Thebes. Next, he led his armies on a ten-year campaign across the ancient world, conquering Egypt, India, and the Persian Empire, the longtime adversary of the Greeks. His soldiers founded dozens of cities and eventually controlled an empire encompassing three continents.

Unlike some conquerors, who sought to impose their beliefs on defeated peoples, Alexander was interested in Persian culture and even adopted many of its customs. This policy angered many of his officers—especially after thousands of Alexander's soldiers were forced to marry Persian women in a mass wedding. This event, held in the city of Susa, was intended by Alexander to promote Greek-Persian harmony.

The cause of Alexander's death in the city of Babylon has remained a mystery. Some contemporaries suspected that he was poisoned—"overcome at last, not by the prowess of any enemy, but by a conspiracy of those whom he trusted." However, in 1998 a team of researchers concluded that he probably died of typhoid fever.

ADDITIONAL FACTS

1. *Irish actor Colin Farrell (1976–) played the title role in the 2004 Oliver Stone (1946–) film* Alexander. *The conqueror has also been portrayed by William Shatner (1931–) and Richard Burton (1925–1984), among many other actors.*

2. *Alexander supposedly slept with a copy of his favorite book,* The Iliad, *under his pillow.*

3. *According to legend, Alexander was mummified after his death. His body was taken to Alexandria, Egypt, a city named in his honor, where it was displayed for centuries afterward.*

Plato

He was born Aristocles, scion of a wealthy and politically powerful family in ancient Athens. But it was the young man's wrestling coach, impressed by his broad-shouldered physique, who gave the youth the name better known to history: Plato (c. 429–347 BC).

From the Greek word *platos,* for "broad," the moniker applied equally well to the philosophy for which Plato would become famous. Although his writings about political theory may be the best known of his works today, the Athenian wrote on a vast array of other subjects, including poetry, sex, and math.

As a young man, Plato enjoyed a privileged upbringing and studied under the philosopher Socrates (c. 470–399 BC). The student was shocked by his teacher's trial and execution. Along with several other students of Socrates, Plato briefly fled the city after the teacher's death and traveled to Italy and Sicily.

Plato returned to Athens at about age forty to open his famous Academy. The school, which he intended to be a philosophical workshop for the youth of Athens, was the first of its kind in the Western world. It attracted pupils from across Greece, including Aristotle, who arrived in Athens to study under Plato in about 367 BC.

Dozens of works by Plato still survive, most of them in the form of invented dialogues, a technique he used to bring to life his philosophical concepts. For instance, one of his best-known works, *The Republic* (c. 360 BC), is a lengthy set of fictional conversations between Socrates and other Greeks. *The Republic* contains one of Plato's best-known concepts, the Allegory of the Cave. The famous story concerns a group of people who have been chained inside a cave throughout their lifetimes and have never seen the sun. The only images they see are the shapes of a few objects that are projected onto the cave wall by a fire. According to Plato, the people in the cave will eventually come to believe that the projected images are, in fact, reality. But if one of them escapes into the sunlight, he will come to comprehend the wider world. Plato used the story as an allegory for education and the role of the philosopher, who has escaped from the cave and is able to understand metaphysics—the ultimate nature of reality.

Plato's school continued for centuries after his death in Athens, and his thinking remains a vital source of inspiration for contemporary political theorists.

ADDITIONAL FACTS

1. *The words* academy *and* academic *are derived from Plato's Academy in Athens. The Academy itself, however, was named after its location, a grove of trees dedicated to the Greek hero Academus.*

2. *Plato's philosophy school in Athens remained open for nearly 1,000 years before it was shuttered in AD 529 by the Byzantine emperor, who was concerned that the school was undermining Christianity.*

3. *According to Plato's family's legends, he was descended from Poseidon, the Greek god of the sea.*

✦✦✦

Euclid

The laws of nature are but the mathematical thoughts of God.
—Euclid

For more than 2,000 years, a textbook written by the ancient Greek mathematician Euclid (c. 325–c. 265 BC) served as the primary introduction to geometry across the Western world. In its thirteen volumes, *The Elements* provided explanations of the basic mathematical laws governing triangles, polygons, prime numbers, and dozens of other concepts.

The book made Euclid one of the most famous figures in history. Yet virtually nothing is known about his life—and his contributions to *The Elements* may have been slight. Rather, his achievement was to summarize in a single treatise the laws and theories that had been developed by the Greeks over hundreds of years.

Euclid lived in the Greek-controlled city of Alexandria, Egypt. He flourished during the rule of Ptolemy I (367–283 BC), one of Alexander the Great's generals. In all likelihood, Euclid was educated at the Academy founded by Plato (c. 429–347 BC) in Athens and then followed the Greeks to Egypt after Alexander's conquest.

Euclid's book, *The Elements,* organized the discoveries of Eudoxus (c. 395–c. 342 BC), Theaetetus (c. 417–c. 369 BC), and other mathematicians into a single system of geometry that some of Euclid's contemporaries found perplexing. In one of the few recorded events of Euclid's life, when the king received a copy of *The Elements,* its length and complexity dismayed him, and he summoned the mathematician to explain himself. Ptolemy asked if there wasn't an easier way to learn geometry; there was no "royal road to geometry," Euclid supposedly retorted.

Euclid started the book with an outline of a relatively narrow set of axioms—statements that he considered so self-explanatory that he did not need to prove them. For instance, one of his axioms is that any two points can be joined together by a straight line. Using the axioms as a base, he proceeded to prove more complex theorems.

Copies of Euclid's treatise were preserved by Arab scholars after the ninth century AD and rediscovered in Europe after Adelard of Bath (c. 1116–c. 1142), an English scholar, disguised himself as a Muslim student in order to read and translate the book. Adelard's translation into Latin appeared in about 1120. By one estimate, more than 1,000 editions of the book have appeared since then.

ADDITIONAL FACTS

1. *As the world's main math textbook for more than 2,000 years,* The Elements *is said to have sold more copies than any other book except the Bible.*

2. *Abraham Lincoln (1809–1865) was a fan of Euclid and kept a copy of* The Elements *with him as a young lawyer. He would later sprinkle mathematical language into some of his speeches—for instance by referring to political equality as one of "the axioms of a free society."*

3. *Many streets and buildings in the United States take their names from Euclid. In addition, the city of Euclid, Ohio, and a small moon crater, Euclides, are named after him.*

◆ ◆ ◆

Pausanias

A king who betrayed his city, Pausanias was both a successful general and a legendary traitor. One of the two co-kings of Sparta, he led the city's fabled warriors to victory in several battles against Persia between 480 and 478 BC—but then conspired with the Persians to betray the Greeks.

Sparta, known for its well-trained and ferocious fighters, uncovered the plot in about 474 BC. After the plan was detected, the former king fled to a temple, where he was walled up inside the building and starved to death.

Pausanias's betrayal was considered especially shocking because of the legendary discipline of the Spartan military. Sparta, along with Athens, was one of the superpowers of the ancient Greek world. Unlike Athens, however, the entire culture of Sparta revolved around producing great warriors, who were trained in warfare from childhood. Sparta was not known for its philosophers, artists, or playwrights—only its soldiers.

Although they were normally adversaries, Sparta and Athens joined together in 480 BC to defend Greece from the Persians. The alliance suffered a defeat at the Battle of Thermopylae in 480 BC, and one of the two co-kings was killed. Pausanias helped command the victorious Greek armies at the Battles of Plataea (479 BC) and Byzantium (478 BC).

The Greek alliance splintered after the victory, with most city-states siding with either Sparta or Athens. Pausanias's imperious conduct caused many Greeks to side with Athens. Worse, rumors reached Sparta that he was communicating with the Persians about switching sides and conspiring to recruit Spartan slaves known as *helots* to join him in exchange for their freedom. The discovery of the conspiracy led to his downfall.

ADDITIONAL FACTS

1. *Sparta was destroyed by the Goths in AD 396. The present-day town on the site was founded in 1834, and the city's ancient ruins were excavated in the early twentieth century.*

2. *Pausanias's son, Pleistoanax, ruled Sparta intermittently as one of the city's kings for fifty years, beginning in 458 BC. His rule included the early stages of the Peloponnesian War against Athens.*

3. *The combined Athenian-Spartan alliance against the Persians was portrayed in the 2007 film* 300, *directed by Zack Snyder (1966–).*

❖❖❖

Phidias

In 1958, archaeologists unearthed a small cup in an excavation at Mount Olympia, the ancient site of the Greeks' Olympic games. On the side of the mug, carved in Greek letters, was an inscription: "I belong to Phidias."

The 2,400-year-old cup may be the only remaining artifact that can be conclusively linked to ancient Greece's greatest sculptor. Although Phidias (c. 490–c. 430 BC) was renowned in his own day, all of his statues—including his two gold-sheathed masterpieces, statues of Zeus and Athena—have been destroyed.

Phidias's fame in the ancient world was so great that the statue of Zeus at Olympia was considered one of the Seven Wonders of the Ancient World. Archaeologists believe that the sculptor must have lost the inscribed cup at a workshop he set up while building the forty-two-foot-tall statue in about 430 BC.

Very little else is known about Phidias's life. A resident of Athens, he was an ally of Pericles (c. 495–429 BC), the city's political leader for much of the fifth century BC. It was through Pericles that Phidias was commissioned to build the statue of Athena for the Parthenon. *Athena Parthenos,* made of ivory, clad in gold, and standing thirty-eight feet tall, was the focal point of the famous building's interior until the building was looted about 900 years later.

Phidias also directed the construction of the statuary that lines the building's frieze. Much of the frieze still exists, providing examples of art produced by Phidias's assistants that may have been based on his designs. The cost of the project apparently landed Phidias in trouble—he was jailed at one point for failing to account for gold used in the work.

The statue of Zeus, the last major work that Phidias is known to have completed, celebrated the most important god in the Greek pantheon. Carved from ivory and gold, the statue depicted Zeus seated, holding a scepter. For hundreds of years, it was a major attraction and was featured on coins and in travel accounts by awestruck Greek and Roman authors.

According to the historian Plutarch (c. 46–c. 120), Phidias was arrested again and died in prison, though modern scholars have cast doubt on that account.

ADDITIONAL FACTS

1. *The Parthenon frieze has been the subject of a long dispute between Greece and the United Kingdom. A British aristocrat, Thomas Bruce, seventh Earl of Elgin (1766–1841), removed the statues in 1801 and took them to London. He claimed to have permission of the Ottoman Empire, which then included Greece. However, current Greek leaders contend that the removal was illegal and have repeatedly asked the United Kingdom to return the statues—so far with no success.*

2. *The statue of Zeus at Olympia was destroyed about 800 years after its creation, when the temple that housed it was razed by the Byzantine Empire in 426.*

3. *One of the reasons that none of Phidias's works have survived may be the materials he used. Instead of marble, he used mostly bronze and gold, precious materials that were often stolen or melted down for their metallic value.*

✦✦✦

Tiberius Gracchus

By 133 BC, Rome was the greatest power of the ancient world, commanding an empire stretching from Turkey to Spain. Its mighty legions had subjugated virtually every corner of the Mediterranean, establishing a Roman supremacy that would endure for centuries and bring vast riches back to Rome.

But for the men who did the actual fighting, Rome's success often resulted in little benefit. Indeed, many Roman legionnaires returned home from years on the battlefield to find that their farms had gone bankrupt, their savings had vanished, and their families were ruined. Not surprisingly, many veterans grew resentful.

"They were styled the masters of the world, but in the meantime had not one foot of ground which they could call their own," railed the Roman politician Tiberius Sempronius Gracchus (c. 168–133 BC).

Tiberius was the older of the two Gracchi brothers, a pair of Roman social reformers who tried to make life in ancient Rome more equitable by limiting the power of wealthy aristocrats and ensuring that veterans would have farms to come home to. Celebrated by the writer Plutarch (c. 46–c. 119), both Tiberius and his brother Gaius (c. 154–121 BC) would inspire huge popular followings before meeting violent ends.

Tiberius was the grandson of a famous general and fought in Greece and Spain. After his return to Rome, he was elected tribune of the people in 133 BC. Determined to improve the lot of veterans, many of whom were homeless and unemployed on the city's streets, he proposed a series of agrarian reforms, including the confiscation of large farms known as *latifundia* whose lands Tiberius wanted to redistribute to Rome's poor.

Despite strong opposition in the Senate, Tiberius was able to push his reforms into law. At the end of his one-year term, however, he was murdered and thrown into the Tiber River by political opponents to prevent him from running again. His younger brother, Gaius, took up the cause of land redistribution ten years later, but he was also killed by conservatives opposed to reform.

ADDITIONAL FACTS

1. *Although they pursued similar political objectives, the two brothers had very different personalities. According to Plutarch, "Tiberius was gentle and sedate, while Gaius was high-strung and vehement, so that even when haranguing the people the one stood composedly in one spot, while the other was the first Roman to walk about upon the rostra and pull his toga off his shoulder as he spoke."*

2. *Tiberius was aware of the threats against his life and concealed a short sword called a dolo under his toga. However, at his murder, the number of attackers was so great that his weapon was useless. According to Plutarch, about 300 of Tiberius's followers were bludgeoned to death in the same attack.*

3. *The grandfather of the brothers was Scipio Africanus (236–183 BC), the Roman general who defeated Hannibal (247–c. 183 BC) in the Second Punic War in 202 BC.*

◆◆◆

The Buddha

Siddhārtha Gautama, known universally as the Buddha, was born in a small village in modern-day Nepal in roughly the fifth or sixth century BC. According to legend, his father was a powerful local king, and the young Siddhārtha grew up amidst great wealth and privilege in the Himalayan foothills.

However, the young prince found material wealth unfulfilling and was profoundly troubled by the sight of suffering outside the walls of his palace. What was the cause of human misery, he wondered, and how could it be overcome?

Hoping to answer these questions, Siddhārtha fled from his father's kingdom while in his late twenties to embrace a religious life of asceticism, self-denial, and meditation. But he soon found that a lifestyle of extreme deprivation and self-inflicted suffering brought him no closer to the truth than wealth had.

Finally, at age thirty-five, Siddhārtha experienced the seminal event of his life and the foundation of the Buddhist religion, a revelation known to Buddhists as the Great Enlightenment. According to tradition, after meditating for forty-nine days under a fig tree, he achieved nirvana, a state of total enlightenment in which the secrets of existence were revealed to him. Thenceforth, Siddhārtha would be known as the Buddha—the Enlightenment.

Human suffering, the Buddha preached, was caused by want and could be cured only by freeing oneself of desire, abandoning the notion of the self, and following the "noble eightfold path" of moral living, an ethical code that would become the foundation of much of East Asian culture.

After the Great Enlightenment, the Buddha traveled across a region of northern India and Nepal known as the Gangetic Plain, delivering sermons and converting new followers. He eventually returned to his father's kingdom and converted many of his relatives to Buddhism.

Buddhism grew quickly during the Buddha's lifetime, and as the sect's leader, the Buddha survived several assassination attempts. He died at age eighty, having established several monasteries and firmly planted Buddhism as the region's major religion.

ADDITIONAL FACTS

1. *As a young prince, Siddhārtha was so sheltered from reality that the sight of elderly peasants perplexed him. According to legend, one of his servants had to explain to him that all humans aged.*

2. *The Buddha was cremated after his death, but a tooth believed to have been retrieved from the ashes is venerated at a Buddhist shrine in Sri Lanka.*

3. *Siddhārtha was married at age sixteen and had one son, named Rahula. The Buddha is said to have fled from the palace on the same day Rahula was born.*

◆◆◆

Qin Shihuangdi

Qin Shihuangdi (259–210 BC), an important figure in the history of ancient China, was the emperor who united the country for the first time and began building the Great Wall. He was also a legendary tyrant who buried his enemies alive—all in the name of bringing order and stability to China after centuries of civil war.

At the time of the emperor's birth, China was emerging from an era called the warring states period, when regional warlords had battled for control. Qin Shihuangdi was the heir to one of the seven kingdoms, the Qin state. He became king of Qin in 246 BC, at age thirteen.

By 221 BC, the king had defeated the last independent rival state and proclaimed himself the first emperor of China. He moved aggressively to centralize control over the empire by abolishing all vestiges of the old feudal states, confiscating weapons from nobles, and dismantling fortifications within his lands. He also standardized the currency and legal systems across China.

To prevent any possible opponents from emerging, Qin Shihuangdi banned Confucianism, which he saw as a troublesome source of dissent, and ordered scholars to be buried alive. He also embarked on a massive campaign to burn classic books, an act of cultural destruction that has long defined his reign.

Thousands of laborers are thought to have died while building the Great Wall because of the poor working conditions, and many others perished while constructing Qin Shihuangdi's other ambitious projects. The emperor himself survived at least three assassination attempts organized by allies of one of the defeated rival states.

After Qin Shihuangdi's death, many of his laws, including the prohibition of Confucianism, were repealed. But while the Qin dynasty itself was short-lived, the emperorship Qin Shihuangdi established would last for more than 2,000 years after his death.

ADDITIONAL FACTS

1. *In 1974, farmers in central China accidentally unearthed a field full of thousands of statues of soldiers, horses, chariots, and musicians. Archaeologists believe that the so-called Terra-Cotta Army was part of the burial site of Qin Shihuangdi and that the statues were intended to accompany the emperor into the afterlife. The United Nations Educational, Scientific, and Cultural Organization declared the statues' location a World Heritage site in 1987.*

2. *The Great Wall was renovated and expanded by later emperors, and few of the original fortifications built by Qin Shihuangdi remain. Chinese armies continued to use the wall for military purposes into the seventeenth century.*

3. *The tale of one of the assassination attempts against the emperor was made into a 2002 movie, Hero, starring Jet Li (1963–), which was released in the United States in 2004.*

◆◆◆

Aristotle

In 1511, the Italian painter Raphael (1483–1520) completed a giant fresco in Rome called *The School of Athens*. At the heart of the painting, which shows dozens of the most celebrated ancient Greek philosophers, stand two towering figures: Plato (c. 429–347 BC) and his most brilliant student, Aristotle (384–322 BC).

The famous fresco was installed at the Vatican, a symbol of the central role the two thinkers have played in the Western intellectual tradition. Along with his teacher, Aristotle is considered one of the most influential philosophers in history.

Aristotle was born in Stagira, a village in northern Greece. His father, Nichomachus, was the Macedonian royal family's doctor, and Aristotle himself originally trained in medicine. However, he moved to Athens in 367 BC to study at Plato's Academy, where he would remain for about twenty years.

While in Athens, Aristotle completed the first of the scores of texts he would write during his lifetime. Approximately thirty survive. Although he was highly influenced by Plato, the two men differed on some philosophical questions, and Aristotle left the city after his mentor's death.

Returning to Macedonia, Aristotle was hired as the tutor for the king's thirteen-year-old son, Alexander the Great (356–323 BC). When Alexander became king and later conquered Athens, Aristotle returned to the city, where he founded his own school.

Aristotle is credited with laying the foundation for Western philosophy by creating the first system of formal logic. He also pioneered the study of biology, with work that has recently been seen as a major contribution to the field. His writings on metaphysics, when they were rediscovered in Europe in the Middle Ages, would have a profound effect on Christian theologians such as Thomas Aquinas (c. 1225–1274).

After Alexander's death, however, Athens revolted against Macedonian rule. Because of his close links to the Macedonians, Aristotle's life was threatened and he fled. He moved to the island of Euboea, where he died shortly afterward.

ADDITIONAL FACTS

1. *Aristotle offered a supposed proof of the existence of a supreme being. In what's known as the theory of the Unmoved Mover, Aristotle argued that every event in the universe is set in motion by some other event. But the chain of action has to start somewhere—with the force Aristotle called the Unmoved Mover, and which later Christian writers used as logical proof of God's existence.*

2. *According to an ancient historian, Alexander the Great's favorite book was* The Iliad; *during his military campaigns, he always carried a copy of the book that Aristotle had given him.*

3. *Aristotle married a woman named Pythias, the adoptive daughter (or perhaps niece) of a friend and fellow student of Plato's; the couple had one daughter, also named Pythias.*

✦✦✦

Archimedes

The story of Archimedes (c. 287–c. 212 BC) and the Golden Crown is among the most famous in the history of scientific discovery. According to legend, the king of Syracuse asked the great mathematician to determine whether his splendid crown, the symbol of his kingship, was really made of pure gold.

Archimedes, who specialized in using math to solve just such practical problems, agonized over the puzzle for days. Finally, as he was taking a bath one afternoon, the solution occurred to him. Shouting *"Eureka!"*—Greek for "I have found it!"—he sprang out of the tub and ran naked into the streets of Syracuse to spread the news.

Born on the island of Sicily in roughly 287 BC, Archimedes was an engineer, theoretical mathematician, astronomer, and inventor. He was known for decoding the behavior of fluids, explaining how levers work, calculating the value of pi—and inventing terrifying new weapons for the Syracusans.

Indeed, many of Archimedes' inventions arose from the military needs of Syracuse, a Greek-speaking city-state that was at war with Rome for most of the scientist's lifetime. To help the city's naval fleet stay afloat, he invented Archimedes' screw, a device that quickly pumps water out of ships. He also invented the claw of Archimedes, a metal hook anchored onshore that was used to sink enemy ships. His most fantastic military invention was the heat ray—a system of mirrors that was said to concentrate beams of sunlight onto Roman vessels, setting them on fire. (Some scholars have questioned whether his heat ray could actually have worked.)

The eureka moment in the bathtub involved the measurement of volume. Archimedes knew that to determine the composition of the crown, he needed to know its density, since pure gold has a density different from that of other metals. Density, in turn, depends on weight and volume. Archimedes already knew the crown's weight, and he realized from watching the water level rise in his tub that he could determine the crown's volume by measuring the amount of water it displaced. (He proved, to the king's dismay, that the crown was not pure gold.)

Despite Archimedes' ingenious weapons, tiny Syracuse was unable to withstand the Roman onslaught. In 212 BC, Archimedes was killed by a soldier when the city finally fell to the Roman legions. Historians sometimes mark the death of Archimedes as the end of an era; he was the last major Greek scientist of antiquity, before Rome achieved dominance over the ancient world.

ADDITIONAL FACTS

1. *The word* eureka *was adopted in 1953 as the official motto of the state of California in honor of the prospectors who immigrated to the state in the 1840s hoping to strike gold.*

2. *One of the more ambitious projects undertaken by Archimedes was an estimate of the number of grains of sand that would be needed to fill the entire universe. He concluded that it would take roughly 8 vigintillion grains—an 8 followed by 63 zeros.*

3. *A lost work by Archimedes,* Stomachion, *was rediscovered in 1906 by a Danish scholar at a monastery in modern-day Turkey. It was sold to an anonymous billionaire for $2 million in 1998.*

◆◆◆

Capitolinus

Under the laws of the Roman Republic, the gravest crime was to seek to make oneself a king. Marcus Manlius Capitolinus, an aristocrat and military hero, was accused in 385 BC of seeking the crown, found guilty, and punished in the city's traditional manner—by being thrown off a cliff—in the following year.

Accounts of the arrest and trial of the Roman politician differ. Plutarch (c. 46–c. 120) described Capitolinus as a populist rabble-rouser and demagogue who used the "usual arts of those that would found a tyranny." But Livy (c. 59 BC–AD 17) viewed Capitolinus more sympathetically and decried his trial as "a conspiracy to crush a popular hero." Indeed, Capitolinus's real crime may have been to challenge the political status quo.

Capitolinus was born a member of the patrician, or aristocratic, class, but came to sympathize and side with the lower-class plebeians. He sought power by advocating debt relief for the poor and a great sharing of the wealth from Rome's military success.

Marcus Manlius first achieved prominence as one of the city's two consuls in 392 BC. Two years later, he led the defense of the city during a war against the Gauls. According to legend, the Gauls surrounded the city and forced the defenders to retreat to the fortress atop the Capitoline Hill. The enemy sneaked up the hill one night, evading the sentries, and were repulsed only after Manlius was awakened by the cackling of a flock of geese; for saving the city, he was given the honorary surname Capitolinus.

After the victory, Capitolinus was incensed when he saw war veterans falling into debt. He personally paid the debts of about 400 Romans, according to Livy, and helped others fight their cases in court. The Senate had him arrested once, but was forced to release him amid public protests.

When he was brought to trial in 385 BC, the court met in the shadow of the Capitoline, a vivid reminder of the defendant's past service to the city. The judges refused to convict him until the venue was moved to another location, away from the site of his great victory. After his conviction, he was tossed from the Tarpeian Rock on the Capitoline, the punishment Rome reserved for traitors.

ADDITIONAL FACTS

1. *The Tarpeian Rock was named after Tarpeia, a mythological figure in Roman history. The daughter of a military officer, Tarpeia supposedly offered to betray the city to a rival Italian tribe before her plot was foiled.*

2. *The Capitoline is one of the famous seven hills of ancient Rome and was the site of a large temple to Jupiter. Its name is also the basis for the English word* capitol.

3. *After the execution, the Senate razed Capitolinus's house and constructed a temple to Juno Moneta on the spot. The temple was later used as a mint—thus the words* moneta *in Latin and* money *in English.*

♦♦♦

Thucydides

Thucydides (c. 460–c. 404 BC) was a Greek historian and the author of the *History of the Peloponnesian War,* one of the oldest surviving works of scholarship in Western literature. The book is the basis for much of our knowledge of ancient Greece, and it was the first to treat history as a set of human interactions rather than a supernatural process controlled by the gods.

"The first page of Thucydides is, in my opinion, the commencement of real history," wrote the philosopher David Hume (1711–1776) in praising the ancient historian. "All preceding narrations are so intermixed with fable, that philosophers ought to abandon them, in a great measure, to the embellishment of poets and orators."

Thucydides was born in Athens, probably into a wealthy family that owned a gold mine and may have been a part of the old Athenian aristocracy that had been replaced by the democracy. He survived the plague in 430 BC and served as a general in the city's war against its archenemy, Sparta. He was blamed for the Athenian defeat in a battle in 423 BC and was exiled as punishment.

During his years in exile, Thucydides wandered through Greece, observing the war as an outsider. His history, which he began writing while the war was still raging, takes a relatively neutral point of view, a departure from previous ancient histories, which often amounted to cheerleading for the author's home country. "My work is not a piece of writing designed to meet the taste of an immediate public, but was done to last forever," he wrote.

The Peloponnesian War (named after the Peloponnese, the peninsula where Sparta was located) had begun in 431 BC, after decades of tension between Athens and Sparta. Initially, the war went well for Athens, but the city was dealt several setbacks— not the least of which was the defeat of Thucydides at Amphipolis in 423 BC. The two sides agreed to a temporary ceasefire after that battle, but it collapsed quickly.

Thucydides' narrative ends in 411 BC, before the end of the war. Some scholars have theorized that he died or was allowed to return to Athens. In any case, the war ended several years later with a Spartan victory that eliminated Athens as a major power in Greece and ended the city's golden age of the fifth century BC.

ADDITIONAL FACTS

1. *Another Athenian historian, Herodotus (c. 484–c. 425 BC), was older than Thucydides and wrote mainly about the city's wars with Persia. He often ascribed events to divine intervention or interpreted them as moral lessons—conclusions that Thucydides avoided making.*

2. *The Peloponnesian War provided the backdrop for one of the best-known comedies of ancient Athens, Lysistrata, by Aristophanes (c. 450–c. 388 BC). In the play, Lysistrata organizes an effort by the women of Greece to end the war by withholding sex from their husbands until they agree to a peace treaty.*

3. *Although Sparta was victorious in the war, its dominance in Greece was short-lived. Both Athens and Sparta were conquered by Alexander the Great (356–323 BC) seventy years later, ending their existence as independent states.*

✦✦✦

Spartacus

Today, he might be best known for the Academy Award–winning movie about his life, *Spartacus* (1960). But the Roman slave, played by Kirk Douglas (1916–) in the movie, was a real historical figure—and the leader of one of the largest slave uprisings in the Roman Republic.

Spartacus was born free in Thrace, in modern-day Bulgaria, before being enslaved along with his wife by the Romans. They were taken to Capua, a city in southern Italy near Naples, where he was forced into training as a gladiator. Despite the hardships Spartacus endured at the school—gladiators were kept in prisonlike conditions and allowed outside only to fight—he would soon put the combat training to good use.

In 73 BC, Spartacus and about seventy other gladiators escaped from the school, using meat cleavers stolen from the kitchen as weapons. The small contingent, which hid atop Mount Vesuvius to train and gather weapons, formed the core of a rebel army that would eventually grow to more than 100,000.

Initially, the Roman authorities didn't take the uprising seriously and sent an inexperienced officer to suppress the revolt. Spartacus and his men easily defeated the Romans, a victory that convinced more slaves to join the uprising.

Although Spartacus had nominally been elected the leader of the rebellion, in reality the rebels were disorganized and internally divided. Spartacus, a superior military planner, hoped to march the troops to Gaul to join up with another rebel group, but was overruled by other leaders of the rebellion.

In 71 BC, after several more humiliating defeats, the Romans dispatched General Marcus Licinius Crassus (c. 115–53 BC) to battle the rebels. Crassus chased Spartacus and his followers to southern Italy and defeated them at a battle near the Silarus River. Contrary to the depiction in the movie, Spartacus was killed in the battle. Thousands of his followers were then crucified—a gruesome punishment meant to scare off any other would-be rebels.

ADDITIONAL FACTS

1. *Rome's initial defeats by Spartacus were considered so disgraceful that the legions responsible were decimated, a rarely used punishment for battlefield cowardice in which commanders randomly selected one out of every ten soldiers and had him killed.*

2. *The 1960 film by director Stanley Kubrick (1928–1999) starred Douglas as the rebel leader and Laurence Olivier (1907–1989) as Crassus, his Roman nemesis. The film won four Academy Awards and was nominated for two others.*

3. *In Roman history, Spartacus's uprising is often referred to as the Third Servile War. Two previous slave uprisings—the First Servile War (135–132 BC) and the Second Servile War (104–100 BC), both fought on the island of Sicily—had also ended in Roman victory.*

◆◆◆

Confucius

The ancient Chinese philosopher Confucius (551–479 BC) wrote one of the most influential books in history, the *Analects,* and founded the ethical and moral system that bears his name. But despite his great influence on Asian culture and society, very little is known about his life.

According to legend, Confucius was born into a poor but respected family in what is now eastern China, in the kingdom of Lu. After working as a bookkeeper, shepherd, and teacher, Confucius eventually became an official for the local duke. Although a capable administrator, he quit his job for political reasons about thirty years later, perhaps in disgust over the ruler's hedonistic lifestyle.

However, Confucius's decades of experience in the duke's court had given him many ideas about good government, a topic of widespread concern during that period of China's history. At the time, known as the Spring and Autumn Period (722–481 BC), the country was nominally under the control of the emperor, but in fact it was divided into several quasi-independent, feuding kingdoms.

The *Analects,* compiled by Confucius's followers after his death, contains the core tenets of Confucianism. The book has no narrative and is instead a collection of short stories and aphorisms meant to illustrate his key moral concepts. For instance, one section about politics reads:

> The Master said, "He who exercises government by means of his virtue may be compared to the north polar star, which keeps its place and all the stars turn towards it."

The metaphor underscores the importance in Confucian thought of the virtuous ruler, who Confucius believed should be a moral example to the nation.

Although Confucius did not claim to be divine and Confucianism is not a religion, his writings continued to spread after his death at age seventy-three and would be one of the bases of Chinese society.

ADDITIONAL FACTS

1. *Confucius survived an assassination attempt when he was in his late fifties and later accepted the would-be assassin's brother as his student.*

2. *In addition to the* Analects, *Confucius also wrote a book of poetry and* Spring and Autumn Annals, *a chronicle of his home kingdom of Lu.*

3. *During China's Cultural Revolution from 1966 to 1976, Communist leader Mao Zedong (1893–1976) labeled Confucius a "stinking reactionary" and attacked Confucianism as a backward set of beliefs that had held back China's progress. Mao's Red Guards even vandalized a temple marking the spot of Confucius's birth. After Mao's death, however, China's leadership quickly rehabilitated Confucianism.*

✦✦✦

Hannibal

Hannibal (247–c. 183 BC) was a Carthaginian general who battled the Roman legions during the Second Punic War. He may be best known for marching his army—which included a detachment of war elephants—across the snowy Alps in a failed effort to invade Italy.

Although Hannibal was defeated, his mastery of military tactics made him one of the most feared and famous generals of the ancient world. Hannibal was the son of Hamilcar Barca, a general who had been defeated by Rome during the First Punic War. When the child was nine years old, his father made him take an oath to the god Baal to devote his life to fighting the city's great enemy. (*Hannibal* means "Baal's grace.") In 221 BC, Hannibal inherited the position of commander in chief of Carthage's armies.

Two years later, he launched his invasion. The Carthaginian force included about 25,000 men, thousands of horses, and a few dozen elephants. His exact route is unclear, but it ended near the northern Italian city of Turin. Up to half of his troops (and most of the elephants) may have died during the crossing.

For the next seventeen years, Hannibal battled Rome in its own backyard. He never lost a battle to his foes, but was forced to rush back to Carthage when the Romans attacked that city. Hannibal was defeated at the Battle of Zama in 202 BC and shortly thereafter fled into exile in the city of Tyre, never to return to Carthage.

However, Hannibal's days of fighting the Romans were not over. He was a military advisor to the Greek Seleucid Empire and also commanded a Bithynian naval force that defeated a Roman ally. The Romans were determined to capture Hannibal and pressured the Bithynian king to hand him over, but Hannibal committed suicide before the Romans could capture him.

The Roman victory in the Second Punic War was an important milestone in history. With its most formidable rival defeated, Rome established military supremacy over the Mediterranean world—a position it would enjoy for centuries to follow.

ADDITIONAL FACTS

1. *Hannibal appears in* Gulliver's Travels, *a classic satirical novel written by English author Jonathan Swift (1667–1745) in 1726.*

2. *The city of Hannibal, Missouri—the boyhood home of author Mark Twain (1835–1910)—derived its name from the Carthaginian general. The town and its residents provided the inspiration for* The Adventures of Huckleberry Finn *(1885), one of Twain's best-known works.*

3. *Carthage was decisively defeated by the Romans in the Third Punic War (149–146 BC). Vengeful Roman soldiers supposedly poured salt on the fields around the city to ensure that it would never prosper again. Although historians have raised doubts about the story, Carthage never again challenged Roman supremacy in the Mediterranean.*

✦✦✦

Mencius

Is human nature basically good—or is it intrinsically evil?

Mencius (c. 371–289 BC) is best known for defending the idea that human beings are, at heart, fundamentally good. His writings, heavily influenced by the philosopher and religious figure Confucius (551–479 BC), are among the central texts of Chinese philosophy, and they continue to resonate more than 2,000 years after his death.

Born during the Zhou dynasty in present-day eastern China, Mencius lived in an unstable era of political division known as the period of warring states. His father died when Mencius was three. His mother cared deeply about his education, and according to legend she moved to several different cities before finally finding the right teacher for her son.

The teacher she eventually picked was named Zisi, a grandson of Confucius's, who schooled his pupil in Confucian ethics and philosophy. Like Confucius, Mencius went on to work as a government official and also wandered across China spreading his beliefs.

Mencius believed that people were born predisposed to four virtues: empathy, respect for others, a sense of right and wrong, and the ability to feel shame for their misdeeds. These four qualities, the "four beginnings," were the "sprout" from which other virtues originated, he believed. His most eloquent opponents, Mozi (c. 470–c. 391 BC) and Yang Zhu (440–c. 360 BC), countered that people lacked any instinctive virtue and that ethics had to be learned through study and experience.

Mencius also wrote extensively about politics and elaborated on many of Confucius's theories. Like Confucius, he believed that the personal virtue of a ruler was of paramount importance; Mencius added that if a leader lost the mandate of heaven through misrule, it was acceptable to overthrow him.

ADDITIONAL FACTS

1. *An ancient temple devoted to Mencius in his home province of Shandong was damaged during China's Cultural Revolution, but repaired and reopened in 1980.*

2. *A collection of the philosopher's works, the* Mengzi, *is regarded as one of the four books that are the central texts of Confucian thinking.*

3. *Although some of Mencius's writings are reminiscent of those of the Greek philosopher Plato (c. 429–347 BC) and their lives overlapped, there is no evidence that either man was aware of the other's existence.*

◆◆◆

Vitruvius

Vitruvius (c. 80–c. 15 BC) was an author, engineer, and soldier whose ten-volume architectural manual guided the builders of the Roman Empire's famous roads, temples, and aqueducts. A compendium of practical knowledge, construction tips, and basic physics, his *De Architectura* served as a guidebook for centuries after its publication.

De Architectura is also the primary source of information about its author. Vitruvius was a military engineer employed by Julius Caesar (100–44 BC) and the emperor Augustus (63 BC–AD 14) who traveled across the Roman world and became an expert on defensive fortifications, siege engines, catapults, and other ancient weaponry.

After Caesar's death, Vitruvius was sponsored by Augustus and Augustus's sister, Octavia Minor (c. 69–c. 11 BC). He worked as a civilian architect; designed a basilica in Fano, Italy; and wrote his manual.

In *De Architectura,* Vitruvius attempted to summarize the entire body of Roman and Greek engineering. He borrowed heavily from previous writers, but also included his own advice and observations. The book explained how to build city walls and where to dig wells, and even included practical lessons on how to avoid cost overruns. Vitruvius also introduced the three architectural orders—Ionic, Doric, and Corinthian—that formed the basis for Greek and Roman architecture.

Little else of Vitruvius's life is known, but his influence as the founder of Roman engineering would be profound. As the Roman Empire spread, engineers wielding his textbook followed close behind the army, and the roads and aqueducts constructed by Vitruvius's successors formed perhaps the most lasting legacy of the Roman Empire. Through the Middle Ages, Roman-built roads remained the main byways of Europe, and even today some cities in Spain and France continue to receive their water supplies through Roman aqueducts.

ADDITIONAL FACTS

1. *Vitruvius deduced that lead was "hurtful to the human system" and advised against using lead pipes to carry water—2,000 years before lead piping was banned in the United States.*

2. *In the third volume of* De Architectura, *Vitruvius discusses the dimensions of the human body. Leonardo da Vinci (1452–1519) used the measurements as the basis for his famous etching of the ideal human form, known as the Vitruvian Man.*

3. *De* Architectura *was rediscovered in Italy by scholar Poggio Bracciolini (1380–1459) in 1414, spurring a revival of ancient Roman building techniques during the Renaissance.*

❖❖❖

Herostratus

The giant Temple of Artemis overlooked the Mediterranean and was the pride of the city of Ephesus. It had taken 120 years to build and was considered one of the Seven Wonders of the Ancient World—until the day in 356 BC when a young Greek named Herostratus burned it down.

The catastrophe shocked Ephesus, as did the arsonist's motive: After his arrest, Herostratus said he set the temple on fire so his name would be remembered forever. He is the namesake of *herostratic* criminals, lawbreakers who act solely for the purpose of achieving notoriety.

Herostratus's target was carefully chosen. The Temple of Artemis, dedicated to the goddess of childbirth and the hunt, was larger than the Parthenon in Athens. Its construction had been funded by the legendarily wealthy King Croesus. "The Temple of Artemis in Ephesus is the only house of the gods," wrote an admirer, Philo of Byzantium. "For whoever examines it will believe that the gods exchanged the heavenly regions of immortality to have a place upon the earth."

Little is known about Herostratus's life before the fire. After his arrest, he was subjected to torture on the rack, a penalty usually inflicted only upon noncitizens—suggesting that he may not have been a native Ephesan, or may have been a slave.

After his execution, officials in Ephesus imposed an additional punishment on Herostratus. Seeking to deprive him of the glory he had sought, they barred the very mention of his name. Although the ban was widely observed for hundreds of years, one ancient writer violated the prohibition—ensuring that Herostratus's name would survive and acquire the eternal infamy he had desired.

ADDITIONAL FACTS

1. *Ephesus is now Efes, Turkey. The city's extensive Greek ruins, including the remains of the Temple of Artemis, were excavated beginning in the nineteenth century.*

2. *The torching of the temple was the basis for "The Lunacy of Herostratus," by the German poet Georg Heym (1887–1912), and for a Jean-Paul Sartre (1905–1980) short story, "L'Érostrate."*

3. Stratos *means "army" in Greek;* Herostratos *means "army hero."*

◆◆◆

Cicero

Known for the power and eloquence of his speeches, Cicero (106–43 BC) was a Roman statesman, lawyer, and philosopher who was celebrated as the greatest orator of his time. He was elected to a variety of offices during a turbulent period of Rome's history and died fighting to preserve the city's vanishing republican traditions.

Cicero, born Marcus Tullius Cicero, was from Arpinum, a town south of Rome. His father was a member of the aristocratic, or equestrian, class. Educated in both Latin and Greek, Cicero studied law and philosophy in Rome and traveled to Athens in 79 BC, where he took lessons in rhetoric. He married in the same year.

After returning from Greece, Cicero embarked on his political career, first winning appointment as a magistrate in the province of Sicily. He prosecuted the island's Roman governor for corruption, a case that helped establish his reputation for honesty and rhetorical brilliance. Cicero then held a number of other positions that honed his expertise in Roman constitutional law until he was elected consul in 63 BC.

In the Roman Republic, two consuls were elected every year and were jointly responsible for running the government of Rome. During Cicero's tenure, he foiled a plot called the Catiline conspiracy that sought to overthrow the republican government, and then gave four moving speeches urging the death penalty be implemented without trying the conspirators. In his speeches, Cicero swayed the reluctant Senate to support the executions by portraying himself as the republic's savior: "Why should not I rejoice that my consulship has taken place almost by the express appointment of fate for the preservation of the republic?"

In the Roman civil war between Julius Caesar (100–44 BC) and Pompey (106–48 BC), Cicero took Pompey's side but was pardoned by Caesar after his victory. Cicero was troubled by the dictatorial powers Caesar assumed, but was not involved in the assassination plot of 44 BC. After Caesar's death, however, Cicero organized an effort in the Senate to block his successor, Mark Antony (83–30 BC), from taking power.

Antony, enraged, put Cicero on a hit list of his political enemies. The orator was cornered by Antony's men and beheaded on December 7, 43 BC; he was sixty-three. In a grim testament to his oratorical skill, Cicero's severed tongue was supposedly displayed in the Senate as a warning to Antony's would-be critics.

ADDITIONAL FACTS

1. *Although he was not a part of the plot himself, Cicero urged amnesty for those who had been involved in the assassination of Julius Caesar on March 15, 44 BC.*

2. *Unlike most other Roman politicians, Cicero served only briefly in the army and never used his military service to advance his political career. He fought in the Social War of 91–88 BC, a conflict between Rome and several other Italian cities that left him with a hatred of warfare and violence.*

3. *The name Cicero is derived from the Latin name for a chickpea. According to Plutarch (c. 46–c. 120), one of the orator's ancestors acquired the name because his nose resembled the seed.*

◆◆◆

Vercingétorix

Gaul may have been divided into three parts, but a chieftain named Vercingé-torix (82–46 BC) united the country's fractious tribes for a last-ditch effort to resist Roman conquest. He was eventually defeated, however, and what is now France was absorbed into the growing Roman Empire.

Since then, the rebellion of Vercingétorix, which reputedly involved hundreds of thousands of Gallic warriors, has entered French lore as an example of heroic resistance to foreign conquest. In the nine-teenth and early twentieth centuries, French national-ists claimed the ancient warrior as one of the founders of the Gallic spirit.

The Roman conquest of Gaul began in 58 BC, when an up-and-coming Roman general named Julius Caesar (c. 100–44 BC) invaded the province. As described in his memoir of the conflict, *The Gallic War,* most of the fight-ing was finished within the first two years, but intermit-tent violence continued for the rest of the decade.

Vercingétorix was the son of Celtillus the Arvernian, a chief who had been put to death by his fellow Gauls for attempting to take over the whole country. In 53 BC, while Caesar was temporarily away in Italy, Vercingétorix took advantage of his absence to organize a unified coalition against Rome. Caesar was forced to rush back to Gaul during the winter, marching his troops through six-foot snowbanks in pursuit of the rebels.

After a major Gallic victory at the Battle of Gergovia, Vercingétorix was cornered at Alesia, a fortress in the east of France, in 52 BC. Caesar surrounded the town with catapults and booby traps, and thousands of the town's inhabitants starved to death during the siege. Vercingétorix was eventually forced to give up.

Vercingétorix's surrender to Caesar—he supposedly threw his arms at the general's feet with a theatrical flourish—didn't save him from Roman retribution. He was taken to Rome in chains, forced to march in Caesar's victory parade, and then prob-ably executed in prison.

ADDITIONAL FACTS

1. *Vercingétorix was played by German actor Heino Ferch (1963–) in the 2003 TNT movie* Caesar. *A 2001 French movie,* Vercingétorix, *starred Christopher Lambert (1957–), of* Mortal Kombat *(1995) fame, in the title role.*

2. *After his defeat, Vercingétorix was thrown into the Mamertine Prison in Rome. It is thought that Saint Peter was later jailed in the same location; the prison is currently the site of a Roman Catholic church, San Pietro in Carcere—Saint Peter in Prison.*

3. *The site of the Battle of Alesia is uncertain but thought to be close to Dijon, in eastern France.*

◆◆◆

Hillel

One day, according to legend, a man approached the Jewish sage Hillel the Elder with an offer: If he could explain the religion's principles in a single sentence, the man would convert to Judaism.

Hillel responded: "What is hateful to thee, do not unto thy fellow man: this is the whole Law; the rest is mere commentary."

The eloquent Golden Rule, one of the most famous utterances in Western religion, neatly summarized the humanistic impulse at the core of Hillel's teachings. A pivotal figure in the history of Judaism, Hillel was the most respected religious authority of his time and codified many of the religion's laws and traditions. His writings on ethics have provided inspiration to people of all faiths.

Although he lived most of his life in Jerusalem, Hillel was born in the city of Babylon, which had a large Jewish population, at some point in the first century BC. Little is known about his background, but he was supposedly a descendant of the biblical King David. As a young man, Hillel may have worked as a woodcutter.

He eventually moved to Jerusalem, where he impressed scholars with his mastery of Jewish law. After settling one particularly vexing question about an arcane ritual, according to legend, he was made the city's chief religious authority.

At the time, Jerusalem and the surrounding territories had been absorbed into the Roman Empire, and the resulting political turmoil had opened divisions within the Jewish community. Hillel aligned with one sect, the Pharisees, that was in opposition to other Jewish religious groups, especially the Sadducees.

Politically, the Sadducees tended to represent the aristocrats, while Hillel's Pharisees enjoyed more support from commoners. Theologically, the Sadducees favored a literalist approach to the ancient Jewish texts, leaving no room for interpretation. Hillel, however, believed that the texts were more of a starting point and could be interpreted by rabbis. (The position of rabbi, as understood today, did not exist in ancient Judaism.) In practice, Hillel's writings emphasized the importance of community, social justice, and knowledge.

After his death, and especially after the destruction of the Second Temple in AD 70, Pharisaic Judaism emerged as the dominant force within the Jewish community, and eventually it evolved into contemporary rabbinic Judaism—the dominant force within world Judaism today.

ADDITIONAL FACTS

1. *When he arrived in Jerusalem, Hillel was so poor that he was unable to pay the fee for Torah studies. The fee was waived for him, and later it was abolished so that poverty would never prevent a gifted scholar from studying the Torah.*

2. *Commentaries on the scriptures written by rabbis came to be known, collectively, as the Talmud.*

3. *For five centuries after his death, Hillel's descendants were leading religious figures in Jerusalem.*

◆◆◆

Chandragupta Maurya

Chandragupta Maurya (c. 340–c. 296 BC) was an influential Indian monarch who founded the Maurya dynasty and liberated his country from the Greeks. His descendants ruled for two centuries and built a sprawling empire that encompassed almost all of modern-day India.

Alexander the Great (356–323 BC) invaded northern India in 326 BC. When Alexander returned west, he entrusted his conquests to local satraps, governors who were supposed to rule on his behalf. Within only a few years, however, Chandragupta—whose background is largely unknown—had driven out the satraps and founded his own kingdom.

The king, who was only about twenty at the time he assembled his empire, also conquered several small Indian states and overthrew the unpopular Nanda dynasty, consolidating power under a single leader for the first time in Indian history. At the peak of his power, he controlled a territory stretching from Afghanistan in the west to Bangladesh in the east, including most of India.

In 305 BC, a Greek general, Seleucus Nicator (c. 358–281 BC), attempted to rebuild Alexander's empire. He reconquered several eastern provinces and was set to attack the Maurya empire before the two sides negotiated a settlement. In exchange for land, Chandragupta provided 500 war elephants to the Greeks; he also may have married one of Seleucus's daughters to seal the deal.

Shortly thereafter, Chandragupta abdicated the throne in favor of his son, Bindusara. Chandragupta then converted to Jainism and spent the last years of his life in a religious community near Bangalore; he supposedly starved himself to death in a cave in the ultimate act of religious devotion.

ADDITIONAL FACTS

1. *Chandragupta's Greek adversaries referred to him as Sandrocottus or Androcottus.*

2. *Jainism, one of the world's oldest religions, was founded about 3,000 years ago and claims roughly 12 million adherents today. Its followers strive to do no harm to any living creature, which in practice means strict vegetarianism. Some Jains also sweep the ground before them as they walk to avoid hurting insects.*

3. *Chandragupta Maurya's grandson was Ashoka the Great (304–232 BC), who embraced Buddhism and helped popularize the faith across India.*

✦✦✦

Epicurus

For several centuries after the death of Plato (c. 429–347 BC), Greek philosophy was divided into two competing camps. The Stoics taught that life was grim, painful, and arbitrary. The only route to happiness they saw was to live virtuously and free from material desires.

To which their rivals, the Epicureans, responded: Life is short, so let's party.

A friendly, fun-loving teacher in ancient Athens, Epicurus (341–270 BC) is best known for the philosophical tradition that celebrated pleasure and elevated the avoidance of pain and fear as life's two greatest values. Known as Epicureanism, the philosopher's teachings would remain influential for centuries.

Epicurus was born on the island of Samos, the son of a poor Athenian colonist and soldier. He began studying philosophy at age fourteen, but became a refugee after his family was expelled from Samos. He eventually founded a school of philosophy in 311 BC and then moved it to Athens in 307 BC.

In Athens, Epicurus created a stir by rejecting many of the expectations for a philosopher. At the time, philosophers were expected to embrace a frugal, ascetic lifestyle in the mold of Socrates (c. 470–399 BC). But Epicurus taught from his garden and told his students that there was nothing wrong with pleasure. In particular, he said that friendship was the noblest pleasure. He is thought to have written 300 books elaborating on his philosophy, nearly all of which have been lost. Epicurus was not a hedonist—he lived simply and eschewed sex—but saw no purpose in denying himself friendship and other comforts.

Epicurus taught that fear and pain were to be avoided whenever possible. His opposition to fear led him to criticize religion, which he felt caused Greeks to fear death because they believed that they would be condemned in the afterlife. Epicurus believed in the gods, but believed there was no reason to fear them.

Sure enough, on the day of his own death, Epicurus wrote a letter to a friend in which he called it a "truly happy day."

ADDITIONAL FACTS

1. *The word* epicurean *now refers specifically to someone who enjoys gourmet food. Epicurus himself, ironically, lived mostly on bread and water.*

2. *Epicurus harbored resentment toward his childhood teachers, particularly Nausiphanes, whom he referred to in his later writings as the Mollusk.*

3. *Unlike the Stoics, Epicureans avoided politics—on the grounds that in the rough-and-tumble world of Greek politics, acquiring power could only increase the likelihood of a painful end.*

✦✦✦

Pliny the Elder

When the Italian volcano Mount Vesuvius started spewing rock and ash on August 24, AD 79, terrified residents of nearby towns desperately tried to flee to safer ground. One man, however, traveled in the opposite direction. Instead of fleeing, the writer Pliny the Elder (c. 23–79) decided that he wanted a closer look at the catastrophic eruption.

Pliny, a high-ranking Roman military leader, had published his most famous work, a thirty-seven-volume encyclopedia titled *Historia Naturalis*, two years earlier. With topics ranging from wine making to mining, medicine to geography, the book contained as much of the ancient world's knowledge as Pliny could gather. But it had no chapter on volcanoes, and the massive eruption piqued his curiosity.

Pliny, whose full name was Gaius Plinius Secundus, was born into the equestrian class, one of the noble ranks of ancient Rome. He served in the Roman legions during wars against the Germanic tribes and the Britons and wrote a history of the war, now lost, after returning to Rome.

He was promoted to the position of procurator under the emperor Vespasian (AD 9–79). Insatiably curious, he traveled through modern-day Spain and France, taking notes on the wineries, gold mines, and mountain ranges he visited. Pliny spent much of the 70s writing the encyclopedia, which was dedicated to the emperor upon its completion in 77 and remained a standard reference work for centuries. A grateful Vespasian then put Pliny in charge of the Roman navy, the position he held on the day of the fateful eruption.

As the volcano continued to rumble, Pliny sailed across the Bay of Naples, hoping to observe the huge mushroom cloud of smoke over the crater and perhaps rescue survivors from the city of Pompeii. The city was virtually destroyed by the ash and rock that rained down during the eighteen-hour eruption.

However, after landing, Pliny's crew was overcome by the pumice, cinders, and sulfurous gases pouring out of the volcano. He died in a field the next morning, possibly from the fumes or from a heart attack.

ADDITIONAL FACTS

1. *The type of eruption observed at Vesuvius in 79—a huge column of smoke rising above the volcano's crater—is still called a Plinian eruption in honor of the mountain's most famous victim.*

2. *Pliny's nephew, Gaius Plinius Caecilius Secundus (c. 61–c. 113), was also a prominent writer and statesman. He is usually known as Pliny the Younger to distinguish him from his uncle.*

3. *The encyclopedia contained thousands of supposed medical cures derived from plants and animals. For instance, in one section Pliny wrote that the skin of a freshly killed goat could be used to treat snakebites.*

◆◆◆

Judas

One of the original twelve apostles, Judas Iscariot is infamous for betraying Jesus Christ to the Roman authorities. Judas was paid thirty pieces of silver for the tip that lead to Jesus's arrest and crucifixion—earning the informant a place as one of the central villains in Christian theology.

Judas Iscariot—the surname is probably derived from the Latin *sicarius*, meaning "murderer"—was the treasurer of the apostles, the inner circle of disciples that formed around Jesus during his lifetime. In the Gospel of John, he is depicted as a thief who stole donations intended for the poor.

According to the biblical account, Jesus and his followers came to Jerusalem during Passover— probably in AD 33—and enraged the authorities by attacking the moneylenders in the temple. Determined to arrest the troublemaker, the Roman governor Pontius Pilate and high priest Joseph Caiaphas arranged to bribe Judas. The arrest occurred after the Last Supper, in the Garden of Gethsemane, where the apostles had gathered to pray. Judas identified Jesus to the soldiers by kissing him—thus betraying him "with a kiss."

For most of the two millennia since, the role of Judas in the death of Jesus has been a source of controversy and a wellspring of anti-Semitic violence. Judas, along with Jesus and all the other disciples, was Jewish; Pontius Pilate, who ordered his crucifixion, was a Roman pagan. But until 1965, Judas's betrayal was interpreted in the Roman Catholic Church as proof of the collective guilt of Jews for the death of Christ. (After the Holocaust, the church changed its position at the Vatican II conference, concluding that Christ's death "cannot be charged against all the Jews.")

The Bible gives conflicting accounts of Judas's fate. In Matthew, Judas became so ashamed that he returned the silver and hanged himself (from a species of tree now called the Judas tree). In Acts, he used the money to buy a field—and then killed himself.

ADDITIONAL FACTS

1. *The Gospel of Judas, an account of Jesus's death told from Judas's point of view, was discovered in a cave in Egypt in the 1970s and published in English in 2006. In the gospel, the betrayal of Judas is portrayed as a necessary step to fulfill biblical prophecies and allow Jesus to save mankind.*

2. *Judas was played by British singer Murray Head (1946–) in the original production of* Jesus Christ Superstar, *a rock opera about the death of Jesus written by Andrew Lloyd Webber (1948–) and Tim Rice (1944–) in 1971.*

3. *Harvey Keitel (1939–) played Judas in the controversial 1988 film* The Last Temptation of Christ, *directed by Martin Scorsese (1942–). The movie was condemned by some Christian groups because it portrayed Judas positively and depicted Jesus dreaming about marriage to Mary Magdalene.*

◆◆◆

Catullus

Witty, satirical, and occasionally obscene, Catullus (c. 84–c. 54 BC) was an ancient Roman poet who became influential in Western literature after the rediscovery of his works during the Renaissance. His love poems, in particular, are known for their beauty, humor, and eroticism.

Gaius Valerius Catullus was born in Verona, a city north of Rome, and belonged to an elite family; his father was a close friend of Julius Caesar (100–44 BC). Catullus served in the Roman army in Bithynia, but abandoned the military—and with it, hopes for a political career—as soon as his one-year enlistment was up.

Many of the details of Catullus's life are unknown or can only be inferred from his poetry. Before joining the army, he lived in Rome and fell in love with an older woman, Clodia Metelli, with whom he had a brief affair and who provided the inspiration for many of his love poems. While in the army, he apparently visited his brother's tomb near Troy, which inspired the elegy ("forever, Brother, hail and farewell") that is one of his most famous poems.

At some point, Catullus also incurred the wrath of Caesar, whom he poked fun at in one of his poems. Caesar forgave his friend's son, however, and in one account had dinner with the poet that night to celebrate their reconciliation. Catullus returned to Italy after leaving the army and settled in a villa near Tivoli, where he died of unknown causes at age thirty.

In Roman literature, Catullus is classified as one of the neoteric poets, a group that revolutionized Latin poetry by using ordinary, everyday language and writing about familiar topics. His writing was criticized by Cicero (106–43 BC), among others, who subscribed to the more traditional idea that poetry should be morally uplifting.

Catullus's poems were lost in the Middle Ages, but then a single copy resurfaced in Verona. Today he is considered one of the canonical Latin authors, and he was an influence on John Milton (1608–1674), William Wordsworth (1770–1850), and other modern poets.

ADDITIONAL FACTS

1. *Catullus was a devotee of the love poetry of Sappho of Lesbos (c. 630–c. 570 BC) and referred to Clodia by the nickname Lesbia in honor of the poet.*

2. *In one of his love poems to Lesbia, Catullus proposes they exchange as many kisses "as there are grains of sand on Cyrene's silphium shores." A 1994 article in* Archaeology *magazine hypothesized that the line was a coded reference to a type of primitive contraceptive that was derived from the now-extinct silphium plant.*

3. *Catullus's poems were untitled and are usually referred to by number—e.g., "Catullus 50" or "Catullus 101."*

✦✦✦

Marcus Junius Brutus

This was the noblest Roman of them all.
—Antony, in *Julius Caesar*

Marcus Junius Brutus (c. 85–42 BC), a Roman senator, was one of the chief organizers of the plot to assassinate Julius Caesar (100–44 BC). On March 15—the Ides of March—Brutus and his coconspirators stabbed the dictator to death on the steps of the Senate in one of the most famous murders in history.

Brutus's role has often been portrayed as an act of supreme betrayal, because Caesar had appointed him to a powerful position only one year earlier. Indeed, the shock of seeing his former ally turn against him inspired Caesar's famous (and probably apocraphyl) last words, "*Et tu, Brute?*"—Latin for "And you, Brutus?"

Brutus and his coconspirators, however—including his wife, Porcia (c. 70–c. 42 BC)—believed that killing Caesar was the only way to prevent tyranny and restore the Roman Republic. Their fears were prescient: The Roman Empire was established less than two decades after Caesar's death, ending five centuries of republican government.

Born into a high-ranking family in Rome, Brutus entered politics and was initially an enemy of Caesar, siding against him in a civil war in 49 BC. But Caesar pardoned the young senator and eventually made him the governor of the Roman province of Gaul.

In his play about the dictator's assassination, *Julius Caesar*, William Shakespeare (1564–1616) depicted Brutus as a reluctant participant in the plot. He liked Caesar personally, according to Shakespeare's portrayal, but felt that it was his duty as a Roman to "kill him in the shell," before his dictatorial plans could hatch.

After the assassination, Caesar's adopted son, Octavian (63 BC–AD 14), assumed dictatorial powers, and Brutus was forced to flee Rome with the other conspirators. He attempted to rally opposition to Octavian, but was forced to commit suicide in 42 BC after losing the Battle of Philippi to the young dictator—who would soon fulfill Brutus's worst fears by becoming the first Roman emperor, Augustus.

ADDITIONAL FACTS

1. *According to legend, Porcia was so distraught at the death of her husband that she, too, committed suicide, by swallowing hot coals.*

2. *Brutus's brother-in-law, Gaius Cassius Longinus (c. 85–42 BC), was another principal organizer of the assassination plot. In* Julius Caesar, *he is portrayed as the character Cassius. Like Brutus, he died at Philippi after ordering his servant to kill him.*

3. *Even rivals in Rome often shared close family relationships. Brutus's mother, Servilia Caepionis (c. 107–c. 42 BC), was Caesar's mistress for the last twenty years of the leader's life.*

✦✦✦

John the Baptist

In roughly AD 30, a fiery Jewish preacher accused Herod Antipas (21 BC–AD 39), the puppet king of Galilee installed by the Romans, of committing adultery, incest, and other "evil things." Enraged, King Herod arrested the preacher and sent him to a cliff-side prison overlooking the Dead Sea.

The preacher, John the Baptist (c. 6 BC–c. AD 30), is among the most important figures in the New Testament, the foundational text of Christianity. During his ministry, John attracted a large following with his attacks on Herod and his sermons about the imminent end of the world. He was also a major influence on Jesus Christ, who had just begun his own preaching at the time of John's arrest.

There is little historical record of John's life, and the Bible provides only fragmentary details. According to the Gospel of Luke, John was a cousin of Jesus and a fellow Nazarene. He wore ascetic garb in the manner of the ancient Hebrew prophets, lived on locusts and wild honey, and had wandered for years in uninhabited parts of the Judaean desert before beginning his ministry.

In his sermons, John urged his followers to repent their sins, reject greed and extortion, and accept baptism in the Jordan River in preparation for the final coming of the Lord. One of the Jews who answered the call was Jesus, and he was baptized by John before the prophet's arrest.

After John's imprisonment, word reached him that Jesus had begun curing lepers, raising the dead, and performing other miracles. John sent his disciples to investigate, and they confirmed that Jesus was "he that cometh after me"—the Messiah. In Christian theology, John is regarded as the precursor to Jesus and "the voice of one crying in the wilderness" who had predicted the Messiah's arrival.

Unfortunately for John, his end was indeed imminent. To placate his wife, whom John had insulted with the incest accusation, Herod had his men cut off the prophet's head and deliver it to his stepdaughter on a platter as her birthday present.

ADDITIONAL FACTS

1. *The historian Flavius Josephus (37–100) tells a different story about John's arrest. According to his account, John was executed when Herod began to fear that John's following had become so large he might start a revolt.*

2. *Although never formally canonized, John is traditionally regarded as a saint in the Roman Catholic Church. He is the patron saint of Jordan and Puerto Rico, among many other places.*

3. *The shriveled remains of a head said to be John's are on display at Rome's San Silvestro Church.*

◆◆◆

Julius Caesar

"He doth bestride the narrow world like a Colossus," wrote William Shakespeare of Julius Caesar (100–44 BC). The Roman general and politician was among the most prominent men of his age, as well as a pivotal figure in the history of the West. Caesar conquered Gaul, destroyed the power of the Roman Senate, and laid the foundation for the largest empire of the ancient world.

Shortly after he was proclaimed dictator for life, however, Caesar was assassinated. It was his adopted son, Octavian (63 BC–AD 14)—later renamed Augustus—who completed Rome's transformation from republic to empire.

Caesar's life is among the best documented in the ancient world. He was born into an aristocratic family and joined the army as a teenager. According to a well-known story, while crossing the Aegean Sea he was captured by pirates and held for ransom. Caesar, offended by the low price the pirates demanded, insisted that they raise the ransom before he would agree to be freed.

For the next several decades, Caesar rose steadily in the military and in politics. In 69 BC, he was appointed governor of an Roman province in present-day Spain. He was elected *pontifex maximus*, the chief religious official in Rome, in 63 BC.

Four years later, in 59 BC, Caesar. He also formed, with two other generals, the First Triumvirate, which in effect controlled the Roman government. The Senate, fearing Caesar's growing power, ordered him to disband his army in 50 BC.

Caesar's refusal to obey the Senate—and his famous crossing of the Rubicon River in January 49 BC—triggered a civil war that ended with his victory the next year. The Senate, its power broken, elected him dictator for several consecutive years, and then proclaimed him *dictator perpetuo*, dictator for life, in 44 BC.

The last step proved too much for Caesar's critics, who feared that he would reestablish a monarchy and end the Roman Republic. A group of conspirators stabbed him to death on the steps of the Roman forum on March 15—the Ides of March—in 44 BC.

ADDITIONAL FACTS

1. *Caesar's family claimed it was descended from Venus, the Roman goddess of love and fertility.*

2. *Regarded as an excellent orator and writer, Caesar wrote two war memoirs,* Commentaries on the Gallic Wars *and* Commentaries on the Civil War, *which remain two of the best-known primary sources on that period in Roman history.*

3. *After his death, the name Caesar became a synonym for emperor or military leader. The titles of the monarchs of Germany and Russia—kaiser and czar—were both derived from Caesar's name.*

Seneca

A tragic figure in the history of philosophy, Seneca (c. 4 BC–AD 65) was the childhood tutor and advisor of the Roman emperor Nero (37–68). After schooling the young emperor in rhetoric, politics, and Stoic philosophy, however, Seneca was betrayed by his famous student and forced to commit suicide, ending the career of one of ancient Rome's foremost thinkers.

Seneca was born in what's now Córdoba, Spain, and educated at a prestigious academy in Rome. As a young student, he took a particular interest in the Greek school of philosophy known as Stoicism. The Stoics, who had first flourished about two centuries earlier in Athens, believed that living simply, upholding virtue, and accepting one's fate were the keys to happiness.

For an avowed Stoic, however, Seneca's lifestyle during his youth was notably unrestrained. After entering politics, he developed a reputation as an adulterer and was exiled to the island of Corsica in AD 41 for allegedly sleeping with the niece of the emperor Caligula (12–41). Some of the earliest of Seneca's works that still exist were written during his eight-year exile.

After finally returning to Rome in AD 49, Seneca became Nero's tutor and continued to write plays, poetry, and essays. When Nero became emperor in AD 54, at age sixteen, Seneca was initially one of the emperor's closest advisors; he even participated in Nero's plot to kill his mother, Agrippina (15–59). Seneca tried several times to retire, but Nero, increasingly unstable, insisted that his advisor remain in Rome.

In AD 65, however, Nero accused Seneca of participating in the Pisonian conspiracy, a plot to assassinate him. The emperor ordered his teacher to commit suicide—an order that Seneca obeyed with Stoic resolve by slitting his wrists. When the wounds failed to kill him, he finished the grim task by immersing himself in a bath and suffocating himself.

ADDITIONAL FACTS

1. *According to the Roman historian Suetonius (69–130), Seneca was briefly a vegetarian but was forced to eat meat by the emperor Tiberius (42 BC– AD 37), who distrusted vegetarians.*

2. *The first English translation of Seneca's writings appeared in 1614.*

3. *Seneca's wife, Paulina, tried to commit suicide with her husband, but was prevented from doing so by Nero's soldiers because the order applied only to the philosopher himself.*

✦✦✦

Cai Lun

In the annals of invention, Cai Lun (c. 62–121) is rarely mentioned. But the product the ancient Chinese government official is credited with perfecting—paper—has undoubtedly changed the world.

Before paper, ancient scribes depended on papyrus, a fragile reed that decayed easily, or parchment, a rare and expensive product made from animal skin. Both cheap and durable, paper made it possible to keep far more extensive records and greatly lowered the cost of producing books. Papermaking gradually spread across the world, even contributing to the European Renaissance by making widespread literacy practical.

Originally from Hunan province, Cai Lun was an imperial eunuch in the court of the Han dynasty emperor He (79–105). (Castrated men were preferred for imperial service because they had no children and thus were thought to be less likely to attempt to overthrow the government and start a new dynasty.) In 89, Cai Lun was put in charge of the department that produced weapons and other instruments, where he quickly grasped the need to produce a cheap and reliable writing medium.

After years of experimentation, he unveiled his invention to the emperor in 105. It is thought that Cai Lun borrowed from earlier papermakers and local traditions, but it was his version of paper that became popular and eventually spread throughout the world.

Although he was hailed in his lifetime, Cai Lun's glory did not last. The emperor died in 105, and his nephew, Emperor An of Han (94–125), turned on many of his father's advisors after assuming the throne. About to be sent to prison, Cai Lun committed suicide in 121.

ADDITIONAL FACTS

1. *The Han dynasty lasted until AD 220 and had such a large influence on Chinese culture that* Han *became a synonym for people.*

2. *Cai Lun was given the honorary title Marquis for his invention, and he was venerated for centuries afterward in China as the patron saint of papermaking.*

3. *Chinese emperors kept the technique of papermaking a closely guarded secret for centuries after Cai Lun's death. According to tradition, the secret was finally revealed in 751, when several Chinese papermakers were captured after a battle with Arabs and forced to divulge the recipe.*

✦✦✦

Agrippina

When Agrippina (15–59) decided to assassinate the Roman emperor Claudius (10 BC–AD 54), she had no problem getting close to her target. After all, they were married. In the year 54, she served the emperor a plate of poisoned mushrooms—killing her husband and setting in motion one of the most disastrous periods in Roman history.

Among the most powerful women of ancient Rome, Agrippina was a descendant of the emperor Augustus (63 BC–AD 14) and a member of an influential political dynasty. Her brother, Caligula (12–41), was emperor between 37 and 41. She married Claudius, her third husband, in 49. Agrippina had one son from her first marriage, Lucius Domitius Ahenobarbus (37–68)—who later became the emperor Nero.

Known as a ruthless political schemer, at the time of her marriage to Claudius she had already been implicated in an assassination plot against her brother and spent time in exile on an island in the Mediterranean. Her family remained powerful in Rome; in fact, Claudius was her uncle. For Agrippina, the marriage was purely political and offered an opportunity to maneuver Nero into the line of imperial succession.

Claudius, however, began to have second thoughts after 53 and considered putting his own biological son, Britannicus (41–55), next in line for the throne. Agrippina's motive for the assassination was seemingly to prevent the emperor from removing Nero as his heir.

Nero's rule was legendary for its tyranny and incompetence. He launched the first major persecution of the Christians; executed thousands of opponents, including his stepbrother Britannicus; and famously "fiddled while Rome burned" during a huge fire in 64. He was deposed in 68 and committed suicide.

One of his victims, ironically, was Agrippina. After ascending to the throne at age sixteen, Nero was at first strongly influenced by his mother. But she disapproved of his relationship with Poppaea Sabina. Wishing to remove all obstacles to his marriage to Poppaea, Nero ordered Agrippina's death in 59. She was forty-four.

ADDITIONAL FACTS

1. *An opera,* Agrippina, *was written by the baroque composer George Handel (1685–1759) in 1709.*

2. *Claudius's third wife, Valeria Messalina (c. 20–48) was infamous in her own right. According to Pliny the Elder (c. 23–79), she once won a sex competition with a prostitute, "the commonest strumpet in all Rome," by having relations with twenty-five men in twenty-four hours.*

3. *Poppaea Sabina's second husband, Marcus Salvius Otho (32–69), became emperor for three months in 69, during the so-called Year of the Four Emperors. He committed suicide after losing a battle against one of his opponents.*

✦✦✦

Virgil

Virgil (70–19 BC) was an ancient Roman poet and the author of *The Aeneid,* an epic poem about Rome's founding that became one of the most influential Latin texts of antiquity and helped shape the Roman view of the city's history and its role in the world.

He was born Publius Vergilius Maro, but other details of Virgil's early life are unknown. During the period after the assassination of Julius Caesar (100–44 BC), Virgil emerged from obscurity as an ally and propagandist for Caesar's adopted son, Octavian, the future emperor Augustus (63 BC–AD 14).

Virgil's first major work, *Eclogues,* was written in the period just after Caesar's death. The poem—in parts erotic, in others political—served a useful purpose for Octavian by supporting the legitimacy of his claims to power.

Virgil's next poem, *The Georgics,* was finished in 29 BC, just after Octavian had defeated his major enemy, Mark Antony (83–30 BC). Virgil supposedly read it aloud to the emperor as Octavian was recuperating from an illness that summer.

The Aeneid took Virgil the last ten years of his life to write, and it was still unfinished at the time of his death. The poem tells the mythological story of Aeneas, a Trojan warrior who fled after Troy's defeat in the Trojan War and then traveled, surviving many hardships, to Italy, where his ancestors founded Rome. It ends by casting Roman imperialism in terms of divinely ordained national destiny, an ideology that underpinned the expansion of the empire for the next four centuries.

> Others, I take it, will work better with breathing bronze and draw living faces from marble; others will plead at law with greater eloquence, or measure the pathways of the sky, or forecast the rising stars. Be it your concern, Roman, to rule the nations under law (this is your proper skill) and establish the way of peace; to spare the conquered and put down the mighty from their seat.

Virgil died while accompanying Augustus on a trip to Greece. *The Aeneid* was published after the poet's death and immediately hailed as a masterpiece in the tradition of Homer's Greek epics *The Iliad* and *The Odyssey.* And, by establishing the national myth of its founding, *The Aeneid* helped define the self-image of Rome and justify its growing empire.

ADDITIONAL FACTS

1. *Many memorable Latin phrases from Virgil's works are still cited in Western culture.* Omnia vincit amor—*"Love conquers all"—appears first in Virgil's* Eclogues; timeo Danaos et dona ferentes—*"I fear Greeks even when they bring gifts"—comes from* The Aeneid; *and the motto of the United States,* E pluribus unum, *meaning "one composed of many," was adapted from one of Virgil's poems.*

2. *One of the original volumes in the US Library of Congress was a well-thumbed copy of* The Aeneid *donated by Thomas Jefferson (1743–1826).*

3. *Virgil was a major influence on Dante (c. 1265–1321) and appears as a character in* The Divine Comedy *(c. 1321).*

◆◆◆

Boudicca

Merely the physical appearance of Boudicca, warrior queen of the Celts, was enough to inspire dread in the Romans. She had wild, red hair that flowed down to her knees, and she wore a gnarled gold necklace; according to Roman historians, she carried a spear and was "terrifying of aspect."

Indeed, the Romans had good reason to fear Boudicca, who led her army into a ferocious, bloody clash with their legions in AD 61. Hoping to drive the Roman invaders out of Britain, Boudicca and her allies sacked and burned several Roman settlements, leveled London, and slaughtered thousands of Romans.

For Boudicca, the war with the Romans was a matter of both Celtic pride and personal revenge. The Romans had invaded the island of Britain less than twenty years earlier and subjugated many of the Celtic tribes, leading to widespread resentment. Roman soldiers had also raped and tortured Boudicca's two teenaged daughters, stoking her anger at the invaders.

Boudicca's tribe, the Iceni, occupied a part of East Anglia, northeast of London. She had inherited the throne from her husband, Prasutagus. But the Romans refused to recognize an inheritance by a woman and claimed the kingdom for themselves.

The war began in 61, while the Roman governor of Britain was leading a military campaign in Wales. Taking advantage of his absence, the Iceni, joined by other Celtic warriors, attacked the capital of Roman Britain, Colchester, burned several other cities, and sacked London. Roman historical accounts of the carnage—while probably biased—suggest that tens of thousands of Romans were killed.

The Romans, believing that the Celts were disorganized barbarians, had been caught off guard, and the governor had to rush back to London to suppress the revolt. Boudicca was forced to flee and is believed to have committed suicide.

ADDITIONAL FACTS

1. *The site of Boudicca's death is unknown. However, according to the BBC, a myth has evolved that she is buried in London, under what is now platform 9 of the city's Kings Cross Railway Station.*

2. *At the time of Boudicca's uprising, Colchester, then known as Camulodunum, was the capital of Roman Britain. London (formerly Londinium) became the capital in about 100.*

3. *Several British navy vessels have been named after the Celtic queen, including HMS* Boadicea, *a destroyer that was sunk by the Germans in 1944.*

◆◆◆

Jesus

Who was the real Jesus Christ? His teachings inspired what is today the world's largest religion, but many details of the life of the Jewish carpenter who lived from roughly AD 1 to 33 remain elusive.

According to biblical tradition, Jesus was born in Bethlehem but grew up mostly in Nazareth, a village in the Galilee region, near the Dead Sea. He was raised in a typical Jewish household and probably spoke Aramaic, then the most common language in the Middle East.

Jesus lived during a period of great upheaval and social strife among Jews in the Near East. Judaea and Galilee, once independent Jewish kingdoms, had been subjugated by the Roman Empire; some Jews were themselves divided into several quarreling factions.

At some point, the young Jesus was introduced to John the Baptist, a wandering Jewish preacher who was not aligned with either faction but had attracted a large independent following with his apocalyptic preaching. John baptized Jesus—at the Jordan River, according to the Bible—but was soon executed as a troublemaker by the Roman authorities.

After John's arrest, Jesus began his own ministry as a preacher and miracle worker. He spent several years traveling around the Jewish heartland of Judaea, spreading his teachings, establishing a following, and recruiting the apostles who would later spread his message. According to the Gospels, Jesus was scornful of the religious establishment and criticized powerful groups like the Pharisees.

Jesus arrived in Jerusalem, the home of the temple that was the center of Judaism, just before Passover in AD 33. He soon managed to alienate the Roman governor, Pontius Pilate, who had him crucified after only a few days in the city.

Historical details about the life of Jesus are scant, and most of the traditional stories about his life and teachings were compiled in Gospels written many decades after his death. But the community of followers inspired by his teachings would spread quickly throughout the Roman world.

ADDITIONAL FACTS

1. *Aramaic is still spoken in Syria, Iraq, Turkey, and Iran, but the number of native speakers is rapidly declining.*

2. *Jesus did not consider his teachings to be a religion separate from Judaism; the gradual separation of Christianity into a distinct faith occurred decades after his death.*

3. *A widespread method of execution in the Roman Empire, crucifixion was usually reserved for common criminals. It was abolished after the empire embraced Christianity in the fourth century.*

◆◆◆

Cleopatra

The last pharaoh of Egypt, Cleopatra (69–30 BC) was among the most famous and powerful women of the ancient world. She is an object of enduring fascination for her role in Rome's civil wars, her romances with Julius Caesar (100–44 BC) and Mark Antony (83–30 BC)—and her grisly suicide.

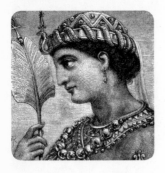

Cleopatra was born into a line of Greek-speaking monarchs who had ruled Egypt since the country had been conquered by Alexander the Great (356–323 BC). When she was eighteen, Cleopatra inherited the throne jointly with her brother, Ptolemy XIII (c. 61–47 BC).

The two siblings were then married to each other. (This type of incestuous pairing was not uncommon among Egyptian royalty; in fact, Cleopatra's mother and father were uncle and niece.) Both siblings schemed constantly to seize power from each other, until Cleopatra was forced into exile in about 50 BC.

In 48 BC, Cleopatra began her affair with Caesar, who took her side in the ongoing civil war with Ptolemy. With her lover's help, Cleopatra was restored to the throne. In 47 BC, she gave birth to a son fathered by Caesar and named him Caesarion (47–30 BC).

Cleopatra hoped that her son would be Caesar's successor. But after the dictator's death in 44 BC, Caesar's adopted son, Octavian (63 BC–AD 14), took power, ruling jointly with Antony and another general. Antony and Cleopatra then became lovers and plotted to wrest power in Rome away from Octavian.

In 31 BC, Octavian went to war against Antony and Cleopatra and defeated their navy at the Battle of Actium. Both lovers then committed suicide; Cleopatra supposedly induced an asp, a type of poisonous snake, to bite her on the breast.

Cleopatra was the last in the line of Egyptian pharaohs, ending a succession that had lasted more than 3,000 years. The region became a Roman province, Aegyptus; it would not regain its full independence until the twentieth century.

ADDITIONAL FACTS

1. *Cleopatra was actually the seventh Egyptian queen by that name; her namesake, Cleopatra I, ruled from roughly 180 to 176 BC.*

2. *The last Egyptian queen was played by actress Elizabeth Taylor (1932–) in* Cleopatra *(1963); her paycheck of $7 million for the performance was a Hollywood record at the time.*

3. *Cleopatra had four children—one (Caesarion) with Caesar and three with Mark Antony. Caesarion was executed by Octavian, and the other three were arrested, paraded through the streets of Rome in Octavian's victory procession, and later raised by foster parents.*

✦✦✦

Marcus Aurelius

Both a powerful Roman emperor and an important philosopher, Marcus Aurelius (121–180) penned one of the most influential philosophical texts of his era. *Meditations,* which the emperor wrote between battles in eastern Europe, remains one of the best-known works of Stoic philosophy, a school of thought that emphasized the importance of personal virtue and acceptance of one's fate.

Marcus, known as the last of the Five Good Emperors, ruled Rome when the empire was at the peak of its might. The arts, philosophy, and commerce flourished during a time of relative peace known as the Pax Romana, or Roman peace, which the philosopher-monarch struggled to maintain and which ended shortly after his death.

Born Marcus Annius Verus, he was a distant relative of the emperor Trajan (53–117). His father was a Roman official whom Marcus credited with teaching him "modesty and a manly character." At age seventeen, however, after his father's death, Marcus was adopted by Antoninus Pius (86–161), who became emperor in 138 and hired one of Rome's best teachers, Marcus Cornelius Fronto (c. 100–170), to tutor the boy.

After the death of Antoninus, Marcus took the throne at age forty, renaming himself Marcus Aurelius. His adoptive brother, Lucius Verus (130–169), served as coemperor for the first eight years of his rule. Wars with the Parthian Empire in Asia and Germanic tribes in Europe preoccupied Marcus for much of his reign.

It is believed that it was during a war with one of the German tribes, the Quadi, that Marcus began writing the *Meditations*. A compilation of twelve shorter books, the *Meditations* is both an autobiography of the emperor and the best-known treatise on Stoicism.

According to the Stoics, there is no afterlife, every man and woman is fated for oblivion, and the tribulations of existence are meaningless. "Everything is by nature made but to die," the emperor wrote.

Still, Marcus believed that people should live virtuously, following natural law. "If thou holdest to this, expecting nothing, fearing nothing, but satisfied with thy present activity according to nature, and with heroic truth in every word and sound which thou utterest, thou wilt live happy," he wrote. While visiting what's now the city of Vienna, Marcus Aurelius died at age fifty-eight. He was succeeded by his son, Commodus (161–192).

ADDITIONAL FACTS

1. *Spotted early in life as being brilliant and hardworking, Marcus was only eight years old when he was named a priest by the emperor Hadrian (76–138).*

2. *Although in theory the position of Roman emperor was hereditary, Marcus was the fifth consecutive Roman emperor who was not the biological son of his predecessor. His own son, Commodus, was the first son to succeed his father to the Roman throne in almost a century.*

◆◆◆

Zhang Heng

The Chinese astronomer, poet, and mathematician Zhang Heng (78–139) achieved fame and honors during his lifetime for inventing the world's first seismometer, a device that could pinpoint the location of earthquakes from hundreds of miles away. In earthquake-prone China, the bronze seismometer filled a crucial need by alerting authorities so they could send aid to the stricken region.

According to one famous story, the seismometer detected a quake in February 138, even though nobody in the capital city of Luoyang felt anything. Zhang Heng's skeptics derided the instrument for ringing what they were sure was a false alarm. Then, a few days later, messengers arrived from more than 350 miles away, carrying news of a devastating temblor.

In addition to his seismometer, Zhang Heng was known for his poetry, which is still included in anthologies of Chinese verse, and the three-dimensional working model of the cosmos that he constructed. He also calculated a more accurate estimate of pi than any other contemporary Chinese scholar had produced.

Zhang Heng was born into a distinguished family in Xi'e, a city in central China. At age seventeen he embarked on a tour of China, collecting material he would use in two of his best-known poems. He was named to a minor government position in 103, where he worked on his poetry and began his studies of astronomy and mathematics.

The emperor An (94–125) promoted Zhang Heng in 111, summoned him to the capital city, and appointed him court astronomer, one of the most senior positions in the imperial government, a few years later. The job required Zhang Heng to record weather and earthquakes, compile the calendar, and predict eclipses and other unusual events.

He unveiled the seismometer in 132 and was promoted for his services. Later that decade, however, he became involved in a dispute with the court eunuchs. He eventually left the court in 136, becoming the governor of Hejian province. He retired in 138 and died the next year.

ADDITIONAL FACTS

1. *Zhang's seismometer—Houfeng Didong Yi, or the "instrument for inquiring into the wind and the shaking of the earth"—was reconstructed by a Chinese museum in 2005. The device used a pendulum in the middle of an urn that was lined with eight dragons, each pointing outward in a different direction. When the machine detected a quake, the pendulum dislodged a bronze ball that then dropped out of the mouth of one of the dragons and into the mouth of a metal toad—indicating the direction of the earthquake's epicenter.*

2. *A rare mineral that was discovered by Chinese scientists in a meteorite that crashed to Earth in 1986 was named zhanghengite in honor of the ancient scholar.*

3. *Zhang Heng improved the estimate of the value of pi offered by previous Chinese mathematicians, but was still off. He estimated pi at 3.1724; the actual value is an irrational number beginning with 3.14159.*

◆◆◆

Diocletia.

The emperor Diocletian (245–316) unleashed the final and most violent persecution of the Christians in Roman history. Tens of thousands of individuals may have been killed under the four separate persecution edicts he issued in 303 and 304. Apart from his bloody crackdown on Christians, however, Diocletian's reign was a relatively peaceful period that temporarily halted the decline of the Roman Empire.

Gaius Aurelius Valerius Diocletianus was a soldier and bodyguard who was declared emperor by his troops in 284. He defeated a rival, Carinus, in a brief civil war and assumed undisputed control over the empire in 285.

By the time Diocletian took power, the empire had struggled through a long period of near anarchy. By the third century, there had been dozens of emperors, some of whom had survived only a few months before being assassinated.

As emperor, Diocletian moved to establish order and restore what he viewed as the ancient Roman virtues of military discipline, respect for private property, and worship of the traditional pagan gods. He sharply curtailed the power of the Senate, reformed the civil service, and overhauled the Roman tax code. Militarily, Diocletian crushed opponents in Egypt, Armenia, and Syria.

Christians had been subject to intermittent persecutions since the reign of Nero (37–68), but the first two decades of Diocletian's rule were marked by relative tolerance. Historians have long puzzled over what caused the emperor's abrupt reversal in 303, when he announced the first of his persecutions. He may also have come to believe that Christianity posed a threat to the civic unity of the empire.

The persecution began with the torching of churches and expanded into an unprecedented campaign of torture and execution. Christians who refused to make sacrifices to the pagan gods were boiled alive, crucified, or, infamously, fed to the lions in the arena. Many others were sent to work in the mines.

In 305, Diocletian became the first emperor in Roman history to voluntarily abdicate. He retired to his palace on the Adriatic, where he grew vegetables and suffered from increasingly ill health. Diocletian died there in 316—three years after one of his successors, Constantine (c. 272–337), had overturned the ban on Christianity and ended the persecution.

ADDITIONAL FACTS

1. *The triumph held by Diocletian and Maximian (c. 250–310) on November 20, 303, to celebrate their victory over the Persians was the last such parade in the history of Rome.*

2. *Diocletian spent most of his emperorship outside of Rome. He preferred Nicomedia (now Izmit, Turkey) and Antioch (now Antakya, Turkey). His retirement palace in Salonae (now Split, Croatia) is still standing.*

3. *During the persecutions, many Roman Christians took refuge in the catacombs, a network of caves outside the city walls. Many of the catacombs are now open to the public.*

◆◆◆

Ovid

One of the great mysteries of Western literature unfolded in AD 8, when the Roman poet Ovid (43 BC–c. AD 17) was abruptly banished and forced to flee the city. From his forlorn exile on the Black Sea, Ovid himself never explained what happened—except to acknowledge that he had committed a crime worse than murder.

Before his exile, Ovid was one of the leading poets of ancient Rome, known for his Latin verses about love, seduction, and marriage. In the absence of historical evidence, many critics have wondered if Ovid's bawdy *Ars amatoria* (*The Art of Love*), a love manual published in about 1 BC, may have offended the emperor and played a role in his mysterious exile.

Born Publius Ovidius Naso, Ovid was educated in Rome and traveled widely in the empire as a young man. Although his father wanted him to become a lawyer, Ovid defied his wishes and published his first collection of love poems, *Amores*, in about 19 BC. The well-researched book—Ovid had already been married three times and divorced twice by age thirty—was later removed from Rome's libraries on the order of Emperor Augustus (63 BC–AD 14).

Just before his banishment, Ovid completed the work that is generally regarded as his masterpiece, the *Metamorphoses*. Fifteen volumes in length, the poem is a series of stories inspired by Greek and Roman mythology, all on the theme of changes in shape. The poem would be an inspiration to Geoffrey Chaucer (c. 1343–1400), William Shakespeare (1564–1616), and many other writers.

The last ten years of Ovid's life were spent in Tomis, a remote frontier outpost in what is now Romania. Despite repeated appeals from Ovid's friends, neither Augustus nor his successor, Tiberius (42 BC–AD 37), would allow the poet to return to Rome. He died in exile at roughly age sixty.

ADDITIONAL FACTS

1. *Shakespeare referenced Ovid in several of his plays—perhaps most extensively in* The Tempest *(c. 1611), in which one passage is adapted from a section of the* Metamorphoses.

2. *The city to which Ovid was banished, Tomis, is near the modern-day city of Constanta, Romania.*

3. *Augustus banished his promiscuous granddaughter, Julia, in the same year that he banished Ovid. Some historians have theorized that Ovid was aware of Julia's indiscretions and that Augustus may have punished him for failing to alert the emperor to her activities.*

✦✦✦

Shimon Bar-Kokhba

Shimon Bar-Kokhba (?–c. 135) was a Jewish commander who revolted against the Roman Empire in 132. He ruled for three years before the Romans reconquered Judaea—making him the last leader of an independent Jewish state until the founding of Israel 1,800 years later.

After suppressing Bar-Kokhba's rebellion, the emperor Hadrian (76–138) exacted his revenge by passing laws meant to eradicate Judaism. As part of that effort, he ordered the widespread deportation of Jews from their ancestral homeland, a key event in the creation of the Jewish Diaspora.

Little is known about Bar-Kokhba's life prior to the revolt. He claimed to be a descendant of King David, the ancient king of the Israelites. Because of this illustrious lineage, Bar-Kokhba was regarded as a messiah by some Jews.

The revolt was sparked by Hadrian's attempt to outlaw traditional Jewish religious practices. The emperor had ordered a ban on infant circumcision, which he considered barbaric, and had also offended Jews by building a pagan temple atop the ruins of the Temple of Jerusalem.

Bar-Kokhba's revolt eventually included about 400,000 soldiers. The rebels took control of hundreds of towns, evicted the Romans from dozens of their forts, enforced Jewish religious laws, and even minted their own coins. For about three years, before Hadrian dispatched a new army to the region, Judaea was functionally independent.

In total, it took twelve Roman legions to subdue the revolt, one of the bloodiest wars of the period of the Pax Romana. The rebels' last stand came in Bethar, a town near Jerusalem; Bar-Kokhba and all his followers were killed when the Romans overran the city in 135. In the wake of the war, many Jews were killed, deported, or sold into slavery; it would be centuries before Jews would begin to trickle back into the ancient capital of Jerusalem.

ADDITIONAL FACTS

1. *Bar-Kokhba was said to initiate new members of his army by amputating one of their fingers.*

2. *After the revolt, Roman authorities destroyed much of Jerusalem and renamed it Aelia Capitolina. Hadrian also changed the name of the province from Judaea to Syria Palaestina—the root of the word Palestine.*

3. *A twentieth-century Zionist youth group, Betar, took its name from the site of the last battle of Bar-Kokhba's uprising.*

✦✦✦

Paul of Tarsus

After the death of Jesus in AD 33, an adventuresome missionary named Paul of Tarsus played an instrumental role in spreading the new faith of Christianity throughout the far-flung provinces of the Roman Empire. Although initially a skeptic, Paul became the religion's most zealous and intrepid advocate, and he may even have ensured its survival by winning thousands of converts and opening its doors to non-Jews.

Paul was born—under the name of Saul—into a Jewish family in modern-day Turkey. He was a Roman citizen, a rare privilege at the time for a resident of an outlying province, and worked as a tent maker.

As a student in Jerusalem shortly after the death of Jesus, Paul initially opposed Christianity and supported anti-Christian persecution. However, during a trip to Damascus he experienced a religious epiphany and converted to the new faith.

Paul returned to Jerusalem, where he contacted the surviving apostles, who were initially suspicious of their former tormentor. They were astounded, according to the New Testament, that "he which persecuted us in times past now preacheth the faith which once he destroyed." But Paul's high social status and unexpected determination to spread the faith made him an invaluable asset to the early Christian church.

In his travels, Paul sought out Jewish communities in cities in present-day Lebanon, Turkey, Greece, and Cyprus. Unlike some other Christians, however, he also supported converting non-Jews, which laid the foundation for the explosive growth of Christianity and the final separation of Christianity and Judaism into two separate faiths.

Paul's adventures came to a halt when he was arrested for admitting a non-Jew into the Temple of Jerusalem and sent to Rome for trial. He was acquitted and is believed to have stayed in Rome to help organize the Christian church in the heart of the imperial capital. But his stay in Rome was short: He was beheaded during the first major wave of anti-Christian persecution in about AD 65.

ADDITIONAL FACTS

1. *The story of Paul's conversion on the road to Damascus is so famous that any sudden change of opinion is often referred to as a road-to-Damascus reversal.*

2. *A sarcophagus thought to contain Paul's remains was unearthed under a Roman basilica in 2006.*

3. *Paul is credited with authoring seven books of the New Testament—Romans, 1 and 2 Corinthians, Galatians, Philippians, 1 Thessalonians, and Philemon—and may have written six others.*

◆◆◆

Augustus

The founder of the Roman Empire, Augustus (63 BC–AD 14) established a centralized, authoritarian system of government that lasted for five centuries and brought an unprecedented level of stability and prosperity to the Western world.

Born Gaius Octavius and more widely known in his early life as Octavian, he was the adopted son of Julius Caesar (100–44 BC). After Caesar's assassination, the eighteen-year-old Octavian inherited many of his father's allies—and enemies. In the civil war that followed Caesar's death, Octavian defeated the leaders of the assassination plot, Brutus and Cassius, in two battles at Philippi in 42 BC.

For the next decade, Octavian split power with two other generals, Mark Antony (83–30 BC) and Marcus Aemilius Lepidus (90–c. 13 BC), in an arrangement called the Second Triumvirate. The triumvirate collapsed in 36 BC; Lepidus was forced out of power, and Antony committed suicide after being defeated by Octavian in 31 BC.

In 27 BC, after establishing total control over Rome, Octavian was proclaimed Augustus by the Senate—meaning, literally, the divinely ordained or "illustrious one"—as well as *imperator,* or "commander." The Senate continued to exist, but ceded most of the powers it had held during the republic to the new emperor.

Augustus would rule for more than forty years, restoring order and stability to Rome after decades of intermittent civil war. He also reformed the military, established a postal system, added large parts of central Europe and Africa to the empire, and constructed roads and aqueducts throughout his lands.

After Augustus's death, he was proclaimed a god by the Senate. His adoptive son, Tiberius (42 BC–AD 37), followed him as emperor.

ADDITIONAL FACTS

1. *Roman emperors often incorporated the name Augustus into their titles, and some used it in their personal names; the last Roman emperor, who was deposed in 476, was named Romulus Augustulus.*

2. *After Octavian's death, the Senate voted to change the name of the month Sextilis to August in his honor. (July had already been renamed in honor of Julius Caesar.)*

3. *In 1961, American poet Robert Frost (1874–1963) referred to Augustus in the poem he wrote to celebrate the inauguration of John F. Kennedy (1917–1963). The words expressed hope that the new president would usher in the "next Augustan age" of strength and pride.*

✦✦✦

Hypatia

To teach superstitions as truth is a most terrible thing.
—Hypatia

An inventor, mathematician, and philosopher, Hypatia (c. 370–415) was one of the most prolific women writers of the ancient world. Before her gruesome murder at the hands of a Christian mob, she was also a leading citizen of Alexandria, Egypt, and one of the city's most influential teachers.

The daughter of Theon (c. 335–c. 405), a well-known teacher of mathematics, Hypatia was raised in one of the ancient world's most important intellectual centers. Site of the famed great library, Alexandria was home to a diverse community of Greek-speaking Christian, Jewish, and pagan scholars.

Hypatia began her academic career as a collaborator with her father, editing or cowriting several math and astronomy books. She became a popular lecturer on science and philosophy in her own right and was named director of an Alexandria philosophy school in 400. Although she was nominally a pagan, among Hypatia's students were many Christians, including two future bishops.

At a time when few women participated in higher education, Hypatia was an exceptionally rare figure. She drove her own chariot, dressed in the clothing of a male teacher, and corresponded with scholars across the Greek world. According to some accounts, she invented several scientific instruments, including an improved version of the astrolabe. A confidante of the city's governor, she also acquired political influence during a time of increasingly bitter religious rivalry.

It was the religious disputes in the city that eventually cost Hypatia her life. According to ancient historians, Christians in the city suspected her of taking sides against them in a political dispute between the governor and the bishop. The bishop spread rumors that she was a witch, and one day while driving her chariot through the streets, she was accosted, stripped naked, brutally killed, and torn to pieces by the mob.

The murder of Hypatia has been seen as a pivotal event in world intellectual history—the end point of the ancient Greek philosophical tradition. Many scholars fled the city to avoid meeting the same fate; "after this," as Bertrand Russell (1872–1970) wrote, "Alexandria was no longer troubled by philosophers." She was roughly sixty years old at the time of her death.

ADDITIONAL FACTS

1. *A feminist philosophy journal,* Hypatia, *is named after the ancient writer.*

2. *Hypatia's killers were never punished. Her main Christian antagonist in Alexandria, the bishop Cyril (c. 378–c. 444), was later named a saint.*

3. *A movie about Hypatia called* Agora, *directed by Alejandro Amenábar (1972–) and starring Rachel Weisz (1970–) as the philosopher, was released in 2009.*

◆◆◆

Ptolemy

The Greek astronomer, mathematician, and geographer Ptolemy (c. 100–170) may be best known to history for his greatest mistake: In the landmark astronomical treatise the *Almagest,* he claimed that the sun, stars, and planets all revolved around Earth. His conclusion was accepted by virtually all astronomers for the next 1,400 years, until it was finally debunked in the sixteenth century.

But before Nicolaus Copernicus (1473–1543) proved that it was Earth that revolved around the sun, Ptolemy was widely regarded as the greatest astronomer of history, as well as the West's leading authority on the cosmos.

Ptolemy was born in Egypt and lived much of his life in Alexandria, the capital of the Roman province. Prior to the Romans, Egypt had been under Greek rule, and Ptolemy spoke and wrote in ancient Greek. However, he was also a Roman citizen, a privileged status granted to relatively few elite inhabitants of the territories.

In the 120s, Ptolemy began recording his astronomical observations, which he used to write the *Almagest.* Also containing summaries of the work of other major ancient astronomers, especially Hipparchus, an astronomer from Rhodes who studied eclipses and the motion of the sun, the *Almagest* was a compilation of all the astronomical knowledge in the ancient world. Completed in about 150, the text was used by astronomers and astrologers for centuries afterward to predict eclipses and compile horoscopes.

Ptolemy was also a noted cartographer who produced some of the ancient world's most accurate maps. He was the first mapmaker to make extensive use of longitude and latitude, as well as the first whose maps reflected the curvature of the earth. Like his astronomy, Ptolemy's geography would be considered the pinnacle of scientific knowledge for centuries after his death.

ADDITIONAL FACTS

1. *Ptolemy's goal in his* Geography, *a world atlas and mapmaking guide, was to provide sufficiently detailed directions so that any reader could draw his or her own world map. To make the map as thorough as possible, he listed the longitudes and latitudes of 8,000 locations in the ancient world— one of the most complete historical records of ancient cities and place names in existence.*

2. *Like those of many other ancient Greek thinkers, Ptolemy's works were preserved thanks to the efforts of Arab scholars during the Middle Ages. Indeed, the most frequently used English title of Ptolemy's astronomical manual,* Almagest, *is derived from the book's Arabic name.*

3. *Ptolemy believed there were only six planets, including Earth, a view that prevailed for about the next 1,700 years. The outermost planets, Uranus and Neptune, were not discovered until 1781 and 1846, respectively.*

❖❖❖

Alaric

Visigoth chieftain Alaric (c. 370–410) led the sack of Rome in 410, an epochal event in Western history that signaled the imminent demise of the Roman Empire. Although relatively mild by ancient standards—the Goth occupation lasted only six days, and most major buildings were spared—the sack of Rome exposed how feeble the once-mighty empire had become.

The Goths were a Germanic people who had begun raiding the fringes of the Roman Empire in the second century. In the fourth century, they separated into the Ostrogoths (eastern Goths) and Visigoths (western Goths). Alaric, a onetime mercenary for the Romans, was elected chief of the Visigoths in 395.

After taking charge, Alaric led a two-year campaign against Roman settlements in Greece, including the cities of Piraeus, Corinth, Argos, and Sparta, the last of which he leveled. The Eastern Roman emperor bribed him in exchange for peace in 397, and thereafter Alaric turned his attention to the west.

Invading Italy for the first time in 401, Alaric was defeated by the Romans on this and his next attempt. He finally reached the walls of Rome in 408, and after besieging the city three times, he entered it on August 24, 410. It was the first time in almost 800 years that Rome had fallen to a foreign army.

News of the stunning Goth victory spread across the ancient world. As the historian Edward Gibbon (1737–1794) wrote in *The History of the Decline and Fall of the Roman Empire*, "This awful catastrophe of Rome filled the astonished empire with grief and terror." It was a foretaste of what was to come: Just a little more than a half century later, the Western Roman Empire collapsed.

After sacking Rome, Alaric marched his troops north. He died in Italy soon after.

ADDITIONAL FACTS

1. *Alaric's troops entered Rome via the Porta Salaria, a gate in the city walls that was not demolished until 1921.*

2. *The sack of the imperial capital dealt a profound shock to many Romans. One Roman writer living in Africa, Saint Augustine of Hippo (354–430), responded by writing* The City of God, *a famous book in the history of Christian theology that offered religion as a consolation for the empire's political troubles.*

3. *According to Gibbon, after Alaric's death the Goths diverted the course of the Busento River, buried Alaric in the riverbed, and then restored the normal flow to conceal the grave.*

◆◆◆

Murasaki Shikibu

Murasaki Shikibu (c. 978–c. 1014) was a Japanese poet, novelist, and diarist whose book *The Tale of Genji* was one of the first novels ever written. The book is thought to have been published in 1008; its 1,000th anniversary in 2008 brought renewed attention to the work, which is considered a landmark of world literature and the Japanese language.

MURASAKI SHIKIBU.
[JAPAN'S MOST DISTINGUISHED AUTHORESS.]

Born in Kyoto, the capital of imperial Japan, the author was a member of a noble family and became a lady-in-waiting to the empress. Murasaki received what was, at the time, an unusually extensive education for a Japanese woman from her father, a senior imperial official. It is thought that she began writing the novel after the death of her husband, Fujiwara Nobutaka, in 1001.

The Tale of Genji tells the story of Genji, the son of the emperor, and his many love affairs. It involves hundreds of characters, several different settings in Japan, and a span of several decades. The book lacks many familiar features of a novel—such as a plot with a climactic ending—and is incomprehensible to modern Japanese speakers due to the formal, archaic language Murasaki used. Adding to the confusion, Murasaki generally did not use proper names, since calling a person by his or her name was considered insulting in Japan at the time she was writing. (The author's own name is unknown; Murasaki Shikibu was a nickname.)

In addition to *The Tale of Genji*, Murasaki wrote dozens of poems and a diary that provided an important historical record of everyday life and customs in Heian-period Japan, an era from roughly 794 to 1185. The diary ends in about 1010; Murasaki died four years later.

ADDITIONAL FACTS

1. *For the 1,000th anniversary of the novel, scientists at Kyoto University invented a robot that recites passages from Murasaki's writing.*

2. *The book was first translated into English by Arthur Waley (1889–1966) in 1935.*

3. *There are almost 800 poems included in the book, which was meant to be recited aloud.*

♦♦♦

Zenobia

So mighty was in warfare, and so keen,
That no man her surpassed in hardiness.
—Chaucer

The Roman Empire reached its greatest size in about 117, when it stretched from Morocco in the west to Persia in the east. Under the Pax Romana—the peace of Rome—inhabitants of this vast empire enjoyed a long period of relative stability and prosperity.

However, the peace began to fray with a series of civil wars and rebellions after the second century. One of the most famous was led by Zenobia (c. 240–c. 274), the queen of the Roman province of Palmyra (in Syria), who declared her land independent in 269 and led a five-year war against the Romans.

Zenobia's uprising was eventually suppressed by the emperor Aurelian (c. 215–275), and the captive queen was paraded through the streets of Rome in golden chains. But the rebellion dramatically exposed the teetering state of Rome's imperial authority; within two centuries, the empire would collapse completely.

Born in Palmyra, in what is now Syria, Zenobia married Septimius Odaenathus, the king of the city, in 258. After Odaenathus was assassinated in about 267—in a plot that may have involved Zenobia—she inherited the throne.

Well educated in the Greek classics, Zenobia spoke three languages and was an avid hunter. Historical accounts by Roman authors often portray Zenobia as conspicuously "manly": She rode a horse into battle and trudged through the desert alongside her soldiers. (And, according to English historian Edward Gibbon [1737–1794], she "never admitted to her husband's embraces but for the sake of posterity.") In 269, she invaded the Roman province of Egypt and beheaded the Roman governor. Aurelian, determined to recover Syria and Egypt, launched a counterattack against Zenobia in 272, and he eventually cornered her in the city of Emesa. She attempted to flee on the back of a dromedary—an Arabian camel—but was captured.

While many of her supporters were executed, Zenobia was spared the normal fate of rebels against Roman authority. Impressed by her bravery, Aurelian granted her a villa in Tivoli, near Rome, where she spent the remainder of her life.

ADDITIONAL FACTS

1. *Zenobia appears in "The Monk's Prologue and Tale," one of the* Canterbury Tales, *by English writer Geoffrey Chaucer (c. 1343–1400).*

2. *Palmyra, one of the ancient world's greatest cities, was virtually destroyed by the Romans in revenge for Zenobia's uprising. What little of the city remained was mostly abandoned after an earthquake in 1089. The ruins of Palmyra were declared a United Nations Educational, Scientific, and Cultural Organization World Heritage site in 1980.*

3. *Zenobia is also the scientific name of a genus of white-flowered plants that grow in the southeastern United States; they are commonly known as honeycups.*

◆◆◆

Arius

In 1553, a prominent Spanish doctor named Michael Servetus (c. 1509–1553) was burned at the stake for heresy in Geneva, Switzerland. His sin, according to the city's authorities, was the crime of Arianism—denying the existence of the Holy Trinity.

That heretics were still being executed for Arianism more than 1,200 years after the death of the Egyptian theologian Arius (250–336) is a testament, perhaps, to the power of the dissident priest's ideas. During his lifetime, Arius provoked a major crisis in the Christian world by attacking the belief that Jesus Christ was a divine coequal with God.

A native of Alexandria, Egypt, Arius was educated in Antioch, a city in modern-day Turkey. He returned to his home city, a major intellectual center of early Christianity, and became a deacon in about 306. He was excommunicated for the first time in 311, but reconciled with the church a few years later.

The Arian controversy erupted in full force in 318, when Arius and a local bishop became enmeshed in a debate over the relationship between God and Jesus Christ. The bishop, like most Christians, believed that God existed in three forms: the Father, the Son, and the Holy Spirit. Arius questioned the concept of the Trinity.

Arius attracted hundreds of prominent followers, especially in Syria, and the schism grew into such a crisis that the church was forced to convene the Council of Nicaea in 325, the first such gathering in the history of Christianity. Defeated, Arius was banished alongside his followers. He later returned to Constantinople, where he died after being poisoned, likely by his opponents. At Nicaea, a city near Constantinople, a second meeting occurred in 381, where hundreds of bishops officially endorsed the concept of the Trinity and wrote the Nicene Creed, a fundamental statement of official Christian doctrine that for the first time tried to standardize the religion's major tenets. (The gathering wrote the famous credo "We believe in one God, the Father Almighty, maker of heaven and earth, and of all things visible and invisible.")

Arius' objections to the concept of the Trinity, however, never completely disappeared in the Christian world, despite centuries of persecution. In modern times, the Unitarian theology that sees Jesus as a prophet and moral authority—but not as God himself—resonates with the teachings of Arius.

ADDITIONAL FACTS

1. *In official terms, the church branded Arius a heresiarch—one who originates a heretical belief or movement.*

2. *At Nicaea, only two Egyptian bishops out of the roughly 300 delegates voted to support Arius. After the vote, Arius and the two bishops were banished to Illyricum, a Roman province in the Balkans.*

3. *A second Council of Nicaea was held in 787 to resolve another simmering dispute, this time about the proper role of religious icons in Christian worship. The council supported the use of icons, ruling against the iconoclasts, who wanted the images removed from churches.*

✦✦✦

Hadrian

Hadrian (76–138) was one of the most successful emperors in the history of ancient Rome. His twenty-one-year reign marked the high-water points of the empire's geographic size and military might, and it was a period of relative peace and prosperity. Hadrian was also a sponsor of the arts who rebuilt the Pantheon of Rome—a landmark of architectural history that still stands today.

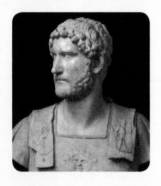

Born in the Roman province of Spain, Hadrian was the son of a senator. His father died in 85, when Hadrian was ten, and he was raised by the future emperor Trajan (53–117). Hadrian held a variety of imperial offices; fought in Germany, Syria, and Dacia (present-day Romania); and was designated Trajan's heir in the emperor's will.

Hadrian's experiences fighting in the provinces gave him a firsthand look at the empire's weaknesses. After becoming emperor, he gave up territory that he considered indefensible and embarked on a program of building fortifications to protect the rest. Hadrian's Wall, a stone fortification that stretches across northern England and is still mostly intact, was one of his most famous projects.

In Rome, he sponsored the reconstruction of the Pantheon to replace an earlier temple that had been destroyed by fire. The Pantheon, a huge, domed temple dedicated to all the Roman gods, has been in continuous use since then, and it provided architectural inspiration for the Jefferson Memorial in Washington, among many other buildings. Hadrian was also interested in and tolerant of non-Roman peoples within the empire, as well as an advocate of Greek culture.

For the most part, Hadrian's reign was peaceful. But he is also remembered as a tyrant for crushing a Jewish revolt in 135, killing hundreds of thousands of Jews. Historian Edward Gibbon (1737–1794) described the balance of violence and prosperity that characterized his rule: "The terror of the Roman arms," he wrote with understatement, "added weight and dignity to the moderation of the emperors."

Hadrian died in 138 and was succeeded by his adoptive son, Antoninus Pius (86–161).

ADDITIONAL FACTS

1. *Although the boundary shifted slightly over the centuries, for most of its length Hadrian's Wall is only a few miles from the present-day border between England and Scotland.*

2. *Hadrian was a mountain climber who ascended two of the best-known peaks in his empire, Mount Etna in Sicily and Jabal Agra in Syria.*

3. *As a child, the future emperor was nicknamed Graeculus ("Little Greek") for his fondness for Greek literature.*

✦✦✦

Boethius

By the time he turned forty years old, Severinus Boethius (c. 480–c. 524) was one of the most respected and powerful men in Italy. An accomplished scholar, he had translated the work of many of the ancient Greek philosophers into Latin. As a political figure, he enjoyed the patronage of King Theodoric (c. 454–526), who frequently relied on the Roman scholar for advice.

But in 523, without warning or explanation, the philosopher's fortunes changed drastically: He was arrested for treason, condemned to death without a trial, and thrown into a prison cell in northern Italy to await execution.

Such cruel twists of fate form one of the central themes in the landmark book that Boethius wrote while awaiting his death, *De Consolatione Philosophiae* (*The Consolation of Philosophy*). The book, a treatise on God, human virtue, and destiny, would become one of the best-known philosophical texts of the first millennium.

Boethius was born in Rome shortly after the Roman Empire collapsed in 476. He was orphaned at an early age, but received an extensive education in the Greek classics. A member of an influential Roman family, he went to work for the Ostrogoths, one of the Germanic tribes that had destroyed the empire and taken control of Italy.

Before his arrest, Boethius's primary scholarly activity had been translating ancient philosophical works by Plato (c. 429–347 BC) and Aristotle (384–322 BC). Boethius has been called the Last of the Romans because of his devotion to classical philosophy, which was quickly falling out of favor in Europe with the demise of the empire and the ascendancy of Christianity. He also wrote about music theory, theology, and mathematics.

After Boethius had won the king's trust, Theodoric made him the head of his civil service, a powerful position. Boethius's arrest came after his political opponents convinced Theodoric that the philosopher was conspiring to overthrow him.

The most famous image in *The Consolation of Philosophy* is Boethius's concept of the wheel of Fortune. He writes that all people are subject to the whims of Fortune, and he compares it to a spinning wheel; some may receive wealth and happiness, others calamity. After Boethius's execution, his book would become one of the most widely read nonreligious books in the Christian world, influencing generations of Europeans.

ADDITIONAL FACTS

1. *The TV game show* Wheel of Fortune *takes its name from the sixth-century philosopher's metaphor for fate.*

2. *Boethius had hoped to complete translations of all of Plato's and Aristotle's works, a project that was cut short by his imprisonment.*

3. *His translations of Aristotle were the only Latin versions of the philosopher's texts available in the West until the twelfth century, when Europeans rediscovered the ancient Greek writers.*

Galen

In the autumn of 157, a young doctor in Pergamum, an outpost of the Roman Empire in present-day Turkey, won a prestigious job as the physician to the city's gladiators. Gladiatorial combat in the Roman Empire was particularly bloody, affording the doctor a chance to study human anatomy up close.

The doctor, Galen (129–c. 216), would use his gruesome experiences at the arena as the bases for some of his hundreds of medical treatises on the human body. During his lifetime and for more than 1,000 years after his death, Galen would be regarded as the foremost authority on anatomy and medicine in Western culture.

The son of a prosperous Pergamum architect named Nicon, Galen entered a medical training school at about age fifteen, after Nicon purportedly had a dream in which the Greek god Asclepius ordered him to raise his son to be a doctor.

As a young physician, Galen traveled widely in the Greek-speaking provinces of the Roman Empire before returning to Pergamum to care for the gladiators. He stayed in Pergamum for four years before moving to Rome, where he hoped to establish himself.

Galen's first trip to Rome was a failure, however, and he returned to Pergamum in 166. Three years later, he was recalled to Rome amid an outbreak of plague, and he remained there for the rest of his life. He served as doctor to several emperors and accompanied them on at least one military campaign in Italy.

To better understand the human body, Galen performed dissections of pigs and monkeys. He was legally barred from performing autopsies on humans, however, a restriction that often forced him to make educated guesses about human anatomy. Until Renaissance scientists began to disprove his theories, Galen's works were widely regarded as the foremost authorities on human anatomy.

ADDITIONAL FACTS

1. *Galen is believed to have written about 300 books in his lifetime. The first,* Three Commentaries on the Syllogistic Works of Chrysippus, *was completed when he was thirteen years old.*

2. *A fire at the Temple of Peace in Rome in about 191 destroyed most of Galen's library, including the only copies of many of his books. He was untroubled, however, writing that "no loss was enough to cause me grief."*

3. *Galen was personal physician to three Roman emperors: Marcus Aurelius (121–180), his son Commodus (161–192)—who went insane and was assassinated—and Commodus's successor, Septimius Severus (146–211).*

♦♦♦

Attila

Attila the Hun (c. 406–453) was a barbarian king who inspired such fea. the Roman Empire that he was nicknamed *Flagellum Dei*—"the Scourge c God." His horsemen overwhelmed large parts of central Asia and Europe before they were finally halted attempting to conquer France.

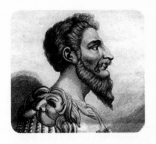

Although he may be the best known, Attila was only one of many tribal leaders who attacked the decaying Roman Empire in the fourth and fifth centuries. In 476, a few decades after Attila's death, the Western Roman Empire collapsed. The Eastern Roman Empire, much reduced, survived for another thousand years.

Attila and his brother, Bleda, were born in central Europe and inherited the Hunnic kingdom from their uncle in 434. The brothers initially ruled as co-kings, until Attila had Bleda murdered in 445. Attila's capital was probably in what is now Romania.

At the time Attila took over, the Hunnic empire already stretched from the Caspian to the Baltic. He extracted a large tribute payment from the Eastern Roman Empire and razed several cities, including present-day Belgrade and Sofia, when the Romans stopped making payments.

In 451, he marched west, invading the Western Roman Empire's province of Gaul. He met the Romans at the Battle of the Catalaunian Plains—his first and only defeat. Afterward, his forces invaded Italy and sacked a number of cities, including Milan, Verona, and Padua.

Attila married in 453 and, according to legend, died the next night, supposedly of a nosebleed. Without his leadership, the Hunnic empire collapsed shortly thereafter.

ADDITIONAL FACTS

1. *Attila demanded a tribute of 2,100 pounds of gold every year from the Eastern Roman Empire in exchange for peace.*

2. *The workers who dug Attila's grave and buried him were supposedly put to death to prevent them from revealing its secret location.*

3. *During World War I, the term* hun *was sometimes used as an epithet for Germans in Allied propaganda. There is no historical connection, however, between modern-day Germany and Attila's tribe.*

❖❖❖

Omar Khayyam

Author of *The Rubaiyat,* Omar Khayyam (1048–1131) was a Persian poet, mathematician, and astronomer. Though he was known mostly for his scientific work during his lifetime, Khayyam's poetic masterpiece was rediscovered in the nineteenth century and is now considered a classic of medieval Islamic literature.

The Rubaiyat is made up of more than 500 quatrains, or four-line poems, about religion, nature, and love. Wistful and sometimes elegiac, the general message of the compilation is to make the most of life: "While you live / Drink!—for, once dead, you never shall return," Khayyam urges in one of the verses.

Khayyam was born in Nishapur, a Persian city in what is now northeastern Iran. His name means "tent maker," which is believed to have been his family's profession. He studied philosophy, became an important mathematician, and wrote *Treatise on Demonstration of Problems of Algebra,* an influential textbook, in 1070. The sultan appointed him one of his court astronomers, in which post his duties included calculating the length of the year and reforming the Persian calendar.

The Rubaiyat came to prominence in the West after it was discovered and translated by a British scholar, Edward FitzGerald (1809–1883). Many of the poems ruminate on the theme of how life can be lived and enjoyed given the certainty of death. Khayyam, in two passages, recommends living life to the fullest so that one is prepared when death comes, but also keeping the insignificance of one's life in perspective.

> *So when that Angel of the darker Drink*
> *At last shall find you by the river-brink,*
> *And, offering his Cup, invite your Soul*
> *Forth to your Lips to quaff—you shall not shrink. . . .*

> *When You and I behind the Veil are past,*
> *Oh, but the long, long while the World shall last,*
> *Which of our Coming and Departure heeds*
> *As the Sea's self should heed a pebble-cast.*

Although he was raised as a devout Muslim, Khayyam's religious views came under attack later in life, and he was suspected of disbelief. (He bitterly alludes to his plight in one of the quatrains.) He died in Nishapur at age eighty-three.

ADDITIONAL FACTS

1. *President Bill Clinton (1946–) recited a quatrain from* The Rubaiyat *in one of his statements asking forgiveness in the wake of the Monica Lewinsky (1973–) scandal. "The moving finger writes; and having writ, / Moves on: nor all your piety nor wit / Shall lure it back to cancel half a line, / Nor all your tears wash out a word of it," he said.*

2. *Actor Cornel Wilde (1915–1989) played the title role in the 1957 film* Omar Khayyam. *The same movie also featured Yma Sumac (1922–2008), who would go on to fame as a singer, in a minor role.*

3. *While working as an astronomer in Esfahàn, Khayyam calculated the length of a year to be 365.24219858156 days. It was the most accurate estimate of his time.*

❖❖❖

William Wallace

The real-life inspiration for the movie *Braveheart* (1995), William Wallace (c. 1270–1305) was a Scottish knight who led an armed uprising against the English. Before his capture, Wallace scored an improbable victory at the Battle of Stirling Bridge, a feat for which he is still remembered as a national hero in Scotland.

Despite his hero status, however, very little is known about Wallace's life—a void that has been filled with centuries' worth of myth and speculation. The movie, directed by Mel Gibson (1956–), was based primarily on an epic poem that was written hundreds of years after Wallace's death and is not considered accurate. The real Wallace was born at some point in the late thirteenth century into a relatively prosperous, landowning family. He had two brothers, both of whom also became involved in the Scottish independence cause.

The roots of the conflict with England dated back to the death of King Alexander III (1241—1286) of Scotland. Because he had no living children, Alexander's throne passed to a four-year-old Norwegian princess, Margaret, who died during the voyage to Scotland. The English king, Edward I (1239–1307), seized the opportunity presented by the power vacuum to assert control over his smaller neighbor.

But it would take the English more than fifty years to subdue Scotland. According to legend, Wallace's animosity toward the English was sparked by an incident in which several invading soldiers tried to steal fish he had caught.

Whatever the source of his grudge, Wallace became the first major figure of popular resistance to English rule. He raised an army in 1297 and won the Battle of Stirling Bridge that September against a much larger enemy force by luring the English across a narrow footbridge and attacking them as they crossed. After the victory, he was knighted and given the title Guardian of Scotland.

The victory, and Wallace's subsequent raids into northern England, infuriated Edward. The next year, the king personally led the English army against Wallace and delivered a victory at the Battle of Falkirk. Defeated, Wallace gave up command of the army and was sent to France as a diplomat for the Scottish. He returned in 1303, but was captured by the English in 1305 and executed. By 1357, the English takeover was complete—although England and Scotland were not formally joined as the United Kingdom until 1707.

ADDITIONAL FACTS

1. *Unlike the character in* Braveheart, *Wallace did not wear a kilt. Although the garments are often associated with medieval Scotland, kilts did not become popular until the seventeenth century.*

2. *Wallace's nemesis, King Edward I of England, celebrated his victory by having the Latin words* Scottorum malleus—*"hammer of the Scots"—carved on his tombstone.*

3. *A giant sandstone monument to Wallace was built in the nineteenth century near the Stirling Bridge battlefield. The monument also displays a sword allegedly carried by the Scottish warrior, although the authenticity of the so-called Wallace Sword has been disputed.*

◆◆◆

Augustine

Born to a Catholic mother and a pagan father, Saint Augustine of Hippo (354–430) struggled with his own spiritual beliefs for years before finally embracing Christianity when he was in his early thirties. After his conversion, Augustine went on to become a bishop and one of the most influential theologians in the church's history.

According to Augustine's famous autobiography, *The Confessions,* he was born in the city of Tagaste, in the Roman province of northern Africa (present-day Algeria). As a teenager, he moved to Carthage and quickly succumbed, as he wrote in *The Confessions,* to "wickedness and the carnal corruptions"—sex, alcohol, and theft.

But lust and debauchery, Augustine soon discovered, didn't satisfy what he referred to as his "hidden hunger" for meaning in life. He first converted to Manichaeism, but eventually became disillusioned. He was intrigued by Christianity and accepted a job as a rhetoric teacher in the Italian city of Milan, where he came into closer contact with leading Catholic thinkers.

Still, it took Augustine years to fully accept Christianity and give up his past. "Lord, give me chastity," he famously prayed, "but not yet." He finally converted in 386.

Returning to Africa, the convert was made the bishop of Hippo Regius, a city on the Mediterranean coast. In Hippo, he wrote many of his most influential works, including *The Confessions* and *The City of God,* a primer on basic Christian beliefs.

Augustine's writings helped shape Catholic doctrine on a variety of topics, including baptism, original sin, and just war. He also tried to bridge the gap between ancient philosophy and Christianity by writing treatises that sought to reconcile Plato (c. 429–347 BC) and Aristotle (384–322 BC) with the Gospels. Turning his back on the sexual adventures of his youth, Augustine also became firmly conservative in his views on sex and women.

In historical terms, Augustine's writings reflected the growing sophistication of Christian thought as the once-outlawed faith was transformed into the official state religion of the Roman Empire. Indeed, Augustine's fate was intertwined with Rome's decline: He died in 430 during a siege of Hippo, shortly before the Roman outpost was captured by Vandals.

ADDITIONAL FACTS

1. *In recognition of his rowdy lifestyle before he converted to Christianity, Augustine is considered the patron saint of brewers. His feast day is commemorated on August 28.*

2. *Augustine's hometown of Hippo Regius is now known as Annaba, a large city on Algeria's Mediterranean coast.*

3. *He is one of thirty-three Doctors of the Church recognized by the Vatican.*

◆◆◆

The emperor Constantine (c. 272–337) legalized Chris[...]
Empire, ending centuries of persecution and clearing [...]
illegal faith to become the dominant religion of Europe. [...]
moving the empire's capital from Rome, its home for 1,000 years, to a new city
in the east—Constantinople.

Constantine was born in Serbia, then a Roman prov-
ince known as Naissus. Under the emperor Diocletian
(245–316), responsibility for governing the empire was
divided among four tetrarchs, one of whom was Con-
stantine's father, Constantius Chlorus (250–306).
When Constantius died while fighting in Scotland,
Constantine inherited his place in the tetrarchy.

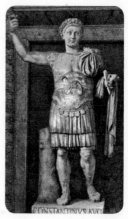

Tensions among members of the tetrarchy led to a
series of wars and revolts between 305, when Diocle-
tian retired, and 325, when Constantine defeated the
last of his rivals and consolidated control over the
entire Roman Empire. He relocated the imperial capi-
tal to the city of Byzantium, which he renamed Con-
stantinople, in 330.

The Edict of Milan, which Constantine issued in 313,
allowed Christians to practice their religion and own property. The emperor himself
had converted to Christianity the previous year, when he had reported seeing a cross
in the sky just before the Battle of Milvian Bridge, a key victory and turning point
in the civil war. The edict marked a sudden shift in Roman policy; the last major
persecution of Christians had ended only a few years earlier.

Despite his newfound religious faith, however, Constantine was capable of ruthless
leadership. In one famous incident in 326, he executed his son with poison and his
wife by locking her in a hot steam bath. (The exact reason he had them killed is
disputed.) The emperor himself died in 337—leaving as his legacy the transforma-
tion of Rome into a Christian state.

ADDITIONAL FACTS

1. *Milvian Bridge, the site of Constantine's decisive military victory and his vision of the cross, still
 stands north of Rome. Built in the first century BC, the stone arch bridge is one of the oldest such
 structures still in existence.*

2. *The name Constantinople was dropped from common usage after the collapse of the Byzantine
 Empire in 1453, and the city was officially renamed Istanbul in 1930. The capital of Turkey was also
 moved to Ankara in 1923, ending Istanbul's 1,500-year history as a world capital.*

3. *After Christianity was legalized, it continued to spread and became the Roman Empire's dominant
 religion. It became the official faith in 380, and—less than a century after its followers had been
 persecuted—the only permitted religion in 392.*

✦✦✦

selm

A medieval theologian, philosopher, and church leader, Saint Anselm of Canterbury (1033–1109) was one of the foremost thinkers of the eleventh century. He is best known today for the "ontological argument" for the existence of God, an attempt to prove God's existence using the tools of deductive logic.

Anselm was born into a wealthy family in Aosta, a northern Italian town nestled in the Alps. At age twenty-three he left Aosta for France, arriving in Normandy in 1059. He entered the Benedictine abbey at Bec as a novice in 1060, and there his intelligence was quickly recognized and he became the abbot in 1078.

The Norman conquest of England in 1066 provided a boost for the abbey, which acquired huge land holdings in England. Two successive abbots of Bec were named archbishop of Canterbury, England's highest ecclesiastical office; Anselm took the office in 1093. However, he quickly became involved in a dispute with King William II (c. 1056–1100) and was barred from England between 1097 and 1100. In that year, however, William died under mysterious circumstances, and his successor, Henry I (c. 1068–1135), allowed Anselm to return. Anselm squabbled with the new king too, and again was barred from England for several years.

Beginning in the 1070s, Anselm wrote prodigiously on philosophy and theological disputes. He wrote the *Monologium,* which contained his proof of God's existence, in 1077. In Anselm's famous proof, he first defines God as "something than which nothing greater can be conceived." In other words, God is the greatest thing that mankind can imagine or comprehend. And if God can be imagined in the mind, he must exist in reality, because existence in reality is superior to existence in the mind. And remember, God is the greatest thing that exists, which means that if he existed only in the mind, he wouldn't be the greatest being that could be imagined.

This ontological argument (ontology is a branch of philosophy that studies the nature of being) has attracted many critics, including philosophers such as Thomas Aquinas (c. 1225–1274). One line of criticism points out that Anselm's logic can be used to prove the existence of almost anything. As Immanuel Kant (1724–1804) pointed out, if merely being able to imagine that something exists in perfect form is proof that it does, does that mean that the best possible unicorn is real?

However, by subjecting theological beliefs to more rigorous philosophical scrutiny, Anselm helped usher in the revival of European philosophy that began in the century after his death in England at age seventy-six.

ADDITIONAL FACTS

1. *In 1494, nearly four centuries after Anselm's death, Pope Alexander VI (1431–1503) canonized him.*

2. *Anselm's monastery at Bec was destroyed during the French Revolution, but it reopened in 1948.*

3. *The death of William II is one of the most enduring mysteries in English history. He was killed by an arrow to the chest while hunting deer. The incident was reported to be an accident, but William's brother—who became Henry I after William's death—was a member of the hunting party.*

◆◆◆

Muhammad al-Khwarizmi

The inventor of algebra, Muhammad ibn Musa al-Khwarizmi (c. 780–c. 850) was a Baghdad-based scholar, astronomer, and theologian. His surviving mathematical treatises had an enormous impact on both the Islamic and the Christian worlds. Among other accomplishments, he is known for devising algorithms and popularizing the system of Arabic numerals whose use prevails across the world today.

Al-Khwarizmi was thought to have been born in modern-day Uzbekistan, but spent most of his life in Baghdad, then the capital of the Islamic world. He was a member of the House of Wisdom, the caliphate's leading intellectual institution. Sitting at the cultural crossroads of Europe and Asia, the Baghdad scholars had access to texts from both Hindu mathematicians in the East and ancient Greek thinkers such as Ptolemy and Aristotle in the West.

The algebraic system originated in a book al-Khwarizmi wrote in about 820, *Hisab al-jabr w'al-muqabala* (*Handbook for Calculation by Completing and Balancing*). *Al-jabr,* meaning "completion" in Arabic, eventually became the word *algebra* in English.

At some later point, al-Khwarizmi wrote *On the Hindu Art of Reckoning,* which endorsed the use of the Hindu numeral system. The book became famous in his lifetime: Copies were circulated in Spain, then under Islamic control, and from there it spread to Christian Europe, where the numbers soon replaced Roman numerals. (Confusingly, the numerals are often referred to as Arabic numerals, even though al-Khwarizmi made it clear that the system originated in India.)

Al-Khwarizmi also studied Islamic astronomy, geography, and religious law. His most famous works were dedicated to the caliph al-Ma'mun (786–833), a keen supporter of the House of Wisdom and a major figure in Baghdad's golden age of learning.

ADDITIONAL FACTS

1. *The word* algorithm—*meaning a rule of calculation in mathematics—is derived from an early Latin translation of al-Khwarizmi's name.*

2. *Many of al-Khwarizmi's original works were lost when Baghdad was sacked by the Mongols in 1258. The invaders destroyed the House of Wisdom and, according to legend, threw its library into the Tigris River.*

3. *Although algebra is derived from al-Khwarizmi's work, his original treatise on the topic does not contain any algebraic equations. He explained his ideas only in words, without using symbols or numerals.*

❖❖❖

Ivarr

A furore normannorum, libera nos, domine.
"From the fury of the Northmen deliver us, O Lord."
—English prayer

One of the most colorful of the Viking chieftains who rampaged across northern Europe in the Middle Ages, Inwaer Ragnarsson (c. 795–c. 873), also known as Ivarr the Boneless, was a leader of the Danish invasion of England in the ninth century. Behind their legendary berserker warriors, the Vikings briefly won control of large swaths of England before they were repulsed.

Ivarr was one of the three sons of Ragnar, a Danish king who had successfully raided Paris in 845. According to the Norse sagas, an Anglo-Saxon warlord in England captured Ragnar and executed him by tossing him into a pit of poisonous snakes. Understandably upset, Ivarr and his brothers launched the invasion to avenge their father's death. Unlike previous Viking raids on England, this time the brothers sought to subjugate the island, rather than simply pillaging and then returning home.

The invasion force—labeled the Great Heathen Army by the terrified Anglo-Saxons—crossed the North Sea in 865, landed on the eastern coast of England, and sacked the city of York. They killed or captured a number of local kings, including the leader who had killed Ragnar; Ivarr personally executed his father's killer in 867, supposedly by cutting open his back and plucking out his ribs one at a time.

The source of Ivarr's nickname is unclear. It may be a sly sexual reference to his possible impotence, or he may have suffered from a genetic disease that causes brittle bones. (If so, it would be especially ironic, since Ivarr's family claimed to be descended from the god Odin.)

Ivarr died at some point in the 870s, and the Viking invasion was successfully stopped by King Alfred the Great (849–899). Danish dominance over parts of England, however, lasted for the next two centuries.

ADDITIONAL FACTS

1. *The werewolf legend is thought to derive from the berserkers, the crazed Norse warriors who sometimes went into battle wearing only wolf skins.*

2. *One of Ivarr's grandsons, Sigtryggr, reconquered Dublin for the Vikings in 917.*

3. *Modern DNA testing has established that more residents of Derbyshire, a part of northern England that was conquered by the Danes in the 800s, have Scandinavian ancestry than do residents of the rest of England.*

✦✦✦

Geoffrey of Monmouth

A medieval "historian" who created one of the most enduring fictional characters in Western literature, Geoffrey of Monmouth (c. 1100–c. 1155) was an English bishop who popularized the story of King Arthur, a tale that has spawned countless songs, poems, novels, and movies.

In his best-known book, *Historia Regum Britanniae,* Geoffrey endeavored to trace the history of the English monarchy from ancient times. Ostensibly based on real Welsh-language sources, the book was a pastiche of myth, history, and Geoffrey's own prodigious imagination; it begins with ancient kings conquering a race of giants that Geoffrey claims once lived on the island.

Arthur, according to Geoffrey, was a king of the Britons who defended the island against Saxon invaders in the fifth or sixth century. Many of the familiar elements in the Arthurian legend date to *Historia Regum Britanniae:* the king's father, Uther Pendragon; his sword, Excalibur; and his sagacious wizard, Merlin. Later writers elaborated on the story provided by Geoffrey and added new elements, such as the Round Table and the quest for the Holy Grail.

In fact, after the Roman Empire abandoned Britain in AD 410, some of the island's residents did resist the Anglo-Saxon invasions that followed. A climactic battle took place at Mons Badonicus in about 500, when Romano-Celts defeated the invaders, temporarily delaying the Anglo-Saxon conquest. But there is no historical evidence supporting the existence of a King Arthur.

Little is known about Geoffrey's life. He was born in Monmouth, a city in southeastern Wales, and attended Oxford. *Historia Regum Britanniae* was written in the 1130s; its sequel, the equally fanciful *Life of Merlin,* followed several years later. Geoffrey was made a bishop in Wales in the early 1150s and died a few years later.

ADDITIONAL FACTS

1. *At least some of Geoffrey's accounts may be more accurate than once believed. His book describes a King Tenvantius, who does not appear in any other historical account and was long considered a figment of Geoffrey's imagination—until Iron Age coins were unearthed in Britain bearing a similar name.*

2. *A French writer, Chrétien de Troyes, introduced the Holy Grail to the Arthurian legend in the late twelfth century. Thomas Malory (c. 1405–1471) introduced the character of Sir Gareth in* Le Morte d'Arthur; *Alfred, Lord Tennyson (1809–1892) changed the ending in* Idylls of the King. *Other well-known contributors to the Arthurian canon include Mark Twain (1835–1910,* A Connecticut Yankee in King Arthur's Court*), T. H. White (1906–1964,* The Once and Future King*), and Monty Python (*Monty Python and the Holy Grail*).*

3. *Two Shakespeare plays,* King Lear *and* Cymbeline, *are based on kings described in* Historia Regum Britanniae. *Geoffrey's Leir is thought to be mythical, while Cunobelinus was a real monarch who ruled just before the Roman invasion. Another of Geoffrey's characters, Sabrina, later appeared in a 1634 play,* Comus, *by John Milton (1608–1674).*

✦✦✦

Owain Glyndwr

The last independent leader of Wales, Owain Glyndwr (c. 1354–c. 1413) led an uprising of Welsh nationalists that briefly drove out the English occupiers. Though his revolt was eventually suppressed, Glyndwr was never captured by the English, and his fate remains a mystery and a source of myth.

A member of the Welsh nobility, Glyndwr was born in the northeastern part of the country and initially served as an officer for King Richard II (1367–1400) of England. Wales had been taken over by the English in the thirteenth century, and the occupiers had stamped out most of the resistance to their rule.

But Welsh opposition flared up in 1400, after Richard was deposed and replaced by his cousin, Henry IV (1366–1413). Richard was perceived as an ally of the Welsh, and many nobles sided with him against the new king. Efforts by some of Henry's supporters to seize land in Wales only added to Welsh dissatisfaction.

Taking control of the revolt, Glyndwr proclaimed himself Prince of Wales in 1400. (He would be the last Welsh person to hold the title.) By the next year, central and northern Wales had joined the rebellion. In 1402, he received a boost from the French, who saw an opportunity to weaken England by aiding the revolt. For a few years, Glyndwr was sufficiently in control of Wales that he was able to convene a parliament and have himself formally crowned in 1404.

In 1405, however, the French began withdrawing their troops, and Henry counterattacked. Several Welsh leaders, including several of Glyndwr's relatives, were captured and imprisoned in the Tower of London. By 1409, the English had retaken most of Wales, and Glyndwr and his remaining supporters had been chased into the forests, from which they continued to mount guerrilla raids on the English for several more years.

Glyndwr was never captured, however, and in the following years he became a hero of Welsh folklore.

ADDITIONAL FACTS

1. *Glyndwr appears in Shakespeare's* Henry IV, Part 1, *as Owen Glendower, the voluble, rebellious leader of the Welsh.*

2. *In 2004, an author claimed to have discovered evidence that Glyndwr's long-lost burial site was beneath a church in Llanwrda, a small village in western Wales. Others believe his remains are buried in England.*

3. *During the celebration of the 600th anniversary of the revolt, Led Zeppelin singer Robert Plant (1948–) donated money for the erection of a statue of Glyndwr in Machynlleth, Wales. Plant, a fan of Celtic mythology, reportedly wrote the lyrics to "Stairway to Heaven" at his home in Powrys.*

◆◆◆

Muhammad

Today, Islam is the world's second-largest religion, with close to 1.5 billion adherents in the Middle East, Africa, and Asia. But it started 1,400 years ago with only a few followers who embraced an Arabian merchant named Muhammad (570–632).

The founding prophet of Islam, Muhammad was an orphan who was raised by his uncle in the city of Mecca, then a thriving commercial outpost near the Red Sea. While in his teens, he began accompanying his uncle on caravans across present-day Saudi Arabia and Syria, where he came into contact with Christians and Jews.

At the time, Mecca was enjoying newfound prosperity, thanks to the profits reaped by metal, spice, and leather traders like Muhammad and his uncle. But along with the city's material abundance, Muhammad worried, had come a sense of spiritual malaise among the formerly nomadic Arab tribesmen.

Mecca's religious life was centered around a temple known as the Kaaba, best known for the black rock in its cornerstone. Mecca's residents worshipped hundreds of different gods at the shrine, including one powerful deity named Allah.

The founding of Islam dates to 610, when Muhammad, worried by what he viewed as Mecca's spiritual decay, retreated to a cave during the month of Ramadan. While meditating in the cave, he said, he was visited by the angel Gabriel, who dictated to him verses that would eventually form the Muslim holy book, the Koran.

Muhammad described the revelation—and the many more that would follow over the rest of his life—as an overwhelming experience. "Never once did I receive a revelation without feeling that my soul was being torn away from me," he said. Inspired by his revelations, Muhammad insisted there was only one god—Allah—and that the rest of the Arab gods should be removed from the Kaaba. Initially, his monotheism was met with intense distrust, and Muhammad, along with his followers, was forced to flee Mecca for Medina in 622.

But by the time of his death, Muhammad had become both the religious and political leader of thousands of Muslims attracted to his emphasis on justice and community, as well as to the beauty of the Koran itself. The prophet returned triumphantly to Mecca just before his death to finally remove the other gods from the Kaaba and make his home city the capital of the rapidly expanding faith.

ADDITIONAL FACTS

1. *Islamic rules forbid pictures or drawings of Muhammad; as a result, there are no contemporary depictions of his physical appearance.*

2. *Muhammad had twelve wives; his descendants are traditionally given the honorific title* sayyid *to denote their ancestry from the prophet.*

3. *Allah's shrine in Mecca—the Kaaba—remains the holiest spot in Islam. All Muslims physically able to make the trip are compelled to make a pilgrimage to Mecca at least once in their lifetimes.*

✦ ✦ ✦

Charlemagne

On Christmas Day in 800, the Frankish king Charlemagne (742–814) was praying at a church in Rome, peacefully minding his own business. Then, without warning, he was ambushed by the pope, Leo III, who sneaked up on the king, placed a crown on his head, and declared him the new emperor of western Europe.

"[Charlemagne] at first had such an aversion that he declared that he would not have set foot in the church the day that [the title was] conferred, although it was a great feast-day, if he could have foreseen the design of the Pope," wrote one of his contemporary biographers.

Voluntary or not, the coronation of Charlemagne was a pivotal moment in the history of Europe—indeed, to some historians, the date when Europe as a cultural entity came into existence. Charlemagne built a large empire that included parts of France, Germany, and Italy, establishing a state that would become part of the shared heritage of western Europe.

Charlemagne was the son of Pippin the Short (714–768), the first king of the Franks, a Germanic tribe. After Pippin's death, Charlemagne ruled jointly with his brother, Carloman (751–771), but became the sole leader after Carloman's death. The Frankish kingdom that Charlemagne inherited spread over almost all of western Europe north of the Pyrenees Mountains. Early in his reign, Charlemagne pushed its borders eastward into Germany and into Spain and Italy.

By crowning Charlemagne the new emperor of the West, Pope Leo III gained a powerful ally, because the title obligated the emperor to defend Rome and the papacy. Charlemagne—who almost certainly was not surprised by his coronation, contrary to the account in his biography—gained the prestige associated with the ancient Roman title of *imperator*.

Because he was able to bring so much of western Europe into a single, strong state, Charlemagne's rule ended the anarchy that had followed the collapse of the old Roman Empire. The stability contributed to a revival of literacy and culture known as the Carolingian Renaissance. The Frankish empire weakened after Charlemagne's death, however, and it was eventually divided between his grandsons. His title evolved into the office of Holy Roman Emperor, which remained influential in Germany and central Europe until the position was abolished in 1806.

ADDITIONAL FACTS

1. *The name* Charlemagne *is a contraction of the emperor's Latin name, Carolus Magnus—meaning "Charles the Great."*

2. *Charlemagne's sword, Joyeuse, was used for centuries in coronation ceremonies for French kings. It is now housed in the Louvre Museum in Paris.*

3. *Charlemagne was buried in the cathedral at Aachen, which served as the coronation spot for Holy Roman Emperors for centuries. The Charlemagne Prize, an award given to world leaders who contribute to European unity, has been awarded just outside the cathedral in every year since 1949.*

◆◆◆

Ibn Rushd

Ibn Rushd (1126–1198) was a devout Muslim philosopher who flourished in medieval Spain while the Iberian Peninsula was under Islamic rule. Ironically, however, his influence would be far more profound in the Christian world, where his books helped trigger a revolution in philosophy and theology beginning in the thirteenth century.

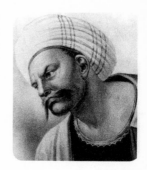

Born in the city of Córdoba, the capital of Islamic Spain, Ibn Rushd came from a family of prominent judges and was a *qadi,* or judge, himself. He also studied Islamic theology, medicine, and philosophy and was named the personal doctor to caliphs Abu Ya'qub Yusuf in 1182 and his son, Abu Yusuf Ya'qub, in 1184.

Spain under Muslim rule—called al-Andalus—was a major center of learning, especially during its golden age of the twelfth century. Under the caliph's patronage, Ibn Rushd embarked on a project to translate the works of the ancient Greek philosopher Aristotle (384–322 BC) into Arabic. He also wrote an important philosophical treatise that defended the ancient philosophers from their Islamic critics, most notably Abu Hamid al-Ghazali (1058–1111).

During Ibn Rushd's lifetime, however, al-Andalus had come under increasing strain due to the constant efforts by Christian armies to conquer the territory. After the caliph's death, Ibn Rushd fell out of favor in Córdoba, was accused of undermining Islam by studying ancient pagan philosophers, and was banished to Morocco. His works were officially condemned and burned in public. He died in exile at age seventy-two.

Shortly after his death, however, Ibn Rushd's works on Aristotle were translated into Latin by a Scottish mathematician, Michael Scot (1175–c. 1235), which led to the rediscovery of ancient Greek philosophy in Europe. The reintroduction of Aristotle to the Christian West spurred a huge intellectual shift, inspiring thinkers such as Albertus Magnus (c. 1193–1280) and Thomas Aquinas (c. 1225–1274), both of whom named Ibn Rushd as a major inspiration.

ADDITIONAL FACTS

1. *Although he lived 1,500 years after Plato (c. 429–347 BC), Ibn Rushd is depicted as one of the Greek philosopher's students in the famous painting* The School of Athens *(1510) by Raphael (1483–1520).*

2. *Ibn Rushd was known to Christians as Averroës; his followers in Europe called themselves Averroists.*

3. *Ibn Rushd's home city of Córdoba was captured by Christians in 1236, one of the key events of the Reconquista, or recapture of the Iberian Peninsula by Christians.*

✦✦✦

Ibn al-Haytham

In 1011, the caliph of Egypt appointed a young civil servant to design and construct a huge dam across the Nile River. Every year, flooding disrupted the country's agriculture, and the caliph hoped that a barrier might prevent the annual deluge. The man he picked for the task, Ibn al-Haytham (965–c. 1040), was renowned as one of the most promising mathematicians of the Islamic world.

After arriving at the proposed dam site, however, al-Haytham quickly realized that the caliph's dream was completely impractical. The Nile, one of the most powerful rivers in the world, would wash away any dam within days. But al-Haytham feared that the caliph, who was known for his cruelty and eccentric behavior, would punish him if he failed to carry out his mission.

Luckily for science, al-Haytham found a way to avoid the caliph's wrath: For the next ten years, he pretended to be insane. He was placed under house arrest, but his life was spared. And while he was in captivity, al-Haytham wrote one of the pivotal works in the history of science, *Optics*.

Al-Haytham was born in the Iraqi city of Basra and educated in Baghdad. Seven volumes in length, *Optics* was a massive inquiry into the behavior of light and the workings of the human eye. Al-Haytham was the first to discover that light moves in a straight line, the first to devise a camera obscura, and the first to deduce how the eye functions. The book was also notable for al-Haytham's reliance on experimentation, an emphasis that helped inspire the scientific method. *Optics* became a favorite of European scholars such as Roger Bacon (c. 1214–c. 1292) after it was translated into Latin in the twelfth century, and it earned its author the title "father of optics."

After the assassination of the caliph in 1021, al-Haytham was finally released from house arrest. For the rest of his life, he continued to experiment—he wrote some 200 books on physics, astronomy, and medicine—while earning a living by producing handwritten copies of other books. He died in Egypt in his seventies.

ADDITIONAL FACTS

1. *The Nile was not successfully dammed until 1902, almost nine centuries after al-Haytham was ordered to attempt it.*

2. *Alhazen's problem, a famous mathematical puzzle named after the Latin translation of the name al-Haytham, vexed mathematicians for centuries. The problem asks whether it is possible to pinpoint the exact spot on a spherical mirror where a ray of light is reflected from its source to an observer. The problem was not solved until 1997, when a mathematician at Oxford devised a method of locating the exact spot.*

3. *After the United States' invasion of Iraq in 2003, the new 10,000-dinar Iraqi banknote that was produced featured al-Haytham's portrait.*

◆◆◆

Erik the Red

A Norse outlaw who was forced into exile for manslaughter, Erik the Red (950–c. 1003) became an explorer and established the first Viking colony on the island of Greenland. His voyage expanded the European map of the known world and opened the way for the discovery of America by his son, Leif (c. 970–c. 1020).

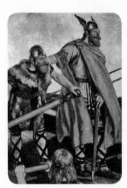

Erik was born in Norway, but was forced to flee after his father, Thorvald, was exiled for "a number of killings." The family settled in Iceland, where Erik married a woman named Tjodhilde and had four children.

In 982, after killing two other Icelanders in property disputes, Erik was himself banished from the island for three years. Along with a handful of followers, he sailed west in a longship until he reached Greenland. The island Erik discovered had a warmer climate than it does today and was well suited for farming, leading to its name.

After the term of Erik's banishment expired, he returned to Iceland and recruited about 500 colonists to move to Greenland. They set sail in 986, along with a load of cows, pigs, sheep, and goats. Just over half the group survived the voyage, but the colony, divided between the Western Settlement and the smaller Eastern Settlement, quickly grew to more than 3,000 inhabitants.

Erik's son, Leif, meanwhile, had broken with family tradition by staying out of trouble and converting to Christianity. He moved to his father's colony in 1000 with a cargo of Christian missionaries, who founded the island's first church and converted the island's pagan population.

The Icelandic sagas, the chief source of information about Erik's life, provide little else about his biography. A plague that swept through the Greenland settlement may have killed its founder. Leif used Greenland as the base for his explorations of North America in the 1000s, which are believed to have been the first European visits to the New World.

ADDITIONAL FACTS

1. *The Viking colony in Greenland lasted almost 500 years, but was abandoned in the fifteenth century for reasons that remain a mystery. It was reestablished by Denmark in 1721 and is now a self-governing Danish dependency.*

2. *Leif Eriksson named the territory he discovered Vinland (Norse for "Wine Land"). His settlement, thought to have been located in Nova Scotia or Newfoundland, lasted three years until it was abandoned. Its name was a reference to the berries that the Vikings found growing along the North American coast, which they mistook for wine grapes.*

3. *The source of the words the Red in Erik's name is uncertain. It most likely refers to the color of his hair and beard, but may also be a reference to his hot-tempered personality.*

Marco Polo

Marco Polo (1254–1324) was a Venetian merchant, traveler, and diplomat who wrote a famous memoir of his adventures in Asia. The book, a bestseller during the Renaissance, captured the imaginations of many Europeans and helped shape Western perceptions of China as an exotic land of wealth and mystery.

Polo's book—often called simply *The Travels of Marco Polo*—describes his arduous trek across Asia on the Silk Road to China, his seventeen-year stay at the court of Kublai Khan (1215–1294), and his subsequent ocean travel to the islands of Japan and Indonesia. Polo wrote the book, which is sprinkled with tales of Oriental sex, magic, and gore, after he returned to Europe in 1294.

Polo was the son of Niccolò Polo, a Venetian trader who was traveling in the Mongolian Empire at the time of his son's birth. Marco was fifteen when his dad returned; two years later, both father and son set out from Venice for another trip east. Their ultimate destination was Xanadu, the capital of Kublai's empire. A grandson of Genghis Khan (c. 1162–1227), Kublai ruled an empire that encompassed much of modern Mongolia, China, and central Asia. The emperor welcomed the Italian travelers and eventually appointed the younger Polo as his personal emissary—a job that allowed him to travel across Asia gathering notes for his book.

After leaving China, the Polos settled in Venice, where their tales of Eastern splendor made them local celebrities. According to legend, Marco was captured during a naval clash between Venice and Genoa in 1298 and spent several months in prison, where he wrote his memoir aided by a fellow inmate, Rustichello da Pisa.

The book would have a huge and enduring influence on Western society. Polo's detailed descriptions of Asian geography improved European maps; his portrayal of Chinese wealth spurred explorers such as Henry the Navigator (1394–1460) to seek faster trade routes to Asia; his account of the splendors of Xanadu even inspired one of the most famous English Romantic poems, "Kubla Khan" (1816), by Samuel Taylor Coleridge (1772–1834).

After a lifetime of travels, Polo returned to Venice for good, married, and had three children. He died in Venice at age seventy.

ADDITIONAL FACTS

1. *Frances Wood (1948–), a scholar of Chinese history in the United Kingdom, published a controversial book in 1995 questioning whether Polo ever actually visited China. Pointing out that Polo's memoir never mentions the Great Wall, Chinese calligraphy, tea, or many other customs,* Did Marco Polo Go to China? *posits that Polo and Rustichello fabricated most of the narrative.*

2. *The Silk Road became too dangerous to travel and disappeared as an important trade route in the fifteenth century. The original purpose of Christopher Columbus's Atlantic exploration in 1492 was to reestablish a trade link to China to replace the Silk Road.*

3. *Polo imported the concept of paper currency—a long-standing practice in China—to Europe. Contrary to legend, however, he did not introduce pasta.*

◆◆◆

Christine de Pizan

Poet and literary critic Christine de Pizan (1363–c. 1434) was born five centuries before her ideas would gain widespread acceptance. In her writings, she battled against negative stereotypes of women in French literature, but was largely ignored until her rediscovery by twentieth-century scholars.

De Pizan was born in Venice and moved to France as a young child when her father was named court astrologer for Charles V (1338–1380). She married at age fifteen, but was widowed in 1390, when she was twenty-five.

After her husband's death, de Pizan began a career as a prolific writer whose wide-ranging literary output included love poems, religious books, commentaries on ancient mythology, and a biography of Charles V.

She is best known, however, for *The Book of the City of Ladies,* which she wrote in 1405. The work was a frontal attack on the prevailing misogyny that she found in medieval literature. In many popular French poems, she wrote, women were portrayed as weak, sinful seductresses who lacked any independent intellectual capabilities. In particular, de Pizan criticized *Romance of the Rose,* a romantic poem by Jean de Meun (c. 1240–c. 1305), for its negative depictions of women.

Reading such works, de Pizan wrote, "made me wonder how it happened that so many different men—and learned men among them—have been and are so inclined to express both in speaking and in their treatises and writings so many wicked insults about women and their behavior."

De Pizan imagined an allegorical city—the City of Ladies—where women were respected for their accomplishments and intellect. The book had three main characters—Lady Reason, Lady Justice, and Lady Rectitude—who symbolized women's values and aspirations.

Although de Pizan was not the first woman writer in Europe, she is believed to have been the first who made a living as a professional, secular writer. Her last work, a poem celebrating the French heroine Joan of Arc (c. 1412–1431), was published in 1429. De Pizan is believed to have died about five years later.

ADDITIONAL FACTS

1. The Book of the City of Ladies *has been translated into English twice, first in 1521 and more recently in 1982 by Earl Jeffrey Richards.*

2. *The king of England, Henry IV (1366–1413), invited de Pizan to join his court, but she refused his offer.*

3. *Christine's last name, de Pizan, is derived from the village in northern Italy, Pizzano, where her father was born.*

◆◆◆

Adi Shankara

One of the greatest Hindu philosophers, Adi Shankara (700–750) lived for less than fifty years but is considered a key figure in Hindu thought. In his short career, he helped end long-standing religious divisions in India and founded four monasteries that would have enormous impact on Hindu theology.

Shankara was born in southern India to parents of the Brahmin, or priestly, caste. A brilliant child, he reportedly had the ability to memorize texts after only one reading. Shankara's father died when he was seven, and the child decided to become a monk at age sixteen after a near-death experience in a crocodile attack.

At the time of Shankara's birth, India was divided into dozens of competing Hindu sects, each of which interpreted the Vedas—Hinduism's four major sacred texts, thought to be more than 3,000 years old—in a different way. Some even rejected the traditional Vedas altogether. The enduring popularity of Buddhism and emergence of Jainism in India also contributed to a sense that Hinduism was in decline.

Shankara wrote his first commentaries on the Vedas while still a teenager and toured present-day India, Nepal, and Pakistan on foot, holding debates with other monks and philosophers. He preached mostly in the countryside, avoiding cities. He founded four monasteries, each devoted to one of the Vedas. Shankara ended up in the Himalayas, which is where he is believed to have died.

The religious tradition Shankara founded is known as Advaita Vedânta, and it remains one of the major forces within Hinduism. He also instructed his followers to worship all six of Hinduism's major deities, rather than separating into factions devoted to one of the six. By bridging divisions within the religion, he helped revitalize Hinduism and stem the spread of rival religions in India.

ADDITIONAL FACTS

1. *According to legend, his mother had a vision that Shiva would reincarnate in the form of her son, Shankara. Shiva is one of Hinduism's principal deities.*

2. *The subject of one of Shankara's first theological debates was the Kama Sutra, the Hindu manual of sex and love. As a celibate monk, however, he had no firsthand experience on the subject. According to legend, he was able to win the debate anyway by inhabiting the body of a recently deceased king and acquiring his ample experience.*

3. *In 1983, Indian director G. V. Iyer (1917–2003) made a critically acclaimed film about the philosopher's life entitled* Adi Shankaracharya. *It was the first movie filmed entirely in classical Sanskrit, the language spoken in eighth-century India.*

◆◆◆

Alfred the Great

Alfred the Great (849–899) was the first king of England—indeed, he was the first person in recorded history to use the word *England*. He unified several small Anglo-Saxon kingdoms to defeat a Viking invasion and then brought about a revival of learning and literacy on the island. For his role in driving off the invaders, Alfred is the only monarch in the nation's history whose name has been appended with *the Great*.

At the time of Alfred's birth, Britain was divided into several small kingdoms ruled by Saxon warlords. Alfred was the fifth son of one of the kings, Æthelwulf of Wessex. Because he was the fifth son, Alfred never expected to become monarch, and he instead trained for the priesthood. He traveled to Rome as a child, learned Latin, and was named a Roman consul by Pope Leo IV.

After the Viking invasion of Britain in 865, however, Alfred joined his older brothers in organizing the defense of Wessex. After destroying the Saxon kingdoms of Northumbria and East Anglia, the Vikings reached Wessex in 870, but they were defeated by Alfred and his brother Æthelred, who made a ferocious uphill charge against the Danes at the Battle of Ashdown in 871. Later that year, Alfred became king at age twenty-two after Æthelred died, probably from wounds of battle.

Over the next several decades, Alfred steadily drove the Vikings from the island, capturing London in 886. In the process, he united the once-divided Saxon kingdoms into the new realm Angelcynn—meaning "land of the English folk." By the time he died, the Danes were confined to a portion of eastern England.

As king of the newly unified England, Alfred was particularly concerned with reviving learning and rebuilding the monasteries that had been destroyed during the Viking wars. He opened a school and, drawing on his own Latin training, personally translated three religious and historical volumes from Latin into Anglo-Saxon. His wish, according to a chronicler, was "if we have the peace, that all the youth now in England . . . may be devoted to learning."

He died at about age fifty and was succeeded by his son, Edward the Elder (c. 870–924).

ADDITIONAL FACTS

1. *The part of England that remained under Viking control was called the Danelaw. Many place names in eastern England, especially those ending in -by or -thorp, are legacies of the Danes.*

2. *Alfred University, a private school in upstate New York, is named after the English king; its athletic teams are called the Saxons.*

3. *Another of Alfred's important contributions to English society was his legal code, which was studied by a number of political leaders, from Thomas Jefferson (1743–1826) to Winston Churchill (1874–1965). It attempted to extend legal protections to the poor and vulnerable, limited dueling, and laid the foundation for the evolution of English common law.*

✦✦✦

Maimonides

One of the central figures in the history of Judaism, Moses Maimonides (1135–1204) was a religious scholar and philosopher born in medieval Spain who sought to explain the intricacies of Jewish law and to reconcile philosophy with ancient traditions. He was also known during his lifetime as one of the most famous doctors in the world, entrusted with the care of kings and sultans.

Raised in the thriving Jewish community of the Muslim-controlled city of Córdoba, Maimonides read widely in Jewish, Muslim, and Greek philosophy. However, the golden age of religious toleration in Spain ended in 1148, when an edict forced the city's Jews to convert to Islam, leave Spain, or face execution. Maimonides' family chose exile, fleeing to Morocco.

Maimonides eventually ended up in Cairo, Egypt, in 1166, where he became the leader of the city's Jewish community. In Cairo, he published *Mishneh Torah,* which established him as a major Jewish thinker. The fourteen-volume work focused mostly on Jewish religious questions, while his *Guide of the Perplexed* (1190) dealt with contemporary philosophical disputes.

In 1175, the rabbi's brother, a jewelry merchant, was killed in a shipwreck, an event that left Maimonides profoundly depressed and inspired him to take up medicine. He was soon one of the leading medical authorities in Egypt, authoring tracts on asthma, hemorrhoids, poisons, and other ailments.

Like the Muslim philosopher Ibn Rushd (1126–1198)—a close contemporary and fellow Córdoban—Maimonides was particularly devoted to connecting the philosophy of Aristotle (384–322 BC) to religious beliefs. Although Maimonides rejected some of Aristotle's findings, he embraced the philosopher's scientific outlook and insisted that reason could be compatible with faith.

Maimonides died at age sixty-nine in Egypt. He is regarded as one of the greatest interpreters of Jewish law in the religion's history, and his philosophy had a major impact on Christianity, influencing Catholic thinkers such as Thomas Aquinas (c. 1225–1274).

ADDITIONAL FACTS

1. *Maimonides is the Greek version of the rabbi's name; he is also referred to as Moshe ben Maimon in Hebrew or as Rambam, a nickname derived from his Hebrew initials.*

2. *After moving to Egypt, Maimonides settled in a section of Cairo called Fustat. The entire neighborhood was burned to the ground a couple of years later, in 1168, to prevent it from falling into the hands of Christian invaders.*

3. *Maimonides was the court doctor to the Egyptian sultan Yusuf ibn Ayyub (1138–1193), better known in the West as Saladin. In one famous tale, the sultan, who was known for his sense of chivalry, sent Maimonides to treat his enemy, the English crusader king Richard the Lionheart (1157–1199), who had fallen ill with a fever while fighting against Saladin.*

♦♦♦

Shen Kuo

A great polymath whose interests ranged from geology to poetry, Shen Kuo (1031–1095) was one of the foremost thinkers of medieval China. He is credited with inventing the modern compass, correctly describing how topography changes over time, and improving upon the astronomical instruments used by Chinese navigators.

Shen Kuo was born in the city of Hangzhou and educated primarily by his mother. His father was a minor government official, so the family moved often during Kuo's childhood. Following tradition, Kuo inherited the job after his father's death in 1051. For the next ten years, he traveled across southern China leading irrigation and agriculture projects and earning a reputation as an able administrator.

His travels afforded Shen Kuo the opportunity to observe the varied landscape of China, as well as natural phenomena like tornadoes and rainbows. After finding shells hundreds of miles from shore, he correctly deduced that the shoreline had shifted as erosion from the mountains changed the shape of the land. He was also the first Chinese writer to describe the cause of rainbows, decades before Roger Bacon (c. 1214–c. 1292) became the first European to reach the same conclusion.

In 1063, Shen Kuo was promoted and dispatched as an ambassador to several neighboring kingdoms. His first wife had died, so he married again, to the daughter of a high-ranking official. He became a favorite of the emperor, who appointed him to head the Bureau of Astronomy in 1072.

Shen Kuo embarked upon two projects: reforming China's calendar and compiling a study of planetary motion. He was aligned with a group of reformers in China known as the New Policies group and was picked to lead a military expedition in 1080.

After losing a battle in which 60,000 soldiers were killed, Shen Kuo was removed from office and placed under house arrest. He was not released until 1086, when he was finally allowed to retire to Dream Brook, his country estate near Zhenjiang. There, he wrote his memoirs, *Brush Talks from Dream Brook*, one of his few works to survive. (The book takes its name from the writing instrument he used: "Because I had only my writing brush and ink slab to converse with, I call it *Brush Talks*," he explained.)

ADDITIONAL FACTS

1. *After having been lost for centuries, Shen Kuo's tomb was rediscovered in the city of Hangzhou and restored in 2001.*

2. *To compile his tables of planetary motion, Shen Kuo and his assistants took measurements three times every night for five consecutive years. No one attempted a similarly exhaustive study again until Tycho Brahe (1546–1601), five centuries later.*

3. *In imperial China, a new calendar system was introduced whenever a new emperor took the throne. The calendar that Shen Kuo created in 1075 was in use for only twenty years before it was replaced with a different system.*

◆◆◆

King John

King John (1167–1216) was a deeply unpopular English monarch who imposed crippling taxes on his subjects, lost several wars to France, and was excommunicated by the pope. Fed up with his oppressive policies, John's barons launched a revolt in 1215 and forced the king to sign the Magna Carta, a document limiting the power of the Crown that has come to be regarded as the cornerstone of English and American constitutional liberties.

John was the fifth and youngest son of King Henry II (1133–1189) and Eleanor of Aquitaine (c. 1122–1204). His older brother became Richard I (1157–1199) in 1189, but left the next year to fight in the Crusades. John effectively took control of the kingdom during Richard's absence—the period of time that is the setting for the fictional tale of Robin Hood, in which John is the principal villain.

After Richard's death, John inherited the crown and immediately began his territorial disputes with France. John is considered the founder of the British navy, which first came into existence in the early 1200s to support his French wars. To pay for the military campaigns, he imposed a series of taxes on his barons, on business revenues, and on English Jews. Still, he lost virtually all his land in France, including Normandy. He was also excommunicated in 1209 amidst a dispute with the pope over who would pick the archbishop of Canterbury.

The excommunication, combined with John's unpopular taxes, spurred many English noblemen to rebel against the king. In 1215, he met twenty-five rebellious barons at Runnymede, a marsh near London, and was forced to sign the Magna Carta in exchange for peace. The document limited the inheritance tax on nobles, prohibited the king from taking property without consent and compensation, and established the principle that the punishment must fit the crime. Most important, it introduced the concept of habeas corpus to English law.

Despite its historic importance, in the short term the Magna Carta failed to end the rebellion, which flared anew later in 1215, when disgruntled nobles launched the First Barons' War. John died the next year at age forty-nine; peace was finally restored under his son, Henry III (1207–1272).

ADDITIONAL FACTS

1. *Since King John's death, British royal families have shunned the name John and observed an informal tradition of not giving it to any potential heirs to the crown.*

2. *Seventeen original copies of the Magna Carta are still in existence. One of them sold for $21.3 million in 2007 to a lawyer. It is kept on display at the National Archives in Washington.*

3. *John was nicknamed Lackland because, as the youngest son of Henry II, initially he did not have any territory of his own.*

❖❖❖

Geoffrey Chaucer

A courtier and diplomat for several English kings, Geoffrey Chaucer (c. 1343–1400) was better known as the author of *The Canterbury Tales*, an influential collection of short fictional stories that was a milestone in the development of the English language.

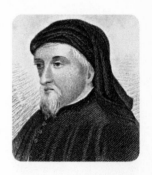

The stories, written in Middle English, were among the first literary works to use the everyday vernacular language of the English people. Most previous writers in England had used either Latin or French.

Chaucer was born in London into a relatively prosperous merchant family. He served in the English army under Edward III (1312–1377) during the Hundred Years' War and was taken prisoner by the French in 1360. He was ransomed back to his family the next year, during a lull in the fighting.

After his return to England, Chaucer wed one of the queen's ladies-in-waiting, Philippa Roet, a marriage that brought him into the king's inner circle. He served as Edward III's envoy to several courts in Italy in the 1370s; the monarch's decision in 1374 to award Chaucer a gallon of wine daily for the rest of his life seems to indicate that he was a successful diplomat.

Chaucer began writing *The Canterbury Tales* in the 1380s while continuing to work for Edward III's successor, Richard II (1367–1400). The tales are a series of vignettes about pilgrims on their way to the cathedral at Canterbury, a major religious site in England. The pilgrims represented a cross-section of English society: Chaucer depicts a knight, a student, a lawyer, an innkeeper, and many other ordinary people.

Richard II was overthrown by his cousin, who crowned himself King Henry IV (1366–1413) in 1399. As an ally of Richard, Chaucer probably suffered as a result of the coup and may have lost his pension. He died the next year of unknown causes.

ADDITIONAL FACTS

1. *When Chaucer was captured by the French and ransomed back to his family for sixteen pounds, Edward paid the ransom, which suggests Chaucer's high social status.*

2. *Chaucer was played by Paul Bettany (1971–) in the 2001 hit movie* A Knight's Tale, *which also starred Heath Ledger (1979–2008) as a champion jouster.*

3. *The exact circumstances of Chaucer's death have long been a mystery. In 2005, Monty Python comedian and medieval scholar Terry Jones (1942–) published a book—*Who Murdered Chaucer?—*in which he theorized that the author was assassinated by allies of Henry IV because his writings ridiculed the church.*

✦✦✦

Joan of Arc

By the time she died at age nineteen, Joan of Arc (c. 1412–1431) was a confidante of kings, a wounded veteran, and a triumphant general. Since then, the illiterate warrior girl has been transformed into the patron saint of France and a cornerstone of its national identity.

Joan was born in Domrémy, a town in northeastern France, in about 1412. Although she is often portrayed as coming from a poor, peasant background, her father was a modestly successful farmer. Still, her region was a focal point of the war with England, which had raged intermittently since 1337, and she witnessed significant destruction during her childhood.

At about age thirteen, according to testimony at her trial, Joan began to hear voices that she believed were those of several saints. The voices told her to take up arms against the English and lead the French to victory.

The Hundred Years' War had begun as a dynastic conflict over which family should rule France—the House of Valois or the House of Plantagenet, which already controlled England. For ordinary peasants and laborers in France, the fight had little relevance to their daily lives.

But Joan recast the war as a national struggle, pitting not the Valois against the Plantagenets, but the French against the English. She was able to travel to the court of the Valois leader, Charles VII (1403–1461), who was so impressed that he put her at the head of the French military in 1429. She won a huge victory that summer by taking the city of Reims.

In 1430, Burgundian troops captured Joan and sold her to the English. She was put on trial on trumped-up heresy charges the next year, and then she was burned at the stake in Rouen. Her conviction was posthumously overturned in 1456, however, and she was proclaimed a Roman Catholic saint in 1920.

ADDITIONAL FACTS

1. *The fighting continued for twenty-two more years after Joan's death, until France finally drove the English out in 1453. However, England did not formally abandon its claim to France until 1801, when King George III (1738–1820) dropped the words* king of France *from his title.*

2. *Joan la Pucelle appears as a villain in Shakespeare's* Henry VI, Part 1, *a historical play about a part of the Hundred Years' War told from the English point of view.*

3. *Joan of Arc has been portrayed on film by dozens of actresses, including Ingrid Bergman (1915–1982), Jean Seberg (1938–1979), and Milla Jovovich (1975–). Joan was also the inspiration for a television series,* Joan of Arcadia, *that aired on CBS from 2003 to 2005.*

❖ ❖ ❖

Al-Ghazali

In 1091, Baghdad was one of the most densely populated cities in the world, an international center of learning and commerce, and the political capital of the rapidly expanding Islamic world. That year, in a decision with fateful consequences for Islam, the city's ruler picked a young Persian theologian named Abu Hamid al-Ghazali (1058–1111) to lead one of Baghdad's most influential mosques.

Only thirty-three years old when he accepted the sultan's offer, al-Ghazali had been hailed as a brilliant scholar from an early age. Born in Tus (near Meshed), in modern-day Iran, he had been sent to a madrassa as a child to study Islamic jurisprudence.

Al-Ghazali's appointment made him one of the most important men in Baghdad, and his theology lectures regularly attracted hundreds of students. In contemporary debates about the relevance of Western thinkers in Islam, al-Ghazali was a traditionalist; he wrote a book called *The Inconsistency—or Incoherence—of the Philosophers* that attacked supporters of Aristotle (384–322 BC). His conservative viewpoint was soon widely embraced, closing a cultural connection between the Western and Islamic worlds.

Yet the young theologian harbored a secret: He was not at all sure that Allah existed. A skeptic by nature, he spent years studying the problem and was tormented by his inability to find proof of Allah's existence. As he wrote, "I have poked into every dark recess, I have made an assault on every problem, I have plunged into every abyss. I have scrutinized the creed of every sect, I have tried to lay bare the inmost doctrines of every community."

Finally, in 1094, wracked by despair, al-Ghazali suffered a breakdown in the middle of a lecture. ("My tongue could not utter a single word," he later wrote.) He left the city, made a pilgrimage to Mecca in 1096, and eventually returned to Khursan, where he founded a private school.

The autobiography that he wrote about his spiritual struggles, *The Deliverer from Error*, is a landmark work in Islamic thought. In the book, al-Ghazali concludes that Allah's existence cannot be proved or disproved because Allah is incomprehensible to the human mind. Instead, al-Ghazali wrote, Allah could be experienced by prophets and mystics, even if his existence could not be proven. His writing helped found Sufism, a school of Islamic mysticism.

ADDITIONAL FACTS

1. *His brother, Ahmad (c. 1060–c. 1126), was also a well-known scholar and preacher.*

2. *Before leaving Baghdad, Abu Hamid al-Ghazali gave away his money and possessions, fearing that wealth derived from the corruption and oppression practiced by the city's elite would endanger his chances for redemption after death.*

3. *Several of al-Ghazali's books were translated into Latin in the twelfth and thirteenth centuries and exported to medieval universities in Europe; Westerners referred to him by the name Algazel.*

❖❖❖

William the Conqueror

William the Conqueror (1027–1087) was a Norman nobleman who mounted a successful invasion of England in 1066. After defeating the old Saxon monarchy and crowning himself king, William introduced major changes in the law, language, and culture of England.

The consequences of the Norman Conquest may be most evident in the English language, which changed rapidly as a result of the arrival of the French-speaking invaders. Many words in modern English are derived from French—including, appropriately, *conquer,* which comes from the Old French *conquerre.*

William was the illegitimate son of the Duke of Normandy, a landholder in northern France. The boy inherited the duchy in 1035, when he was seven. While still in his teens, he fought and won several wars against rebellious nobles. He married a French noblewoman and distant cousin, Matilda of Flanders (1031–1083), in 1053.

The invasion stemmed from a dispute over who would inherit the crown of Edward the Confessor (c. 1003–1066), the Anglo-Saxon king of England who had died in January 1066 with no living heirs. Harold Godwinson (1020–1066) eventually won the power struggle, but William claimed the crown for himself and launched his invasion that September. He defeated and killed Godwinson at the Battle of Hastings and was crowned on Christmas Day of 1066.

William's conquest—commemorated in the famous *Bayeux Tapestry*—led to major changes in England. He constructed many new castles, including the Tower of London, and replaced the old English nobility with his own followers. After the invasion, French would be the language of the English aristocracy for centuries. He also commissioned the *Domesday Book,* a census of England taken in 1086 that is an important source of information about daily life in the Middle Ages.

William died at age fifty-nine; his son, William II (c. 1056–1100), also known as William Rufus, followed him on the throne.

ADDITIONAL FACTS

1. *The Bayeux Tapestry was sewn in the 1070s and hung in Bayeux Cathedral in northern coastal France. Measuring about 231 feet long, the tapestry illustrates William's victory over the Anglo-Saxons and is one of the chief historical documents of the invasion.*

2. *During the Battle of Hastings, three of William's horses were killed under him. A rumor spread through the Norman army that William himself was dead, and he had to ride through the ranks with his helmet off to prove that he was still alive.*

3. *The name William the Conqueror was bestowed on the king many years after his death. During his lifetime, he was known by the less-flattering William the Bastard because of his illegitimate birth.*

◆◆◆

Roger Bacon

During the twelfth and thirteenth centuries, an intellectual reawakening swept Western Europe as scholars rediscovered the work of such ancient philosophers as Aristotle (384–322 BC) and Plato (c. 429–347 BC). Many of the world's most famous universities were founded during this period, including Cambridge (1209) and the Sorbonne (1257).

Few scholars played as large a role in the revival of learning in Europe as Roger Bacon (c. 1214–c. 1292), an English monk who helped breathe life into the intellectual world of the Middle Ages. Bacon was both a philosopher and a spirited advocate of Muslim thinkers, especially Arabic-speaking writers such as Ibn Sina (c. 980–1037) and Ibn Rushd (1126–1198).

Bacon was born sometime between 1214 and 1220 in Ilchester, England. He is believed to have come from a well-off family, although details of his early life are nonexistent. He was educated at Oxford and Paris and inducted into the Franciscan order in 1256 or 1257 in Paris.

Although a devoted Franciscan, Bacon would clash with the order over religious questions for the rest of his life. The Franciscans forbade monks from publishing without specific permission, a ban that Bacon flouted several times. In 1266, he complained that his first decade as a monk had been a virtual imprisonment.

In his writing, Bacon offered several challenges to his colleagues. He argued that scholars relied too heavily on conventional wisdom and ancient sources of authority, without testing their scientific and philosophical beliefs. Bacon, in contrast, was an early advocate of experimental science and pushed his contemporaries to read unconventional sources like the Arabic writers, who were largely responsible for reintroducing the ancient Greeks to Europeans. (Indeed, most of the texts circulating at European universities were translated from Arabic versions, rather than from the original Greek.)

In 1272, Bacon published *Compendium Studii Philosophiae,* which attacked members of the priesthood for what Bacon viewed as their ignorance of philosophical matters. The book was condemned, and Bacon may have been imprisoned in retaliation. He returned to England around 1280, where he died.

ADDITIONAL FACTS

1. *Influenced by Arabic writers, Bacon was a believer in astrology—a position that was condemned by the church in 1277, leading to Bacon's arrest.*

2. *Although he does not appear in the book, Bacon is a key figure in the best-selling novel* The Name of the Rose *(1980), by the Italian author Umberto Eco (1932–).*

3. *One persistent fable about Bacon was that he invented gunpowder. The story is not true; however, Bacon was one of the first Europeans to describe the explosive, which had been invented by Chinese scientists centuries earlier.*

◆◆◆

Fibonacci

Leonardo Pisano (1170–c. 1250), better known by the nickname Fibonacci, was an Italian mathematician who lived most of his life in the city of Pisa. He was a key figure in the development of medieval mathematics who helped popularize Arabic/Hindu–style numbers and the use of decimal notation in the West.

But he is best known for Fibonacci's sequence, a numerical concept so simple that children can grasp it but so profound that mathematicians continue to study its theoretical implications.

In a Fibonacci sequence, each number is the sum of the preceding two numbers. It begins with 1, 1, 2, 3, 5, 8, 13, 21, 34, etc. The Fibonacci sequence is often found in nature, including in the concentric arrangement of sunflower petals, artichoke leaves, and pinecone scales. In art, the sequence can be used to determine the *golden ratio,* a proportion that was a favorite of Renaissance-era painters and was believed to be particularly pleasing to the eye.

Fibonacci was born in Pisa but spent much of his youth in northern Africa, where his father was stationed as a diplomat for the city. Growing up in Arab territory, he was taught the Arabic/Hindu style of writing numbers and quickly realized that it was superior to the Roman numerals still being used in Europe. Indeed, the main purpose of *Liber Abaci,* which he published in 1202 after returning to Pisa, was to demonstrate the superiority of Arabic numerals.

Fibonacci published several other books on geometry and number theory, some of which have been lost. He caught the attention of the Holy Roman Emperor Frederick II (1194–1250), a math buff who challenged Fibonacci with a series of problems that he was able to solve in 1225. Fibonacci was later awarded a pension by his home city and died there at age eighty.

ADDITIONAL FACTS

1. *Fibonacci's nickname came from the Latin words* filius Bonacci, *meaning "son of Bonaccio." Bonaccio, in turn, was the nickname of his father, Guglielmo.*

2. *Pisa was an independent republic during Fibonacci's lifetime. It was conquered by another city-state, Florence, in 1406.*

3. The Fibonacci Quarterly, *a journal devoted to the study of Fibonacci numbers, has been published since 1963.*

❖❖❖

Genghis Khan

Founder of the Mongol Empire, Genghis Khan (c. 1162–1227) was a warrior king whose horsemen were infamous for their brutal attacks on cities across Asia. By the end of his life, Genghis had conquered a huge swath of China and central Asia, along with part of Eastern Europe. After Genghis's death, his sons and grandsons expanded the empire into the largest (by land area) in human history.

The death and destruction caused by Genghis's invasions were legendary. His usual tactic was to surround a city and then kill every inhabitant if they refused to surrender. Although he is considered a national hero in Mongolia, in most of the world the name Genghis Khan has become synonymous with inhuman tactics in wartime.

Originally named Temüjin, Genghis was the son of a nomadic Mongolian chieftain. When Genghis was nine, his father was poisoned by a rival faction in the tribe, and Genghis and his mother were reduced to poverty. He eventually reclaimed the family's control over the clan and went on to exterminate his father's opponents. A charismatic leader, he then went to war against neighboring groups on the Mongolian plains, united the nation under his control, and assumed the title of khan in 1206.

Over the next twenty years, Genghis unleashed a wave of conquest unlike anything ever witnessed before. Riding Mongolian ponies, his troops conquered northern China, capturing Beijing in 1215. In the 1220s, he invaded Persia and the Caucasus region. Although the Mongols were nomads with no prior experience in war against cities, they soon perfected the use of catapults, siege engines, and other medieval military tactics.

In 1227, just after defeating the Tanguts and liquidating their leadership, Genghis died after falling off a horse. He was buried in a secret location that has yet to be discovered. The empire continued to grow for another forty years, reaching its peak under Genghis's sons in the 1250s.

ADDITIONAL FACTS

1. *Genghis's capital city of Karakorum, in northern Mongolia, was rediscovered by Russian archaeologists in 1889.*

2. *According to legend, Genghis asked to be buried in a secret, unmarked grave. In carrying out his wishes, his funeral party murdered anyone it encountered on the way to the grave site. After the burial, all the servants and soldiers were slaughtered as an extra precaution to prevent them from divulging his burial place. It has never been located.*

3. *Under Mongolia's former Communist government, it was illegal to display Genghis's image or even mention his name. The Communists were overthrown in 1990.*

Filippo Brunelleschi

A designer responsible for some of the greatest monuments in the city of Florence, Filippo Brunelleschi (1377–1446) is considered one of the central figures of Italian architectural history. His masterpiece, the city's Duomo, heralded the arrival of a new, ambitious style of architecture that combined the classical influence of ancient Rome with the optimism and humanism of the Renaissance.

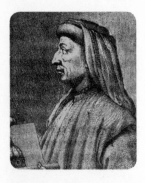

Trained as a goldsmith and sculptor, Brunelleschi first came to prominence in 1401 when he entered a competition to design a bronze door for the city's baptistery. Although he lost the contest to Lorenzo Ghiberti (1378–1455), the entry established the twenty-four-year-old Brunelleschi as an up-and-coming Florentine artist.

In 1418, the city sponsored another contest for a design to complete Florence's cathedral. The cathedral had been built with space left for a massive dome, even though it was unclear how the structure could be finished without causing the whole edifice to collapse. Intended to express the greatness of Florence, the cathedral was built as the city-state neared the pinnacle of its power and wealth.

On his second try, Brunelleschi beat Ghiberti with a design that had been inspired by his study of ancient Roman ruins and engineering treatises. Constructing the eight-sided dome and the lantern at its top would take the rest of Brunelleschi's life; it was still partially incomplete when he died. When it was finished, the 35,000-ton brick dome was the largest in the world.

In addition to the Duomo, Brunelleschi designed a hospital, several churches, and a palace. He also helped design military fortifications during one of Florence's wars with Pisa and tried (unsuccessfully) to invent a new type of barge to transport the massive number of bricks needed for the Duomo. Brunelleschi died in 1446 and was buried beneath the cathedral he had designed.

ADDITIONAL FACTS

1. *The architectural beauty of Florence is so great that a specific disorder,* Stendhalismo, *or Stendhal's syndrome, has been identified among visitors to the city who are physically overwhelmed by its splendor. The reaction is named for the French author Stendhal (1783–1842), who reported experiencing the disorder during a visit to the city in 1817.*

2. *Rome's Pantheon had been the largest dome in the West for 1,300 years when the Duomo was built. At 143 feet 6 inches, the dome just barely exceeded the diameter of the Pantheon, which measures 142 feet.*

3. *Brunelleschi's tomb was rediscovered in 1972, beneath the south aisle of the cathedral.*

✦✦✦

Girolamo Savonarola

Girolamo Savonarola (1452–1498) was a Dominican friar who briefly took over the city government of Florence, Italy. He governed for only four years, but he left a profound mark on the famous city by destroying many of its artistic treasures and enforcing a strict code of Christian morals. He initially enjoyed widespread popular support, but was overthrown and killed in 1498.

Savonarola was born in Ferrara, in northern Italy, and entered the Dominican order against his parents' wishes at age twenty-one. He became an ardent critic of the papacy and the Roman curia, who he believed had betrayed Christian teaching.

He was stationed in Florence from 1482 to 1487, but made little impression on the city until he returned in 1490. The city—one of the wealthiest in Europe and the heart of the Italian Renaissance—was not regarded as a bastion of religious fervor. It was home to some of the world's most opulent palaces and monuments, constructed by the ruling Medici family.

To Savonarola, the city's thriving culture was nothing more than decadence, and its art and literature merely temptations to sin. He recoiled at the paintings, many of which contained nudity, and the city's relatively tolerant attitude toward homosexuality. In his fiery preaching, he denounced the Medici, tapping into an underlying discontent in the city toward their rule.

In 1494, France invaded northern Italy, and in the tumult the Medici were expelled from the city. Savonarola, with popular backing, took control of the city. He set out upon a program of sweeping moral reforms, including applying the death penalty for homosexuality and establishing a "bonfire of the vanities," in which books and works of art that he deemed decadent were burned.

He also continued to preach against the papacy, sermons that led to his excommunication in 1497. Amidst growing unhappiness in Florence, he offered to undergo a test by fire to prove his righteousness. Unhappily for Savonarola, the citizens called his bluff, and he suddenly changed his mind in April 1498. As it turns out, he got a trial by fire anyway: He was arrested that month, condemned to death, and burned at the stake in May 1498, his experiment in populist theocracy over.

ADDITIONAL FACTS

1. *Savonarola's bonfire of the vanities provided the title for the 1987 Tom Wolfe (1931–) novel* The Bonfire of the Vanities, *which satirized the excesses of New York City society in the 1980s.*

2. *Although Savonarola never differed from the Roman Catholic Church on theological matters, he is considered by some Protestants to be a forerunner of the Reformation because of his criticism of Vatican corruption. A statue of him was erected in Worms, Germany, the birthplace of Protestantism, next to the statue of Martin Luther.*

3. *A style of folding chair that was common during the Italian Renaissance is referred to as the Savonarola chair, after the Florentine monk.*

✦✦✦

Peter Abélard

One evening in about 1120, a gang of assailants broke into the Paris bedroom of a leading French scholar, Peter Abélard (1079–1142). Seizing the well-known teacher, the attackers held him down and then, in a vicious act of revenge, castrated him.

The victim, an arrogant and acerbic intellectual known for his brilliant insights and sharp wit, was one of the most influential Christian theologians of the Middle Ages. But today he is probably best known for his forbidden love—and for the gruesome treatment he received as punishment.

Abélard was born in Brittany and moved to Paris in his early twenties. Although he was the son of a minor nobleman, Abélard renounced his family's inheritance so he could concentrate on his studies. He soon became a leading philosophy teacher in Paris and developed a reputation as a formidable debater.

His growing fame attracted the attention of a Paris church official named Fulbert, who hired Abélard as a tutor for his beautiful fifteen-year-old niece, Héloïse (1098–1164). Abélard became infatuated with the girl, who proved to be a brilliant student, and eventually he seduced her.

At first, the two lovers managed to keep their affair a secret from Fulbert, who was Héloïse's guardian. But when Héloïse became pregnant and gave birth to a son, he was enraged. At first, he agreed to a secret marriage between Héloïse and Abélard, who was nineteen years her elder. But after Fulbert disclosed their marriage to the public, Héloïse denied it, as did Abélard—because he could not be married and keep his job. Fulbert, her uncle, interpreted Abélard's decision to denounce Héloïse as his wife as a sign that he would abandon her. Fulbert then ordered the attack on Abélard as revenge for dishonoring him.

After the attack, Héloïse was packed off to a convent, and Abélard, now incapable of being her husband, remained in Paris and became a monk. There are many surviving letters between the two, but they mostly date to before the castration. After the attack, they continued to write to each other, but scholars question the reason for their correspondence. Some argue that they discussed purely religious matters.

When Héloïse died, twenty years after Abélard, the two lovers were finally reunited: They are buried side by side at a graveyard in Paris.

ADDITIONAL FACTS

1. *Héloïse named their illegitimate son Astrolabe, after the scientific instrument used in navigation that had recently been imported to Europe from the Islamic world.*

2. *A Broadway musical about the two lovers,* Abélard and Héloïse, *debuted in 1971, and Diana Rigg (1938–), who portrayed Héloïse, was nominated for that year's Tony Award for Best Actress. The two are also mentioned in the lyrics to the 1935 song "Just One of Those Things," by the composer Cole Porter (1891–1964): "As Abélard said to Héloïse / Don't forget to drop a line to me please."*

3. *Abélard and Héloïse are buried in the same Paris cemetery as rock legend Jim Morrison (1943–1971), the lead singer for the Doors.*

✦✦✦

Godfrey of Bouillon

To Christians, he was a legendary hero and a symbol of valor. To Muslims, he was the face of an unprovoked war that left a trail of bloodshed, misery, and destruction across the Middle East.

Godfrey of Bouillon (c. 1060–1100) was one of the leaders of the Christian armies during the First Crusade, an invasion of the Holy Land aimed at taking control of Jerusalem. The Crusades were collectively a turning point in the history of both religions and would be a flash point of tension for centuries—arguably, up to the present day.

The First Crusade was initiated by Pope Urban II (1035–1099) in 1095, when he sent messages to the kings of Europe asking them to contribute troops to the cause. The ostensible purposes of the expedition were to protect Christians in the Holy Land and to support the Byzantine Empire, which had been losing territory to Muslim invaders.

Godfrey was a knight from Brabant, a region of what is now Belgium. He responded to Urban's call with enthusiasm and was among the first wave of European feudal leaders to "take the cross." With an army of several thousand French knights, he marched through central Europe to Constantinople, the Byzantine capital, where he joined up with other groups of crusaders.

Most of the fighting took place between 1097 and 1099, when the crusaders won a series of battles against the Turks. The invasion culminated with the capture of Jerusalem in July of 1099. After the Christians took over the city, Godfrey was crowned its leader; refusing the title of king, he was instead called Defender of the Holy Sepulchre.

After his death the next year, Godfrey became one of the most heavily romanticized of the crusaders, lauded for his supposed piety and heroism in battle. For hundreds of years after his death, he was held up as a model of Christian knighthood.

His kingdom, however, proved short-lived. After regrouping, the Turks drove the crusaders out of Jerusalem in 1187. In total, nine Crusades were fought for control of the Holy Land, leaving a legacy of mistrust and religious antagonism in the region.

ADDITIONAL FACTS

1. *Godfrey was one of the Nine Worthies, a list of military leaders who were cited as models of chivalry in medieval literature. The European reverence for the nine, including Godfrey, was parodied by Miguel de Cervantes (1547–1616) in his novel* Don Quixote, *which poked fun at the romantic notions of chivalry in European literature.*

2. *Although Christians lost control of Jerusalem in 1187, the title King of Jerusalem still exists. It is currently held by King Juan Carlos (1938–) of Spain.*

3. *Godfrey's tomb in Jerusalem was destroyed in 1808.*

◆◆◆

William of Occam

The name of the medieval English philosopher William of Occam (c. 1285–c. 1347) lives on in a famous logical concept known as Occam's razor: The simplest possible explanation, William argued, is usually the correct one. The philosopher's body of work, however, spanned a wide range of topics that included Christian theology, physics, and epistemology (the study of the nature of knowledge).

William took his name from Occam, the village in southern England where he was born. Very few details are known of his early life. He was educated at Oxford and joined the Franciscan order of monks, which required him to embrace a life of poverty, in about 1306.

His first major work, published in 1323, was *Summa Logicae,* a textbook on logic. Partly in response to the controversy surrounding his work and partly because of political disputes, William was summoned before the pope in 1324 on charges of heresy. He would be in and out of trouble with ecclesiastic authorities for the rest of his life, and he was formally excommunicated from the Roman Catholic Church in 1328. A wanted man, he was never able to return to England.

William is considered one of the founders of nominalism, an influential school of thought that emerged in Europe in the Middle Ages. Previously, the theory of universals advocated by Plato (c. 429–347 BC) had held sway among many intellectuals. This theory held that in addition to individual dogs, for instance, there also existed the universal "form" of a dog. The nominalists rejected this view, arguing that only dogs exist; "doghood," they believed, was merely a construction of the human mind.

William did not invent Occam's razor, but he used the concept so often that it became associated with him. The *razor* refers to the process of shaving away unlikely assumptions to reach the most plausible explanation. In essence, William believed, the simplest explanation that required the fewest assumptions was probably correct. In other words, in all likelihood there are only dogs, and not the unseen universal dog of Plato.

After his excommunication, William spent most of the rest of his life in exile in Italy and Germany, where he continued to write philosophy and carry on his political disputes with the pope. He died during an outbreak of the Black Death in Munich.

ADDITIONAL FACTS

1. *All of William's books were written in Latin, but he is believed to have spoken Middle English, a version of English that emerged after the Norman Conquest of England in 1066 introduced many French words into the language.*

2. *William supposedly escaped punishment after his excommunication by fleeing to Bavaria, a German-speaking principality, on a stolen horse.*

3. *The major cause of William's rupture with Pope John XXII (1249–1334) was disagreement over the idea of apostolic poverty. Like other Franciscans, William believed that Christ's apostles had lived in poverty, setting an example for future churchmen. The pope disagreed, however, precipitating the clash.*

◆◆◆

Albertus Magnus

Albertus Magnus (c. 1200–1280) was a renowned medieval theologian and philosopher who was later canonized for his services to the Roman Catholic Church. His scientific reputation, however, has suffered over the centuries, thanks to his association with one of the most notorious scientific hoaxes of history—the search for the philosopher's stone, a mythical substance that could supposedly turn base elements into pure gold.

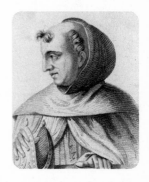

According to legend, Albertus discovered the secret of the philosopher's stone at the end of his life and whispered it to his protégé, Thomas Aquinas (c. 1225–1274), while on his deathbed. The incident never happened—Aquinas died before Albertus— but it has cemented the latter's reputation as the epitome of the medieval pseudoscientist.

In fact, Albertus was one of the most revolutionary thinkers of his time. His defense of the compatibility of reason and religion helped to usher in modern science. Like his contemporary Roger Bacon (c. 1214–c. 1292), he defended scientific inquiry from its medieval critics and conducted his own studies of botany, physiology, astronomy, geography, and chemistry. "The aim of natural science," he wrote, "is not simply to accept the statements of others, but to investigate the causes that are at work in nature."

Albertus was born in Germany and educated at the University of Padua in Italy. He joined the Dominican order in 1223 and taught at various schools in his native Germany. He later moved to the University of Paris, where his students included the young Aquinas. In his classrooms, Albertus did much to reintroduce the work of such Greek thinkers as Aristotle (384–322 BC) into European thought.

Albertus was also a major figure in church politics, serving as the bishop of Regensburg, a city in Bavaria, for three years and helping to organize the unsuccessful Eighth Crusade in 1270. Hailed as one of the great thinkers of Europe, he died in Cologne in 1280.

ADDITIONAL FACTS

1. *In Latin,* magnus *means "the great," an honorific that was bestowed upon Albertus during his lifetime in recognition of his theological influence. He is sometimes referred to as Albert the Great in English.*

2. *Although he failed to create the philosopher's stone, Albertus was the first European to discover arsenic. He isolated the poisonous metalloid in about 1250.*

3. *Albertus was made a saint in the Roman Catholic Church by Pope Pius XI (1857–1939) in 1931. He is the patron saint of students, scientists, and the city of Cincinnati, Ohio.*

✦✦✦

Vlad the Impaler

Prince Vlad III (1431–1476) staved off an Ottoman invasion of Walachia and is still regarded as a folk hero in his native Romania for resisting Muslim expansion. Almost everywhere else, however, Vlad is best known for the sadistic punishments he meted out to his enemies and for his notorious surname: Dracula.

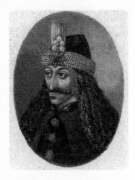

The historical namesake of the fictional vampire brought to immortal life by Bram Stoker (1847–1912), the Transylvania-born prince is also widely known as Vlad the Impaler, or Vlad Tepeş. His preferred method of disposing of enemies was to slowly impale them; he once supposedly impaled thousands of victims in a single day and then held a feast amidst a field of writhing bodies.

Vlad was the son of Prince Vlad II (c. 1390–1447). The younger Vlad's surname, Dracula, is derived from the Latin *draco,* for "dragon," and referred to his father's membership in the Order of the Dragon, a group formed to defend the Holy Roman Empire against Ottoman invasion.

In 1447, Vlad's father and older brother were assassinated by Walachian nobles. He struggled for the next nine years to win control of the principality in a series of wars that established his reputation for ruthlessness. He finally took power in 1456.

In the meantime, the Turks had conquered Constantinople in 1453, bringing a Muslim army to Europe's doorstep. The sultan then invaded Walachia in 1462. He was met by a gruesome sight: Vlad had impaled 20,000 Ottoman prisoners as a warning to the would-be invaders. The invasion was repulsed, but Vlad was deposed in the same year and spent the next twelve years in prison. He returned to power briefly in 1476, but was killed by the Turks later that year, at age forty-five.

Four centuries later, Stoker ran across Vlad's name, combined his story with traditional eastern European folk beliefs about vampires, and created the fictional Count Dracula. The novel and subsequent movie adaptations have ensured that the Walachian prince's name remains synonymous with torture and cruelty.

ADDITIONAL FACTS

1. *Mihnea the Bad (c. 1462–1510), Vlad's son, succeeded him on the Walachian throne. As the name suggests, Mihnea was not much gentler than his father, and he was said to punish his enemies by cutting off their noses.*

2. *A plan for a vampire-themed amusement park near Vlad's birthplace in Transylvania was canceled in 2002.*

3. *After his death, Vlad was buried at a secluded monastery on the island of Snagov. His grave was excavated in 1931—and reportedly found to be empty.*

◆◆◆

Leonardo da Vinci

A thinker of legendary genius, Leonardo da Vinci (1452–1519) was an expert in virtually every field of knowledge known to Renaissance Europe. He was an engineer, inventor, mathematician, architect, anatomist, and writer—and excelled at each. Perhaps most famously, he was also the painter whose enigmatic portrait of an Italian noblewoman, the *Mona Lisa,* is generally considered one of the greatest masterpieces in the history of Western art.

The illegitimate son of a Tuscan peasant, Leonardo was born in the village of Vinci, a part of the Italian city-state of Florence. He was apprenticed to a Florentine painter as a teenager and also spent parts of his life in Milan, Rome, Bologna, Venice, and France.

While living in Milan between 1482 and 1499, Leonardo painted *The Last Supper,* a large mural, for a Dominican convent in the city. The painting, one of his most famous works, shows Jesus at a table with his twelve disciples at the moment when he predicts that one of them will betray him.

Leonardo returned to Florence in 1500, where he began work on the *Mona Lisa.* The painting, which remained unfinished until shortly before his death, depicts the wife of a Tuscan merchant, Lisa del Giocondo (1479–1542). The canvas was purchased by King François I (1494–1547) of France and currently hangs in the Louvre Museum in Paris.

In addition to painting, Leonardo was a military engineer for Venice and Florence, an anatomist who dissected human bodies and produced some of the first drawings of human fetuses, and an architect who drafted a visionary design for a bridge in Istanbul. His notebooks—written backward—are filled with designs showing the great scope of Leonardo's intellect and contain designs of primitive helicopters and hang gliders, among other sketches. His diagram of an ideal human body, the Vitruvian Man, is one of the most famous drawings of the Renaissance.

François I invaded Italy in 1516 and took Leonardo with him back to Paris, where the painter died at age sixty-seven.

ADDITIONAL FACTS

1. *The fragile condition of* The Last Supper *has worried art lovers since virtually the day the painting was finished. Much of the original paint has chipped off or faded, and the painting was damaged in both the Napoleonic Wars and World War II. Today, to help protect the mural, tourists are limited to a fifteen-minute visit.*

2. *Microsoft chairman Bill Gates (1955–) bought one of Leonardo's notebooks, the* Codex Leicester, *in 1994 for $30.8 million.*

3. *In one of the most famous thefts of the twentieth century, the* Mona Lisa *was stolen from the Louvre in 1911. The French police investigated for two years—Pablo Picasso (1881–1973) was briefly questioned as a suspect—before an Italian janitor, Vincenzo Peruggia (1881–1947), was arrested for the crime. The painting was returned to the Louvre in 1914.*

◆ ◆ ◆

Bartolomé de las Casas

One of the few colonial-era Spanish officials to protest the mistreatment of Indians in the New World, Bartolomé de las Casas (1480–1566) was a Dominican friar and bishop who risked his career to expose the torture and genocide of indigenous peoples in the New World.

In a famous debate before the king of Spain in 1550 and 1551, de las Casas spoke eloquently in favor of the rights of Native Americans. But his opponent in the debate, a fellow Dominican, argued that whites had a natural right to enslave "lesser" races—the view that would prevail.

Forgotten for centuries, de las Casas's sweeping indictment of Spanish colonial practices has more recently been cited as one of the first recorded anti-imperialist tracts. De las Casas himself was proposed for sainthood in the Roman Catholic Church in 2008.

De las Casas was born in Seville. After the Spanish explorer Christopher Columbus (1451–1506) made his first trips to the New World, de las Casas joined the wave of immigrants moving to the new territory. He arrived in Hispaniola in 1502 and became the first Catholic priest ordained in the New World in 1512.

The arrival of the Spanish had had devastating consequences for indigenous populations in the Caribbean. De las Casas estimated that the native population of Hispaniola had gone from about 3 million at the time of Columbus's arrival to about 300 a few decades later. The majority of the deaths were caused by diseases brought by Europeans, to which the Indians had no natural immunity. But de las Casas argued that the Spanish *encomienda* system, which allowed colonists to enslave Indians for agricultural and mining labor, contributed to the misery.

He returned to Spain several times over the next three decades to petition the government for better treatment of Indians and participated in his famous debate about the theological validity of slavery in 1550. Two years later, he published *A Short Account of the Destruction of the Indies,* a compendium of human rights abuses committed by Spanish colonists.

De las Casas was uncompromising in his beliefs, and by the end of his life, he was deeply cynical about his country's policies in the New World. "Their reason for killing and destroying such an infinite number of souls," he wrote, "is that the Christians have an ultimate aim, which is to acquire gold."

ADDITIONAL FACTS

1. *De las Casas was a friend of Columbus's and edited the first edition of his journal.*

2. *In 1544, de las Casas was named bishop of Chiapas, a region in modern-day Guatemala. He ordered his priests to deny absolution to any Spaniards who refused to release their slaves, but his order was ignored.*

3. *The* encomienda *system was not formally abolished until 1720. Slavery in the Spanish colonies lasted, in most cases, until their independence in the nineteenth century.*

✦ ✦ ✦

Francis of Assisi

On a sunny morning in 1206, a young man named Giovanni Francesco Bernardone (c. 1181–1226) was walking near his home in the nearby city of Assisi. The road passed a decrepit hilltop church called San Damiano, where the young man stopped to pray.

Then, suddenly, Bernardone heard a voice that he believed was that of Jesus Christ. It delivered a message that would change the young man's life: "Rebuild my church."

Saint Francis of Assisi—as the young man would later be known—was born into a wealthy family but received little formal education. Instead, he worked in his father's textile shop and spent his profits on partying and expensive clothes. He enlisted in Assisi's army in 1201, fought against Perugia, and in 1203 was captured and spent almost a year in a dungeon as a prisoner of war.

The revelation on the hilltop, however, inspired the twenty-five-year-old to give up his material riches and dedicate his life to religion. He sold some of his father's cloth, found the elderly priest who maintained the church and offered him all of his profits. (The priest declined, and the bishop eventually forced Francis to give the money back to his father.) From that day on, Francis embraced a life of poverty.

Returning to Assisi, he traded his fancy clothes for rags. He started a small religious group, the Franciscans, whose members took vows of poverty and spent their days caring for lepers and society's other outcasts. His goal was to rebuild the church, both literally—he gathered stones to repair San Damiano—and metaphorically, by reinvigorating the church as a whole.

Initially, the Franciscans were met with suspicion by religious authorities, and Francis was never formally ordained a priest. But his group was recognized by Pope Innocent III (c. 1161–1216) in 1209, giving the order the official right to preach. In addition to his simple lifestyle, Francis was known for his love of animals and supposed ability to communicate with them. In one tale, he purportedly convinced a wolf to stop terrorizing an Italian village.

With his ranks of followers growing, Francis joined the Fifth Crusade. He was captured by the Egyptian sultan in 1219, but eventually released. He later returned to Assisi, where he died at age forty-five.

ADDITIONAL FACTS

1. *Canonized in 1228, only two years after his death, Francis is the patron saint of animals, the nation of Italy, and ecology.*

2. *Francis was also a poet; dozens of his poems have survived, and his religious song "Canticle of the Sun" is still performed.*

3. *A sister organization to the Franciscans, the Poor Clares, was founded by Saint Clare of Assisi (1194–1253), the daughter of a local nobleman, in 1212.*

✦✦✦

Eleanor of Aquitaine

One of the most powerful women in medieval Europe, Eleanor of Aquitaine (c. 1122–1204) was the queen of both France and England, and a key figure in the history of both nations. She fought in one of the Crusades, was the mother of two kings, and helped establish the Plantagenet dynasty, which went on to rule England for three centuries.

Eleanor was the sole heir of the Duke of Aquitaine, whose lands were in a region of southwestern coastal France. She inherited his duchy in 1137, when she was fifteen, making her one of the most desirable princesses in Europe. Three months later, she married Louis (1120–1180), the crown prince of France.

When her husband became King Louis VII soon after, Eleanor was crowned queen of France, though she still kept her holdings in Aquitaine and ruled them separately. The couple had two daughters. In 1147, they fought in the unsuccessful Second Crusade; Eleanor astonished her courtiers by marching alongside the army of Aquitaine.

By the time she returned from the crusade, Eleanor's marriage with Louis had deteriorated, and the couple obtained an annulment in 1152. Six weeks after the annulment, Eleanor remarried, to the future Henry II of England (1133–1189).

This pairing was happier than Eleanor's first marriage—although Henry would imprison his wife in 1174 for her alleged role in a failed revolt against him. They had eight children, including two sons who would become kings of England: Richard the Lionheart (1157–1199) and John (1167–1216).

When Richard became king in 1189, he released his mother from prison. After Richard's death, Eleanor's youngest son, John, became king. Eleanor, who had outlived all but two of her children, died five years later.

ADDITIONAL FACTS

1. *In Shakespeare's historical play about one of Eleanor's sons,* King John, *she appears as the character Queen Elinor.*

2. *Through her ten children, Eleanor was an ancestor of many prominent individuals, including actress Audrey Hepburn (1929–1993), animator Walt Disney (1901–1966), and former US president George W. Bush (1946–), who is the queen's twenty-fourth great-grandson.*

3. *Eleanor and Henry are the main characters of* The Lion in Winter, *a play written by James Goldman (1927–1998) in 1966 that was adapted for film in 1968. Actress Katharine Hepburn (1907–2003) won an Academy Award for her role as Eleanor in the movie version.*

◆◆◆

Niccolò Machiavelli

After the death of Niccolò Machiavelli (1469–1527), the Roman Catholic Church swiftly banned his books. Leading philosophers condemned the Italian writer as amoral and rushed to discredit his theories about politics and government. Even in the twentieth century, one American commentator called him "one of the most wicked men who ever lived."

Machiavelli, a diplomat and bureaucrat, incurred the wrath of critics over the centuries by writing *The Prince,* one of history's most controversial treatises on political philosophy. The book, which was based on the author's own experience in the government of the city-state of Florence, offers a cynical, ruthless guide to governing that is still studied for its insights into human nature and political power.

During Machiavelli's childhood, Florence was under the control of the Medici family, famous for its patronage of the arts and hard-nosed approach to politics. Machiavelli was born into a middle-class family and promoted to the position of second chancellor in 1498, after the Medici had been toppled earlier in the 1490s. He spent fourteen years in politics, often serving as an envoy to the surrounding Italian city-states, until the Medici returned to power in 1512.

The return of the Medici was a turning point in Machiavelli's life. Deposed from power, Machiavelli found himself impoverished and unable to return to government. He wrote *The Prince,* which was dedicated to Lorenzo di Piero de' Medici (1492–1519), in an effort to convince the city's new rulers to take him back.

The Prince was controversial in nearly every respect. For centuries, political philosophers had insisted that leaders needed to be virtuous in order to be effective. Machiavelli argued just the opposite: A good prince should be willing to rule by deception, violence, and fear, if necessary. Most contemporaries believed princes and monarchs should be good Christians; Machiavelli said it was only important to pretend to be a good Christian. The ends—maintaining the security and independence of the state—justified even the most evil means.

For Machiavelli, however, *The Prince* never achieved its purpose: Barred from returning to government, he lived the rest of his life in poverty on his farm, writing plays, poems, essays, and a history of the city of Florence. He died at age fifty-eight.

ADDITIONAL FACTS

1. *Machiavelli was a friend of the painter Leonardo da Vinci (1452–1519) and at one point even worked in the same building with him. The two men helped devise a military strategy to divert the river Arno in order to cut off the water supply to Pisa, a nearby city-state that was one of Florence's enemies. Florentine authorities actually tried the plan in 1503, but canceled the project after flooding damaged their own farmland.*

2. *The word* Machiavellian *is commonly used to describe cunning or deceptive political actions.*

3. *One of the models for Machiavelli's ideal prince was Cesare Borgia (c. 1475–1507), whom he met in 1502 while on a diplomatic mission. Borgia, the illegitimate son of Pope Alexander VI (1431–1503), was a military schemer known for his ruthlessness in battle.*

◆◆◆

Ibn al-Nafis

A Syrian physician who became the first man in history to describe the pulmonary circulation system, Ibn al-Nafis (1213–1288) was the personal doctor of the Egyptian sultan and one of the leading medical authorities of the Middle Ages. He also authored an influential, eighty-volume medical encyclopedia and compiled notes for hundreds of other volumes that he did not live to complete.

Ibn al-Nafis was born in Damascus and learned medicine at a hospital in the city. He published his first major work, *Commentary on Anatomy,* while still in his twenties. The book was a landmark in medicine, overturning an older theory on the heart that dated back to ancient Greece. Ibn al-Nafis showed that the heart pumped blood to the lungs and then back to the heart—the earliest description of pulmonary circulation.

In 1258, the Mongols sacked Baghdad, killing thousands and destroying several centuries of Arab scholarship. Ibn al-Nafis, who was an orthodox Sunni Muslim, compiled his medical encyclopedia partly in an effort to preserve the vast scientific knowledge that had been destroyed in the invasion. The encyclopedia was in print for centuries and remains an important contribution to the study of medicine.

For his prolific work on anatomy, surgical techniques, ophthalmology, and other topics, Ibn al-Nafis was hailed a "second Avicenna" in the Arab world (Avicenna was another name used for Ibn Sina [c. 980–1037], a famous Iranian doctor and philosopher). Ibn al-Nafis was named the first director of the al-Mansuri Qalawun hospital in Cairo. He also served as the personal doctor of Sultan al-Zahir Baybars (1223–1277), who led the successful counterattacks against both the Mongols and the Christian crusaders.

Upon his death in Cairo, Ibn al-Nafis bequeathed his house and library to the al-Mansuri hospital. Many hospitals in the Islamic world are named in his honor—a sign of his enormous influence on doctors everywhere.

ADDITIONAL FACTS

1. *Ibn al-Nafis also wrote a novel,* Risalat Fad il ibn Natiq, *about the adventures of a child on a desert island who is discovered by sailors and brought to civilization. It was translated into Latin as* Theologus Autodidactus.

2. *The US invasion of Iraq in 2003 pushed Ibn al-Nafis's name into the headlines. Baghdad's central hospital—Ibn Al Nafis—has treated many of the victims of the violence.*

3. *His full name was Alā' al-Dīn Abū al-Hasan 'Alī Ibn Abi al-Hazm al-Qarshī al-Dimashqī'.*

✦✦✦

Richard III

nnot prove a lover,
well-spoken days,
ove a villain.
—Richard III

Shakespeare (1564–1616) and many others, the historical
II (1452–1485) is sometimes overshadowed by his fictional
kespeare's Richard III was a murderous, hunchbacked tyrant.
d was not quite so evil—though he is still widely considered one
ccessful English monarchs.

the youngest son of the Duke of York (1411–1460) and grew up during
he Roses, a dynastic struggle between the House of York and a rival fam-
use of Lancaster. King Henry VI (1421–1471) and later Henry Tudor (1457–
the House of Lancaster. Both houses had a claim to the throne as a result of
scent from King Edward III (1312–1377). (The war's name comes from the
of the badges worn by the two armies—white for York and red for Lancaster.)

he duke's eighth child, Richard was not expected to figure in the line of succes-
n. His older brother, Edward IV (1442–1483), became king in 1461 after deposing
e Lancastrians. For much of the next two decades, Richard ruled northern
England on his brother's behalf. Edward died in 1483, leaving the crown to his teen-
aged son, Edward V (1470–c. 1483)—Richard's nephew.

But the new king ruled for only a few weeks before his uncle seized power in a coup
d'état. Edward, along with his half-brother, was then imprisoned in the Tower of
London, where the two princes were probably murdered on Richard's orders.

Richard's coronation, however, ended up dooming York's fortunes in the war. Led
by Henry Tudor, the Lancastrians landed in England and defeated Richard at the
two-hour Battle of Bosworth Field on August 22, 1485. Richard was unhorsed and
killed in the fighting. (In Shakespeare's *Richard III,* he famously offers "My king-
dom for a horse!" before he is slain.) After the battle, Tudor became King Henry VII,
effectively ending the War of the Roses.

ADDITIONAL FACTS

1. *The fate of the two princes imprisoned in the tower has never been conclusively determined. They
 were probably murdered, either by Richard or by Henry VII. In 1674, two bodies thought to be those
 of the boys were found and reburied at Westminster Abbey.*

2. *Numerous adaptations of Shakespeare's Richard III have been filmed. Among the many actors to fill
 the lead role are John Barrymore (1882–1942), Laurence Olivier (1907–1989), Ian McKellen (1939–),
 and Al Pacino (1940–). One of the best-known stage actors to play Richard III was John Wilkes Booth
 (1838–1865)—later the assassin of Abraham Lincoln (1809–1865).*

3. *The Richard III Society, a group dedicated to rehabilitating the king's reputation, was founded in
 1924.*

✦✦✦

Michel de Montaigne

French essayist and philosopher Michel de Montaigne (1533–1592) m
been one of the last children in Europe to speak Latin as a first languag
family's castle in southwestern France, even the servants were fluent
taigne's wealthy father had hired them so that his son would be surroun
the sound of Latin until he left for school at age six.

Perhaps not surprisingly for a child who read Virgil in the original, Monta
would become known as one of the most erudite thinkers in Renaissance Eur
His essays—he was the first essayist, having invented the term—were known
their originality, skepticism about religious and political traditions, and trench
insights into human nature, as well as the vast range of classical allusions sprinkl
amidst his own arguments.

After graduating from school, Montaigne worked briefly as a lawyer for the Bor
deaux government, and he married in 1565. However, he retired from his job at age
thirty-seven and returned to the family castle, determined to lead a life of scholarly
reflection.

The first two volumes of *Essays* appeared in 1580, and a third appeared in 1588. In
the essays, Montaigne picked broad topics—marriage, religion, dishonesty, fear,
etc.—and expounded on them, invariably introducing fresh and provocative ways to
think about the topic. In an essay about cannibalism, for instance, he meanders
through several thousand words—citing Aristotle, the legend of Atlantis, and Stoic
philosophy—before making the surprising argument that Europeans have little
standing to criticize cannibals, since the torture of a live body is more objectionable
than eating a dead one.

Montaigne's willingness to question the assumed superiority of Western civilization
made him an unusual, even radical voice in Renaissance Europe. He also opposed
the European colonization of the Americas, reasoning that it would lead to misery
for Native Americans.

Montaigne died in 1592 at his castle, but his essays continued to provoke thought
and debate for centuries. "That such a man has written," wrote philosopher Fried-
rich Nietzsche (1844–1900), "joy on earth has truly increased."

ADDITIONAL FACTS

1. *Montaigne was appointed mayor of Bordeaux for four years beginning in 1581. He attempted to turn down
the job, but received a letter directly from King Henry III (1551–1589) commanding him to take it.*

2. *The word* essay *comes from the French word* essai, *meaning "an attempt." Each essay, in Montaigne's
view, was an attempt to understand the topic at hand.* Essay *is also a little-used verb in English,
meaning "to attempt" or "to endeavor."*

3. *Montaigne's writing first appeared in English translations in 1603. Some literary scholars have spec-
ulated that William Shakespeare (1564–1616) may have read and been inspired by Montaigne, in
particular in writing* The Tempest, *which seems to have been directly influenced by Montaigne's
essay on cannibalism.*

Galileo

He set the earth on its foundations; it can never be moved.
—Psalms 104:5

And yet, it moves.
—Galileo Galilei

Nicolaus Copernicus (1473–1543) discovered that the earth revolved around the sun, but he was afraid to publish his controversial findings until the last year of his life. Galileo Galilei (1564–1642), an Italian astronomer and physicist, broadcast the same view to the public—and suffered the consequences.

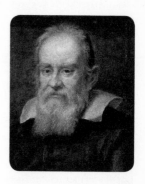

Branded a heretic and an enemy of the Roman Catholic Church, Galileo was threatened with execution and forced to recant his support for heliocentrism.

To his critics, Galileo's dangerous ideas threatened not just their understanding of the cosmos, but also the theological foundation of Western civilization. By undermining the biblical account of creation, they feared, he undermined the authority of Christianity itself. If the earth was not the center of the universe, then was the God that created it really all-powerful?

In time, Galileo's ideas would spur a revolution in science and in the West's understanding of the natural world. He has been called the father of physics and of modern science for his willingness to hold his culture's deepest beliefs up to scrutiny.

Galileo was born in Pisa and studied astronomy at the University of Pisa. He was appointed a professor of mathematics at the University of Padua in 1592. Using the most advanced telescopes of his day, he discovered four of the moons of Jupiter and was among the first to observe sunspots. He also became convinced that Copernicus was correct, and he openly praised the heliocentric theory.

In 1616, Galileo received a warning from the church to stop teaching Copernicanism. In 1633, he was summoned to Rome for a trial; he was forced to publicly recant the next year. He was placed under house arrest at his country house until his death.

ADDITIONAL FACTS

1. *Galileo was an inventor, and he received a patent in 1594 for a horse-powered water pump. He also invented the thermoscope, a primitive forerunner of the thermometer.*

2. *The four moons of Jupiter that Galileo first identified—Io, Europa, Callisto, and Ganymede—are collectively known as the Galilean satellites in honor of their discoverer.*

3. *Galileo, an unmanned probe named after the astronomer, was launched by NASA in 1989 to explore the moons of Jupiter. It took six years to reach the planet and sent measurements and photographs back to Earth until 2003, when it crashed into Jupiter.*

◆◆◆

Thomas Aquinas

Widely regarded as the most influential Christian theologian of the Middle Ages, Saint Thomas Aquinas (c. 1225–1274) was born into an aristocratic Italian family at his father's castle in the town of Roccasecca, near Rome. He began his religious studies as a child, when his father sent him to live in a nearby monastery as an oblate, or monk in training.

However, Aquinas infuriated his father by fleeing to France at age nineteen to enter the University of Paris. On the road to France, his father's men kidnapped him, hoping to persuade him to remain in Italy. Aquinas spent a year in captivity before he was finally allowed to enroll at the university.

At the university, which had been established on the banks of the Seine only about fifty years earlier, the young Aquinas encountered a lively scholarly community in the Latin Quarter that was far different from the traditional, feudal society in Italy from which he had escaped. In particular, the scholars in Paris were captivated by new translations of the works of the ancient philosopher Aristotle (384–322 BC), who had only recently been rediscovered in Christian Europe.

Aristotle's philosophy, with its emphasis on rationalism and science, posed a serious challenge to many Christian beliefs and would form the touchstone of much of Aquinas's writing. He received his Master of Theology degree in 1256 and was soon at work on the two books for which he is best known, the *Summa contra Gentiles* (1264) and the *Summa Theologiae,* the latter of which was unfinished at the time of his death.

In the two books, Aquinas sought to examine the relationships between faith and reason and to answer the questions Aristotle had raised. While some traditional theologians found Aristotle threatening, Aquinas believed that using Aristotle's tools of critical reasoning could lead to a deeper understanding of religion and that theology could be approached like a science. His *Summa Theologiae* contained five elegant arguments in favor of the existence of God—the *Quinque viae*—that would be widely embraced.

Aquinas returned to his homeland in 1272, settling at the University of Naples. He was summoned to a conference in France by Pope Gregory X (1210–1276), but fell ill and died en route. He was canonized in 1323 and named a Doctor of the Church, the highest distinction for a Catholic theologian, in 1567.

ADDITIONAL FACTS

1. *Aquinas is considered the patron saint of Catholic schools—dozens of which are named in his honor across the world.*

2. *It took many years before Aquinas's theology was generally accepted by Catholic scholars. Indeed, he was posthumously excommunicated three years after his death by the bishop of Paris.*

3. *One of Aquinas's teachers in Paris was the German philosopher Albertus Magnus (c. 1200–1280), who is also considered a Doctor of the Church.*

✦ ✦ ✦

Edward III

One of the most powerful medieval kings of England, Edward III (1312–1377) turned his country into a major European military power, started the Hundred Years' War against France, and shepherded the evolution of the English parliamentary and legal systems.

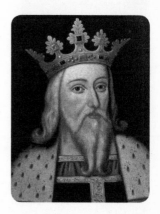

Inadvertently, however, Edward also planted the seeds of civil war: Decades after his death, disputes among his many heirs triggered a bloody dynastic war known as the War of the Roses.

Edward was born at Windsor Castle, the first son of Edward II (1284–1327). Edward II's reign was disastrous, and he was deposed and died when his son was only fifteen. A regent—young Edward's mother's lover, Roger Mortimer (1287–1330)—was appointed to rule for the teenager along with his mother, but when Edward was eighteen, he overthrew and executed Mortimer and then removed his mother from power.

As king, Edward consolidated English control over Scotland and sought to add France to his kingdom. Based on his family tree—Edward was the grandson of a French king through his imprisoned mother—he claimed the throne of France in 1337. The dispute with the French would flare up intermittently until 1453, a struggle known as the Hundred Years' War.

Domestically, Edward's rule saw Parliament develop into a bicameral legislature, the House of Commons and the House of Lords. Edward depended on Parliament to impose taxes to finance his wars, which elevated the legislature's importance in English government. Edward also codified many aspects of English common law, the foundation for the English and American legal systems.

Toward the end of his fifty-year rule—the longest ever in England until the eighteenth century—Edward grew increasingly senile. Upon his death, the crown passed to his grandson, Richard II (1367–1400).

ADDITIONAL FACTS

1. *Edward III, along with many members of his court, spoke French, not English, and many of the laws from the period were written in "law French." Law French continued to be used in England for centuries, and certain legal terms that are still in use, including* mortgage *and* voir dire, *are derived from the language.*

2. *In a feat almost unheard of among English kings, Edward is not believed to have fathered any illegitimate children.*

3. *Edward's reign coincided with the arrival of the bubonic plague in England in 1347.*

✦✦✦

Erasmus

The first printing press was invented in Germany in roughly 1439. Six decades later, a Dutch priest named Erasmus (c. 1469–1536) invented the bestseller.

Erasmus, a theologian, philosopher, and polymath, was one of the most widely read thinkers of the sixteenth century, as well as the first writer to gain a wide readership because of the new invention. He wrote in Latin on matters ranging from church politics to war. At one point, about 10 percent of all books sold in Europe were reputedly written by the prolific author.

Born in the port city of Rotterdam, Erasmus was the illegitimate son of a Catholic priest. He attended religious schools and was ordained a priest himself at age twenty-four, primarily to escape poverty.

Erasmus's true love, however, was scholarship, and he spent most of the 1490s travelling to the intellectual centers of France, England, and Italy, where he learned Greek and studied theology. He began his first major literary project, a new translation of the Old Testament from Greek to Latin, in the early 1500s. *The Praise of Folly,* his best-known nonacademic text, was published in 1511. Erasmus also published numerous editions of his popular *Adagia,* a compilation of adages that included famous phrases and proverbs like "Leave no stone unturned" and "God helps those who help themselves."

In church affairs, Erasmus was bothered by corruption in the Roman Catholic hierarchy and urged reform. But unlike Martin Luther (1483–1546), he never abandoned Catholicism, and attempted instead to steer a middle course between the traditionalists and the Protestant reformers.

Erasmus has been labeled the Prince of the Humanists in recognition of his pivotal place in European intellectual history. He symbolized the dawn of a new era, when books became far more widely available across the continent, breaking the monopoly of the Roman Catholic Church on higher learning.

ADDITIONAL FACTS

1. *Although universally known by his adopted academic name of Erasmus, the writer was born under the Dutch name Gerrit Gerritszoon.*

2. *One of Erasmus's friends at Oxford was Thomas More (c. 1477–1535), who would later be executed by another of the philosopher's friends, King Henry VIII (1491–1547). More had enraged the king by refusing to take an oath disavowing the pope. Considered a Roman Catholic martyr, More was canonized in 1935.*

3. *By refusing to take sides, Erasmus was at times distrusted by both sides of the religious schism of the 1520s. All of his books were banned by the Roman Catholic Church in 1559, and Luther called his writings "poison."*

❖❖❖

Thomas Bradwardine

His knowledge was praised by poets, prized by kings, and acclaimed by his fellow scholars. Arguably the most learned man of his generation, Thomas Bradwardine (c. 1290–1349) was eventually granted a title that reflected his vast expertise in theology, mathematics, physics, and diplomacy: *doctor profundus.*

Bradwardine graduated from Oxford in 1321 and became a fellow at the university's Merton College. He was a member of the Oxford Calculators, a group of intellectuals who studied the laws of motion and acceleration, making discoveries that anticipated Galileo by three centuries. Bradwardine wrote one of the major texts produced by the Merton group, *Tractatus de proportionibus,* in 1328.

In Bradwardine's time, Aristotle (384–322 BC) was still the accepted authority on physics and motion. Bradwardine correctly pointed out some of the flaws in Aristotle's writing on how objects behave in motion, reflecting a growing willingness in Europe to question ancient science. Although Bradwardine's own theories would themselves be disproved, the new spirit of inquiry and skepticism that he exhibited would endure.

In 1337, Bradwardine was made the chancellor of Saint Paul's Cathedral in London, and later he was named chaplain to King Edward III (1312–1377). As the king's religious advisor, Bradwardine traveled with the English army in the 1340s, during the first part of the Hundred Years' War with France, and he also served as a diplomat in negotiations with the French king, Philip VI (1293–1350).

After returning to London in 1349, Bradwardine was elevated to archbishop of Canterbury, the most senior clerical post in England. He died of the plague less than three months later.

ADDITIONAL FACTS

1. *While in the service of King Edward III, Bradwardine said the victory mass after the English triumph at the Battle of Crécy, a crucial 1346 clash in the Hundred Years' War.*

2. *Bradwardine's immediate predecessor as archbishop of Canterbury, John de Ufford, also died of the plague. Historians estimate that the plague epidemic of 1348–1349 may have killed about half of the population of England.*

3. *Bradwardine is praised by Geoffrey Chaucer (c. 1343–1400) in "The Nun's Priest's Tale," one of the stories in* The Canterbury Tales. *Chaucer compares his scholarly knowledge to that of Saint Augustine (354–430) and Severinus Boethius (c. 480–c. 524).*

◆◆◆

Tomás de Torquemada

As the first leader of the Spanish Inquisition, Tomás de Torquemada (1420–1498) directed the religious tribunals that condemned thousands of people to death in the fifteenth century. Aimed at eliminating "secret" Jews and Muslims—as well as heretics, adulterers, and sorcerers—the Inquisition was intended to ensure religious conformity in Spain, but it has come to be viewed instead as a symbol of misguided religious zealotry.

The number of individuals burned at the stake during Torquemada's tenure has been estimated at around 2,000. Many others were tortured or jailed. As the Inquisition grew increasingly unpopular in Spain, Pope Alexander VI (1431–1503) eventually had to rein in the aggressive inquisitor—although the Spanish Inquisition itself continued to function into the nineteenth century.

Torquemada was a Dominican monk and close ally of King Ferdinand V (1452–1516) and Queen Isabella (1451–1504), the dual monarchs who had united Spain in 1479. He was Isabella's personal confessor, and he used this access to the queen to advocate harsh religious policies. In the fifteenth century, Spain was one of the most religiously diverse countries in Europe, with large Jewish and Muslim populations that Torquemada—and many other Spanish Catholics—viewed as a threat to national unity. He was especially fixated on false converts who were outwardly Catholics but continued to practice their old faiths in secret.

In 1483, the monarchs appointed Torquemada grand inquisitor. He moved quickly to establish offices across Spain and expanded the list of offenses subject to the Inquisition to include a wide array of religious and moral offenses ranging from sodomy to usury. Punishments were meted out at autos-da-fé, elaborate ceremonies in which the religious authorities handed suspects over to the government for execution.

By 1494, Torquemada's investigations had made him so unpopular in Spain that he traveled under armed guard. The pope put limits on his authority that year, although Torquemada remained nominally in charge of the Inquisition until his death four years later.

ADDITIONAL FACTS

1. *The Spanish Inquisition was formally abolished in 1834. The last recorded auto-da-fé took place in Mexico in 1850.*

2. *Torquemada was played by Mel Brooks (1926–) in his 1981 comedy,* History of the World: Part I. *He was also portrayed by Marlon Brando (1924–2004) in* Christopher Columbus: The Discovery *(1992).*

3. *Many of the defendants in the Inquisition were tried in absentia. If found guilty, they were burned in effigy.*

◆◆◆

Miguel de Cervantes

Miguel de Cervantes (1547–1616) has been called the first modern novelist, on the basis of *Don Quixote,* a sprawling, comic epic that is among the most beloved works in the Spanish language.

The book, which appeared in two volumes in 1605 and 1615, was innovative for its wry humor, frequent moral ambiguity, and psychological insights. Cervantes was one of the first Western authors to delve into the inner emotions of his characters instead of simply relating a series of events.

Cervantes was born in Alcala de Henares, just outside of Madrid, and enlisted in the Spanish army in 1570. In the Battle of Lepanto, a 1571 naval clash between the Ottoman Empire and a combined Spanish-Venetian fleet, he suffered injuries that rendered his left hand useless for the rest of his life. The battle was a turning point in European history, and his role in it remained a source of pride for Cervantes.

In 1575, after a long recovery from his war wounds, a boat Cervantes was traveling in was attacked by corsairs, and he was taken captive. He spent the next five years as a slave in Algeria until his family raised enough money to pay his ransom.

Beginning his literary career, Cervantes published his first work, *La Galatea,* in 1585. He later worked as a tax collector, and he was imprisoned for three years beginning in 1597 for bookkeeping irregularities.

Cervantes began writing *Don Quixote* while in prison. The book follows the adventures of an elderly man named Don Quixote of La Mancha, who decides to become a heroic knight after reading too many chivalric novels. Aided by his befuddled sidekick, Sancho Panza, Don Quixote rides through the countryside seeking maidens to save, monsters to slay, and wrongs to right. While obviously delusional, Don Quixote ultimately emerges as a sympathetic, even tragic figure.

The book was enormously popular, but was widely plagiarized and spawned dozens of unauthorized "sequels." Cervantes published a real sequel in 1615—along with an introduction lambasting the copycats—and died the next year at age sixty-eight.

ADDITIONAL FACTS

1. *La Mancha is a region of Spain just south of Madrid.*

2. *Spain's premier literary award is known as the Cervantes Prize. Past recipients include Argentinean short-story writer Jorge Luis Borges (1899–1986), and Peruvian novelist Mario Vargas Llosa (1936–).*

3. *In 2002, a poll of world novelists placed* Don Quixote *atop the list of the greatest books of all time, beating runner-up* In Search of Lost Time, *by Marcel Proust (1871–1922).*

◆◆◆

Oliver Cromwell

During the past 1,000 years, England has been without a monarch only once: between 1649 and 1660, when a short-lived republican government replaced the king as a result of the English civil war.

The "lord protector" of England during most of this period was Oliver Cromwell (1599–1658), a zealous Puritan who had risen from obscurity to lead the fight against the monarchy. Cromwell was the driving force behind both the revolution and the subsequent commonwealth, and the experiment quickly fizzled after his death.

Cromwell was born near Cambridge, England, into a relatively low-status land-owning family. Many details of his early life are unknown, but he appeared to experience a religious awakening in the 1630s, when he became a committed Puritan.

At the time, England was one of the most tranquil corners of Europe. But religious and political disputes would put an abrupt end to peace in 1642, when a conflict between Parliament and King Charles I (1600–1649) blossomed into war. The war pitted the parliamentarian (or Roundhead) faction against the supporters of the king (or Cavaliers). Roundheads included many Puritans, who viewed the king's religious policies as too friendly to Catholicism. He contended that he possessed the "divine right" to rule and could ignore the legislature's decrees, which also contributed to war.

Cromwell entered the war as the commander of a cavalry unit on the Roundhead side. Despite a lack of military experience, he played a major role in winning the Battle of Marston Moor in 1644. Nicknamed Old Ironsides for his military prowess, he was named second-in-command of Parliament's New Model Army the next year.

After the Roundhead victory and the execution of the king in 1649, Cromwell was put in charge of the government. He pursued aggressive foreign and domestic policies, launching a brutal invasion of Ireland to reestablish English supremacy and passing laws closing theaters and enforcing Puritan ideas of virtue.

Cromwell ruled with the support of the army, but his death at age fifty-nine opened up divisions within the ranks of his supporters. Richard Cromwell (1626–1712), his son, lasted only a few months as lord protector before being ousted by the military. With total chaos looming, the military eventually invited the son of the executed monarch back to England, ending the commonwealth.

ADDITIONAL FACTS

1. *One of Cromwell's lesser-known acts was to repeal the law banning Jews from living in England, which had been imposed by King Edward I (1239–1307) four centuries earlier.*

2. *After his death, Cromwell was interred in Westminster Abbey, the burial site of English kings. The honor was short-lived, however: In 1661, after the restoration of the monarchy, his remains were believed to have been transferred to an unmarked grave.*

3. *Richard Cromwell left England when the military took over. He later wrote to his family from exile, and his letters to them are now held at the Cambridgeshire Archives and Local Studies Service at the Huntingdon Library in Huntingdon, England.*

✦✦✦

Catherine of Siena

Catherine Benincasa (1347–1380) was born in the walled city of Siena, Italy, during a troubled period in the city's history. Siena was divided politically; worse, a year after her birth, the plague swept through the Tuscany region of Italy, killing thousands of the city's residents.

Against this backdrop, the young girl, one of twenty-five children in her family, decided to become a Dominican tertiary at age sixteen, defying her father's hope that she would marry. As a tertiary—a religious figure similar to a nun—Catherine lived in seclusion for three years, rarely venturing into the streets outside her window, until she experienced what she termed a "mystical marriage" to Jesus Christ at age nineteen.

Even as Catherine gradually emerged from isolation, conditions in the city continued to decay. In 1368, her father became ill, and she rushed to his side to take care of him. He later died, and in that same year, Siena's rulers were overthrown in a revolution.

Amid the strife in Siena and across Italy, Catherine began writing the first of what would be hundreds of letters commenting on religious topics and Italian politics, which were greatly intertwined. The letters—addressed to popes, kings, monks, and members of her family—show a deeply devout Catholic who also possessed a keen instinct for politics. She became preoccupied with convincing the pope, Gregory XI (c. 1329–1378), to return the papacy to Rome from Avignon, France, where the cardinals had moved in 1309 as a result of a political dispute. Catherine's lobbying—and a personal visit to Avignon in 1376—played a major role in convincing the pope to return to Rome in 1377.

Gregory's return to Rome, however, outraged the French and precipitated the Western Schism, a period of deep division in Catholicism that lasted until the early fifteenth century. A rival claimant to the papacy, an "antipope," was elected by renegade cardinals in 1378. Catherine, troubled by the divisions, continued to lobby for reconciliation after moving to Rome, where she died at age thirty-three.

ADDITIONAL FACTS

1. *In her letters to Gregory XI, Catherine addressed the pope by the nickname Babbo—Italian for "Daddy."*

2. *Catherine was canonized in 1461 and is considered the patron saint of nurses, firefighters, the sick and dependent, and Allentown, Pennsylvania. She was also named the patron saint of Europe in 1999.*

3. *Although her letters are considered landmarks in Italian literature, Catherine was "unlettered"—partially illiterate—until three years before her death and had to dictate most of her letters to scribes.*

✦✦✦

Henry the Navigator

Prince Henry (1394–1460), often called Henry the Navigator, was a Portuguese nobleman who organized some of the first voyages of Atlantic exploration in the fifteenth century. His trips established Portugal as a major naval power, spurred technological developments in shipbuilding, and opened the way for the sailors who would soon discover the water routes to India and the New World.

However, Henry's legacy also includes his role as one of the first architects of the African slave trade—which would continue in the Portuguese empire for four centuries.

Henry was the third son of King John I (1357–1433) and Queen Philippa (1360–1415). When he was twenty-one, he participated in the Portuguese conquest of Ceuta, a city on the northern coast of Morocco that became the first colony in the Portuguese Empire. The conquest and subsequent defense of Ceuta almost bankrupted Portugal, but it nonetheless convinced the prince of the enormous possibilities for territorial expansion in Africa.

He began exploring the African coast and the eastern Atlantic Ocean in a fleet of caravels. His sailors discovered the Azores, Cape Verde, and the Madeira islands in the Atlantic, all of which became Portuguese possessions. Slaves and gold flowed back to Lisbon as a result of Henry's expeditions, turning Portugal into an economic power.

Henry died in 1460, at age sixty-six, but the forces that he unleashed would soon change the face of the globe. In 1498, a Portuguese explorer, Vasco da Gama (c. 1460–1524), successfully sailed around the Cape of Good Hope and reached India, where he established a Portuguese trading colony, opening a new chapter in the history of Europe and Asia.

ADDITIONAL FACTS

1. *The prince's uncle was King Henry IV (1366–1413) of England.*

2. *Six hundred years after their discovery, the Madeira islands remain part of Portugal—one of the country's only remaining overseas possessions. Madeira, a variety of fortified wine, was invented on the islands.*

3. *The motto on the prince's crest was "Talant de bien faire"—"the desire to do well."*

◆◆◆

Francis Bacon

Knowledge is power.
—Francis Bacon

A key figure in the history of science and logic, Francis Bacon (1561–1626) turned his full attention to philosophy only after his political career ended in disgrace at age sixty. In the few works he managed to complete before his death, Bacon is credited with laying the groundwork for the scientific method and the English philosophical school of empiricism.

Bacon was born into a politically powerful family in London, educated at Cambridge, and elected to Parliament at age twenty. He was elevated to the position of Keeper of Great Seal in 1617. A year later, he was named lord chancellor, England's most important judicial post.

In 1621, however, Bacon's career collapsed after he admitted to accepting bribes from litigants in his cases. He was fined, stripped of his office, and imprisoned in the Tower of London, the city's infamous prison for high-profile criminals. Barred from public office after his release from prison, Bacon devoted the rest of his life to writing and scientific experiments, which he had pursued on the side for years before his public humiliation.

In Bacon's writing, he sought to draw a distinction between philosophy, which he believed should be based on reason, and theology, which was based on revelation. He also wrote on logic, astronomy, and mathematics. One of his most famous arguments was against deductive reasoning—favored by Western intellectuals since Aristotle (384–322 BC)—in favor of inductive reasoning. Deductive reasoning involves the use of syllogisms to derive particular facts. For instance, if George Washington was a man and men have arms, then George Washington had arms.

Inductive reasoning, however, uses observed facts to derive general principles. For instance, ice is cold in every observed case; therefore, we can safely say that all ice is cold, even without testing every last ice cube. This form of logic, although it has been criticized, is a guiding principle of modern empirical science.

One of Bacon's own scientific goals was to discover the nature of heat and cold. Unfortunately for him, this quest led to his death; he succumbed to bronchitis after an experiment that involved stuffing a chicken carcass full of snow. He was sixty-five.

ADDITIONAL FACTS

1. *Despite a lack of evidence, Bacon has long been suspected of being the actual author of the plays of William Shakespeare (1564–1616). The two men both lived in London at the same time, and supporters of the hypothesis claim to have found numerous clues in the plays pointing to Bacon's authorship.*

2. *Bacon was knighted in 1603, made a baron in 1618, and created a viscount in 1621. At the time of his death, his official title was First Viscount Saint Alban.*

3. *Although sentenced to indefinite imprisonment for bribery, Bacon actually spent only four days in the Tower before he was released by King James I (1566–1625).*

✦✦✦

Johannes Gutenberg

The inventor of the movable type printing press, German craftsman Johannes Gutenberg (c. 1398–1468) made mass production of books possible. His press, a wooden frame with rows of letters made from lead and copper, had far-reaching consequences: Within a century of its introduction, books manufactured on Europe's new printing presses had sparked an intellectual and religious revolution across the continent.

Gutenberg was born in Mainz, a city in western Germany, into an upper-class family. He attended the University of Erfurt and may have been trained as a goldsmith. After several failed business ventures, including an ill-fated mirror business, and a lengthy lawsuit involving several of his partners, he unveiled his first press in 1450.

Prior to Gutenberg's press, most books were copied by hand, making them extremely expensive. Because the copyists were usually monks, the traditional method of producing books also meant that the Roman Catholic Church had virtually complete control over the material available to European readers.

Gutenberg's printing process, while slow by modern standards (his famous Bible may have taken about five years to produce), was far quicker than traditional hand copying. In Gutenberg's original press, each letter was made from lead and then arranged into pages of type. After printing, the type could be broken apart and the letters reused for other pages.

Gutenberg was never a particularly savvy businessman, and the cost of running the press eventually drove him deep into debt. He was briefly exiled from Mainz, but was granted a pension by the city's archbishop in 1465. Gutenberg died in the city of his birth three years later, just as the radical implications of his invention were starting to become clear. Within fifty years of his death, his invention had spread across the continent. Independent printing presses would play a crucial role in fostering the Protestant Reformation.

ADDITIONAL FACTS

1. Time *magazine proclaimed Gutenberg one of the ten "people of the millennium" in 1992, alongside Albert Einstein, Martin Luther, Thomas Jefferson, and other luminaries.*

2. *Copies of an original Gutenberg Bible are among the most sought-after collector's items in the world. Only about 180 were produced. The last time one of the originals was auctioned, in 1987, the top bid was $5.4 million.*

3. *Johannes Gutenberg University of Mainz was established nine years after Gutenberg's death. It is now one of the largest universities in modern Germany, with about 35,000 students.*

✦✦✦

Queen Mary I

Nicknamed Bloody Mary for the religious persecutions unleashed during her reign, Queen Mary I (1516–1558) was the first woman to be crowned ruler of England. She attempted to reintroduce Roman Catholicism two decades after it had been banned by her father, Henry VIII (1491–1547)—and enforced the reversal by burning hundreds of religious dissidents at the stake.

Mary's campaign was unsuccessful, however, and it provoked bitter opposition. After Mary's death, her half-sister, Queen Elizabeth I (1533–1603), ended the religious wars of the sixteenth century by permanently restoring Protestantism as England's official religion.

The only child of Henry and his first wife, Catherine of Aragon (1485–1536), Mary was considered an unsuitable heir to the throne because of her gender. Desperate for a male heir, Henry divorced Catherine in 1533 to marry the first of five younger women. In addition to removing Mary from the line of succession, the divorce precipitated Henry's break with Rome. He eventually managed to father a male heir, the future Edward VI (1537–1553), with his third wife.

Edward continued his father's religious policies after succeeding to the throne at age nine, but his death six years later provided an opening for Mary. Edward's officially designated successor, the fifteen-year-old Protestant Lady Jane Grey (1537–1554), lasted only nine days and enjoyed little popular support. At age thirty-seven, Mary seized the crown and later had Jane beheaded.

After taking the throne, Mary alienated many in England by marrying Philip II (1527–1598), a Spanish prince and a Catholic, in 1554. The marriage provoked a rebellion led by Sir Thomas Wyatt (1521–1554). In the same year, Mary restored the heresy laws and launched a wave of persecutions against Protestants. In the context of England's religious strife in the sixteenth century, Bloody Mary's persecutions were not especially bloody. Indeed, her father had killed far more people in introducing Protestantism than Mary did in trying to prohibit it. But the gruesome nature of the killings—and the fact that they were committed by what was ultimately the losing side—have contributed to Mary's dark historical reputation.

Unable to give birth to a Catholic heir, Mary died in London at age forty-two, leaving the kingdom to the Protestant Elizabeth.

ADDITIONAL FACTS

1. *Midway through Mary's reign, her husband became King Philip II of Spain. In 1588, he sent the Spanish armada to attempt to wrest control of England from Queen Elizabeth I—his half-sister-in-law—but was defeated.*

2. *During Mary's reign, England lost control of Calais, a port on the French coast that was the last vestige of the nation's once-extensive territory in France.*

3. *A Bloody Mary cocktail contains vodka, tomato juice, and spices. Bloody Mary is also the name of a DC Comics supervillain affiliated with the Female Furies.*

◆◆◆

William Shakespeare

William Shakespeare (1564–1616) enjoys unique status in the history of English literature. The Bard is generally considered the greatest writer the language has ever produced: All of his thirty-eight plays are classics, his sonnets have influenced generations of poets—and the mysteries of his life have kept biographers gainfully employed for centuries.

Shakespeare's religion, personal beliefs, education, literary influences, and sexuality are all subject to significant debate among historians. Shakespeare's existence has even been challenged, with some critics doubting that a single individual could have changed the course of English literature so dramatically.

The basic facts of Shakespeare's life, however, are generally accepted. He was born in Stratford-upon-Avon, England. He married at age eighteen to Anne Hathaway (1556–1623); their first child was born six months later. At some point, probably in the late 1580s, Shakespeare moved to London to begin his career in the theater, leaving Anne in Stratford.

Most of his plays from the 1590s were either historical plays or comedies, including *The Taming of the Shrew* (c. 1590), and *Love's Labour's Lost* (c. 1594). By the end of the decade, he had shifted to writing tragedies, which included some of his best-known plays: *Julius Caesar* (c. 1599), *Hamlet* (c. 1600), and *Othello* (c. 1603). In the final phase of his theatrical career, Shakespeare wrote "tragicomedies," serious plays that sometimes ended with improbably happy or wistful endings, such as *Cymbeline* (c. 1610).

Shakespeare was less prolific as a poet, but he published verse consistently throughout his career. His long poems *Venus and Adonis* and *The Rape of Lucrece* were written in the early 1590s, and his collection of sonnets was published in 1609.

For most of his career, Shakespeare was associated with the Lord Chamberlain's Men, a theatrical troupe in London. He was apparently part owner of the group's Globe Theater and became a relatively wealthy man. He retired to Stratford in about 1613 and died there at about age fifty-two. In his will, he bequeathed his wife his "second-best bed"—yet another enigmatic clue that has tantalized historians for centuries.

ADDITIONAL FACTS

1. *William and Anne had three children, Susanna (1583–1649), born six months after their wedding, and a pair of twins, Hamnet (1585–1596) and Judith (1585–1662).*

2. *Shakespeare added a dramatic touch even to his own tombstone. The monument, at a church in Stratford-upon-Avon, includes a poem that ends "cursed be he that moves my bones."*

3. *The original Globe Theater was shut down by the Puritans in 1642 and demolished. A reconstruction opened in London in 1997.*

◆◆◆

Metacomet

In 1675, a Native American who had converted to Christianity was found dead in an icy pond near Plymouth, Massachusetts. A few days later, a predominantly white jury convicted three members of the Wampanoag tribe of the murder and sentenced them to death.

The executions of the three Wampanoag set off a bloody chain of events that brought about King Philip's War, one of the most devastating conflicts in early American history. Almost half of the settlers in New England would die during the fourteen-month war; an even higher percentage of Native Americans were killed.

The leader of the Wampanoag during the war was a sachem named Metacomet (c. 1639–1676), who was often referred to by his English name, King Philip. By the end of the war, Metacomet was among the most feared and hated men in New England; centuries later, he has been reclaimed by Native American activists as a hero of the indigenous resistance to European colonization.

Indeed, from his hideouts in the hills and swamps of Rhode Island, Metacomet mounted the last serious military threat to the survival of the English colonies in North America. After his defeat, the number of Native Americans in New England shrank rapidly and never again posed an obstacle to the English.

Relations between the settlers and the Wampanoag had deteriorated steadily since 1620, when Metacomet's father, Massasoit (c. 1590–1661), had aided the pilgrims after their arrival at Plymouth Rock. The population of the English colonies grew rapidly after 1630, creating a demand for land that began to put a squeeze on the Wampanoag.

After becoming sachem in 1662, Metacomet began to reverse his father's friendly policies toward the English, and his people were ready for war when the hangings of the three Wampanoag in Plymouth provided a casus belli. Metacomet and his allies attacked English settlements in Rhode Island, Connecticut, and Massachusetts, burning farms and taking hostages.

Although he won initial victories, the English turned the tide in 1676 and cornered Metacomet in Rhode Island. He was killed in August 1676; his head was mounted on a pike outside Plymouth as a warning to other would-be rebels.

ADDITIONAL FACTS

1. *After the war, Metacomet's son was sold into slavery and transported to Bermuda, along with many other Wampanoag. Some of their descendants still live on Bermuda's St. David's Island.*

2. *In 1998, under pressure from Native American groups, the town of Plymouth agreed to erect a plaque to King Philip, whose remains had been displayed at the town's gates three centuries earlier.*

3. *Metacomet's older brother, Wamsutta, preceded him as sachem from 1660 to 1662. Wamsutta died under mysterious circumstances—possibly as a result of poisoning—shortly after being imprisoned by the English, an event that fueled Metacomet's distrust of the colonists.*

✦✦✦

Martin Luther

The founder of Protestantism whose radical teachings shook Europe to its core and redefined for many what it meant to be a Christian, Martin Luther (1483–1546) was born in the German city of Eisleben and raised in a highly conservative, peasant household. His father, Hans, was a copper trader who wanted nothing more than for his son to grow up to be a lawyer.

Martin, however, had other ideas. At the University of Erfurt, which he entered in 1501, he was nicknamed the Philosopher by his classmates for his studiousness but dropped out of law school. At age twenty-two, he entered a monastery and was formally ordained as a Roman Catholic priest two years later.

In 1510, Luther made a trip to Rome that would have an enormous impact on his religious views. Among the city's ornate churches, Luther was appalled by the luxurious, even decadent lifestyles of the pope and Catholic hierarchy. The sale of "indulgences"—which allowed the wealthy to buy eternal forgiveness for their sins and fueled the construction of Rome's palaces—was also seen as a symptom of widespread church corruption.

Seven years later, on October 31, 1517, Luther nailed to the cathedral door in Wittenberg a famous document outlining his objections. Known as the 95 Theses, Luther's manifesto was the opening salvo of the Protestant Reformation aimed at abolishing indulgences, taming the church hierarchy, and remaking Christianity. For the rest of Luther's life—and indeed, for decades after his death—theological disputes, political clashes, and even wars sparked by his writing would rage across the continent. Luther was condemned at the Diet of Worms in 1521, briefly went into hiding, and continued to write treatises questioning church teaching.

In 1522, Luther published a German-language version of the New Testament, breaking with Catholic tradition that forbade translations. An Old Testament translation followed in 1534. By making Christian writings accessible, the two books would have an enormous impact on the spread of Protestantism and on the German language.

Luther himself was earnest, strict about morals, and plagued by an acute sense of religious guilt that he described in his 1545 autobiography. He was also an anti-Semite whose writings on Jews would be praised four centuries later by the Nazis. After falling ill in 1537, Luther spent most of the rest of his life writing increasingly bitter tirades against Jews, the pope, and his perceived enemies. He died in Eisleben in 1546 and was interred inside the same church to whose door he had pinned the 95 Theses.

ADDITIONAL FACTS

1. *Rejecting the traditional Catholic belief in priestly celibacy, Luther married Katherina von Bora (1499–1552) in 1525. (He said he married to "spite the devil.") They had six children.*

2. *Following his condemnation at Worms, Luther was declared an outlaw. For about a year, he lived in hiding at a castle belonging to a sympathizer and disguised himself as a knight named Junker Georg.*

3. *Luther also wrote several hymns. Perhaps his most famous was "Ein feste Burg ist unser Gott," or "A Mighty Fortress Is Our God," in 1524.*

◆◆◆

Queen Isabella

Queen Isabella (1451–1504), a pivotal leader in the history of Spain, united two of its largest regions under one crown and completed the Reconquista of the Iberian Peninsula from the Muslims. She was also the sponsor of the expeditions of Christopher Columbus (1451–1506), who discovered the New World in 1492—thus opening a vast new continent to Spanish colonization.

In her home country, Isabella and her husband, King Ferdinand II (1452–1516), were viewed as pious rulers who laid the groundwork for the modern Spanish state. But Isabella also opened the Spanish Inquisition, expelled the Jews from Spain, and unleashed a deluge of violence against Native Americans in her colonial empire.

Isabella was the oldest daughter of King John II (1405–1454) of Castile, a region that encompassed most of southern and central Spain. She married Ferdinand, the heir to the throne of Aragon, in northeastern Spain, in 1469. The marriage effectively joined the two kingdoms, and the union would be the basis for the political entity of Spain.

By the time Ferdinand and Isabella succeeded to the throne, only a small part of the Iberian Peninsula, the Kingdom of Granada, remained under Muslim rule. The duo spent ten years besieging the city of Granada before it finally fell in 1492. The defeat of Granada ended more than 700 years of Islamic presence in Spain.

With Granada conquered, the two monarchs were determined to build an entirely Roman Catholic state. A few months after the city's fall, they issued a decree ordering all Jews to either convert to Catholicism or leave the country. Ten years later, they issued a similar edict targeting Muslims. The Inquisition, which was given the task of punishing heretics and "false converts" from Judaism and Islam, was also established during their reign and quickly earned a reputation for cruelty.

The event with the greatest long-term global significance, however, may have been Isabella's decision to sponsor Columbus's expedition. In 1492, she granted him three ships to sail west. His successful expedition triggered a massive wave of Spanish colonization; millions of Native Americans were killed or enslaved as the Spanish sought to find gold and spread Christianity in the new territories.

Isabella died in 1504, at age fifty-three.

ADDITIONAL FACTS

1. *Isabella's youngest daughter, Catherine (1485–1536), was the first of the six wives of King Henry VIII (1491–1547) of England. The pope's refusal to grant an annulment to Henry resulted in his break with Roman Catholicism in the 1530s.*

2. *Before marrying Ferdinand, Isabella spurned offers of marriage from the heirs to both the French and English thrones.*

3. *Modern genetics has confirmed the extent of the forced conversions under Isabella and Ferdinand: A study completed in 2008 showed that 20 percent of the Spanish population has Sephardic Jewish ancestry, while another 11 percent are of Moorish descent.*

◆◆◆

René Descartes

René Descartes (1596–1650)—physicist, mathematician, and philosopher—is one of the founders of modern philosophy and a major transitional figure in Western intellectual history. Descartes, more than any of his predecessors, rejected ancient Greek ideas and laid the foundation for what would become modern philosophical thought.

Born in La Haye, France, Descartes was the son of a leading judge. The boy's mother died when Descartes was only one year old, and he was raised primarily by his grandmother and great-uncle. Descartes graduated with a law degree from the university in Poitiers, joined the army at age twenty-two, and was stationed in Breda, a city in the Netherlands. (He left a year later, just avoiding a war with Spain.)

After traveling through Germany, the Netherlands, and Italy, Descartes settled in Paris. A prolific writer, he penned several scientific works on optics, meteorology, and math. In 1636, he moved to Leiden, a city in the Netherlands, where he published *Meditations on First Philosophy,* one of his best-known works.

In Descartes' own words, his philosophy sought to "destroy the principles of Aristotle," whose writings had been the bedrock of Western philosophy for two millennia. Aristotle had believed that everything in nature had a purpose—a *telos*—that determined its form. In contrast, Descartes believed a scientist should study only what was empirically observable—a school of thought that acquired the name *rationalism.*

Having become famous, Descartes corresponded with many of the leading luminaries of seventeenth-century Europe. Queen Christina of Sweden (1626–1689), one of his supporters, invited him to found a school in Stockholm, where he fell ill and died at age fifty-three.

ADDITIONAL FACTS

1. *One of the most famous quotations from Descartes is "Cogito ergo sum"—Latin for "I think, therefore I am"—which appeared in a 1644 book. The famous passage was written as a response to a philosophical debate about whether it is possible to know whether anything—even oneself—truly exists, or whether things only seem to exist.*

2. *The remains of Descartes' brain are kept at the Musée de l'Homme in Paris.*

3. *The philosopher's hometown, La Haye, was renamed Descartes in 1967.*

✦✦✦

Copernicus

Astronomer Nicolaus Copernicus (1473–1543) was the first modern thinker to revive the ancient theory that Earth revolved around the sun, rather than vice versa. His writing revolutionized the study of the cosmos, inspired Isaac Newton (1643–1727) and Johannes Kepler (1571–1630), and put him in direct opposition to Christian beliefs—an ironic fate for a lifelong church official.

Copernicus was born in modern-day Toruń, Poland. His father, also named Nicolaus, was a prosperous and well-connected copper trader who secured his youngest son's entrance to the universities in Padua and Bologna. After receiving his doctorate in canon law in 1503, he went to work for his uncle, the bishop of Warmia, as a church canon. The job paid well and gave Copernicus time to pursue stargazing as a hobby. He wrote an essay, *Commentariolus*, at some point between 1510 and 1514 to outline his theory of the heliocentric universe.

Copernicus was not the first to propose that Earth revolved around the sun; several ancient Greek thinkers had proposed the same idea. But Christian theology held that God had placed Earth at the center of the universe, and respected Western thinkers since Aristotle (384–322 BC) had agreed.

Perhaps aware of the risks of publishing his views, Copernicus shelved the heliocentric theory for the next three decades and concentrated on church duties. He was promoted to be the bishop's doctor, wrote a technical guide to minting coins, and also helped organize a defense of the area against attacks by Teutonic knights.

Finally, just before his death, Copernicus agreed to publish *De revolutionibus orbium coelestium,* the six-volume treatise on the planets that he had spent most of his life drafting. His publisher was so scared about possible controversy that he added a preface, without the author's permission, explaining that the book was not meant to be taken literally. Both Protestants and Catholics objected to Copernicus's findings. Still, the book was widely disseminated across Europe and helped spur modern astronomy, a paradigm shift known as the Copernican Revolution.

Copernicus, however, suffered a stroke and slipped into a coma just before the book's printing. According to legend, he was given a copy of the book on his deathbed, woke up from his coma just long enough to see that his life's work was finally published, and then died a happy man. He was seventy.

ADDITIONAL FACTS

1. *Copernicus completed only one other book in his lifetime—a translation of letters by the seventh-century Byzantine author Theophylactus Simocatta from Greek into Latin. It was published in 1509.*

2. *De revolutionibus orbium coelestium (On the Revolutions of the Heavenly Spheres) was dedicated to Pope Paul III (1468–1549), but the Roman Catholic Church nonetheless condemned the book as heretical in 1616. It was not removed from the list of banned books until 1822.*

3. *The airport in Wrocław, Poland, was named after the astronomer in 2005.*

✦✦✦

Martin Guerre

Martin Guerre was a French peasant who fell victim to a still-famous case of identity theft. After going off to war in 1548, Guerre returned home many years later to find that another man had taken his name, house, and family. The impostor, Arnaud du Tilh (c. 1524–1560), was so convincing that even Guerre's wife had been fooled.

Since then, the story of Guerre's return—and the subsequent conviction of Du Tilh for fraud and adultery—has inspired novels, movies, cartoons, scholarly books, and even a musical. It also foreshadowed many similar cases of men assuming new identities in the chaotic aftermath of war.

The real Martin Guerre was born in southern France. He moved to the village of Artigat as a child, where he married his wife, Bertrande. They had one son before Guerre departed in 1548.

For the next eight years, Bertrande raised the child alone—until the day Du Tilh appeared on her doorstep. The impostor looked like Bertrande's missing husband, talked like him, and knew many details of Guerre's life. Despite skepticism, most of the townspeople, including Bertrande, eventually accepted Du Tilh as Guerre.

Martin's uncle, however, refused to believe that the impostor was Guerre, and he accused him of impersonating his nephew in 1559. Du Tilh was convicted of fraud and adultery in 1560 and was sentenced to death. He immediately appealed the verdict—leading to an unexpectedly dramatic courtroom clash.

As the court was hearing the appeal, the original Martin Guerre suddenly hobbled into the courtroom on a wooden leg. Guerre explained to the astonished judges that he had joined the Spanish army, lost a leg in war (fighting against the French, no less), and spent time recovering in a monastery. Guerre's family all identified the one-legged veteran as the real Guerre, and Du Tilh was hanged that September.

Although he was initially angry with his wife, Guerre eventually accepted that she had been legitimately fooled, and the couple then disappeared from history. The story of Du Tilh's imposture and Guerre's return was widely disseminated across France and was the source of the 1982 movie *The Return of Martin Guerre.*

ADDITIONAL FACTS

1. *The 1982 film was followed by a 1996 musical about the famous case.* Sommersby, *a fictionalized American version of the tale set during the Civil War, was released in 1993.*

2. *Michel de Montaigne (1533–1592) witnessed Du Tilh's trial and wrote about the case in his* Essays. *He considered the trial an illustration of the impossibility of reaching certainty and criticized the judge for imposing a death sentence.*

3. *Jean de Coras (1515–1572) participated as a court official in the Guerre case and wrote the most important record of the trial,* Arrest memorable du parlement de Tolose *(1560). He later converted to Protestantism and was assassinated in 1572 during a period of religious strife in France.*

◆◆◆

Diego Velázquez

Diego Velázquez (1599–1660) pioneered new ways to use color and light in his paintings and created striking portraits of peasants, popes, and members of the Spanish royal family. He is considered one of the most influential figures in the baroque period of European art, a period that lasted from the seventeenth into the eighteenth centuries.

Velázquez's most famous works include *The Water Carrier of Seville* (c. 1619), a portrait of Pope Innocent X (1650), and *Las Meninas,* or *The Maids of Honor,* a giant portrait of a Spanish princess and her courtiers that he completed in 1656.

Born in Seville, Velázquez entered art school when he was eleven and produced several of his most famous early works, including *The Water Carrier,* before age twenty. The paintings caught the attention of officials in Madrid, who summoned the young artist to the court of King Philip IV (1605–1665) in 1622.

Philip IV, who presided over Spain as it reached the height of its imperial power in Europe and the Americas, would become Velázquez's lifelong patron. Velázquez went on to paint hundreds of canvases of the king, his political allies, and his family, culminating with *Las Meninas.*

Las Meninas, which currently hangs in the Prado Museum in Madrid, is considered by many critics to be Velázquez's masterpiece. The complex, enigmatic painting shows the princess in a dimly lit room with her father, the king, peering in from an open doorway. Velázquez himself appears in the shadows at the side of the painting, brush in hand, although it is unclear whether the artist in the portrait is painting the princess or another subject. The elaborate use of lighting and shadow in the painting is considered characteristic of the baroque style.

In addition to painting Spanish royalty, Velázquez made portraits of poets, servants, and religious figures. He traveled to Italy twice and developed a friendship with the Flemish painter Peter Paul Rubens (1577–1640). Velázquez was knighted shortly before his death at age sixty-one.

ADDITIONAL FACTS

1. *The main figure in* Las Meninas *is Princess Margarita (1651–1673), the youngest daughter of Philip IV. She married the Holy Roman Emperor, Leopold I (1640–1705), when she was fifteen years old and died at age twenty-one after several miscarriages.*

2. *Velázquez painted more than forty portraits of his patron, Philip IV.*

3. *The term* baroque *is derived from a word in Spanish and Portuguese meaning "irregular," "contorted," or "grotesque." Art from the period is typically richly detailed, but lacks the concern for absolute realism that was shown in earlier generations. It is often associated with the Counter-Reformation of the seventeenth century, when the Roman Catholic Church regained or strengthened its power in many parts of Europe and supported the artists of the movement.*

✦✦✦

Nathaniel Bacon

Nathaniel Bacon (c. 1647–1676) was a farmer and rebel leader in colonial Virginia. In 1676, he waged a brief but widespread revolt against the colony's government—one of the largest uprisings in North America before the American Revolution a century later.

Known as Bacon's Rebellion, the revolt stemmed from dissatisfaction with William Berkeley (1605–1677), the governor of Virginia. Bacon and his supporters, mostly small tobacco farmers and frontiersmen, were upset over taxes and what they felt was Berkeley's unwillingness to protect them from attacks by Native Americans.

At its peak, the rebellion had thousands of supporters and controlled large swaths of the colony. But the movement collapsed in late 1676 after Bacon died of dysentery; after the leader's death, Berkeley swiftly quashed the rebellion and hanged dozens of Bacon's officers.

A member of a prestigious English family, Bacon was born in Suffolk, England, and graduated from Cambridge. He moved to London and then immigrated to Virginia in 1674. The family established a farm near what is now the city of Richmond.

Initially, Bacon was a supporter of Berkeley and a member of the governor's council. But Bacon came to sympathize with Berkeley's critics. Many settlers felt vulnerable to attack, and they wanted the Indians killed or removed from the colony. But Berkeley was hesitant, fearing that he would disrupt trade as well as provoke a wider war if he pursued the Indians aggressively.

Bacon, seizing upon the anxiety of the settlers, asked the governor for permission to lead an attack on the Indians. When Berkeley refused, Bacon went to war anyway, massacring several groups of Native Americans. Berkeley, enraged, declared Bacon a traitor in early 1676. Bacon was unrepentant: "If to plead the cause of the oppressed . . . be treason," he said, "Lord Almighty judge and let the guilty die."

Bacon's death a few months later quickly ended the conflict. But the impact of his revolt reverberated for decades in British North America and served as a model of disobedience to the Crown. A century later, a patriot leader from Virginia, Patrick Henry (1736–1799), echoed his fellow Virginian in one of his famous calls for revolution: "If this be treason, make the most of it!"

ADDITIONAL FACTS

1. *One of the houses seized by the rebels in Westmoreland, Virginia, belonged to Colonel John Washington (c. 1631–1677)—the great-grandfather of George Washington (1732–1799).*

2. *The king, Charles II (1630–1685), was so annoyed by Berkeley's mismanagement of the Virginia colony that he recalled him to London, where Berkeley died the next year.*

3. *Bacon's cousin—also named Nathaniel Bacon—remained loyal to the Virginia government during the rebellion. He was rumored, at the time, to have offered to bribe Bacon to stay loyal to protect the family's reputation.*

✦✦✦

Henry VIII

Best known as the English monarch who married six times and executed two of his wives, Henry VIII (1491–1547) cannot be called a particularly pious man. But, almost by accident, the king managed to create the Church of England, which replaced Roman Catholicism as his nation's official faith.

The third child of King Henry VII (1457–1509), the younger Henry never expected to become king. His older brother, Arthur, was next in line for the throne, but died suddenly in 1502. Henry then inherited both his brother's title and his widow, the Spanish princess Catherine of Aragon (1485–1536). When Henry VII died, the couple became king and queen of England.

In the early years of the Protestant Reformation, Henry remained a loyal Roman Catholic, more concerned with building England's navy than with the controversies over religious reform that had erupted in continental Europe. Pope Leo X (1475–1521) even awarded the English king the title *Fidei defensor,* or Defender of the Faith, after Henry defended the church against Martin Luther.

However, politics and Henry's troubled marriage to Catherine eventually led him to make a dramatic break with the church. Catherine gave birth to six children, but only one—the future Queen Mary I (1516–1558)—survived infancy. Without a male heir, Henry feared the kingdom would collapse into instability after his death.

Determined to produce a son, Henry asked the pope to grant an annulment so he could marry Anne Boleyn (c. 1507–1536). When the pope refused, Henry defied Rome, declared himself the nation's top religious authority, and married Boleyn anyway in 1533. (She was beheaded three years later after failing to produce a son.)

Henry's decision to reject the pope's authority—a policy the king enforced with a round of executions of papal loyalists in 1535—would have enormous consequences for English politics and religion. The country would be engulfed in religious turmoil for the rest of the century as Catholics and Protestants jostled for power. Henry, however, finally got his wish in 1537, when his third wife, Jane Seymour (1509–1537), gave birth to the future King Edward VI (1537–1553).

ADDITIONAL FACTS

1. *The abolition of papal authority in England allowed for the first English-language Bible. (Translations had been illegal under Roman Catholicism.)*

2. *After Catherine, Anne Boleyn, and Jane Seymour, Henry's other three wives were Anne of Cleves (1515–1557), Catherine Howard (c. 1523–1542), and Catherine Parr (1512–1548).*

3. *For the rest of her life, Catherine of Aragon maintained that she was Henry's rightful wife. But when she died in a castle near Cambridge, Henry ordered his subjects to celebrate the news.*

◆◆◆

Elizabeth I

Elizabeth I (1533–1603) was the queen of England who defeated the Spanish armada, sponsored the first English explorations of the New World, and presided over the renaissance of English literature and drama known as the Elizabethan Age. She also ended the English religious wars of the mid-sixteenth century by firmly establishing Protestantism as the dominant religion of England.

The daughter of Henry VIII (1491–1547), Elizabeth never expected to become monarch. Her mother, Henry's second wife, Anne Boleyn (c. 1507–1536), had been beheaded for adultery and incest after failing to give birth to a male heir, and Elizabeth had been declared retroactively illegitimate after her mother's execution.

Instead, her younger half-brother, Edward VI (1537–1553), became king after Henry's death. When Edward died, another half-sibling, Mary (1516–1558), took the throne. Mary was a Roman Catholic, and she attempted to reverse the Protestant reforms enacted by her father and half-brother and restore Catholicism as the official religion.

During Mary's reign, leading Protestant clerics were executed, and Elizabeth was imprisoned for her Protestant sympathies. Still, Mary named Elizabeth her heir, and the young princess became queen in 1558, at age twenty-five.

One of Elizabeth's first acts was to pass a bill through Parliament that reestablished Protestantism as the official religion. In foreign affairs, one of Elizabeth's most significant accomplishments was defeating the massive Spanish naval fleet that tried to invade England in 1588.

Playwrights and poets of the Elizabethan Age included William Shakespeare (1564–1616), Christopher Marlowe (1564–1593), and Edmund Spenser (c. 1552–1599), whose best-known poem, *The Faerie Queene,* celebrated Elizabeth's rule.

Elizabeth never married, and after her death at age sixty-nine, she was succeeded by a cousin, King James VI (1566–1625) of Scotland—who became James I of England.

ADDITIONAL FACTS

1. *Elizabeth spurned numerous suitors during her reign, including King Philip II of Spain (1527–1598), Mary's widower, and the Duke of Anjou (1554–1584), who was heir to the French throne.*

2. *Many actresses have portrayed Elizabeth on film, including Cate Blanchett (1969–), Judi Dench (1934–), and Bette Davis (1908–1989).*

3. *The famous ocean liner* Queen Elizabeth 2 *was named after Elizabeth I, not her twentieth-century relative, Queen Elizabeth II (1926–). The confusion is due to the fact that the vessel was the second to be named after Elizabeth I—thus the numeral 2 in its name.*

◆◆◆

Thomas Hobbes

English philosopher Thomas Hobbes (1588–1679) dabbled in dozens of fields ranging from geometry to history. But he is best known today for writing the 1651 philosophical treatise *Leviathan,* a book that introduced the notion of the "social contract" and would have an enormous impact on the development of Western political philosophy.

The book, which Hobbes wrote shortly after the traumatic English civil war, argued that individuals voluntarily submit to a strong government in order to prevent anarchy. Without powerful rulers to uphold this social contract, Hobbes wrote, mankind would fall back into the chaos of the original "state of nature." And life in the state of nature, he warned in a famous passage, would be "solitary, poor, nasty, brutish, and short."

Hobbes's support for strong governments—and his generally gloomy view of human nature—was heavily influenced by the strife he witnessed in seventeenth-century England. The son of a disgraced ex-minister, Hobbes graduated from Oxford in 1608 and worked as a tutor for young noblemen, including the future King Charles II (1630–1685), for much of his life. He was an ardent royalist and was forced to flee to Paris at the outbreak of the English civil war, when the monarchy was temporarily overthrown.

Leviathan, published in Paris, outraged the French, and Hobbes was forced to return to England. (He avoided punishment for his royalist views by promising to stay out of politics.) He spent the rest of his life in England and regained influence after the restoration of the monarchy in 1660.

Controversy surrounding his works, however, flared anew in 1666, after the Great Fire of London. Many citizens blamed the fire on God's wrath, which they believed had been incurred by English atheist writers. Because Hobbes believed that the state was a human, rather than divine, construct, he was included on the list of writers targeted for prosecution as heretics.

Hobbes managed to escape punishment and continued to publish—with several translations of Greek classics being among his works—until his death at age ninety-one. Many later political philosophers, especially John Locke (1632–1704) and Jean-Jacques Rousseau (1712–1778), were influenced by his writings.

ADDITIONAL FACTS

1. Leviathan *takes its name from a mythical sea monster in the Bible. Hobbes used the beast as a metaphor for the state, which he believed was a powerful giant composed of numerous individuals.*

2. *Hobbes's forays into geometry were less successful than his philosophical career. In 1660, he announced that he had solved an ancient math problem, the duplication of the cube—but his solution was swiftly debunked.*

3. *His last words were reportedly "A great leap in the dark."*

Tycho Brahe

A superstitious, impulsive aristocrat who was one of the wealthiest men in his native Denmark, Tycho Brahe (1546–1601) was an unlikely scientist. But over the course of several decades at his observatory, Brahe compiled the most accurate measurements of the stars and planets ever attempted, and he is considered one of the founders of modern astronomy.

Brahe was born in Scania, a Danish province that is now part of Sweden. At age twelve, Brahe entered the University of Copenhagen, where he studied law and astronomy.

One of the most famous incidents in Brahe's life occurred in Germany in 1566, when he lost part of his nose in a drunken duel with a classmate. For the rest of his life, the astronomer was forced to wear a prosthetic nose made of gold and silver to hide the injury.

After returning to Denmark in 1570, Brahe enraged his family by marrying a peasant commoner, Kirsten Jørgensdatter. He also began lecturing in astronomy at his alma mater and built Europe's first astronomical observatory on the island of Ven, which was given to him by his chief patron, King Frederick II (1534–1588).

Brahe's most significant contributions to astronomy were the detailed measurements of stars and planets that he compiled over the next several decades. On the basis of his observations, Brahe correctly theorized that planets revolve around the sun in elliptical orbits, rather than circles.

After the king's death, however, Brahe bickered with the new monarch, Christian IV (1577–1648), who accused Brahe of having an affair with the king's mother. The king evicted Brahe from his island and forced him to leave Denmark altogether. Brahe moved to Prague, taking many of his assistants with him.

Brahe hoped to build a new observatory in Prague, but he died abruptly at age fifty-four before his plans came to fruition. But one of his assistants, Johannes Kepler (1571–1630), would soon use Brahe's data to formulate his laws of planetary motion.

ADDITIONAL FACTS

1. *Brahe's uncle, Jørgen Brahe, died of pneumonia in 1565 after rescuing King Frederick II from drowning in a river.*

2. *Brahe's court at Ven included scholars, craftsmen, a pet elk, and a dwarf named Jeppe. Believing the dwarf had the ability to see the future, Brahe consulted him on the best ways to control his unruly peasants.*

3. *Brahe was reportedly highly superstitious and was particularly afraid of rabbits and old women. According to a 1990 biography, he would return home if he saw either on the street.*

◆◆◆

Ivan the Terrible

Czar Ivan IV (1530–1584) killed tens of thousands of Russians, started three wars against neighboring countries, and even killed his own son with a scepter. Nicknamed Ivan Grozny—Ivan the Terrible—he has gone into history as one of Russia's cruelest rulers.

However, Ivan's brutal reign was also marked by significant political and foreign policy accomplishments. He centralized the power of the Russian state, weakened the traditional boyar aristocracy, and expanded the country's borders. Some, including dictator Joseph Stalin (1879–1953), have viewed him as a Russian national hero.

Ivan, the son of Grand Prince Vasily III (1479–1533), inherited the crown at age three. His family, the Rurik dynasty, had governed Russia since the ninth century. As a child monarch, however, Ivan struggled to win the support of various boyar factions, leaving him with a lifelong hatred of the Russian nobility.

Ivan married for the first time in 1547. He would eventually have seven wives and eight children, including Ivan Ivanovich (1554–1581), whom he murdered, and Fyodor Ivanovich (1557–1598), who succeeded him as czar.

During the early years of Ivan's reign, the czar's major priorities were to fight the nobles at home and the Tatars abroad. Ivan won a major victory against the Tatars in 1556, but was less successful in his wars against Poland and Sweden between 1558 and 1583. The czar was also a notable writer and propagandist for his wars, and his pamphlets are considered Russian literary landmarks.

After the death of Ivan's first queen in 1560, the czar became increasingly mentally unbalanced. Convinced that he was surrounded by enemies, he slaughtered thousands of nobles and seized their lands. In 1570, he unleashed the Massacre of Novgorod, in which up to 60,000 people may have been murdered.

The murder of the crown prince occurred November 16, 1581. That day, Ivan assaulted his pregnant daughter-in-law for wearing light clothing, which he considered indecent. When the prince heard his wife's screams and rushed to her defense, Ivan became infuriated and struck the prince with his staff. The prince lost consciousness and died four days later. Three years later, Ivan himself died while playing chess. He was fifty-three.

ADDITIONAL FACTS

1. *Ivan was the first Russian ruler to use the title* czar, *which is derived from the word* Caesar.

2. Ivan the Terrible *was a two-part movie filmed by the Soviet director Sergei Eisenstein (1898–1948). The second installment, which portrayed Ivan in an unflattering light, was banned by Joseph Stalin and not released until after the dictator's death. It featured a score by the classical musician Sergei Prokofiev (1891–1953).*

3. *Ivan ordered the construction of the famed Saint Basil's Cathedral on Red Square. According to legend, he then had the architect blinded so he could never design another that would surpass the famous onion-domed monument.*

John Milton

John Milton (1608–1674) narrowly escaped execution for his role in the English civil war. For the sake of world literature, it is fortunate that Milton was spared: He went on to write *Paradise Lost,* which is considered one of the most influential texts in the English language.

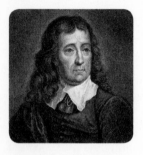

Indeed, one critic, surveying the history of British literature in the *New York Review of Books* in 2009, declared *Paradise Lost* "the finest narrative poem in English"—a judgment supported by the generations of writers who have turned to the poem for inspiration.

The epic poem, divided into twelve books, is a retelling of the biblical story of Adam and Eve, Satan's efforts to tempt them to sin, and their eventual expulsion from the Garden of Eden. Like William Shakespeare (1564–1616), Milton wrote the poem in blank verse, a form of poetry that follows a meter but does not rhyme.

Born in London, where his father was a successful scrivener and moneylender, Milton was educated at Cambridge and wrote one of his most famous early poems, "Lycidas" (1638), in memory of a university classmate who was lost at sea.

The political activities that nearly cost Milton his life began in the 1640s. He published several controversial pamphlets in favor of divorce—inspired, perhaps, by his unhappy first marriage—and a famous defense of free speech, *Areopagitica,* in 1644. He sided with the parliamentary faction in the English civil war and wrote a pamphlet defending the execution of King Charles I (1600–1649) in 1649. Milton later served in the republican government of Oliver Cromwell (1599–1658).

After the restoration of the monarchy in 1660, many of the figures associated with the execution of Charles I were themselves beheaded. Milton was arrested and spent time in prison, but was released after a member of Parliament intervened on his behalf.

Now a political outcast—and nearly blind—Milton spent the rest of his life writing *Paradise Lost* (1667); its sequel, *Paradise Regained* (1671); and another epic, *Samson Agonistes* (1671). He died in London at age sixty-five.

ADDITIONAL FACTS

1. *"Lycidas" has been a favorite of and inspiration to generations of poets. American Beat poet Allen Ginsberg (1926–1997) reportedly knew the 193-line poem by heart.*

2. Paradise Lost *is almost 11,000 lines long.*

3. *When he was touring Italy in 1638, Milton met with the Italian astronomer Galileo Galilei (1564–1642), who was under house arrest for heresy. The encounter influenced both* Paradise Lost *and Milton's 1644 pamphlet in favor of free speech,* Areopagitica.

✦✦✦

Samuel Adams

In 1743, a twenty-year-old student mounted the podium at Harvard's graduation to give the college's commencement speech. With the British governor of the Massachusetts colony in attendance, the young man delivered an oration—entirely in Latin—that would prove prescient: Citizens, he declared, had the natural right to resist governments that failed to protect their welfare.

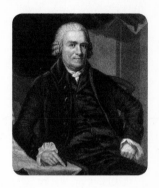

The student was Samuel Adams (1722–1803), the son of a Boston brewer. Twenty years later, Adams would reemerge as the leading opponent of British rule, organizing the widespread discontent in Boston into a resistance movement that eventually sparked the American Revolution.

Until he found his calling as a troublemaker, however, Adams was generally considered a failure. Unable to manage money, Adams inherited his father's brewery but ran the business into the ground. He started a newspaper that was financially unsuccessful. He was elected Boston's tax collector, but was too softhearted to collect taxes.

The passage of the Stamp Act in 1765, a tax on paper and other goods, engendered widespread opposition in Boston and reawakened the rebellious spirit Adams had expressed in his graduation speech. In newspapers and at civic meetings, he inveighed against British taxes and urged resistance in the form of boycotts. He later helped organize an underground resistance group, the Sons of Liberty, which carried out the Boston Tea Party in 1773 to protest a tax on tea.

In 1775, tensions erupted into rebellion when the British attempted to arrest Adams and a fellow agitator, John Hancock (1737–1793). The next year, Adams and Hancock both signed the Declaration of Independence.

After the war, Adams played a less prominent role in politics. He served one term as governor of Massachusetts and lived to see the election of his younger cousin, John Adams (1735–1826), as the nation's second president. Samuel Adams died at age eighty-one in Boston.

ADDITIONAL FACTS

1. *The Samuel Adams brand of beer was founded in 1985. Despite the prominent picture of Adams on the label, the company has no relation to the Revolutionary War figure.*

2. *At the Continental Congress in 1775, the Adams cousins proposed the nomination of George Washington (1732–1799) as commander in chief of the Continental Army—passing over Hancock, who wanted the job despite his lack of military experience.*

3. *Adams's son, Samuel Adams Jr. (1751–1788), served as a doctor in Washington's army. He became ill during the war, never recovered enough to practice medicine again, and died of tuberculosis.*

✦✦✦

Ignatius Loyola

A crippled Spanish soldier named Ignatius Loyola (1491–1556) founded the Society of Jesus—better known as the Jesuits—in 1534 and built his organization into a powerful religious and political force across Europe. Under his leadership, the Jesuits played a major role in the revival of Catholicism during the Counter-Reformation.

Born at a castle in northern Spain, Loyola was the youngest of thirteen children in a prosperous and well-connected family. He joined the army in 1517 during a war with France and was seriously injured in 1521, after a French cannonball passed between his legs, breaking one leg and disfiguring the other.

Loyola spent his long, painful recovery praying and reading religious books. Afterward, he roamed across Spain visiting various holy sites, fasted, spent several months praying in a cave, made a pilgrimage to Jerusalem, and at one point considered suicide. He eventually ended up in France, where he enrolled as a theology student at the University of Paris in 1528.

When Loyola arrived in France, Protestant ideas were spreading rapidly throughout northern Europe. Martin Luther (1483–1546) had nailed his 95 Theses to a cathedral door in Germany in 1517, and a theologian in Paris, John Calvin (1509–1564), was about to unleash his own version of Protestant reform in 1536.

Loyola, however, remained loyal to the Vatican. Along with six comrades, he founded the Jesuits in 1534 for the specific purpose of serving the pope. Pope Paul III (1468–1549) recognized the order in 1539, and Loyola was appointed the group's first leader. The group grew rapidly, attracting Catholics intent upon rejuvenating the church and reversing the Protestant tide. In France, Germany, Poland, and other nations in Europe, Loyola's men sought to reconnect wavering Catholics with the church, and they were largely successful at thwarting the spread of Protestantism.

By the time he died in Rome, Loyola's followers had already founded dozens of colleges and had sent missionaries to Asia, Europe, and South America. He was beatified in 1609 and canonized in 1622.

ADDITIONAL FACTS

1. *One of Loyola's most intrepid followers was Francis Xavier (1506–1552), who was sent to Goa, India, on a missionary trip in 1542. Xavier—later sainted as the most successful Christian missionary since ancient times—also traveled to Mozambique, Indonesia, Japan, and China.*

2. *Loyola's book,* The Spiritual Exercises, *which was written during the long recovery from his war wound, is still used by many Catholics as a thirty-day plan for strengthening their faith.*

3. *In many Protestant countries, Jesuits were regarded as the pope's personal spy network and were widely feared. Many Jesuits were executed in England following the Gunpowder Plot in 1605, when they were suspected of aiding the plan to bomb Parliament.*

✦✦✦

Akbar the Great

Akbar the Great (1542–1605) led the Mughal Empire in India at the peak of its political, military, and cultural might. He has been compared to the Roman emperor Augustus (63 BC–AD 14) for the length of his reign, the size of his empire, and his role in establishing a long-lasting system of government.

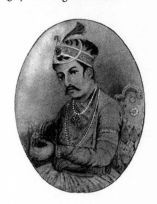

Akbar was also a keen believer in religious tolerance and left as another part of his legacy improved relations between Muslims, Hindus, and Christians in India. His wives even included members of different religions—perhaps the most tangible sign of his commitment to tolerance and diversity within his empire.

Akbar was born at a fort in modern-day Pakistan. His grandfather was Babur (1483–1530), the founder of the Mughal Empire, a Muslim dynasty that would control portions of the Indian subcontinent until the mid-nineteenth century. Akbar's father died when the child was only fourteen, elevating him to the throne in 1556.

Consolidating and expanding Mughal rule and cooling religious tensions within the empire were the dominant themes of Akbar's reign. He conquered parts of present-day Afghanistan, Pakistan, India, and Bangladesh. To keep the peace among his conquests, he is thought to have protected some Hindu temples and repealed a special tax that had been assessed on non-Muslims. He also allowed Christian missionaries to enter his court.

Akbar also greatly supported the arts. Under his sponsorship, Indian artists produced thousands of paintings, published collections of literature, and constructed many of the architectural landmarks in Agra, the Mughal capital.

During the last years of Akbar's life, a controversy erupted over who would be his successor. Two of his three sons had died as infants; the other, Prince Salim Jahangir (1569–1627), had tried to overthrow his father in 1599. With no other credible successor available, Akbar was forced to name his rebellious son as his heir. Jahangir followed his father as emperor in 1605.

ADDITIONAL FACTS

1. *Emperor Shah Jahan (1592–1666)—Akbar's grandson—was the builder of the Taj Mahal, a palace in northern India that he constructed as a monument to his favorite wife.*

2. *Akbar moved his capital city several times, from Agra to Lahore and then back to Agra. That city contains Akbar's tomb, now a tourist attraction.*

3. *The Mughal Empire continued to control large parts of modern-day India until the eighteenth century, when India was taken over by the British.*

Blaise Pascal

It's impossible to know with certainty whether God exists. Therefore, one might as well play it safe by believing in him, since in the event that God does exist, it's better to be on his good side than to suffer eternal damnation.

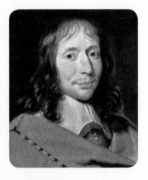

That logic, in a nutshell, forms the famous philosophical argument known as Pascal's wager, named for the French scientist and mathematician Blaise Pascal (1623–1662). Published as part of a philosophical treatise released after Pascal's death, the wager remains one of the most pragmatic—or, to critics, disingenuous—arguments in favor of religious belief.

Indeed, Pascal has a role in the history of philosophy as one of the last mainstream Western philosophers to offer a full-throated defense of traditional Christian religious belief, even as Enlightenment-era contemporaries such as Baruch Spinoza (1632–1677) increasingly abandoned the Judeo-Christian concept of God in their philosophies.

Pascal was born in Montferrand, France, and educated at home by his mathematician father. A sickly child, he suffered from health problems his whole life and was unable to eat solid food after age twenty-four.

In his short lifetime, however, Pascal made enormous contributions to science. At age nineteen, he invented a device known as Pascal's calculator, or the Pascaline, that added and subtracted numbers. He was also a pioneer in hydrodynamics and helped prove the existence of vacuums in a famous 1648 experiment. In math, he helped invent the study of probability.

Pascal abruptly abandoned science and math, however, after having a dream in 1654 that he interpreted as a religious awakening. He became convinced that his scientific pursuits had been a waste of time, and he broke off contact with many of his friends. Pascal spent most of the remainder of his life writing a defense of the Roman Catholic faith that was published after his death as *Pensées*. He died in Paris at age thirty-nine.

ADDITIONAL FACTS

1. *Pascal's calculator, which he originally invented to help his father, who was a tax collector, used an elaborate system of mechanical gears to add and subtract numbers. The device was so time-consuming—and expensive—to produce that only about fifty were made in his lifetime.*

2. *A computer programming language—Pascal—was named after the mathematician in 1970. In physics, a pascal is a unit of pressure—also named in his honor.*

3. *When he was only sixteen years old, Pascal wrote a paper on conic sections that was sent to the famous French philosopher and mathematician René Descartes (1596–1650).*

✦✦✦

Johannes Kepler

During the lifetime of astronomer Johannes Kepler (1571–1630), his native Germany was torn apart by continual religious violence, social turmoil, and political chaos. Kepler himself survived palace coups, peasant uprisings, and even witchcraft scares, some targeting his own family.

It was against this challenging backdrop that he created the modern scientific understanding of how planets move through the heavens.

Kepler was born into a modest family in the southwestern German province of Swabia. His father was "an immoral, rough and quarrelsome soldier" who abandoned his mother; Kepler was raised by his grandparents during part of his childhood. Originally intending to become a Protestant minister, he entered a seminary at age thirteen and obtained a theology degree in 1591.

He settled in the city of Graz, where he became a math professor in 1594 and married three years later. However, he was forced to leave the university in 1600 after he refused to convert to Roman Catholicism. In that year, he fled to Prague, where he was introduced to the Danish astronomer Tycho Brahe (1546–1601). Brahe, who had also recently sought refuge in Prague, hired the young mathematician to assist him, positioning Kepler to become imperial mathematician after Brahe's death.

Relying in part on Brahe's detailed observations, Kepler outlined three physical laws governing celestial motion. He published the first two laws in the 1609 treatise *Astronomia Nova;* the third law was published in 1619. Unlike Brahe, Kepler was a firm believer in the Copernican system, publishing one of the first defenses of the heliocentric model.

The chaos of the Thirty Years' War—the name given to the intermittent religious conflict that raged in central Europe between 1618 and 1648—eventually made it impossible for Kepler to do his work. He spent the last two years of his life traveling between German cities, trying to avoid the violence. After his death, the churchyard where he was buried was ransacked and vandalized by invading armies—composing a sad postscript to Kepler's tumultuous life.

ADDITIONAL FACTS

1. *NASA launched a satellite named in Kepler's honor in March 2009. The satellite is equipped with special instruments designed to search the galaxy for Earth-size planets in remote solar systems, part of an effort to identify other planets that could support life.*

2. *Kepler was forced to go to Württemberg several times between 1615 and 1620 to defend his mother, Katharina, against charges of witchcraft. She was accused of paralyzing a twelve-year-old girl with a "witch grip," imprisoned, and threatened with torture, but ultimately spared after Kepler pulled strings with the Duke of Württemberg. She was lucky to escape execution: Tens of thousands of European women, including Kepler's great-aunt, were burned amidst a witch hysteria that swept central Europe in the early seventeenth century.*

3. *In addition to his astronomy, Kepler was the first to date the birth of Jesus Christ to 4 BC, which is now the generally accepted year.*

◆◆◆

Guy Fawkes

The man behind a failed plot to blow up the English Parliament in 1605, Guy Fawkes (1570–1606) is one of the most notorious figures in the nation's history. Had his plan succeeded, it would have killed the king, his ministers, and most of the English government. November 5, the anniversary of his arrest in a London basement, is still celebrated annually in Britain as Guy Fawkes Day.

Fawkes, a Roman Catholic, planned the attack with other English dissidents to protest increasingly strict anti-Catholic laws. The discovery of the plot, however, only served to worsen the plight of English Catholics, who were subjected to a series of punitive, discriminatory laws. The holiday itself was initially an overtly anti-Catholic celebration, with the festivities often including burning the pope in effigy.

Born in York, Fawkes converted to Catholicism at age sixteen and traveled to continental Europe in 1593 to fight in religious wars in France and the Netherlands. During his time in the Netherlands, he connected with a network of exiled English Catholics who would form the center of the Gunpowder Plot.

During the reign of Queen Elizabeth I (1533–1603), Catholics faced constant harassment and were required to attend Anglican services. Many Catholics hoped for improved conditions under her successor, King James I (1566–1625), and were enraged when he continued Elizabeth's religious policies. The plot was hatched by Robert Catesby (1573–1605), who recruited Fawkes to lead the conspiracy in 1604.

The plotters rented a house next door to the building where Parliament met and began clandestinely moving barrels of gunpowder into the basement. They planned to strike during the ceremonial opening of Parliament, which virtually the entire government establishment would attend.

The plot was discovered, however, after one of the conspirators attempted to warn a Catholic peer, Lord Monteagle (1575–1622), against attending the ceremony. He tipped off the government, and the authorities arrested Fawkes the next week. Along with the other conspirators, he was executed, after a one-day trial.

ADDITIONAL FACTS

1. *After Fawkes was arrested, the barrels of gunpowder were tested and found to be decayed; even if he had lit the fuse, the explosives probably would not have gone off.*

2. *In the aftermath of the Gunpowder Plot, Parliament passed a wave of discriminatory legislation that barred British Catholics from practicing law, serving as military officers, or voting. The right to vote was not restored to Catholics until 1829.*

3. *The Parliament building burned down in 1834 after fire spread from a stove. The current Palace of Westminster, home to both houses of Parliament, was constructed in the 1840s and 1850s.*

❖❖❖

Rembrandt

Usually referred to simply by his first name, Rembrandt Harmenszoon van Rijn (1606–1669) was born in the Dutch city of Leiden and received an extensive Latin education. He began painting as a teenager and found a patron in Constantijn Huygens (1596–1687), a Dutch poet and diplomat who supported the artist beginning in 1629. With his career prospering, Rembrandt moved to Amsterdam, opened a studio, and married Saskia van Uylenburgh (1612–1642) in 1634.

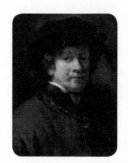

Rembrandt's early paintings, many of them on Old Testament religious themes, were notable for his use of intense lighting, exotic details, and vivid action. *The Blinding of Samson* (1636), one of his best-known early canvases, shows a shaft of light pouring into a dark tent just at the moment when the Philistine soldiers thrust a hot poker into the biblical character's eyes.

By 1640, Rembrandt was the most popular artist in Amsterdam, sought after by merchants, soldiers, and Dutch royals. He suffered a string of personal and financial setbacks in that decade, however, beginning with the death of Saskia in 1642. The Dutch economy collapsed, bankrupting many of his customers. His paintings fell out of fashion, and Rembrandt—a poor manager of his money—accumulated a massive debt that nearly drove him into bankruptcy. In 1656, a Dutch court seized his paintings and auctioned them off to pay his creditors.

After 1650, Rembrandt's paintings became more restrained, and he focused more on capturing the emotional depth of his subjects. His poignant 1665 work, *The Return of the Prodigal Son,* lacks the bright lighting and precise detail of his earlier work and instead seeks to capture the touching, somber moment when father and son reunite after a long absence.

Rembrandt never fully recovered from his financial problems. He died in Amsterdam at age sixty-three.

ADDITIONAL FACTS

1. *Deeply in debt, Rembrandt disinterred his wife's body in 1662 so that he could resell the grave site.*

2. *In 1975, two thieves stole a Rembrandt work,* Portrait of a Girl Wearing a Gold-Trimmed Cloak, *from a museum in Boston. At the time, it was the biggest art theft in American history. The painting was recovered a year later.*

3. *After his wife's death, Rembrandt had affairs with several of his servants. One of them, Geertge Dircx, who was also a model for some of his paintings, had a child and sued the painter for palimony, but lost the case and was thrown in jail for her supposedly false accusation.*

◆◆◆

Mercy Otis Warren

I cannot wish to see the sword put up quietly in the scabbard, until justice is done to America.
—Mercy Otis Warren

She did not fight on the battlefield or sign the Declaration of Independence. Still, Mercy Otis Warren (1728–1814), a Massachusetts housewife, has been called the "conscience of the American Revolution" and a Founding Mother for her proindependence essays, poems, and plays, which she published anonymously in colonial newspapers to support the patriot cause.

Her passion for the revolution was so great that John Adams (1735–1826), the second president and a family friend, suggested that she write a history of the conflict. Her three-volume *History of the Rise, Progress, and Termination of the American Revolution*, completed in 1805, was one of the first published chronicles of the war.

But Warren, a mother of five, also witnessed the personal toll that the war took on her own family. Her husband was an officer in the Continental forces and fought at the Battle of Bunker Hill, and her oldest son lost a leg while serving in the Continental Navy.

Warren was born on Cape Cod at a time when the educational opportunities available to women were extremely limited. She learned to read at home and married James Warren (1726–1808), a Plymouth, Massachusetts, lawyer and distant cousin, in 1754. They had five children between 1757 and 1766.

Like many other Massachusetts residents, both of the Warrens became ardent critics of the British in the 1760s as a result of a series of taxes imposed on the colonies. The Sons of Liberty and the Committees of Correspondence, two underground patriot groups, met in the parlor of the couple's Plymouth home in the 1770s. Her plays, thinly veiled satires of the British, were circulated in New York and Philadelphia and, according to Adams, helped inspire support for the cause.

After the war, Warren published poetry under her own name and began working on the history Adams had urged her to write. When it was finally released, however, the book portrayed her old friend in an unflattering light, causing him to cut off all contact with her. After reconciling with Adams in 1812, Warren died in Plymouth two years later, at age eighty-six.

ADDITIONAL FACTS

1. *Warren wrote five plays—an especially impressive achievement because theaters were banned in Massachusetts under Puritan-era blue laws. The plays were written not to be performed, but simply to be read.*

2. *Both Warren and her husband were descendants of passengers on the* Mayflower.

3. *Warren's younger brother was James Otis (1725–1783), the Massachusetts patriot who coined the famous slogan "Taxation without representation is tyranny."*

◆ ◆ ◆

Pope Paul III

By 1545, the Roman Catholic Church was reeling from the forces unleashed by the Protestant Reformation. One by one, countries across northern Europe— Denmark, Sweden, England, large parts of Germany—had turned their backs on Catholicism.

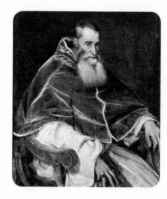

The man charged with halting the church's downturn was Pope Paul III (1468–1549), an Italian cardinal who was elected pope in 1534 and began the long process of Catholic renewal known as the Counter-Reformation. Beginning with the Council of Trent in 1545, the church moved to reform itself internally while defending its core beliefs.

Paul was born Alessandro Farnese into a wealthy Roman family that included bishops, military leaders, and at least one other pope, Boniface VIII (c. 1235–1303). Farnese was educated in Florence in the palace of Lorenzo the Magnificent (1449–1492). In 1493, when Farnese was only twenty-five, he became a cardinal.

In his youth, the future Paul III embodied many of the abuses that the Protestant reformers decried. His position in the church was a benefice that guaranteed him an enormous income derived from church property, and he spent it on art and palaces.

After he was elected pope, however, Paul recognized more clearly than many other Catholic leaders that without changing its ways, the church was doomed. Over the objection of many cardinals, he convened the Council of Trent to clean up corruption in the church. The council met intermittently for years and did not conclude until after Paul's death, but it did ban the most unpopular abuses.

In addition to the reforms, however, Paul III also moved to quash dissent and reassert his power over church doctrine. One of his most notorious creations was the Holy Office, also known as the Roman Inquisition, which was given the responsibility in 1542 of identifying and punishing heretics and defending Catholic doctrine.

ADDITIONAL FACTS

1. *Despite his vows of chastity, Paul had an illegitimate son, Pier Luigi Farnese (1503–1547), who was made duke of Parma in 1545 and assassinated in 1547. Pier had a son, Ranuccio (1530–1565)—Paul's grandson—whom Paul made a cardinal when the boy was only fifteen years old.*

2. *A famous 1537 edict issued by Paul III,* Sublimus Dei, *prohibited the enslavement of Native Americans in the New World. The order, which was prompted by concerns of Spanish mistreatment of the Indians, was widely ignored by Spain and Portugal.*

3. *After his death, Paul was buried in a tomb in Rome designed by the artist and architect Michelangelo (1475–1564), whom Paul had hired to paint* The Last Judgment.

✦✦✦

Wahunsenacawh

Wahunsenacawh (c. 1550–1618) was the Native American king who first met the English settlers at Jamestown in 1607. He was also the father of Pocahontas (c. 1595–1617), the legendary teenage princess who supposedly saved the life of John Smith (c. 1580–1631), the leader of the colonists.

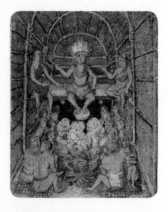

Also known as Powhatan, Wahunsenacawh was the chief of a powerful confederation of Algonquin tribes in coastal Virginia. He was born in roughly 1550 and established his capital at Werowocomoco, a Native American village near where the English landed on May 14, 1607.

Later that year, an Algonquin hunting party captured Smith and brought him before Wahunsenacawh. According to Smith's account of the meeting, he was threatened with execution, but was saved after Pocahontas took pity on the prisoner and asked her father to spare him.

Wahunsenacawh later agreed to sell food to the colonists during their first difficult year in Jamestown, and he even hoped to build a cooperative relationship with the settlers. However, between 1610 and 1614, the two sides fought a war that resulted in the destruction of several Native American villages and the capture of Pocahontas. The chief was forced to allow his daughter to marry an English planter, John Rolfe (c. 1585–1622), in the peace settlement.

The settlement led to a brief period of peaceful relations. Pocahontas and her husband traveled to England in 1616, where she was received as a royal and met King James I (1566–1625). After Wahunsenacawh's death in 1618, however, his brother Opechancanough took over the confederacy and renewed the war against the English in 1622.

ADDITIONAL FACTS

1. *In 1977, archaeologists located the site of Werowocomoco—on the York River, only about twelve miles from Jamestown.*

2. *The chief was played by August Schellenberg (1936–) in the 2005 movie* The New World. *Native American activist Russell Means (1939–) provided Wahunsenacawh's voice in the 1995 Disney animated movie* Pocahontas.

3. *The Algonquin language spoken by Wahunsenacawh and his tribe began to die out in the late eighteenth century—but not before lending many words to English.* Raccoon, terrapin, moccasin, *and* tomahawk *are all derived from Virginia Algonquin.*

✦✦✦

Baruch Spinoza

On July 27, 1656, the small Jewish community in the Dutch city of Amsterdam issued a decree expelling a heretic from its midst. The accused, a twenty-four-year-old man named Baruch Spinoza (1632–1677), was condemned for unspecified "monstrous deeds" and soon forced to leave the city of his birth.

Spinoza, whose work also earned the enmity of Holland's Christian majority, was widely denounced as an atheist and became one of the most hated men of his generation. Yet his philosophy and ethics were rooted in his belief that love of God was the highest human good.

Born into a family of Sephardic Jews who had fled to Amsterdam to escape the Portuguese Inquisition, Spinoza received a standard Jewish education at the city's Talmud Torah school. The exact reason for his expulsion from the community is unknown, but the rabbis were sufficiently enraged that the edict not only expelled Spinoza, but also barred other Jews from having any contact whatsoever with the young dissenter.

Forced to leave the city, Spinoza settled near The Hague, where he worked as a lens grinder while laboring over the manuscript of his most influential work, *Ethics*. The book was published posthumously, after he died at age forty-four of a lung infection caused by inhaling toxic glass dust.

A compilation of his views on religion and philosophy, *Ethics* provides ample explanation for why the Jewish community condemned Spinoza. In the book, he rejected the traditional Judeo-Christian concept of God as the world's creator who ruled by divine intervention in the affairs of mankind.

Instead, Spinoza redefined *God* to mean the impersonal forces of nature and logic. The universe, he wrote, was ruled by logic, not by the providential acts of God. People had no free will, he believed, since logic determined everything. The only way to be happy was to seek understanding of God and recognize one's inability to change the course of fate.

Although shunned in his lifetime—and for a century afterward—Spinoza's beliefs would form the basis of the Enlightenment.

ADDITIONAL FACTS

1. *Before his banishment, the Jewish community offered Spinoza 1,000 florins a year—an enormous sum—to conceal his heretical views. He refused the offer. Spinoza also survived an assassination attempt before he was finally booted from the city.*

2. *The terms of his exile made it illegal for Dutch Jews to do business with Spinoza, read his books, or even come into physical proximity with him.*

3. *Spinoza was also known as Benedict, the Latin version of Baruch (both mean "blessed"). He was also called Bento, the Portuguese version of the name.*

❖❖❖

William Harvey

William Harvey (1578–1657) was the first doctor in the Western world to offer a complete description of the body's circulatory system. His discoveries—and the animal experiments he used to prove them—would change forever both the medical profession and the way biologists conduct research.

Harvey was born in Folkestone, Kent, the oldest of nine children. His father owned a carting business and was the town's mayor, and the family was prosperous enough to send him to Cambridge, which he entered in 1593. He graduated at age twenty and then studied medicine at the University of Padua in Italy.

After returning to England, he married Elizabeth Browne in 1604. Browne's father, Lancelot, had been the personal doctor to Queen Elizabeth I (1533–1603) and King James I (1566–1625), a family connection that proved beneficial for Harvey. He was eventually named court doctor himself, serving as physician to James I and Charles I (1600–1649).

With the king's support, Harvey embarked on a series of experiments in the 1620s, dissecting deer and other animals in an effort to gain a better understanding of the body. At the time, most of the prevailing medical theories were still based on the writings of Galen (129–c. 216). But like Ibn al-Nafis (1213–1288), the Arab doctor who had discovered pulmonary circulation several centuries earlier, Harvey eventually concluded that Galen's theories were implausible. The result was *Exercitatio Anatomica de Motu Cordis et Sanguinis in Animalibus* (*Anatomical Exercise on the Motion of the Heart and Blood in Animals*), which Harvey published in 1628.

Although the defeat of the royalist faction in the English civil war cost Harvey his job, he continued his medical experiments, turning to the "dark business" of conception. His *Essays on the Generation of Animals* (1651) was the first to hypothesize that animals came into existence as the result of the meeting of sperm and egg—hundreds of years before the theory could be proven with a microscope.

After the downfall of the royalist side in 1651, Harvey attempted suicide with poison, but survived. He died of a stroke six years later, at age seventy-nine.

ADDITIONAL FACTS

1. *Harvey's hometown of Folkestone later became famous as the site of the western portal of the channel tunnel linking England and France.*

2. *As the king's personal physician, Harvey treated the wounded at the Battle of Edgehill in 1642, the first major battle of the English civil war.*

3. *The Harvey family had a coat of arms emblazoned with the motto "The greater the effort, the greater the reward."*

◆◆◆

Walter Raleigh

Sir Walter Raleigh (c. 1554–1618) was an English poet, explorer, and soldier who ended his career in disgrace and was executed for treason. For his unauthorized attacks on the Spanish, he was beheaded on the order of King James I (1566–1625). Raleigh's most nefarious legacy, however, may be the exotic new habit from the Americas that he popularized in England: smoking.

Raleigh was born in western England into a zealously Protestant family. He fought in religious wars in Ireland and France and developed an intense hatred for Roman Catholics and for the Spanish. Queen Elizabeth I (1533–1603) rewarded him for his service with a huge estate, trade monopolies, a tin mine, and, in 1585, a knighthood.

Beginning in 1584, Raleigh launched the first major effort to establish English colonies in the New World. An expedition he sponsored established a colony in present-day Roanoke, North Carolina, in 1587, but it vanished within a few years. Raleigh also named the planned colony of Virginia after the unmarried queen. It was through his colonial enterprises that Raleigh discovered tobacco and became its primary English importer.

Raleigh envisioned English colonization of the Americas as a way of counterbalancing Spanish power, which had reached its height in the late sixteenth century. Catholic Spain and Protestant England fought intermittently throughout Elizabeth's rule, culminating in the defeat of the Spanish armada in 1588.

By the time of the queen's death, Raleigh was already losing popularity due to his extravagant spending and scandalous marriage to Elizabeth Throckmorton (c. 1565–c. 1647), one of the queen's ladies-in-waiting. Elizabeth's successor, James, favored more conciliatory policies toward Spain and had Raleigh arrested in 1603 for treason. He was condemned to death, but James commuted the sentence and sent him to the Tower of London instead. While in prison, Raleigh wrote *The History of the World*.

Raleigh was released in 1616 and asked to lead another expedition. During his trip, Raleigh attacked a Spanish outpost without permission, and when he returned to London, the Spanish ambassador demanded that the king reinstate his death sentence. To placate the Spanish, Raleigh was executed on October 29, 1618.

ADDITIONAL FACTS

1. *King James I not only loathed Raleigh, but also hated smoking. In 1604—380 years before the tobacco industry acknowledged a link between cigarettes and lung cancer—the king called smoking "a custom loathsome to the eye, hateful to the nose, harmful to the brain, dangerous to the lungs, and in the black, stinking fume thereof, nearest resembling the horrible Stygian smoke of the pit that is bottomless."*

2. *The capital of North Carolina, Raleigh, is named for the explorer.*

3. *The fate of the Roanoke Island settlement—the Lost Colony—remains one of American history's great unsolved mysteries. The only clue found was the word* Croatoan *carved into a post. Historians theorize that the colonists may have assimilated with local Indian tribes or drowned while attempting to sail back to England.*

✦✦✦

Christopher Wren

A mathematician and astronomer by training, Christopher Wren (1632–1723) achieved fame as the architect who rebuilt London after the devastating fire of 1666. Wren designed dozens of churches and other buildings, including St. Paul's Cathedral, and was almost single-handedly responsible for the city's architectural revival after the catastrophic blaze.

Fittingly, the inscription on Wren's tomb in London reads: "Reader, if you seek a monument—look about you."

Wren attended Oxford and was named to the faculty in 1661 as a professor of astronomy. He also dabbled in architecture, designing a theater at the university, but did not quit his professorship and become a full-time architect until several years after the fire.

The Great Fire of London, which lasted from September 2 to September 5, 1666, was the biggest conflagration in the city's history. Beginning at a bakery, the flames spread quickly through the densely packed, medieval core of the city; by the time the blaze was doused, tens of thousands of buildings—about two-thirds of the city—had been destroyed.

Wren arrived in London a few days later and immediately began drafting a plan to rebuild the city. He was named to the royal commission that oversaw the reconstruction effort, and for the next fifty years he would be England's most influential architect.

A student of European baroque styles, Wren created designs that were considered unconventional and were criticized by many observers for departing too much from traditional English design. Parliament altered his blueprints for St. Paul's several times, and even withheld his pay at one point to encourage him to finish the cathedral more quickly. Still, the building is a major architectural landmark and was the inspiration for the Capitol Building in Washington, DC, and the Panthéon in Paris.

Wren was finally paid for building the cathedral at age seventy-nine. He died eleven years later.

ADDITIONAL FACTS

1. *In 1662, Wren was one of the cofounders of the Royal Society, a group of scientists and scholars that is still in existence. Election to the society is considered one of the greatest honors for British academics.*

2. *Wren also won the commission to design the Royal Observatory in Greenwich in 1675. By international agreement, the observatory is the point designated as the prime meridian, or 0° longitude.*

3. *For his services in the rebuilding effort, Wren was knighted by Charles II (1630–1685) in 1673.*

◆ ◆ ◆

Túpac Amaru II

The leader of an indigenous Peruvian revolt against Spain, Túpac Amaru II (c. 1740–1781) rallied thousands of Indians in a brief, brutal war against the colonial government. After winning several battles in 1780, Amaru was captured the next year and put to death by the Spanish authorities.

His revolt, however, is credited with helping to awaken the South American independence movement. Since his death, Túpac Amaru has also served as an enduring source of pride for Native Americans and a symbol of resistance in Peru.

Túpac Amaru II was born as José Gabriel Condorcanqui, but adopted his nom de guerre in honor of his great-grandfather, Túpac Amaru. The original Túpac Amaru was the last independent king of the Incas, and he had also led a rebellion against Spain that resulted in his execution, in 1572.

Raised in Cuzco, the ancient Incan capital, Túpac Amaru II enjoyed a relatively privileged upbringing. Because of his ancestral ties to the Incas, the Spanish conferred on him the rank of marquis and allowed him an unusual degree of economic freedom. But he identified with native Peruvians, who accounted for the great majority of the country's population but lived in conditions of near slavery.

In 1780, he organized a rebel army—about 80,000 poorly armed Indians—that swiftly took control of highland areas in what are now Peru, Bolivia, and Argentina, executing hundreds of Spanish colonial officials. Six months later, Spanish troops arrived to quell the rebellion, aided by two of Túpac Amaru's officers who had changed sides and helped the Spanish capture the rebel leader.

He was drawn and quartered in Cuzco's square, the same site where his ancestor had been beheaded two centuries earlier. But the desire for independence from Spain endured, and, forty years later, Peru gained its freedom.

ADDITIONAL FACTS

1. *The mother of American rapper Tupac Amaru Shakur (1971–1996) named her son after the Peruvian revolutionary.*

2. *The Tupamaros, a rebel group in Uruguay in the 1960s, 1970s, and 1980s, took their name from Túpac Amaru.*

3. *The word túpac means, roughly, "noble" in Quechua, the language of the Inca Empire. Today, about 10 million people speak Quechua, mostly in the Andean highlands of Peru and Bolivia.*

✦✦✦

John Calvin

Born in Roman Catholic France, theologian John Calvin (1509–1564) achieved fame as a leading thinker of the Protestant Reformation, which dramatically broke away from Catholicism in the 1520s and 1530s. He eventually fled France for Geneva, Switzerland, where he became the leader of the city's Protestant religious community and a powerful political figure. Calvinism, the brand of Protestantism inspired by his teachings, would become one of the most influential religious forces in European and American history.

Calvin was born in the city of Noyon, about sixty miles north of Paris. His father, a staunch Catholic and the administrator of Noyon's cathedral, sent him to study rhetoric, logic, and grammar in Paris when he was fourteen. By 1528, the Protestant Reformation, which had been sparked in Germany by Martin Luther (1483–1546), had begun to spread in secret to France, and several of Calvin's university friends were sympathetic to the reform movement. Because of suspicions aroused by these friendships, Calvin was forced to flee Paris in 1533. Calvin himself, however, would not completely reject Catholicism until 1536.

During his years on the run, Calvin began writing the *Institutes of the Christian Religion*, a book that summarized his reformist religious beliefs. While broadly sympathetic to Luther, Calvin differed in some significant respects. For instance, Calvinists embraced the doctrine of predestination, believing that God had already determined who would go to heaven, while Lutherans believed that the faithful could earn their salvation.

Calvin was invited to Geneva, home to a large but embattled Protestant community, in 1541. Given near-dictatorial powers in the city, he formed a strict religious court called the Consistory, which had the power to mete out punishments for moral offenses such as dancing or domestic violence. Under his watch, the city also tortured dissidents, executed dozens of supposed witches, and burned a famous heretic, Michael Servetus (c. 1509–1553), at the stake.

After being afflicted with gout, which results from too much uric acid in the blood, for the last decade of his life, Calvin died in Geneva at age fifty-four. His teachings were adopted by many religious groups, including the Presbyterians, the Reformed Church of Germany, and the English Puritans.

ADDITIONAL FACTS

1. *John Calvin is an Anglicized version of the priest's name in Latin,* Ioannis Calvinus; *his birth name in France was Jean Cauvin.*

2. *Calvin's first book was a commentary on* De Clementia, *by the Spanish philosopher Seneca (c. 4 BC–AD 65), published in Paris in 1532.*

3. *Calvin is the namesake of the cartoon six-year-old in the comic strip* Calvin and Hobbes, *by Bill Watterson (1958–). The character's stuffed tiger, Hobbes, is named after the English philosopher Thomas Hobbes (1588–1679).*

◆◆◆

Charles II

The Merry Monarch, Charles II (1630–1685) was known for his raucous lifestyle, jovial wit, and pivotal role in British history. He was crowned in 1661, following the restoration of the monarchy, and helped steer his country back to stability after the violence and tumult of the English civil war.

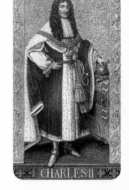

Charles was born in London, the eldest son of King Charles I (1600–1649) and Queen Henrietta Maria (1609–1669). As a teenager, he fought on the royalist side during the civil war and was forced into exile in France after the defeat and execution of his father.

In 1650, he sailed to Scotland, hoping to rally opponents of Oliver Cromwell (1599–1658), the victor in the civil war. The next year, after losing a battle against Cromwell's forces, he famously hid in an oak tree to avoid capture. He made his way back to France, where he lived for most of the next decade.

After Cromwell's death, England suffered through two years of chaos until Parliament, tiring of the political turmoil, invited Charles to return to the throne. His triumphant entrance into London on May 29, 1660—his thirtieth birthday—marked the beginning of the Restoration, a period of relative peace and stability.

Domestically, Charles forgave most of his father's enemies. Charles also took a moderate stance on religious questions, opposing harsh measures against Roman Catholics. Under Charles, the strict Puritan laws passed under Cromwell were relaxed, allowing theaters to reopen and old customs like dancing around the Maypole to reappear.

Charles, though married to a Portuguese princess, was a prolific adulterer who fathered more than a dozen illegitimate children by a variety of women. He had no legitimate heirs; his brother, James II (1633–1701), would inherit the crown after his death. James was a Catholic, and thus unacceptable to many Protestants. He ruled for only three years before he was overthrown in the Glorious Revolution; thereafter, Parliament passed a law (still in force) excluding Catholics from the English throne.

ADDITIONAL FACTS

1. *Numerous settlements in the eastern United States were established during the reign of Charles II and are named in his honor. The list includes Charleston, South Carolina; Charlestown, Rhode Island; and both North and South Carolina.*

2. *The late Diana, Princess of Wales (1961–1997), was a descendant of several of Charles's illegitimate children.*

3. *Royal custom required that the Portuguese give Charles a dowry for marrying Catherine of Braganza (1638–1705). He received the city of Bombay, which would become one of the major outposts of the British Empire in India.*

◆◆◆

Anne Conway

One of the few women able to obtain an advanced education in seventeenth-century England, Anne Conway (1631–1679) became a respected philosopher and intellectual. Her works consist of one book published after her death, *The Principles of the Most Ancient and Modern Philosophy* (1690), and hundreds of letters she wrote to the professor at Cambridge who broke the university's rules to teach her in secret.

Conway was born as Anne Finch to a wealthy London family and raised at Kensington Palace. Her half-brother, John Finch (1626–1682), a student at Cambridge, introduced her to his philosophy professor, Henry More (1614–1687). Impressed by Anne's intellect, More agreed to instruct her in philosophy. Cambridge barred female students, however, so More had to teach her by mail.

For an Englishwoman of the seventeenth century, it was exceptionally rare to be allowed into intellectual society. Anne had several advantages, however, including her family's connections and the wealth and status of her husband, Edward (c. 1623–1683), Viscount Conway, whom she married in 1651 at age nineteen. (Officially, she became Lady Anne Conway after her marriage to the noble.)

The couple had one son, who died of smallpox as a baby. Conway was increasingly ill for the rest of her life, suffering from chronic headaches. Near the end of her life, she developed an interest in kabbalah, a form of Jewish mysticism, and also Quakerism. She converted to Quakerism in 1679, shortly before her death at age forty-seven.

Conway's philosophy, published after her death, contained a criticism of many leading philosophers, including Thomas Hobbes (1588–1679) and René Descartes (1596–1650). It was an influence on later writers, particularly the German philosopher Gottfried Wilhelm Leibniz (1646–1716).

ADDITIONAL FACTS

1. *Conway's father, Sir Heneage Finch (1580–1631), was a former speaker of the House of Commons. He died a month before Anne was born.*

2. *In 1656, Conway traveled to France for an experimental cure for her headaches. Known as trepanation, the miracle treatment involved boring holes in her skull to relieve the pain. It didn't work.*

3. *At one point, Conway was treated by the renowned doctor William Harvey (1578–1657)—better known for discovering the circulatory system.*

✦✦✦

Pierre de Fermat

Pierre de Fermat (1601–1665) was a prominent French lawyer, politician, and mathematician who made significant contributions to the development of modern calculus. But he is perhaps best remembered for his Last Theorem, a seemingly simple math problem that humbled the greatest minds in mathematics until it was finally solved in 1994.

Fermat was born in Beaumont-de-Lomagne, a small town in southern France. He attended the Universities of Bordeaux and Orléans, where he studied mathematics and law. He received his legal degree in 1631 and spent most of the rest of his life working in the local government and pursuing math as a hobby.

Wealthy and erudite, Fermat corresponded with other leading French thinkers, including Blaise Pascal (1623–1662), with whom he collaborated to develop some of the first theories of probability. Some of his mathematical projects, however, may have been abandoned because of the turbulent period in which he lived: Fermat endured the Fronde, a civil war in France, and even became one of the few victims to survive a bout of plague in 1653.

Fermat's Last Theorem is derived from a mysterious note that was written in about 1637 but not discovered until after Fermat's death. In the margins of a book by the Greek mathematician Diophantus (c. 200–c. 284), Fermat had scrawled out the problem and written, "I have a truly marvelous demonstration of this proposition, which this margin is too narrow to contain."

The problem—and Fermat's claim of having solved it—would tease mathematicians for the next 350 years. Fermat's Last Theorem states that the equation $x^n + y^n = z^n$ cannot be true if x, y, and z are nonzero integers and n is an integer greater than two. The theorem looked true—try it—but could not be mathematically proved for all cases.

Not until 1994 did a professor at Princeton University, Andrew Wiles (1953–), who had spent eight years toiling over the equation in his attic, finally prove that Fermat was, indeed, correct.

ADDITIONAL FACTS

1. *Whether Fermat himself had actually proved his Last Theorem remains subject to scholarly debate. Many mathematicians discount the handwritten note in the book margin, claiming it would have been impossible for Fermat to prove the theorem with the tools at his disposal.*

2. *Fermat's Last Theorem is a mainstay of popular culture, especially in science fiction. For instance,* The Simpsons *has parodied the theorem on several occasions, inserting an equation that seemed to disprove the theory in one of the show's Halloween episodes.*

3. *Fermat was born as Pierre Fermat, but changed his name to the more aristocratic-sounding Pierre de Fermat after entering government.*

✦✦✦

Sarah Good

To the Puritan settlers of Massachusetts, there was no greater crime than witch-craft—and no greater witch than Sarah Good (1655–1692). One of the first women accused during the Salem witch trials, Good was convicted of bewitch-ing several young girls and executed in the summer of 1692. At her trial, Good's own husband and five-year-old daughter were forced to testify against her.

Of course, Good was no witch—and neither were the other nineteen women and men killed during the hysteria that swept through Salem that summer. Instead, she was a poor, unpopular woman who had few friends to defend her. Along with the rest of the victims of the Salem witch hunt, she has endured as a powerful symbol of the danger of religious zealotry, intolerance, and mob justice.

Good was the wife of William Good, a colonist who had gone to prison for debt. The couple had one daughter, Dorothy. Like many of the other victims, she was of low social status. Good was unpopular in Salem, and she had the reputation of being rude, unkempt, and dependent on charity.

The trials began in February 1692, when three young girls began accusing neighbors of bewitching them. Good and two other women were the first to be accused. When she went on trial in March, more townspeople chimed in with accusations. One claimed to have seen Good flying on a broomstick. Another accused her of exercis-ing magic powers over cats and birds. Her daughter was also imprisoned—at age five—and eventually forced to give evidence against her mother.

Defiant to the end, Good was said to have proclaimed her innocence as she was being taken to the gallows. Good was thirty-seven when she was executed.

The witch trials originally had the support of the colony's top civil and religious leaders, but they were shut down later that year. Two decades later, the victims were exonerated and their families were invited to apply for compensation. The letter to the court that Good's widower wrote, in shaky handwriting, was a poignant coda to Good's trial and execution: "I leave it unto the Honourable Court to Judge what damage I have sustained by such a destruction of my poor family."

ADDITIONAL FACTS

1. *All the victims of the Salem witch trials were formally declared innocent by Massachusetts in 2001.*

2. *One of the judges who condemned Good and other prisoners was John Hathorne (1641–1717)—the great-great-grandfather of novelist Nathaniel Hawthorne (1804–1864).*

3. *Arthur Miller (1915–2005) used the trials as the basis for his play* The Crucible *(1953). Written at the height of the McCarthy hearings, the play was intended to draw a comparison between the witch hunt and the atmosphere of paranoia in 1950s America. Good is a minor character in the play.*

◆◆◆

Johann Sebastian Bach

A renowned organist and composer, Johann Sebastian Bach (1685–1750) was one of the central figures of the German baroque period. He wrote hundreds of organ and orchestral pieces that have come to be regarded as some of the most influential compositions in the history of Western music.

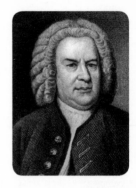

Bach is considered a master of contrapuntal musical technique, in which two different melodic lines are played together. His complex arrangements were not especially popular during his lifetime, but they were a major source of inspiration for Wolfgang Amadeus Mozart (1756–1791), Ludwig van Beethoven (1770–1827), and many other classical composers.

Born into a musical family in Eisenach, Germany, Bach was tutored in organ, violin, and harpsichord from boyhood. After the deaths of his parents when he was nine, Bach was raised primarily by his older brother, Johann Christoph Bach. The elder Bach, who was also an organist, imparted much of his expertise and many of his professional connections to his younger brother.

After marrying in 1707 and fathering the first of twenty children, Bach settled into a position as court organist in the city of Weimar. Many of his best-known fugues date from his Weimar period and were gathered into a compilation called *Das wohltemperierte Clavier* (*The Well-Tempered Klavier*). He also composed "Jesu, Joy of Man's Desiring," often played at weddings, during his Weimar years. The *Brandenburg* Concertos, a series of pieces written in 1721 for a German aristocrat, are widely considered some of his greatest works.

In 1723, Bach was appointed the director of music in Leipzig. He was responsible for providing compositions to the city's Lutheran churches. The appointment was to be Bach's last: He died at age sixty-five in Leipzig after a botched operation to correct his failing eyesight.

ADDITIONAL FACTS

1. *Bach had twenty children with two wives, Maria Barbara Bach (1684–1720) and Anna Magdalena Wilcke (1701–1760). Only ten of the children survived infancy.*

2. *Only one portrait of Bach was thought to have been painted in his lifetime, but its authenticity has long been questioned. In 1894 his bones were exhumed to enable a sculptor to create a bust of the musician. In 2008, a forensic anthropologist used the same bones to create a computer-generated model of Bach, which showed a relatively heavy man with short, white hair.*

3. *Most of Bach's works were written primarily for organ or harpsichord. The piano—originally called a pianoforte—was not invented until the early eighteenth century. Bach was introduced to a piano in the 1730s, did not like the sound of it, and did not learn how to play it.*

✦✦✦

Thomas Paine

In late 1774, the American representative in London, Benjamin Franklin (1706–1790), was introduced to a combative young Englishman named Thomas Paine (1737–1809). Franklin, impressed by Paine's intellect, gave the young man a piece of advice: Come to America.

Later that year, on Franklin's recommendation, Paine sailed for Philadelphia. Within eighteen months, Paine had become one of the most famous writers on the continent and the author of fiery anti-British political tracts that would play a major role in mobilizing support for the American Revolution.

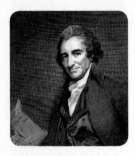

For Paine, leaving England was, perhaps, a relief. By the time he met Franklin, Paine had failed at several businesses and only narrowly escaped going to debtor's prison. He had married twice; his first wife died in childbirth, and he had separated from his second. He had also worked as a schoolteacher, tax collector, and servant.

Paine had developed an intense hatred for British monarchy and a growing belief in republicanism. Moving to America, already on the verge of revolution by 1774, gave him the opportunity to put his beliefs into action.

In early 1776, Paine published *Common Sense,* a fifty-page pamphlet that attacked the Crown in direct, lucid prose and argued for independence. After the war, Paine moved back to England and began writing *Rights of Man,* a more expansive political treatise on human rights. He was forced to leave England in 1792 and moved to France, where he was an enthusiastic backer of the French Revolution. He was arrested in 1793, however, and narrowly escaped the guillotine.

During his stay in the French prison, assuming that he was about to die, Paine wrote his most controversial book, *The Age of Reason,* an attack on organized religion. The book enraged many of his allies, including Adams, and he was shunned when he returned to the United States in 1802. He died in New York City at age seventy-two.

ADDITIONAL FACTS

1. *Paine was granted honorary French citizenship in 1792 and made a member of the French National Assembly. He voted against the death penalty for Louis XVI (1754–1793)—a stance that eventually helped lead to his own arrest the next year.*

2. *Although he offended Adams with his views on religion, Paine was a lifelong friend of Thomas Jefferson (1743–1826), who said in 1821 that "no writer has exceeded Paine."*

3. *Originally born Thomas Pain, Paine added the final e to his name after immigrating to America.*

❖❖❖

Teresa of Ávila

Although she is regarded today as one of the most influential women in the history of the Roman Catholic Church, Saint Teresa of Ávila (1515–1582) faced hostility and suspicion throughout her lifetime. She was hauled before the Inquisition, mocked for her intense mystical experiences, and denounced by a church official as "an unstable, restless, disobedient and contumacious female."

Still, despite the ridicule she endured, Teresa founded a new religious order and left a legacy as a leading theologian of Catholic mysticism.

The future saint was born Doña Teresa de Cepeda y Ahumada to a struggling noble family in the Spanish province of Ávila. She was the granddaughter of a convert from Judaism who had been condemned by the Inquisition for supposedly practicing his old religion in secret. Teresa received a strict Catholic upbringing and embraced the faith so zealously that she tried to run away from home at age seven to seek martyrdom fighting the Moors.

A rebellious teenager, Teresa entered the Carmelite convent in Ávila at age twenty. At the time, many nunneries functioned as holding pens for unmarried, disobedient daughters of the gentry and were not entirely devoted to religious training. Three years later, however, she fell seriously ill, an experience that triggered her deepening interest in religion.

Determined to reform convent life into a more serious religious undertaking, she founded the first Discalced Carmelite convent in Ávila in 1562. Teresa and a handful of followers wore rags, slept on straw mattresses, and whipped themselves with scourges as self-punishment.

At about the same time, Teresa began to experience the mystical ecstasies and convulsions for which she became well known and which she believed brought her into union with God. By the time she died, Teresa had overcome her critics to start seventeen more convents across Spain. Her writings on Christian mysticism—the quest to create a deeply felt, spiritual experience of God—proved a major influence on later theologians.

ADDITIONAL FACTS

1. *Teresa is one of only three women to hold the title of Doctor of the Church, the highest distinction for Catholic theologians. The others are Saint Catherine of Siena (1347–1380) and Saint Therese of Lisieux (1873–1897).*

2. *Canonized by Pope Gregory XV (1554–1623) in 1622, Teresa is the patron saint of headache sufferers, lace, and Spain.*

3. *After Teresa's death, her body was divided into pieces and distributed to her followers, a relatively common practice with Roman Catholic saints. The pieces became valuable relics; twentieth-century Spanish dictator Francisco Franco (1892–1975) acquired four of the fingers of her left hand and kept them by his bed.*

✦✦✦

Louis XIV

He was nicknamed the Sun King because, in seventeenth-century France, everything was said to revolve around King Louis XIV (1638–1715). The prototype of the absolute monarch, Louis occupied the throne of France for seventy-two years, a record unsurpassed in Europe before or since, and consolidated the power of the French state almost entirely in his hands.

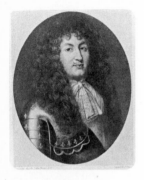

The king's attitude toward his role in government was summed up in his famous motto, *L'état, c'est moi*—"I am the state."

Louis, the oldest son of King Louis XIII (1601–1643), inherited the crown when he was only five years old. During the first eight years of his reign, his mother, Queen Anne (1601–1666), ruled in his place as regent. When he turned twenty-three, Louis took full control of the kingdom.

As king, Louis reduced the power of both the French nobility and the government ministers. Whereas his parents had delegated the day-to-day responsibilities of governing France to an aide, Cardinal Mazarin (1602–1661), Louis assumed full personal control over the government after Mazarin's death. He built the famous Palace of Versailles, just outside Paris, as a monument to both the growing international power of France and its increasingly centralized government under the king.

Louis fought and won several European wars, defeating the Netherlands and its allies in 1678 and seizing Alsace from the Holy Roman Empire in 1684. The outcome of the wars made France the strongest military power in Europe, although the nation was dealt a setback in the War of the Spanish Succession (1701–1714), which prevented France from uniting with Spain to form a continental superpower.

The Sun King's reign was also a period of artistic and cultural flowering in France. In addition to building Versailles, Louis improved the Louvre Museum and built a massive military complex in Paris, the Hôtel des Invalides, for retired soldiers. By the time Louis died at age seventy-seven, he had outlived both his son and his grandson; he was succeeded on the throne by his great-grandson, Louis XV (1710–1774).

ADDITIONAL FACTS

1. *Louis revoked the Edict of Nantes, which had granted Protestants freedom to worship in France, in 1685. French Jews and Protestants were not accorded full citizenship until the French Revolution in 1789.*

2. *Louis married a Spanish princess, María Theresa (1638–1683), in 1660. They had three children. After the queen's death, he secretly married his longtime mistress, Françoise d'Aubigné Scarron (1635–1719).*

3. *The state of Louisiana, which was founded as a French colony in 1682, was named after the king.*

✦✦✦

John Locke

Writing in 1689, the English philosopher John Locke (1632–1704) described his ideal form of government as one that respected the natural rights of its people. The government, he wrote, should not take away the "life, liberty, and estate" of its citizens.

Almost a century later, when Thomas Jefferson (1743–1826) wrote the American Declaration of Independence in 1776, he borrowed Locke's words almost exactly, writing that citizens of the thirteen colonies had an inalienable right to "Life, Liberty, and the Pursuit of Happiness."

Jefferson's homage to Locke reflected the English philosopher's central place in European and American political thought of the eighteenth century. Perhaps more than any other philosopher, Locke was a direct inspiration to the leaders of both the American and French revolutions. More than any other single document, his anti-monarchical *Two Treatises of Government* helped establish the conceptual framework of Western democracy.

Locke was born near Bristol, England. His childhood coincided with the English civil war, in which his father fought for the victorious Puritan faction. After the war, Locke attended Oxford, where he studied philosophy and medicine.

Locke's original goal was to become a doctor. But one of his patients, the Earl of Shaftesbury (1671–1713), steered him into politics in the 1670s. Locke and Shaftesbury were both forced to flee to Holland after they were implicated in a plot to assassinate King Charles II (1630–1685).

It was while in exile that Locke wrote his two treatises, both of which attack the idea of absolute monarchy. Advancing the theory of the "social contract" formulated by Thomas Hobbes (1588–1679), Locke argued that the contract between the people and the state could be voided if the state failed to respect the rights of the people.

Locke returned to England in 1688, following the revolution, which overthrew King James II (1633–1701) and established Parliament, rather than the monarchy, as the decisive power in English politics. A hero to the revolutionaries, Locke died in 1704.

ADDITIONAL FACTS

1. *Locke never married, but he was romantically involved with the philosopher Damaris Cudworth (1659–1708). She married another man, Sir Francis Masham (1645–1722), while Locke was in exile.*

2. *In 1669, Locke helped write the first constitution for the British colonies of Carolina. The constitution established the right to a representative legislature, an innovative feature at the time, but also endorsed slavery. It was abandoned within a few decades.*

3. *Another of Locke's best-known and most influential works is* A Letter Concerning Toleration *(1689), in which he argued that allowing religious freedom was in society's best interests because it removed a cause of civil unrest. His idea of religious toleration, however, extended only to different Protestant denominations; Locke believed Catholics and atheists should be excluded from civil society.*

✦✦✦

Athanasius Kircher

Athanasius Kircher (c. 1601–1680) wrote more than forty books on a stunning variety of topics during his lifetime—a record befitting an intrepid, frenzied scholar whose goal in life was nothing less than to know everything.

The epitome of the Renaissance man, Kircher spoke twelve languages, was history's first Egyptologist, authored the first science fiction novel, and once studied volcanoes by lowering himself into the smoking crater of Mount Vesuvius. His love of learning is perhaps best reflected in the title of a book he wrote in 1669: *The Great Art of Knowing.*

Kircher was born in the Roman Catholic city of Geisa in central Germany, a country torn by religious strife during his lifetime. He was forced to flee his hometown to escape Protestant forces in 1622. He became a Jesuit priest in 1628 and moved through France, Austria, and Italy before settling in Rome.

The first book Kircher published, in 1631, was a treatise on magnetism. He also wrote on sundials, gravity, and mathematics. In 1656, he became one of the first to theorize that bubonic plague might be caused by microorganisms.

Kircher's *Oedipus Aegyptiacus,* in which he attempted to decode the ancient Egyptian hieroglyphic alphabet, was one of his best-known books. Although Kircher ultimately failed, he ignited widespread interest in ancient Egypt and left behind notebooks that were invaluable resources for Jean-François Champollion (1790–1832), the French scholar who eventually succeeded in decoding the ancient writing.

Over the course of his lifetime, Kircher collected a vast array of books, artifacts, and inventions, which were housed in the Museum Kircherianum in Rome. The museum was one of the city's largest until it was broken up in the nineteenth century.

Known during his lifetime as the "master of a hundred arts," Kircher was one of Europe's most famous scholars, largely self-taught and motivated by a zeal for knowledge for its own sake. After his death, however, Kircher's reputation dimmed, as his amateur approach to scientific studies gave way to greater professionalization and specialization.

ADDITIONAL FACTS

1. *Kircher invented a perpetual motion machine, a talking dummy, and a music-writing machine— none of which worked. His inventions were satirized in* The Island of the Day Before *(1994), by the Italian novelist Umberto Eco (1932–).*

2. *One of Kircher's projects was attempting to translate the Voynich manuscript, a famous fifteenth-century book written in an unidentified language. Kircher was unable to decipher the manuscript, however, and all attempts by modern code breakers to do so—including one by a team from the National Security Agency—have also been stymied. Some scholars have theorized that the book may have been an elaborate medieval hoax.*

3. *In his* Physiologia *(1680), Kircher was the first observer to accurately measure the airspeed velocity of a swallow—an impressive feat, given that stopwatches hadn't been invented yet.*

✦✦✦

Blackbeard

English privateer and pirate Edward Teach (c. 1680–1718), better known as Blackbeard, was one of the central figures of the "golden age" of piracy in the early eighteenth century. With long, gnarled hair; a scarlet coat; and two sabers at his side, Blackbeard deliberately cultivated a fearsome image that ensured him a place in nautical lore. His actual career was relatively short, however, and ended when he was cornered off North Carolina and killed.

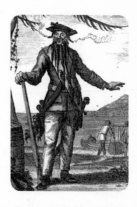

Blackbeard's early life is obscure. He was born in England and served aboard a privateer during the War of the Spanish Succession. A privateer was a privately owned warship whose crew was granted permission by the Crown to attack enemy ships and to keep whatever it captured. The British employed privateers in the Caribbean to disrupt Spanish commerce—and trained a generation of pirates in the process.

When the British dropped out of the war in 1713, many privateers, including Blackbeard, continued to attack ships in the Caribbean. He was offered—and declined—a pardon from the British, making him officially an outlaw. Over the next four years, he is believed to have captured and plundered about fifty ships; his personal armada grew to four vessels and about 300 pirates. He often hid near Ocracoke Island, on North Carolina's Outer Banks, and fenced stolen goods to the American colonists.

In November 1717, Blackbeard attacked and took over a French slave ship, *La Concorde,* as it sailed off Martinique. He renamed it the *Queen Anne's Revenge* and turned it into his flagship. The next spring, the *Queen Anne's Revenge* and several other ships under Blackbeard's command blockaded the port of Charleston, South Carolina. After plundering several ships, he escaped to his hideaway off North Carolina.

Blackbeard was killed by a squadron of Royal Navy ships that November, and his head was placed on a pike in Virginia to dissuade any other would-be pirates. Since then, he has figured in dozens of pirate-themed movies and books, a symbol of the romance and lawlessness of the high seas.

ADDITIONAL FACTS

1. *Blackbeard had his own flag, which depicted a white skeleton against a black background. The more notorious Jolly Roger flag, which shows only a skull and crossbones, was introduced at about the same time by a different English pirate, Edward England.*

2. *In the 2006 movie* Blackbeard, *the title role was played by Scottish actor Angus Macfadyen (1963–).*

3. *The wreck of the* Queen Anne's Revenge *was found in twenty feet of water at Beaufort Inlet, North Carolina, in 1996. It was identified by a bronze bell found amidst the debris and other artifacts.*

✦✦✦

Voltaire

Man is free at the instant he wants to be.
—Voltaire

A champion of free speech and civil liberties, Voltaire (1694–1778) was a hugely prolific French writer and philosopher who was popular—and controversial—across Europe. His essays, plays, novels, and pamphlets in favor of social reform and the separation of church and state were read by the leaders of the French and American revolutions, and he is considered a major influence in the political histories of both countries.

Born in Paris as François-Marie Arouet, Voltaire adopted his famous pseudonym in 1718. His first play, *Oedipe,* was a success on the Parisian stage, and he penned his first satirical poems against the French aristocracy when he was in his early twenties.

Voltaire's trenchant satires quickly landed the young writer in hot water: He was imprisoned for the first time in 1717 and forced into exile in England in 1726. The years Voltaire spent in England were a major influence on his political beliefs. The British constitutional monarchy, he concluded, was more respectful of individual rights than French absolutism was.

Voltaire was allowed to return to France in 1729, but was exiled from Paris after publishing a book that praised the British political system. Banished to the French countryside, he began a relationship with a French noblewoman, the Marquise du Châtelet (1706–1749), and published a series of increasingly critical essays about the Roman Catholic Church in France. He went into exile again in 1751, this time settling in the German city of Potsdam.

Unable to return to Paris, Voltaire moved to Geneva in 1754 and then to Ferney, a city on the French side of Lake Geneva. He wrote *Candide,* a novel that is perhaps his most influential work, in 1759. *Candide* tells the story of a young, naive nephew of a German baron, relating his adventures across Europe and his eventual disillusionment with European society.

Voltaire was finally allowed to return to Paris in 1778, three months before his death at age eighty-three. He was reportedly asked to accept Christ on his deathbed and angrily replied, "For God's sake, let me die in peace." They were his last words.

ADDITIONAL FACTS

1. Candide *was based on several real events, including the Lisbon earthquake of 1755, a massive temblor that killed up to 100,000 people—the worst natural disaster in modern European history.*

2. *Voltaire was briefly imprisoned in the Bastille, the famous Paris prison whose invasion by an angry mob sparked the beginning of the French Revolution in 1789.*

3. *American composer Leonard Bernstein (1918–1990) turned* Candide *into a Broadway musical in 1956.*

◆◆◆

Tadeusz Kosciuszko

True to a single object, the freedom and happiness of man . . .
—Thomas Jefferson, on Tadeusz Kosciuszko

A national hero on two continents, Tadeusz Kosciuszko (1746–1817) served as an officer in the American Revolution and later directed an uprising against Russian rule in his native Poland. Deeply idealistic, Kosciuszko came to epitomize the Enlightenment-era values of democracy and independence that animated the revolutionary movements in both countries.

Kosciuszko was born in a small village in what is now Belarus. He attended a military academy, excelled in his studies, and won a scholarship to Paris, where he studied painting and attended lectures on military tactics. When the American Revolution broke out, the American ambassador to France, Benjamin Franklin (1706–1790), recruited Kosciuszko to join the Continental Army in 1776.

Kosciuszko's training in tactics and military engineering made him an invaluable asset to George Washington (1732–1799), who was charged with assembling a modern army out of untrained colonial militias. Kosciuszko helped design and build forts in Pennsylvania and New York and led the defense of West Point. Congress promoted him to the rank of brigadier general in 1783.

He returned to Poland the next year and lived in poverty for five years before he was allowed to join the Polish army in 1789. Militarily weak, Poland was in a precarious position, wedged between two strong powers. In 1792, Russia invaded and divided up the country with Prussia, leaving only a small area free from foreign rule. Two years later, hoping to recover Poland's independence, Kosciuszko launched a revolt against the Russians.

The Kosciuszko Rebellion, however, was short-lived: Its leader was captured in 1794 and imprisoned for two years before he was pardoned by the czar in 1796. Kosciuszko went into exile in the United States and France, working without success to organize a new revolt against the Russians. He died in Switzerland at age seventy-one.

ADDITIONAL FACTS

1. *Many streets in the United States and Poland are named after Kosciuszko. He is also the namesake of Mount Kosciuszko, the highest mountain in Australia, which was discovered by a Polish explorer.*

2. *The house Kosciuszko lived in in Philadelphia was made a National Memorial.*

3. *In his will, Kosciuszko directed that his estate be used to buy freedom for as many slaves in the United States as possible. However, the will was held up by legal wrangling until 1852, when the Supreme Court ruled that the money should go to the general's European relatives instead.*

✦✦✦

Anne Hutchinson

Anne Hutchinson (1591–1643) immigrated to Boston in 1634, part of a wave of English dissidents who came to Massachusetts seeking religious freedom. Only four years later, however, Hutchinson was banished from the colony forever, never to return.

But in those four tumultuous years, Hutchinson earned a unique place in American religious history as the colonists' first major woman religious leader. She started her own prayer group, which soon grew into one of the largest and most influential in Boston—so large, in fact, that the colony's male elders feared she was threatening their power and ordered her banished.

Hutchinson was born Anne Marbury in Alford, England, and married a merchant, William Hutchinson (1586–1642), in 1612. After the family immigrated to Massachusetts, Hutchinson quickly established herself as a nurse and midwife, crucial jobs in the young colony.

Initially, her Bible study groups were informal gatherings where women discussed sermons. But as her following grew to dozens of members, including men, the study group emerged as a powerful religious faction that counted the colony's governor, Sir Henry Vane (1613–1662), as a follower.

In her meetings, Hutchinson criticized many of the colony's civil and ecclesiastical leaders and offered a series of dissenting religious views. In particular, she promoted the *covenant of grace,* the strict Calvinist notion that God had already decided who would go to heaven. She believed that salvation depended on God's grace, which could not be seen, and criticized Puritan ministers who preached that one could earn salvation through good deeds, an idea known as the *covenant of works.*

The dispute, known as the Antinomian controversy, culminated in Hutchinson's arrest and trial in 1637 for "traducing the ministers." Abandoned by many of her allies, Hutchison was convicted, imprisoned for seven months, and banished to Rhode Island in 1638. She moved to Long Island in 1642 and was killed by Native Americans the next year.

ADDITIONAL FACTS

1. *Massachusetts governor Michael Dukakis (1933–) officially pardoned Hutchinson in 1987, 349 years after her banishment.*

2. *New York's Hutchinson River Parkway is named in honor of the Puritan dissenter.*

3. *Hutchinson's chief defender, Henry Vane, eventually returned to England, where he joined the Puritan side in the English civil war. He was beheaded in 1662 for high treason after the monarchy was reinstated.*

◆◆◆

Kangxi

One of the greatest monarchs in the history of China, the Kangxi Emperor (1654–1722) sat on the throne for sixty-one years and presided over a period of widespread growth and prosperity in the Middle Kingdom. He is credited with defeating rebel groups in Taiwan and Tibet, expanding the empire's borders, and introducing new Western influences to China.

The Kangxi Emperor succeeded to the throne when he was seven years old. He was the second monarch in the Qing dynasty, a ruling clan that originated in the northern province of Manchuria and seized power from the Ming dynasty in 1644.

Although the Qing had claimed the "mandate of heaven," the traditional source of authority in the Chinese imperial system, and installed themselves in the Forbidden City in Beijing, many pockets of resistance remained. The early years of the Kangxi Emperor's reign were marked by military campaigns against holdouts in southern China and Taiwan. He also fought a civil war against three rebellious generals between 1673 and 1681.

By 1690, the emperor had largely succeeded in stamping out opposition. He made efforts to reconcile with former Ming dynasty supporters by inviting scholars to rejoin the civil service and sponsoring Chinese-language literature. (The Qing emperors spoke Manchu, not Mandarin Chinese.)

Interaction between China and the Western world increased during the emperor's rule and often resulted in tension. The emperor fought a brief war against Russia in 1688 and 1689; in 1706 he expelled a papal legate who had tried to assert Vatican control over China's population of Roman Catholics. In other respects, though, the Kangxi Emperor welcomed foreign influences, inviting Jesuit mathematicians and astronomers to his court.

The final years of his reign were dominated by a lengthy civil war in Tibet, which ended just before his death in Beijing at age sixty-eight. A dispute over succession broke out among his twenty-four sons; the fourth-oldest son eventually took the throne as the Yongzheng Emperor (1678–1735).

ADDITIONAL FACTS

1. *The Qing dynasty was the last imperial dynasty to rule China; its final emperor was deposed in 1912.*

2. *The Kangxi Emperor abandoned the Great Wall as a military fortification, but ordered renovations to another ancient Chinese landmark, the nearly 1,100-mile Grand Canal. The canal, one of the oldest and longest man-made waterways in existence, has been in continuous operation since roughly 600 BC.*

3. *Under the naming system for Chinese emperors, the Kangxi Emperor had three names: his birth name, Aisin-Gioro Xuanye; the name he assumed as emperor, Kangxi; and the ceremonial name used after his death, Shengzu.*

✦✦✦

Gottfried Wilhelm Leibniz

Philosophers sometimes come across as a dour bunch. But the German ratio-nalist theologian, mathematician, and philosopher Gottfried Wilhelm Leibniz (1646–1716) may be best known for his uplifting declaration "This is the best of all possible worlds."

The reasoning behind Leibniz's optimistic argument was simple. An all-powerful God, he wrote, had many choices when creating the world. And, being all-powerful, he would have chosen nothing but the best. The world God created isn't perfect, Leib-niz admitted, but it must—by definition—have been the best option on God's menu.

Leibniz, one of the most prolific writers of the period known as the Enlightenment, was born in the German city of Leipzig and taught himself Latin and Greek as a child. After rejecting a professorship at a German university in 1667, he embarked on a career as a court historian, diplomat, and scientific advisor for the powerful dukes of Hanover. A man of wide-ranging learning—his colleagues called him a "universal genius"—he also invented modern calculus independently of the British physicist Isaac Newton (1643–1727).

As a diplomat, Leibniz had the opportunity to travel widely in Europe, visiting Paris, London, Italy, and the Netherlands. His main goal was to thwart the aggressive expansion of French power under King Louis XIV (1638–1715), who was perceived as a threat by many of the smaller German states, including Hanover.

In his philosophy, which he began publishing in the 1680s, Leibniz was influenced by Baruch Spinoza (1632–1677) and had a famous three-day meeting with the Dutch philosopher in The Hague shortly before Spinoza's death from lung disease. Although the two differed over religion—Leibniz was a Christian, while Spinoza rejected traditional Judeo-Christian notions of God—Spinoza helped inspire Leib-niz's works *Theodicy* (1710) and *Monadology* (1714).

Leibniz never married, and he became unpopular in Hanover near the end of his life. Today, however, he is considered a major figure in the history of mathematics and a significant influence on such German philosophers as Immanuel Kant (1724–1804).

ADDITIONAL FACTS

1. *Leibniz's optimistic philosophy was widely derided for centuries after his death, including in the famous satire* Candide *(1759), by the French author Voltaire (1694–1778). In the book, the character Dr. Pangloss, who was modeled after Leibniz, believes that everything is for the best, even tragic events like earthquakes. In turn, the word* Panglossian *is sometimes used to criticize naively optimis-tic worldviews.*

2. *In the final years of his life, Leibniz engaged in an acrimonious debate with Newton over who had invented calculus first. Modern historians believe that Newton was probably first, although Leibniz was the first to publish his system. The symbols commonly used in modern calculus—including the integral symbol—were first devised by Leibniz.*

3. *Leibniz's employer, the Duke of Hanover, became King George I of England (1660–1727) in 1714. Although he wanted to move to London with the king, Leibniz was denied permission until he com-pleted his history of the House of Brunswick.*

◆◆◆

Christiaan Huygens

Considering his upbringing, it is perhaps no surprise that Christiaan Huygens (1629–1695) became one of Europe's greatest scientists. His father, a Dutch diplomat, was a personal friend of the French mathematician René Descartes (1596–1650), who frequently visited their home in The Hague and tutored the young Huygens. Another family friend, the mathematician Marin Mersenne (1588–1648), was in the habit of mailing puzzles to the precocious scholar.

By age twenty-six, Huygens had already graduated from the University of Leiden and made his most famous astronomical find. Using the most technologically advanced telescope in Europe, whose lenses he had made himself, Huygens discovered that Saturn had a moon, Titan. He was also the first to correctly infer that the planet had rings; earlier observers had been stumped by what appeared to be the planet's bulging sides.

Encouraged by Blaise Pascal (1623–1662), Huygens also wrote the first work on probability theory—in the guise of a gambling manual. Published in 1657, the book was later published in English as *The Value of All Chances in Games of Fortune; Cards, Dice, Wagers, Lotteries, etc. Mathematically Demonstrated.*

In 1666, Huygens moved to Paris, where he was elected a member of the French Academy of Sciences. However, as a Protestant, he was barred from France when the king revoked the Edict of Nantes in 1685, ending a period of religious toleration in the predominantly Roman Catholic country.

Huygens then visited England, where he clashed with the English mathematician Isaac Newton (1643–1727). Newton's theory of gravitation, Huygens wrote, "appears to me absurd." The two scientists also disagreed about the nature of light, but in that controversy it was Huygens who was eventually vindicated. Huygens believed light was a wave—a view confirmed by modern physicists—while Newton thought light was composed of tiny particles called corpuscles.

After suffering a chronic illness, Huygens died in the Netherlands at age sixty-six.

ADDITIONAL FACTS

1. Huygens's father was an early patron of the Dutch painter Rembrandt (1606–1669), but had a falling-out with the artist after Rembrandt delivered a few religious paintings that the elder Huygens found lacking.

2. After Huygens discovered Saturn's moon, he initially shared the news with other astronomers using a coded anagram in Latin. To decode the anagram, the recipient needed to rearrange a quote from Ovid into Huygens's secret message: "A moon revolves around Saturn in sixteen days four hours."

3. When he discovered Saturn's moon, Huygens called it simply Luna Saturni—Latin for "Saturn's moon." The British astronomer John Herschel (1792–1871) dubbed it Titan after the Titans, figures in Greek mythology.

✦✦✦

Dick Turpin

He was a swashbuckling rogue—or perhaps just a common criminal. The life of Dick Turpin (1705–1739), an English highwayman, has been heavily romanticized since his death. But the man depicted in the ballads, films, and television shows inspired by Turpin's exploits bears only a loose resemblance to the real historical figure.

Turpin achieved notoriety in the eighteenth century for his daring murders and thefts on the roads of England, and he was one of the nation's most-wanted men until his capture and execution. His criminal career coincided with the construction of England's first turnpike system—and the heyday of highway robberies.

From his beginnings as a cattle thief, Turpin lived on the fringes of English society. He was part of a gang of robbers and poachers near London until he began his solo career, so to speak, in about 1735. He robbed stagecoaches and merchant shipments, and the bounty on his head was upped after he murdered a man in Epping Forest, outside London.

The most famous incident in the Turpin mythology, however, may never have occurred. According to legend, in London he stole a horse named Black Bess, whose owner then called the constables. After a brief gunfight, Turpin rode the horse to York, outrunning his pursuers. Turpin's ride is probably the best-known, and least historical, part of the folklore that later sprang up around the bandit.

After relocating to northern England, Turpin resumed horse stealing under a fake name, John Palmer. When he was arrested for shooting a landlord's gamecock, authorities discovered that Palmer was actually the notorious Turpin.

In the early eighteenth century, British law called for the death penalty for virtually all the crimes of which Turpin was accused. He was convicted of horse theft and hanged on April 19, 1739.

ADDITIONAL FACTS

1. *Numerous movies have been filmed about the legendary English bandit.* Dick Turpin, *a British television series starring Richard O'Sullivan (1944–), aired for four years in the late 1970s and early 1980s.*

2. *Turpin spent his last few pounds to hire five mourners to attend his hanging. Each received ten shillings.*

3. *Much of the mythology surrounding Turpin's life was invented or embellished by William Harrison Ainsworth (1805–1882), a Victorian romance novelist, in his book* Rookwood *(1834).*

◆◆◆

Marquis de Sade

One of the most controversial writers in the history of Western literature, the Marquis de Sade (1740–1814) was a French aristocrat and pornographer whose frank depictions of sexual violence have shocked readers for two centuries. His best-known book, *The 120 Days of Sodom*, inspired the word *sadism*—meaning to take pleasure by inflicting physical pain on others.

De Sade's writing—and his own scandalous lifestyle—provoked horrified reactions in France, and at various points in his life he was imprisoned, declared insane, and sentenced to death. Still, he survived until the age of seventy-four and doggedly promoted in plays and books his view that sexual pleasure, unbounded by any sense of morality, was the highest good.

Born into an ancient noble family, de Sade was born in Paris and grew up at his family's castle in the town of La Coste. He served as an officer in the French army and inherited the castle and his father's title of marquis in 1767.

Beginning in the late 1760s, de Sade transformed La Coste into his own sexual playpen—and dungeon. He hired both male and female prostitutes for orgies at the castle, some of whom would allege that he held them there against their will. After he poisoned several prostitutes, de Sade was tried and sentenced to death for sodomy, but escaped to Italy. He was eventually caught and sent to prison, but successfully appealed the death sentence.

De Sade spent the next twelve years behind bars, where he wrote his controversial novel *120 Days of Sodom*. The book describes the activities of four wealthy libertines who kidnap, abuse, and eventually murder a group of victims. Involving rape, bestiality, and necrophilia, among other topics, the book was not published until the twentieth century and remains a source of enormous controversy.

After the French Revolution, which de Sade supported, he was released from prison and published several pornographic books anonymously. He was returned to jail by Napoléon Bonaparte (1769–1821) in 1801 and spent most of the rest of his life in an insane asylum.

ADDITIONAL FACTS

1. *De Sade was imprisoned at the Bastille in Paris until July 4, 1789—ten days before the storming of the prison that started the French Revolution.*

2. *A movie version of* 120 Days of Sodom *was filmed by Italian director Pier Paolo Pasolini (1922–1975) in 1975. His version,* Saló o le 120 giornate di Sodoma, *is one of the most-banned films in movie history and was never released in the United States.*

3. *A play about de Sade's incarceration at the Bastille,* Marat/Sade, *by Peter Weiss (1916–1982), premiered on Broadway in 1964 and won a Tony Award the next year. It was made into a movie two years later, with Patrick Magee (1922–1982) playing de Sade. A revival of the play was staged in 2007.*

❖❖❖

Maximilien Robespierre

Maximilien Robespierre (1758–1794) was a leader of the French Revolution who, in the name of republican ideals, sent thousands of his opponents to the guillotine in a massive wave of political killings. Known as the Reign of Terror, the explosion of violence in Paris ended only with Robespierre's own arrest and execution in the summer of 1794.

Robespierre was unmoved by the mayhem he unleashed. "Terror is nothing other than prompt, severe, inflexible justice" he once declared.

Robespierre was born in Arras, a city in northern France. He was a gifted student, and he was particularly moved by the individualist philosophy of Jean-Jacques Rousseau (1712–1778), which he read as a teenager. Robespierre was elected to a regional assembly while still only in his twenties. In 1788, with France's financial situation deteriorating, King Louis XVI (1754–1793) was forced to convene the National Assembly for the first time since 1614. Robespierre, only thirty years old, was selected to represent Arras at the gathering.

The meeting of the assembly failed to settle grievances against the king, however, and the French Revolution began on July 14, 1789, with the storming of the Bastille prison. In the government that was established in the wake of the Revolution, Robespierre emerged as a prominent member of the Jacobin Club, an extreme left-wing faction within the assembly. In the assembly, he argued for universal voting rights, religious toleration, and military reforms.

In 1792, Robespierre supported the execution of the king. The next year, he was elected to the Committee of Public Safety, which was established to halt the civic unrest and riots that the Revolution had unleashed across France. Although in theory only one of twelve members of the body, Robespierre became its unofficial leader, and he used his position to direct the Terror.

Tens of thousands of men and women—including the former queen, Marie Antoinette (1755–1793)—were killed during the Terror for offenses as minor as hoarding grain or criticizing the government. Robespierre believed that France was in a state of emergency and harsh measures were needed to safeguard the gains of the Revolution. By the next summer, however, even his former allies had seen enough. He was overthrown in a coup on July 26, 1794, and guillotined two days later. He was thirty-six.

ADDITIONAL FACTS

1. *Robespierre was nicknamed l'Incorruptible—"the Incorruptible"—because of his reputation for selflessness, personal integrity, and total commitment to the Revolution.*

2. *As part of the sweeping social changes in postrevolutionary France, the revolutionaries created a new calendar that designated 1792, the year of the monarchy's downfall, as year 1 of the new era.*

3. *Robespierre first entered politics in 1788 as a representative of the Third Estate in the French assembly; under the monarchy, France was divided into the three estates, the first representing the clergy, the second the nobility, and the third everyone else.*

❖ ❖ ❖

Roger Williams

Clergyman Roger Williams (1603–1683) founded Rhode Island in 1636, helped to write the colony's legal code, commanded its militia in several wars, and served twice as governor. But perhaps his greatest legacy was as an advocate for religious toleration, a then-radical concept that would be enshrined in the US Constitution more than 150 years later.

Williams was born in London and graduated from Cambridge University's Pembroke College in 1627. He was ordained an Anglican minister in 1629, but soon joined the illegal Puritan group, which rejected many mainstream Anglican practices and suffered widespread persecution. Following other Puritan preachers, he fled to Boston in 1631.

Soon after his arrival, Williams was in trouble again, this time after he criticized the colonial government for stealing Native American lands, meddling in church affairs, and trying to enforce religious laws in civil courts. Enraged by his "dangerous opinions," the colony's legislature banished him in October 1635.

Moving south, Williams founded Providence the next year, purchasing the land from Narragansett Indians. Unlike Massachusetts, Williams decreed, the new colony would keep church and state totally separate and make no effort to enforce religious conformity. He traveled back to London in 1643 to convince Parliament to grant an official charter for Rhode Island, and he wrote a book the next year, *The Bloudy Tenent of Persecution for Cause of Conscience*, explaining his beliefs.

At the time, most Europeans believed that religious conformity was necessary to safeguard civil order, and they questioned how such a diverse colony could survive. Under Williams's guidance, however, Rhode Island would become a haven for members of minority religious groups in Europe, including Baptists, Quakers, and Jews. As Williams wrote, any "persons distressed of conscience" were welcome in the colony. One of the most famous dissenters of colonial New England, Anne Hutchinson (1591–1643), moved to Rhode Island after her expulsion from Boston.

Williams retired as governor in 1657, but returned to aid the colonists during King Philip's War, a devastating conflict between colonists and the Narragansetts in 1675. In one raid, which Williams witnessed, Providence was burned to the ground, destroying much of his life's work. He died at age seventy-nine and is buried in Providence.

ADDITIONAL FACTS

1. *Williams initially refused to leave Massachusetts after his banishment and was on the verge of being arrested and deported back to England when he finally fled to Rhode Island. John Winthrop (1588–1649), one of his theological adversaries, reputedly tipped off Williams about his impending arrest.*

2. *A statue of Williams was erected in the Rotunda of the US Capitol in 1872. In 1997, as part of an effort to acknowledge more women and minorities in the Rotunda, the statue was relocated.*

3. *Starting in 1631, Williams struggled to learn the languages of the local Wampanoag and Narragansett tribes. He eventually wrote several books on native dialects.*

✦✦✦

Catherine the Great

Catherine the Great (1729–1796) was the empress of Russia for more than three decades and a powerful figure in European politics. She helped solidify her country's place as a major continental power, sponsored literature and the arts—and scandalized her critics by carrying on affairs with dozens of lovers.

A German-born princess, Catherine married the heir to the Russian throne, the future Peter III (1728–1762), in 1745. Peter inherited the crown in 1762, but proved to be a weak and unpopular leader; he was deposed and murdered in a coup six months after his coronation. After her husband's death, Catherine became the new monarch.

Catherine's reign was a period of rapid territorial expansion and military conquest. She annexed Crimea, pushed the borders of her empire into eastern Europe, and even established the first permanent Russian settlement in Alaska (the territory would be sold to the United States in 1867).

Domestically, Catherine sought to make Russia an artistic center. She imported English and German paintings for her personal collection, and these eventually formed the nucleus of the Hermitage Museum in Saint Petersburg. She became friends with leading thinkers of the Enlightenment, including the French satirist Voltaire (1694–1778). The period has been called the Russian Enlightenment, with Russian writers and artists absorbing the influences pouring into the country.

Like many (if not most) of the male monarchs in Europe, Catherine had a series of lovers. Hers became much more notorious, in part because she made little effort to hide her liaisons with a procession of younger men. She had at least one illegitimate son, and even her legitimate son, the future Czar Paul I (1754–1801), may have been fathered by a Russian count and not Peter III. But many of the wilder rumors about Catherine's sex life are thought to have been fabricated by her political enemies.

Catherine died in Saint Petersburg from a stroke at age sixty-seven.

ADDITIONAL FACTS

1. *Catherine was empress during the American Revolution. While Russia did not openly side with the colonists, Catherine aided them indirectly by sending her navy to block British efforts to restrict shipping in the Atlantic.*

2. *She was born Sophia Augusta Frederika, but took the name Catherine upon marrying Peter.*

3. *Between 1788 and 1790, Catherine fought a war against one of her own cousins, King Gustav III (1746–1792) of Sweden.*

✦✦✦

Jean-Jacques Rousseau

On July 10, 1750, the Academy of Dijon in France announced the winner of an international essay contest. He was a hitherto unknown musician from Switzerland who had submitted a composition entitled "Discourse on the Sciences and Arts." His name was Jean-Jacques Rousseau (1712–1778).

Rousseau was thirty-eight years old at the time he submitted the winning entry, and the essay catapulted him to fame across Europe. For the next three decades, he would be regarded as one of his nation's most influential—and inflammatory—philosophers.

Rousseau was born in the Protestant enclave of Geneva. His mother died a few days after his birth, and his father, a clock maker, abandoned him at a young age. Rousseau moved to France in 1728, where he converted to Roman Catholicism, wrote operas, and met his future wife, a maid named Thérèse Levasseur (1721–1801).

The question that Rousseau had answered in his prizewinning essay was "Has the restoration of the sciences and arts tended to purify morals?" Rousseau argued that it had not: Indeed, he wrote, progress had corrupted mankind's natural goodness.

Rousseau's philosophy posed implicit criticisms of both the religious and political establishments in France. His belief in human goodness contradicted Roman Catholic doctrine, which held that humans were born carrying the evil of original sin. And his belief in political equality challenged the absolutist French monarchy.

He published a second treatise, *Discourse on the Origin and Foundations of Inequality,* in 1755 and a successful novel, *Julie, or the New Heloise,* in 1761. *The Social Contract,* perhaps his best-known book, was published in 1762. By elevating the rights of individuals and extolling nature, Rousseau's writings helped shape the Romantic movement and the ideals of the French Revolution.

Rousseau's personal life, however, grew increasingly tempestuous. He conducted numerous affairs and was reputedly a sexual exhibitionist and masochist. After his books were banned in Paris for offending the religious authorities, Rousseau returned to Switzerland and reconverted to Calvinism. He then returned to France under a fake name; he later won permission to stay on the condition that he stop publishing, and he spent the last years of his life earning a living by copying sheet music.

Rousseau died in Ermenonville, just outside of Paris, at age sixty-six. After the French Revolution, his remains were moved to the Panthéon, France's highest honor, in recognition of his influence on the revolutionaries.

ADDITIONAL FACTS

1. *After the publication of* The Social Contract, *which criticized organized religion, Rousseau's house in Switzerland was stoned by an angry mob. He left the country shortly thereafter.*

2. *In addition to his political and philosophical writing, Rousseau penned a successful opera,* Le devin du village *(The Village Soothsayer), which debuted before King Louis XV (1710–1774) in 1753.*

❖❖❖

Isaac Newton

Isaac Newton (1643–1727) was a pioneer in mathematics, physics, and astronomy. He is credited with inventing the first workable telescope, outlining the theory of gravity, and being one of the creators of modern calculus.

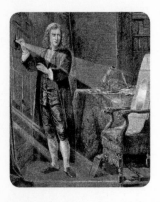

Newton was born on a farm in rural England in 1642, the same year the English civil war began. The war and its aftermath shaped his childhood; he moved several times and was taught largely by his grandparents. He entered Cambridge University at age eighteen, later than most of his classmates, and there studied optics and math.

When the university closed abruptly in 1665 due to an outbreak of plague, Newton was forced to return to his family home. The two years he spent in the countryside, however, would be one of the most productive periods of his life. He formulated many of his breakthroughs in optics and calculus during the outbreak and returned to Cambridge brimming with new ideas.

In 1669, only a few years after graduating from college, Newton was appointed to Cambridge's most prestigious mathematics professorship. He spent the next thirty years at the university and in 1687 published *Mathematical Principles of Natural Philosophy,* a landmark text that outlined the theory of universal gravitation.

According to Newton's theory, all objects with mass exert a gravitational pull on other objects. For huge masses like stars and planets, the gravitational pull is sufficient to hold smaller objects in orbit. Gravity, Newton theorized, explained why the moon revolves around Earth and why Earth revolves around the sun.

Despite his success, Newton tired of Cambridge and suffered a nervous breakdown in 1693. He eventually moved to London in 1701, where his fame brought him significant influence. He was elected president of the Royal Society in 1703 and knighted by Queen Anne (1665–1714) in 1705. He died in London at age eighty-four.

ADDITIONAL FACTS

1. *At Cambridge, Newton was granted the prestigious position of Lucasian Professor of Mathematics. As of 2009, well over 300 years later, only eighteen other men have held the professorship, including noted mathematicians Charles Babbage (1791–1871) and Stephen Hawking (1942–).*

2. *Newton was elected to Parliament in 1689 representing Cambridge University and was named warden of the Royal Mint in 1696. As director of the mint, he successfully caught several counterfeiters—counterfeiting was a capital crime—and sent a number of forgers to the gallows.*

3. *Newton was buried in London's Westminster Abbey, an honor granted only to England's most illustrious citizens.*

❖❖❖

Benedict Arnold

Benedict Arnold (1741–1801) was an American general who switched sides to join the British during the Revolutionary War. His infamous betrayal, motivated primarily by greed and resentment, almost resulted in the loss of the critically important American fortress at West Point. For his actions, Arnold's name has become virtually synonymous with treachery.

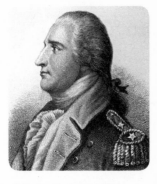

Prior to switching sides, though, Arnold was widely praised. He was one of the leaders of the successful attack on Fort Ticonderoga in New York in 1775, and he also served—and was seriously injured—at the Battle of Saratoga in 1777, a major turning point in the war. Were it not for his actions later in the war, it is possible that Arnold would be remembered as a national hero.

Benedict Arnold V was born in Connecticut and served in the colony's militia during the French and Indian War. Like many colonists, he was outraged by the taxes imposed by the British in the 1760s and rejoined the army after the outbreak of the Revolution in 1775.

Despite his early victory at Ticonderoga, the Continental Congress passed Arnold over for promotion several times. He was also accused of misappropriating funds and forced to repay the army for some expenditures, which added to his considerable personal debt and growing sense of resentment against Congress. Finally, Arnold married the daughter of a Loyalist in 1779, and she encouraged him to defect. With her help, Arnold began secret negotiations with the British later that year.

In 1780, Arnold was put in charge of West Point and intensified his discussions with the British. He eventually reached an arrangement with the British to surrender the fort for £20,000. Had it worked, the scheme would have effectively split New England from the Mid-Atlantic colonies, dealing a major blow to the Continental Army. However, the plan was discovered in September 1780. Arnold narrowly avoided arrest before fleeing.

After his defection, Arnold was named a brigadier general in the British army and fought in several battles against his old allies. He moved to London after the war, where he died at age sixty.

ADDITIONAL FACTS

1. *Arnold's great-grandfather, Benedict Arnold I (1615–1678), was the governor of Rhode Island for three terms between 1663 and 1678.*

2. *The Saratoga battlefield contains the "Boot Monument" to Arnold's leg—a statue of the general's injured limb that makes no mention of the rest of him.*

3. *Arnold was married twice and had eight children, two of whom became British military officers.*

♦ ♦ ♦

Wolfgang Amadeus Mozart

The model, perhaps, for musical sensations through the ages, Wolfgang Amadeus Mozart (1756–1791) lived fast, died young, and left a beautiful corpus. In his short lifetime, the Austrian composer wrote more than 600 concertos, symphonies, operas, and sonatas that left an indelible mark on the development of Western music.

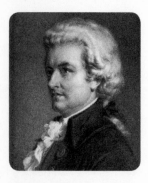

A child prodigy, Mozart was born in Salzburg and was taught violin by his father, Leopold (1719–1787). By the age of six, young Wolfgang was touring Europe and performing before royalty. He wrote his first full-length opera at age fourteen.

At age seventeen, Mozart was given the position of court composer to the ruler of Salzburg, one of the smallest of the independent German-speaking states. Restless and ambitious, Mozart resigned several years later and moved to Vienna in 1781, seeking wider audiences.

Vienna offered a wealth of new artistic opportunities. Mozart's operas for the Vienna stage—*The Marriage of Figaro* (1786), *Don Giovanni* (1787), and *The Magic Flute* (1791)—were well received and moved him into the first rank of the city's musicians. The emperor, Joseph II (1741–1790), had a keen interest in music and was a patron to Mozart, and, later, to a younger German composer named Ludwig van Beethoven (1770–1827). Mozart also met his wife, Constanze Weber (1762–1842), in Vienna; they married in 1782 and had six children.

Mozart's music included masses for church services—and canons about farting. He was fascinated by the complex contrapuntal fugues of Johann Sebastian Bach (1685–1750)—and by Italian opera. The wide mix of interests can all be felt in his music, which encompassed virtually every genre and style of the eighteenth century.

After falling ill with an unknown disease, Mozart died in December 1791, at age thirty-five. His last composition—coincidentally, a funeral requiem—was unfinished at his death.

ADDITIONAL FACTS

1. *The 1984 biopic* Amadeus, *directed by Milos Forman (1932–) and starring Tom Hulce (1953–) as the composer, won eight Academy Awards, including Best Picture and Best Actor. However, some historians criticized the movie for distorting Mozart's biography and exaggerating his rivalry with another Vienna composer, Antonio Salieri (1750–1825).*

2. *Mozart's father was an innovator in teaching techniques for violin. A violin competition named in his honor is held annually in Augsburg, Germany.*

3. *Rock star Eddie Van Halen (1955–) named his son Wolfgang in honor of the composer.*

❖❖❖

Theobald Wolfe Tone

Irish revolutionary Theobald Wolfe Tone (1763–1798) was one of the leaders of the Irish Rebellion of 1798. Although unsuccessful, Tone's revolt helped inspire a century of militant violence and political agitation that culminated in Ireland's independence from Great Britain in 1921.

Tone's commitment to Irish independence was particularly noteworthy because, unlike most later Irish rebels, he was a Protestant. He supported Irish independence out of a principled belief in democracy, and he hoped to create a free Ireland that would not be divided along religious lines.

After the rebellion's failure and Tone's death, however, the struggle for Irish independence became increasingly sectarian in nature, pitting proindependence Roman Catholics against pro-British loyalists. Indeed, Tone's vision has never come to fruition: Today, the predominantly Protestant counties of Northern Ireland remain a part of the United Kingdom.

Born in Dublin, where his father was a coach maker, Tone studied law at Trinity College and practiced briefly in London. He entered politics in the early 1790s as a backer of full legal rights for Roman Catholics, or Catholic Emancipation. Tone's radicalism was influenced by the French and American Revolutions, in particular the writings of Thomas Paine (1737–1809), which he read and cited as an influence.

In 1791, Tone was one of the founders of the Society of the United Irishmen, an underground group that would soon claim hundreds of thousands of supporters. The group was targeted by the British in 1794, and Tone was forced into exile the next year. Along with other Irish expatriates, he fled to France, where the group spent several years planning a revolt.

The uprising began May 24, 1798. The rebels received assistance from France, but were quickly suppressed by the British. Tone was captured by the British, court-martialed, and sentenced to death; he committed suicide while awaiting execution.

ADDITIONAL FACTS

1. *Tone went into exile in the United States in 1795, living in Philadelphia. He disliked the United States, especially the "enormous expense of living in Philadelphia."*

2. *Catholic Emancipation—the repeal of British laws barring Roman Catholics from sitting in Parliament or serving as judges—was not approved until 1829.*

3. *Before entering Irish politics, Tone concocted a scheme to establish a British military base on what is now the island of Hawaii. He delivered the proposal in person to prime minister William Pitt (1759–1806), who ignored it.*

✦✦✦

George Fox

In 1650, a judge in the English city of Derby sent a young dissident preacher named George Fox (1624–1691) to prison and delivered a mocking lecture as he announced the sentence. Fox had exhorted his followers to "tremble at the word of the Lord," and the judge derisively labeled the preacher and his followers "quakers."

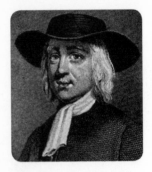

Fox, the founder of the faith that would thereafter be known as Quakerism, spent much of his youth in and out of jail. He was born in a rural village in Leicestershire, the son of a weaver, and received no formal education. Before he began preaching in 1647, Fox's only experience was as a cobbler and a shepherd.

After leaving his village that year, Fox crisscrossed England on foot, preaching in marketplaces and private homes. He believed that a formal, ordained clergy was unnecessary and that anyone could experience the "inner light" of Jesus Christ without the guidance of a preacher. He also rejected churches and taught that religious services could be held anywhere—a cave, a hillside, even an open field.

Because they rejected the authority of the established clergy, Fox and his followers were fiercely persecuted; some of his followers were put to death. The Quakers refused to take off their hats for social superiors, swear loyalty oaths to the government, or pay tithes. Fox also embraced pacifism and directed his followers not to join the army.

The persecution of Quakers continued under King Charles II (1630–1685), who was restored to the throne in 1660, and the jailing of religious dissidents continued into the 1680s. Starting in 1671, Fox traveled to Ireland; Germany; the Netherlands; and the British colonies of Jamaica, Maryland, and Rhode Island seeking new followers. Quakers established a significant presence in colonial America, and today more Quakers live in the United States than in any other country.

Laws against the Quakers were finally abolished in England in 1689. Fox died two years later in London.

ADDITIONAL FACTS

1. *During his career as a preacher and dissident, Fox was sentenced to prison eight times in seven different cities for blasphemy, causing civil disturbances, and other crimes. He spent a total of six years behind bars and narrowly escaped execution for blasphemy in 1653.*

2. *One of Fox's most famous converts was William Penn (1644–1718), the son of a wealthy English merchant, who became a Quaker against his father's wishes at age twenty-two. Penn and Fox became close friends, and Penn later founded Pennsylvania as a haven for persecuted Friends.*

3. *The Nobel Peace Prize was bestowed upon the Quaker religion in 1947 for its commitment to nonviolence.*

✦✦✦

George Washington

George Washington (1732–1799) may have shaped the civic institutions and political culture of the United States more than any other Founding Father. He created what became the United States Army and led it to victory in the Revolution; he chaired the convention that wrote the Constitution in 1787; and, as the nation's first president, he helped define the powers—and limits—of the office.

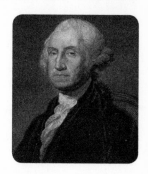

Washington was born into a wealthy family in Virginia. He worked as a surveyor, joined the Virginia militia in 1752, and fought on the British side during the French and Indian War (1754–1763).

Upon returning home from war, he married a wealthy widow, Martha Custis (1731–1802), and moved to Mount Vernon, his estate on the Potomac River. By now one of the wealthiest men in the colony, he was elected to Virginia's legislature, in 1758. When fighting broke out, Washington was the only serious candidate for leading the Continental forces. He was commissioned by Congress on June 15, 1775—the date that marks the founding of the Continental Army, which became the US Army.

Thomas Jefferson (1743–1826), writing many years after the war, described Washington's leadership style with admiration:

> He was incapable of fear, meeting personal dangers with the calmest unconcern. Perhaps the strongest feature in his character was prudence, never acting until every circumstance, every consideration, was maturely weighed; refraining if he saw a doubt, but, when once decided, going through with his purpose, whatever obstacles opposed.

After the war, Washington stepped down from the army. He reluctantly agreed to serve as the first president and set important precedents for the new office. He refused monarchial-style titles, dressed in ordinary clothing, and served only two terms in office, setting the precedent that presidents should not serve for life.

He returned to Mount Vernon after leaving the presidency and died in 1799.

ADDITIONAL FACTS

1. *Many of the more fanciful myths surrounding Washington's life were fabricated by Parson Weems (1759–1825), a nineteenth-century biographer. The Rappahannock River, which Weems claimed Washington threw a silver dollar across, is wide enough to make the story doubtful.*

2. *George and Martha Washington did not have children of their own, but they raised two of Martha's grandchildren from her first marriage, George Washington Parke Custis and Eleanor Parke Custis.*

3. *Ironically, Washington was the only president who was never inaugurated in the city of Washington, DC, which was under construction for most of his presidency. His first inauguration, in 1789, was held in New York City, and his second, in 1793, took place in Philadelphia.*

✦✦✦

Immanuel Kant

The German philosopher Immanuel Kant (1724–1804) was a man of extremely regular habits. Every afternoon, he took a walk around his home city of Königsberg, passing the city's Gothic cathedral at the exact same time every day. According to legend, Kant's timing was so precise that the church began setting its clock according to when the philosopher and ethicist strolled by its door.

But there was one problem: Kant himself started his walks based on the time on the cathedral clock. The church and the philosopher each depended on the other to set the time—meaning that neither of them knew the actual time.

The famous story of the clock illustrates both Kant's austere personality—he never married, and he rarely ventured outside the city of his birth—and a philosophical problem that he sought to explore in his groundbreaking work. What do we really know? And how can we be sure that we really know it?

Kant was born the fourth of nine children and raised in a strict Prussian home. He entered the University of Königsberg at age sixteen and began teaching at the university in 1755. He was awarded a full professorship at age forty-five and published one of his best-known books, *The Critique of Pure Reason,* in 1781.

The question of how people acquired valid knowledge—whether by the senses or through the use of reason—was one of the most contentious philosophical questions of the eighteenth century. Empiricists such as the Scottish philosopher David Hume (1711–1776) argued that people had no innate knowledge and that all learning was acquired by experience and the senses. Rationalists, in contrast, argued that one could use human ability and reasoning to arrive at knowledge.

Kant, in *The Critique of Pure Reason,* essentially agreed with both camps. Yes, he wrote, knowledge can be derived from experience. But there are also *a priori* concepts that form a kind of starting position for human knowledge.

In ethics, Kant was best known for formulating the concept of the categorical imperative. The categorical imperative is, in essence, a version of the golden rule: "Act only according to that maxim by which you can at the same time will that it should become a universal law." In other words, an action is right only if it would be right for *everyone* to do it.

During Kant's lifetime, he was regarded as a leading German philosopher. His reputation has only grown since his death at age seventy-nine; Kant is regarded as one of the most influential Western thinkers since the ancient Greeks.

ADDITIONAL FACTS

1. *Kant's first name was originally Emanuel, but he changed the spelling after learning Hebrew.*

2. *The route of Kant's daily walk was renamed Philosophengang (Philosopher's Walk) in his honor.*

3. *Kant's home city was captured by the Soviet army in 1945 and renamed Kaliningrad after the Communist leader Mikhail Kalinin (1875–1946). It remains part of Russia.*

❖❖❖

Benjamin Franklin

One of the first Americans to make major contributions to science, Benjamin Franklin (1706–1790) was known for his quick wit, support for the American Revolution, and influential experiments with electricity. He also invented scores of devices, including bifocal lenses, the lightning rod, and the Franklin stove. His inventions, coupled with his puckish personality, made him an international celebrity—the embodiment of the nation he helped to found.

Born in Boston, Franklin was apprenticed to his brother, a newspaper publisher, as a teenager. He soon tired of his brother's mistreatment and fled to Philadelphia, where he founded his own newspaper and eventually earned his fortune.

Franklin's financial success gave him the opportunity to begin dabbling in science and politics. After retiring from the printing business in 1748, he began his own experiments with electricity, publishing a paper in 1750 that theorized that lightning was a form of electricity.

In the paper, Franklin described his famous experiment with a kite. If the kite was struck by a bolt of lightning, he theorized, the charge would be transmitted through the string to the ground, proving that lightning was a form of electricity. There is no evidence that Franklin ever actually carried out the experiment as he described it in the paper—indeed, such an exercise could easily have been fatal.

Franklin was sent to England in 1757 to represent the Pennsylvania legislature in London. He remained in England for most of the next two decades, serving as an ambassador for the increasingly restive colonies. He returned in 1775, just after the outbreak of war, and was a signer of the Declaration of Independence in 1776.

Congress soon dispatched Franklin to Paris, where his scientific fame helped him coax the French government into aiding the colonies. In the last years of his life, Franklin completed his autobiography and wrote articles criticizing slavery. He died in Philadelphia at age eighty-four.

ADDITIONAL FACTS

1. *In his will, Franklin left the cities of Philadelphia and Boston 1,000 pounds sterling each, on the condition that the money be allowed to gather interest for 200 years before it was spent. By the 1990s, when the 200-year mark passed, the trusts were each worth millions of dollars.*

2. *Do not fly a kite in a thunderstorm. Several imitators, under the impression that Franklin had safely carried out the test as described in his paper, have been electrocuted trying to replicate his experiment.*

3. *Franklin's first lightning rods were installed at two Philadelphia landmarks: the Pennsylvania State House, now known as Independence Hall, and the steeple atop Christ Church.*

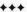

Fletcher Christian

The saga of the mutiny on the HMS *Bounty* has provided fodder for books and movies for more than two centuries. In 1789, a group of crewmen led by Fletcher Christian (1764–1793) took over the British warship at knifepoint, sent the captain off in a tiny lifeboat, and steered the ship to what they believed were the island paradises of Tubuai and Tahiti.

What followed were two epic tales of maritime adventure. The deposed captain, William Bligh (1754–1817), along with a handful of loyal crew members, navigated the lifeboat to Timor—a trip of almost 4,000 miles—using only a watch, a sextant, and the stars. His voyage is considered an astonishing feat of seamanship. Meanwhile, the mutineers aboard the *Bounty* wandered across the Pacific before Christian led them to uninhabited Pitcairn Island, where they settled.

The *Bounty*'s mission was to sail to Tahiti, load the ship with breadfruit trees, and then take them to Jamaica. After a ten-month voyage, the *Bounty* reached sunny Tahiti in late 1788. The crew spent the next five months collecting hundreds of breadfruit samples. Many of the men also began relationships with native women. Few of the men were excited to resume the trip to Jamaica in April 1789.

The mutiny broke out less than a month after their departure. In total, eighteen members of the crew joined the uprising. After forcing Bligh and the eighteen loyal crewmen into the lifeboat, Christian took command of the ship—and headed back to Tubuai and Tahiti.

After dropping off many of the mutineers on Tahiti, Christian sailed west, hoping to find a safe haven where he could avoid arrest. In addition to the English mutineers, the ship carried the Tahitian brides of several of the men, including Christian's, and several Tahitian men. After visiting Fiji and a few other islands, they finally arrived at deserted Pitcairn, where they established a settlement and scuttled the *Bounty*.

From Timor, Bligh had traveled back to England to report the loss of the ship. A mission was dispatched to the Pacific to catch the mutineers. The men who had remained in Tahiti were arrested and taken back to England, where three of them were hanged, but the mutineers on Pitcairn were never located. However, most of them died of disease, in accidents, and in fighting among the island's residents. Christian himself is believed to have been killed in 1793.

ADDITIONAL FACTS

1. *The story of the mutiny on the* Bounty *has been a Hollywood favorite for decades. Actors who have portrayed Christian include Mel Gibson (1956–) in 1984, Marlon Brando (1924–2004) in 1962, Clark Gable (1901–1960) in 1935, and Errol Flynn (1909–1959) in 1933.*

2. *John Adams (1767–1829), the last surviving mutineer on Pitcairn Island, was granted amnesty by the British admiralty in 1825. The capital of the group of islands, Adamstown, is named after him.*

3. *Many of the current residents of Pitcairn are descendants of Christian, including Steve Christian (1951–), who was mayor of the island until he was convicted on rape charges in 2004.*

◆◆◆

Francisco de Goya

The creator of some of the most shocking images of war and brutality in the history of Western art, Francisco de Goya (1746–1828) was a Spanish painter who captured the horrors of the Napoleonic Wars in *The Disasters of War, The Third of May 1808,* and other works.

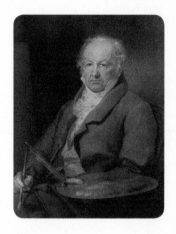

Goya's drawings, some of which were considered too graphic to display in his lifetime, were a revolutionary departure from traditional European art that portrayed battle as grand and heroic. By stripping war of its glory, Goya injected a new level of humanism and inspired generations of antiwar painters.

Born in the village of Fuendetodos, Goya arrived in Madrid in 1766. His early paintings were heavily influenced by the prevailing rococo style and gave little indication of the dark turn his work would take. Rising to the peak of the Spanish art world, Goya was named the court painter to King Charles IV (1748–1819) in 1799.

The French invasion of Spain in 1808 and the subsequent bloodshed, some of which Goya witnessed, provided the material for his striking antiwar paintings and etchings. Shortly after the French invasion, Napoléon's troops summarily executed hundreds of Spanish civilians in Madrid on May 3, 1808. Goya's painting of the event, showing a helpless Spanish civilian in a white shirt the moment before he is shot by faceless French troops, has become a symbol of the cruelty of war. *The Disasters of War,* a series of grotesque etchings of dead bodies, crying children, and terrified civilians, was so unsettling that it was not printed until 1863.

In art history, Goya is considered a transitional figure who was steeped in classical influences but rebelled against them and became one of the first "modern" artists. In the words of the art historian Anthony F. Janson, Goya was "the only artist of the age who may unreservedly be called a genius."

ADDITIONAL FACTS

1. *Director Milos Forman (1932–) made a movie about the Spanish painter,* Goya's Ghosts, *in 2006. Stellan Skarsgård (1951–) starred as Goya, and Randy Quaid (1950–) portrayed Charles IV. Appropriately, it was nominated for three Goya awards—the top film prize in Spain.*

2. *Pablo Picasso (1881–1973) idolized Goya. Picasso's 1951 painting* Massacre in Korea, *which portrays the killing of Korean civilians by US troops, was directly inspired by Goya's* The Third of May 1808.

3. *Goya was deaf for most of his adult life. Some art historians have argued that Goya's despondency over losing his hearing may have inspired the increasing bleakness of his paintings later in life.*

◆◆◆

Toussaint L'Ouverture

The first successful slave uprising of modern times was organized by Toussaint L'Ouverture (c. 1743–1803), a Haitian slave who led a rebellion that drove the French off the Caribbean island. After winning its independence as a free black republic, Haiti became a beacon of hope for enslaved blacks across North and South America.

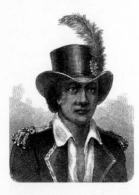

Indeed, two centuries after his death in a French prison, L'Ouverture is still hailed as a hero of black liberation and anti-imperialist resistance. In 2004, the president of South Africa called the Haitian revolt an inspiration to the antiapartheid cause and "one of the greatest revolutions in history."

To many nineteenth-century whites in Europe and the United States, however, the man known as the Black Napoléon was a menacing figure. He was vilified in France for decades after his death, and the United States did not officially recognize Haiti's independence until 1862.

Haiti, then called Saint-Domingue, was a major producer of sugarcane and a significant source of wealth for the French empire, but it relied wholly on slave labor in the harsh tropical climate. The French Revolution in 1789, with its creed of liberty, equality, and fraternity, prompted many Haitian blacks to hope that slavery would be abolished. But when slave owners on the island refused to end the practice, an uprising began in 1791.

L'Ouverture's goal was the abolition of slavery, not independence per se. Indeed, up until his death he called himself a Frenchman. But after 1801, when he declared a new constitution (with himself in the role of governor for life), L'Ouverture was clearly moving in the direction of full independence.

In 1802, he was captured by French troops and taken to a prison on mainland France, where he died after months of harsh interrogation. The next year, Saint-Domingue expelled the last French troops, declared independence, and renamed itself Haiti— the second independent country in the New World, after the United States.

ADDITIONAL FACTS

1. *The main airport in the Haitian capital of Port-au-Prince was named for L'Ouverture in 2003, on the bicentennial of his death.*

2. *Without Haiti, Napoléon Bonaparte (1769–1821) abandoned his dreams of building an American empire and agreed to sell France's remaining American holdings to the United States—the territory in what was known as the Louisiana Purchase.*

3. *In 1936, American director Orson Welles (1915–1985) directed an all-black version of* Macbeth *in which the character of Macduff was modeled on L'Ouverture.*

◆◆◆

Sabbatai Zevi

Sabbatai Zevi (1626–1676) was a charismatic, Turkish-born rabbi whose claim that he was the long-awaited Jewish Messiah attracted hundreds of thousands of followers across Europe and the Middle East. Eventually, though, Zevi's erratic behavior and unorthodox beliefs aroused the ire of both the Jewish establishment and the Ottoman sultan, who had him imprisoned in 1666.

Zevi was born in Smyrna, a prosperous trading city on Turkey's Aegean coast. He received a traditional Jewish education, was recognized as a gifted student of the Talmud, and became a rabbi at about age eighteen.

From an early age, Zevi's bizarre antics began to alienate Smyrna's religious authorities. He alternated between periods of ecstasy and deep depression; during his lows, Zevi often purposely violated Jewish religious and dietary laws. He also claimed to have experienced levitation, and, at age twenty-two, he claimed that he was the Messiah.

Finally, in 1651, Smyrna's rabbis expelled him from the city. He traveled across the Mediterranean; various sources report that he traveled to Greece, Turkey, Palestine, and Egypt before settling in Jerusalem in 1662. In 1665, he again proclaimed himself the Messiah.

This time, the claim found a ready audience among Jews worldwide, who were suffering under a wave of renewed persecution that had begun in Poland and Russia in 1648. Within a few months, the Sabbatean movement had spread by letter throughout the Middle East and to Amsterdam, Hamburg, London, and other centers of Jewish life. Zevi claimed that the world would end the next year, 1666, with the restoration of Israel. Zevi explained his own scandalous acts by arguing that "outward" displays of religious propriety would be meaningless when the apocalypse came.

Worried by his rapidly growing power, the Turkish sultan Mehmed IV (1642–1693) ordered Zevi's arrest in February 1666. Confined to the castle of Abydos, Zevi was offered a choice: He could convert to Islam or be put to death immediately.

To the dismay of many of his disciples, Zevi accepted Islam and remained a Muslim until his death ten years later. However, a smaller number of followers continued to insist that he was the Messiah and that his conversion was only an irrelevant "outward" display. Although he was denounced across the Jewish world, Zevi's influence lingered for decades after his death.

ADDITIONAL FACTS

1. *After his conversion to Islam, Zevi worked briefly as the sultan's personal doorkeeper. He was arrested in 1672, however, and exiled to Dulcigno, Albania, where he died.*

2. *A large community of Sabbateans, called the Dönme, still exists in Turkey. Members of the group outwardly embrace Islam but continue to practice Judaism in secret.*

3. *In 1664, Zevi married Sarah, the daughter of one of the victims of the persecutions that had begun in 1648. After her death, he married Esther, the daughter of a rabbi.*

◆◆◆

Thomas Jefferson

One of the most influential Founding Fathers, Thomas Jefferson (1743–1826) was the author of the Declaration of Independence and the third president of the United States. Under his leadership, the United States acquired the Louisiana Territory from France—instantly doubling the size of the young nation.

Jefferson was born in rural Shadwell, Virginia, into a wealthy landowning family and graduated from the College of William and Mary, the academy of the Virginia aristocracy, in 1762. He inherited his own estate at age fourteen when his father died, and he designed and built Monticello, his famous hilltop mansion, in the 1770s.

Deeply influenced by the ideas of Enlightenment philosophers such as John Locke (1632–1704) and Voltaire (1694–1778), Jefferson entered politics while he was still in his twenties. He was elected to the Virginia legislature, the House of Burgesses, in 1769. In the legislature, he sided with the critics of British taxation and argued that the thirteen colonies had the right to govern themselves.

Jefferson was a delegate to the Second Continental Congress in 1775. He was named to the committee writing the Declaration of Independence the next summer. Drawing on the ideas of Locke, the Declaration explained why the patriots were rebelling against the king and explained, in eloquent language, their beliefs: "that all Men are created equal, that they are endowed by their Creator with certain unalienable Rights, that among these are Life, Liberty, and the Pursuit of Happiness."

After the Revolution, Jefferson served as minister to France and was the first secretary of state. Jefferson was elected vice president in 1796 and defeated the incumbent, John Adams (1735–1826), and a third candidate, Aaron Burr (1756–1836), in the first seriously contested presidential election, in 1800.

Jefferson's presidency was marked by the acquisition of the Louisiana Territory, a war against pirates in the Mediterranean, and ineffectual attempts to defend American shipping from British attacks during the Napoleonic Wars (1799–1815). The Embargo Act of 1807, which Jefferson signed in an effort to punish the British by limiting imports of British goods into the United States, instead crippled American farmers and merchants, especially in New England, contributing to Jefferson's unpopularity in his last year in office.

After leaving the presidency, Jefferson spent the rest of his life at Monticello. He founded the University of Virginia in 1819. He died on July 4, 1826—on the fiftieth anniversary of his most famous contribution to his country.

ADDITIONAL FACTS

1. *Jefferson sold 6,487 volumes from his personal library to the federal government in 1815 to reestablish the Library of Congress, which had been destroyed during the War of 1812.*

2. *The University of Virginia was the first nonreligious college in the United States.*

3. *Jefferson is featured on the front of the $2 bill.*

◆◆◆

David Hume

In 1739, a young Scottish writer published the first of three volumes in a sprawling work called *A Treatise of Human Nature.* The author, the twenty-eight-year-old philosopher David Hume (1711–1776), expected his books to be met with furious denunciations from church authorities and fellow philosophers.

Instead, a chagrined Hume later wrote, he watched his book, which had taken five years to write, "fall dead-born from the press." Aside from a few disgruntled religious zealots, nobody even noticed.

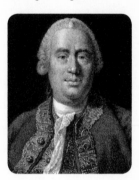

Indeed, during his lifetime, Hume was largely a failure as a philosopher and derived most of his income from a six-volume, million-word *History of England* that was a bestseller later in his lifetime. But he is now considered a major figure in the Scottish Enlightenment, a flourishing of philosophy and political thought based in Hume's home city of Edinburgh.

Hume was born to a modestly wealthy family. His father died when he was two years old, and he was raised primarily by his mother, Katherine. A precocious learner, he entered the University of Edinburgh at age eleven. He considered a career in law or business, but instead moved to France at age twenty-three to live in a country village for three years, where he began drafting *A Treatise of Human Nature.*

After the failure of the treatise, Hume applied twice for professorships in Scotland, but was rejected both times. He worked briefly as a British diplomat in Italy, then took a job as the Edinburgh librarian. The library gave him the time and resources to write the *History of England,* which secured his fame.

A friend to other major figures in the Scottish Enlightenment, including the economist Adam Smith (1723–1790), Hume was known for his self-deprecating sense of humor. He once wrote that when the rigors of writing were too great, he had a simple solution: "I dine, I play a game of backgammon, I converse and am merry with my friends." Hume never married. He died of intestinal cancer at age sixty-five.

ADDITIONAL FACTS

1. *A street in Edinburgh where the philosopher once lived is named St. David's Street in his honor. The sarcastic name—Hume was attacked in his lifetime for his supposed atheism—originated from a joke played by one of Hume's friends, who chalked the name onto the side of a house on that street.*

2. *Hume was born David Home, but changed the spelling of his name in 1734.*

3. *After failing in his first bid to become a philosophy professor in 1744, Hume took a job tutoring a young aristocrat, the Marquis of Annandale (1720–1792). Unfortunately for Hume, the marquis turned out to be insane. Still, Hume tried to teach him for about a year before finding another job.*

✦✦✦

Carl Linnaeus

Swedish botanist Carl Linnaeus (1707–1778) created the modern system of classifying plants and animals by Latin names, providing an orderly framework for the study of life. Linnaeus, also a renowned authority on plants, named hundreds of species himself and was fond of quoting his famous motto: *Deus creavit, Linnaeus disposuit*—"God created, Linnaeus organized."

Linnaeus was born in southern Sweden. His parents, who hoped the boy would become a priest, taught him Latin as a child. Instead, he studied medicine and botany at the University of Uppsala, obtaining a medical degree in 1735. Although Linnaeus practiced medicine for the rest of his life—serving at one time as doctor to the Swedish royal family—botany remained his first love. He mounted his first expedition, to Lapland, in 1731, and another in 1734 to central Sweden. He was named a professor at Uppsala in 1741, where he regaled students with stories of his adventures and inspired a wave of intrepid naturalists who traveled the world looking for new plants and animals in the eighteenth century.

The first edition of Linnaeus's *Systema Naturae* was published in 1735. Putting his childhood Latin to use, Linnaeus proposed that all plants and animals could be assigned a Latin name made up of two parts. The first part of a Linnaean name is the organism's genus, and the second is its species. For instance, in the Linnaean system, human beings are classified as *Homo sapiens*—members of the genus *Homo* and the species *sapiens*. Linnaeus also put each species into broader categories, such as order and phylum. Humans are the only living species in the genus *Homo*, for instance, but we share the order Primates with monkeys, lemurs, apes, and other creatures that have the Primate characteristics of opposable thumbs, developed eyesight, and large brains.

Linnaeus won considerable fame for his system of classification, or *taxonomy*, and was made a member of the Swedish nobility in 1761 in recognition of his accomplishments. But his theories were not without controversy. He appalled some colleagues with his occasionally naughty nomenclature (he called one plant genus *Clitoria*) and frank discussion of sex in plants and animals. Other critics objected on a philosophical or religious basis to the very concept of lumping individual organisms into big, inflexible categories. His main critic was the French naturalist Georges-Louis Leclerc (1707–1788), who felt that the Linnaean system was too rigid and failed to account for variations and change within species.

Linnaeus died in Uppsala at age seventy.

ADDITIONAL FACTS

1. *Linnaeus sometimes used his naming system to strike back at his enemies. For instance, Linnaeus retaliated against a German critic by naming a weed,* Siegesbeckia, *after him.*

2. *During his lifetime, Linnaeus had his portrait painted more than 500 times—at a time when sitting for a portrait took hours or even days.*

3. *Linnaeus estimated that there were only about 15,000 species on Earth; 300 years later, taxonomists have identified about 2 million and counting.*

❖❖❖

Aaron Burr

Aaron Burr (1756–1836) was a vice president of the United States who earned notoriety for killing his chief political rival, Alexander Hamilton (c. 1755–1804), in a pistol duel. Although the killing ended Burr's career and now virtually defines his historical legacy, before the duel he was a successful politician and Revolutionary War veteran who had come within a vote of the presidency in 1800.

Burr was studying law when the Revolution began. He joined the army and served as a staff officer. After the war, Burr entered politics and was elected to the United States Senate in 1791. He tangled several times with Hamilton, a fellow New Yorker. In the emerging party politics of the 1790s, Hamilton sided with the Federalists, while Burr joined the Democratic-Republicans.

In 1800, Burr ran as the vice presidential choice of Thomas Jefferson (1743–1826) and helped the Democratic-Republican ticket carry New York. At that time, the candidate who received the most votes from the members of the Electoral College was appointed president, and whoever received the second most became vice president. Jefferson and Burr technically finished in a tie; it took the House of Representatives thirty-six ballots to affirm that Jefferson was the winner.

In 1804, while still in office as vice president, Burr was nominated for governor of New York, but he was defeated after Hamilton orchestrated a campaign against him. Infuriated, Burr challenged him to a duel that summer.

On the morning of July 11, 1804, Burr and Hamilton rowed to New Jersey and held the shootout with a pair of pistols on the bluffs overlooking the Hudson. Burr shot Hamilton in the liver, and he died the next day. After the shooting, Burr was charged with murder and went into hiding until the charges were dropped. He then returned to Washington to complete his term as vice president.

The killing effectively ended Burr's political career, though he surfaced again in 1807 when he was charged with treason in an elaborate scheme to carve a new country out of the western United States. The trial ended in acquittal, and Burr fled to Europe. He returned to New York in 1812, practiced law, and died in 1836, at age eighty.

ADDITIONAL FACTS

1. *Burr married his second wife, a wealthy widow named Eliza Bowen Jumel (1775–1865), in 1833. She accused him of adultery four months later and filed for divorce (some historians contend that she really divorced him because of money problems). The finalization of the divorce was the second-worst thing that happened to Burr on September 14, 1836; he died on Staten Island on the same day.*

2. *Burr was the grandson of Puritan minister and Princeton University president Jonathan Edwards (1703–1758). An academic building at Princeton is named after Burr.*

3. *Treason is the only crime specifically defined in the US Constitution. Aware of abuses of the law in England, where charges of treason were used to punish political dissidents, the Founders specified that two witnesses had to testify to the same "overt Act" in order to convict. Only a handful of treason trials have been attempted in US history, and most, like Burr's, have ended in acquittal.*

◆◆◆

Jane Austen

Author of *Sense and Sensibility* (1811), *Pride and Prejudice* (1813), and *Emma* (1815), Jane Austen (1775–1817) was an English novelist whose tales of upper-class domestic drama have thrilled readers for generations. Her six completed novels are both engrossing narratives and richly detailed accounts of the social manners of the aristocratic class of which Austen was a part.

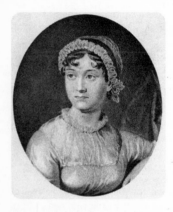

The books, which were originally published anonymously, have grown steadily in popularity over the past two centuries. Although obscure during her own lifetime, Austen is now considered one of the great British novelists of the nineteenth century.

Austen was born the seventh of eight children in the English village of Steventon. Her father, George Austen (1731–1805), was the rector of the local Anglican church. With the exception of a brief spell at boarding school, Austen lived at her father's home for her whole life.

In the early nineteenth century, novels were not considered a respectable literary form, especially for women, and Austen's first effort, *Sense and Sensibility,* was credited anonymously to "a Lady." (The remainder of her works were said to be "by the author of *Sense and Sensibility*.") The novel follows two sisters in their quests for suitable husbands.

The novel established the recurring theme that surfaced in all of Austen's books—namely, the social pressures faced by women to marry and the complexities of the institution of marriage among the English upper classes. Her heroines must weigh such considerations as wealth, social class, and love in finding their mates—factors that often come into conflict in Austen's narratives.

In 1816, after publishing *Emma,* Austen fell ill with a mysterious illness. She continued to write through her illness, finishing two novels that were published posthumously, but died the next year at age forty-one.

ADDITIONAL FACTS

1. *The cause of Austen's early death has been debated for decades by her fans. Many consider Addison's disease, an endocrine disorder that was first described in 1855, to be the most probable cause.*

2. *Two of Austen's brothers, Francis (1774–1865) and Charles (1779–1852), were members of the British Royal Navy and fought in the Napoleonic Wars. Both eventually became admirals.*

3. *Austen's novels were the inspiration for a genre of romance novels known as Regency romances—so called because they take place in England between 1810 and 1820, when the country was ruled by a regent in the place of King George III (1738–1820), who had gone insane.*

◆ ◆ ◆

William Wilberforce

The mother of twelve-year-old William Wilberforce (1759–1833) was appalled by the news she began to receive about her son. The boy, whom she had sent to live with relatives two years earlier, had changed into something unrecognizable: To his mother's consternation, he was becoming an evangelical Christian.

Determined to counter the religious enthusiasm instilled by his aunt and uncle, she summoned the child back home. "No pious parent ever labored more to impress a beloved child with sentiments of piety, than they did to give me a taste for the world and its diversions," Wilberforce later joked about his mother's family.

But it was too late. Motivated by his deep religious faith, Wilberforce would become one of the most prominent reformers in England, as well as the driving force behind the abolition of slavery in the British Empire. He served for nearly five decades as a member of Parliament and died three days after the bill banning slavery passed.

Wilberforce was born in the English port city of Hull, where his father was a prosperous timber merchant. After his father's death, he spent two years living with his aunt and uncle, who exposed him to evangelical Christianity. His large inheritance from his grandfather freed him from the need to earn a living, and after graduating from Cambridge, he decided to enter politics.

Britain was by far the largest slave trader in the eighteenth century, and the huge wealth generated by slavery had turned English port towns like Liverpool into thriving metropolises. Initially, Wilberforce faced long odds in his campaign: Merchants claimed that ending slavery would hamper the economy and diminish the profits pouring into England from its colonies.

Still, after entering Parliament in 1780, Wilberforce proposed a number of bills to abolish slavery. He came within a handful of votes of success in 1793, but legislators lost interest after Britain declared war on France later that year. His first major victory would not come until 1807, when, under pressure from a growing antislavery movement, Parliament banned the slave trade.

It would not be until 1833, however, that slavery within the British Empire was abolished. Wilberforce had retired from Parliament in 1825, but word of the vote reached him on his deathbed. He passed away in London at age seventy-three.

ADDITIONAL FACTS

1. *Wilberforce's life story was made into a 2007 movie,* Amazing Grace, *directed by Michael Apted (1941–) and starring Ioan Gruffudd (1973–) in the title role.*

2. *Abolition was not Wilberforce's only cause in Parliament. He was also a keen supporter of rights for animals and cofounded the Royal Society for the Prevention of Cruelty to Animals.*

3. *Bribery was an accepted part of elections in eighteenth-century Britain. When he first ran for Parliament in 1780, Wilberforce promised voters in Hull two guineas each for their support—equivalent to almost $4,000.*

◆◆◆

Cotton Mather

Minister, theologian, and moral scold, Cotton Mather (1663–1728) was one of Boston's most influential colonial-era preachers and the embodiment of the New England Puritan spirit. From his pulpit at the city's Old North Church and in dozens of books and essays, Mather helped shape public opinion on a range of political and religious controversies, from smallpox inoculation (he was in favor) to witchcraft (against).

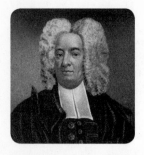

Mather was the son of a leading Puritan, Harvard president Increase Mather (1639–1723), and both of his grandfathers were founders of the Massachusetts colony. Mather graduated from Harvard in 1678, when he was only fifteen, and was ordained a minister in 1685 (overcoming a speech impediment that nearly prevented him from preaching).

He wrote his first major work, *Memorable Providences, Relating to Witchcrafts and Possessions,* in 1689. The book, which chronicled the life of an alleged Irish witch, is sometimes blamed for sparking the 1692 witch hunt in nearby Salem. Mather was indirectly involved in the trials—he corresponded with the judges about how to evaluate evidence—and he wrote a book, *The Wonders of the Invisible World,* that approvingly chronicled the trials and executions of nineteen supposed witches.

Mather's best-known book was *Magnalia Christi Americana* (1702), an admiring history and defense of the Puritans that portrayed the Massachusetts colony as a modern-day promised land. In addition to his religious works, Mather had a keen interest in science and was elected to the Royal Society of London in 1713. In 1721 and 1722, when the city was engulfed in controversy over a plan to administer smallpox vaccines, Mather's support was critical in convincing Bostonians to accept vaccinations.

Mather's influence in Boston, however, provoked resentment among the city's growing ranks of non-Puritans, including the sixteen-year-old Benjamin Franklin (1706–1790), whose earliest newspaper writings satirized Mather's stodgy conservatism. Mather would remain in the pulpit at Old North Church until his death at age sixty-five.

ADDITIONAL FACTS

1. *Cotton Mather was not named after the plant; he was named after his maternal grandfather, John Cotton (1585–1652).*

2. *Mather was married three times and had fifteen children, but nine of them died young. Only two survived him.*

3. *Unlike most other ministers involved in the Salem witch trials, Mather never apologized for his role, and he continued to condemn witchcraft for the rest of his life.*

❖❖❖

Napoléon Bonaparte

Napoléon Bonaparte (1769–1821) was a French general who assembled a massive empire in the early nineteenth century and left a trail of destruction and social upheaval across Europe. He seized power in France in 1799, crowned himself emperor five years later, and terrorized the continent until he was deposed and forced into exile in 1815.

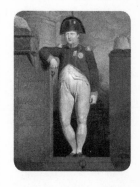

In total, the Napoleonic Wars spanned two decades and involved almost every military power in Europe. The major turning point in the war came in 1812, with Napoléon's failed attempt to invade Russia. His defeat exposed the weakness of the French army and emboldened the coalition of European powers that eventually defeated him at the Battle of Dresden in 1813 and the Battle of Waterloo two years later.

Still, Napoléon left a lasting mark on the legal, political, and social landscape of Europe. He exported the ideas of the French Revolution across the continent and abolished or weakened many old monarchies. The French legal code remains the basis of law across Western Europe. And the peace settlement that ended the war redrew the map of the continent.

Napoléon was born on the island of Corsica and attended the French military academy in Paris. Serving in an artillery regiment at the time of the French Revolution in 1789, he backed the republicans. Napoléon gained fame for suppressing an attempted royalist revolt in 1795 and later led French invasions of Italy, Austria, and Egypt.

In 1799, Napoléon seized power in a coup d'état. Although he claimed to support— and even to personally embody—the principles of the Revolution, Napoléon restored the French monarchy in 1804 and had himself named emperor. He waged war in Germany, Spain, Portugal, Belgium, the Netherlands, Italy, Russia, and Austria—all while battling the British Royal Navy for control of the Atlantic.

Napoléon was deposed for the first time in 1814 and forced into exile on the island of Elba. He escaped in 1815, returned to Paris, and led a brief revival called the Hundred Days before he was defeated at Waterloo and sent into permanent exile on the island of Saint Helena. He died in exile at age fifty-one.

ADDITIONAL FACTS

1. *As a result of his efforts to seize the Papal States, Napoléon was excommunicated by Pope Pius VII (1740–1823). French officers responded by kidnapping the pope, who was kept in exile for five years.*

2. *Napoléon's birthplace, the island of Corsica, had only become a part of France in 1768. His first language was Italian, and he spoke French only with a pronounced Corsican accent.*

3. *The British government continued to use Saint Helena to imprison enemies of the state until the early twentieth century.*

Edmund Burke

In the aftermath of the French Revolution, intellectuals in neighboring Britain were sharply divided. Supporters of the 1789 Revolution included radical thinkers Thomas Paine (1737–1809) and Mary Wollstonecraft (1759–1797), who viewed the revolt as a major advance in the cause of political equality.

But Edmund Burke (1729–1797), a politician, journalist, and political philosopher from Ireland, was appalled by the violence of the Revolution, which culminated in the mass killings of the Great Terror and the guillotining of King Louis XVI (1754–1793). Beginning in 1790, Burke published a series of eloquent denunciations of the revolt, emerging as one of the most influential critics of revolutionary France.

The articles and speeches Burke delivered as a member of Parliament helped precipitate a political clash in Britain, which eventually declared war on France in 1793. In the larger history of ideas, however, Burke's antirevolutionary philosophy stands out as one of the foundations of modern political conservatism.

Burke was born in Dublin and educated at Trinity College. His family had recently converted from Roman Catholicism to Anglicanism, a status that allowed Burke to avoid the restrictive anti-Catholic laws still in place in eighteenth-century Britain. He was first elected to Parliament in 1765.

During the American Revolution, Burke sided with the rebels, arguing that it was pointless for Britain to try to hold on to the thirteen colonies. A member of the Whig party, which favored limiting the power of the Crown, Burke was also critical of British imperial policies in India and Ireland.

Indeed, Burke's opposition to the French Revolution surprised many of his admirers. Burke was no friend of the French monarchy, but he also opposed the doctrine of radical, violent social change that the rebels had embraced. "When ancient opinions and rules of life are taken away, the loss cannot possibly be estimated. From that moment we have no compass to govern us; nor can we know distinctly to what port we steer," he wrote.

The death in 1794 of Burke's only son, Richard, devastated the writer and caused him to lose some of his interest in politics. He resigned from Parliament in the same year and died three years later, at age sixty-eight.

ADDITIONAL FACTS

1. *The names of the two main political parties in eighteenth-century Britain, the Whigs and the Tories, were both derived from Gaelic slurs. A* whiggamore *was a Scottish rebel, while* toraidhe *is an Old Irish word for "robber." The nickname Tory is still used for the British Conservative Party.*

2. *After resigning from Parliament, Burke was offered the aristocratic title of Lord Beaconsfield by King George III (1738–1820), but he refused the honor.*

3. *Burke was an opponent of the mistreatment of Indians in the British colony of India, and he led an ultimately unsuccessful seven-year effort to convict the first British governor-general of India, Warren Hastings (1732–1818), on charges of corruption.*

❖❖❖

Antoine-Laurent Lavoisier

Chemist and physicist Antoine-Laurent Lavoisier (1743–1794) was one of the most distinguished French scientists of the eighteenth century. He is credited with discovering the elements hydrogen and oxygen, formulating the law of the conservation of mass, and introducing the metric system.

But Lavoisier also made the fateful mistake of working for the unpopular government of King Louis XVI (1754–1793). After the French Revolution toppled the monarchy, the scientist was arrested, convicted of treason, and beheaded. A colleague, Joseph-Louis Lagrange (1736–1813), famously lamented after the execution: "It took them only an instant to cut off that head, and a hundred years may not produce another like it."

Lavoisier was born in Paris to a wealthy family and educated at the Sorbonne. He received a law degree, but defied his father's wishes by abandoning law to study chemistry beginning in the 1760s. He later joined a private tax collection firm that handled customs and levies on behalf of the king, and he married the thirteen-year-old daughter of one of France's chief tax collectors.

Chemists were valuable to the French government, and Lavoisier was named commissioner of the Royal Gunpowder and Saltpeter Administration in 1775. One of his missions was to arrange, along with Benjamin Franklin (1706–1790), the shipment of saltpeter to the American rebels after France entered the American Revolution on the side of the colonists.

Meanwhile, he continued his experiments. Lavoisier identified oxygen in 1779 and hydrogen in 1783, naming both elements. He published his *Elementary Treatise on Chemistry*—considered the first chemistry textbook—in 1789. The book summarized his earlier findings and also introduced the law of the conservation of mass, the concept that in a chemical reaction the total mass will always remain the same.

Because of his service to the king and status as a tax collector, Lavoisier lost much influence after the Revolution in 1789 and the king's execution in 1793. His scientific preeminence protected him until the next year, when he was tried, convicted, and guillotined all in one day, May 8, 1794, despite protests from other French chemists. He was fifty.

ADDITIONAL FACTS

1. *Combining the French passions for snails and beheadings, Lavoisier conducted a series of experiments in 1768 that proved that certain species of snails would regrow their heads after they were chopped off.*

2. *Lavoisier borrowed the names* oxygen *and* hydrogen *from the Greek terms meaning "acid-former" and "water-former," respectively. (Oxys means "acid"; hydro means "water.")*

3. *Less than two years after his execution, the French government overturned Lavoisier's conviction and apologized to his widow.*

◆◆◆

Cheng I Sao

A Chinese prostitute who became one of her nation's most feared pirates, Cheng I Sao (c. 1785–1844) commanded a huge force of up to 70,000 brigands between 1807 and 1810. Under her leadership, the pirates plundered villages along the coast of China, ran elaborate extortion rackets, and even set up their own floating society on the high seas. Soon after reaching the height of her power, however, Cheng I Sao abruptly decided to give up piracy, accepted amnesty from the Chinese government, and retired to the mainland.

Born Shih Yang, the future pirate queen first went to sea aboard a "flower boat," or floating brothel, in the South China Sea. She married a pirate captain, Cheng I, in 1801, after obtaining a promise that she would have an equal share of his power.

Her husband was one of numerous pirates in the South China Sea who had been hired by the neighboring Vietnamese to attack Chinese shipping. When the Vietnamese reached a peace accord with China in 1802 and withdrew their support, Cheng I organized the pirates into a close confederation of seven fleets. Cheng I died in 1807, and his widow took command of the massive armada.

Life aboard the 400 junks in Cheng I Sao's fleet was harsh, and her punishments for rule breakers were often draconian. Hundreds of pirates, along with their families, might be crowded aboard a single vessel. They were expected to obey orders instantly, or they would be decapitated. She also set strict rules about the division of treasure and enforced the death penalty for pirates who didn't contribute their share of booty to the common treasury. Cheng I Sao also outlawed rape and adultery aboard her ships, making both punishable by death.

The imperial government attempted to arrest Cheng I Sao in 1808, but the leader of the expedition was killed, and almost half the government fleet was sunk or captured. In 1809, the government was forced to ask the British to lend them a warship, the HMS *Mercury,* to chase the pirates. Six Portuguese men-of-war later joined the imperial fleet as well.

Cheng I Sao managed to evade the European ships, but she decided the next year to give up piracy and accept a government amnesty. Almost all of her pirates were spared; of the tens of thousands, 211 were banished and 126 were executed. Cheng I Sao retired to shore, married one of her late husband's lieutenants, and reputedly operated a gambling establishment for the remainder of her life.

ADDITIONAL FACTS

1. *Cheng I Sao had three sons—two with her first husband and another with her second.*

2. *The name by which she was most commonly known, Cheng I Sao, means "wife or widow of Cheng," after her first husband.*

3. *Cheng I Sao appears in a short story, "The Widow Ching, Lady Pirate" (1933), by the Argentinean writer Jorge Luis Borges (1899–1986).*

Percy Bysshe Shelley

The world is weary of the past,
Oh, might it die or rest at last!
—**Shelley**

Percy Bysshe Shelley (1792–1822) was one of the best known of the British Romantic poets and authored such classics as "Ozymandias," "To a Skylark," and the epic *Prometheus Unbound*. A political radical and atheist, Shelley was mostly shunned during his own life but was rediscovered after his death and is now among the most frequently anthologized writers in British literature.

Shelley's upper-class background gave few indications of his future radicalism. The poet's father was a landowner, minor aristocrat, and member of Parliament from Sussex, England. Shelley attended Eton College and, later, Oxford University. Less than a year after entering Oxford, however, Shelley was expelled for religious disbelief. He had published an inflammatory pamphlet called *The Necessity of Atheism* and then enraged the dons by refusing to renounce it. ("Every reflecting mind must acknowledge that there is no proof of the existence of a Deity," he had argued.)

Shelley spent most of the rest of his life writing poetry, touring Europe with fellow Romantic poets John Keats (1795–1821) and Lord Byron (1788–1824), and writing in support of atheism, vegetarianism, and socialism. In addition to radical politics, the Romantics shared an interest in the natural world and in what they called the *sublime*—the primal feelings of awe and fear experienced by man in nature. "To a Skylark," a poem Shelley wrote in 1820, contains many of the recurring themes of the Romantics. Inspired by a bird that Shelley noticed during a walk in Italy, the poem praises the simple, sublime "art" of the bird's song:

Hail to thee, blithe Spirit!
Bird thou never wert,
That from Heaven, or near it,
Pourest thy full heart
In profuse strains of unpremeditated art.

Shelley married the daughter of a tavern keeper in 1811, but abandoned his wife three years later to live with novelist Mary Wollstonecraft (1797–1851). (His first wife, distraught, committed suicide in 1816; Shelley promptly married Wollstonecraft.) The poet himself drowned in a shipwreck just shy of his thirtieth birthday.

ADDITIONAL FACTS

1. *Shelley's second wife, Mary, was the daughter of feminist philosopher Mary Wollstonecraft (1759–1797), as well as the author of* Frankenstein *(1818).*

2. *The poem "Ozymandias" takes its name from another name for Ramses II (c. 1303–1213 BC), an Egyptian pharaoh known for erecting huge statues of himself.*

3. *Despite Shelley's vocal atheism, his heart was buried at the Protestant Cemetery in Rome. The monument contains the Latin epitaph* Cor Cordium—*"Heart of Hearts."*

❖❖❖

Simón Bolívar

Six different countries claim the South American revolutionary Simón Bolívar (1783–1830) as their founder. The number reflects Bolívar's amazing success as a fighter—and his notable failures as a politician. The general was able to virtually eliminate Spanish power on the continent, but he died without achieving his ultimate goal of creating a strong, unified South America.

Bolívar was born into a wealthy family in Caracas, Venezuela, that had made its fortune in mining. He was educated in Spain, which in the early nineteenth century was still clinging to its vast imperial holdings in South America and the Caribbean.

The Napoleonic Wars in Europe, however, greatly weakened the Spanish government and made it unable to defend its grasp on its colonies. Bolívar, who returned to Venezuela in 1807, joined the growing resistance movement and led the campaign to liberate Venezuela in 1813. In recognition of his success, he was nicknamed el Libertador—the Liberator.

An admirer of George Washington and the American Revolution, Bolívar hoped to create a South American republic on the model of the United States. In a string of military victories, he freed present-day Colombia (1819), Panama (1819), Ecuador (1822), Peru (1824), and Bolivia (1825). Bolívar launched his Gran Colombia, which he hoped would be a continent-wide confederation, in 1821.

Gran Colombia, however, proved to be Bolívar's downfall. The federation was deeply divided and failed to agree to a constitution at a convention in 1828. Despite his idealistic hopes and belief in democracy, Bolívar then named himself dictator in an effort to create a functioning country. The plan backfired and Bolívar—once the most beloved man in South America—was widely reviled. He survived an assassination attempt in 1828 and was forced to resign in 1830.

Suffering from tuberculosis, Bolívar planned to go into exile in Europe or the Caribbean. He died before he could leave South America, however, at a small plantation in Colombia. He was forty-seven.

ADDITIONAL FACTS

1. *Other individuals who have countries named after them include King Philip II of Spain (1527–1598; the Philippines), explorer Christopher Columbus (1451–1506; Colombia), and Amerigo Vespucci (1454–1512), an Italian mapmaker whose Latin name was given to the newly discovered continent in 1507 and subsequently incorporated into the official name of the United States of America.*

2. *The Nobel Prize–winning Colombian novelist Gabriel García Márquez (1928–) published a fictionalized account of the last several months of Bolívar's life,* The General in His Labyrinth, *in 1989. The book was controversial in Latin America because of its unvarnished looks at the general's indecisiveness and womanizing.*

3. *Bolívar visited the United States in 1807, during his return trip to Venezuela from Europe. Two towns in the United States—Bolivar, Missouri, and Bolivar, West Virginia—are named in honor of the South American general.*

◆◆◆

Jonathan Edwards

Best known for fiery, emotional sermons that often reduced his listeners to tears, Congregationalist minister Jonathan Edwards (1703–1758) was one of the leading figures of the Great Awakening, a religious revival that swept through the thirteen American colonies in the 1730s.

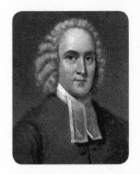

Edwards was the son of Timothy Edwards (1668–1759), a Connecticut preacher, and the grandson of influential Northampton minister Solomon Stoddard (1643–1729), whose church was one of the largest in Massachusetts outside of Boston. Edwards entered Yale when he was only thirteen years old and graduated as valedictorian in 1720. He was ordained in 1727 as his grandfather's assistant.

At the time, many ministers in New England were worried by what they saw as the region's declining morals and by the growing number of colonists who were not full members of the church. Many Congregationalist preachers, including Stoddard, had lowered their admission requirements, adopting a controversial policy known as the Half-Way Covenant, which was designed to increase church membership.

When Edwards became Northampton's minister after Stoddard's death in 1729, he began to give more-dramatic sermons. By 1733, Edwards had sparked a religious revival in Northampton, and he began traveling to other New England churches. He delivered his best-known sermon, "Sinners in the Hands of an Angry God," at a church in Enfield, Connecticut, in 1741; his listeners reportedly wailed and fainted as he described the awful torments awaiting sinners in Hell.

However, the vivid style of Edwards and other Great Awakening preachers alienated more-traditional Congregationalists, and he also upset some of his own congregants by opposing the Half-Way Covenant. He was eventually forced out of his church in 1750.

After leaving Northampton, Edwards served as a missionary to the Native Americans in western Massachusetts from 1751 to 1757. In 1758, he accepted the presidency of Princeton University, but died the next year at age fifty-five from a botched smallpox inoculation.

ADDITIONAL FACTS

1. *A residential dorm at Yale University, Jonathan Edwards College, was named in the preacher's honor.*

2. *Edwards married Sarah Pierrepont, the daughter of one of Yale's founders, in 1727; the couple had ten children.*

3. *Despite his own upright reputation, Edwards came from a family with more than its share of black sheep. His great-aunt killed one of her own children, and one of his great-uncles was an ax murderer. One of Edwards's grandsons, New York politician Aaron Burr (1756–1836), became notorious for killing Founding Father Alexander Hamilton (c. 1755–1804) in a duel.*

✦✦✦

Shaka Zulu

Shaka Zulu (c. 1787–1828) was among the most historically significant kings of the Zulus, an African tribal confederation that mounted stiff resistance to European colonization in the nineteenth century. In a series of brutal wars during his twelve-year reign, Shaka built an empire that spread over a large part of what is now South Africa and created an army capable of fighting British invasions later that century.

Hundreds of thousands of people were killed during the wars Shaka launched to build his empire. Still, he remains a folk hero, and his name is a rallying cry to Zulus, now one of South Africa's largest ethnic groups.

Shaka was the son of a Zulu chieftain, but his mother became estranged from his father, and both mother and son were banished when Shaka was six years old. After his father's death in 1816, Shaka returned from exile to claim the throne and unleashed a wave of death upon his opponents.

He also began subjugating neighboring tribes (*Zulu* means "high above," or "heavenly") and absorbing them into his empire. In the process, he turned the Zulu military into a formidable force, deploying new types of weapons, organizing his warriors into fighting units, and instilling a warrior ethos.

In 1828, Shaka was assassinated by his half-brother, who took over the empire Shaka had established. The Zulu kingdom lasted until 1879, when Shaka's nephew, Cetshwayo (c. 1827–1884), was defeated by the British in the bloody Anglo-Zulu War.

Shaka's memory, however, has continued to play a significant role in South Africa. During the apartheid era, Zulus formed the core of the Inkatha Freedom Party, and images of Shaka were often used as potent symbols of native power during the anti-apartheid struggle.

ADDITIONAL FACTS

1. *In 2008, the Grammy Award–winning South African band Ladysmith Black Mambazo released a tribute album to the Zulu king,* Ilembe: Honoring Shaka Zulu.

2. *A made-for-TV miniseries,* Shaka Zulu, *aired in 1986, with South African actor Henry Cele (1949–2007) in the title role.*

3. *The American civil rights leader and Black Panther official James Forman (1928–2005) named his son Shaka after the Zulu monarch.*

❖❖❖

Mary Wollstonecraft

A pioneering feminist philosopher, Mary Wollstonecraft (1759–1797) is best known for her groundbreaking 1792 treatise *A Vindication of the Rights of Woman* (1792). The book offered an eloquent defense of sexual equality and has been cited by historians as one of the opening salvos of the feminist movement that emerged in Europe and the United States in the nineteenth century. During her own lifetime, however, Wollstonecraft was better known for her tumultuous personal life, association with political radicals, and premature death.

Wollstonecraft was born in the East End of London, the second of seven children. She had little to no formal education, but read widely from Shakespeare, Milton, and the Bible. She became a schoolteacher in 1784, an experience that helped shape her first book, *Thoughts on the Education of Daughters: With Reflections on Female Conduct in the More Important Duties of Life* (1787). She wrote a novel the next year, *Mary, A Fiction* (1788), and published an anthology for women readers under a pseudonym.

Wollstonecraft's first explicitly political book, *A Vindication of the Rights of Men* (1790), was published in the midst of a raging debate in Britain over the French Revolution. Many Britons were horrified by the violence in Paris, but Wollstonecraft sided with radicals who supported the overthrow of the French monarchy. After publishing *A Vindication of the Rights of Men,* she began work on its sequel. In *A Vindication of the Rights of Woman,* Wollstonecraft criticized the institution of marriage and attacked the educational system for cheating women out of opportunities. Women had the same inherent capabilities as men, she argued, but had been denied the chance to use them.

Wollstonecraft traveled to Paris in 1792 and lived there during the height of the Great Terror. While in Paris, she began an affair with an American, Gilbert Imlay (c. 1754–1828). Because British citizens were at risk of persecution in revolutionary France, Wollstonecraft posed as Imlay's wife to avoid imprisonment. The couple eventually had an illegitimate child before separating in 1796.

In the same year, she met the English radical William Godwin (1756–1836). They married the next year. She died at age thirty-nine from complications soon after giving birth to the couple's only child.

ADDITIONAL FACTS

1. *Wollstonecraft's younger daughter, Mary (1797–1851), married the poet Percy Bysshe Shelley (1792–1822) in 1816 and wrote the 1818 novel* Frankenstein. *Wollstonecraft's older daughter, Fanny Imlay (1794–1816), committed suicide at age twenty-two.*

2. *Godwin wrote a biography of his late wife,* Memoirs of the Author of "A Vindication of the Rights of Woman," *which was published after her death. It was controversial for its frank depiction of her affairs and suicide attempts, but is the most thorough source of information about her life.*

3. *A Vindication of the Rights of Woman was dedicated sarcastically to one of Wollstonecraft's critics, Charles Maurice de Talleyrand-Périgord (1754–1838), who would later become a famous French diplomat and, briefly, the prime minister of France.*

Johann Carl Friedrich Gauss

By the age of three, Johann Carl Friedrich Gauss (1777–1855) was calculating his father's finances. By seven, he had astonished his elementary school math teachers by solving a complex problem in seconds. As a teenager, he was tackling geometry theorems that had gone unsolved since the ancient Greeks.

Yet despite his obvious talent, Gauss struggled for acceptance as a mathematician. His father, a poor peasant, disapproved of his studies and wanted his son to follow in his footsteps as a mason. The young Gauss was able to attend college only on a scholarship.

But the publication of his most famous book, *Disquisitiones Arithmeticae* (1801), cemented Gauss's reputation as one of the most powerful minds in modern mathematics. The book compiled discoveries Guass had made over the preceding decade, including his proof that it was possible to draw a regular heptadecagon—a figure with seventeen equal sides—with only a ruler and compasses, a problem that had vexed mathematicians since it was first posed by the Greeks 2,000 years earlier.

The same year, Gauss won renown by accurately predicting the path of Ceres, a large asteroid between Jupiter and Mars that had been discovered by an astronomer. Gauss famously claimed that he had calculated the trajectory in his head.

Outside the classroom, Gauss suffered a series of personal tragedies in the early nineteenth century, culminating in the death of his first wife in 1809. His second wife—the best friend of his first wife—also died young. Ironically, even after Gauss's own youthful rebellion to become a mathematician, he became estranged from two of his own sons after they disobeyed his wishes and immigrated to the United States.

Gauss was given a professorship at the University of Göttingen in 1807 and stayed there for the rest of his life. He died at age seventy-seven.

ADDITIONAL FACTS

1. *In one of the most famous incidents of Gauss's youth, a math teacher asked his elementary school class to add all the integers from 1 through 100, expecting the problem to be a time-consuming task. But to the teacher's surprise, the seven-year-old Gauss instantly solved the problem and correctly gave the answer, 5,050. Gauss had realized that each pair of numbers—1 and 100, 2 and 99, 3 and 98, etc.—added up to 101. He simply multiplied 101 by 50 pairs, arriving at the total.*

2. *The gauss, a unit of magnetic attraction, is named after the German mathematician. To degauss something means to demagnetize it.*

3. *Gauss invented a primitive, 5,000-foot telegraph line that connected the observatory in Göttingen with the university in 1833—a decade before the more famous Samuel Morse (1791–1872) telegraph linked Baltimore and Washington.*

✦✦✦

Henry Wirz

Henry Wirz (1822–1865) was the only individual executed for war crimes after the US Civil War. Since then, a debate has raged over whether the Confederate officer was unjustly scapegoated—or was truly responsible for the deaths of tens of thousands of Union prisoners.

Wirz was the superintendent of the South's largest prisoner-of-war (POW) camp, at Andersonville, Georgia. In the fourteen months the camp operated, approximately 13,000 of 49,485 inmates died of starvation, gangrene, scurvy, and other ailments.

A Swiss-born doctor, Wirz was convicted of conspiracy and murder for failing to protect the prisoners. But his trial was marked by numerous irregularities, and critics have argued that he was blamed for circumstances that were far beyond his control.

Wirz was born in Zurich and attended medical school in Europe. He immigrated to the United States in the 1840s and settled in Louisiana, where he established a successful medical practice. He joined the Confederate Army in 1861 and was eventually elevated to captain. Wirz was placed in charge of Andersonville in March 1864, a month after the camp opened.

Before 1863, neither army in the Civil War held POWs for extended periods of time. Instead, they swapped prisoners regularly, a system that relieved both sides of the need to care for captured enemy soldiers. But the exchange system broke down in 1863 for a variety of reasons, including the unwillingness of the Confederacy to trade black Union soldiers for white Confederate POWs.

Supplies of food and medicine at Andersonville were scarce. The camp was also severely overcrowded, holding tens of thousands more prisoners than was intended. At his trial, Wirz said that he had asked for more food, but had been ignored. (By 1864, food shortages were common across the Confederacy, not just in prisoner-of-war camps.)

Wirz was arrested after the war, imprisoned in Washington, and tried in July 1865. Many former Union prisoners testified against him, including some who were never actually held at the camp. President Andrew Johnson (1808–1875) ignored a request for clemency, and Wirz was hanged in November 1865. The Confederate leaders who had opened Andersonville and filled it far beyond capacity—Confederate States of America president Jefferson Davis (1808–1889) and secretary of war James Seddon (1815–1880)—were never punished.

ADDITIONAL FACTS

1. *The National Prisoner of War Museum, located at the site of the Andersonville prison, opened in 1998.*

2. *After his arrest, Wirz was jailed in Washington, DC, at a prison on the current site of the US Supreme Court building. (Until the 1930s, the Court met in the Capitol building.)*

3. *The judge at Wirz's trial was Union general Lew Wallace (1827–1905), who later went on to literary fame as the author of* Ben-Hur: A Tale of the Christ *(1880).*

❖❖❖

Fryderyk Chopin

Polish patriot and composer Fryderyk Chopin (1810–1849) spent most of his adult life in Paris, but is regarded as a hero in his home country for his support for Polish independence. He is also one of the best-loved and most-often-imitated composers of the nineteenth century, and his piano compositions have become standard parts of the classical repertoire.

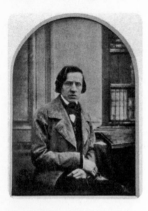

Chopin was born in Zelazowa Wola, a village near Warsaw. His mother was a housekeeper for a local nobleman, and his father was a Frenchman who had immigrated to Poland in the 1780s. Shortly after Fryderyk's birth, the family moved to Warsaw, where he would spend most of his childhood.

A musical prodigy, Chopin began taking piano lessons at age six and had already finished his first two compositions within a year. His piano teacher ended Chopin's lessons when he was twelve, declaring that there was nothing left to teach the young prodigy.

In 1829, after studying music theory at Warsaw University, Chopin left Poland for Vienna. A few days after his arrival in Vienna, news of the Polish uprising against Russian rule reached the city. Chopin considered returning to Poland to join the rebels, but decided to stay in Vienna; as it turned out, the uprising failed, and Chopin would never set foot in Poland again.

Chopin moved to Paris in 1831, where he joined the large Polish refugee community and wrote many of his best-known piano compositions. In about 1837, he began a love affair with the divorced French novelist George Sand (1804–1876), a storied and tempestuous relationship that Sand eventually ended in 1847—reportedly at her son's insistence.

After fighting a mysterious illness for more than a year, Chopin died in Paris at age thirty-nine. In accordance with his wishes, his body was buried in France—but his heart was returned to Poland and buried at a church in Warsaw.

ADDITIONAL FACTS

1. *Chopin did not name any of his compositions and referred to them only by number. Many of them have acquired nicknames over the years, such as* Funeral March *for Piano Sonata no. 2 in B-flat Minor, Opus 35, and* Heroic *for the Polonaise in A-flat Major, Opus 53.*

2. *After his death, Chopin's body was interred at Père Lachaise Cemetery in Paris—the same graveyard where rock singer Jim Morrison (1943–1971) was later buried.*

3. *Actor Hugh Grant (1960–) played Chopin in the 1991 movie* Impromptu.

◆ ◆ ◆

Nat Turner

Nat Turner (1800–1831), a slave in Virginia, led the most successful slave rebellion in the United States before the Civil War. Although short-lived, the revolt led to dozens of deaths, spread fear widely across the South, and contributed to the growing sectional tensions in antebellum America over the issue of slavery.

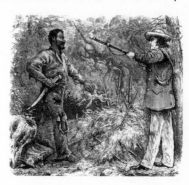

In assessing the historical impact of Turner's uprising, the abolitionist writer William Lloyd Garrison (1805–1879) called it "the first step of the earthquake."

Turner was born and spent his whole life in Southampton County, Virginia, a rural area on the border with North Carolina. While educating slaves was frowned upon in the South, Turner learned how to read, mastered the Bible, and became a Baptist preacher to fellow slaves in the fields.

In the late 1820s, Turner began to experience religious visions and became convinced that he had been picked by God to lead an uprising. Turner interpreted a solar eclipse in February 1831 and atmospheric disturbances later that year as omens and began the revolt on the night of August 21, 1831.

Turner and his followers went on a rampage the next day, stabbing and clubbing to death dozens of whites. The men attempted to seize the town of Jerusalem, Virginia, but were repulsed on the afternoon of August 22, ending the revolt.

As news of the killings spread, many Southern whites responded with panic. Hundreds of innocent blacks were targeted in revenge killings. The Turner uprising also helped polarize the political issue of slavery: In the eyes of many fearful Southerners, abolitionists were no longer seeking merely to end slavery, but also to kill slaveholders. The small abolitionist movement in the South virtually disappeared.

Turner escaped into the forest near Jerusalem, but was captured about two months later. He was hanged on November 11, 1831.

ADDITIONAL FACTS

1. *Some scholars have argued that Turner's ability to read enabled him to determine when the next solar eclipse would occur and that he used that information to demonstrate to other slaves that God had ordained the revolt.*

2. *The Confessions of Nat Turner, a historical novel based on the revolt and written by William Styron (1925–2006), won the Pulitzer Prize in 1968.*

3. *A PBS movie, Nat Turner: A Troublesome Property, was broadcast in 2003. The filmmaker, Charles Burnett (1944–), acknowledged the conflicting stories about Turner by casting seven different actors, with each actor playing the version of Turner presented in a different account.*

✦✦✦

John Wesley

In 1709, a fire swept through the home of an Anglican preacher in the town of Epworth, England. Miraculously, the preacher's six-year-old son, John Wesley (1703–1791), somehow managed to survive the flames.

Years later, after he founded the Methodist Church, Wesley would write that he thought of himself as a "brand plucked from the burning"—saved from the flames in order to serve God.

Wesley had been born into a deeply religious family in eastern England. His father, Samuel Wesley (1662–1735), served as Epworth's rector for forty years and was also a noted poet. His mother, Susanna Wesley (1669–1742), wrote several commentaries on the Ten Commandments and other religious topics. In 1720, John Wesley entered Oxford University, where he and his brother Charles joined a "holy club" of particularly devout Christian students who were derisively known around campus as *methodists*. He was ordained a minister in 1728. After leaving Oxford, he moved to Savannah, Georgia, in 1735, hoping to convert Native Americans to Christianity.

Wesley's trip to Georgia was a disaster, both professionally and personally. The Native Americans were uninterested in his preaching. His personal life collapsed into turmoil after he fell in love with a Georgia woman who spurned him to marry another man, and he was eventually forced to return to England after the woman's husband accused him of slander.

He returned to England in 1738, despondent. Then, on May 24, 1738, he heard a sermon at a Moravian Church in London that, as he famously wrote, left his "heart strangely warmed." The sermon revived his faith, and he began preaching, traveling across England on horseback to speak in cottages, farms, even cemeteries. He organized his followers into the Methodist Society of England in 1739.

Wesley's main differences with the official Church of England were in tone—he was an evangelical, revivalist preacher who spoke in emotional, optimistic language about the possibility of salvation—and church governance. He ordained his own preachers instead of deferring to the Anglican bishops, which effectively divided Methodists from the Anglican Church.

By the time he died at age eighty-seven, Wesley had a growing following of thousands. Methodism claims about 8.6 million adherents in the United States today.

ADDITIONAL FACTS

1. *Charles Wesley was an extremely prolific hymnist. He is credited with writing an astonishing 6,000 Methodist hymns, which helped earn the Methodists their reputation as a "singing people."*

2. *Wesley fell in love several times but did not marry until 1751, when he wedded Mary Vazeille, the widow of a London merchant. The marriage came under strain because Wesley spent so much of his time traveling, and she later left him.*

3. *Wesley's famous last words were, reportedly, "The best of all is, God is with us."*

◆ ◆ ◆

Andrew Jackson

On the day in 1829 that he was inaugurated president, Andrew Jackson (1767–1845) invited his supporters to celebrate with him at the White House. The reception that followed—a raucous, drunken bash—caused a minor scandal and thousands of dollars of damage to the executive mansion.

Jackson's rowdy inaugural party—the president was eventually forced to escape the White House by a secret exit to avoid the mob—symbolized the massive political earthquake that his election represented. He was the first president who was not an Easterner, who lacked a college education, and who was not born wealthy.

Born in Waxhaw, South Carolina, Jackson grew up in the shadow of the American Revolution. His family was killed during the war, and Jackson spent time in a prisoner-of-war camp, where he developed an intense loathing for the British.

After the war, Jackson moved to Tennessee, where he took up practice as a lawyer (in the eighteenth century, no law degree was required). He also fought in wars against Native Americans and returned to service in the War of 1812 to fight the British. Jackson's exploits in the war—he led the Americans to victory at the Battle of New Orleans in 1815—brought him national attention. He ran for president in 1824 against John Quincy Adams (1767–1848) and won the recorded popular vote, but did not get a majority of Electoral College votes. His supporters were outraged when the House of Representatives declared Adams the winner; Jackson spent the next four years agitating for electoral reform and defeated Adams in 1828.

As president, Jackson focused attention on the needs of the western and southern farmers who had elected him. He pursued the "removal" of Indians from the South, a demand of whites, and rescinded the charter of the Second Bank of the United States, which he and his supporters viewed as a tool of the Eastern financial elites. Jackson's tenure also coincided with an intensification of regional divisions over the issue of slavery. Though Jackson was himself a slaveholder and sympathetic to the South, he was an opponent of the states' rights doctrine and sent federal troops to South Carolina to enforce an unpopular tax law.

Although enormously popular, Jackson retired after two terms to his plantation, the Hermitage, near Nashville. He remained a powerful behind-the-scenes figure in national politics, offering advice to his successors and helping to build his Democratic Party, until his death at age seventy-eight.

ADDITIONAL FACTS

1. When Jackson moved to Tennessee, it was part of the state of North Carolina. The region was split off and admitted to the Union as a separate state in 1796.

2. Jackson acquired a 640-acre plantation in 1804. He initially called the farm Rural Retreat, but then changed its name to the Hermitage. It was recognized as a National Historic Landmark in 1960.

3. One of Jackson's officers in the War of 1812 was Davy Crockett (1786–1836), the famous frontiersman who would die at the Battle of the Alamo during the Texas Revolution.

◆◆◆

Hegel

On the eve of the French attack on the Germany city of Jena in 1806, a philosophy teacher at the city's local university was rushing to finish a manuscript. The French victory the next day would devastate the town and destroy the Prussian army. But the book that Georg Wilhelm Friedrich Hegel (1770–1831) finally finished that night would change history.

Hegel, arguably the most important German thinker of the early nineteenth century, came of age during the turbulent period of European history following the French Revolution in 1789. The Revolution, and the series of wars across the continent that followed, shaped Hegel's life and, in some respects, his philosophy. His philosophy, in turn, was a significant influence on Karl Marx (1818–1883) and other continental thinkers.

Born in the Protestant enclave of Stuttgart, a city in mostly Roman Catholic southern Germany, Hegel was initially raised to be a Protestant clergyman before switching to philosophy. He attended a provincial university and in 1801 accepted an unpaid teaching position at Jena, where he lived off an inheritance and began writing *Phenomenology of Mind* (1807), the book that he finished during the war.

Early in life, Hegel supported the French revolutionaries, even planting a "freedom tree" to honor the storming of the Bastille. He edited a pro-Napoleonic newspaper in Bamberg and, like many young Europeans, hoped the emperor would import French-style social change across the Continent. He would lose his enthusiasm for the revolutionaries, however, after enduring the hardships of the Napoleonic Wars.

In and out of financial distress for decades, Hegel was not able to secure a steady academic job until 1816. He was awarded a professorship at the University of Berlin in 1818, and his *Philosophy of Right* was published in 1820. By then, his youthful enthusiasm for the revolutionaries had abated. Hegel's later writing celebrated German national unity, denounced revolutionary riots in Prussia, and supported the authoritarian Prussian state that he had opposed as a young man.

Hegel's philosophy resonated throughout the nineteenth century and was debated for decades after his death at age sixty-one during a cholera epidemic. His approach to the study of history was a major influence on Marx, who incorporated elements of Hegelianism into his political theories.

ADDITIONAL FACTS

1. *Hegel's younger brother, Georg Ludwig Hegel (1776–1812), joined Napoléon's army and was killed during the French emperor's invasion of Russia in 1812. Hegel's illegitimate son, Ludwig, suffered a similar fate, joining the Dutch army and dying of fever in 1831 during an expedition to the Dutch East Indies.*

2. *Although he was baptized with three first names, Hegel didn't use any of them. His wife, Marie Helena Susanna von Tucher (1791–1855), apparently referred to him simply as Master; friends and colleagues called him the Old Man.*

3. *After leaving Jena following the battle, Hegel worked briefly as a newspaper editor and then was the principal of a high school in Nuremberg from 1808 to 1815.*

◆◆◆

Charles Babbage

I wish to God these calculations had been executed by steam.
—Charles Babbage

In 1832, a group of machinists started work on a mysterious invention at a workshop in England. Expected to weigh fifteen tons, the device would be five times larger than early railroad locomotives. Blueprints for the steam-powered machine, which had the financial backing of the British government, called for 25,000 separate parts—a staggeringly complex array of gears and rods that seemed to serve no purpose.

Designed by the mathematician Charles Babbage (1791–1871), the device taking shape at the factory was the world's first mechanical calculator. A full century before the invention of computers, Babbage had designed a machine that he was convinced could execute complex mathematical functions with unerring speed and accuracy. Although its cost was enormous, Babbage predicted that his Difference Engine No. 1 would revolutionize science, business, and engineering.

Babbage was born in London and graduated from Cambridge in 1814. A prolific writer, he was elevated in 1828 to his alma mater's prestigious Lucasian professorship, the chair once held by Isaac Newton (1643–1727).

Like many other mathematicians in Victorian-era England, Babbage was troubled by the unreliable mathematical tables that architects, engineers, and navigators depended on. Compiled by hand and subject to human error, the tables were often full of mistakes. Beginning in the 1820s, Babbage began crafting blueprints for his Difference Engine. He also designed a second, more compact version, the Difference Engine No. 2 (it weighed only 2.6 tons), and an Analytical Engine, a programmable computer that he was still tinkering with at the time of his death.

Only the Difference Engine No. 1, however, ever left Babbage's drawing board. He spent the equivalent of about $1 million building the machine in the early 1830s. But only about one-seventh of the device was ever finished. In 1833, after a payment dispute with the contractor, Babbage's project was abruptly canceled.

For the rest of his life, Babbage worked on designs for his machines and developed a reputation as the quintessential eccentric British scientist. Finally, in 2002, a museum completed the Difference Engine No. 2 from Babbage's blueprints. When the museum tested the device, Babbage was vindicated: It worked.

ADDITIONAL FACTS

1. *Babbage was a candidate for a seat in Parliament in 1832, running as a liberal reformer. He was defeated and never ran for office again.*

2. *He married Georgiana Whitmore in 1814. The couple had eight children, but five died in infancy.*

3. *In addition to his mathematical pursuits, in 1847 Babbage also invented the ophthalmoscope, the device used by eye doctors to examine the retina.*

◆◆◆

John Wilkes Booth

April 14, 1865, Good Friday, began as a day of jubilation in Washington, DC. The Civil War was effectively over. Confederate general Robert E. Lee (1807–1870) had surrendered five days earlier. That evening, President Abraham Lincoln (1809–1865) and First Lady Mary Todd Lincoln (1818–1882) celebrated by attending a play, *Our American Cousin,* at Ford's Theater. When they arrived at their flag-draped box a few minutes late, the audience erupted into cheers, and the orchestra stopped the performance to play "Hail to the Chief."

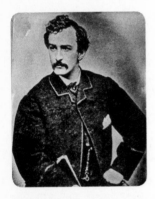

John Wilkes Booth (1838–1865), who was boarding at a house a few blocks away from the theater, was already nationally famous as the day began, a renowned Shakespearean actor considered by some to be the handsomest man in America.

But Booth was also a Confederate sympathizer who was enraged by the South's impending defeat. In 1864, he had devised a plot to kidnap Lincoln. That morning, however, Booth hatched a new plan: He would kill Lincoln, and several of his coconspirators would kill other top government officials.

Booth was the only plotter who managed to complete his mission. He sneaked into Lincoln's box, shot him in the back of the head, and then leaped from the box onto the stage. According to most accounts of the assassination, he shouted, "*Sic semper tyrannis*"—Latin for "Thus always to tyrants"—and fled on horseback to Maryland.

The killing of Lincoln stunned the nation, provoked a massive manhunt for the conspirators, and probably had the opposite of Booth's intended effect by ensuring harsher treatment for the defeated Confederacy. Four of the conspirators were apprehended, tried at courts-martial, and hanged in July 1865. Booth was a fugitive for twelve days, until he was tracked down by Union forces at a barn in rural Virginia. He was shot in the ensuing melee; he was twenty-six at the time of his death.

ADDITIONAL FACTS

1. *Ford's Theater was reopened by President Barack Obama (1961–) in 2009 after an extensive renovation. (He sat in the front row, not in the presidential box.)*

2. *The Maryland doctor who treated Booth's broken leg after the assassination, Samuel A. Mudd (1833–1883), was convicted of aiding and abetting and sentenced to life in prison. He was pardoned and released four years later.*

3. *Booth's plot also targeted secretary of state William Seward (1801–1872) and vice president Andrew Johnson (1808–1875). Seward was stabbed several times by Lewis Powell (1844–1865) but survived; George Atzerodt (1835–1865) was supposed to kill Johnson, but got cold feet at the last minute. Both Powell and Atzerodt were arrested, convicted at courts-martial, and hanged on July 7, 1865.*

◆◆◆

Charles Dickens

A hugely popular novelist, Charles Dickens (1812–1870) was perhaps the leading author of Victorian Britain. His long, suspenseful novels set in the slums and factories of Industrial Revolution–era London introduced several of the most beloved characters in English literature, from Tiny Tim to Oliver Twist—and also some of its most memorable villains, from Scrooge to Fagin.

Dickens published most of his novels in serial form, charging his readers a shilling for each chapter as it was written. Fans were so riveted by the books that, according to contemporary news accounts, anxious crowds gathered at the docks in New York City to wait for the ship carrying the next installment of *The Old Curiosity Shop* (1841).

Born in Portsmouth, England, Dickens enjoyed a relatively happy childhood that ended abruptly when his father was arrested for debt and thrown in prison. Forced to support his family at age twelve, Dickens went to work making shoe polish under conditions that would later be described as Dickensian. He worked ten-hour days with several other children in a run-down building swarming with rats.

After an inheritance rescued the family from poverty, Dickens returned to school and eventually worked as a legal clerk and journalist. His first novel, *The Pickwick Papers,* was serialized beginning in 1836. The book was a hit and was followed by *Oliver Twist* (1837), *Nicholas Nickleby* (1838), *The Old Curiosity Shop,* and *Barnaby Rudge* (1841). The series of novels established him as one of the most popular writers in England. He published *A Christmas Carol,* his famous holiday morality tale, as a single volume in 1843.

Aimed at the general public, Dickens's novels have met with mixed reviews since their publication. He was a master of narrative techniques such as the cliffhanger, and his experiences as a child laborer and reporter gave him an unusual degree of insight into the struggles of his working-class characters. Dickens's fictional writing about conditions in London slums and prisons was powerful enough to spur reform in the real world. Still, some critics have faulted him for the sentimentality of the books and his frequently one-dimensional characters.

Later in life, Dickens experimented with historical fiction in *A Tale of Two Cities* (1859). He survived a famous railroad crash in 1865 and died five years later, after a stroke. He was fifty-eight.

ADDITIONAL FACTS

1. *Early in his career, Dickens published under the pseudonym Boz. He began publishing under his own name with* Oliver Twist.

2. *Irked by American publishers who reprinted his books without paying royalties, Dickens traveled to the United States in 1842 to urge Congress to pass a copyright law. He was rebuffed and later wrote a book,* American Notes, *expressing his general disdain for the United States. With some exceptions, British authors could not copyright their works in the United States until 1891.*

3. *The mahogany desk on which Dickens wrote many of his novels was auctioned for $848,000 in 2008.*

♦♦♦

Hong Xiuquan

Convinced that he was the brother of Jesus Christ, Hong Xiuquan (1814–1864) launched one of the bloodiest wars in human history in 1851 when he attempted to overthrow the emperor of China and install himself as a new Christian monarch instead.

The war, known as the Taiping Rebellion, would last fourteen years and kill roughly 20 million soldiers and civilians. Although Hong was able to seize large amounts of territory for his Heavenly Kingdom of Great Peace, the tide turned after European powers sent troops to support the emperor. Hong committed suicide just before the collapse of his kingdom.

Hong was an aspiring teacher from southern China who had repeatedly failed the examination required to enter the Chinese civil service. After again flunking the test in 1837, he had a nervous breakdown and began to experience visions. In one dream, he claimed, God appeared to him and ordered him to rid the world of demon worship. The visions sparked his interest in Christianity, which had been introduced into China by Western missionaries.

By the time Hong began experiencing his visions, China was entering a disastrous period in its history. In the early nineteenth century, the nation suffered through a series of floods, droughts, famines, and foreign invasions. Many Chinese blamed the Qing emperor for the calamities, creating fertile ground for religious and political dissidents such as Hong.

After receiving religious training from an American missionary, Hong spent the 1840s preaching and gaining followers, most of them in southwestern China. He argued that the Qing emperor violated the Christian rules against idol worship.

The rebellion began in 1851, and Hong's troops captured the city of Nanjing in 1853. He made the city his capital and proclaimed a series of laws that banned opium, gambling, slavery, and the ancient Chinese practice of binding the feet of young women. (He also issued an edict against polygamy, but kept a large harem of his own.)

After 1860, however, the emperor was bolstered by support from France and Britain. Hong killed himself in 1864; his son briefly tried to continue the revolt, but it was put down by the end of the year.

ADDITIONAL FACTS

1. *The translation of the Bible that Hong provided to his followers altered several key passages that he found offensive. For instance, he removed the story in Genesis in which Judah has sex with the wife of his deceased son. Hong also changed King David's title to marquis.*

2. *Issachar J. Roberts (1802–1871), the Tennessee-born American preacher who introduced Hong to the Bible, went on to serve as a foreign minister in Hong's government.*

3. *When the Taiping revolt ended, the practice of binding the feet of young women was reestablished across China. It was not banned until 1911 and may have continued in secret for years afterward. Some elderly women in China have deformities caused by having their feet bound.*

♦♦♦

Ann Lee

Ann Lee (1736–1784) was the charismatic leader of the Shakers, a utopian religious group founded in upstate New York that was best known for its raucous church services, high-quality furniture, and total prohibition on sexual intercourse. The ecstatic singing, trembling, and shouting adherents engaged in at their services earned the group its name.

Born to a poor blacksmith in the industrial center of Manchester, England, Lee was sent to work in a factory as a child and never learned to read or write. She tried to avoid marriage. But her father forced her to wed another blacksmith, Abraham Standerin, in 1762.

Unhappy in her marriage, Lee joined a small religious sect led by Jane and James Wardley that had split away from the Quakers. The Wardleys were famous for their confrontational attitudes and had been known to burst into Anglican churches to disrupt services. Lee joined in several such escapades and was jailed repeatedly beginning in 1770. Encouraged by the Wardleys, she also decided to embrace celibacy, to her husband's consternation. (The couple split up five years later.)

Seeking religious freedom, Lee and eight other Shakers immigrated to New York, where she founded the American wing of the Shaker church in 1774. An unusual event—the "Dark Day" of May 19, 1780—played an important role in Shaker history. On that morning, the sun seemed not to rise over New England. Although probably caused by thick smoke from a large fire, the event was interpreted as a bad omen and triggered a wave of religious fervor across New England and New York.

In 1781, Lee left New York to seek more converts in New England. She established the settlement at Harvard, Massachusetts, one of what would eventually be twenty-one Shaker communities in the United States. The communities lived by principles of hard work, shared property, celibacy, and equality of the sexes. Lee believed that God was both the father and the mother, and many of her followers believed she was Christ's female counterpart.

Lee died in 1784 at age forty-eight, but the church founded by "Mother" Ann Lee grew quickly after her death. At its height in the mid-nineteenth century, the Shakers claimed 5,000 adherents living by one of Lee's famous mottos: "Hands to work, and hearts to God."

ADDITIONAL FACTS

1. *While still living with her husband, Lee had four children, all of whom died in infancy, and suffered four stillbirths.*

2. *American composer Aaron Copland (1900–1990) incorporated the melody of the Shaker hymn "'Tis the Gift to Be Simple" into his ballet* Appalachian Spring, *which won the Pulitzer Prize in 1945. The song was originally written by Shaker elder Joseph Brackett (1797–1882).*

3. *Unable to retain male members, the ranks of Shakers began to dwindle in the late nineteenth century. As of 2010, only a handful of Shakers remain at the 1,800-acre community of Sabbathday Lake, Maine, which was founded in 1794.*

✦✦✦

Queen Victoria

Queen Victoria (1819–1901) was the monarch of Great Britain for a record sixty-three years and ruled the British Empire at a time when it was the world's unquestioned military superpower. The era—dubbed the Victorian Age—was also a period of great scientific and technological advances, political change, and cultural transformation in Britain.

During Victoria's reign, the British monarchy evolved into a primarily symbolic office that ceased to exert real political power. But it was as a figurehead—she was arguably the most recognizable person in the world, as well as a symbol of British might—that Victoria left her imprint on the world's imagination.

Victoria was a granddaughter of King George III (1738–1820), and she inherited the throne after the death of her uncle, King William IV (1765–1837), who had no legitimate children of his own. She was eighteen years old when she became queen.

Three years later, Victoria married a German prince, Albert of Saxe-Coburg-Gotha (1819–1861), and gave birth to the first of nine children. Albert's death from typhoid in 1861 was a profound shock to the queen; she spent the rest of her life in mourning, never remarried, and was nicknamed the Widow of Windsor after she largely withdrew from public life.

For the most part, Victoria's reign was a time of growing economic prosperity in England, with massive industrial growth and a burgeoning middle class. The labor movement also gained power and clamored for more political power during her rule. Internationally, Victoria was inextricably linked with the British Empire, which reached the height of its power in the late nineteenth century. In 1876, she was named empress of India. In 1897, her Diamond Jubilee—the sixtieth anniversary of her coronation—became a giant celebration of the empire. (Rudyard Kipling's poem "Recessional," a celebration of British imperialism, was composed for the occasion.)

Victoria died at age eighty-one and was succeeded by her son, Edward VII (1841–1910).

ADDITIONAL FACTS

1. *Victoria reigned for the longest time of any monarch in the history of the United Kingdom. The incumbent queen, Elizabeth II (1926–), will need to reign until 2016 to surpass her predecessor's record.*

2. *Victoria was nicknamed Drina after her baptismal first name, Alexandrina.*

3. *Victoria had nine children, several of whom married members of other European royal families. The current monarchs of Sweden, Norway, Spain, and Denmark are all descendants of Victoria.*

✦✦✦

Arthur Schopenhauer

In 1865, a twenty-one-year-old student at a German university was idly browsing at a bookstore in Leipzig when he discovered a dusty volume that had been published almost fifty years earlier. The book, called *The World as Will and Representation,* portrayed the world as chaotic and turbulent—a view that left a profound impression on the young man.

The student at the bookstore was Friedrich Nietzsche (1844–1900). The old book's author was Arthur Schopenhauer (1788–1860), an idiosyncratic German philosopher whose gloomy, pessimistic philosophy was a major influence on Nietzsche and legions of other philosophers in Germany and across Europe.

Schopenhauer was an improbable philosopher and did not enjoy great success during his lifetime. Born in the prosperous port city of Danzig, he was raised to follow in the footsteps of his merchant father, Heinrich. Even Arthur's first name was selected because his parents thought it would help him in business. But after his father's early death—a suicide, according to rumor—the young German became disillusioned. At age nineteen, he decided to abandon his business training and instead pursued a university education.

In 1813, he received a doctorate from the University of Jena. *The World as Will and Representation,* the book Nietzsche would discover forty-seven years later, was published in 1818. Schopenhauer was awarded a professorship at Germany's most prestigious university in Berlin, but he was unpopular and lasted only a few years before resigning.

Schopenhauer fled Berlin in 1831 to avoid an epidemic of cholera, never to return. He settled in Frankfurt, where he lived for the rest of his life alongside a pair of French poodles named Atma and Butz. His *On the Will in Nature* was published in 1836, a book that broadened the scope of his philosophy and reflected the influence of Hinduism and of Asian thinkers such as Confucius (551–479 BC).

After he'd lived most of his life in obscurity, Schopenhauer's writings began to attract scholarly attention in his final years. Since his death at age seventy-two, the Philosopher of Pessimism has been hailed as one of the major figures in nineteenth-century German thought.

ADDITIONAL FACTS

1. *Schopenhauer's hometown, known as Danzig at the time of his birth, has changed hands several times over the past three centuries. At various times Germany, Prussia, and Poland have all claimed control of the city. Danzig reverted to Polish control after World War II, however, and is now known as Gdansk.*

2. *During his brief academic career at the University of Berlin, Schopenhauer engaged in a rivalry with his faculty colleague Georg Wilhelm Friedrich Hegel (1770–1831). In 1820, Schopenhauer scheduled a class for the same time that Hegel had one scheduled, forcing students to chose. Most of them chose Hegel, and Schopenhauer quit teaching shortly thereafter.*

3. *Schopenhauer never married, but had one illegitimate child who died in infancy.*

Charles Darwin

The HMS *Beagle,* a ten-gun warship in the Royal Navy, sailed from Devonport, England, on December 27, 1831. Aboard the sloop were a few dozen crewmen, a cache of scientific instruments—and one very seasick naturalist.

"The misery is excessive," complained Charles Darwin (1809–1882) in the journal he kept during the trip. "It far exceeds what a person would suppose."

On the day the *Beagle* set sail, few would have predicted that its woozy, twenty-two-year-old passenger would become one of the most famous and influential thinkers in the history of science. The scientific discoveries that resulted from Darwin's five-year voyage aboard the *Beagle,* however, forever changed the study of biology and sparked a huge clash over religion and science in the nineteenth century. Indeed, Darwin's theory of evolution, the Harvard biologist Ernst Mayr (1904–2005) wrote, is "perhaps the greatest intellectual revolution experienced by mankind."

Darwin, the fifth of six children, graduated from Cambridge with a theology degree, but had little interest in fulfilling his father's wish that he join the ministry.

The expedition, which Darwin chronicled in *The Voyage of the Beagle* (1839), circumnavigated the globe. After his return, Darwin married his first cousin, Emma Wedgwood (1808–1896), and settled into the comfortable life of an upper-class gentleman scientist. He corresponded widely with other researchers and spent much of the next two decades drafting *On the Origin of Species* (1859). In the book, he introduced his theory that species change and evolve over time to adapt to new conditions as the result of a process he called *natural selection.*

Darwin was keenly aware that by contradicting the traditional Christian belief that God had created the world's animals, the *Origin of Species* would be controversial. He even delayed it's publication for years, in part to avoid hurting Emma, who was a devout Anglican. In 1871, he provoked more controversy with *The Descent of Man,* which explicitly applied his theory of natural selection to human evolution. Darwin did not argue that humans descended from apes, but did posit that apes and humans shared a common ancestor.

Widely considered the greatest scientist of his age, Darwin received an official state funeral after his death at age seventy-three.

ADDITIONAL FACTS

1. *Darwin wrote an average of 1,500 letters a year at a clip of about four a day. According to one biographer, his postage and stationery bill for 1877 was greater than the entire salary of his butler.*

2. *After his voyage aboard the* Beagle, *Darwin had a mysterious sickness that would afflict him for the rest of his life. Modern scholars believe it may have been Chagas' disease, a rare illness caused by the bite of a South American insect, the vinchuca or assassin bug.*

3. *In 2003, the British government launched an unmanned spacecraft named* Beagle 2, *after Darwin's ship, to Mars. The probe was intended to look for signs of life on the red planet, but lost contact with Earth after landing on the Martian surface.*

◆◆◆

Boss Tweed

William M. "Boss" Tweed (1823–1878) was a notoriously corrupt politician who virtually controlled New York City in the mid-nineteenth century. The head of the city's Democratic Party machine, Tweed was famous for doling out jobs, favors, and millions of dollars' worth of city contracts to his cronies. He also became famous as the target of artist Thomas Nast (1840–1902), whose series of political cartoons lampooning Tweed contributed to his eventual downfall.

Tweed himself recognized that the cartoons were far more damaging than political opponents, critical newspaper articles, or even police investigations. "Stop them damn pictures," he is supposed to have said. "I don't care what the papers write about me. My constituents can't read. But damn it, they can see the pictures!"

Tweed was a New York City native who was elected to the House of Representatives as a Democrat in 1852. He was not reelected in 1854, but his political career hardly suffered: He later held seats on the New York City board of supervisors, in the state senate, and as the commissioner of the department of public works.

His most influential position, however, was as the "grand sachem" of Tammany Hall, a civic organization aligned with the Democratic Party. Tammany Hall was especially popular with Irish immigrants, a new voting bloc that formed the foundation of Tweed's political power. Tammany organized the vote and also provided social services to its supporters, a model that was relatively common for urban political machines that emerged across the United States in the nineteenth century.

Known for his size—he was six feet tall and weighed 300 pounds—Tweed was a cartoonist's dream, and Nast, a German-born illustrator, made the most of him. In cartoons published in *Harper's Weekly* beginning in 1869, Nast portrayed Tweed as a bloated crook gorging on taxpayer dollars. The cartoons, and an exposé of Tweed's corruption published in the *New York Times,* led to his arraignment in 1871 on charges of stealing millions of dollars from the city. He was convicted and spent several years in prison before jumping bail and fleeing to Spain. He was extradited back to the United States in 1876 and died in prison. But Tammany Hall continued to exert influence in city politics until the mid-twentieth century.

ADDITIONAL FACTS

1. *The Tweed ring controlled its own quarry in Sheffield, Massachusetts, and used its stone to build the Tweed Courthouse, a landmark in downtown Manhattan.*

2. *Tammany Hall was named after a Native American chief, Tamanend (c. 1628–1698).*

3. *The actual Tammany Hall occupied several different addresses in Manhattan during its history. The last, on East Seventeenth Street, is now a theater.*

✦✦✦

Richard Wagner

I can't listen to that much Wagner. . . . I start getting the urge to conquer Poland.
—Woody Allen

On an autumn evening in 1933, an opera by Richard Wagner (1813–1883) was performed for Nazi leader Adolf Hitler (1889–1945). Upon arriving at the show, the führer was surprised to find the theater virtually empty. Furious, he sent the police to raid nearby bars and brothels to fill the empty seats for the performance of his favorite opera, *Die Meistersinger.*

Wagner's role as Hitler's favorite composer has ensured the nineteenth-century conductor and writer a controversial place in history. To his critics, Wagner's German nationalism and anti-Semitism were an ideological gateway to the Nazis. His admirers contend that Wagner cannot be held responsible for the use of his music as the soundtrack to fascism five decades after his death.

What both camps agree on, though, is that Wagner was one of the preeminent cultural figures of his age, a man whose influence extended beyond music into painting, poetry, and philosophy. In the era when Germany first came into existence as a political entity, Wagner sought to fashion a national identity for the new country, complete with mythic gods, heroes—and villains.

Wagner was born in Leipzig and educated mostly in Dresden. Wagner's first love was theater; he would become one of the relatively few opera composers who wrote both the words and the music to his operas. He wrote his first opera, *Die Feen,* in 1833, and married an actress, Christine Planer (1809–1866), in 1836. In 1849, Wagner was forced to flee after playing a minor role in an uprising against the government of Saxony. He spent the 1850s in France, Italy, and Switzerland. In exile, he authored his diatribe against Jews, "Das Judentum in der Musik" (1850), and began working on the four-opera "Ring" cycle, a mammoth, fifteen-hour masterpiece based on tales from Norse mythology.

Wagner's views on race and Judaism were not atypical for nineteenth-century Germany, and some of his defenders believe that those views have unfairly tainted his musical accomplishments. Wagner died in Venice at age seventy-one; his operas, especially the "Ring" cycle, are now considered classics.

ADDITIONAL FACTS

1. *Wagner's opera house in Bayreuth, the Festspielhaus, remains in operation and hosts a performance of the "Ring" cycle every year.*

2. *"The Ride of the Valkyries," a theme from* Die Walküre, *has appeared in the United States, appearing on the soundtracks to movies, in commercials, and even in Warner Bros. cartoons (with the lyrics "Kill the wabbit, kill the wabbit, kill the wabbit").*

3. *In 2000, a conductor and Holocaust survivor, Mendi Rodan (1929–2009), violated an unwritten taboo in Israel by performing a Wagner composition in public. It was believed to have been the first live Wagner performance in the country's history, and it provoked widespread condemnation.*

◆◆◆

Giuseppe Garibaldi

A charismatic hero to millions of Italians, Giuseppe Garibaldi (1807–1882) led the fight for Italian unification and independence. Famous for his military acumen, fervent patriotism, and red-clad followers, Garibaldi emerged as a symbol of resurgent nationalism—not just in Italy, but across nineteenth-century Europe.

The Italian leader was born, ironically, in France. He spent his youth in Nice, a French coastal city with a large Italian-speaking population, and became a merchant sailor as a teenager. After coming into contact with Italian revolutionaries while at sea, Garibaldi joined the underground Young Italy movement, a prounification group, in the 1830s.

At the time, Italy was divided into dozens of small, weak states, many of them hereditary monarchies. In addition, the pope personally controlled a large region of central Italy known as the Papal States. The prounification forces, influenced by other liberal movements in nineteenth-century Europe, sought to introduce democracy across Italy and abolish the Papal States.

Garibaldi was sentenced to death in 1834 after participating in a failed uprising. He fled to South America, where he volunteered to fight in the Uruguayan civil war and adopted the red-shirt uniform for which he became famous. He briefly returned to Italy in 1848, but was forced back into exile in northern Africa, England, and Staten Island, where he lived for about two years.

His major victories would not occur until 1859 and 1860, after he aligned himself with Victor Emmanuel II (1820–1878), the king of Piedmont-Sardinia, and the French emperor Napoléon III (1808–1873). Together, they were able to establish the Kingdom of Italy in 1861. But it was a painful compromise for Garibaldi, who had supported democracy and was annoyed that his home city of Nice was returned to France in exchange for Napoléon's support.

After the war, Garibaldi toured Europe, where he was acclaimed as an inspiration to participants in other nationalist movements. He served in the Italian parliament and retired to an island off Sardinia, where he died at age seventy-four.

ADDITIONAL FACTS

1. *At least one Italian-speaking city-state—San Marino—opted to remain independent instead of joining the newly reunited Italy. San Marino, at only twenty-four square miles, is one of the smallest sovereign countries in the world.*

2. *Thousands of streets and squares in Italy are named after Garibaldi.*

3. *After the outbreak of the US Civil War in 1861, President Abraham Lincoln (1809–1865) offered the Italian command of the Union Army. Lincoln eventually withdrew the offer when Garibaldi demanded that the president explicitly state that the purpose of the war was to abolish slavery.*

◆◆◆

Joseph Smith

The first leader of the Mormon church, Joseph Smith Jr. (1805–1844) was reviled and persecuted during his lifetime but is now revered by millions of Mormons worldwide as the church's founding prophet.

Smith was born in a tiny farming village in central Vermont, and he and his family moved to Palmyra, New York, in 1816. A sensitive child, Smith experienced religious visions in 1820 and again in 1823, purportedly of an angel named Moroni who appeared to him as he was walking in the woods.

The angel told Smith that the authentic Christian church had vanished from the world and it was Smith's job to bring it back. He was instructed to dig into a hillside near Manchester, New York, where he would find holy books inscribed on gold plates. In 1827, according to Smith, he uncovered the plates in a large stone box. They were written in a hitherto unknown language, "reformed Egyptian," and Smith was able to complete what he claimed was a translation, which was published in 1830 as the Book of Mormon.

According to the story related in the Book of Mormon, the ancient Hebrews of the Old Testament had migrated to North America thousands of years before by sailing across the Pacific Ocean. Although their society and language had been destroyed, their descendants lived on as the Native Americans.

Smith officially organized the church on April 6, 1830. However, the Mormons were immediately regarded with suspicion, Smith's gold plates were widely derided, and he was even tarred and feathered by a mob in 1832. The Mormons eventually fled to Ohio and Missouri to avoid persecution and finally moved to the town of Commerce, Illinois, which Smith renamed Nauvoo.

By the time he settled in Nauvoo, Smith had nearly 20,000 followers. He set himself up with near-dictatorial powers in the town, formed a militia, and shut down a newspaper, the *Nauvoo Expositor,* that opposed him. The closure of the newspaper provoked protests, and when Smith called out the city's militia to protect Nauvoo, he was arrested by the Illinois authorities and charged with treason. While awaiting trial, he was killed by an angry mob on June 27, 1844.

ADDITIONAL FACTS

1. *Only 5,000 first-edition copies of Smith's Book of Mormon were printed; one copy sold at auction in 2007 for $105,600.*

2. *After Smith's death, many of his followers departed for Utah. The territory tried to join the United States in 1849, but was refused because congressional leaders were opposed to the Mormon practice of polygamy. Church leaders banned plural marriage in 1890, and Utah was finally admitted to the Union as the forty-fifth state in 1896.*

3. *Smith married his first wife, Emma Hale (1804–1879), in 1827. After founding Mormonism, he wed dozens more women—as many as thirty-four, by some estimates.*

✦✦✦

Abraham Lincoln

The president who won the Civil War, preserved the Union, and freed the slaves, Abraham Lincoln (1809–1865) usually ranks as one of the most-admired figures in American history. He was seen, in the words of one of his cabinet secretaries, as "the most perfect ruler of men the world has ever seen."

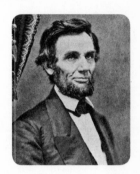

Lincoln was born in a log cabin in Kentucky, moved frequently as a child, and was largely self-educated. As a young man, he failed at a variety of professions, including working on a riverboat and dealing liquor. Reduced to practicing law, he was admitted to the Illinois bar in 1837. His first foray into politics was a failure: He was elected to Congress as a Whig, but lasted only one term after making an unpopular vote against the Mexican War.

Upon returning to Illinois, he resumed his law practice and joined the Republicans, a newly created party. Under the motto "Free Soil, Free Labor, Free Men," the Republicans advocated expansion into the West and limits on slavery, which had emerged as the single dominant issue in national politics. Lincoln was the party's candidate for the Illinois Senate in 1858, but lost the race to Stephen Douglas (1813–1861).

He won the 1860 Republican presidential nomination and was elected in a bitterly contested four-way race. Southern legislators, convinced that Lincoln would abolish slavery, responded to his election by voting, one by one, to secede from the Union. The secession crisis turned into war in April 1861.

The war tested not only Lincoln's skills as a leader, but also the ability of a democracy to fight and win a war for survival. Despite his scant military experience—Lincoln had served in the Illinois militia in 1832—he was an adept commander in chief, prodding his generals to go on the offensive against the Confederacy. He also maintained public support for the war in the face of mounting deaths.

In 1864, Lincoln prevailed in the first US presidential election conducted in wartime. By the time he was inaugurated in March 1865, Union victory was seemingly assured; his inauguration speech urged a speedy forgiveness of the South. However, he was assassinated the next month, just five days after the surrender of Robert E. Lee (1807–1870) and a few weeks before the final collapse of the Confederacy.

ADDITIONAL FACTS

1. *Lincoln was the first US president who was not born in one of the original thirteen colonies.*

2. *The capital city of Nebraska was named after Lincoln in 1867. Three other state capitals are named in honor of presidents: Jefferson City, Missouri; Jackson, Mississippi; and Madison, Wisconsin.*

3. *Lincoln's Democratic opponents were known as Copperheads, a derisive nickname derived from a species of venomous snake.*

Margaret Fuller

On the stormy night of June 19, 1850, the freighter *Elizabeth* ran aground on a sandbar near Long Island, New York. In the high wind and surf, only a few of the ship's passengers managed to reach shore alive. One of the dead was the American philosopher, social reformer, and adventurer Margaret Fuller (1810–1850), who was returning home from Italy aboard the doomed ship.

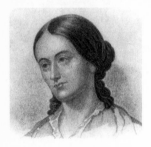

Fuller, who was forty years old at the time of her drowning, was a member of the Transcendental Club, an early nineteenth-century philosophical movement centered in Boston. She was also known for writing *Woman in the Nineteenth Century* (1845), one of the earliest feminist works in American intellectual history.

Fuller was born in Cambridge, Massachusetts, and educated by her father, congressman Timothy Fuller (1778–1835). He drilled her in literature, music, and Greek, a grueling schedule that left her exhausted. "I was often kept up till very late; and as he was a severe teacher, both from his habits of mind and his ambition for me, my feelings were kept on the stretch till the recitations were over," she later wrote.

At age twenty-six, she met the philosopher Ralph Waldo Emerson (1803–1882), who invited her to contribute to the transcendentalist magazine *The Dial*, an influential journal that published such writers as Emerson, Bronson Alcott (1799–1888), and Elizabeth Peabody (1804–1894). Fuller became the journal's editor in 1839. In an 1843 issue of the magazine, Fuller wrote an essay titled "The Great Lawsuit: Man vs. Men and Woman vs. Women." She expanded the article two years later into *Woman in the Nineteenth Century*, which argued for women's equality.

Fuller's work impressed *New York Tribune* editor Horace Greeley (1811–1872), who hired her to write dispatches about a revolutionary movement in Italy. While in Italy, she fell in love with an Italian nobleman and revolutionary leader, the Marchese Giovanni Angelo Ossoli. The couple had a son, Angelo, in 1848.

After the revolution failed, the family was forced to flee Rome and decided to move back to the United States. Ossoli and their infant son were accompanying Fuller aboard the *Elizabeth*; all of them perished in the shipwreck.

ADDITIONAL FACTS

1. *Nathaniel Hawthorne (1804–1864), who disliked Fuller, supposedly based two fictional characters on her: Zenobia in* The Blithedale Romance *(1852) and Hester Prynne in* The Scarlet Letter *(1850).*

2. *Fuller's grandnephew was Buckminster Fuller (1895–1983), who invented the geodesic dome.*

3. *After the wreck of the* Elizabeth, *Emerson sent the writer Henry Thoreau (1817–1862) to search for Fuller's remains. He was unable to find anything at the site, but a monument to Fuller was erected in Mount Auburn Cemetery in Cambridge, Massachusetts.*

◆◆◆

Florence Nightingale

An icon of modern medicine, Florence Nightingale (1820–1910) is credited with saving thousands of lives by improving the care of sick and wounded British soldiers—and, in the process, reinventing the nursing profession.

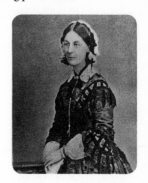

Nightingale, born into an aristocratic British family, decided to become a nurse at age seventeen, when she thought she heard God talking to her as she walked in the garden at her family's estate.

At the time, however, nursing was perceived as disreputable, and Nightingale's family resisted her wishes. Instead, they sent her on a grand tour of Italy, Greece, Germany, and Egypt. The plan backfired, however, when Nightingale enrolled in a nursing class in Germany; she was finally allowed to become a nurse after returning to Britain in 1853.

The event that made Nightingale famous was the Crimean War, a conflict between Britain, France, and Turkey on one side and Russia on the other, which began in 1854. After lobbying Britain's minister of war—a friend of Nightingale's family—she was allowed to join an army hospital in Turkey.

In the hospital, however, the conditions she encountered were hellish: Sewers overflowed, rats and insects swarmed the wards, and far more soldiers died from disease than from wounds on the battlefield.

By providing fresh food and water to the wounded and keeping the hospital clean, Nightingale was able to bring about dramatic improvements. When she first arrived at the hospital, the mortality rate for patients was about 60 percent. By the time she left, it was 2 percent. She was idolized by the British soldiers, who nicknamed her the Lady with the Lamp for her habit of making nighttime rounds to visit the sick.

After the war, Nightingale argued for better conditions at hospitals in Britain and founded a nursing school to spread her methods. She died in London at age ninety.

ADDITIONAL FACTS

1. *Nightingale's parents, who had embarked on a long tour of Europe after their marriage, named Florence after the Italian city in which she was born. Her older sister, also born in Italy, was named Parthenope after the Greek name for the city of Naples.*

2. *The Florence Nightingale effect, named after the famous nurse, refers to a psychological phenomenon in which nurses or doctors fall in love with their patients. There is no evidence that Nightingale herself ever experienced the trait named after her.*

3. *In 1907, Nightingale became the first woman in British history to win the Order of Merit, which King Edward VII (1841–1910) awarded her for her wartime service.*

❖❖❖

Jesse James

Jesse James (1847–1882) killed and stole his way into American folklore with a string of brazen bank and train robberies in the 1860s and 1870s. His gang of ex-Confederate soldiers terrorized Missouri, Kansas, Iowa, and Minnesota before James was finally shot by one of his own men.

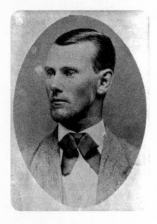

James was glorified during his lifetime, and for many years afterward, as an American Robin Hood, but there is no evidence he spent the stolen money on anyone but himself. And James's gang was notorious for its savagery, especially toward blacks and anyone associated with the Union cause during the Civil War.

James was born in a part of Missouri known as Little Dixie. His father, a slave-owning hemp farmer, died when the child was two, and Jesse was raised primarily by his mother, Zerelda. A border state, Missouri was split over whether to secede, but the James family sided enthusiastically with the Confederacy.

During the war, James and his older brother, Frank (1843–1915), became part of a Confederate death squad that targeted suspected Union sympathizers in Missouri. The Confederacy collapsed in 1865, but for Jesse, the war never ended. The brothers continued robbing banks and trains and assassinating federal officials. They often targeted banks and railroads run by Republican political figures, which inspired some Southern newspapers to embrace the James brothers as heroes.

The demise of the gang began in 1876, when they botched a bank robbery in Northfield, Minnesota. All but two of the robbers—Frank and Jesse—were killed or captured.

With the gang broken up, the brothers went into hiding. Jesse tried to make a living as a farmer under the name of J. D. Howard, but he soon returned to crime, and a $10,000 bounty was placed on his head. Hoping to claim the reward, one of his gang members, Robert Ford (1862–1892), shot James from behind as James was dusting a picture frame. The legendary bandit was thirty-four at the time of his death.

ADDITIONAL FACTS

1. *Actor Brad Pitt (1963–) played James in the 2007 film* The Assassination of Jesse James by the Coward Robert Ford. *James has also been played by Robert Duvall (1931–), Colin Farrell (1976–), and Audie Murphy (1924–1971). James's son, Jesse James Jr. (1875–1951), portrayed his father in several silent films.*

2. *The James gang was only one of many like-minded armed groups of disaffected Confederate veterans that unleashed mayhem in the years after the war. Indeed, James and his fellow gang members reportedly wore Ku Klux Klan robes for their first train robbery in 1873.*

3. *Robert Ford fled Missouri after collecting his reward for killing James. He eventually settled in Colorado, where he was himself murdered in 1892.*

✦✦✦

Eadweard J. Muybridge

One of the great technical and artistic innovators in the history of photography, Eadweard J. Muybridge (1830–1904) was an English immigrant to the United States who became famous for his groundbreaking picture sequences of horses and people in motion. The pictures, and the new techniques Muybridge invented to make them, dramatically demonstrated the capabilities of the camera and are considered important predecessors to movie technology.

In addition to his artistic accomplishments, however, Muybridge was also notorious during his lifetime for his bizarre appearance, frequent name changes, and acquittal on murder charges in 1874.

Muybridge was born Edward Muggeridge in Kingston-upon-Thames, England. He changed his name a total of five times, eventually settling on Eadweard Muybridge after he immigrated to the United States in the early 1850s. He moved to San Francisco in 1855, where he worked primarily as a landscape photographer.

In 1872, Muybridge met Leland Stanford (1824–1893), a railroad baron and former California governor. Stanford, a racehorse owner, offered the photographer $2,000 to settle definitively an age-old question: Do all four legs of a galloping horse leave the ground at the same time?

Answering the question required Muybridge to develop entirely new photographic techniques in order to "freeze" the horse in motion. The project took six years in total and was interrupted by his murder trial in 1874. (Stanford paid for his defense lawyer.) After thirteen hours of deliberation, a Napa, California, jury acquitted Muybridge on the grounds of "justifiable homicide" for killing his wife's lover.

The famous sequence of horse pictures was taken with twelve cameras on the morning of June 15, 1878, at a track in Palo Alto. Twenty minutes later, with a crowd of spectators watching, Muybridge developed the pictures. They proved that, as suspected, all four legs of a running horse do briefly leave the ground at the same time.

Muybridge went on to make more motion sequences of horses, bison, people, and other animals. He invented a primitive motion picture device, the zoopraxiscope, which was the ancestor of the movie projector. He spent the last ten years of his life in retirement in his English hometown, where he died at age seventy-four.

ADDITIONAL FACTS

1. *Muybridge took more than 100,000 still pictures of animal and human locomotion.*

2. *A 1982 opera by composer Philip Glass (1937–),* The Photographer, *was based on Muybridge's murder trial.*

3. *The greatest technical challenge for Muybridge was developing a shutter fast enough to freeze a moving horse—about 1/500th of a second—and a film capable of exposing in such a short time. At the time, most film took from 15 seconds to several minutes to expose. A mechanical shutter invented by John D. Isaacs, solved the first problem, while new film technologies developed in the 1870s solved the second.*

✦✦✦

Saigo Takamori

Saigo Takamori (1827–1877), dubbed the Last Samurai, led a doomed fight against modernizing forces in nineteenth-century Japan. The seeming futility of his revolt—and his old-fashioned notions of samurai honor and chivalry—have made him a romantic figure in literature and a popular hero in Japanese culture.

Saigo was born in the isolated city of Kagoshima, on the southern Japanese island of Kyushu, and educated at traditional samurai schools in Confucian literature, arithmetic, and martial combat. The samurai, the military elite of feudal Japan, were governed by an unwritten set of laws called Bushido, meaning "way of the warrior," which Saigo absorbed in school. The rules required loyalty, frugality, and an honorable death—by suicide, if necessary.

As expected of samurai, Saigo entered government service after completing his education, first working as a low-ranking county clerk. For reasons that are unknown, he was given a major promotion in 1854 and brought to the capital city of Edo (now Tokyo) by his daimyo, or feudal lord, Shimazu Nariakira (1809–1858).

When Saigo arrived in Edo, he encountered a government that was paralyzed over the question of how Japan should respond to the economic and political superiority of the West. The year before, American naval ships had arrived off the Japanese coast, and the Americans had forced the shogun to sign a diplomatic treaty, an event that had exposed Japan's military impotence and technological backwardness.

The promodernization forces believed that catching up with the West would require abolishing the feudal shogunate, establishing a strong central government under the emperor, and replacing the hereditary samurai with a professional, Western-style military. Under pressure, the shogun resigned in 1867, leading to the Meiji Restoration of the emperor, who had previously been seen mostly as a symbolic figure.

The end of the shogunate sparked a conflict, the Boshin War, in which Saigo sided with the emperor and the modernizers. After their victory, however, he became disillusioned over foreign policy differences and by the order to abolish the privileges of the samurai. In 1877, he started the Satsuma Rebellion, drawing on a force of ex-samurai angry over the changes.

Saigo's forces stood little chance of success. By the time he made his last stand, at the Battle of Shiroyama in 1877, Saigo's army numbered about 400, and they were pitted against 30,000 imperial soldiers. According to legend, he committed ritual suicide to avoid capture, as required by the Bushido code.

ADDITIONAL FACTS

1. *A Hollywood adaptation of the 1877 war,* The Last Samurai, *was filmed in 2003. Starring Tom Cruise (1962–), the movie featured Ken Watanabe (1959–) as a character based closely on Saigo Takamori. He was nominated for an Academy Award for Best Supporting Actor, but lost to Tim Robbins (1958–).*

2. *Due to enduring popularity, Saigo was posthumously pardoned by the emperor in 1889.*

3. *Some samurai teachings on sword combat live on in kendo, a Japanese martial art.*

❖ ❖ ❖

William Miller

For thousands of Americans, the morning of October 22, 1844, loomed large on the calendar. On that day, according to a Vermont preacher named William Miller (1782–1849), the world would end with the triumphant return of Jesus Christ to Earth.

Miller, a War of 1812 veteran, had become obsessed with the end of time after returning home from the war. Based on his reading of passages in the Old Testament's Book of Daniel, he was convinced that Christ would return in the 1840s.

In the 1830s, Miller began giving lectures explaining his prophecies, and several newspapers in New England and New York printed his predictions. Beginning in about 1840, through his sermons and the magazines he published, Miller began to attract thousands of followers—up to 100,000, by one reckoning.

Miller had no formal religious training, and the reasoning he used to justify his predictions was bewilderingly complex. Still, he found a receptive audience in rural New England and New York. Millerism became one of the most prominent religious groups of the Second Great Awakening, a period of intense religious revival in the United States just before the Civil War.

Initially, Miller gave his followers only a rough estimate, predicting that the savior would descend from heaven sometime in the one-year period after March 1843. When March of 1844 passed without incident, however, the estimate was revised to April 18, 1844. With the world still spinning on April 19, Miller's followers rescheduled the apocalypse one last time, to October 22.

Miller's prophecies concerned not only the date of Christ's return, but also its nature. Miller believed that the Rapture would begin the sequence of events described in the Book of Revelation: The earth would be "cleansed" with fire, the righteous would be elevated to heaven, and Christ would rule for a thousand years.

Excitement and giddiness built among Miller's followers in the weeks and days leading up to October 22. When the world failed to end, however, a crisis ensued. Miller blamed a math error, but many of his followers abandoned him after the Great Disappointment. He died in New York five years later.

ADDITIONAL FACTS

1. *After the Great Disappointment, some of Miller's remaining followers reorganized into a new denomination that became the Seventh-Day Adventist Church. The Jehovah's Witnesses also trace their roots to the Millerites.*

2. *The Bible verse at the center of Miller's prophecy was Daniel 8:14, which reads: "And he said unto me, Unto two thousand and three hundred days; then shall the sanctuary be cleansed." Miller believed that "days" should be interpreted as years and used the rebuilding of Jerusalem in 457 BC as the starting date.*

3. *Miller fought as an army captain in the Battle of Plattsburgh in 1814, a turning point in the War of 1812 in which the Americans repelled a British invasion from Canada.*

✦✦✦

Otto von Bismarck

Nicknamed the Iron Chancellor, Otto von Bismarck (1815–1898) was a German politician who engineered the unification of Germany in the mid-nineteenth century. Under his leadership, Germany was transformed from a patchwork of small, weak states into one of the great military powers of Europe.

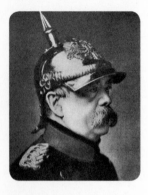

Bismarck was born in Prussia, one of the largest German states. His father was a Junker, or Prussian aristocrat. Bismarck was educated at the Universities of Göttingen and Berlin, and he married a Prussian noblewoman in about 1847.

In the same year, Bismarck was elected to the Prussian parliament, where he earned a reputation as a hard-line right-wing supporter of the king, Frederick William IV (1795–1861), and his successor, Wilhelm I (1797–1888). Bismarck later served as ambassador to France and Russia and was appointed prime minister of Prussia in 1862.

Bismarck's primary goals were to defend the king's power, strengthen the Prussian military, and encourage German unification. Although Germans widely supported the idea of unification, few of the German states wished to give up their individual sovereignty; Bismarck solved the problem by using Prussia's military might to pressure weaker states to join a newly created federation. The final impetus for unification was the Franco-Prussian War, which erupted in 1870 and inspired the other German states to rally to Prussia's side. In 1871, after defeating France, Wilhelm was proclaimed kaiser, or emperor, of Germany; he quickly appointed Bismarck the federation's first chancellor.

As chancellor, Bismarck sought to preserve peace in Europe and allow the newly unified Germany to grow economically and militarily. He was particularly known for a cautious brand of international relations called realpolitik—a foreign policy that places balance-of-power considerations ahead of ideology. Bismarck also pursued a domestic agenda that included the 1889 establishment of one of the world's first public social security programs.

After Wilhelm's death, Bismarck lost political power in the government of the kaiser's grandson, Wilhelm II (1859–1941), who preferred a more aggressive foreign policy. Bismarck died several years later at age eighty-three.

ADDITIONAL FACTS

1. *One of the most famous vessels in Germany's World War II navy, the* Bismarck, *was named for the chancellor. It was sunk by the British in 1941 following a two-day battle.*

2. *The capital city of North Dakota was named after Bismarck in 1873.*

3. *Under Bismarck, Germany acquired its first colonies in Africa, including the modern-day independent nations of Cameroon, Namibia, and Tanzania.*

Søren Kierkegaard

The titles of some of his best-known books offer telling insights into the philosophy of the Danish writer Søren Kierkegaard (1813–1855): *Fear and Trembling* (1843), *The Concept of Anxiety* (1844), *The Sickness Unto Death* (1849).

In his short and mostly unhappy life, Kierkegaard wrote prolifically about angst, despair, and what he viewed as the decay of the Christian church in his native Denmark. He is sometimes called the Father of Existentialism, a nickname that recognizes his influence on European philosophers in the twentieth century.

Kierkegaard was born in the Danish capital of Copenhagen, where he lived for most of his life. His father was a deeply religious and guilt-ridden man who believed his son was fated to die early as punishment for his own sins. Kierkegaard attended the University of Copenhagen to study philosophy and theology, earning his doctorate in 1841.

A key event in his life occurred in 1837, when he first met fourteen-year-old Regine Olsen (1822–1904), who would become the object of his lifelong desire. The couple was briefly engaged, but Kierkegaard broke off the engagement in 1841 for reasons that are unclear. For the rest of his life, however, he would pine for Regine, even after she married another man.

His most famous work, *Either/Or,* was published in 1843. The work contained a detailed criticism of Hegel (1770–1831), arguing that Hegel's dialectic denied the importance of free will.

Two years later, another of Kierkegaard's books was lampooned by a Danish newspaper, the *Corsair*. The incident started a war of words between the philosopher and the newspaper's editors, which culminated in 1846 when the paper published a series of personal attacks against him. At one point, he was even accosted by readers of the newspaper as he walked down a Copenhagen street.

Kierkegaard continued to write for the rest of his life, living off his inheritance from his father. He published a series of increasingly pointed criticisms of the official Danish Lutheran church; Kierkegaard targeted the clergy especially, believing priests were more concerned with repeating church dogma than helping individuals understand their relationships with God.

He died in a Copenhagen hospital at age forty-two.

ADDITIONAL FACTS

1. *Kierkegaard wrote under a variety of assumed names—some of them purposely ridiculous. His pseudonyms included Constantin Constantius, Vigilius Haufniensis, Hilarius Bogbinder, and Johannes Climacus.*

2. *French director Daniele Dubroux (1947–) turned Kierkegaard's 1843 essay "The Diary of a Seducer" into a movie in 1996.*

3. *Kierkegaard left Denmark only five times, visiting Germany four times and Sweden once.*

Gregor Mendel

Johann Gregor Mendel (1822–1884), an Austrian monk and biologist, founded the modern study of genetics with a series of painstaking experiments on thousands of pea plants in the garden of his monastery. In the experiments, Mendel was able to establish how specific traits such as size and color were passed from one generation to the next—an insight that changed the way scientists understand life on Earth.

Mendel was born to a peasant family in what's now the Czech Republic and entered an Augustinian monastery in the city of Brno at age twenty-one as a way to escape poverty. The monastery supported the young friar's scientific interests and allowed him to study at the University of Vienna; he was eventually promoted to abbot in 1868.

The experiments on pea plants were intended to answer a simple question: What determined the variation within a species of plants or animals? What determined if a plant was big or small, or whether its flowers were white or purple?

At the time, most biologists believed that such traits were the result of blending. Under the blending theory, a plant with white flowers and a plant with purple flowers would produce an offspring with light pink flowers. Likewise, a tall plant and a short plant would produce a medium-size plant.

Over the course of his experiments, Mendel realized that the blending theory couldn't be correct. Pea plants, he observed, always had either white or purple flowers, but never a mix. A single trait might disappear for several generations, but then reappear.

Mendel hypothesized that such characteristics as size and color were controlled by genetic markers (later named *genes*) that were inherited from both parents. But after he published his paper in an Austrian journal in 1866, Mendel's research was largely ignored. After his elevation to abbot, he had no time to continue his scientific experiments, and for most of the remainder of his life, he was enmeshed in a controversy related to the abbey's taxes.

Mendel died of kidney disease at age sixty-one. Fifteen years later, his paper was finally rediscovered, and shortly thereafter he was posthumously embraced as the father of genetics.

ADDITIONAL FACTS

1. *In total, Mendel examined seven different traits in his experiments, an effort that required 28,000 pea plants and took eight years to complete.*

2. *Although Mendel showed that traits were passed from one generation to the next, he had no idea how the process actually occurred. That mystery was solved in 1953, when Francis Crick (1916–2004) and James D. Watson (1928–) discovered DNA.*

3. *A research station in Antarctica, the Johann Gregor Mendel Czech Antarctic Station, was named in the botanist's honor in 2006. The Czech government also named a university after Mendel.*

❖ ❖ ❖

Wild Bill Hickok

In theory, Wild Bill Hickok (1837–1876) was one of the good guys. He fought for the Union Army during the Civil War and, for much of his adult life, carried a lawman's badge. He was elected sheriff in several towns across the West and seldom failed to provide law and order—or at least order.

But Hickok was also one of the most notorious gunfighters in the American West, with perhaps dozens of lawless killings under his belt. He was famous as a gambler, duelist, and freewheeling gun for hire. Many legends of the Western frontier originated with Hickok, from the "quick draw" gunfight to the fateful poker hand that cost him his life.

James Butler Hickok was born in Illinois. By age twenty-five, he had already been tried and acquitted once for murder, after he killed several people in a shootout in Nebraska. (The jury accepted his self-defense argument.) He then fought for the North during the war, serving as a scout and occasionally a spy.

After the war, Hickok fought, and won, the first recorded "quick draw" duel—the type of gunfight that would be immortalized in countless Western movies. He faced off with a former Confederate soldier in Missouri, beating him on the draw when they met in a town square at dusk. Hickok was arrested for murder, but again beat the charge.

Hickok deliberately encouraged his growing national reputation, claiming in interviews that he had killed a hundred men. He also briefly appeared in a play with William "Buffalo Bill" Cody (1846–1917) about their supposed exploits in the West. Dressed in buckskin and brandishing two revolvers, Hickok embodied—and helped create—the stereotype of the Western gunslinger.

In the 1870s, he served as sheriff or marshal in several towns in Kansas. He moved to South Dakota in 1876, hoping to get rich in the gold rush in the Black Hills.

On August 2, 1876, he visited Saloon #10 in the town of Deadwood, where he joined a game of poker. He was dealt a good hand—two pairs, aces over eights—and bad luck: As he looked at his cards, he was shot and killed from behind by Jack McCall (c. 1853–1877). Hickok was thirty-nine. McCall's motives are disputed; at his trial, he claimed that he shot Hickok to avenge the death of his brother. Another theory was that he was mad at Hickok for insulting him that morning, or that he was drunk. In any case, McCall was convicted and hanged the next year.

ADDITIONAL FACTS

1. *In 2008, Democratic presidential candidate Barack Obama (1961–) claimed he was distantly related to Hickok through the family of his Kansas-born mother, Ann Dunham (1942–1995).*

2. *A character based on Hickok was played by Keith Carradine (1949–) in the HBO series* Deadwood.

3. *In poker, a hand containing two aces and two eights is called the dead man's hand and is considered bad luck by many gamblers.*

◆ ◆ ◆

Mark Twain

On February 3, 1863, a newspaper in the frontier town of Virginia City, Nevada, published a humorous article. The article was written by Samuel Clemens (1835–1910), who had come to Nevada from his native Missouri two years earlier. But instead of using his real name, Clemens signed the piece with what would become one of the most famous names of nineteenth-century literature: Mark Twain.

The legacy of Mark Twain in American literature can hardly be overstated. Novelist, humorist, and essayist, he was one of the first American authors to earn an international following. His writing made him a celebrity. And his most famous book, *The Adventures of Huckleberry Finn* (1885), is regarded by some critics as the "great American novel."

Twain spent most of his childhood in Hannibal, Missouri, a city on the Mississippi River. The town's ever-shifting population of thieves, grifters, cardsharps, con men, riverboat gamblers, and wandering adventure seekers would provide inspiration for many of Twain's most colorful fictional characters.

After working in a number of jobs, Twain became a riverboat pilot in 1859. When the outbreak of the Civil War ended river commerce, he faced the choice of serving in the Confederate military or going west. After a few weeks in a Southern militia, he changed his mind, deserted his unit, and headed to Nevada. Twain spent several years in the West, where he earned his first literary fame. He married in 1870, moved east in 1871 to Hartford, Connecticut, which would be his home for the rest of his life.

The Adventures of Tom Sawyer, based on Twain's childhood in Missouri, appeared in 1876. It was followed by *Huck Finn* in 1885. Named after its narrator, an uneducated young boy, the book follows Huck's voyage down the Mississippi on a raft with a runaway slave, Jim. Huck meets a cast of characters inspired by Twain's Hannibal childhood, including a pair of swindlers posing as French noblemen, a gentleman Southern colonel, and two families engaged in an obsessive blood feud.

Some of Twain's other prominent works include *The Prince and the Pauper* (1881), *A Connecticut Yankee in King Arthur's Court* (1889), and *Pudd'nhead Wilson* (1894). He died in Connecticut at age seventy-four.

ADDITIONAL FACTS

1. *Twain was the vice president of the American Anti-Imperialist League, a group that opposed American expansion into the Pacific and annexation of the Philippines.*

2. *According to Twain, his pseudonym was inspired by a term used by riverboat crews on the Mississippi. Boats needed a depth of at least two fathoms (twelve feet) to navigate safely;* mark twain *meant that the water was deep enough.*

3. *Twain was awarded an honorary doctorate from Oxford University in 1907.*

✦✦✦

Geronimo

Geronimo (1829–1909), the war chief of the Apache Indians, was one of the last sources of resistance to American expansion in the Southwest. Before his capture and imprisonment by the US Army in 1886, Geronimo was legendary across the West for his tenacious, often-ruthless defense of the Apache's traditional lands.

The capture of Geronimo marked the end of large-scale, organized indigenous opposition in what is now Arizona and New Mexico. Geronimo spent the rest of his life as a prisoner of war and died in captivity.

Geronimo was born in what is now southern Arizona. Apaches still controlled the territory during Geronimo's youth, but were under increasing threat from both Mexico and the United States. Geronimo married at seventeen and went to war against the Mexicans in the early 1850s; his young wife was killed by Mexican soldiers, fueling his hostility toward the invaders.

Famous for his quick raids on horseback and ability to evade the huge military expeditions sent to arrest him, Geronimo fought almost continuously for the next thirty years. After the death of Cochise (c. 1815–1874), the Apache chief, Geronimo became the tribe's most prominent warrior and, over time, the last holdout against the power of the federal government.

The army nearly succeeded in finding Geronimo in 1875 and 1885, but he avoided capture both times. But his forces were dwindling; there were only about 400 men, women, and children with him when he was finally arrested.

In prison, Geronimo became a kind of living symbol of the rapidly disappearing West. He appeared at the World's Fair in 1904 and even marched in the inaugural parade for Theodore Roosevelt (1858–1919) in 1905. But even as a seventy-nine-year-old man, he was feared enough that the federal government repeatedly denied his requests to return to his homeland. He died at Fort Sill, Oklahoma, in 1909.

ADDITIONAL FACTS

1. *The name Geronimo was invented by Mexicans and widely embraced. The chief's Apache name was Goyathlay, meaning "one who yawns" in the native language.*

2. *During World War II, American airborne troops often yelled "Geronimo!" before parachuting out of a plane. The tradition is thought to have been started by a paratrooper who had watched a Western about Geronimo the night before a big jump and yelled his name the next morning to relieve stress before jumping out of his plane.*

3. *US Army captain H. W. Lawton (1843–1899), who captured Geronimo in 1886, was later killed while fighting in the Philippine-American War.*

❖ ❖ ❖

Kate Fox

Kate Fox (c. 1839–1892) was the most infamous of the three Fox sisters, a trio who managed to convince thousands of Americans and Europeans that they had occult powers to communicate with the dead. She conducted hundreds of séances for credulous followers—earning thousands of dollars in the process—but died in poverty after one of her own sisters exposed "spiritualism" as a fraud.

The Fox girls—Kate, Leah (c. 1818–1890), and Margaret (c. 1833–1893)—were born on a farm in Canada and moved to upstate New York in 1847. They first reported hearing mysterious rapping sounds in their bedroom in 1848; their superstitious mother told curious neighbors that the noises were messages from the dead.

Word of the mysterious "Rochester Rappings" quickly spread, and by 1850 the young Fox sisters had become a sensation. Many prominent Americans, including novelist James Fenimore Cooper (1789–1851), historian George Bancroft (1800–1891), and journalist William Cullen Bryant (1794–1878), attended public demonstrations staged by the girls. Rich New Yorkers paid the sisters for private séances to communicate with dead relatives or deceased historical figures. (Benjamin Franklin was a favorite phantom whom the sisters would conjure up.)

Spiritualism appealed to many of the same Americans who had embraced abolitionism, women's rights, and radical political causes. Amy Post (1802–1889), a radical Quaker abolitionist, hosted the sisters at her home and introduced them to other reformers.

By the 1860s, however, enthusiasm began to wane, and both Kate and Margaret had become alcoholics. After spending several years in a sanatorium, Kate traveled to England in 1871, married and had two sons, and returned to the United States in 1885. She was arrested for drunkenness in 1888 and lost custody of her sons.

Then, in an 1888 newspaper interview, Margaret publicly recanted spiritualism and admitted that the girls had made up the whole thing as a prank. Exposed as a fraud, Kate was left penniless and died five years later in obscurity.

ADDITIONAL FACTS

1. *In her 1888 exposé, Margaret explained that the sisters had produced the mysterious rapping noises by throwing their big toes out of joint and then cracking them back into place. They had also used an apple tied to a string to make the bumping sound.*

2. *One of the Fox sisters' biggest supporters was the abolitionist newspaper editor Horace Greeley (1811–1872) of the* New York Tribune, *who began paying for Kate's education in 1850 after attending one of her séances.*

3. *The region of upstate New York where the Fox sisters lived was home to so many new religious groups in the 1840s and 1850s that it was referred to as the Burned-Over District—its residents had been "burned" by so many preachers that there were no more left to convert. The Millerites and Mormons both originated in the area, and several utopian communities, including the Oneida Community, opened in upstate New York as well.*

✦✦✦

Sitting Bull

Sitting Bull (c. 1831–1890) was a Sioux warrior, holy man, and chieftain who may be best known for defeating the US Army's Seventh Cavalry at the Battle of Little Bighorn in 1876. The unexpected Sioux victory over Lieutenant Colonel George Armstrong Custer (1839–1876) was a huge shock to the American public—and it elevated Sitting Bull to heroic status among Native Americans.

Born near the Grand River in what is now South Dakota, Sitting Bull was a member of the Hunkpapa Lakota branch of the Sioux, a tribe that stretched across the Great Plains from Minnesota to Montana. He became a warrior as a teenager and fought in his first battle, against the Crow, at age fourteen. Sitting Bull fought against the US Army for the first time in June 1863.

Meanwhile, the pace of US expansion into the West had quickened dramatically after the Civil War. Railroads and telegraph lines were built across ancient Sioux hunting grounds, and the bison herds that provided the tribe's food were hunted to the brink of extinction. The discovery of gold in the Black Hills of Dakota, a sacred territory for the Sioux, brought a fresh wave of settlers. The Black Hills had been specifically protected in a treaty between the Sioux and the US Government, but the United States canceled the treaty in 1876.

The Battle of Little Bighorn—which Sitting Bull had supposedly foreseen in a dream—occurred on June 25, 1876, when Custer's cavalry attacked an encampment of Sioux warriors. Custer, a decorated Civil War veteran, had badly underestimated the size of the Sioux force, and his entire detachment was destroyed by warriors led by Sitting Bull and the Oglala Lakota Sioux war chief, Crazy Horse (c. 1842–1877).

When news of the massacre reached Washington, thousands more soldiers were dispatched to the Dakota Territory. For the next five years, the army hunted down the Sioux chiefs; Sitting Bull escaped to Canada in 1877, but was forced to return and surrender in 1881. "I wish it to be remembered that I was the last man of my tribe to surrender my rifle," he said.

In 1890, confined to reservations, the Sioux tribes conducted a series of Ghost Dances, religious ceremonies they believed would drive away the whites and restore their old way of life. Federal authorities, fearing that the dances would revive Native American resistance, sent policemen to arrest Sitting Bull to prevent him from joining the ceremonies; he was killed in a gun battle during his arrest.

ADDITIONAL FACTS

1. *Sitting Bull is buried in Mobridge, South Dakota. Plans to build a $12 million memorial at the site were put on hold in 2007 after some of the chief's descendants objected to turning the grave into a tourist attraction.*

2. *American Indian activist and actor Russell Means (1939–), who was born on an Oglala Lakota Sioux reservation, played Sitting Bull in the 1995 movie* Buffalo Girls.

3. *According to the 2000 US Census, the Sioux tribe is the third most populous in the United States, after the Cherokee and the Navajo.*

Karl Marx

Karl Marx (1818–1883) may have had a more far-reaching impact on world history than any other political philosopher. The German-born journalist and political commentator was the intellectual founder of world Communism, and dozens of governments were founded in the twentieth century with the purported goal of establishing a "Marxist" society guided by his principles.

The fact that those Communist regimes included some of the most murderous in human history has, inevitably, tarnished Marx's reputation. But Marx saw himself as a historian who merely tried to document and analyze the interplay of economics, government, and society.

Marx was born in Trier, a city in Germany's Rhineland. He studied philosophy, earning a doctorate in 1841 after writing a dissertation about ancient Greek philosophers. However, Marx was unable to get an academic job and began working as a journalist in 1840, reporting on the growing radical movement in many European countries. In 1848, a wave of revolutions swept across Italy, France, and some of the German states. Marx coauthored a short pamphlet called *The Communist Manifesto* in the same year in an attempt to give voice to continent-wide discontent.

The *Manifesto*—with its famous warning that "a spectre is haunting Europe—the spectre of Communism"—is probably Marx's most famous work. But in many ways it is atypical of his writing. The book that consumed most of Marx's life, *Das Kapital*, is a lengthy, dense treatise about class and economics. Marx put forward a "theory of history" that postulated that history was controlled by advances in productive capacity. The industrial capitalism of the nineteenth century, he believed, was merely a stage in human development that had replaced feudalism and would eventually give way to Communism. Under Communism as Marx described it, the workers themselves would control the creation of wealth and ensure its even distribution.

Because of his association with radicals, Marx was kicked out of several countries, including Germany, Belgium, and France. He ended up in London in 1849, where he spent the rest of his life and died at age sixty-four.

ADDITIONAL FACTS

1. *Although Marx never visited the United States, he was an ardent backer of the Union cause during the Civil War and worked briefly as a European correspondent for the* New York Tribune.

2. *Marx frequently collaborated with Friedrich Engels (1820–1895). Engels cowrote* The Communist Manifesto *with Marx and later edited the last two volumes of* Das Kapital.

3. *To describe social classes, Marx coined two terms that have become part of the world's political vocabulary. The proletariat, he believed, was the exploited working class. The middle class, meanwhile, formed what he called the bourgeoisie.*

◆◆◆

Louis Pasteur

On July 4, 1885, a nine-year-old French boy named Joseph Meister was playing near his home when he was mauled by a rabid dog. The dog's teeth penetrated Joseph's skin during the attack, almost guaranteeing that the boy would contract the much-feared disease rabies from its saliva. His prognosis was grim: Rabies in humans almost always resulted in paralysis, followed by an excruciating death.

In desperation, Meister's mother visited the Paris laboratory of France's most famous scientist, Louis Pasteur (1822–1895). Pasteur had been developing a cure for rabies for three years and had tested it on several dogs and rabbits. But Pasteur didn't believe the treatment was ready to try on a human patient.

Pasteur, considered the founder of microbiology for his studies of germs, was born in eastern France and earned his doctorate in chemistry in 1847. He was known as a fearless researcher who was unconcerned about the personal risks associated with handling the deadly diseases he studied in his lab. One of his major discoveries, the process of pasteurization, eliminated the threat of deadly molds and bacteria in the French milk supply, saving thousands of lives. A similar process invented by Pasteur helped save the French beer and silk industries. His research on germs led him to recommend that doctors wash their hands and sterilize their instruments before operations—simple steps that sharply reduced mortality rates.

Pasteur's rabies experiments began in 1882. Vaccines work by infecting the patient with a small, nonfatal dose of the disease—too little to cause illness, but enough for the body to build up immunity. Pasteur theorized that if he could obtain rabies from an infected animal and then allow the disease to weaken in the lab, he could produce a vaccine.

The vaccine had been successfully tested on eleven dogs when Meister's mother appealed for his help. After some hesitation—Pasteur feared the vaccine would fail, or simply hasten the boy's death—Pasteur agreed to administer the medicine. The vaccine worked, curing the child—and many other rabies victims over the following ten years—and providing Pasteur with the crowning achievement of his career.

ADDITIONAL FACTS

1. *After recovering from rabies, Meister served in the French army in World War I and was a caretaker at the Pasteur Institute. He committed suicide in 1940, in despair over the German invasion of France.*

2. *In 1995, a historian at Princeton University, Gerald L. Geison (1943–2001), published an analysis of Pasteur's laboratory notebook that revealed that Pasteur had stolen ideas from colleagues and falsified some of his research. Among other things, Geison accused Pasteur of lying when he claimed to have tested the vaccine given to Meister on dogs. In fact, Pasteur had used a slightly different vaccine on dogs; the medicine Pasteur gave to the nine-year-old had never been tested.*

3. *The Pasteur Institute still exists as a center for research on infectious diseases; scientists there were the first to isolate HIV, the virus that causes AIDS, in 1983.*

◆◆◆

Ned Kelly

A near-legendary figure in Australia, Ned Kelly (1855–1880) was a bushranger and bandit who came to be regarded as a national folk hero. He is known for his last stand against colonial authorities, when he wore a homemade suit of armor into a shootout. Captured and convicted of murdering three policemen, he was hanged in Melbourne at age twenty-four.

Kelly, a Roman Catholic, claimed that his actions were motivated by the abuse suffered by Catholics in Australia. To some, he is a symbol of struggle against oppression, and a "social bandit" whose crimes reflected broader opposition to British colonial practices.

In the early nineteenth century, Australia was a penal colony for British criminals. Kelly's father, John Kelly, was a convict from Ireland who had been deported to Tasmania in the 1840s and married an Australian woman, Ellen, after his release. Ned was their first son. John Kelly was later rearrested, and he died when Ned was eleven.

The younger Kelly began his own criminal career shortly thereafter. In the early 1870s, he was arrested for or suspected of various cases of assault, robbery, and cattle rustling and was sent to prison twice as a teenager.

After his release, Kelly was accused of a far more serious crime, assaulting a police officer. Along with his brother, Dan (1861–1880), he went into hiding in 1878. When police arrived to capture them, the Kelly brothers murdered three of the officers, an action that turned them into the territory's most-wanted outlaws. With a huge bounty placed on their heads, the brothers then embarked upon a spree of bank robberies.

While in hiding, Kelly wrote a letter to the public explaining his motives. The letter attacked police harassment of Catholics and also criticized land policies that seemed to favor Protestants.

Kelly was finally cornered at an inn in Glenrowan, the site of perhaps his most famous exploit. Surrounded by police, he emerged from the inn clad in a homemade suit of armor and survived a hail of bullets. He was eventually shot in the legs; only then were police able to capture the celebrated bandit.

ADDITIONAL FACTS

1. *Ned Kelly has been portrayed in several movies; actors who have played the outlaw include Mick Jagger (1943–) in 1970 and Heath Ledger (1979–2008) in 2003.*

2. *The song "Ned Kelly" was written by Johnny Cash (1932–2003) in 1971.*

3. *A novel based on Kelly's life,* True History of the Kelly Gang, *by Australian Peter Carey (1943–), won the Man Booker Prize in 2001.*

◆◆◆

Vincent van Gogh

Ironically, Vincent van Gogh (1853–1890) had to *leave* the Netherlands to find inspiration for the wild, hallucinogenic paintings for which he is now famous. After struggling in his home country at the beginning of his career, Van Gogh moved to France in 1886, where the verdant countryside of Provence provided the setting for many of his most colorful, inventive, and influential works.

Van Gogh was born in a small village in southern Holland. Deeply religious, he studied for the priesthood but never passed the entrance exam for theology school. Undeterred, Van Gogh briefly worked as a Protestant missionary at coal mines in Belgium, where the impoverished workers inspired some of his first drawings.

After finally giving up on a religious career in 1880, Van Gogh moved to Brussels, where his family encouraged him to take painting lessons. Both his uncle and his younger brother, Theo, were art dealers who would support Van Gogh throughout his life. The painter completed one of his first major works, *The Potato Eaters,* a portrait of a poor peasant family at their dinner table, in 1885.

Van Gogh was largely self-taught, and his paintings broke many conventional artistic rules. Perspective was sometimes distorted, and his colors often bore little resemblance to reality. "Instead of trying to reproduce exactly what I see before my eyes," he once explained, "I use color more arbitrarily, in order to express myself forcibly."

Van Gogh's burst of creativity between 1885 and 1890 was his most productive interval. Especially after moving to Paris in 1886, Van Gogh produced one classic painting after another at a manic pace fueled by both absinthe and his growing mental instability—producing more than 200 paintings in the two years after his move.

As his mental health problems worsened, Van Gogh cut off the lower part of one of his own ears late in 1888 and committed himself to a mental hospital. He made one of his most famous paintings, *The Starry Night,* while confined to the sanatorium.

By 1890, his paintings were beginning to attract praise in Paris. Van Gogh is often classified as a postimpressionist, one of a group of predominantly French painters who experimented with vivid, unnatural colors in their art. Later that summer, however, Van Gogh suffered a relapse of depression and killed himself in a field north of Paris at age thirty-seven.

ADDITIONAL FACTS

1. *Van Gogh's great-grandnephew, Theo van Gogh (1957–2004), was an acclaimed Dutch film director who was assassinated by an Islamic extremist on a street in Amsterdam after he released a short movie criticizing the treatment of women in Islamic countries.*

2. *American director Martin Scorsese (1942–) played Van Gogh in a 1990 Japanese film,* Yume.

3. *Van Gogh sold only one painting in his lifetime—but his works are now among the most expensive pieces of art in existence. In 1990, a portrait that Van Gogh painted of his psychiatrist, Dr. Paul Gachet, was sold for $82.5 million to a Japanese businessman.*

✦✦✦

Ida B. Wells

One had better die fighting against injustice than die like a dog or a rat in a trap.
—Ida B. Wells

A crusading journalist and social reformer, Ida B. Wells (1862–1931) exposed the brutal violence endured by African Americans in the American South after Reconstruction. Her most famous book, *Southern Horrors: Lynch Law in All Its Phases* (1892), shocked the nation with its graphic descriptions of violence against blacks—but it would be decades before lynchings ended in the South.

Born a slave in Mississippi, Wells was freed along with her family at the end of the Civil War. Both of her parents died during a yellow fever epidemic when she was a teenager, and Wells was forced to leave school. She eventually worked her way through college and moved to Memphis in 1880.

Two events affected Wells's views on racial justice. In 1883, she was ejected from a whites-only railroad car and unsuccessfully sued the railroad for discrimination. Ten years later, three of her friends were murdered by a white mob in Memphis.

After the deaths in Memphis—which Wells called her "first lesson in white supremacy"—Wells began writing denunciations of racial violence, describing specific instances of blacks being killed by whites. Many black men were killed after accusations that they had associated with white women, but Wells exposed how rape accusations were often used as a pretext to target blacks for other reasons. Her friends in Memphis, for instance, had run a successful grocery store that competed with white-owned stores.

Throughout the next three decades, Wells cataloged cases of lynching, forcing Americans to confront the issue. Her reporting often exposed her to personal danger, and she narrowly escaped being lynched herself on at least one occasion. She was also a founder of the NAACP and traveled abroad to publicize the plight of blacks in the United States.

Wells wrote an autobiography, *Crusade for Justice,* in 1928 and died three years later at age sixty-eight.

ADDITIONAL FACTS

1. *Wells married a Chicago newspaper editor, Ferdinand L. Barnett (c. 1859–1936), in 1895. She defied convention by keeping her maiden name—Wells was one of the first American women to do so.*

2. *The NAACP continued to record instances of lynching into the 1940s. While the overall total of victims is disputed, roughly 3,000 died between the Civil War and World War I.*

3. *Wells was featured on a US postage stamp in 1990.*

✦✦✦

William Gladstone

William Gladstone (1809–1898) was one of the longest-serving prime ministers of Great Britain. He served four terms in the mid-nineteenth century and compiled a record as a Liberal reformer who expanded democratic institutions during the Victorian era and tried to enhance the political rights of the Irish.

He was also known for his long-standing rivalry with Conservative leader and two-time prime minister Benjamin Disraeli (1804–1881). The men were bitter enemies—both politically and personally. Disraeli referred to Gladstone as "the arch-villain" and suspected he was insane; Gladstone considered his rival an insufferable dandy.

Born in Liverpool, Gladstone attended Eton and Oxford, the breeding grounds for British politicians. He was first elected to Parliament in 1832 as a Tory and served in the Conservative cabinet as chancellor of the exchequer in 1852.

Gladstone first met Disraeli at a dinner party in London in 1835. Although the two ambitious young politicians were political allies at the time, their personalities clashed almost immediately: Gladstone was an earnest, deeply religious Christian with little sense of humor, while Disraeli was a combative, often sarcastic speaker with few religious convictions.

After drifting to the left in the 1850s, Gladstone switched to the Liberals in 1859 and was elected party leader in 1867. The next year, the Liberals won the general election, and he was named prime minister—replacing Disraeli. During his first term, Gladstone passed several bills that eased the restrictions on Roman Catholics in Ireland, established an elementary school system, and reduced the income tax. But Disraeli defeated him in a landslide in 1874. In defeat, Gladstone became a sharp critic of Disraeli's government and accused him of turning a blind eye to Turkish repression in Bulgaria. He was returned to the premiership in 1880, and again in 1886 and 1892.

By the end of his career, Gladstone—nicknamed GOM, for the Grand Old Man—had become synonymous with British liberalism. He was accorded a state funeral after his death in Wales at age eighty-eight.

ADDITIONAL FACTS

1. *Like many other British politicians, Gladstone was sympathetic to the Southern side during the US Civil War. He gave a speech supporting the Confederacy in 1862—a stance he later claimed to regret.*

2. *Queen Victoria (1819–1901), who was often appalled by Gladstone's policies, once referred to him as a "half-mad firebrand."*

3. *Among British prime ministers, Gladstone trails only Winston Churchill (1874–1965) in length of time served in Parliament. Churchill was a member for sixty-three years and 358 days, compared with sixty-two years and 206 days for Gladstone.*

◆◆◆

John Humphrey Noyes

The controversial founder of a utopian religious community in Oneida, New York, John Humphrey Noyes (1811–1886) was most notorious for his radical teachings on sex and marriage. But his community also embodied a new sense of religious optimism that spurred a revival of American Christianity in the nineteenth century.

Born in Brattleboro, Vermont, where his father was a state legislator, Noyes attended Dartmouth College. After graduating, he briefly practiced law in New Hampshire, but decided to enter divinity school after hearing an inspiring sermon by the preacher Charles Grandison Finney (1792–1875).

At Yale Divinity School, Noyes immersed himself in the Bible and found himself drawn to one particular passage in the Gospel of John. Based on the passage, Noyes concluded that the second coming of Christ had already occurred in AD 70, meaning that the millennium—the period of human perfection that would follow Christ's return, according to the Bible—must have already begun.

Noyes's assertion countered mainstream Christian belief, and Noyes was expelled from Yale for heresy in 1834. However, his doctrine of "perfectionism" found an audience in New York and New England. He formed his first "holy community" of followers in Putney, Vermont, in 1840 and moved the group to Oneida in 1848.

Because Noyes believed that humans were perfect and free from sin, he renounced traditional sexual norms and declared that there was no "reason why sexual intercourse should be restrained by law." Noyes led by example, exchanging his wife, Harriet, with another member of the community in 1847, and was arrested for adultery.

Although Oneida became best known for "group marriage," the community was also a thriving and self-sustaining economic enterprise that produced suitcases, thread, and the famous Oneida silverware. Members were expected to share in the work and the rewards, creating one of the few successful utopian communities in nineteenth-century America.

Noyes fled to Canada in 1879 to avoid a charge of statutory rape, and he died in Ontario at age seventy-four. The Oneida community formally dissolved in 1881 but was resurrected as the Oneida silverware corporation, which remains in existence.

ADDITIONAL FACTS

1. *One of Noyes's cousins was Rutherford B. Hayes (1822–1893), the nineteenth president of the United States.*

2. *Under the rules instituted by Noyes, men at the Oneida community were solely responsible for contraception. They were expected to practice "continence," or self-control, to avoid pregnancies.*

3. *Most of the members of the Oneida community adhered to a strict vegetarian diet and were forbidden from drinking alcohol and smoking tobacco.*

✦✦✦

John Stuart Mill

John Stuart Mill (1806–1873) was raised from an early age to be a famous philosopher. His father, the Scottish radical James Mill (1773–1836), taught his son Greek at three and Latin when the child was only eight years old. By the age of ten, Mill could read Plato in the original Greek. At age twelve, at his father's urging, he began to study medieval scholasticism. To avoid distractions, the budding philosopher was forbidden from playing with other children.

This upbringing left Mill profoundly exhausted, and he suffered a prolonged nervous breakdown at age twenty. But, true to the elder Mill's wishes, John Stuart Mill became one of the central philosophers of the nineteenth century and a leading advocate of an English philosophical tradition called utilitarianism.

After emerging from his bout of depression, Mill spent the remainder of the 1820s traveling. He met Harriet Taylor (1807–1858) in 1830; although she was married, the two began a relationship—much to the dismay of Mill's father. The pair remained close for two decades and married in 1851, after the death of Harriet's first husband.

Mill's first major philosophical work, *A System of Logic,* was published in 1843. His *Principles of Political Economy* followed in 1848. The books established him as one of the leading Liberals and utilitarians in England. Utilitarians believed that the morality of an action could be judged solely by its contribution to the overall happiness of society at large; they are often associated with the motto "the greatest good for the greatest number."

In practice, utilitarianism led Mill to adopt positions on many political issues that were considered radical at the time. He supported electoral reform, easing British policies toward Ireland, and economic and political rights for women—all stances that placed him on the fringes of nineteenth-century British politics.

Until 1858, Mill worked for the British East India Company, a corporation that controlled British trade with India. Mill then entered politics and was elected to the House of Commons in 1865, where he sponsored the first legislation to extend voting rights to women. (It failed.) He outlined his views on gender equality in a famous 1869 book, *The Subjection of Women,* which was published after he failed to win reelection to Parliament.

Mill died in France at age sixty-six.

ADDITIONAL FACTS

1. *Mill also served as the rector of the University of Saint Andrews in Scotland between 1865 and 1868.*

2. *He was a godfather to the philosopher Bertrand Russell (1872–1970).*

3. *Women in the United Kingdom were not fully enfranchised until 1928, more than sixty years after Mill first proposed equal suffrage.*

◆◆◆

Alexander Graham Bell

The inventor of the telephone, Alexander Graham Bell (1847–1922) changed the way the world communicates and founded the company that became AT&T, one of the most successful businesses in American history. But Bell was highly ambivalent about his famous creation and confessed near the end of his life that he found phones an annoyance—refusing even to keep one in his study.

Bell was born in Edinburgh, Scotland, and nicknamed Aleck as a child. The sciences of hearing and sound were concerns of his from a young age: His mother, Eliza Grace Symonds (1809–1897), had lost her hearing as a child, and his father, Alexander Melville Bell (1819–1905), was a teacher of the deaf and mute who trained his son to follow in his footsteps.

The family immigrated to Canada in 1870 after the deaths of both of Bell's brothers from tuberculosis. Bell soon moved to Boston, where he was hired to teach at a school for the deaf. (Later, one of his students would be Helen Keller [1880–1968].)

While in Boston, Bell began his experiments on the telephone, aided by his eighteen-year-old assistant, Thomas A. Watson (1854–1934). Bell finally perfected the device in 1876; the famous first words transmitted over a telephone line were "Mr. Watson, come here. I want you."

Bell demonstrated the device to the public in 1876, and the first working commercial systems were installed within two years. Bell and his financial backers founded Bell Telephone Company to operate the systems, and the firm became the American Telephone and Telegraph Company in 1885. AT&T quickly grew into one of the most profitable businesses in the nation, until it was broken up by federal antimonopoly regulators in 1982.

Bell spent most of the rest of his life at his estate in Nova Scotia, focusing on experiments in aeronautics. He also invented a primitive metal detector that was deployed in a desperate effort to locate the bullet that killed President James Garfield (1831–1881). In all, Bell filed eighteen patents during his lifetime.

He died in Nova Scotia at age seventy-five.

ADDITIONAL FACTS

1. *Bell was granted the patent for the telephone—number 174,465—on his twenty-ninth birthday.*

2. *The nation's first citywide phone system opened in 1878 in New Haven, Connecticut. An original edition of the first phone book, listing 391 subscribers, was auctioned at Christie's in 2008 for $170,500.*

3. *The bel, a unit of sound intensity, was named in honor of the telephone's inventor. The unit equaling one-tenth of a bel—the decibel—is more commonly used.*

✦✦✦

Jack the Ripper

In one of history's most notorious unsolved crimes, a serial killer nicknamed Jack the Ripper killed at least five prostitutes in the slums of London in 1888. Jack was never caught, and his true identity has been a subject of debate ever since, with dozens of theories arising as to who carried out the gruesome murders.

The killings took place in an impoverished area of London known as Whitechapel, then home to about 1,200 prostitutes. The Ripper—the name was popularized by the London newspapers that covered the case in gory detail—typically targeted middle-aged women and struck on Friday, Saturday, and Sunday nights. The victims' mutilated bodies would be left in alleyways.

Coverage of the case dominated the London press for months. Sensational newspaper stories that appeared after each killing drew public attention to the conditions in London's teeming slums—and also exposed the inadequacy of the police.

In late 1888, a London news agency received several letters purportedly written by the killer. The letters threatened more murders; "I shant quit ripping," he taunted. One was signed "Jack the Ripper," a name that caught on immediately. The notes were originally believed to have been authentic, but they are now regarded as more likely to have been hoaxes. A piece of anti-Semitic graffiti found near one of the victims may also have been linked to the case, but police concluded it was either unrelated or a trick to make them believe the murderer was Jewish.

Police eventually narrowed the list of suspects to four men, but no one was ever charged with the crimes. In the century since, amateur Ripperologists have nominated dozens of other suspects, ranging from a prominent impressionist painter to the grandson of the queen.

Although unsolved, the famous case had far-reaching consequences. London's police chief, Charles Warren (1840–1927), resigned after failing to catch the killer. Over the next two decades, the police force rapidly expanded and developed more sophisticated crime-solving techniques, such as fingerprinting. The Ripper case also provided an early example of how newspapers popularize macabre nicknames for serial killers—though none have surpassed the original in notoriety.

ADDITIONAL FACTS

1. *The Ripper was elected "history's worst Briton" in a 2006 BBC poll, beating out second-place villain Thomas Becket (1118–1170).*

2. *American crime novelist Patricia Cornwell (1956–) spent about $6 million of her own money researching the Ripper case and attempting to prove that painter Walter Sickert (1860–1942) was the killer. She published her findings in a 2002 book,* Portrait of a Killer: Jack the Ripper—Case Closed, *but her findings have been dismissed by most Ripperologists.*

3. *In 1988 the FBI compiled a psychological profile of the killer. They concluded that he was a white heterosexual male, a loner in his late twenties to midthirties who had a domineering mother who had many male sexual partners. The FBI profiler considered it unlikely that he committed suicide, and guessed that he only stopped killing because he feared being caught.*

✦✦✦

Émile Zola

J'Accuse.
—Front page of *L'Aurore,* January 13, 1898

The author of one of the most legendary headlines in the history of newspapers, Émile Zola (1840–1902) was a prominent French novelist, journalist, and social critic. He may be best known today for his role in the Dreyfus affair, a scandal that rocked France and pitted Zola against the French military and political elite.

Zola was born in Paris and worked as a shipping clerk, art reviewer, and journalist before publishing his first novel, *Thérèse Raquin,* in 1867. He was a proponent of naturalism, a nineteenth-century literary movement in France that sought to inject more realistic observations of social conditions into fiction.

The Dreyfus affair began in 1894, when a Jewish officer in the French army, Alfred Dreyfus (1859–1935), was accused of leaking secrets to Germany, convicted by a military court on thin evidence, stripped of his rank, and imprisoned. Suspecting that Dreyfus had been railroaded by anti-Semitic generals and politicians, Zola published a series of articles questioning the evidence against Dreyfus.

Zola's most famous article, appearing under the inflammatory headline *"J'Accuse"*— "I accuse"—specifically accused the French army of a miscarriage of justice. The article, in the form of a letter to the French president, caused an enormous uproar; Zola was convicted of libel several weeks later and forced to flee to England to avoid prison.

The Dreyfus affair was a major turning point in French history, creating a lasting political schism between liberal Dreyfusards, who thought the officer was innocent, and conservative anti-Dreyfusards. Dreyfus was eventually pardoned in 1899 and restored to his rank when evidence suggested that another officer, Ferdinand Ester-hazy (1847–1923), was most likely responsible for the leaks.

Zola returned to France in 1899. He was killed three years later, when his chimney was blocked and he died of carbon monoxide poisoning. His death was ruled an accident, though many have theorized that his political opponents might have blocked the chimney.

ADDITIONAL FACTS

1. Zola is buried in the Panthéon, the resting place of French luminaries, next to the author Victor Hugo (1802–1885). Dreyfus attended the interment and was wounded in an assassination attempt at the ceremony.

2. Dreyfus was reinstated in the French military after his exoneration, served on the front lines in World War I, and received the Legion of Honor in 1918.

3. Zola was a close childhood friend of the painter Paul Cézanne (1839–1906), who attended the same school as Zola in Provence. The neurotic, insecure painter in Zola's 1886 novel L'Oeuvre was based on Cézanne, which humiliated the artist and ended their friendship.

✦✦✦

José Martí

Percy Bysshe Shelley (1792–1822) once remarked that poets are the "unacknowledged legislators of the world" for their ability to stir passions, instill hope, and guide society's moral compass.

José Martí (1853–1895), a Cuban poet, journalist, and political agitator, was the man who proved the truth of Shelley's maxim. Considered the founding father of independent Cuba, the diminutive Martí served his country not with military feats, but with poetry and essays that helped sway his countrymen toward revolution. Indeed, Martí's influence in Cuba is so great that even today, both Fidel Castro (1926–) and his enemies claim the Havana-born poet as inspiration. Castro's Communist youth group and the US government's anti-Castro radio station based in Florida are both named after Martí.

By the late nineteenth century, the island of Cuba was virtually all that remained of Spain's once-vast American empire. The Spanish colonial governors were noted for their cruelty and incompetence; two revolts, one in 1868 and another in 1895, had led to harsh crackdowns on the island.

Martí supported the 1868 revolt as a high school art student. As a result, he was convicted of treason while still a teenager and sent to Spain in the hope that he would lose interest in Cuban politics.

Instead, Martí's exile only fostered his yearning for a free Cuba. He would spend most of the rest of his life in exile, including fifteen years in New York City, writing countless poems and political tracts in favor of Cuban independence. He toured the world drumming up international support for the Cuban cause and drawing attention to Spanish atrocities.

In 1894, after years of building alliances with other Cuban dissidents, Martí traveled to Mexico to plan another revolt. He landed on the island in 1895 and declared an uprising, but was killed by Spanish soldiers in one of the first battles of the war. He was forty-two at the time of his death.

Three years later, after the United States entered the war on the side of the rebels, Spain surrendered the island. Following a brief American occupation, the island officially became independent in 1902.

ADDITIONAL FACTS

1. *In addition to his political writing, while living in New York City, Martí founded a Spanish-language children's magazine called* La Edad de Oro—"The Golden Age."

2. *Martí had no military experience before returning to Cuba in 1895, and he was killed within a few weeks of entering combat. He may have been a particularly easy target because he was riding a white horse and had gotten separated from the rest of the Cuban force.*

3. *A bronze equestrian statue of Martí was erected in New York City's Central Park in 1965, next to statues of two other Latin American heroes: Simón Bolívar (1783–1830), the liberator of six South American countries, and José de San Martin (1778–1850), the national hero of Argentina.*

✦✦✦

Bahá'u'lláh

Which is the one true religion? A Persian mystic named Bahá'u'lláh (1817–1892) gave an unorthodox answer in 1863 that sparked the creation of the Bahái'í faith: all of them.

The unity of all religious traditions is the central tenet of Bahái'í, which Bahá'u'lláh founded in Palestine and which now claims about 5 million followers worldwide. Bahá'u'lláh denounced divisions along religious and ethnic lines and embraced Jesus, Muhammad, the Buddha, and scores of other religious figures as valid "manifestations of God."

Bahá'u'lláh was born as Mirza Hoseyn Ali Nuri in the Persian capital of Tehran. He was raised in Shiite Islam but changed his name when he joined an underground sect, the Babi, whose leader was executed for treason by Persian authorities in 1850. After the founder's death, Bahá'u'lláh assumed leadership of the Babi.

In the mass persecution that followed, Bahá'u'lláh was banished from Persia and traveled to Baghdad, Kurdistan, and Constantinople. In Turkey, he declared himself the "rightly guided leader" and manifestation of God who had been predicted by the Babi founder. Bahá'u'lláh was banished for a second time, this time by the Ottoman government, and confined to a prison colony in Acre, a Mediterranean city in what is now Israel.

From Acre, he continued to write books, prayers, and letters to followers outlining his religious beliefs. He claimed that he was God's messenger, the messiah figure predicted by many religious traditions who would unite the religions and overcome earthly divisions.

In addition, Bahá'u'lláh outlined a set of rules for his followers that included ritual fasting, daily prayer, and total abstinence from drugs and alcohol. Bahái'í has no clergy or ceremonies; services in Bahái'í temples consist of readings from scriptures of other religions.

Although legally confined at Acre for the rest of his life, Bahá'u'lláh was allowed to travel in the region, receive visitors, and communicate with his followers. After his death, through the work of his son, the religion spread throughout the Middle East, Africa, and the United States.

ADDITIONAL FACTS

1. *Bahái'í is now headquartered in Haifa, Israel, a few miles from the site of Bahá'u'lláh's imprisonment in Acre.*

2. *Other prophets recognized by Bahá'u'lláh include Abraham, Moses, and Zoroaster.*

3. *After his death, Bahá'u'lláh was succeeded as leader of the Bahái'í by his son, 'Abdu'l-Bahá (1844–1921), and his grandson, Shoghi Effendi Rabbani (1897–1957).*

❖ ❖ ❖

Theodore Roosevelt

Theodore Roosevelt (1858–1919) was a hunter, soldier, author, and two-term president of the United States. During his tenure in office, Roosevelt aggressively expanded American influence overseas while promoting stricter regulation of business and protection of the environment domestically.

Roosevelt was born in New York City, graduated from Harvard, and briefly attended Columbia University's law school before dropping out to run for the New York legislature in 1881. His wife and mother both died on the same day in 1884, a blow that Roosevelt refused to talk about for the remainder of his life.

He was appointed assistant secretary of the navy in 1897, but resigned the next year to fight in the Spanish-American War. He recruited volunteers for a new cavalry unit nicknamed the Rough Riders and won a Medal of Honor for his role in combat at the Battle of San Juan Hill in 1898.

By that time nationally famous for his wartime exploits, Roosevelt was elected governor of New York in November 1898. Less than two years later, William McKinley (1843–1901) selected him as his vice presidential running mate. After McKinley's assassination, Roosevelt became president on September 14, 1901.

In foreign affairs, the United States entered the twentieth century as a growing world empire. Roosevelt increased the size of the navy, took control of Panama to build the Panama Canal, and pursued the war against nationalist rebels in the Philippines, which the United States had taken from Spain in the treaty ending the Spanish-American War. His interventionism set the template for American foreign policy for the rest of the century.

Domestically, Roosevelt aligned himself with the progressive wing of the Republican Party, pursuing business monopolies and regulating railroads. He also established the Food and Drug Administration to protect consumers against impure drugs. Roosevelt was also an ardent conservationist, and he established the United States Forest Service to protect the American landscape.

Roosevelt left office in 1909, but returned to run again in 1912 as a third-party progressive candidate. As he campaigned, he was wounded in an assassination attempt—but finished his ninety-minute speech before checking in to a hospital. Roosevelt lost the election, but was active in politics until his death at age sixty.

ADDITIONAL FACTS

1. *Roosevelt, who traveled to Buffalo after McKinley's shooting there, stayed at the president's bedside until his death. The new president was inaugurated at the home of a friend, now a national historic site.*

2. *College football gained national popularity during Roosevelt's administration. But the president, alarmed by the number of deaths attributed to the sport, forced college presidents to legalize the forward pass, which he believed—correctly—would make the game safer.*

3. *The teddy bear is named after Roosevelt, who, according to a famous tale, refused to shoot a bear cub during a hunting trip in Mississippi.*

♦♦♦

Friedrich Nietzsche

God is dead.
—Nietzsche

Traditional morals are outdated. The strong can abuse the weak. The arrival of Christianity in Europe was a curse. Germans drink too much beer.

Friedrich Nietzsche (1844–1900), one of the most influential figures in modern philosophy, specialized in provocative musings that shocked his readers but have inspired generations of artists and skeptics. Born in Germany, Nietzsche devoted much of his short career to attacking the underlying precepts of Western civilization—above all, the code of Christian ethics that formed its core.

Nietzsche was born in a rural area near Leipzig and named in honor of the Prussian king, Friedrich Wilhelm IV (1795–1861). In 1867, Nietzsche entered the Prussian military and suffered a serious chest injury during training. He was released from the army, but his wounds never fully healed, and he suffered from poor physical and mental health for the rest of his life.

Returning to university life, Nietzsche obtained his first teaching position in 1869 and began publishing three years later. He wrote about a wide range of topics, including morals, art, and music—especially that of his friend Richard Wagner (1813–1883). Nietzsche's writing was not concerned with art directly, but rather with its philosophical implications. For instance, in *Birth of Tragedy,* Nietzsche finds hope in the ancient literary form of the Greek tragedy, finding that it contains a full range of emotional experiences that represent the fullness and meaning of life.

Nietzsche's philosophy has been controversial since its publication. One of his most notorious and misunderstood concepts is the "will to power," an argument that all people are inclined to seek power and that the will to have power is stronger than the "will to survive." A version of the concept was embraced by the Nazis fifty years later.

In poor health due to chronic headaches and vision problems, Nietzsche resigned from teaching in 1879. He suffered a total nervous breakdown on January 3, 1889. Incapacitated by his mental health problems, he moved back in with his mother in Germany and later died of pneumonia at age fifty-five while under his sister's care.

ADDITIONAL FACTS

1. *Nietzsche's final breakdown occurred in the city of Turin, Italy. In one of the city's main squares, he supposedly witnessed a rider whipping his horse, ran to the horse to protect it, and then collapsed.*

2. *About 150,000 copies of one of his books,* Thus Spoke Zarathustra *(1883–1885), were distributed to German troops as a morale booster during World War I.*

3. *Despite his injuries, Nietzsche served in the Prussian army during the Franco-Prussian War (1870–1871). He worked in a military hospital caring for wounded soldiers.*

❖ ❖ ❖

Nikola Tesla

Early in life, Nikola Tesla (1856–1943) enjoyed national fame for his visionary inventions and research on electricity. By the time he died in a New York City hotel room, however, Tesla had become the real-life inspiration for the mad scientist of the movies, thanks to his increasingly eccentric personal behavior, unusual appearance, and obsession with building a "death ray."

Born in Croatia and trained in electrical engineering, Tesla immigrated to the United States in 1884 after the deaths of his parents. Tesla went to work for the American inventor Thomas Edison (1847–1931) in New Jersey, but the men had a falling-out when Edison refused to pay Tesla a bonus he had been promised.

After quitting Edison's company, Tesla started his own lab, the Tesla Electric Light and Manufacturing Company, in New Jersey in 1886. The company helped devise the alternating current (AC) system of transmitting electricity, a rival to Edison's direct current (DC) standard. In the 1890s, the so-called War of the Currents pitted Edison against his former employee, with the future of the electricity industry at stake. Tesla's AC had several advantages over DC—the biggest being the ability to transmit current over long distances—but Edison contended that AC was too dangerous.

A turning point in the war came in 1893, when Tesla and his business partner, George Westinghouse (1846–1914), won a contract to electrify the World's Fair in Chicago. The fair gave them the opportunity to demonstrate AC to millions of visitors. By the end of the decade, AC had clearly triumphed, and only a handful of cities continued to use DC in the twentieth century.

Tesla, meanwhile, had moved on to new challenges. He filed a patent for a radio in 1897 and built a giant lab on a mountain in Colorado in 1899 to study atmospheric electricity. With the backing of tycoon J. Pierpont Morgan (1837–1913), he constructed a steel tower for transmitting power wirelessly—the first of its kind.

An obsessive and imposing personality, Tesla never married, and he was repulsed by contact with other people. He lived the last ten years of his life in a hotel room, feeding pigeons and claiming to have invented a death ray so powerful it could sink battleships and kill a million men at once. In contrast to his rival Edison, who died rich and famous, Tesla was virtually penniless and forgotten at the time of his death at age eighty-six. His room was searched for death ray plans after his death; no blueprint was ever found.

ADDITIONAL FACTS

1. *For more than four decades, Tesla was engaged in a patent dispute with the Italian inventor Guglielmo Marconi (1874–1937) over who deserved credit for inventing the radio. The Supreme Court finally sided with Tesla in 1943—a few months after his death.*

2. *The tesla—a unit of magnetic flux density—was named after the inventor in 1960.*

3. *Although he spent years designing his death ray, Tesla was never able to build one of the devices. He offered the invention to the US and British governments in the 1930s, but both politely declined.*

◆◆◆

Lizzie Borden

Lizzie Borden took an axe
And gave her mother forty whacks.
And when she saw what she had done,
She gave her father forty-one.
—**Traditional**

One of the most sensational crimes of the nineteenth century occurred August 4, 1892, when an ax murderer killed Andrew (1822–1892) and Abby Borden (1828–1892) at their home in Massachusetts. Suspicion immediately fell on their daughter, Lizzie (1860–1927), who was soon arrested and charged with the crimes.

Because of its gruesome nature, the case of Lizzie Borden transfixed New England. Borden was—and still is—widely believed to have committed the murders. But she was acquitted due to lack of evidence, a controversial verdict that shocked many Americans.

Borden was born to a wealthy family and lived in a large house with a maid in Fall River, Massachusetts. Abby was Andrew's second wife; Lizzie's mother, Sarah A. Borden, had died in 1863.

On the day of the murders, Andrew Borden ran errands in the morning and took a nap on a sofa after returning home. Lizzie claimed that she found his body later that day; he had apparently been killed while sleeping. The body of her stepmother was discovered upstairs shortly afterward. Both bodies had been hacked repeatedly (although not forty times, as the children's rhyme later suggested).

Strong circumstantial evidence linked Lizzie to the killings. Police found a hatchet during a search of the Borden basement. A druggist testified that she had attempted to buy poison a few days before the murders. And Borden acknowledged burning a dress in the stove a few days after the murders.

At trial, however, some of the most damning evidence was ruled inadmissible, and prosecutors were unable to convince jurors that the hatchet from the basement was the murder weapon. She was acquitted after only sixty-eight minutes.

After her acquittal, Borden inherited a small fortune from her parents and lived the rest of her life in Fall River. She died at age sixty-six.

ADDITIONAL FACTS

1. *Borden was accused of shoplifting two porcelain paintings in Providence, Rhode Island, in 1897. She avoided charges, reaching a private settlement with the jewelry store.*

2. *An opera about the Borden case,* Lizzie Borden, *debuted in New York City in 1965.*

3. *Borden's father was notoriously cheap. He refused to install indoor plumbing in the house.*

✦✦✦

Oscar Wilde

While serving a two-year sentence at a prison in Reading, England, the author, playwright, and poet Oscar Wilde (1854–1900) witnessed the hanging of a fellow prisoner who had been convicted of murder. The death of the man, whom Wilde had befriended, deeply troubled the writer and formed the basis for a poem that he wrote after his release, "The Ballad of Reading Gaol" (1898):

> *I never saw a man who looked*
> *With such a wistful eye*
> *Upon that little tent of blue*
> *Which prisoners call the sky. . . .*

"The Ballad of Reading Gaol" was the last major work that Wilde completed before his own death in 1900, at age forty-six. More somber than many of Wilde's earlier works, the poem was marked by the sadness and tragedy of the last years of Wilde's life, starting with his arrest and conviction for homosexual acts in 1895 and his self-imposed exile in France for the last three years of his life. "Something was dead in each of us," another passage read, "And what was dead was Hope."

Wilde had begun his literary career as a student at Oxford, where he wrote poetry and became involved with the "aesthetic" movement. The aesthetics believed that art should exist for its own sake, rather than to convey a message or teach a moral lesson. Wilde, with his long hair, subversive wit, and flamboyant dress, became one of the spokesmen for the movement. Wilde published his only novel, *The Picture of Dorian Gray*, in 1891. He also wrote many plays, including *The Importance of Being Earnest* (1895).

In the early 1890s, Wilde began an affair with Lord Alfred Douglas (1870–1945), the son of a prominent aristocrat, the Marquess of Queensberry (1844–1900). The marquess was furious and accused Wilde of being a "somdomite [*sic*]"—a crime in nineteenth-century Britain. Wilde was soon arrested on the charge of "gross indecency," convicted, and sentenced to two years' hard labor. After his release, Wilde fled to France, where he lived under an assumed name. He died of cerebral meningitis in a Paris hotel three years later.

ADDITIONAL FACTS

1. *The Marquess of Queensberry is also known for sponsoring an athletic club in England that standardized the rules of boxing in the 1880s. The rules, still in effect for professional boxing, are widely known as the Marquess of Queensberry rules.*

2. *Wilde's 1891 novel,* The Picture of Dorian Gray, *was made into a Hollywood movie in 1945. A remake, starring Colin Firth (1960–), was released in the United Kingdom in 2009.*

3. *The ban on male homosexual acts in England and Wales, under which Wilde was convicted, was repealed in 1967.*

♦♦♦

Emiliano Zapata

It is better to die on your feet, than to live on your knees.
—Emiliano Zapata

With his long black mustache, broad sombrero, and piercing eyes, rebel leader Emiliano Zapata (1879–1919) is one of the most famous faces in Mexican history. Leader of a large-scale peasant revolt from 1910 until his assassination, Zapata fought for a more equitable distribution of the nation's farmland, making him an enduring hero to many Mexicans, especially the poor.

Zapata grew up during the dictatorship of Porfirio Díaz (1830–1915), who had seized power in an 1876 coup. For peasant farmers like Zapata's family, the Díaz years were a disastrous period, as the government allowed large landowners to consolidate control over the countryside at the expense of the peasantry.

In 1909, Zapata was elected one of the guardians of his village, Anenecuilco, in the southern state of Morelos. When the Mexican Revolution began in 1910, Zapata supported the rebels, who toppled Díaz in 1911, forcing the dictator to flee to France.

The end of the Díaz regime, however, did not address Zapata's land reform demands or end the revolution. Zapata detailed his proposals in the Plan de Ayala, a 1911 manifesto for land reform that would make it easier for poor farmers to own farms.

Over the next eight years, several different presidents ruled Mexico as rebel factions vied for power. Zapata drew his support mostly from southern Mexico, until he was assassinated in 1919 after being tricked into a meeting with his enemies. The war petered out after 1920; some of Zapata's reforms were enacted, but rebel groups claiming to continue Zapata's unfinished struggle are still in existence.

ADDITIONAL FACTS

1. *Zapata was played by actor Marlon Brando (1924–2004) in a 1952 film about his life,* Viva Zapata! *which also starred Anthony Quinn (1915–2001) as the rebel leader's brother. Quinn won an Academy Award for Best Supporting Actor, and the film was nominated for four other Oscars. The screenplay was cowritten by John Steinbeck (1902–1968)—better known as a Nobel Prize–winning novelist.*

2. *In 1994, a group of rebels calling themselves Zapatistas launched a revolt against Mexican land reforms and trade policy in the state of Chiapas.*

3. *The anniversary of Zapata's assassination, April 10, is often marked in Mexico with protests by various groups that claim the rebel as an inspiration.*

◆◆◆

Mary Baker Eddy

Founder of the Church of Christ, Scientist, Mary Baker Eddy (1821–1910) was born into an austere Congregationalist household on a farm in New Hampshire. She endured chronic illness as a child and was in poor health for most of her life, a condition that influenced many of her religious beliefs.

Baker Eddy married for the first time at age twenty-two and soon became pregnant, but her husband died before their son, George, was born in 1844. Unable to support the boy on her pay as a schoolteacher, she remarried to a local doctor, but they soon divorced and she eventually lost custody of her son.

These financial and emotional setbacks, combined with her lifelong medical problems, left Baker Eddy deeply depressed. Despite her religious background, she found little solace in the harsh religion of her upbringing.

In the 1850s and 1860s, Baker Eddy experimented with a procession of medical and religious fads, including homeopathy (using natural compounds such as tree bark and oyster shells as medicine), hydropathy (a system by which one could supposedly cure diseases with hot and cold baths), and Quimbyism (named for Phineas Parkhurst Quimby [1802–1866], a Maine clock maker who believed he could cure illness through hypnosis). However, her woes continued until 1866, when she fell on the ice and was left immobile. She then read the Bible for three days straight and suddenly felt better—evidence, she concluded, of God's power to heal.

In 1870, Baker Eddy began writing *Science and Health with Key to the Scriptures,* which was published in 1875 and became a bestseller. She married a follower, Asa Gilbert Eddy, in 1877 and founded the Church of Christ, Scientist, in Boston in 1879. The church stressed the power of the Bible, rather than medicine, to cure disease.

To spread her teachings, Baker Eddy required that Christian Science churches open free reading rooms where members of the public could study the Bible and church publications. The reading rooms, along with the *Christian Science Monitor* newspaper, remain perhaps the two most widely known faces of the church.

She retired from day-to-day leadership of the church in 1889, moved to New Hampshire, and was buried in Cambridge, Massachusetts, after her death at age eighty-nine.

ADDITIONAL FACTS

1. *Baker Eddy's brother, Albert (1810–1841), was a law partner in New Hampshire of Franklin Pierce (1804–1869), later the fourteenth president of the United States.*

2. *After the death of her first husband, Baker Eddy opened a children's school along the lines of a kindergarten. It failed within a few months.*

3. *Since its founding, many detractors have criticized Christian Science for its opposition to medicine. Irish writer George Bernard Shaw (1856–1950), noting that Christian Scientists rejected both modern medicine and the traditional Christian concept of sin, quipped that the church was "neither Christian nor scientific."*

✦✦✦

Kemal Atatürk

Mustafa Kemal Atatürk (1881–1938) was the founder and first president of the Republic of Turkey. More than any other political leader, he was responsible for preserving Turkey's independence after its defeat in World War I and rebuilding the nation into a modern, secular state.

Atatürk was born in Thessaloniki, a city in the Ottoman Empire. The empire controlled much of eastern Europe and the Middle East, but its economic and military power was in decline. (The Ottomans had been dubbed "the sick man of Europe.")

After graduating from the Ottoman military academy in 1905, Atatürk joined the army and was stationed in Syria, Libya, and the Balkans. The Ottomans entered World War I in 1914 on the side of Germany and Austria; Atatürk commanded an army division that won a major battle against the British at Gallipoli in 1915.

The eventual Allied victory in 1918, however, spelled the end of the Ottoman Empire: Its territory in the Middle East was divided up between the victorious France and Britain, and the last caliph was deposed. The Allies also planned to divide up Turkey, the heartland of the Ottoman Empire, but Atatürk was able to preserve Turkish unity with a brief war of independence.

The Republic of Turkey was established in 1923, with Atatürk as its president. He set about writing a constitution, founding schools and museums, and implementing social reforms meant to bring Turkey closer to the West. He replaced Arabic characters with a Western-style Turkish alphabet, adopted European-style suits and hats while banning traditional Turkish clothing, and forced Turks to adopt surnames, among other Western customs.

Secularization and modernization were the hallmarks of Atatürk's rule, and they were also at the core of the philosophy that became known as Kemalism. Long after his death, Turkish military leaders would justify coups against elected governments as necessary steps to protect the founder's legacy. Atatürk remained in office until his death from liver disease at age fifty-seven.

ADDITIONAL FACTS

1. *It is illegal in Turkey to insult Atatürk. As recently as 2008, a professor was given a fifteen-month suspended jail sentence for suggesting that Atatürk's record as a reformer had been exaggerated in history books.*

2. *As part of his reforms to modernize Turkey, Atatürk banned men from wearing the traditional fez— and led by example by donning a Western-style Panama hat.*

3. *He acquired his last name in 1935, when Turkey instituted the Western practice of individual surnames; Atatürk means "Father of the Turks."*

◆◆◆

William James

One of the first Americans to make a major contribution to world philosophy, William James (1842–1910) was an educator, a psychologist, and the founder of the philosophical school of pragmatism. Two of his books—*The Principles of Psychology* (1890) and *The Varieties of Religious Experience* (1902)—are considered landmark texts in the modern understanding of the human mind.

James was born in New York City to a wealthy family that also included his younger brother, the acclaimed novelist Henry James (1843–1916). William spent his childhood in a Manhattan mansion, received a gold-plated education at boarding schools in Geneva and Paris, and graduated from Harvard in 1869 with a degree in medicine.

For most of his early life, however, James suffered from precarious mental health and frequent bouts of suicidal depression. His malaise began to ease in 1870, after he read an uplifting essay by French philosopher Charles Renouvier (1815–1903); James began teaching physiology at Harvard in 1872 and married in 1878.

The Principles of Psychology took James twelve years to write, but it was hailed as a classic almost immediately upon its publication. Part textbook, part philosophical treatise, the book became a standard reference for psychology students and introduced such ideas as the "stream of consciousness," the manner in which James believed the mind blends past ideas and experiences.

James's *Varieties of Religious Experience* cataloged the various epiphanies, miracles, and mystical visions reported by believers from several religions—"the feelings, acts, and experiences of individual men in their solitude, so far as they apprehend themselves to stand in relation to whatever they may consider the divine." The book treated the experience of religion as a biological function no different from walking or breathing; James concluded that religion was worthwhile, even as he avoided endorsing it as true.

In 1907, James published a summation of his philosophical beliefs, *Pragmatism*. The pragmatists rejected dogmatic, absolute philosophical stances and said that truths were formed by human experience—something was true if it *worked*.

James spent his last several years traveling, but suffered from worsening health woes. He died at his country home in New Hampshire at age sixty-eight.

ADDITIONAL FACTS

1. *According to some of his biographers, James was briefly hospitalized at McLean Asylum for the Insane, an institution outside Boston. The hospital, which remains in existence, still refuses to confirm or deny whether James was ever a patient.*

2. *James's students at Harvard included a future president, Theodore Roosevelt (1858–1919), who graduated in 1880, and the famous writer W. E. B. DuBois (1868–1963), of the class of 1890.*

3. *Two of the James brothers, Wilky and Bob, served in the Union Army during the Civil War. William and Henry did not, both claiming ill health.*

◆◆◆

Marie Curie

The first woman to win a Nobel Prize, French chemist Marie Curie (1867–1934) helped solve the mysteries of radiation, discovered two new elements, and blazed a trail for women entering the male-dominated fields of chemistry and physics. Curie remains the only individual to have won the Nobel Prize in two different scientific categories, a feat that testifies to her unrivaled place in scientific history.

Curie was born in Warsaw, Poland, as Maria Sklodowska and immigrated to France in 1891 to study physics at the Sorbonne. She met physicist Pierre Curie (1859–1906) in 1894; they married the next year. Marie, who had been barred from teaching in her native Poland because she was a woman, adopted French citizenship after marrying Pierre.

The Curies spent most of the next decade in the lab or on bicycle trips together in the French countryside. Their research into the new and poorly understood field of radioactivity—a term they coined—earned them the 1903 Nobel Prize in Physics. In the same year, Marie Curie became the first woman in French history to be awarded a doctorate.

Tragedy befell the Curies in 1906, when Pierre was killed in a street accident. Marie was devastated by her husband's death, but she only intensified her work in the lab. She won another Nobel Prize in 1911, this time in chemistry, for more advances in the study of radiation.

During World War I, Curie was forced to smuggle her precious radium stash—which then amounted to only a single gram—out of Paris for safekeeping. But the war also gave her an opportunity to demonstrate a practical application for radiation: the x-ray machine. The device, mounted on ambulances, allowed doctors at the front to locate bullets and shrapnel in the bodies of wounded soldiers, saving hundreds of lives.

Curie's fame grew in the 1920s, and she toured Europe and the United States collecting accolades. (President Warren G. Harding [1865–1923] gave her a gram of radium in 1921 on behalf of the women of the United States.) A lifetime of exposure to radiation eventually took its toll on Curie, however. She developed aplastic anemia, a bone marrow disease, and died in 1934.

ADDITIONAL FACTS

1. *During World War I, Curie offered her two Nobel Prize medals to the French government to support the war effort. Although the government was desperate for gold and silver, authorities declined her offer.*

2. *Curie discovered two new elements, polonium—which she named after her home country, Poland— and radium.*

◆◆◆

Mata Hari

I wanted to live like a colorful butterfly in the sun.
—**Mata Hari**

Mata Hari—born Margaretha Zelle (1876–1917)—was an exotic dancer and courtesan who was executed as a German spy during World War I. Her life and espionage trial have been a source of enduring fascination. Many supporters believe Mata Hari was unjustly targeted because of her free-spirited sexuality—and because the French needed a scapegoat for their military setbacks.

A citizen of the Netherlands, Zelle was expelled from school at age sixteen for sleeping with her principal. She married a Dutch army officer at age eighteen and moved with him to the Dutch East Indies (now Indonesia). He was an abusive husband who infected her with syphilis, and they divorced several years later.

Returning to Europe, Zelle moved to Paris in 1903, where she began dancing at nightclubs and adopted the stage name Mata Hari—Indonesian for "Eye of the Day." Her exotic costumes and sultry striptease routine, supposedly based on native Indonesian dances, became a sensation. Mata Hari also began acquiring lovers among the French elite, a list that eventually included prominent businessmen and military officers.

By the time World War I began, Mata Hari was famous throughout Western Europe and had performed across the continent. As a citizen of neutral Holland, she was able to travel freely among the warring powers in Europe, and she visited France, Germany, England, the Netherlands, and Spain during the war.

Almost a century after her arrest, the details of her case remain somewhat murky. Mata Hari had lovers on both the German and French sides of the trenches, and she apparently volunteered to spy for both sides. It is unclear whether she actually learned secrets of any importance. In 1917, however, the French intercepted a German military communication that named her as a spy, and they arrested her that February. She was quickly convicted and sentenced to death. On the morning of October 15, she put on one last show, blowing a kiss to her firing squad and refusing to wear a blindfold. She was forty-one at the time of her death.

ADDITIONAL FACTS

1. *Famed actress Greta Garbo (1905–1990) played Mata Hari in a 1931 movie.*

2. *A Mata Hari is a cocktail whose recipe includes Courvoisier, vermouth, pomegranate juice, lemon juice, and sugar.*

3. *Dutch lawyers filed suit in 2001 to clear Mata Hari's name, arguing that she had been framed by the government.*

◆◆◆

Auguste Rodin

A temperamental genius who struggled for recognition in his lifetime, Auguste Rodin (1840–1917) is known today as one of the founders of modern sculpture. His two most famous works, *The Thinker* and *The Kiss,* are among the most instantly recognizable statues in Western art and the inspirations for countless tributes, imitations, and parodies.

In his pathbreaking work, Rodin abandoned the rigid realism of classical sculpture in favor of rougher, less conventional statues. He left many of his figures purposefully incomplete, showing only the most expressive parts of his subjects' bodies. Rodin's controversial statue of the author Honoré de Balzac (1799–1850), for instance, portrays only the author's face and head, submerging the rest of his body under a billowing robe.

Rodin was born in Paris and attended art school, but was rejected when he applied to France's main sculpture academy. He worked as a journeyman decorator, served in the French army during the Franco-Prussian War of 1870 and 1871, and traveled to Italy, where he was deeply impressed by the sculpture of Renaissance artists such as Michelangelo (1475–1564) and Donatello (1386–1466).

In 1880, Rodin received his first major commission, designing the gate for a planned museum in Paris. The gate itself would never be built. But Rodin's work on the project led to both *The Thinker* and *The Kiss,* which were originally conceived as parts of the gate but which Rodin later offered as stand-alone works. Another famous work, *The Burghers of Calais,* was unveiled in 1889 and added to Rodin's growing fame.

Rodin was a transitional figure in sculpture who helped lead the movement away from classicism and portraiture and toward abstraction. By the end of his life, he was arguably the best-known sculptor on the globe; he died in Meudon, a town near Paris, at age seventy-seven.

ADDITIONAL FACTS

1. *Rodin initially began* The Thinker *with the intention of portraying the Italian writer Dante (c. 1265–1321), but later decided not to give it any specific name.* The Kiss *was originally meant to represent Paolo and Francesca, two characters from Dante's* Inferno, *but Rodin again decided not to give the figures any personal identities.*

2. *The French writer Émile Zola (1840–1902) picked Rodin to make the memorial statue of Balzac for a French writers' association. Rodin's design—which he said was "the sum of my whole life"—was so unorthodox that the writers rejected it, and it was not cast in bronze until after his death.*

3. *In 2005, the publication* ARTnews *included Rodin on its list of the ten most-faked artists of all time. The winner was Jean-Baptiste-Camille Corot (1796–1875), a French landscape painter who actually encouraged forgeries because he felt sorry for the obscure painters who turned to faking paintings to support themselves.*

❖❖❖

Patrick Pearse

Ireland unfree shall never be at peace.
—Patrick Pearse

A schoolteacher, lawyer, and fervent Irish nationalist, Patrick Pearse (1879–1916) was one of the most notable leaders of the Easter Rising against British rule in 1916. The uprising—the most significant Irish rebellion in more than a century—would set in motion a chain of events that led to Irish independence in 1921.

Pearse, a stirring orator who often evoked the heroes of Irish history in his speeches, did not live to see an independent Ireland. He was arrested by the British, court-martialed, and shot in Dublin on May 3, 1916. The site of his execution has since become a national monument.

Born in Dublin, Pearse was attracted to the Irish cause from a young age. Influenced by such historical figures as Theobald Wolfe Tone (1763–1798), he joined an Irish nationalist group at age sixteen and was editing its newspaper by the time he was twenty-three. He was a leading proponent of the Gaelic language, Ireland's ancient tongue, which had been replaced by English in most schools. In 1908, Pearse and his brother, Willie (1881–1916), founded an Irish-language school, Saint Enda's School.

In 1913, Pearse was among the founders of the Irish Volunteers, a more militant nationalist group that would later become the Irish Republican Army (IRA). He rose through the ranks of the underground organization and was chosen as one of the leaders of the planned 1916 revolt.

The Rising began on the day after Easter. Rebels took control of the General Post Office in Dublin, and Pearse, standing on the building's steps, proclaimed the island's independence from the British. Pearse hoped that the Irish population would rally to support the rebellion, but after six days of violence, he was forced to surrender.

In total, sixteen leaders of the Rising—including Willie Pearse—were executed by the British. The deaths of the men caused an uproar and contributed to the victory of the radical proindependence Sinn Féin party in the 1918 elections. The next year, the IRA launched the Irish War of Independence, which ended with British recognition of Ireland in 1921.

ADDITIONAL FACTS

1. *One of the leaders of the Easter Rising was Eamon de Valera (1882–1975), who narrowly escaped execution and later served as the president of Ireland from 1959 until 1973.*

2. *The General Post Office building is still the main postal headquarters in Dublin. It was renovated, but some bullet marks were left in the facade as a memorial to the Rising.*

3. *Ireland remained formally a part of the British Commonwealth until 1949, when it declared itself a republic.*

✦✦✦

Robert Ingersoll

In the nineteenth-century United States, openly questioning the existence of God was likely to provoke either bafflement or scorn. It was in this challenging environment that lawyer Robert G. Ingersoll (1833–1899) launched a seemingly quixotic campaign to make religious disbelief acceptable.

Descended from one of the original Puritan settlers of Massachusetts, Ingersoll was raised in a stern Calvinist household. After leaving home in 1852, he worked briefly as a schoolteacher before starting a law firm with his brother, Ebon (1831–1879), in Peoria, Illinois.

Strongly opposed to slavery, Ingersoll volunteered for the Union Army during the Civil War, fought at the Battle of Shiloh in 1862, and was later captured by Confederate soldiers and briefly held as a prisoner of war. He became active in politics after his release and managed Ebon's successful 1864 campaign for an Illinois seat in the House of Representatives.

Although Robert Ingersoll hoped to run for governor of Illinois himself, his political career was stymied when Illinois Republicans became aware of his unorthodox religious views. At the time, nominating an agnostic was seen as political suicide, and despite a lifetime spent supporting Republican politicians, Ingersoll was never allowed to run for any office on the party's ticket or granted a position in a Republican president's cabinet.

Undeterred, Ingersoll hit the lecture circuit in the 1860s, speaking out against traditional religious beliefs and in favor of "free thinking," a term he coined to reflect his argument that beliefs should be rooted in reason, not emotion or superstition. A powerful orator, Ingersoll established the American Secular Union in 1884, a group dedicated to promoting free thinking, abolishing chaplains in the army, and separating church and state.

Although he was not the first American agnostic—he claimed Thomas Jefferson (1743–1826) and Thomas Paine (1737–1809) as predecessors—Ingersoll was one of the first willing to endure public ridicule for openly proclaiming his unpopular views. He wrote dozens of books outlining his beliefs and remained an active lecturer and Republican politician until his death at age sixty-five. Ingersoll is buried at Arlington National Cemetery.

ADDITIONAL FACTS

1. *Ingersoll served briefly as the attorney general of Illinois, from 1867 to 1869.*

2. *In addition to his advocacy for agnosticism, Ingersoll was a celebrated defense lawyer. One of his most famous clients was former Arkansas senator Stephen Dorsey (1842–1916), who was tried and acquitted in 1883 on charges of defrauding the federal government of $5 million.*

3. *The inscription on Ingersoll's tombstone reflects his two most cherished causes, agnosticism and the abolition of slavery: "Nothing is grander than to break chains from the bodies of men—nothing nobler than to destroy the phantoms of the soul."*

◆◆◆

Susan B. Anthony

When Congress approved a constitutional amendment granting women the right to vote in 1920, supporters called the landmark bill the Anthony Amendment. Its namesake was Susan B. Anthony (1820–1906), the longtime leader of the women's suffrage movement who had died only a few years before her lifelong goal finally became a reality.

Anthony was born in Adams, Massachusetts, into a strict Quaker family that forbade her from playing with toys or games. Anthony's progressive political beliefs were instilled at a young age by her parents. She volunteered for the abolitionist movement when she was a teenager, campaigned for the prohibition of alcohol (then viewed as a reform that protected women from drunken, abusive husbands), and supported protections for labor unions.

But it was the suffrage movement that would become Anthony's passion. In 1851, she met Elizabeth Cady Stanton (1815–1902), one of the first leaders of the suffragists, who recruited Anthony into the movement. A gifted speaker, Anthony soon was one of the country's highest-profile suffrage activists.

During the Civil War, Anthony and Stanton were enthusiastic backers of the Union, but they were dismayed when the postwar Congress extended voting rights to blacks without including women. The Fifteenth Amendment split the suffrage movement; some supported the amendment as a step in the direction of equality, while critics, including Anthony, held out for full voting rights for everyone.

In 1872, Anthony won publicity for the cause by illegally voting in that year's presidential election. She was arrested by federal marshals and convicted early in 1873, but the trial resulted in renewed attention for the suffrage movement.

In 1892, Anthony became the president of the National Woman Suffrage Association, a group she had founded with Stanton two decades earlier. Anthony retired from that position in 1900. A few months before her death in 1906, she gave a famous farewell speech at a suffrage convention in Baltimore. "I am here for a little time only, and then my place will be filled," she said. "The fight must not cease. You must see that it does not stop. Failure is impossible."

Fourteen years later, the bill bearing her name was made law.

ADDITIONAL FACTS

1. *Anthony learned to read and write by age three.*

2. *In 1900, Anthony convinced the University of Rochester, in her hometown, to admit women—decades before most other private American colleges went coed.*

3. *When she was convicted in 1873 of illegal voting, Anthony was fined $100. She never paid the fine.*

❖ ❖ ❖

John Dewey

In his books, lectures, and classroom experiments, American philosopher John Dewey (1859–1952) changed the face of American education and fundamentally redefined the profession of teaching. By the time of his death, Dewey was regarded as the single most influential educator in the United States and a leading public intellectual on issues of war, peace, and civil rights.

Dewey's philosophy of education was summed up in an 1893 essay: "Cease conceiving of education as mere preparation for later life, and make of it the full meaning of the present life."

Born in northern Vermont, Dewey was educated at public schools and the University of Vermont. He studied philosophy at Johns Hopkins University in Baltimore and was heavily influenced by the pragmatic philosopher William James (1842–1910). In 1894, Dewey was recruited to become the head of the philosophy department at the University of Chicago, which had been established four years earlier.

It was in Chicago that Dewey founded his famous Laboratory Schools in 1896. True to its name, Dewey intended the school to be a testing ground for his progressive theories about education, and he staffed the institution with students from the university's department of pedagogy.

Dewey's reforms called for teaching children by "directed living" rather than by simply drilling them with rote instruction. For instance, instead of making pupils memorize facts about the American Revolution, Dewey's followers would encourage "hands-on learning" in which students would conduct group projects that allowed them to learn the history of the period. For Dewey, educational reform was intricately linked with his views on philosophy and politics. Only a well-educated citizenry, he believed, had the capacity to govern itself in a democratic system.

Dewey was active in politics, beginning with his support for women's suffrage and US involvement in World War I. He drifted to the left after the war, criticized the New Deal as an inadequate response to the Depression, and opposed American involvement in World War II until Pearl Harbor. Unlike many other liberal intellectuals, however, he distrusted Communism because of its antidemocratic character.

Dewey left Chicago in 1904 and spent most of the rest of his life at Columbia University. He died of pneumonia in New York City at age ninety-two.

ADDITIONAL FACTS

1. *Dewey was an early member of the American Civil Liberties Union.*

2. *For his ninetieth birthday, Dewey received just the gift to warm the heart of a pragmatist: money. At a gala celebration in New York, his friends and supporters gave him $90,000 to donate to whatever causes he thought were worthy.*

3. *Dewey married twice: His first wife was Harriet Alice Chipman, whom he met at the University of Michigan when he was there as a professor and she was a student, and after her death he remarried to Roberta Grant.*

Max Planck

Max Planck (1858–1947) was the founder of quantum theory, a field of physics devoted to the study of tiny subatomic particles—electrons, protons, and neutrons. His discoveries made him one of the most prominent scientists in Germany and a mentor to a generation of brilliant physicists, including Albert Einstein (1879–1955) and Erwin Schrödinger (1887–1961). In 1918, at the age of sixty, Planck won the Nobel Prize.

Despite his accomplishments, Planck was humiliated after the Nazi takeover of Germany when he was harassed for teaching "Jewish science." He was forced to resign his professorship in 1938, endured the execution of one of his sons by the Nazis, and died shortly after the end of the war.

Planck was born in the German-speaking region of Holstein, which was under Danish control at the time of his birth. Germany took over the province in 1864, and the Planck family moved to Munich later that decade. He studied physics at the University of Munich starting in 1874—ignoring a warning from a professor that there was nothing left to discover.

Quantum physics, which Planck first described in 1900, represented a fundamental shift in science so great that Planck himself did not fully realize its significance until years later. In a conceptual revolution, Planck and the researchers he inspired theorized that the tiny particles inside an atom do not follow the rules of classical mechanics laid down by Isaac Newton (1643–1727). For instance, they realized, the law of gravity does not cause atoms to collapse into the nucleus.

During World War I, Planck broke with his colleague Einstein to back the German war effort. Still, his close association with Jewish physicists made him suspect during the Third Reich, when he was attacked by Nazi newspapers and investigated for allegedly concealing his own supposedly Jewish heritage. His younger son, Erwin Planck (1893–1945), was a participant in the 1944 assassination plot against Hitler and was hanged by the Gestapo just before the end of the war. Heartbroken, Max Planck died in 1947 at age eighty-nine.

ADDITIONAL FACTS

1. *Planck received his doctoral degree at age twenty after writing his dissertation.*

2. *Germany's premier physics research organization, the Kaiser Wilhelm Institute, was renamed the Max Planck Institute in 1948.*

3. *All of Planck's other children also died under tragic circumstances. Planck's older son, Karl, was killed in World War I. His two daughters both died in childbirth.*

◆◆◆

Charles Ponzi

When he arrived in Boston as an immigrant from Italy, Charles Ponzi (1882–1949) had only the shirt on his back and a few dollars in his pocket. "I landed in this country with $2.50 in cash and $1 million in hopes, and those hopes never left me," he later boasted in a newspaper interview.

Ponzi, who eventually amassed a fortune of about $15 million, might have been a symbol of the American dream. Instead, his name is synonymous with an elaborate financial swindle that victimized about 40,000 Bostonians and is now commonly known as a Ponzi scheme.

In a period of just a few months between 1919 and 1920, Ponzi collected the life savings of laborers, widows, and priests, including many fellow Italian immigrants. By the time of his arrest, he was nationally famous for his seemingly miraculous double-digit returns.

The scheme was hatched after Ponzi received a letter from Spain that included an international reply coupon. The coupons allowed a sender—in this case, a Spanish business—to prepay for return postage at the same price as the original postal rate. But because of fluctuations in the exchange rate, a stamp in Spain cost less than a stamp in the United States. The Spanish business was, in effect, getting a slight discount on the return postage. Ponzi reasoned that if he could buy enough of the coupons, the pennies saved on each one would translate into huge profits. Promising fantastic returns, he offered investors a chance to join in the enterprise. In February 1920, he took in $5,290. In June, it was $440,000. In July, he raked in $6.5 million.

His scheme, ironically, was not illegal. But he never actually bought the coupons, since importing that many stamps from Europe would have been expensive and impractical. Instead, he used new deposits to cover redemptions—the very definition of a Ponzi scheme. And he kept a major portion of the proceeds for himself.

After a newspaper, the *Boston Post*, exposed the scheme, Ponzi went to prison for several years and was eventually deported back to Italy. He ended up working for an Italian airline in Brazil, losing his eyesight, and dying in a charity hospital at age sixty-six. Still, he finished ahead: He had $75 when he died, up $72.50 from where he started. It was just enough to pay for his funeral.

ADDITIONAL FACTS

1. The Boston Post *won a Pulitzer Prize for exposing Ponzi's scheme in 1921.*

2. *Most of the cash Ponzi took in was never accounted for. After years of investigation, his investors received about thirty cents on the dollar of their principal.*

3. *The State of Massachusetts was one of Ponzi's investors. Fred Burrell, the state treasurer, was forced to resign after admitting he put $125,000 into a bank connected with Ponzi.*

◆◆◆

Marcel Proust

In one of the best-known passages he ever wrote, novelist Marcel Proust (1871–1922) described the torrent of memories evoked by a bite of cake. The taste of the pastry, a petite madeleine, instantly transports the adult narrator of *In Search of Lost Time* back to the happy days of his childhood, when he often ate the cakes with his aunt.

The rush of memories also causes the narrator to reflect on the ability of the smallest sensations—the whiff of a familiar scent, a bite of cake—to evoke the most powerful remembrances. "The smell and taste of things remain poised a long time, like souls, ready to remind us, waiting and hoping for their moment, amid the ruins of all the rest; and bear unfaltering, in the tiny and almost impalpable drop of their essence, the vast structure of recollection."

The passage is famous for introducing one of the major themes of Proust's masterpiece, the "vast structure of recollection" and the complex roles those memories play in human consciousness. It is also famous for arriving near the beginning of the seven-volume, 3,000-page narrative, which is about as far as many readers get in Proust's sprawling, challenging, and massively influential work.

Proust, one of the most significant authors of twentieth-century world literature, was born in the Paris suburb of Auteuil and spent much of his youth in Illiers, a rural village. The fictional town of Combray, the setting for much of *In Search of Lost Time,* was a composite of his two childhood homes. He suffered frequent health problems as a child, but nonetheless served for a year in the French army.

Proust was frequently ill as an adult and spent the last years of his life as a virtual invalid. He normally worked at night and slept during the day and confined himself to a room lined with soundproof cork to allow him to concentrate on his writing.

Massive in scope and subject matter, *In Search of Lost Time* unfolds over several decades and encompasses the period of social and technological change in France between the Franco-Prussian War and World War I. The novel has hundreds of characters and revolves around the unnamed narrator, Proust's alter ego. The book was one of the first to deal frankly with homosexuality (Proust was openly gay) and also touches on themes of aesthetics, music, and philosophy.

Finishing the book took a major toll on what remained of Proust's health, and he died of pneumonia at age fifty-one. The last volumes were published posthumously, and the entire series was finally completed in 1927.

ADDITIONAL FACTS

1. *Proust was a fan of the English essayist John Ruskin (1819–1900) and translated two of his books into French.*

2. In Search of Lost Time *is also frequently known as* Remembrance of Things Past, *an alternative translation of the original* À la recherche du temps perdu. *The book is more than 1,250,000 words.*

◆ ◆ ◆

Sun Yat-Sen

Three thousand years of imperial rule in China ended when revolutionary leader Sun Yat-Sen (1866–1925) deposed the last emperor and installed a republican government in his place. Considered by many the founder of modern China, Sun set up a government that sought to unify the vast country and weaken regional warlords, but it collapsed into civil war shortly after his death.

After Sun died in 1925, both the Communist and nationalist factions in China's civil war claimed him as a guiding inspiration. To this day, he is considered a hero in both Taiwan and China—countries that agree on little else.

Sun Yat-Sen is thought to have been born in southern China, near the port city of Hong Kong. He spent much of his youth in Hawaii, which at the time was an independent country with a large community of Chinese expatriates. He was educated at an Episcopalian school and forced to return to China in 1883 after his family discovered that he was planning to convert to Christianity.

Returning to Hong Kong, he attended a medical school sponsored by the British, learned to play cricket, and was impressed by British governance of the colony. He would later claim that his years in Hong Kong made him embarrassed by the comparative backwardness and corruption of China's imperial system.

The Chinese government was in serious decline, a fact highlighted by its humiliating defeat in a war with Japan in 1894 and 1895. As a result of the war, China lost control of Taiwan and was forced to pay a huge sum as reparation. Sun Yat-Sen participated in a failed coup in the same year, and as a result he spent much of the next ten years in exile, traveling in Europe, the United States, and Japan. While in exile, he formulated the Three Principles of the People—nationalism, democracy, and socialism—that would form the basis of his ideology.

When the five-year-old emperor, Pu Yi (1906–1967), was finally overthrown in 1911, Sun returned to China to take control of the fledgling republic. He spent most of the rest of his life trying to build political support for a strong central government and feuding with warlords who controlled many of China's provinces. He enlisted the support of China's tiny Communist Party—an alliance that fell apart after his death, plunging the nation into civil war.

ADDITIONAL FACTS

1. *Sun Yat-Sen entered into an arranged marriage with a peasant woman, Lu Muzhen (1867–1952), in 1884, but abandoned her in 1915. He remarried to Soong Ching-ling (1893–1981), who later became a high-ranking official in the Communist People's Republic of China. One of his second wife's sisters married nationalist leader Chiang Kai-shek (1887–1975), meaning that members of Sun's family occupied influential positions on both sides of the conflict.*

2. *Communist leaders renamed the city of Xiangshan in Guangdong province, where Sun Yat-Sen was born, Zhongshan in his honor.*

3. *As a child, he listened to stories about the Taiping Rebellion and was intrigued by details about the war.*

◆◆◆

Charles Parham

The fastest-growing religion in the world today, its adherents claim, is Pentecostalism, a Christian sect that is rooted in supernatural healing, miracles, and—most famously—the ritual of speaking in tongues. The church was founded in 1901 by a Topeka, Kansas, preacher, Charles Fox Parham (1873–1929).

Parham was originally trained in the Holiness movement, a nineteenth-century religious denomination that emerged as an offshoot of Methodism. He opened his Bethel Bible College in Topeka in 1900, enrolling forty students.

It was in the next year that Parham and some of his students first experienced glossolalia, or speaking in tongues. To an observer, a person speaking in tongues appears to be talking gibberish; to Pentecostals, speaking in tongues is a divine gift. Parham found biblical support for this concept in the Acts of the Apostles, which describes episodes of glossolalia among adherents of the earliest Christian churches.

Still, Parham had few takers until 1903, when he expanded his message to include "divine healing," or the belief in healing through prayer. The first major wave of new converts came in 1906 when one of Parham's students, William Joseph Seymour (1870–1922), held a series of successful meetings in Los Angeles known as the Azusa Street Revival. Pentecostalism later spread in the Appalachian and Ozark mountain regions, where it held a particular appeal for poor farmers and mill workers.

Highly conservative in doctrine, Pentecostalism forbids smoking, drinking, dancing, and other "frivolous" pursuits. Detractors referred to Seymour's followers derisively as "holy rollers," because many episodes of glossolalia were accompanied by writhing on the floor. (Parham himself later denounced some of his adherents' "jerking, trembling, falling to the floor, jabbering, screaming and other disorders.")

Parham's role in the religion he founded, however, diminished even as its numbers grew, in part because he rejected any formal governing structure. He also became embroiled in a sex scandal after he was arrested in Texas on an unspecified morals charge, allegedly sodomy. The church itself divided into several rival factions.

After Parham's death, however, Pentecostal missionaries spread to Latin America and Africa, where the church has experienced explosive growth in the late twentieth and early twenty-first centuries.

ADDITIONAL FACTS

1. *Pentecostalism takes its name from Pentecost, a Christian holiday that takes place fifty days after Easter and marks the day that the Holy Spirit was said to have descended upon the first Christians.*

2. *Glossolalia comes from the Greek words* glossa, *meaning "tongue," and* lalia, *meaning "talking." Some Pentecostal groups also believe in xenoglossy, the sudden, God-given ability to speak in foreign languages. (Xeno is Greek for "stranger.")*

3. *Many of the first Pentecostals—including Seymour—were African American. Initially, Parham welcomed the multiracial makeup of his followers and preached to racially diverse audiences, but he later rejected black members and supported the Ku Klux Klan.*

❖ ❖ ❖

Woodrow Wilson

A college professor who was elected to the presidency, Woodrow Wilson (1856–1924) transformed American foreign policy by embracing a more active role in world affairs. During Wilson's second term, the United States entered World War I, sending combat troops to Europe for the first time—a major event in the evolution of the United States as a global power.

The son of a Presbyterian minister, Wilson was born in Staunton, Virginia, and educated at Princeton University. He earned his doctorate in history in 1886 from Johns Hopkins University in Baltimore and returned to Princeton in 1890. Immensely popular with students, he was named the university's president in 1902. He entered politics in 1910, winning election as a Democrat to the New Jersey governorship.

Wilson won the Democratic nomination for president in 1912 and capitalized on a split in the Republican Party to win a three-way race against incumbent William Howard Taft (1857–1930) and former president Theodore Roosevelt (1858–1919). In 1916, Wilson was reelected to a second term.

After the outbreak of World War I in Europe in 1914, Wilson initially maintained the long-standing American policy of neutrality. Indeed, he ran for reelection in 1916 under the slogan "He Kept Us Out of War." But within six months of his reelection, German U-boat attacks on American ships had turned public opinion against Germany, and Wilson asked Congress for a declaration of war on April 2, 1917. Wilson outlined the American war aims in his famous Fourteen Points speech, including dismantling the European empires and establishing a League of Nations to arbitrate future international disputes.

The American contribution to the war helped turn the tide against the Central Powers, and an armistice was signed in November 1918. The next year, Wilson became the first sitting president to travel to Europe when he sailed to Paris for negotiations on the formal peace treaty. The treaty incorporated several of the Fourteen Points, including establishing the League of Nations. When he returned home, however, Wilson was unable to convince isolationists in the Senate to approve the treaty. The opposition was led by Massachusetts senator Henry Cabot Lodge (1850–1924), who feared the League of Nations would usurp American sovereignty.

Physically exhausted, Wilson suffered a stroke in 1919 and was unable to govern effectively for the rest of his term. The Treaty of Versailles was never ratified, and the United States never joined the League of Nations. Wilson died in Washington in 1924.

ADDITIONAL FACTS

1. *Wilson's first name was Thomas, and he went by Tommy as a child. He started going by his middle name, Woodrow, after graduating from Princeton.*

2. *Dyslexic as a child, Wilson did not learn to read until age ten.*

3. *Wilson is the only US president to hold a doctoral degree, and the only full-time, professional academic elected to the office.*

◆◆◆

Bertrand Russell

With a shock of white hair and the elegant bearing of a British aristocrat, Bertrand Russell (1872–1970) was among the most recognizable philosophers of the twentieth century. A hugely prolific writer, Russell was also notorious as a political agitator, and he went to prison twice for his antiwar activities.

Born into an influential British family, Russell inherited the rank of earl in 1931. His parents both died young, and he was raised primarily by his grandmother, Lady Russell. He entered Cambridge at age eighteen.

Russell first achieved distinction as a mathematician, publishing *The Principles of Mathematics* in 1903. Writing his next book, *Principia Mathematica*, which aimed to explain the logical underpinnings of mathematics, was so taxing that it left him physically drained. It also established his academic career, however.

Beginning with World War I, Russell's interests increasingly turned toward philosophy and politics. He became an ardent opponent of World War I and was sentenced to six months in prison for publishing pacifist views. After the war, he toured the Soviet Union but was appalled by Communism; he would later write, "I dislike Communism because it is undemocratic and capitalism because it favors exploitation."

Russell's turbulent personal life—he married four times and conducted numerous love affairs—caused a scandal in 1940, when his appointment to a professorship at New York's City College was rescinded after protests by religious leaders. The experience humiliated Russell and soured his views on the United States.

In the 1950s, Russell, by now an elderly don, joined the antinuclear movement. He was arrested following a protest against Britain's nuclear arsenal and spent seven days in the same jail where he had been imprisoned during World War I.

In addition to his philosophical and mathematical works, Russell was known for his nonfiction aimed at popular audiences, including *The History of Western Philosophy* (1945) and his own three-volume autobiography, written in the 1960s. He died in Wales at age ninety-seven.

ADDITIONAL FACTS

1. *Russell wrote letters, books, and essays constantly, producing about 2,000 words a day during his adult life, according to the estimate of one biographer.*

2. *His grandfather, John Russell (1792–1878), served two terms as prime minister of England. J*

3. *Bertrand Russell described the end of his first marriage, to Alys Smith, in his biography: "I went out cycling one afternoon and, suddenly, as I was riding along a country road, I realized that I no longer loved Alys."*

✦✦✦

George Washington Carver

Did George Washington Carver (c. 1864–1943) really invent peanut butter?

Generations of schoolchildren have been taught that Carver, an ex-slave who became one of the first prominent African American scientists, created the lunchtime staple at his lab in Alabama, along with dozens of other agricultural innovations.

But like many other facets of Carver's life, his role in the invention of peanut butter is more nuanced than is often realized. *Nutmeal* was actually patented by another scientist, John H. Kellogg (1852–1943), in 1895.

But Carver did play a crucial role in popularizing peanut butter—and dozens of other food products—by touting its benefits to thousands of small farmers and sharecroppers. Carver is credited with reviving agriculture across the American South by convincing poor farmers to diversify their crops with peanuts and sweet potatoes instead of relying solely on cotton, the traditional staple crop.

In the larger culture, Carver was embraced as a symbol of African American accomplishment by both blacks and whites—albeit for different reasons. To blacks, he was proof that a former slave could succeed. To many whites, on the other hand, his nonconfrontational attitude was a model for how to be a "good" black.

Carver was born in Missouri and graduated from Iowa State College in 1894—the school's first African American graduate, and one of only a handful of blacks to obtain college degrees in nineteenth-century America. Two years later, he was hired by Booker T. Washington (1856–1915) to teach at Washington's Tuskegee Institute in Alabama. Washington was a leading advocate of "accommodationist" politics, accepting Jim Crow segregation while working to improve the economic status of African Americans. Carver would remain at the institute for the rest of his life, adhering to the apolitical stance of its founder.

By the 1920s, Carver was one of the most famous African Americans in the United States; *Time* magazine referred to him as the black "Leonardo" because of his wide-ranging interests (which, like Leonardo's, included painting). Carver died at roughly age seventy-eight after falling down the stairs at his home in Tuskegee.

ADDITIONAL FACTS

1. *Carver is credited with publishing 325 uses for the peanut—including peanut soup, peanut bisque, peanut muffins, peanut doughnuts, liver with peanuts, peanut coffee, and peanut shaving cream.*

2. *The George Washington Carver National Monument was established in his hometown of Diamond, Missouri, shortly after Carver's death in 1943.*

3. *Carver was reportedly once offered a job by Thomas Edison (1847–1931), but decided to remain at Tuskegee, where he could help poor farmers.*

❖ ❖ ❖

Al Ca~

The gangster kingpin of Chicago, Al Capone (1899–1947) has passed into legend as one of the most colorful mobsters of the Roaring Twenties. He controlled a huge network of smugglers, crooked cops, and speakeasies and supplied booze to much of the Midwest. Until his downfall in 1931, Capone was also known for his own outsize appetites for food, cigars, liquor, and women.

Inadvertently, Capone may also have contributed to the eventual demise of Prohibition. A ban on alcohol enacted in 1919, Prohibition was repealed in 1933 amid widespread revulsion at the huge increase in violence associated with bootleggers. The gruesome Saint Valentine's Day Massacre in 1929, which Capone unleashed against a rival outfit, was one of the most famous of the wave of gangland slayings.

The child of Italian immigrants, Capone was born in Brooklyn and joined a street gang as a teenager. He received the famous scar on the side of his face while working as a bouncer at a mob-controlled nightclub. After marrying in 1918, Capone moved to the South Side of Chicago, where he began building his illicit empire.

Within a few years, Capone was one of the dominant forces in the Chicago underworld. His only significant source of local opposition was a rival North Side gang run by George "Bugs" Moran (1893–1957), who organized failed attempts to assassinate Capone in the 1920s.

The Saint Valentine's Day Massacre was designed to eliminate Capone's competition once and for all. On Valentine's Day, a group of gunmen disguised as police officers raided a garage that was a hangout of the Moran gang. Pretending they were arresting the seven men inside the garage, Capone's henchmen ordered them to line up against a wall—and then mowed them down with submachine guns.

But the massacre failed. Not only was Moran out of the garage that day, but the killings galvanized public opposition to mob rule in Chicago. Federal agent Eliot Ness (1903–1957) was dispatched to put Capone behind bars. Ness eventually won a conviction against Capone for tax evasion—the gangster had not paid income tax on any of his illegal businesses. Capone spent the 1930s in prison and was released in poor health in 1939. Mentally unstable, he was unable to resume his role in the mob and died after a stroke in 1947.

ADDITIONAL FACTS

1. *In 1932, the Treasury Department seized Capone's bullet-proofed Cadillac to pay his back taxes. The vehicle later served as the first armored presidential limousine, carrying President Franklin D. Roosevelt (1882–1945) during World War II.*

2. *In 1986, construction workers discovered a locked vault in a hotel on Chicago's Michigan Avenue that had once belonged to Capone. Mafia buffs speculated that it might contain cash, liquor, or even bodies. But when it was opened on live, national television by reporter Geraldo Rivera (1943–), the vault was found to contain only a whiskey bottle. (The bottle was empty, no less.)*

3. *Capone is one of only two Mafia kingpins to make the cover of* Time *magazine. The other was John Gotti (1940–2002).*

❖❖❖

Pablo Picasso

Photographed countless times with a beret, a cigarette, and a wry smile, Pablo Picasso (1881–1973) symbolized avant-garde art for much of the twentieth century. A painter and sculptor, Picasso influenced virtually every artistic movement of recent times, became a global celebrity, and continued to paint almost until the day of his death in France at age ninety-two.

Picasso was born in Málaga, Spain, and moved several times before his family settled in Barcelona, where he attended art school. He visited Paris, the capital of the international art world, for the first time in 1900 and soon moved there permanently.

Picasso's early career is often divided into two periods, each named for the dominant color he used: the Blue Period (1901–1904) and the Rose Period (1904–1906). His blue paintings, as the color choice suggests, were often sad portraits of beggars and criminals. The rose paintings introduced more vivid colors and generally feature more upbeat subjects, such as comedians and circus performers.

In Paris, Picasso joined the city's thriving bohemian artistic community, which included painters Henri Matisse (1869–1954) and Georges Braque (1882–1963). He married for the first time in 1918, but quickly embarked on a lifelong career of womanizing. (In total, he had four children with three different women.)

Along with Braque, Picasso was a founder of cubism, an artistic style he introduced in 1907 with the famous *Les Demoiselles d'Avignon,* a painting of five prostitutes at a brothel. The subjects of cubist paintings were often ordinary objects such as guitars or wine bottles, but they were broken up into angular, boxy distortions.

By the end of World War I, Picasso was one of the world's best-known artists. His fame grew in the interwar period, and he created one of his greatest paintings, *Guernica,* in 1937. The giant work commemorates the victims of the German bombing of the Basque village of Guernica during the Spanish civil war and is one of the most recognizable icons of all twentieth-century art.

Picasso, a Spanish citizen, remained in Paris during the Nazi occupation in World War II. He continued to paint after the war and also produced many sculptures and ceramics. He died at his home in Mougins in 1973.

ADDITIONAL FACTS

1. *In his will, Picasso stipulated that* Guernica *could be moved to Spain only after the country had returned to democracy. After dictator Francisco Franco (1892–1975) died, a republican constitution was adopted in 1978, and the painting was shipped to Spain in 1981.*

2. *During his lifetime, Picasso completed about 20,000 works of art—a total that includes not only paintings but also ceramics, sculptures, and theater sets. A curtain designed by Picasso is still in use at the Four Seasons restaurant in New York City.*

3. *In 2003, a framer in New York City left a folder containing an original Picasso on a subway train. It was found by a book vendor from Queens and returned several days later.*

◆◆◆

Emmeline Pankhurst

Deeds, not words.
—Slogan of the Women's Social and Political Union

Emmeline Pankhurst (1858–1928), an English social activist, was the leading advocate of women's suffrage in early twentieth-century Britain. Largely thanks to her thirty-year crusade, the British government was forced to grant equal voting rights to women in 1928.

Pankhurst was born in Manchester, England, into a family with radical political leanings. One of her first memories, Pankhurst would later recall, was celebrating the abolition of slavery in the United States. She was an enthusiastic supporter of the French Revolution and was educated for a time in France.

She returned to England to marry Richard Pankhurst (1834–1898), a radical lawyer and women's rights advocate who was the author of landmark British legislation protecting the property rights of married women. The couple had five children.

The death of her husband was a devastating blow to Pankhurst, but it led her to intensify her involvement in politics. Along with two of her daughters, she founded the Women's Social and Political Union (WSPU) in 1903.

The group, known as the suffragettes, differed from the existing British suffrage movement in two ways. First, the WSPU did not ally itself with any political party. Second, it did not admit men as members. Pankhurst felt both policies were necessary to keep the movement focused on its sole goal, equal rights for women.

Over the next ten years, the group embarked on a series of high-profile acts of civil disobedience. In 1908, two suffragettes were arrested for throwing stones at 10 Downing Street. Another volunteer, Emily Davison, threw herself under the hooves of the horse of King George V (1865–1936) and was trampled to death in 1913. Although controversial, the movement helped bring attention to the group's demands.

During World War I, Pankhurst reached a tacit agreement with prime minister David Lloyd George (1863–1945) to suspend the campaign in exchange for voting rights after the end of the war. In 1918, Parliament extended voting rights to women over the age of thirty. Ten years later, the age requirement was dropped to twenty-one—the same as for men.

ADDITIONAL FACTS

1. *The term* suffragette *was originally coined in 1906 by a newspaper, the* Daily Mail, *as a term of derision. But the word was proudly embraced by women's rights advocates, and Pankhurst's daughter Sylvia (1882–1960) titled her history of the campaign* The Suffragette Movement.

2. *Pankhurst is mentioned in the lyrics to one of the songs in the 1964 Disney movie* Mary Poppins, *which is set in London during the 1910s.*

3. *Pankhurst was born on July 15, 1858, but usually gave her birthday as July 14—the anniversary of the French Revolution.*

◆◆◆

Billy Sunday

An orphan who became one of the most famous Christian ministers in the United States, Billy Sunday (1862–1935) preached in hundreds of American cities and was famous for his strong voice, folksy sermons, and indomitable energy. He was both a traditionalist—Sunday's religious views were highly conservative—and an innovator whose canny use of mass media paved the way for such later fundamentalist evangelicals as Billy Graham (1918–).

William Ashley Sunday was born in Ames, Iowa, during the Civil War. His father, a Union soldier, died a few weeks after the boy's birth, and his mother was forced to put the child in an orphanage.

In the orphanage, Sunday displayed the talent that first made him famous: baseball. A speedy runner, he was discovered by a talent scout and played professionally for the Chicago White Stockings, Pittsburgh Alleghenys, and Philadelphia Phillies. Although error-prone in the outfield, Sunday was a fan favorite for his exploits on the base paths and was often among the league's leaders in stolen bases.

After retiring from baseball in 1891, Sunday began his career in the ministry. He started touring in 1896, crisscrossing the Midwest by rail and giving sermons at revival meetings. Sunday used his fame as a baseball player to attract publicity to his campaigns, and he often umpired amateur games in the cities he visited.

In his preaching, Sunday thundered against drinking, evolution, and dancing. Although he was a Presbyterian, Sunday's services were interdenominational, which increased attendance. Under the direction of his wife, Nell Thompson Sunday (1868–1957), Sunday's tours became a huge, complex business sustained by millions of dollars in donations.

Sunday reached the height of his popularity during World War I, which he avidly supported. His advocacy also helped pass the Eighteenth Amendment, which banned alcohol in 1919. However, scandals caused by Sunday's sons dimmed his reputation, and by the time he died at age seventy-two, his influence was much diminished.

ADDITIONAL FACTS

1. *Sunday stole eighty-four bases in 1890, finishing in third place in the National League that year behind Phillies teammate William "Sliding Billy" Hamilton (1866–1940), with 102, and Brooklyn Bridegrooms second baseman Hubert "Hub" Collins (1864–1892), with eighty-five. Sunday is still among the top 100 single-season base stealers in league history.*

2. *All three of Sunday's sons were involved in sex scandals that hurt the preacher's reputation. The oldest, George, committed suicide in 1933.*

3. *Although he began holding revival meetings in 1896, Billy Sunday was not actually ordained a minister until 1903.*

✦✦✦

Benito Mussolini

The first Fascist leader in Europe, Benito Mussolini (1883–1945) was the dictator of Italy for twenty-one years. During his ironfisted rule, Il Duce outlawed the free press, crushed his opponents, and provided political inspiration to his German ally, Adolf Hitler (1889–1945). Known for his charisma, flamboyance, and stirring oratory, Mussolini enjoyed widespread popular support in Italy before leading his country to ruin in World War II.

The son of a blacksmith and schoolteacher, Mussolini was born in Predappio, Italy. He was a rebellious child who was expelled from several schools for trying to stab other students with a penknife. Mussolini left Italy at age nineteen to avoid conscription and settled in Switzerland.

Mussolini returned to Italy in 1904 and went to work as a journalist for Socialist newspapers. He became known for his inflammatory anticapitalist articles and bombastic speaking style. Mussolini initially opposed Italian involvement in World War I, but abruptly changed his position and became an enthusiastic backer of the war in 1916. As a result, he was expelled from the Socialist Party.

The Fascist Party was formed in 1919, with Mussolini at its head, and attracted support from many Italian war veterans. Taking advantage of labor strife and political gridlock in Italy, the Blackshirts seized power in 1922 and forced the king to install Mussolini as prime minister.

Domestically, Mussolini outlawed rival political parties and labor unions, nationalized key industries, and embarked on a massive public works program of road, railway, and factory construction. Hoping to increase Italy's international prestige, he invaded Ethiopia in 1935, provided military support to the nationalist side in the Spanish civil war, and joined Nazi Germany in the Axis "Pact of Steel" in 1939. Although Mussolini had expressed little enthusiasm for Germany's harsh racial policies, he joined Hitler in approving anti-Jewish legislation in 1938.

Italy formally entered World War II in 1940. Three years later, the Allies invaded Italy, and Mussolini was removed from power. He was briefly imprisoned, freed by the Nazis, and installed as puppet leader of Nazi-controlled territory in northern Italy. He was deposed again in 1945, caught attempting to flee to Switzerland, and executed by partisans at age sixty-one.

ADDITIONAL FACTS

1. *Mussolini survived a number of assassination attempts, including one by an American, Michael Schirru (1899–1931), who was a banana peddler in the Bronx before joining an anarchist plot to kill Il Duce. Schirru was executed after the plot's discovery.*

2. *In 2008, a small, right-wing party in southern Italy reportedly offered couples payments of $1,900 if they named their newborns after Mussolini or his wife.*

3. *Mussolini's youngest son, Romano Mussolini (1927–2006), became a successful jazz musician and leader of a band called the Romano Mussolini All Stars.*

◆◆◆

Ludwig Wittgenstein

In April 1889, two baby boys were born in Austria, each of whom would have a major impact on the world of the twentieth century. The first was Adolf Hitler (1889–1945). The second, born six days later, was the philosopher Ludwig Wittgenstein (1889–1951).

Wittgenstein, the youngest son of a wealthy Austrian steel baron, attended the same secondary school as the future German dictator, and the two shared a history teacher. Both served in the army during World War I, an experience that helped inspire both men to write books.

The books, however, could not have been more different: Hitler's was *Mein Kampf* (1925), the angry blueprint for Nazi totalitarianism. Wittgenstein's was *Tractatus Logico-Philosophicus* (1922), a complex work of philosophy that he wrote while imprisoned at an Italian prisoner-of-war camp.

Tractatus, the only book of philosophy that Wittgenstein would publish during his lifetime, is a landmark in twentieth-century philosophy. Wittgenstein himself claimed that the book had solved all the problems in philosophy, and after its publication he retired from philosophy and took a job as an elementary school teacher.

His retirement, however, proved short-lived. In 1926, Wittgenstein was fired from his teaching job after a parent complained about his excessive beatings of an eleven-year-old boy. Wittgenstein returned to philosophy and ended up in England, where he was given a teaching position at Cambridge in 1929.

After Hitler's Germany took over Austria in 1938, Wittgenstein renounced his citizenship and became a British subject. He also personally negotiated with the government of his former classmate to ensure that his sister would be allowed to leave Austria, despite the family's Jewish ethnic background. Wittgenstein volunteered for the British during World War II. He spent the last years of his life writing *Philosophical Investigations,* which was published posthumously in 1953.

In his two books, Wittgenstein advanced a set of arguments contending that many philosophical problems were, in fact, language problems, since language frames the way we understand the world. Indeed, he argued, because language is imprecise, it introduces needless confusion.

He died of prostate cancer at age sixty-two in Cambridge.

ADDITIONAL FACTS

1. *After Hitler's Germany took control of Austria in 1938, Wittgenstein and his brother were forced to give the Nazis 1.7 metric tons of gold in order to secure non-Jewish status for their sister, a designation that allowed her to leave the country. (At 2009 gold prices, that's roughly $62 million.)*

2. *According to the New York Times, a 1998 poll of "professional philosophers" ranked Wittgenstein fifth of all time, behind Aristotle, Plato, Immanuel Kant, and Friedrich Nietzsche.*

3. *Wittgenstein's last words, according to his doctor, were "Tell them I've had a wonderful life."*

❖ ❖ ❖

Albert Einstein

Shortly before his death, Albert Einstein (1879–1955) made a startling confession to a friend. The most famous thinker of his time, Einstein had won a Nobel Prize, revolutionized the study of physics and mathematics, and become a worldwide icon of scientific genius. But, if he had his life to live over again, Einstein confided, he would have been a plumber.

Indeed, Einstein was deeply conflicted about his own accomplishments. His discoveries had earned him great acclaim, but had also opened the door for the invention of the atomic bomb. The destruction of Nagasaki and Hiroshima in 1945 weighed heavily on Einstein's conscience: The last letter he ever wrote endorsed a ban on atomic weapons.

Einstein was born in Ulm, Germany, but left in 1894 and renounced his German citizenship in 1896 to avoid military service. He graduated from a Swiss university in 1900 and went to work at the Swiss Patent Office in Bern. In 1905, while working full-time at the patent office, he submitted four papers to a German publication, *Annalen der Physik*. Each would shatter the foundations of physics. He would be rewarded with the Nobel Prize in Physics in 1921, primarily for the discoveries detailed in those four papers.

From 1914 to 1932, Einstein was a professor at Germany's most prestigious research institution, the Kaiser Wilhelm Institute of Physics. He was forced to flee Germany after Hitler took power and ended up at the Institute for Advanced Study in Princeton, New Jersey, where he lived for the rest of his life. In 1939, he wrote a famous letter to President Franklin D. Roosevelt (1882–1945) warning that his own discoveries might allow the Nazis to build an atomic weapon of unimaginable destructive force. Einstein spent the rest of his life convinced that his letter had inspired the Americans to build the bomb instead.

After the war, Einstein spoke out against atomic weapons, to little avail. He also rattled his adopted home country by opposing racial segregation, American foreign policy, and McCarthyism. He died in Princeton at age seventy-six.

ADDITIONAL FACTS

1. *During World War II, Einstein raised money for the Allied cause by writing out, in longhand, a copy of one of his famous 1905 papers. It was auctioned for $6 million.*

2. *An extremely rare chemical element, einsteinium, was named after Einstein in 1952.*

3. *Einstein has been portrayed by numerous actors over the decades, including Walter Matthau (1920–2000) in I.Q. (1994), John Ehrin (1908–1995) in Bill and Ted's Bogus Journey (1991), Robert Downey Jr. (1965–) in That's Adequate (1989), and Yahoo Serious (1953–) in Young Einstein (1988).*

◆◆◆

Bruno Hauptmann

No story transfixed the American public quite like the kidnapping and murder of the infant son of Charles Lindbergh (1902–1974) in 1932. Dozens of suspects—the maid, the nanny, the mafia—were investigated in what was quickly dubbed the crime of the century. But in the end, it was a German immigrant named Bruno Hauptmann (1899–1936) who was convicted of killing the baby of America's most famous aviator.

Hauptmann, who proclaimed his innocence even as he was led to the electric chair, was a German World War I veteran who had immigrated to the United States in 1923. He settled in the Bronx, married a waitress, and was working as a carpenter at the time of the kidnapping.

On the night of March 1, 1932, the Lindberghs' nanny discovered that the child, Charles A. Lindbergh Jr. (1930–1932), was missing from his crib. A handwritten ransom note demanding $50,000 was left on the windowsill, and a handmade ladder was found nearby.

Lindbergh, a national hero after his successful flight across the Atlantic in 1927, received a second note a few days later upping the ransom to $70,000. By then, a nationwide hunt was under way for the baby and the kidnapper. Through an intermediary, Lindbergh eventually paid a ransom of $50,000 on April 2.

But the baby was already dead. On May 12, his decomposing body was found less than five miles from Lindbergh's house. With the discovery, the kidnapping case turned into a murder investigation.

Hauptmann was arrested more than two years later, after the serial number on a bill he used at a gas station on Lexington Avenue in New York City matched one of the notes included in the ransom payment. When police searched Hauptmann's house, they found another $13,000 of the ransom money in his garage. Handwriting experts then matched the ransom notes to samples of Hauptmann's writing.

The trial began in 1935 and lasted five weeks. Hauptmann claimed that the shoebox full of money had belonged to another man, but the jury convicted him of the murder, and he was executed the next year. His widow, Anna (1899–1994), spent the rest of her life trying to exonerate him, claiming the trial had been tainted.

ADDITIONAL FACTS

1. *The superintendent of the New Jersey State Police during the investigation was H. Norman Schwarzkopf (1895–1958), whose son—General H. Norman Schwarzkopf Jr. (1934–)—would lead US forces during the Gulf War.*

2. *Anne and Charles Lindbergh had five other children. She lived to age ninety-four.*

3. *Hauptmann was played by Anthony Hopkins (1937–) in a 1976 movie about the kidnapping,* The Lindbergh Kidnapping Case.

◆◆◆

James Joyce

Although he published only three novels in his lifetime, Irish writer James Joyce (1882–1941) revolutionized Western literature. In his novels and short stories, Joyce introduced new literary techniques that were an enormous influence on twentieth-century authors and provided new ways for writers to capture the innermost thoughts and emotions of their subjects.

Born in Dublin, Joyce was educated at Jesuit schools. Although he rejected Roman Catholicism as a teenager, the church and its role in Irish society formed a recurring theme in Joyce's work. His first novel, *A Portrait of the Artist as a Young Man* (1916), tells the story of his alter ego, Stephen Dedalus, and his coming of age in a repressive Catholic culture, and it closely parallels Joyce's own struggles.

On June 16, 1904, while struggling to begin his writing career, Joyce went on a first date with a hotel worker named Nora Barnacle (1884–1951). She would become his lifetime companion, and Joyce immortalized the date by setting his second novel, *Ulysses,* on the same day. ("Bloomsday," named for the main character in *Ulysses,* is still celebrated annually by Joyce aficionados.)

Joyce and Barnacle intended to elope to Europe and moved to Trieste, a port city in what is now Italy, the next year. The couple had two children, but would not marry until 1931. Joyce supported the family by teaching English and borrowing money while attempting to publish his collection of short stories, *Dubliners.* It finally appeared in 1914.

After the outbreak of World War I, Joyce and Barnacle moved to neutral Zurich, where he worked on *Ulysses,* the novel that would be seen as his masterpiece. Joyce was in increasingly poor health and underwent numerous eye surgeries for glaucoma and cataracts while living in Switzerland. Joyce finished the novel in 1922.

Almost immediately upon its publication, *Ulysses* was hailed as one of the most consequential works of modern Western literature. The sprawling, 1,000-page book, which follows its hero Leopold Bloom through a single day in Dublin, employed a form of stream-of-consciousness narration that attempted to capture the unfiltered internal monologues of its characters without regard to punctuation or traditional narrative structure. Joyce followed *Ulysses* with *Finnegans Wake* (1939), an even denser and more difficult book that is rarely read outside of academia.

Joyce returned to Switzerland after the outbreak of World War II; he died in Zurich at age fifty-eight.

ADDITIONAL FACTS

1. Ulysses *was first published in Paris. It was banned in the United States until 1933, when a federal judge, John Monro Woolsey (1877–1945), ruled that the book was not obscene.*

2. *According to Joyce biographer Peter Costello, the real-life model for Leopold Bloom was Alfred H. Hunter, a friend of the author's in Dublin who had once rescued him in a bar fight.*

3. *One of the short stories in* Dubliners, *"The Dead," was turned into a feature-length film in 1987 by director John Huston (1906–1987) and starred his daughter, Anjelica Huston (1951–).*

✦✦✦

Vladimir Lenin

The leader of the Russian Revolution of 1917 and founder of the Soviet Union, Vladimir Ilyich Lenin (1870–1924) established the world's first Communist state, brutally destroyed his enemies, and inspired generations of revolutionaries with his writings on political theory. His scowling visage—a statue of Lenin once occupied the center of almost every town in Eastern Europe—is among the most famous in history, a symbol of the totalitarian ideology that would eventually control the lives of billions of people across the globe.

Lenin was born Vladimir Ilyich Ulyanov into a well-off family. Despite their relative wealth, opposition to the Russian monarchy ran in the family: Lenin's older brother,

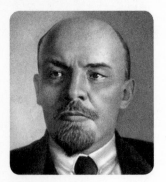

Alexander (1866–1887), was hanged for his role in a failed plot to assassinate Czar Alexander III (1845–1894), a turning point in Lenin's life.

Lenin—he adopted the name in 1902—was trained as a lawyer but spent virtually his entire life between his university graduation and 1917 in exile because of his political activities. He shuttled between Germany, Switzerland, England, and Finland, writing for Communist newspapers and refining his political theories.

When the czar was overthrown in 1917, Lenin rushed back to Russia from Switzerland to assume leadership of the Communists. He quickly organized a coup—the October Revolution—against the provisional government that had replaced the czar, which put the Soviets firmly in charge. For the next several years, Lenin implemented a radical agenda of economic and social change, abolishing private property, nationalizing industry, forcing workers into collectives, and executing thousands of political opponents. His economic policies proved disastrous, culminating in a famine that killed an estimated 5 million Russians in 1921.

After having a stroke in 1922, Lenin was in ill health for the rest of his life. Suffering from paralysis caused by the stroke and possibly from syphilis, he gradually lost his powers to Joseph Stalin (1879–1953), who won a power struggle to control the USSR after Lenin's death on January 21, 1924, at age fifty-three.

ADDITIONAL FACTS

1. *According to biographer Robert J. Service, Lenin was in such excruciating pain by the end of his life that he twice requested poison to commit suicide. Both times, he reconsidered.*

2. *Lenin's embalmed body is still on display at a mausoleum in Moscow's Red Square, despite protests from Russian religious leaders and anti-Communist political groups, who want his corpse buried.*

3. *The Russian city of Saint Petersburg was renamed Leningrad after Lenin's death in 1924. In 1991, amidst the collapse of the Soviet Union, the city's residents voted to return to the old name.*

◆◆◆

Gandhi

A global icon who fused traditional Hindu religious beliefs with the political aspirations of millions of Indians, Mohandas K. Gandhi (1869–1948) played the pivotal role in freeing India from centuries of British rule. Gandhi's insistence on nonviolence—he used boycotts, hunger strikes, and peaceful marches instead—made him a hero and inspiration to a generation of reformers, including Martin Luther King Jr. (1929–1968).

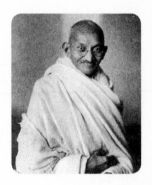

Gandhi was born in western India and left for London at age eighteen to study law. After earning his degree, Gandhi took a job at a law firm in South Africa, a British territory that had a large Indian expatriate community. Living in the city of Durban, he witnessed racial discrimination against Indians for the first time, an experience that soured his views of the British and inspired his first involvement in politics. He became a leader of the Indian community in South Africa, fighting against proposals to strip Indians of voting rights and other civil liberties.

He returned to India in 1914, joined the country's proindependence Indian National Congress, and was named its leader in 1920. Within a few years, he was widely considered the face of the Indian independence movement. Gandhi's humble lifestyle—he was a vegetarian, didn't drink alcohol or coffee, and gave up sex after age thirty-six—contributed to his image as a selfless advocate for his people's rights.

During World War II, with Britain weakened by its fight with Nazi Germany, Indians renewed their press for independence, launching the Quit India Movement, which resulted in mass arrests of Indian rights activists. In 1945, the British elected a proindependence prime minister, Clement Attlee (1883–1967), who finally approved the end of the Raj in 1947. Before leaving, Britain partitioned India into two countries, predominantly Hindu India and predominantly Muslim Pakistan. The two neighbors went to war almost immediately.

In the first year of independence, Gandhi enraged some of his fellow Hindus by advocating a conciliatory stance toward Pakistan, and in 1948 he was assassinated by a Hindu extremist.

ADDITIONAL FACTS

1. *Gandhi was given the honorific Mahatma, meaning "great souled," after returning to India from South Africa. He was also sometimes referred to by the affectionate nickname Bapu.*

2. *While living in South Africa, Gandhi served in the British army, hoping to prove that Indians could work alongside whites. He was a member of a medical corps during a war with the Zulus in 1906.*

3. *Gandhi had four children with his wife, Kasturba (1869–1944), whom he married at age thirteen. Both were imprisoned by the British during World War II, and Kasturba died in jail in 1944.*

✦✦✦

Winston Churchill

In 2002, the BBC conducted a nationwide vote to pick history's greatest Briton. The competition was fierce—for second place.

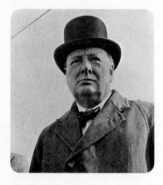

The first-place finisher had never been in serious doubt: Winston Churchill (1874–1965), the prime minister who led his nation through its darkest hour and defeated Nazi Germany, topped the poll, as expected.

The son of a British aristocrat and an American heiress, Churchill was born at Blenheim Palace near Oxford, England, and graduated from the British military academy, Sandhurst. He fought in the Boer War in South Africa (1899–1902) and covered several other conflicts as a war correspondent for British newspapers.

Churchill made his first foray into politics in 1900, winning election to Parliament as a Conservative. He switched to the Liberals in 1904 and then back to the Conservatives in 1924. ("Anyone can rat, but it takes a certain ingenuity to re-rat," he once quipped of his party switches.)

Early in his political career, Churchill was dealt two major setbacks: He was blamed for the 1915 British defeat at Gallipoli during World War I and for the disastrous decision in 1925 to return Britain to the gold standard. As a result, he was a deeply unpopular figure for much of the 1930s, a time he called his "wilderness" years.

During his time on the backbenches of Parliament, Churchill was one of the strongest voices warning against the threat from Nazi Germany. After the war started in 1939, Churchill joined the War Cabinet and was placed in charge of the navy. He was promoted to prime minister of the national unity government in May 1940. Churchill, in his first speech to Parliament as prime minister, set the tone of defiance and determination for which he would be famous over the next five years: "I have nothing to offer but blood, toil, tears, and sweat," he said.

Despite his heroic status, however, Churchill was turned out of office in 1945 in favor of Labour Party leader Clement Attlee (1883–1967). Churchill remained the leader of the Conservatives, served a second term as prime minister from 1951 to 1955, and was knighted by Queen Elizabeth II (1926–) in 1953. He died in London at age ninety.

ADDITIONAL FACTS

1. *Churchill won the Nobel Prize in Literature in 1953 for his war memoirs, which were published between 1948 and 1954.*

2. *The second-place finisher in the BBC's Greatest Britons poll was a nineteenth-century engineer, Isambard Kingdom Brunel (1806–1859).*

3. *Churchill coined the term Iron Curtain to describe the Cold War divide between Communist Eastern Europe and democratic Western Europe at a speech in Fulton, Missouri, in 1946.*

◆◆◆

Martin Heidegger

More than three decades after his death, the legacy of German philosopher Martin Heidegger (1889–1976) remains highly contentious. Both supporters and detractors agree that Heidegger's books on existentialism, religion, and language have left an indelible mark on world philosophy. But his ties to the Nazis—Heidegger wore a swastika armband, gave Nazi salutes to his students, and proclaimed "Heil Hitler" at the end of lectures as late as 1936—have stained his reputation in the eyes of many critics.

Heidegger was born in southwestern Germany and raised in a Catholic household. His first academic interest was theology, and he briefly trained for the priesthood. But he developed an interest in philosophy, abandoned Catholicism in 1919, and won his first paid teaching position at a German university in 1923.

Most of Heidegger's most famous works were published in the 1920s and 1930s. His first, *Being and Time* (1927), was a landmark in European philosophy.

Prior to the early 1930s, Heidegger had never expressed an interest in politics. But when Hitler took power in 1933, Heidegger welcomed the Nazi movement and joined the party. He was elected rector of his university and gave an infamous speech urging his students, "Let not theories and 'ideas' be the rules of your being. The Führer himself and he alone is German reality and its law, today and for the future." Although he became privately disillusioned with Hitler in the late 1930s, Heidegger retained his party membership until the end of World War II.

After the war, Heidegger was forbidden to teach. He was eventually rehabilitated, in part thanks to the efforts of a former lover, the Jewish philosopher Hannah Arendt (1906–1975), who thought Heidegger had been too naive to understand the evil nature of Nazism. Heidegger himself refused to talk about his Nazi period, except for an interview with a German magazine that was published after his death.

Heidegger continued to write and lecture prolifically after the war and was hailed as a highly influential force in French philosophy. But he was also famous for his impenetrable prose; one American reviewer described Heidegger's writing as "a distasteful mixture of nonsense and banality."

ADDITIONAL FACTS

1. *Heidegger enlisted in the German army upon the outbreak of World War I in 1914, but was released two months later because of his delicate health. He was recalled to service near the end of the war and served on the western front for part of 1918 before Germany's defeat.*

2. *Many of Heidegger's students ended up as refugees in the United States during World War II. Two of the most famous were ideological rivals: Leo Strauss (1899–1973), who became one of the heroes of American neoconservatism, and Herbert Marcuse (1898–1979), who influenced many left-wing radicals of the 1960s and 1970s.*

3. *In the summer of 1944, at age fifty-five, Heidegger was deemed "expendable" by his university and ordered to help dig trenches for the Nazi army near the Rhine.*

✦✦✦

Erwin Schrödinger

He was a brilliant physicist, the winner of a Nobel Prize, and a close friend of Albert Einstein (1879–1955). One thing that Erwin Schrödinger (1887–1961) apparently was not, however, was a cat person.

Outside of theoretical physics, the Austrian scientist may be best known for the metaphor of Schrödinger's cat, a thought experiment he invented that helps explain a key problem in quantum mechanics through the life and death of one unfortunate feline. Indeed, Schrödinger's cat has become so famous that references to the metaphor have appeared in science fiction, on TV shows, and even in cartoons.

Schrödinger was born in Vienna, Austria; earned his doctorate in physics in 1910; and was named to a prestigious professorship in Berlin in 1927. He won the Nobel Prize in Physics in 1933, but was forced to flee Germany in the same year because of his opposition to the Nazis. After spending most of the war years in Ireland, he returned to Austria in 1956, where he died at age seventy-three.

The thought experiment of Schrödinger's cat, which he developed along with Einstein in 1935, addresses a problem encountered in the study of subatomic particles. Many physicists had concluded that it was possible to pinpoint the location or the direction of a subatomic particle—but not both. Until the moment a particle was observed, they theorized, it occupied many possible locations, or *superpositions,* at once.

The story of Schrödinger's cat raises problems with this theory. It begins with a cat that is locked inside a steel box. Alongside the cat is a vial of deadly poison, which will immediately kill the animal if the vial breaks. Attached to the vial is a device that may or may not break the vial at any moment, depending on the unpredictable actions of subatomic particles in the device. To a human observer outside the box, there is no way of knowing whether the poison has been released and whether the cat is alive or dead.

The crux of the metaphor is the state of uncertainty that exists for as long as the box is shut. (Uncertainty for the human observer, that is—not for the cat.) Has the vial been broken or not? Is the cat dead or alive? Just as the scientists don't know the location of a particle until it is observed, the cat occupies two superpositions—alive and dead—until the box is opened. And yet, that conclusion also seems faulty, since common sense indicates that the cat must be either alive or dead, and can't be both.

The story illustrates a continuing problem for physicists—how, or if, superpositions at the subatomic level translate into observable differences in objects like cats. There is no answer—the problem remains, in a word, *purrplexing.*

ADDITIONAL FACTS

1. *Schrödinger served as an artillery officer in the Austro-Hungarian army during World War I.*

2. *A crater on the dark side of the moon was named after Schrödinger.*

3. *Schrödinger was offered a professorship at Princeton University in 1934, but he turned it down.*

✦ ✦ ✦

Ma Barker

Kate "Ma" Barker (1872–1935) was the matriarch of a notorious family of mid-western bank robbers. During the Great Depression, Barker and her sons were accused of dozens of bank heists and murders after leaving a trail of violence from Oklahoma to Chicago. Proclaimed a public enemy, she was the target of a sensational nationwide hunt until the gang was cornered in Florida and gunned down by the FBI.

Born in Missouri, Kate Clark married a man named George Barker in the 1890s. They had four sons—Herman, Lloyd, Arthur (1899–1939), and Fred (1902–1935)—all of whom would grow up to become criminals. For much of the 1910s and '20s, the Barker sons were in and out of jail for bank robbery, car theft, and other crimes. One of the sons, Herman, committed suicide in 1927.

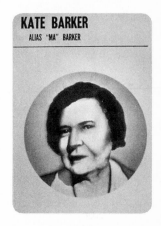

KATE BARKER
ALIAS "MA" BARKER

The family business took a more violent turn after 1931, when Fred Barker teamed up with Alvin "Creepy" Karpis (1907–1979), a convicted thief he had met in prison, to form the Barker-Karpis Gang. The gang embarked on a crime spree that would last for the next four years.

Ma Barker's role in the gang has long been debated. In press accounts, she was often portrayed as the leader of the gang. During an era of deep public anxiety over crime, Barker joined other famous criminals, such as John Dillinger (1903–1934) and Willie Sutton (1901–1980), as a symbol of the breakdown of law and order during the Depression.

The gang was implicated in the killings of several policemen and the kidnapping for ransom of a Minnesota millionaire. Ma and Fred Barker were eventually traced to a rental house in Florida, where they were killed in a shootout. Barker was sixty-two; she was allegedly cradling a tommy gun when she died. Since then, however, critics have suggested that the FBI may have exaggerated her importance to the gang so the bureau could claim credit for bringing down a major criminal.

ADDITIONAL FACTS

1. *Another of Barker's sons, Arthur, was killed while trying to escape from the federal penitentiary at Alcatraz Island. The Barkers' accomplice, Alvin Karpis, served twenty-six years at the Rock, the longest of any inmate at the infamous prison. He was released in 1969.*

2. *Ma Barker was the inspiration for the Disney comic character Ma Beagle, the head of the Beagle Boys gang, which habitually attempts to steal Scrooge McDuck's fortune.*

3. *A B movie, Ma Barker's Killer Brood, was released in 1960. It starred Lurene Tuttle (1907–1986)—who was probably better known for her minor role in* Psycho, *released in the same year. Academy Award–winning actress Shelley Winters (1920–2006) played Barker in* Bloody Mama *(1970).*

❖❖❖

Virginia Woolf

In her innovative novels and short stories, Virginia Woolf (1882–1941) helped pioneer techniques for writing fiction that introduced new ways to explore time and consciousness and proved a major influence on a generation of writers.

Woolf's novels include *Mrs. Dalloway* (1925), *To the Lighthouse* (1927), and *Orlando* (1928). She also published a famous book-length essay, *A Room of One's Own* (1929), which contains her famous piece of advice for female authors: "A woman must have money and a room of her own if she is to write fiction."

Born Adeline Virginia Stephen, Woolf belonged to a prominent London family. Her father, Sir Leslie Stephen (1832–1904), was an author and mountaineer who climbed several peaks in the Swiss Alps. She grew up in her parents' thriving literary circle, which included the American expatriate author Henry James (1843–1916).

After the death of her father in 1904, Woolf moved to the Bloomsbury neighborhood of London, where she became one of the leaders of an intellectual club called the Bloomsbury Group. Made up of authors, poets, and social scientists, the club was oriented around progressive politics and modernist approaches to literature. She married fellow Bloomsbury Group member, Leonard Woolf (1880–1969), in 1912.

Five years later, the couple founded a publishing house, Hogarth Press, which published much of Woolf's fiction. In her fiction, Woolf sought to express the discontinuous nature of time and the way characters often experience the past and the present at the same moment. She used a stream-of-consciousness style of narration to convey the jumble of emotions and observations experienced by her characters.

Woolf experienced several bouts of depression and was devastated by the destruction of her home in a Nazi bombing raid during World War II. She committed suicide by drowning at age fifty-nine.

ADDITIONAL FACTS

1. *The Woolfs originally used a hand-operated printing press in the basement of their house to print the works published by the Hogarth Press. They continued printing by hand until 1932.*

2. *The Hogarth Press published the first complete English translation of the works of Sigmund Freud (1856–1939) in the 1920s and '30s. Woolf did not actually meet the famous psychoanalyst until 1939, and she described him as "a screwed up shrunk very old man."*

3. *Woolf's name was memorably appropriated by playwright Edward Albee (1928–) in the title of his Tony Award–winning play* Who's Afraid of Virginia Woolf? *(1962). Albee claimed that he found the phrase scrawled on the mirror of a restaurant bathroom in New York City, could not get it out of his head, and used it as the inspiration for a climactic moment in the play.*

◆◆◆

Leon Trotsky

On August 20, 1940, in a sedate suburb of Mexico City, an assassin entered into the house of Communist leader Leon Trotsky (1879–1940), walked past his unsuspecting bodyguards, and drove an ice axe into his skull. Twenty-six hours later, after numerous desperate operations to save his life, Trotsky was dead.

The assassination—ordered by Soviet leader Joseph Stalin (1879–1953)—eliminated one of the dictator's most feared opponents, who had been living in exile since 1929. Although Trotsky was an ardent Communist and, like Stalin, a veteran of the Russian Revolution, Trotsky had emerged as a leader of the anti-Stalinist wing of the Communist Party after denouncing Stalin's brutal tactics.

Trotsky was born in a tiny village in Ukraine and raised on a farm. He discovered Marxism as a student and was imprisoned for two years in 1898 for his involvement in revolutionary circles. He left Russia for London in 1902, where he joined other Communist leaders who were plotting to overthrow the czar. Trotsky returned to Russia to participate in a 1905 revolution and was arrested and deported after the uprising failed. For the next twelve years, he traveled across Europe and the United States trying to heal rifts within the Russian opposition and build support for Communism.

At the time of the Russian Revolution in 1917, Trotsky was living in New York City. He returned to Russia in May, becoming Lenin's second in command. Trotsky played a key role in negotiating the Russian exit from World War I, winning the civil war against anti-Communist factions, and formally establishing the Union of Soviet Socialist Republics in 1922.

After Lenin's death, a power struggle for the Soviet leadership began. Although theoretically the successor to Lenin, Trotsky was quickly sidelined by Stalin and eventually forced to leave Russia.

From exile, Trotsky, known around the world for his trademark goatee, became the face of Russian opposition to Stalin. He never rejected Communism, insisting that it could be implemented without the massive political violence of the Soviet Union. During the purges of the 1930s, Trotsky was sentenced to death in absentia—a sentence that elevated his stature in the West. Trotsky was sixty at the time of his death.

ADDITIONAL FACTS

1. *Trotsky has been played by Richard Burton (1925–1984) in* The Assassination of Trotsky *(1972) and* Geoffrey Rush *(1951–) in* Frida *(2002).*

2. *One of the most famous political satires ever written,* Animal Farm *(1945), by George Orwell (1903–1950), features an allegorical retelling of the Russian Revolution and its aftermath. In the book, a group of farm animals led by two pigs named Snowball (based on Trotsky) and Napoleon (based on Stalin) overthrow the farmer, but soon argue over how to rule the farm. Snowball is eventually exiled from the farm, and Napoleon establishes a dictatorship that proves to be just as bad as the farmer's.*

3. *The ice axe used to kill Trotsky disappeared from a Mexican police station in 1940. Sixty-five years later, the daughter of a police official revealed that he had stolen the murder weapon as a keepsake.*

◆◆◆

Elijah Muhammad

He was born Elijah Poole on a cotton plantation in Sandersville, Georgia, one of thirteen children of former slaves. But he became famous as Elijah Muhammad (1897–1975), the leader of the Nation of Islam, a religion that attracted hundreds of thousands of African American followers in the twentieth century with its message of racial pride and self-sufficiency.

Raised in a Baptist home, Poole dropped out of school at age nine and worked at a sawmill, in the cotton fields, and on a railroad track gang. He eventually joined the migration of blacks from the Deep South to the industrial North and began working at a General Motors plant in Detroit.

In 1930, after losing his job during the Great Depression, Poole met a silk salesman named Wali Farad, who claimed that he was Allah and had started a temple in Detroit named the Nation of Islam. Farad eventually converted Poole, who then dropped his "slave name" and adopted his Islamic moniker. He took over Farad's organization after the preacher's mysterious disappearance in 1934 and moved its headquarters to Chicago.

The theology of the Nation of Islam, as articulated by Elijah Muhammad, bears only a loose resemblance to mainstream Islam. Like most Muslims, members of the Nation of Islam are expected to avoid drugs, alcohol, and pork. Unlike most Muslims, Muhammad's followers believed that whites were "devils by nature" who had been created by a mad scientist named Yakub and had taken power through "tricknology."

Elijah Muhammad was jailed during World War II for refusing to register for the draft, and he converted many new followers in prison. The group continued to grow in the 1950s, and a young convert named Malcolm X (1925–1965) became Muhammad's top lieutenant. (Malcolm X eventually abandoned the Nation of Islam, converted to mainstream Islam, and was assassinated the next year; although suspected of being linked to the shooting, Muhammad was never implicated in the crime.)

At the time of Muhammad's death, his organization claimed a growing membership of thousands of worshippers in dozens of temples across the United States.

ADDITIONAL FACTS

1. *One of Muhammad's most famous converts was boxer Muhammad Ali (formerly Cassius Clay, 1942–), who announced that he had joined the Nation of Islam.*

2. *Muhammad's followers used the term* the honorable *before his name, a tradition that was continued for black Muslim leaders after his death.*

3. *In the name of self-sufficiency, the Nation of Islam founded its own bakeries, grocery stores, and banks and started a newspaper called* Muhammad Speaks.

❖ ❖ ❖

Joseph Stalin

Joseph Stalin (1879–1953) was the leader of the Soviet Union between 1922 and 1953 and ranks as one of the most murderous dictators in history. In the name of building a Communist utopia, as many as 20 million people may have been killed during Stalin's tenure.

Still, many Russians fondly remember Stalin as the man who modernized Soviet industry, turned the USSR into a military superpower, and led the nation to victory over Adolf Hitler (1889–1945) in World War II. More than a third of Russians, in a 2003 poll, claimed that Stalin did more good than harm.

Born in Georgia as Iosif Vissarionovich Dzhugashvili, Stalin was the son of a cobbler and a former serf. He adopted his famous pseudonym years later, after becoming involved in revolutionary politics. He was an ally of Vladimir Lenin (1870–1924) and helped organize bank robberies to fund the cause. After the outbreak of the Russian Revolution in 1917, Stalin was named editor of the official Communist newspaper, *Pravda*. When Lenin died, Stalin won a power struggle to succeed him as leader of the Soviet Union, driving his chief opponent, Leon Trotsky (1879–1940), into exile.

Stalin was intent upon transforming the USSR into an industrial power, and he instituted a series of five-year plans designed to help the country catch up with the West. His plans caused enormous harm—famines killed millions of people after he seized privately owned farms to form collectives—but the USSR made huge strides in increasing its economic output.

Politically, Stalin spent the 1930s consolidating his power via a series of show trials that inevitably resulted in the execution of his alleged opponents. Up to a million people may have been shot. He also nurtured a "cult of personality" that encouraged citizens to regard him as the living personification of Soviet patriotism.

In 1939, Stalin signed a nonaggression pact with Hitler. But two years later, Hitler broke the treaty, launching an invasion of Russia. The war took a tremendous toll on the Soviet military—its losses far exceeded those of the other Allies. After the war, Stalin pushed to install Communist governments in areas of Eastern Europe that had been liberated by the Red Army. He also formulated Soviet policy during the early phases of the Cold War. He died in 1953, at age seventy-four.

ADDITIONAL FACTS

1. *A memorial to the victims of Stalin's purges opened in Moscow in 2007.*

2. *In one of history's more ironic twists, a Soviet peace award designed to be the Communist equivalent of the Nobel Peace Prize was named for Stalin. Its winners included American actor Paul Robeson (1898–1976), Chilean poet Pablo Neruda (1904–1973), and German playwright Bertolt Brecht (1898–1956). The award was renamed after Stalin's death.*

3. *Stalin's successor, Nikita Khrushchev (1894–1971), delivered a famous speech in 1956 denouncing Stalin's "cult of personality." The speech, a crucial turning point in Soviet history, opened the door to criticism of the once-feared dictator and began the process of "de-Stalinization" in the USSR.*

✦✦✦

Jean-Paul Sartre

One of the fathers of existentialism, Jean-Paul Sartre (1905–1980) acquired larger-than-life status in Western Europe due to his fiction, movies, political activism, love affairs, and provocative philosophy. He was awarded the Nobel Prize in Literature in 1964, but declined the distinction, saying that a true writer must remain aloof from such honors.

Sartre was born in Paris, where he earned a doctorate in philosophy and met his lifelong partner, Simone de Beauvoir (1908–1986). He studied for two years in Germany, then returned to France to write *Nausea,* a seminal existentialist novel.

During World War II, Sartre was drafted into the French army, captured by the Germans, and held for nine months in a Nazi prison camp. He was released due to poor health (he had lost sight in one eye at age three). For the rest of the war, Sartre contributed to underground magazines and organized opposition among intellectuals to the Nazi occupation. He also embraced Communism at this time and published the landmark existentialist treatise *Being and Nothingness* in 1943.

Existentialism, a movement influenced by earlier European philosophers, especially Friedrich Nietzsche (1844–1900), amounted to a repudiation of almost all classic Western philosophy since Plato (c. 429–347 BC). It takes its name from the famous motto "Existence precedes essence." Roughly speaking, the existentialists believed that humans create their own lives and beings and there are no metaphysical or religious forms that define them.

After World War II, Sartre and Albert Camus (1913–1960) emerged as two of the most famous French existentialists. Sartre—in part because of his public involvement with controversial political stances and his high-profile relationship with Beauvoir—became a pillar of French culture, the archetype of the café-dwelling Left Bank intellectual.

Sartre's personal life included numerous affairs with young admirers; he sometimes had four or five mistresses at a time. He would then chronicle his exploits in candid letters to Beauvoir (to whom he had promised "transparency," if not monogamy). Still, the two philosophers remained inseparable until his death from a lung infection at age seventy-four.

ADDITIONAL FACTS

1. *Sartre's books were banned en masse by the Catholic Church in 1948.*

2. *One of his most famous quotes, from the play* No Exit *(1944), is "Hell is other people."*

3. *Before receiving the Nobel Prize, Sartre wrote a letter to the Nobel Institute in Sweden, asking to be removed from consideration. The letter was never opened, however.*

◆◆◆

Howard Carter

On the afternoon of November 26, 1922, just before teatime, a group of British archaeologists broke through a stone wall that lay deep beneath the sands of Egypt. Hot air rushed through the opening, escaping from a tomb that had been undisturbed for more than 3,000 years. One of the men asked the chief archaeologist, Howard Carter (1874–1939), whether he could see anything. "Yes," he replied as he held a candle to the darkness. "Yes, wonderful things."

The discovery of the tomb of Tutankhamen was one of the most sensational archaeological finds in history. The immense amounts of gold and artifacts found in the chamber made Carter internationally famous. The discovery also sparked a wave of interest in ancient history, inspiring a generation of archaeologists to search for long-lost treasures. And the deaths of some members of Carter's expedition gave rise to the notorious legend of the mummy's curse.

Carter was raised in Swaffham, Norfolk, the son of a painter. At age seventeen, he joined an expedition to Egypt for the first time as the assistant. He would move to Egypt permanently in his twenties (although nominally independent, Egypt was a de facto British protectorate until after World War II). Carter worked for the Egyptian government until 1905, when he quit his job to become a freelance archaeologist.

By then, Carter had discovered the tombs of several pharaohs, but all of the sites had been ransacked by ancient tomb robbers. No fully preserved burial chamber had ever been located. After leaving his job, Carter found a sponsor, George Herbert (1866–1923), who was determined to unearth a fully intact tomb. Carter spent the years between 1915 and 1922 digging in the Valley of the Kings, a cluster of royal tombs near the ancient Egyptian capital of Thebes. By 1922, he was on the verge of giving up. Finally, that November he discovered a mysterious set of steps in the corner of another tomb. His workmen excavated tons of sand out of the stairway leading to another tomb's entrance.

In the aftermath of the discovery, a legend arose that Tutankhamen had placed a curse on the men who had disturbed his resting place. Herbert, the main benefactor of the expedition, died a few months after the tomb was opened. Another visitor, an American railroad baron, died a few months after that.

But Carter apparently was unaffected by the curse, and he spent the rest of the 1920s basking in the fame of his discoveries. He died in 1939 at age sixty-four.

ADDITIONAL FACTS

1. *A year after discovering the tomb, Carter traveled to the United States, where he received an honorary degree from Yale University.*

2. *Tutankhamen's famous burial mask weighs twenty-four pounds and is made of solid gold. The gold alone would cost nearly $500,000 at today's prices.*

3. *The Egyptian government sponsored a worldwide tour of Tutankhamen artifacts in the 1970s, including stops in seven cities in the United States.*

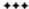

Lucky Luciano

The inspiration for countless mafia movies, Lucky Luciano (1897–1962) was a Sicilian-born gangster who became the most powerful capo in New York City in the 1920s and 1930s. He murdered his way to the top of the mob hierarchy, established peace between the Italian and Jewish mafias, and built an illicit empire that made him one of the richest men in the nation.

Luciano also played an important—albeit secret—role in World War II. From his prison cell, he used his mob contacts to ensure labor peace on the Manhattan waterfront, and he also helped plan the Allied invasion of his native Sicily in 1943. For his assistance in the war effort, Luciano was released from prison in 1946—on the condition that he never return to the United States again.

Salvatore Luciana was born in Sicily, where his father was a sulfur miner. (The mob boss later changed both his first and last names.) The family immigrated to New York City, where Luciano attended public school and met Meyer Lansky (1902–1983) and Bugsy Siegel (1906–1947), both of whom would become important mob associates. Many older mobsters were hesitant to ally with non-Sicilians. But Luciano, Lansky, and Siegel had little patience for ethnic divisions when there was money to be made.

Starting in the late 1920s, the trio dealt with the older generation of Sicilians by killing them one by one. By 1932, Luciano was in command of a huge operation encompassing loan-sharking, drug trafficking, and organized labor.

Indeed, what most Americans came to think of as the mafia was created by Luciano. He divided the organized crime world into five families—Gambino, Lucchese, Colombo, Genovese, and Bonanno—and established "the Commission" to settle gangland disputes. He even instituted the gangster dress code of fedoras and conservative suits, insisting that his men look respectable. At the height of the Depression, Luciano generated millions of dollars in profits, lived in the Waldorf-Astoria Hotel in Manhattan, and dated showgirls. His reign over the underworld was short-lived, however; the US attorney, Thomas E. Dewey (1902–1971), successfully prosecuted Luciano on ninety counts of extortion and "organized harlotry" in 1936.

After his release, Luciano was exiled to Italy, but he remained involved in heroin smuggling and other mob activities. Never allowed to return to the country he considered his home, Luciano died in Italy at age sixty-four.

ADDITIONAL FACTS

1. *Luciano's crime family is now known as the Genovese family, one of the Five Families of New York City's organized crime world.*

2. *In 1998,* Time *magazine named Luciano one of its 100 most important people of the century.*

3. *Luciano was the subject of a 1973 feature film,* Lucky Luciano, *which starred Gian Maria Volonté (1933–1994). Luciano has also been portrayed by Christian Slater (1969–) in* Mobsters *(1991), Bill Graham (1931–1991) in* Bugsy *(1991), and Andy Garcia (1956–) in* Hoodlum *(1997). The character of Michael Corleone in* The Godfather *(1972) is also based partially on Luciano.*

❖ ❖ ❖

Walter Gropius

The founder of the influential Bauhaus school of architecture, Walter Gropius (1883–1969) built some of the twentieth century's most critically acclaimed structures. His designs include the Pan Am Building in New York City, the US Embassy in Athens, Greece, and several buildings in Gropius's adopted home of Massachusetts, to which he fled in 1934 after the Nazi takeover of his native Germany.

The Bauhaus style, which Gropius taught a generation of architects in Germany and later at Harvard, was typified by sleek designs, lack of ornamentation, and an emphasis on practicality and functionality. Along with Le Corbusier (1887–1965), Gropius is considered one of the most influential modernist architects, a group that simplified design and embraced the credo that in architecture, "form should follow function."

The son of an architect, Gropius attended technical school in Munich and Berlin and began his own practice in 1910. One of his first major projects, a shoe factory, was constructed in 1913. He married the widow of composer Gustav Mahler (1860–1911), Alma, in 1915 and served in the German army during World War I.

Returning home from the war after Germany's defeat, Gropius joined a group of radical designers and architects in founding the Bauhaus, which was named after the Berlin school's first director in 1919. The Bauhaus school rejected the ornate decorative style that was typical of classical European design—a symbolic rejection, too, of the militaristic politics that had led Germany to ruin in the war.

After fleeing Adolf Hitler (1889–1945) in 1934, Gropius settled in the Boston suburb of Lincoln, Massachusetts, where he designed a new home for himself. The house mixed traditional New England building methods with cutting-edge, industrial-style materials, creating one of the first modernist buildings in the United States. He also designed the Pan Am (now MetLife) Building, a controversial skyscraper completed in 1963 that rises over Grand Central Terminal in Midtown Manhattan.

Gropius died in Boston at age eighty-six, but his style of glass-and-steel construction and minimal design remains a dominant influence in skylines around the world.

ADDITIONAL FACTS

1. *When Gropius resigned as director of the Bauhaus in 1928, he was replaced by Ludwig Mies van der Rohe (1886–1969). Van der Rohe's projects included the Seagram Building in New York City and the main public library in Washington, DC.*

2. *The Bauhaus school offered instruction in both architecture and art. One of Gropius's colleagues in Berlin was the Russian abstract painter Wassily Kandinksy (1866–1944), one of the central figures in expressionist painting.*

3. *After divorcing Gropius, Alma Mahler (1879–1964) married the novelist Franz Werfel (1890–1945). The story of her life, including her marriages to three significant artistic figures, was the subject of the 2001 movie* Bride of the Wind. *In the film, German actor Simon Verhoeven (1972–) played Gropius.*

✦✦✦

Claus von Stauffenberg

A hero of the resistance to the Nazis, Colonel Claus von Stauffenberg (1907–1944) nearly succeeded in a complicated plot to assassinate Adolf Hitler (1889–1945) in 1944. He managed to plant a bomb that came within inches of killing the German dictator—an outcome that could have ended World War II, shortened the Holocaust, and prevented the Soviet invasion of Eastern Europe.

Handsome and charismatic, von Stauffenberg was the scion of an aristocratic and devoutly Roman Catholic military family in southern Germany. Von Stauffenberg eventually rose to the rank of army chief of staff, putting him in regular contact with Hitler.

Although von Stauffenberg was an ardent German nationalist, he became disillusioned with the Nazis and Hitler soon after the beginning of World War II. The persecution of Jews and mistreatment of Soviet prisoners of war, in particular, convinced him that Hitler had to be stopped. In 1942, when a friend asked him how to change Hitler's mind, von Stauffenberg replied, "Kill him."

The plot against Hitler eventually involved hundreds of soldiers, including several high-ranking officers. Von Stauffenberg volunteered to carry the briefcase bomb into Hitler's bunker in East Prussia. He arranged to leave the room just before the bomb was set to explode, when he would join the other plotters to take control of the government and negotiate a peace settlement with the Allies.

But von Stauffenberg had a poor understanding of how bombs worked, and he armed only one of the two explosives packed into his suitcase. Still, the plot might have been successful if another officer had not moved the briefcase to get a closer look at a map after von Stauffenberg left the room. The bomb killed four people in the bunker, but not Hitler. Von Stauffenberg was arrested and executed by a firing squad later that night. Many of the coconspirators soon met a similar fate, often after prolonged torture by the Gestapo.

The majority of the military and civilian casualties in Germany occurred during the final ten months of the war, and they might have been averted if the July 20 plot had been successful. The failure of the conspiracy haunted the participants. As one of his coconspirators told a newspaper decades later, "Stauffenberg was the wrong man for this—but no one else had the guts."

ADDITIONAL FACTS

1. *A memorial to von Stauffenberg and the other conspirators was opened at the Bendlerblock by the government of West Germany in 1980.*

2. *Actor Tom Cruise (1962–) played von Stauffenberg in a 2008 movie adaptation of the July 20 plot,* Valkyrie, *which was filmed on location in Germany. One of von Stauffenberg's grandsons, Philipp von Schulthess (1973–), appears in the film as a German military officer.*

3. *The last surviving member of the plot, Philipp von Boeselager (1917–2008), died in Germany at age ninety.*

◆◆◆

Dorothy Day

A crusading left-wing activist who fought on behalf of the hungry and forgotten, Dorothy Day (1897–1980) was the cofounder of the *Catholic Worker* newspaper, a powerful voice for social change and pacifism during and after the Great Depression. During her lifetime, Day's politics were considered so extreme that she was monitored by the FBI, but many Catholics considered her a hero, and she was officially proposed for sainthood in 2000.

Day was born in Brooklyn and moved frequently as a child; she was living in San Francisco in 1906 and survived that year's earthquake. Her parents were not religious—and, for the first several decades of Day's life, neither was she. As a young college student, she became enamored with socialist politics, dropped out of school in 1916, and worked as a reporter for a radical newspaper, the *Call.*

During the 1920s, Day gravitated toward radical political circles in New York City. She adopted a Bohemian lifestyle, lived with multiple lovers, and had an illegal abortion, an experience she would later say she regretted.

Pregnant again in 1927, Day experienced a religious awakening and converted to Catholicism. For the rest of her life, she would remain a deeply devout and theologically conservative Catholic, enthusiastically backing the church's position against abortion.

But she also remained committed to her political ideals, and she combined the two in May 1933, when she started the *Catholic Worker* with Peter Maurin (1877–1949). The two hoped to spark a movement of socially involved, left-wing Catholics; in addition to the newspaper, they founded shelters for the homeless, clinics, and hospices.

Day was a controversial figure even among Catholics, thanks to her strong leftist and antiwar beliefs. She opposed the draft during World War II and agitated passionately against the Vietnam War; according to her *New York Times* obituary, Abbie Hoffman (1936–1989) once referred to Day as "the first Hippie."

After her death at age eighty-three, Day was proposed for sainthood by John Cardinal O'Connor (1920–2000), the archbishop of New York City.

ADDITIONAL FACTS

1. *She was played by actress Moira Kelly (1968–) in the 1996 movie* Entertaining Angels: The Dorothy Day Story.

2. Catholic Worker *is still published on a monthly basis—and still has a cover price of one cent.*

3. *For much of her life, Day refused to pay taxes, vote, or salute the American flag in protest over war and social injustice.*

❖❖❖

Franklin D. Roosevelt

Elected to an unprecedented four terms in the Oval Office, Franklin D. Roosevelt (1882–1945) led the United States through the Great Depression, World War II, and massive social and economic changes.

A distant cousin of President Theodore Roosevelt (1858–1919), Franklin Roosevelt was born in the wealthy enclave of Hyde Park, New York. He attended Harvard, worked on Wall Street, and married another member of the Roosevelt clan, Eleanor Roosevelt (1884–1962), in 1905.

Although his cousin was a Republican, Franklin Roosevelt entered politics as a Democrat and ran for vice president on the party's ticket in 1920. He failed in his first national race, but was elected governor of New York in 1928, a time when the governorship of the nation's biggest state was considered a springboard to the presidency.

In 1932, after the stock market collapse plunged the US economy into a cataclysmic economic depression, Roosevelt easily defeated the Republican incumbent, Herbert Hoover (1874–1964), who was widely blamed for the crisis.

In office, Roosevelt offered a set of economic programs, collectively called the New Deal, to combat the crisis. He spent billions on public works—roads, bridges, dams—to put people back to work and created social welfare programs to protect workers and the elderly. The programs massively expanded the federal government's role in managing the economy. During World War II, Roosevelt shifted the US economy to a war footing and, along with British prime minister Winston Churchill (1874–1965), laid the groundwork for the postwar world.

Roosevelt died of a cerebral hemorrhage in April 1945, just after being elected to a record fourth term. He was sixty-two.

ADDITIONAL FACTS

1. *In the last five years of his presidency, Roosevelt owned a Scottish terrier named Fala (the name came from one of Roosevelt's ancestors). A statue of the dog is included in the Roosevelt memorial that opened in Washington, DC, in 1997.*

2. *Roosevelt had three different vice presidents: John Nance Garner (1868–1967), who broke with Roosevelt and challenged him for the 1940 nomination; Henry A. Wallace (1888–1965), whom Roosevelt dropped from the ticket over foreign policy differences in 1944; and Harry S. Truman (1884–1972), his eventual successor.*

3. *Roosevelt appointed the first woman cabinet member, secretary of labor Frances Perkins (1882–1965).*

❖ ❖ ❖

Simone de Beauvoir

Author and polemicist Simone de Beauvoir (1908–1986) was among the most prominent feminist philosophers of the twentieth century and the author of the landmark book *The Second Sex* (1949). She was also, along with her lifelong partner, Jean-Paul Sartre (1905–1980), one of the few modern philosophers to become a genuine international celebrity.

Beauvoir was the youngest-ever graduate of the philosophy program at France's most prestigious university, the Sorbonne, where she met Sartre. The two classmates began their relationship in 1929 and would remain partners—romantic, political, and intellectual—until his death in 1980.

Beauvoir's first novel was published in 1943; several essays in philosophy followed. She released her best-known work, *Le deuxième sexe* (*The Second Sex*), in 1949. It was translated into English in 1953 and released in the United States, where it was an enormous bestseller.

The Second Sex is part history, part philosophical argument. In the book, Beauvoir relates the history of the oppression of women by men and by society at large. Women, she argued, are constrained by a definition of femininity that robs them of opportunity and artificially limits their prospects. "One is not born, but rather becomes, a woman," she wrote. "It is civilization as a whole that produces this creature, intermediate between male and eunuch, which is described as feminine."

Since its release, women's rights leaders such as Gloria Steinem (1934–) and Betty Friedan (1921–2006) have hailed *The Second Sex* as one of feminism's founding texts; Steinem said after Beauvoir's death, "If any single human being can be credited with inspiring the current international woman's movement, it's Simone de Beauvoir."

Beauvoir remained a prolific writer and political activist throughout her life, penning a four-volume autobiography between 1958 and 1972 and lending her support to a procession of left-wing causes. Her relationship with Sartre, meanwhile, became one of the most celebrated love affairs in French society. The two never married, and they carried on numerous affairs with others. (As Sartre wrote, "What we have is an essential love; but it is a good idea for us also to experience contingent love affairs.") They exchanged hundreds of letters explicitly detailing their liaisons with others. But each remained the other's muse and closest confidant, and she was buried beside him after her death at age seventy-eight.

ADDITIONAL FACTS

1. *At the Sorbonne, Beauvoir's classmates nicknamed her* le Castor—*French for "the beaver"—in recognition of her industrious work ethic.*

2. *Beauvoir won the Prix Goncourt—a French literary award roughly analogous to the Pulitzer Prize—in 1954 for her novel* Les Mandarins *(The Mandarins), which satirized the academic establishment.*

3. *In 1971, Beauvoir joined the movement to legalize abortion in France, signing a document along with other famous French women disclosing that they had had illegal abortions. Abortion was decriminalized in France in 1974.*

✦✦✦

Edwin Hubble

A scientist known for his enormous ego, Edwin Hubble (1889–1953) was widely loathed and resented by his colleagues. But his discoveries and undeniable genius changed our fundamental understanding of outer space by proving that the universe was far larger than previously imagined—and growing at an unimaginable speed.

Indeed, Hubble's work paved the way for the big bang theory, the most widely accepted theory of the beginning of the universe. His legacy can even be felt in popular culture: It was Hubble, after all, who proved that there were galaxies a long time ago and far, far away.

Hubble was born in Missouri, where he was a state champion athlete in high school, and graduated from the University of Chicago in 1910. He attended Oxford as a Rhodes scholar and affected a British accent for the rest of his life, to the annoyance of his colleagues.

After serving briefly in the US Army in World War I, Hubble was hired at Mount Wilson Observatory near Los Angeles. The observatory had what was then the world's largest telescope, which allowed Hubble up-close looks at mysterious objects known as nebulae.

Most astronomers and physicists in 1919 believed that the Milky Way was the only galaxy in the universe and that nebulae were clouds of gas within the Milky Way. But Hubble proved that the nebulae were, in fact, entire galaxies millions of light-years from ours. By measuring the "red shift" of the galaxies, Hubble also discovered that they were rapidly moving away from Earth, meaning that the universe as a whole was expanding at an ever-increasing rate.

The discovery of a massive universe beyond our galaxy made Hubble a celebrity, and he was feted by such Hollywood stars as Charlie Chaplin (1889–1977). Hubble was featured on the cover of *Time* magazine and hailed by Albert Einstein (1879–1955), who admitted that Hubble had proved him wrong. (Einstein later called his earlier belief in a static universe "the greatest blunder of my life.")

Hubble returned to military service during World War II, heading a ballistics unit in Maryland that improved bazookas and other weapons. After the war, however, Hubble's health declined. He died at age sixty-three.

ADDITIONAL FACTS

1. *When Hubble was a college student, a promoter in Chicago attempted to recruit him to fight the world heavyweight boxing champion, Jack Johnson (1878–1946). Wisely, Hubble declined.*

2. *The Hubble home in San Marino, California, was declared a National Historic Landmark in 1976.*

3. *The Hubble Space Telescope, a satellite named in Hubble's honor, was launched by NASA in 1990 and has produced some of the most detailed color pictures of the universe ever taken. It is due to be decommissioned in roughly 2013.*

✦✦✦

Albert Speer

The legacy of Albert Speer (1905–1981) remains deeply controversial. A top official in the Nazi government, he was instrumental in the German war effort and was the closest personal friend of Adolf Hitler (1889–1945). After the war, Speer was convicted of using slave labor and sentenced to twenty years in prison—narrowly avoiding the death penalty.

But Speer—uniquely among former Nazi leaders—pleaded guilty at his Nuremberg trial, expressed remorse, and tried to atone for his crimes. He claimed that he was unaware of the Holocaust until after the war. When his book *Inside the Third Reich* (1969) was published, he donated much of the proceeds to Jewish charities.

To many of his countrymen, Speer gradually became a symbol of the "good German," a fundamentally decent person who had been swept up by an evil system. On the other hand, critics viewed his remorse as self-serving and insincere. Either way, his case vividly highlighted the difficulty of assigning individual guilt for the collective crimes of the Nazis.

Speer was trained as an architect, and he met Hitler at a Nazi Party rally in 1930. He joined the party the next year, at age twenty-six. With Hitler's backing, Speer became the top architect in Germany in the 1930s. One of his most famous designs was a palatial parade ground in Nuremberg for the Nazi Party rally of 1933. (The design would be the inspiration for the set in the final scene in *Star Wars*.)

After the outbreak of World War II, Speer was named minister of armaments in 1942, a job that effectively put him in charge of the German economy. He proved to have a genius for organization and was able to keep Germany's factories running despite the heavy Allied bombing.

Whether Speer knew of the Holocaust remains a source of debate. He may have attended a meeting in 1943 at which the genocide of European Jews was discussed. Speer always claimed that though he made Germany's trains run on time, he had no idea they were carrying millions of prisoners to their deaths.

After serving his twenty-year sentence for war crimes, Speer published two books about the Nazi years. He even visited London, the city he had spent his political career building weapons to destroy. He died at age seventy-six at a London hotel, where he was having an affair with a younger woman.

ADDITIONAL FACTS

1. *Almost all of Speer's architecture was destroyed during or after the war.*

2. *Speer's son—also named Albert Speer (1934–)—is a German architect and urban planner based in Frankfurt. He designed the main boulevard for the 2008 Beijing Olympics.*

3. *In the late twentieth century, evidence surfaced that Speer had personally signed off on a plan to deport 75,000 Jews from Berlin. The document contradicted Speer's oft-stated denials that he knew about the widespread execution of European Jews.*

Diego Rivera

One of the most prominent Mexican artists of the twentieth century, Diego Rivera (1886–1957) was a painter known for his sprawling, colorful murals detailing sweeping historical themes. He is also famous for his Communist politics and his tumultuous marriages to the painter Frida Kahlo (1907–1954).

Rivera was born in Guanajuato, a city in central Mexico, and earned scholarships to study art in Mexico City and Europe. He moved to Paris in 1909 to study painting and lived in France and Spain for the next fourteen years. He also visited Italy, where his encounters with Renaissance-era frescoes inspired his interest in murals.

Returning home in 1921, Rivera painted his first major mural in Mexico City in 1922. In the same year, he joined the Mexican Communist Party. Rivera's enthusiasm for the mural was linked, in large part, to his political beliefs: Rivera hoped that large, outdoor public art could bypass museums and elite institutions and connect directly with the people. He also benefited from a Mexican government program sponsoring murals, an initiative that supported a flourishing community of muralists in 1930s Mexico.

After divorcing his first wife, Rivera married Kahlo in 1929. Both painters were frequently unfaithful to each other, and they divorced ten years later, only to remarry in 1940. The pair shared a commitment to leftist politics and helped arrange permission for exiled Soviet leader Leon Trotsky (1879–1940) to move to Mexico.

Rivera's murals often revolved around epic historical or social themes. For instance, he painted a famous series of murals in Detroit in 1932 and 1933 depicting different aspects of the American industrial workplace, most of them based on a Ford plant in Dearborn, Michigan. (Despite his avowed Communism, Rivera also worked for the Rockefeller family and painted the San Francisco Stock Exchange.)

In Mexico, Rivera's influence on other muralists, including his competitors David Alfaro Siqueiros (1896–1974) and José Clemente Orozco (1883–1949), was significant. The Mexican mural program also served as a model for the Works Progress Administration (WPA), a New Deal agency that supported American artists, and Rivera's influence can be felt in much of the public art sponsored by the WPA.

Rivera died in Mexico City at age seventy.

ADDITIONAL FACTS

1. *Rivera had a twin brother, José Carlos, who died as a child.*

2. *Early twentieth-century Paris was a magnet for artists from around the world. Rivera lived next door to the modernist painter Piet Mondrian (1872–1944) in the fashionable Left Bank neighborhood of Montparnasse.*

3. *Rivera was played by actor Alfred Molina (1953–) in the Academy Award–winning biopic about Rivera's wife,* Frida *(2002).*

◆ ◆ ◆

Ho Chi Minh

Ho Chi Minh (1890–1969) was the leader of the Vietnamese nationalist forces that defeated first France and then the United States to secure an independent Vietnam. He is revered today as his nation's founder.

Ho, a nom de guerre he adopted in his thirties, was born as Nguyen Sinh Cung in a village in central Vietnam. His father was a minor village official in the French colonial government. After completing school in Vietnam, Ho moved to France looking for work, and he also visited the United States, Britain, and the Soviet Union.

It was during his time living in Paris that Ho was drawn into revolutionary and Communist politics. He became convinced that Marxism offered the best route to his country's liberation, and he joined the Communist Party in 1920.

After the outbreak of World War II, Ho hoped that France would be forced to relinquish its colonies in order to devote its resources to war with Germany. Instead, Ho found himself enmeshed in a three-way war between the French and the Japanese, who had also invaded Vietnam.

Vietnam declared independence at the end of the war and appointed Ho president, but France immediately moved to recover its former colony. After a brutal war between 1946 and 1954, the French were forced to relinquish Vietnam, although in the peace settlement the country was divided between a Communist North under Ho's control and the Western-aligned South Vietnam. The precarious settlement collapsed in 1959, sparking another war. This time, the United States entered the conflict on the side of South Vietnam. Policy makers in the United States viewed the conflict as part of the Cold War and wanted to thwart the expansion of the Communist North; the Vietnamese, however, saw the war as a patriotic struggle to unify the country and drive out foreign influence.

By the 1960s, Ho was no longer in day-to-day command, but instead was considered a unifying hero and symbolic leader. He died in 1969, six years before the last American troops left Vietnam.

ADDITIONAL FACTS

1. *In his early twenties, Ho Chi Minh traveled to the United States and worked as a baker at a Boston hotel, the Parker House. The same hotel would later employ Malcolm X (1925–1965) as a busboy.*

2. *After the Communist victory in 1975, the South Vietnamese capital of Saigon was renamed Ho Chi Minh City.*

3. *In the 1980s, Vietnam began dismantling its Communist economic system and encouraging private investment. Today it is a major exporter of oil, textiles, and shoes. Its single largest export market is the United States, which normalized relations with Vietnam in 1995.*

◆◆◆

Dietrich Bonhoeffer

In the last month before the Allied victory in World War II, the embattled Nazis embarked upon a final round of brutal killings of their political enemies inside Germany. One of the victims of this purge was a thirty-nine-year-old Lutheran priest who was tortured and hanged at Flossenbürg concentration camp at dawn on April 9, 1945.

The young minister was Dietrich Bonhoeffer (1906–1945), who would be hailed after the war as one of the few German religious figures brave enough to defy the Third Reich.

Bonhoeffer was born into a prominent German family in Wrocław, a city in present-day Poland. Although too young to fight in World War I, he witnessed the destruction wrought by the war and was devastated by the death of his older brother, Walter. After receiving his doctorate in 1927, Bonhoeffer traveled to Spain, Britain, and the United States; he began publishing well-received books on Protestant theology and was officially ordained a minister when he returned to Germany in 1931.

Bonhoeffer was living in Berlin in 1933, when the Nazis took power and began forcing the German Protestant and Catholic churches to submit to government control. Under pressure from Adolf Hitler (1889–1945), the German Protestant church became the Protestant Reich Church. That year, Bonhoeffer helped organize the Confessing Church and its seminary, insisting that Christianity was incompatible with Nazism. He also objected to the pervasive anti-Semitism of Nazi propaganda.

During the 1930s, the Gestapo shut down Bonhoeffer's seminary. As war loomed, he briefly fled to the United States, but returned to Germany to join the resistance, declaring that he would have "no right to take part in the restoration of Christian life in Germany after the war unless I share the trials of this time with my people."

Bonhoeffer was arrested in 1943 when he was caught helping Jews escape from Germany. Although he was in prison on July 20, 1944, the day of a failed assassination attempt on Hitler, he was implicated in that plot. He, along with other conspirators, was executed in brutal fashion at Flossenbürg.

Just fourteen days later, the Allies liberated the death camp—and within a month, the war was over.

ADDITIONAL FACTS

1. *In total, four members of Bonhoeffer's immediate family were executed for their roles in the plot to assassinate Hitler, including his brother, Klaus, and two brothers-in-law.*

2. *As a theologian with pacifist leanings, Bonhoeffer agonized over his own decision to join the plot to kill Hitler. He explained the thinking that informed his choice in his 1943 book* Ethics: *"Christians are, therefore, faced with a dilemma: when assaulted by evil, they must oppose it through direct action. They have no other option. Any failure to act is simply to condone evil."*

3. *A statue of Bonhoeffer was erected in Westminster Abbey in London, celebrating the German priest as a modern Christian martyr.*

❖ ❖ ❖

Eva Perón

Eva Perón (1919–1952) was the first lady of Argentina between 1946 and 1952 and an enormously popular figure among the nation's poor and working classes. A beautiful, charismatic former movie star, Perón inspired a level of devotion in her countrymen that was virtually without precedent; in 1952, she was officially named the Spiritual Leader of the Nation—the first and only Argentinean to hold the title.

Perón's life was cut short that year, however, when she died of cancer at the age of thirty-three. Perón's funeral triggered a nationwide outpouring of grief.

Evita, as her adoring supporters called her, was born out of wedlock at a time when illegitimacy was heavily stigmatized. Her father abandoned her mother when she was an infant, and Perón grew up in the poorest neighborhoods of her hometown, Junin.

At age fifteen, she moved to Buenos Aires, dreaming of a movie career. She worked as a model, appeared in a handful of films, and acted in a series of popular radio dramas. In 1944, she met an Argentinean army officer and politician, Juan Perón (1895–1974), at a fund-raiser for victims of an earthquake; they married the following year.

When Juan Perón ran for president in 1946, his wife campaigned for him in radio appearances and rallies. Her ability to form an emotional connection with audiences, especially the poor, made her a major asset to her husband's campaign; critics, however, considered both Peróns to be dangerous, populist demagogues.

Juan Perón won the election handily, and Eva—still not yet thirty—became one of the most famous women in the world. She spent the next six years representing her husband on foreign tours and leading the Perónist party at home. When her husband ran for reelection in 1952, she attempted to run as his vice president, but was blocked by the military. She pushed, successfully, for women's suffrage in Argentina, and the election in 1952 was the first in which women could vote.

Less than two months after the election, however, Eva Perón died of cervical cancer. Her husband remained president until 1955, when he was overthrown.

ADDITIONAL FACTS

1. Evita, *a musical by Tim Rice (1944–) and Andrew Lloyd Webber (1948–) based on Perón's life, was an enormous hit in 1978. The singer Madonna (1958–) played the title role in the 1996 film version.*

2. *Perón's funeral in Buenos Aires drew about 700,000 spectators, according to an account in* Time *magazine. Sixteen people were trampled to death in the crowd.*

3. *In 2000, the* New York Times *reported that Perón was never told about her cancer diagnosis, and she died believing she suffered from unspecified "female problems."*

❖❖❖

Frantz Fanon

Violence is a cleansing force.
—Frantz Fanon

In 1954, the French colony of Algeria erupted in revolt. Over the next eight years, hundreds of thousands of Algerians would be tortured, displaced, or killed as the French government struggled to maintain its hold on the predominantly Muslim North African territory.

One of the central figures in the Algerian uprising was a quiet, slender doctor and World War II veteran named Frantz Fanon (1925–1961). Fanon was born in Martinique and had come to Algeria in 1953 to work at a hospital. But he quickly emerged as the revolution's chief philosopher, and his fiery writing would be hailed as an inspiration for anticolonial movements across the globe.

During the early stages of the revolt, Fanon treated casualties on both sides of the conflict, concealing his sympathies for the rebels. He also began interviewing the victims of French torture, material that he would use to write *The Wretched of the Earth*.

By 1957, Fanon was known to be a supporter of the Algerian rebel force, the Front de Libération Nationale (FLN). In that year, the French government expelled him from Algeria. He spent the rest of the 1950s touring Africa seeking support for the Algerian rebels and becoming a major contributor to the FLN newspaper, *El Moudjahid*.

Upon its publication in 1961, *The Wretched of the Earth* was immediately banned in France, and it remains highly controversial for its unabashed support of violence. According to Fanon, violence against a colonial oppressor offered therapeutic redemption to people who had suffered the emasculation of foreign rule. Violence, he wrote, "frees the native from his inferiority complex and from his despair and inaction; it makes him fearless and restores his self-respect."

The book was embraced by third-world revolutionaries such as Ernesto "Che" Guevara (1928–1967) as well as Western radicals. Fanon, however, never lived to witness the success of the Algerian revolt. He died of leukemia at age thirty-six, a year before Algeria finally won its independence.

ADDITIONAL FACTS

1. *A volunteer for the Free French during World War II, Fanon was awarded a Croix de Guerre for injuries he sustained. However, he was detached from his unit when Paris was retaken from the Nazis because the French leadership wanted the news to show all-white troops liberating the capital.*

2. *Fanon visited the United States to receive medical treatment for his leukemia at an American hospital. The treatment was unsuccessful, and he died in Bethesda, Maryland. His body was returned to Algeria, where he was given a hero's burial.*

3. *The first phase of the Algerian revolution was depicted in the film* The Battle of Algiers *(1966), which was directed by the Italian filmmaker Gillo Pontecorvo (1919–2006) and funded by the Algerian government. The movie was banned in France upon its release. In the United States, the film was released, but torture scenes were removed.*

Werner Heisenberg

At the beginning of World War II, Nazi dictator Adolf Hitler (1889–1945) ordered Germany's greatest scientists to build him an atomic bomb, hoping that the weapon would ensure German victory. In the race for the bomb that ensued, Germany had many advantages over the Allies: easy access to uranium, advanced scientific facilities, and a head start of more than two years.

Most important of all, the Nazis had Werner Heisenberg (1901–1976), the brilliant, thirty-seven-year-old physicist who was tapped to lead the Uranverein, the Nazi bomb project. Regarded as one of the greatest scientific minds of the twentieth century, Heisenberg had been Germany's youngest physics professor at age twenty-six and had won a Nobel Prize at age thirty-one.

Yet despite their advantages, the Nazis never came close to building an atomic bomb. Since then, historians have raised an intriguing possibility: Did Heisenberg fail on purpose? And if he did, did the scientist known for his arrogance single-handedly save the world from Nazi domination?

Heisenberg was born in Bavaria, graduated at the top of his high school class, taught himself calculus, and won a scholarship to study physics in Denmark under Niels Bohr (1885–1962).

In the 1930s, he lectured in Europe and the United States, even as many scientists were fleeing Nazi Germany. Heisenberg himself was attacked by some Nazis because he taught theories that had originally been proposed by Jewish physicists.

According to some evidence, Heisenberg may have deliberately dragged his feet on the German bomb project. He later claimed to have expressed moral qualms about the project in a 1941 meeting in Copenhagen with his old mentor, Bohr. (Some historians have flatly rejected this assertion.) The next year, he convinced the Nazi authorities that the bomb project was impractical.

After the war, Heisenberg was captured by the Allies and interrogated for six months at a manor in the English countryside. He returned to Germany after his release and died there at age seventy-four.

ADDITIONAL FACTS

1. *Heisenberg met Albert Einstein (1879–1955) for the first time in 1924; the older physicist was so impressed by the twenty-three-year-old that he nominated Heisenberg for the Nobel Prize in 1928.*

2. *In 1944, the United States was so worried about the Nazi bomb project that plans were hatched to kidnap or kill Heisenberg. The man selected for the mission was Morris "Moe" Berg (1902–1972), a former catcher for the Boston Red Sox who had been recruited as a spy by the Office of Strategic Services, the predecessor of the CIA. Berg was sent to Switzerland, where Heisenberg was scheduled to give a lecture. Berg managed to smuggle a loaded handgun into the lecture hall, but decided at the last minute not to kill Heisenberg after the scientist made no mention of an atomic bomb project.*

3. *The 1941 meeting between Bohr and Heisenberg was the basis for a play,* Copenhagen, *by the British playwright Michael Frayn (1933–). It won a Tony Award for best play in 2000.*

◆◆◆

Kim Philby

One of the most notorious spies of the Cold War, Kim Philby (1912–1988) was a senior British intelligence officer who secretly worked for the KGB for two decades. The story of Philby's betrayal shocked the British public when it was uncovered, provided a major propaganda victory for the USSR, and formed the basis for numerous spy thrillers—in particular the novels of John le Carré (1931–), himself a former British spy.

Harold A. R. Philby was born in India, the son of a British colonial official. He attended prestigious prep schools and then Cambridge University, where he became a Communist sympathizer. Philby and several other Cambridge students were recruited by Soviet intelligence as undergraduates and formed a tight-knit group that would later be known as the Cambridge spy ring.

Philby and the other young Cambridge spies were given an audacious long-term assignment: burrow into the British intelligence establishment, rise to senior levels, and then report back to Moscow. Philby worked as a reporter for a British newspaper during the Spanish civil war and then joined the British intelligence service after the outbreak of World War II. All the while, he continued feeding information to his Soviet controllers.

However, Philby's luck began to turn in the 1950s, when two of the other Cambridge spies were unmasked. Philby was able to tip off the two men before they could be arrested, and both fled to the USSR. Because he was known to be a friend of the two, however, Philby came under suspicion of being the "third man" in the plot and was questioned intensively. (In reality, there were five members of the ring; the last would not be made public until the late 1970s.) Philby was eventually cleared and resumed working informally for the British spy agencies.

When he was finally unmasked as a spy in 1963, Philby fled to the USSR, where he lived for the remainder of his life. He died in Moscow at age seventy-six.

ADDITIONAL FACTS

1. *He was nicknamed Kim as a child after the hero of a novel by British writer Rudyard Kipling (1865–1936).*

2. *Philby's agents during World War II included Graham Greene (1904–1991) and Malcolm Muggeridge (1903–1990), both of whom would later become celebrated British writers. Philby continued to correspond with Greene even after going into exile.*

3. *Philby was honored on a Soviet postage stamp in 1990.*

◆◆◆

Tennessee Williams

Tennessee Williams (1911–1983) was an American playwright whose works frequently revolved around fragile Southern women and their dying dreams of social success. Many of his plays have entered the canon of American theater, including *The Glass Menagerie* (1944), *A Streetcar Named Desire* (1947), and *Cat on a Hot Tin Roof* (1955), among others. Williams won two Pulitzer Prizes and saw several of his plays turned into critically acclaimed movies that introduced his poignant, lyrical creations to a nationwide audience.

Thomas Lanier Williams III was born in Mississippi and endured a chaotic childhood. Williams's parents, and especially his neurotic mother, would provide inspiration for many of his plays.

Williams enrolled at the University of Missouri in 1929, where he acquired the nickname Tennessee because of his accent. Finding the unusual moniker distinctive, he adopted it as his legal name at twenty-eight, the same year he moved to New Orleans, came out as a homosexual, and began writing professionally.

His first play, *Battle of Angels,* debuted in 1940. During World War II, Williams moved west to work at MGM Studios in Hollywood, where he honed his writing skills and began working on the script for *The Glass Menagerie.*

The Broadway opening of *The Glass Menagerie* in 1945 marked Williams's arrival as a major playwright. The play's main character is Amanda Wingfield, an older woman modeled after Williams's mother. She lives with her son and daughter in the smothering confines of the family's St. Louis apartment, surrounded by sentimental glass figurines. Obsessed with social propriety, Amanda hopes to find a "gentleman caller" to marry her shy daughter, despite the family's obviously reduced circumstances.

A Streetcar Named Desire was an even bigger success and spawned the 1951 film version starring Marlon Brando (1924–2004). The play introduced one of Williams's most memorable characters, Blanche DuBois, another impoverished Southern belle whose conflict with Stanley is the driving force of the play.

Williams's career faded after the 1950s as his own drug and alcohol problems intensified. He choked to death at a New York City hotel in 1983 after accidentally swallowing a bottle cap.

ADDITIONAL FACTS

1. *Williams won two Pulitzer Prizes—one for* A Streetcar Named Desire *(1948) and the second for* Cat on a Hot Tin Roof *(1955).*

2. *The publication of Williams's revealing memoirs in 1972 caused a minor sensation; a crowd at a book-signing event in Manhattan grew so large it was dubbed the Great Fifth Avenue Bookstore Riot.*

3. *Williams was featured on a US postage stamp in 1994.*

✦✦✦

Che Guevara

The man whose face launched a million T-shirts, South American revolutionary Ernesto "Che" Guevara (1928–1967) emerged as one of the twentieth century's most recognizable icons of left-wing rebellion. Guevara, originally trained as a doctor, fought in revolutions in Cuba and the Congo and was killed while leading a guerrilla insurgency in Bolivia.

Since his death in the jungle, the mythology surrounding Guevara has only grown, and he is still revered by some segments of the Latin American left. But his critics charge that Guevara was a misguided romantic who was implicated in hundreds of political executions and human rights abuses.

Born to an affluent family in Argentina, Guevara experienced a political awakening in medical school, when he took a motorcycle tour through South America and witnessed the rampant poverty across the continent. Like many South Americans, he blamed the region's woes on American economic hegemony and embraced Communism as a solution.

Guevara was an early backer of the Cuban revolutionary Fidel Castro (1926–), joining Castro's guerrilla insurgency in 1956. When Castro finally drove out American-backed dictator Fulgencio Batista (1901–1973), Guevara was elevated to a senior position in the new revolutionary government, giving him international stature. He also personally ordered the executions of hundreds of political prisoners without trials in 1959—foreshadowing his own demise.

In the 1960s, at Guevara's urging, the Castro government sought to export its revolution to other parts of the developing world. Guevara traveled to the Congo to organize a revolution there, but returned to Cuba after its failure. His next assignment was to Bolivia, where he targeted the ruling military junta.

But the Bolivian military, with assistance from the CIA, was ready for Guevara and hunted down his guerrilla force in 1967. He was captured and shot by troops, who tried to make it look as if he had been killed in battle. Hailed as a revolutionary martyr and romantic, Guevara remains a hero in Cuba and parts of South America and a fashion statement throughout the rest.

ADDITIONAL FACTS

1. *His last words, supposedly, were "Shoot, coward, you're only going to kill a man."*

2. *A movie based on Guevara's memoir,* The Motorcycle Diaries, *was released in 2004, starring the Mexican actor Gael García Bernal (1978–) as the young guerrilla leader.*

3. *After Guevara's execution, his burial site was kept secret by the Bolivian government. The grave was rediscovered in the 1990s, and his remains were transferred to Cuba for reburial in 1997.*

❖ ❖ ❖

Haile Selassie

Haile Selassie (1892–1975) was the last emperor of Ethiopia, a symbol of resistance to European colonialism, and a respected global statesman. But to a group of followers in Jamaica, Selassie was something far more than that: He was a living god.

The story of Selassie and the religious group he inspired, the Rastafarians, may be among the most unique in the history of religion. Selassie, a devout Ethiopian Orthodox Christian, rejected the notion that he had divine powers. Still, the Rastafarian movement grew during the emperor's lifetime and remains strong decades after his death.

Selassie was born in an Ethiopian village, took control of the country after a coup in 1916, and was formally crowned its leader in 1930. According to legend, the ancient monarchy's lineage traced back 3,000 years to the biblical Queen of Sheba and King Solomon. Ethiopia was one of the few African countries that had never fallen victim to European conquest, a status Selassie—the 225th emperor in the line—struggled to maintain during his reign.

Ethiopia's independence made Selassie a hero to many blacks in North America, who looked back to Africa for inspirational examples of self-sufficiency. One of his admirers was the Jamaican-born activist Marcus Garvey (1887–1940), who embraced Selassie as a symbol of black liberation and self-reliance.

In 1936, in a conflict that made international headlines, Ethiopia was invaded by the Italian fascist government of Benito Mussolini (1883–1945). Selassie was forced out of the country, but became famous for his eloquent defense of his country's rights. ("It is us today. It will be you tomorrow," he warned the League of Nations.) During World War II, he marshaled opposition while in exile in London and returned home after his country was liberated in 1941.

By then, Selassie's followers in Jamaica had begun worshipping him, perceiving him as the black messiah and the second coming of Jesus Christ. They called themselves Rastafarians, taking the name from Selassie's name in Amharic. Selassie was alternately bemused and perplexed by the Rastafarians, and by the adoration he encountered whenever he traveled outside his country. But he also firmly rejected their theology, and Rastafarianism never took root in Ethiopia.

ADDITIONAL FACTS

1. *Selassie, who used the ceremonial title Conquering Lion of the Tribe of Judah because of his family's purported links to King Solomon, lived in regal settings at his three palaces. His entourage included trained dogs, cheetahs, and even a pride of lions that guarded his throne.*

2. *After returning from exile, twenty-three years later, Selassie abolished slavery in Ethiopia in 1964.*

3. *Selassie was deposed by army officers amid a devastating drought in 1974, and the Ethiopian monarchy was officially abolished the same year.*

✦✦✦

Harry Truman

Harry S. Truman (1884–1972), a virtually unknown politician from Missouri, was unexpectedly elevated to the presidency on April 12, 1945, upon the death of president Franklin D. Roosevelt (1882–1945). Truman took the oath of office at the White House that afternoon—and was soon grappling with some of the most daunting challenges ever faced by any American president.

"I felt like the moon, the stars, and all the planets had fallen on me," he later said in describing the shock of suddenly inheriting responsibility for a nation still fighting World War II.

When Truman took power, Germany was on the verge of defeat and much of Europe lay in ruins. Japan, however, was still fighting, and the Japanese leaders promised a long, bloody battle in the Pacific.

The man in the Oval Office had virtually no foreign policy experience; in Congress, he had been known for his investigations of crooked defense contractors. But the doctrines he implemented would guide American foreign policy for the next forty years.

In Europe, Truman committed to the Marshall Plan, a huge package of aid to rebuild the Continent's shattered economies. He included Germany in the plan, a conciliatory gesture toward the defeated adversary. In the Pacific theater, he authorized the use of the atomic bomb against Japan—a weapon he had not known existed until he became president. The two bombs, which were dropped in August 1945, killed hundreds of thousands of Japanese civilians, but brought the war to a speedy end. Domestically, Truman's accomplishments included an order in 1948 that integrated African Americans into the armed forces. He was reelected that year.

Truman's second term was dominated by the Korean War. Following through on his promise to stand against Communist expansion, he sent US troops to South Korea in 1950 to protect the country against invasion from the Communist north. The war initially went well, but bogged down after two years and became enormously unpopular. When Truman left office in 1953, he had the lowest popularity rating ever recorded.

He died two decades later, at age eighty-eight.

ADDITIONAL FACTS

1. *Truman was the last president who was not subject to the eight-year presidential term limit. The Twenty-Second Amendment to the Constitution, which set the limit, was ratified in 1951, and took effect with the presidency of Dwight D. Eisenhower (1890–1969).*

2. *After leaving the presidency, Truman was essentially penniless. His plight convinced Congress to provide ex-presidents with a pension, currently about $200,000 annually.*

3. *Truman served without a vice president for almost four years, until he selected Alben Barkley (1877–1956) as his running mate for the 1948 election.*

✦✦✦

Hannah Arendt

Hannah Arendt (1906–1975), a journalist, essayist, and political philosopher, is best known for grappling with the question that haunted the twentieth century: What explains the human capacity for evil?

In her widely read essays and books about Nazi war criminals, Arendt forcefully rejected the notion that genocidal violence and brutality were the products of only uniquely disturbed minds. Indeed, she noted, top Nazi and Communist leaders were often outwardly normal people.

Instead, Arendt blamed social forces within Germany and the Soviet Union that had led people to blindly follow mass opinion.

Arendt was born in Hanover, Germany, to Jewish parents. She majored in philosophy at the University of Heidelberg and received a doctorate at age twenty-two. She continued to teach and study philosophy in Germany; one of her friends was the philosopher Martin Heidegger (1889–1976), with whom she had a brief affair.

Adolf Hitler (1889–1945) came to power in 1933, prompting Arendt to flee the country. She ended up in Paris, where she spent six years working for relief organizations that helped Jewish orphans relocate to Palestine. After the Nazis invaded France in 1940, at the beginning of World War II, Arendt was forced to flee once more. She settled in New York City, where she would live for most of the rest of her life.

Arendt published her first major work, *The Origins of Totalitarianism*, in 1951. *The Human Condition* (1958), *On Revolution* (1962), and *Men in Dark Times* (1968) would follow.

Perhaps her most famous work, however, was *Eichmann in Jerusalem: A Report on the Banality of Evil* (1963), which she published after covering the trial of Nazi war criminal Adolf Eichmann (1906–1962) for the *New Yorker* magazine. The book explores how Eichmann—who emerged at his trial as a meek, pathetic man—could have masterminded the murders of millions in the Holocaust.

Made famous by her penetrating studies of evil and violence, Arendt obtained teaching positions at Cornell University, the University of Chicago, and other schools. In 1959, she became the first woman to be appointed a full professor at Princeton. She died in her apartment in New York at age sixty-nine.

ADDITIONAL FACTS

1. *In addition to her philosophy texts, Arendt wrote a 1958 biography of Rahel Varnhagen (1771–1833), a German intellectual who was at the center of many European scholarly circles during the Napoleonic era.*

2. *After moving to the United States in 1941, Arendt was naturalized as a US citizen in 1951.*

3. *Eichmann, who was convicted of crimes against humanity and hanged in 1962, was working at a Mercedes-Benz factory in Buenos Aires at the time of his capture. He remains the only person ever executed in Israel, which has no death penalty for conventional crimes.*

❖❖❖

Kurt Gödel

In the 1940s and 1950s, residents of Princeton, New Jersey, often reported seeing two unusual-looking men walking through the streets of their bucolic college town. The two men, usually deeply engaged in conversation in German, were a study in contrasts: The older, a sloppy dresser, rarely bothered to wear socks or cinch a belt around his paunchy belly, while his younger companion sported a fedora and a crisply tailored white linen suit on his rail-thin frame.

The older man was Albert Einstein (1879–1955), the most famous scientist in the world. His companion was Kurt Gödel (1906–1978), an eccentric mathematician whose breakthroughs in the theoretical underpinnings of mathematics, while less known to the public, may have rivaled the importance of those of his best friend.

Gödel was born in Brno, a city in what is now the Czech Republic. He attended university in Vienna, where he became a member of the city's thriving café culture of artists, philosophers, and scientists. There, he met a nightclub dancer, Adele Porkert (1899–1981); against his family's wishes, they married in 1938.

Austria was annexed to Nazi Germany in 1938. Faced with the threat of Gödel being drafted into Hitler's army, the couple fled in 1939, taking the Trans-Siberian Railway across Russia and then sailing across the Pacific to reach the United States.

Gödel was best known for his "incompleteness theorems," which proved that in any formal system of logic, there are some propositions that cannot be proved or disproved. The theorems dashed the hopes of many logicians for constructing a completely logical framework for the laws of math.

Einstein's death in 1955 was a severe blow to Gödel, who became increasingly unstable and paranoid. He became convinced that the refrigerator and radiators in his home were poisoning him, and he moved frequently. He also feared plots to poison his food and limited his diet to butter, baby food, and laxatives.

In 1977, Adele fell ill, leaving Gödel to fend for himself. Unwilling to eat food, he died of starvation at a Princeton hospital in January 1978. Gödel weighed sixty-five pounds at the time of his death; his death certificate listed his cause of death as "starvation and inanition, due to personality disorder."

ADDITIONAL FACTS

1. *According to biographer Rebecca Goldstein (1950–), Gödel was such an inquisitive child that his family gave him the nickname der Herr Warum—Mr. Why.*

2. *At Einstein's urging, Gödel decided to apply for US citizenship in April 1948. While studying for the citizenship exam, he became convinced that he had discovered a logical flaw in the Constitution that could allow a dictator to take power. He complained about the loophole to the judge in Trenton, New Jersey, who oversaw the test—but was granted citizenship anyway.*

3. *Gödel's favorite movie was reportedly Snow White and the Seven Dwarfs (1937). "Only fables," he said, "present the world as it should be and as if it had meaning."*

✦✦✦

Byron De La Beckwith

Byron De La Beckwith (1920–2001) wore a Confederate flag pin and a look of self-confidence to his trial. The Ku Klux Klan member had been tried twice before in Mississippi courtrooms for killing civil rights activist Medgar Evers (1925–1963). Both times, all-white juries had refused to convict him.

Martin Luther King Jr. (1929–1968) once said, "The arc of the moral universe is long, but it bends toward justice." The observation may never have been truer than in the case of Beckwith, a white supremacist fertilizer salesman who evaded justice for more than thirty years before his crimes finally caught up with him.

That morning in 1994, when a jury of eight blacks and four whites returned to the courtroom, Beckwith was found guilty and sentenced to life in prison. His conviction put an end to one of the last outstanding cases of the civil rights era and was seen as a sign of changing times in the South and across the United States.

"When it was over, every pore was wide open and the demons left. I was reborn when that jury said, 'Guilty!'" Evers's widow, Myrlie Evers (1933–), told the *New York Times* after the verdict.

Beckwith was born in California but moved to Mississippi as a child. He served in the Marines during World War II and joined the Klan after his return. Opposed to civil rights for blacks, immigrants, and Roman Catholics, the Klan remained a powerful force in the Deep South in the 1950s and '60s, exercising control over many local politicians and police forces.

Evers was an army veteran of World War II who was field secretary of the NAACP in Mississippi. He had received numerous death threats for his role in desegregating the University of Mississippi in 1962. Evers was returning home from an NAACP meeting on June 12, 1963, when Beckwith shot him in the back with a sniper rifle.

The evidence against Beckwith—his fingerprints were on the murder weapon—was substantial, and he was arrested within two weeks of the killing. But two policemen testified that they had seen him ninety miles away at the time of the shooting, and both of his trials ended in hung juries. (Years later, it emerged that his supporters may have tampered with the juries.)

When prosecutors put him on trial in 1994, several witnesses said they had heard Beckwith boasting about his role in the murder. He was convicted after six hours of deliberation. His appeals were unsuccessful, and he died in prison at age eighty.

ADDITIONAL FACTS

1. *The murder of Evers inspired the Bob Dylan song "Only a Pawn in Their Game" (1963).*

2. *Bobby DeLaughter (1954–), the Mississippi prosecutor who put Beckwith behind bars, later became a judge. DeLaughter himself went on trial in 2009 for allegedly taking bribes.*

3. *Evers's widow, Myrlie, served as chairwoman of the NAACP from 1995 to 1998.*

◆◆◆

Elizabeth Bishop

Elizabeth Bishop (1911–1979) published just more than ninety poems in her lifetime and was known to spend years writing and rewriting a single composition. Despite the relatively few works she completed, Bishop was a major influence in twentieth-century American poetry, a Pulitzer Prize winner, and poet laureate of the United States in 1949.

Bishop was especially popular among other poets, who appreciated the craftsmanship, complexity, and formal brilliance of her compositions. She was, joked the poet John Ashbery (1927–), a "writer's writer's writer."

Born in Massachusetts, Bishop had a lonely childhood after her father died and her mother was committed to an asylum. She was raised primarily by her grandparents and by an aunt. Bishop entered Vassar College in 1930, where she met the poet Marianne Moore (1887–1972), who would become a major influence on Bishop.

After college, Moore convinced Bishop not to enroll in medical school, as she had intended, and instead to travel and work on her poetry. She won a nationwide poetry contest sponsored by Houghton Mifflin in 1946, which led to the publication of her first book, *North and South,* the next year.

Bishop's poems are noted for their concise language, ironic humor, impersonal subject matter, and careful descriptions of nature. Unlike many of her contemporaries, Bishop was more interested in writing about trees, fish, and houses than about herself. In "At the Fishhouses," she describes a seal that appeared near the docks.

> *Then he would disappear, then suddenly emerge*
> *almost in the same spot, with a sort of shrug*
> *as if it were against his better judgment.*

In 1951, Bishop received a fellowship to travel to Brazil, where she lived for most of the next eighteen years. She fell in love with a Brazilian architect, Lota de Macedo Soares (1910–1967), learned Portuguese, and edited an anthology of Brazilian poetry.

She lived for most of her life off her inheritance from her father, but returned to the United States in 1970 to teach at Harvard. Her last collection, *Geography III,* was published in 1976. She died three years later in Boston, at age sixty-eight.

ADDITIONAL FACTS

1. *Bishop was five years old the final time she saw her mother, Gertrude. Bishop's prose narrative "In the Village" recounts her mother's breakdown and confinement to a mental hospital in Dartmouth, Nova Scotia.*

2. *Bishop planned to spend only a few months in Brazil. However, her departure was delayed after she had a severe allergic reaction to a cashew. She met Soares during her recovery and decided to stay.*

3. *Bishop's epitaph was selected from one of her poems, "The Bight": "All the untidy activity continues, / awful but cheerful."*

◆◆◆

César Chávez

A union organizer and civil rights activist, César Chávez (1927–1993) drew widespread attention to the plight of migrant farmworkers in the 1960s and 1970s with high-profile hunger strikes and boycotts. The union he founded, the United Farm Workers (UFW), eventually forced growers to pay higher wages and stop exposing their predominantly Mexican American workforce to harmful pesticides.

Chávez was born in Arizona and began working on farms as a teenager. He joined the US Navy after World War II and became involved in community organizing efforts after his return in 1948. He spent the 1950s leading voter registration drives in California and cofounded the National Farm Workers Association, a predecessor of the UFW, in 1962.

Unfolding at the same time as the civil rights movement in the South, Chávez's UFW campaign was a social movement as much as an economic one. In addition to raising wages and improving safety, Chávez sought to restore the basic dignity of Chicano farmworkers, who had been subjected to decades of mistreatment by farm and orchard bosses.

The grape boycott, Chávez's most famous campaign, began in 1965. Urging consumers to avoid California grapes until growers recognized the union, he attracted high-profile support from such politicians as Robert F. Kennedy (1925–1968). With the boycott hurting their profits, the first group of growers signed a union contract in 1970.

By the early 1980s, however, many growers had found ways to avoid the union, and Chávez's autocratic leadership of the UFW came under criticism. Despite its fame, the union never managed to organize all of California's farmworkers—most of whom are still nonunion.

Still, since his death in 1993 at age sixty-six, Chávez has been embraced as a civil rights hero in the Mexican American community. His birthday, March 31, is a holiday in several states.

ADDITIONAL FACTS

1. *In 1995, the* Los Angeles Times *revealed that FBI agents had compiled a 1,434-page file on Chávez, apparently out of fear that he was a "subversive."*

2. *One of Chávez's best-known slogans, "Sí, se puede"—"Yes, we can"—was adopted by Democratic presidential candidate Barack Obama (1961–) in the 2008 presidential election.*

3. *Chávez reportedly attended thirty-eight different schools before dropping out after eighth grade.*

◆◆◆

L. Ron Hubbard

L. Ron Hubbard (1911–1986), the founder of the Church of Scientology, was born in Tilden, Nebraska, and raised in several different cities in the western United States. After dropping out of George Washington University in the 1930s, he began his career as a moderately successful science fiction novelist and pulp fiction writer.

After serving in the US Navy during World War II, in 1950 Hubbard published *Dianetics,* a purported self-help guide for better mental health. Although dismissed as quackery by psychiatrists, Hubbard's book, full of scientific-sounding terms and recommendations, sold well.

Capitalizing on the success of *Dianetics,* Hubbard founded Scientology in 1954. Initially, the group operated as a counseling service that charged, in some cases, hundreds of dollars an hour to "audit" the mental health of patients; Hubbard would eventually earn millions of dollars from these revenues and sales of his books.

Widely condemned by psychiatrists, however, and under investigation for tax violations, Hubbard declared Scientology a religion (religions are exempt from taxation). In 1967, hoping to avoid numerous investigations into the group in several countries, Hubbard moved to a yacht called the *Apollo* that had been converted from a cattle ferry, and announced his intention to live in international waters.

In 1975, after several years on the high seas, Hubbard returned to the United States. Three years later, Hubbard's offices were raided, and his third wife, Mary Sue Hubbard (1931–2002), was imprisoned for her role in a plot to wiretap law enforcement agencies. Hubbard spent the last years of his life in seclusion at an isolated ranch near San Luis Obispo, California.

Hubbard remains a polarizing figure. To his many critics, Hubbard was a charlatan who profited from the gullibility of his followers. But to the upwards of 700,000 Scientologists—including many Hollywood celebrities—he is a spiritual guide whose writings have changed their lives.

ADDITIONAL FACTS

1. *There is no god or afterlife in Scientology's theology. Instead, Hubbard taught that every individual contains an undying soul, or thetan, that is reincarnated after death. But the thetans were damaged by an evil intergalactic tyrant named Xenu who set off hydrogen bombs on the earth about 75 million years ago, Hubbard said, which is why Dianetics is needed to repair damaged souls.*

2. *In much of Europe, Scientology is regarded as a cult. In Germany, especially, the group is seen as a threat to the state so serious that it is analogous to Islamic extremism.*

3. *Hubbard also wrote under a variety of pseudonyms, including Winchester Remington Colt and Rene LaFayette.*

◆◆◆

Konrad Adenauer

Konrad Adenauer (1876–1967) was the first chancellor of West Germany after World War II. He served for fourteen years and was generally praised for his efforts to rebuild the German economy and restore his country's international reputation after the horrors of the Holocaust.

However, Adenauer also attracted critics who believed that in his rush to move Germany past the traumas of war, he had allowed some former Nazis to escape punishment and had prevented the German people from fully confronting the crimes of the Hitler years.

Adenauer was born in Cologne, Germany, and was elected the city's mayor in 1917. In 1933, he lost his office and was forced into hiding for refusing to fly the Nazi flag from civic buildings. He was arrested twice and spent several years in hiding.

After the war, the US Army reinstalled Adenauer as mayor of Cologne. As one of the few German politicians untainted by Nazism, he helped found a new postwar political party, the Christian Democratic Union (CDU), and was named the party's leader in 1946. After the division of Germany into East and West, the CDU won the first West German elections in 1949, and Adenauer, at age seventy-three, became chancellor.

In that post, Adenauer steered West Germany into the North Atlantic Treaty Organization, reached an agreement to pay reparations to Israel for the Holocaust, and rebuilt the military. He also negotiated with the Soviet Union for the release of the last German prisoners of war who were still imprisoned in Russia.

More controversially, Adenauer also rehabilitated thousands of former Nazis and elevated many to senior government positions. By 1958, virtually all the German war criminals had been given pardons and released from prison.

Adenauer resigned in 1963 and died four years later. By the time of his death, a rising generation of young Germans had come to regard him as a symbol of conservatism and to agitate for a more honest reckoning with the country's war guilt.

ADDITIONAL FACTS

1. *Adenauer was an admirer of President Harry S. Truman (1884–1972) and told an interviewer in 1964 that he always kept a copy of Truman's memoirs on his coffee table.*

2. Time *magazine named Adenauer its man of the year in 1953 for guiding "the hated land of the Hun and the Nazi back to moral respectability."*

3. *Adenauer was arrested by the Gestapo in 1944 as a suspect in a plot to kill Hitler. However, there was no evidence tying him to the conspiracy, and he was released a few months later.*

◆◆◆

Isaiah Berlin

When the prime minister of the United Kingdom nominated Isaiah Berlin (1909–1997) for knighthood in 1957, he joked that the citation ought to recognize Berlin for his greatest skill: "talking." The philosopher, writer, and diplomat may have been the most prolific public intellectual of twentieth-century Britain, writing and lecturing on a stunning variety of topics.

Perhaps Berlin's most famous accomplishment, however, was his trenchant criticism of Communism. A native of Russia, he wrote penetrating criticisms of the utopian mind-set that had convinced many of his countrymen that any crime was justified in order to build their vision of a perfect society.

Berlin's fascination with Communism stemmed from his family's own troubled history. He was born in the then-Russian province of Latvia, the son of a timber merchant who was forced to flee after the Communist revolution in 1917.

After the family moved to England in 1921, Berlin was educated at Oxford. He would be affiliated with the university in some fashion for the rest of his life, taking his first teaching post there in 1932. During World War II, Berlin was dispatched to the United States and later to the British embassy in Moscow. During his tenure in the Soviet Union, friendships he cultivated with Russian writers and dissidents confirmed his dislike of Communism.

Berlin's political philosophy—expressed in his 1959 essay "Two Concepts of Liberty"—took aim at utopian political movements like Communism that sought to reshape human society. In the essay, he introduced the notions of "negative" liberty and "positive" liberty. A negative liberty is freedom *from* something—such as the freedom from giving self-incriminating testimony that is guaranteed by the US Bill of Rights. Positive liberty involves a guarantee of certain rights—such as the freedom to vote or the freedom to make a living. To Berlin, positive liberties carry the risk of totalitarianism, because they require government action and perhaps coercion in order to be realized. Utopian political projects that seek to guarantee positive liberties, he wrote, "can prove literally fatal" because supporters come to believe that their idealistic ends justify even the most oppressive means. In place of utopianism, he advocated a moderate liberalism that recognized human differences and did not attempt to coerce citizens into utopian schemes they might not support.

He died of a heart attack in Oxford at age eighty-eight.

ADDITIONAL FACTS

1. *Early in Berlin's career, he applied for a job at a British newspaper, the* Guardian. *The editor rejected him, explaining that he wasn't a good enough writer.*

2. *During World War II, Berlin was stationed at the British embassy in Washington, where he wrote a weekly memo to prime minister Winston Churchill (1874–1965) summarizing American news.*

3. *In addition to his lifelong association with Oxford University, Berlin taught in the United States at Harvard, Princeton, Bryn Mawr College, and the University of Chicago.*

✦✦✦

Alan Turing

In 1945, mathematician Alan Turing (1912–1954) was honored by the British government as one of the heroes of the Allied victory in World War II. But less than ten years later, he was driven to suicide after the same government arrested, prosecuted, and humiliated him because of his homosexuality.

Turing's suicide at his home in Manchester, England, made him an early martyr in the gay rights movement. It also deprived the world of a brilliant mind that helped invent and build the world's first computers and cracked the secret codes used by the German military.

Born in London, Turing attended a top English boarding school, where he became aware of his homosexuality. He went on to study math at King's College at Cambridge University. He graduated in 1934.

Turing's first major paper, "On Computable Numbers," was published in 1936, when he was only twenty-four. In the paper, Turing introduced the concept of a "universal machine" that could perform any task. At the time, Turing intended the idea to be a purely theoretical exercise, but it would soon form the basis of computer science.

On September 4, 1939, the day after Great Britain declared war on Germany, Turing reported for duty at Bletchley Park, a top-secret military installation. Over the next five years, the team of mathematicians at Bletchley Park devised a method of deciphering the Nazi "Enigma" code, a discovery that allowed the Allies to read German military communications—giving them a huge battlefield advantage.

After the war, Turing continued his research on computers and helped build the Manchester Mark I, one of the world's first working computers. He also devised the world's first computer chess program—even before a computer existed to run it.

Turing's arrest on "gross indecency" charges came in 1952. He narrowly avoided prison but was forced to undergo medical treatments to "cure" his homosexuality, including injections of estrogen. He died at age forty-one after eating an apple laced with cyanide; the death was ruled a suicide, although some skeptics, especially his mother, believe the death may have been accidental or even a murder made to look like a suicide.

The British government formally apologized for its treatment of Turing in 2009.

ADDITIONAL FACTS

1. *An international prize for contributions to computer technology, the A. M. Turing Award, was named after the mathematician in 1966.*

2. *Turing's hobbies included long-distance running; he once clocked two hours, forty-six minutes, and three seconds in a marathon (26.2 miles) and nearly qualified for the British Olympic team in 1948.*

3. *The Station X decryption facility at Bletchley Park remained a state secret for decades after World War II. The British government only disclosed its existence to the public in the 1970s—finally allowing the scientists who worked there to win recognition for their contributions to the war effort.*

◆◆◆

E. Howard Hunt

One of the central figures in the Watergate conspiracy, E. Howard Hunt (1918–2007) was the White House operative who organized the failed break-in at Democratic Party headquarters in 1972. The arrest of the burglars, and the discovery of their connection to Hunt, set in motion a chain of events that ended with the resignation of President Richard M. Nixon (1913–1994) in 1974.

In the words of conservative writer William F. Buckley (1925–2008)—a friend of Hunt's—he was "more responsible than any single other human being for bringing about Nixon's resignation."

Everette Howard Hunt Jr. was born in upstate New York and educated at Brown University. He joined the navy in World War II and later served in the Office of Strategic Services, the predecessor of the CIA. He remained with the agency after the war and was one of the organizers of the CIA-backed coup against the democratically elected government of Guatemala in 1954.

Beginning in the 1940s, Hunt also published a string of spy thrillers under a variety of pseudonyms. Several of his early books received favorable reviews, and his short stories were published in *Cosmopolitan* and the *New Yorker*.

Fervently anti-Communist, Hunt participated in the planning of the Bay of Pigs invasion in 1961. After the failure of the invasion, he was sidelined at the CIA and became disillusioned with President John F. Kennedy (1917–1963) for not pursuing regime change in Cuba more aggressively. Hunt resigned from the agency in 1970.

The next year, he was hired as a "security consultant" by the Nixon White House and paid $100 a day to conduct spy operations against Nixon's political enemies. As the 1972 election neared, Hunt hired five men to break into the Watergate complex to plant wiretaps on the Democratic Party's phone system. When the burglars were caught, one of them was carrying an address book with Hunt's name in it.

For his role in the burglary, Hunt eventually served thirty-three months in prison. After his release, he continued to write spy thrillers and defend his actions in Watergate; his only regret, he said, was the failure of the Bay of Pigs invasion.

Hunt died in Miami at age eighty-eight.

ADDITIONAL FACTS

1. *Hunt published more than eighty novels under a variety of pseudonyms, including Gordon Davis, John Baxter, and David St. John.*

2. *One of the burglars who carried out the Watergate break-in was Frank Sturgis (1924–1993), a former anti-Castro operative. The main character of one of Hunt's most successful books, Bimini Run (1949), had almost the same name.*

3. *Although no connection has ever been proven, Hunt figures in many conspiracy theories regarding the Kennedy assassination. He sued a tabloid in 1985 for suggesting that he played a role in Kennedy's killing. A jury ruled against him.*

◆◆◆

Naguib Mahfouz

In 1994, two knife-wielding Islamic extremists attacked an eighty-two-year-old man who was on his way to a café in Cairo. Police later linked the assassination attempt to the Egyptian terrorist group al-Jihad. The target of the attack, novelist Naguib Mahfouz (1911–2006), was stabbed in the neck and gravely wounded, but survived.

Frail and elderly by the time he was targeted for assassination, Mahfouz was one of the most prominent novelists and intellectuals of the Arab world and the winner of the Nobel Prize in Literature in 1988. He was also an outspoken liberal, secularist, and defender of free speech—stances that provoked the attack.

Mahfouz was born in Cairo and raised by strict Muslim parents. He studied philosophy at the University of Cairo, but gradually drifted away from his devout upbringing. He published his first novel, *Mockery of the Fates,* in 1939. The narrative was set in ancient Egypt, a period in history from which Mahfouz often drew inspiration.

After World War II, the settings of Mahfouz's books shifted to contemporary working-class Egypt. His Cairo Trilogy—*Palace Walk* (1956), *Palace of Desire* (1957), and *Sugar Street* (1957)—told the story of an Egyptian family, culminating with the revolution in 1952 that overthrew the country's monarchy. His 1959 book, *Children of Gebelawi,* was attacked by religious authorities; its allegedly blasphemous content would later be one of the motives given for the 1994 assassination attempt.

Mahfouz was a critic of Islamic extremism and was one of the few Arab intellectuals to back the 1978 peace accords between Egypt and Israel. Consequently, his books were banned across the Arab world. He created an even greater stir in 1989, just after winning the Nobel Prize, by defending novelist Salman Rushdie (1947–). Rushdie had been widely condemned in the Islamic world for allegedly insulting Islam in his novel *The Satanic Verses,* and the leader of Iran issued a fatwa calling for Rushdie to be killed.

The attack on Mahfouz in 1994 left him with serious health problems for the rest of his life and made it difficult for him to grip a pencil with his writing hand. He died in Cairo at age ninety-four.

ADDITIONAL FACTS

1. *Mahfouz worked in several government jobs to supplement the meager income he earned from his books. In the 1960s and early '70s, he worked in the Egyptian office responsible for censoring movies, a role that has been condemned by some of his critics.*

2. *Unhappy with much of his early writing, Mahfouz destroyed about fifty of his short stories in the 1930s. He still managed to publish thirteen short story collections and thirty screenplays, in addition to his thirty-three novels.*

3. *Mahfouz left Egypt only three times in his life and did not travel to Stockholm to collect the Nobel Prize. His daughters accepted the honor in his place.*

✦✦✦

Huey Newton

To his critics, Black Panther leader Huey P. Newton (1942–1989) was a street thug, extremist, and murderer. He spent two years in prison for shooting a California police officer, returned to jail on gun charges in 1987, and was eventually killed by a drug dealer.

But to his admirers, Newton and the Panthers were defenders of black America against white brutality and icons of African American self-reliance. To many, Newton embodied the ethos of black power and racial pride that swept across the United States in the late 1960s.

Born in Louisiana and named after governor Huey Long (1893–1935), Newton moved with his family to Oakland, California, when he was a child. He spent much of his childhood getting into trouble, and he was arrested for the first time on gun charges when he was fourteen. By Newton's own account, he was illiterate when he graduated from high school.

Determined to learn to read, he started with Plato's *Republic* and later recounted that he read it five times before it began to make any sense. Reading the book was a turning point in his life, he said, and the beginning of his political consciousness.

Gravitating to the Bay Area's black radical community, Newton, along with Bobby Seale (1936–), founded the Black Panthers in 1966. Newton was named the group's "minister of defense." The Panthers organized armed patrols of the slums, ostensibly to fight police brutality, but also opened free breakfast programs and health clinics for the poor, attracting thousands of members in cities across the United States.

Newton was arrested in 1967 for murdering a police officer, John Frey, but was released in 1970 after a judge overturned the verdict. The Panther membership had declined significantly in Newton's absence. He was arrested again in 1974, but fled to Cuba before he could face charges of murdering a prostitute. (He returned in 1977 and was acquitted.)

By the end of the 1970s, the Panthers had mostly disbanded. Newton enrolled in graduate school and earned a doctoral degree for a dissertation about the Panthers. He spent the last decade of his life battling addictions to heroin and cocaine, and he was shot in 1989 by an Oakland drug dealer.

ADDITIONAL FACTS

1. *Director Spike Lee (1957–) in 2001 made a documentary about Newton's life entitled* A Huey P. Newton Story. *The movie starred Roger Guenveur Smith (1959–) in the title role.*

2. *Despite his pledge to become a militant senior citizen, the other founder of the Panthers, Bobby Seale, has mellowed considerably with age. He currently works at Temple University in Philadelphia as a community liasion and formerly was a celebrity endorser for Ben and Jerry's ice cream.*

3. *After years of battling his addictions, Newton checked into rehab in 1984. The treatment, paid for by comedian Richard Pryor (1940–2005), helped him stay sober briefly, but he was later arrested again for possession of drug paraphernalia.*

◆◆◆

Maharishi Mahesh Yogi

In 1968, the Beatles were at the peak of their fame, enjoying the mammoth international success of the hit album *Sgt. Pepper's Lonely Hearts Club Band* (1967). But that spring, the four members of the group stunned the world by announcing that instead of recording another album, they would fly to India to study transcendental meditation at a secluded mountain retreat.

Their guru in India was Maharishi Mahesh Yogi (1917–2008), a well-known Hindu sage who popularized transcendental meditation and toured the world for five decades touting its benefits. Part spiritual guide, part celebrity—and, to critics, part huckster—the Maharishi was, for a brief period, one of the world's best-known mystics.

Boosted by his association with the Beatles, the Maharishi's list of followers would eventually included an impressive roster of famous musicians, artists, and politicians, including Beach Boys singer Mike Love (1941–) and director David Lynch (1946–).

Mahesh earned a physics degree before going to work as a secretary to a Hindu holy man. After his mentor died in 1953, Mahesh moved to the Himalayas, where he developed his meditation technique and founded an ashram, or religious retreat.

The technique, which Mahesh began promoting in 1955, is intended to eliminate stress, improve health, and help the user achieve inner fulfillment through silent meditation and the repetition of sacred mantras. Until his death in the Netherlands at age ninety-one, Mahesh—always wearing a white robe and garlands of flowers—was the movement's leader and chief spokesman.

The Beatles stayed at the Himalayan ashram for about two months and composed many of the songs that later appeared on *The Beatles* (also known as the White Album) while there. But singer John Lennon (1940–1980) became disillusioned with the Maharishi, and the group's infatuation with the guru ended a few months later.

ADDITIONAL FACTS

1. *The 1968 Beatles song "Sexy Sadie" was originally a satire called "Maharishi" that Lennon wrote after he grew disillusioned with the guru.*

2. *The Maharishi's top representative in the United States was Harvard-educated physicist John Hagelin (1954–), who ran for president three times on a platform of solving national and international problems through transcendental meditation.*

3. *Maharishi Vedic City was established in 2001 just outside Fairfield, Iowa. In accordance with the guru's teachings, all buildings in the city face east, Sanskrit is the town's preferred language, and nonorganic food is banned within the city limits.*

✦✦✦

Golda Meir

The first woman prime minister anywhere in the Western world, Golda Meir (1898–1978) was the leader of Israel from 1969 until 1974. Her tenure spanned a difficult time for her country, a period that included the massacre of Israeli athletes at the Munich Olympic Games in 1972 and the Yom Kippur War of 1973.

To allies and enemies alike, Meir was known for her firm, no-nonsense personal style; wry sense of humor; and deep, abiding passion for the Zionist project—a conviction demonstrated over a lifetime of working to establish a Jewish homeland and then to protect its fragile independence.

Meir was born in Ukraine, then part of czarist Russia, and immigrated to the United States in 1906 to escape poverty and anti-Semitism. Her family settled in Milwaukee, where she learned English and helped her parents run a grocery store. She joined a Zionist youth organization in high school and moved to Palestine in 1921.

After moving to Palestine, Meir lived on a collective farm for several years and then became a political official at a labor council. She was a prominent fund-raiser for various Zionist causes, touring Europe and the United States to raise money for Jewish settlers. World War II and the Holocaust added new impetus to the calls for a Jewish state, and Israel declared its independence in 1948. Meir was among the twenty-five signers of the Israeli Declaration of Independence and was issued the new nation's first passport.

Meir served as foreign minister from 1956 to 1966. She became secretary of the Mapai Party and then in 1969 went on to replace prime minister Levi Eshkol (1895–1969), who had died in office.

Meir's premiership was dominated by conflict with Israel's Arab neighbors and by the attack on Israel's Olympic athletes by the Black September Palestinian terrorist group. Meir's role in the Yom Kippur War has been criticized; Israel was caught off-guard by the Arab attack, but still managed to fight off the combined force of the Egyptian and Syrian armies within three weeks.

The next year, amidst questions about her performance in the war, Meir retired again. She died four years later, at age eighty.

ADDITIONAL FACTS

1. *Meir was named the first Israeli ambassador to the Soviet Union.*

2. *A play about Meir's life—*Golda, *with Anne Bancroft (1931–2005) in the title role—debuted on Broadway in 1977.*

3. *Meir was played by Lynn Cohen in* Munich, *a 2005 movie directed by Steven Spielberg (1946–) about the Israeli retribution for the Munich killings.*

Michel Foucault

Michel Foucault (1926–1984) described himself as a historian, not a philosopher. But the French author's books and lectures on prisons, insanity, and sexuality helped spur a revolution in philosophy that has inspired a generation of postmodern writers, historians, and theorists.

Indeed, Foucault—instantly recognizable for his shaved head and black wardrobe—was an academic star in both Europe and the United States, acclaimed as "the most famous intellectual in the world" by the *New York Review of Books* after his death.

Foucault was born in Poitiers, a city in central France, and educated in philosophy at the École Normale Supérieure in Paris. He was deeply depressed for much of his adolescence, was hated by his peers, and once reportedly tried to kill another student with a dagger. His discovery while in college of the works of Friedrich Nietzsche (1844–1900) had a major impact on his thinking.

Foucault's doctoral dissertation, published in 1961 as *Madness and Civilization,* was a sensation in French academic circles and even became a popular bestseller. The book established many of the themes that preoccupied Foucault throughout his career, especially the relationship between social authorities and concepts of madness and criminality.

In the book—and in subsequent works, such as *Discipline and Punish* (1975)—Foucault argued that mental illness was a fiction that was intended to serve the social purpose of imprisoning and punishing nonconformists. He particularly opposed efforts to "cure" the mentally ill, which he viewed as even more oppressive than physical incarceration.

Foucault's personal life was occasionally erratic and, ultimately, tragic. Beginning in the 1970s, he made an annual trip to San Francisco to lecture in philosophy and to participate in orgies at the city's bathhouses. He presumably contracted HIV during one such encounter and became one of the first high-profile victims of the AIDS epidemic when he died at age fifty-seven.

Today, Foucault remains one of the most influential—and controversial—figures in contemporary academic discourse. His critics have dismissed his arguments as turgid and his periodization of the past as inaccurate. But to his supporters, Foucault exposed new and important ways of thinking about power and how it is deployed.

ADDITIONAL FACTS

1. *Foucault was a member of the Communist Party for three years in the early 1950s, but quit in disgust over Joseph Stalin (1879–1953) and later became a staunch anti-Communist.*

2. *In addition to France and the University of California at Berkeley, Foucault also held teaching positions in Sweden, Poland, Tunisia, and Germany.*

3. *At the time of his death, Foucault had written three volumes of his* History of Sexuality. *The fourth volume was nearly complete but cannot be published under the terms of Foucault's will.*

Linus Pauling

As a child, Linus Pauling (1901–1994) visited his grandparents most weekends at their home in Oswego, Oregon. During one such visit, he later recalled, Pauling discovered in the woods near their home an abandoned smelter that was stocked with bottles of sulfuric acid, hydrochloric acid, and other mysterious chemicals.

The thirteen-year-old Pauling was ecstatic and hauled the bottles back home aboard the trolley. "It was really great to get those chemicals," he later wrote. Back home, he used them for the first experiments in what would become one of the most fabled careers in American science.

A chemist, teacher, and antiwar activist, Pauling is the only individual to win two undivided Nobel Prizes. His first, in chemistry, was conferred in 1954. He also won a Nobel Peace Prize in 1962 in recognition of the campaigns he launched against nuclear weapons after World War II.

Pauling obtained his doctorate from the California Institute of Technology (Cal Tech) and spent the next several decades teaching at the school. His early research focused on the chemical bond, the force that holds molecules together. He also studied nucleic acids, narrowly losing to James D. Watson (1928–) and Francis Crick (1916–2004) in the race to discover DNA.

After 1950, Pauling devoted an increasing share of his time to political agitation, joining several antinuclear protests. He was accused of being anti-American, hauled before Congress, and forced to swear that he was not a Communist. Still, the United States denied him a passport in 1952.

Later in life, Pauling became obsessed with proving that vitamin C could cure serious diseases such as cancer. Although dismissed by the medical establishment, he wrote two books—*Vitamin C and the Common Cold* (1970) and *How to Live Longer and Feel Better* (1986)—that established his reputation as a health food guru to Americans who had never heard of his chemistry.

Although Pauling's claims about the benefits of vitamin C could never be verified, they seemed to work for him: He lived until the ripe age of ninety-three, dying at his ranch in Big Sur, California.

ADDITIONAL FACTS

1. *Pauling dropped out of high school because he didn't want to take a required American history course. His choice of college, Oregon Agricultural College, did not require a diploma at the time. His high school finally relented and granted Pauling an honorary degree in 1962—after he had won his second Nobel Prize.*

2. *As a nine-year-old, Pauling was such a voracious reader that his father wrote a letter to the* Portland Oregonian *asking for book recommendations for his son. "Please don't suggest the Bible and Darwin's* The Origin of Species," *the elder Pauling wrote, "because he's already read these books."*

3. *During World War II, Pauling volunteered his lab at Cal Tech for military research. He developed a meter to monitor the level of oxygen in submarines, a synthetic blood plasma for wounded soldiers, and a new explosive for the navy—which he called, with typical modesty, linusite.*

♦♦♦

John Gotti

Nicknamed the Dapper Don for his expensive suits, blow-dried hair, and monogrammed socks, John Gotti (1940–2002) was one of the most famous mafiosos of recent decades. As the head of New York's Gambino family, he presided over a vast criminal empire that included loan-sharking, car theft, and heroin smuggling. His conviction in 1992 and subsequent life imprisonment, represented a major victory for the government in its war on organized crime.

Gotti was, in many respects, an atypical mobster. Unlike publicity-shy gangsters of the past, he relished the spotlight. Gotti also condoned drug smuggling, which had been frowned upon by some of his predecessors. The one mob tradition he did understand, however, was violence: Gotti was convicted of thirteen gangland murders, and he may have ordered dozens more. He is also thought to have arranged the disappearance of one of his neighbors, who had accidentally struck and killed Gotti's twelve-year-old son, Frank, in 1980.

Gotti was born in the Bronx and later moved to Brooklyn, where he joined a local street gang. He became an associate in the Gambino family, one of New York's five mafia groups, in the early 1960s. He became a capo at some point in the late 1970s or early 1980s. Gotti organized the killing of the Gambino boss, Paul Castellano (1915–1985), outside a steakhouse in Manhattan and took over the gang in 1985.

As boss, Gotti controlled a total of 300 "made" members. The gang generated hundreds of millions of dollars in revenue, a portion of which went to Gotti. (For tax purposes, however, he claimed to be a plumbing supply salesman from Queens.)

Gotti beat two federal indictments, earning him the nickname the Teflon Don. He was finally brought down by a turncoat, Sammy "the Bull" Gravano (1945–), who agreed to testify against him in exchange for a reduced sentence for his own role in the murders. Gotti was sentenced to life imprisonment and died in jail at age sixty-one. His son, John A. Gotti (1964–), succeeded him as Gambino boss until he too went to prison in 1999.

ADDITIONAL FACTS

1. *Gotti was an enthusiastic gambler who once reportedly lost $60,000 in a single dice game.*

2. *Gravano, whose testimony against Gotti helped put his former boss behind bars, was placed in the federal witness protection program and relocated to Arizona. He returned to a life of crime, however, and was imprisoned in 2002 for running an Ecstasy ring in Phoenix.*

3. *Gotti's defense lawyer in the early 1970s was Roy M. Cohn (1927–1986)—who was already nationally famous for his work as chief counsel to Senator Joseph McCarthy (1908–1957) in the 1950s.*

◆◆◆

John Lennon

A cultural icon for the baby-boomer generation, John Lennon (1940–1980) was the rhythm guitarist for the Beatles and the cowriter, along with Paul McCartney (1942–), of many of the most memorable and influential pop hits of the twentieth century. Later in his career, Lennon also became a prominent peace activist whose songs captured both the rage against the Vietnam War and the hope for a more peaceful world that animated the international protest movement of the 1960s and '70s.

Like the other members of the Beatles, Lennon was born in Liverpool, England. His mother bought him his first guitar in 1957, and he met the fifteen-year-old McCartney at a concert the same year, thus beginning a long and complicated friendship.

After struggling to win a recording contract, the Beatles released their first hit, "Love Me Do," in 1962. Inspired by American rhythm and blues music, the record was a huge hit: By 1963, Beatlemania had swept across Britain. In early 1964, after their triumphant arrival at John F. Kennedy International Airport in New York City, the quartet topped the charts in the United States.

Lennon and McCartney shared writing credits for most of the Beatles' hits, but in practice often wrote separately. Lennon's best-known contributions to the partnership included "Help!" (1965), "All You Need Is Love" (1967), and "Come Together" (1969).

The Beatles broke up amidst personal and financial disputes in 1970. Lennon and his wife, Yoko Ono (1933–), moved to New York City in 1971, where he would make his home for the rest of his life. His antiwar single "Give Peace a Chance" (1969) and utopian hymn "Imagine" (1971) represented a departure from the relatively apolitical songs of the Beatles; both became anthems of the protest movement.

In 1980, just after releasing the album *Double Fantasy,* Lennon was shot and killed by a deranged fan, Mark David Chapman (1955–), on the street in front of Lennon's apartment. He was forty at the time of his death.

ADDITIONAL FACTS

1. *A Broadway musical about Lennon's life,* Lennon, *premiered in 2005 but closed after only forty-nine performances.*

2. *In 2007, a lock of Lennon's hair was sold for $48,000 at a Beatles memorabilia auction in Worthing, England. Sunglasses frames he wore during a tour of Japan in 1966 sold for $1.5 million.*

3. *Chapman was sentenced to twenty years to life and imprisoned at New York's Attica State Prison. State parole authorities have rejected his requests for parole five times as of 2008.*

◆◆◆

Desmond Tutu

A leading opponent of South African apartheid, Archbishop Desmond Tutu (1931–) gained fame in the 1970s and 1980s for organizing a wave of nonviolent resistance to his nation's racist government. In part as a result of his work, South Africa finally abolished apartheid in 1991 and held its first democratic, multi-racial elections in 1994.

Tutu, an ordained Anglican minister, emerged from the apartheid struggle one of the world's most respected human rights advocates. He won the Nobel Peace Prize in 1984, chaired South Africa's Truth and Reconciliation Commission, and remains an influential figure in African and global politics.

Born in Transvaal, South Africa, Tutu worked as a high school teacher before entering the ministry in 1958. At the time, the country's racial codes made it difficult for blacks to pursue most professions. Following his ordination, he studied and worked in England, returning to South Africa in 1967.

As a black minister with a mostly white congregation, Tutu had a unique place in the struggle against apartheid. Unlike other anti-apartheid leaders, such as Nelson Mandela (1918–), Tutu never spent time in prison and never endorsed violence. Instead, he called upon the world to halt investment in South Africa, a strategy that put enormous economic pressure on the apartheid government.

Tutu was elevated to bishop of Lesotho in 1976 and became the archbishop of Cape Town in 1986—the first black to lead South Africa's Anglican Church.

After the end of apartheid in 1991, Tutu was named to head the Truth and Reconciliation Commission, which investigated human rights abuses during the apartheid era. He retired as archbishop in 1996. He left South Africa after being diagnosed with cancer and was successfully treated in the United States. In 2000, he founded the Desmond Tutu Peace Foundation, which is committed to giving a voice to marginalized people who seek to speak their truth in the name of social justice.

ADDITIONAL FACTS

1. *A critic of American foreign policy, Tutu appeared in an off-Broadway play in New York in 2004, Honor Bound to Defend Freedom, in which he played the part of a judge who questioned the legal justification for holding terrorism suspects at the US prison camp at Guantánamo Bay.*

2. *Tutu invented the term* rainbow nation *for multiracial South Africa. South Africans, in turn, invented the nickname "the Arch" for Tutu, who officially holds the title archbishop emeritus.*

3. *Tutu has held several academic posts, including that of visiting professor at Emory University in Atlanta and chancellor of the University of the Western Cape in Bellville, South Africa.*

◆◆◆

The Dalai Lama

In 1935, a baby named Lhamo Thondup was born in western China. The fifth of seven children, he lived the first three years of his life in an isolated hilltop farming village, where his parents grew potatoes.

Meanwhile, hundreds of miles to the south, a group of Buddhist monks assembled at a palace in Lhasa to begin the search for a new leader for the ancient mountain kingdom of Tibet. The previous leader, Thupten Gyatso (1876–1933), had died after a thirty-eight-year reign, leaving the position of Dalai Lama vacant.

According to tradition, Tibet's ruler was no ordinary man: He was, instead, the living incarnation of a Buddhist sage born in 1391. Thupten had been the thirteenth reincarnation. The fourteenth was somewhere in Tibet, the monks believed—they just needed to find him.

Following a series of omens, the monks eventually arrived at the doorstep of the potato farmer and declared that his toddler was the new Dalai Lama, setting the peasant child on a course that would make him one of the most famous spiritual and political leaders of the twentieth century. The child was taken from his village to the Tibetan capital, where he studied Buddhism and was trained to rule the country. He was officially enthroned in 1950, at age fifteen.

Only a month later, Chinese troops invaded Tibet. China's Communist leaders considered Tibet a historical part of China and rejected the young Dalai Lama as a superstitious anachronism. Initially, the young Dalai Lama tried to accommodate the Chinese, bowing to their demands while maintaining the region's distinct Buddhist culture. However, he joined a failed effort to drive out the Chinese in 1959 and was then forced into exile in India, where he remains today.

Since then, the Dalai Lama has proved a constant thorn in China's side, and he has toured the world rallying support for the cause of restoring Tibet's autonomy. He was awarded a Nobel Peace Prize for his efforts in 1989 and given a Congressional Gold Medal by the US Congress in 2007. Recently, he condemned China's crackdown in Tibet following unrest there in March 2008.

ADDITIONAL FACTS

1. *In China, the Dalai Lama has a significantly less rosy reputation. Many Chinese see him as a dangerous separatist and tool of Western powers, pointing out that he accepted money from the CIA in the 1960s to train anti-Chinese fighters.*

2. *The Chinese government announced in 2007 that when the Dalai Lama dies, his replacement will have to be approved by Communist authorities. Many Tibetans have rejected the order, setting up a likely clash after the Dalai Lama's death.*

3. *Although he enjoyed near-total power in the old Tibetan theocracy, the Dalai Lama now says he does not favor restoring total independence under his rule and only seeks more cultural autonomy.*

◆◆◆

Augusto Pinochet

Military dictator Augusto Pinochet (1915–2006) became a worldwide symbol of political repression for his ironfisted rule over Chile in the 1970s and 1980s. Under the Pinochet regime, thousands of political opponents "disappeared," while countless others were tortured, imprisoned, or driven into exile.

Yet for most of his rule, Pinochet enjoyed the tacit support of Western governments—including that of the United States. Because he was fervently opposed to Communism, Pinochet was welcomed by Washington after he overthrew Chile's democratically elected government in 1973.

Even in Chile, Pinochet's legacy is seen as mixed. While his human rights abuses are widely decried, his supporters continue to point out that the economic growth that occurred under his dictatorship made Chile one of the most prosperous nations in South America. His death in 2006 provoked an outpouring of popular affection.

Pinochet graduated from a military academy in 1936. He rose steadily through the army ranks and was promoted to general in 1968. Two years later, a Socialist politician, Salvador Allende (1908–1973), was elected president of Chile. Allende quickly began a series of left-wing economic reforms. Allende, worried by rumors of an impending coup and believing that Pinochet would be a reliable officer, promoted him to commander of the army in August 1973. Less than a month later, however, Pinochet and other military leaders deposed Allende.

The number of "disappeared" during Pinochet's dictatorship has been estimated at about 3,000 people. Victims were sometimes snatched from their homes in the middle of the night, never to be heard from again. Pinochet also implemented a series of right-wing economic reforms. He restricted union activities, privatized state-owned industries, and lowered income taxes. Pinochet attributed Chile's economic growth in the 1980s—the "Miracle of Chile"—to these policies.

In 1988, Pinochet called for a referendum that he expected would give popular backing to his dictatorship. To his surprise, the junta lost the referendum. Pinochet remained a powerful force in Chilean politics in the 1990s, but he was arrested for murder in 1998 while visiting England. He was eventually returned to Chile, but the arrest emboldened his critics to seek charges against him for human rights violations. He was under house arrest for murder and kidnapping at the time of his death.

ADDITIONAL FACTS

1. *In 2004, investigators discovered that Pinochet had hidden about $28 million in bank accounts in the United States and other countries during his rule—puncturing his image of personal rectitude. His wife and five children were arrested for embezzlement in connection with the funds in 2007.*

2. *One of Pinochet's opponents, Chilean exile Orlando Letelier (1932–1976), was assassinated with a car bomb in Washington, DC. A Chilean general was convicted of the murder in 1993.*

3. *In 2006, a former political prisoner of the Pinochet regime, Michelle Bachelet (1951–), was elected president of Chile. Upon Pinochet's death, Bachelet refused to attend the ex-dictator's funeral.*

❖❖❖

Jacques Derrida

Born in the French colony of Algeria, Jacques Derrida (1930–2004) moved to Paris after World War II and was educated during the postwar renaissance of French philosophy. He is best known for creating "deconstruction," a method of analyzing texts that quickly gained a large following in literature, history, and political science departments in the United States and Europe.

To Derrida, written words very rarely meant what they seemed to. Instead, he argued, texts are full of hidden meanings, prejudices, and contradictions. To "deconstruct" a book or article, he taught in lectures crammed with his fans, was to unpack its web of concealed meanings.

Derrida graduated from the École Normale Supérieure in Paris in 1956, studied briefly in the United States, and published two influential essays in 1964 that established him as a major European philosopher. In 1967, he published three books within twelve months, *Writing and Difference, Speech and Phenomena,* and *Of Grammatology,* and coined the term *deconstruction.*

In his early career, Derrida was notable for his quirky personality (he refused to be photographed, and his lectures were often incomprehensible) and debonair appearance. Unlike many postwar French intellectuals, he avoided politics until later in life and never joined the French Communist Party.

Derrida's influence was particularly strong in the United States, where he was embraced by many self-proclaimed feminist, postcolonial, and postmodern theorists. To Derrida's supporters, deconstruction provided a powerful tool for discovering new meanings in old texts and exposing the racist or sexist assumptions inherent in traditional ideas. To critics, however, deconstruction was—and remains—controversial because it reduces time-honored philosophical and political texts to the status of literary metaphors.

By the end of his life, Derrida had mellowed, giving more interviews and allowing his picture to be taken. An academic star on both sides of the Atlantic, he taught courses at Johns Hopkins, Yale, the State University of New York at Buffalo, and the University of California at Irvine. Derrida died of pancreatic cancer in Paris at age seventy-four.

ADDITIONAL FACTS

1. *After Germany invaded France in 1940, at the beginning of World War II, the puppet Vichy regime installed by the Nazis passed a series of anti-Jewish laws in France. One of the laws capped Jewish enrollment in public schools; as a result, Derrida was expelled from his school at age twelve.*

2. *Although he was famous around the world by the 1970s, Derrida was never awarded his philosophy doctorate until 1980, when he was fifty years old.*

3. *In 1991, Derrida's lawyers blocked the release of a book that contained an interview in which Derrida seemed to defend the Nazi ties of German philosopher Martin Heidegger (1889–1976). Derrida maintained that the translation misstated his views, but critics accused him of censorship.*

✦✦✦

Jonas Salk

Before April 12, 1955, polio was one of the most feared diseases in the United States. The virus, which struck mostly infants, killed about 5 percent of its victims and left the rest with crippling, permanent paralysis in the arms or legs. In 1952, the worst year of the polio epidemic ever recorded, polio killed 3,000 children in the United States and crippled another 55,000.

But on that day, a New York City–born doctor, Jonas Salk (1914–1995), made front pages around the world with the announcement that he had invented a successful polio vaccine. The impact of the polio vaccine was enormous; by 1969, no deaths from the virus were reported anywhere in the United States—one of the greatest public health triumphs in medical history.

Salk was born into a poor immigrant family in the Bronx. His father, Daniel, was a garment worker, and Salk attended public schools. He received his medical degree in 1939 and spent World War II developing a flu vaccine for US troops.

After the war, Salk shifted his efforts to polio, directing a team of researchers at the University of Pittsburgh. Known for his intense and demanding personality, he raced against dozens of other scientists to complete his vaccine in 1954; it was tested for a year before the successful results were announced to the public.

Salk won immediate acclaim as a national hero, but his place within the scientific community has been more controversial. Critics accused Salk of taking too much credit for the work of others, especially the polio researcher John Enders (1897–1985), whose work was a critical component of Salk's vaccine. In part due to the controversy, Salk never achieved full recognition from the American scientific establishment. To overcome his ostracism from the medical community, he founded the Salk Institute for Biological Studies; "I couldn't possibly have become a member of this institute if I hadn't founded it myself," he joked.

Salk remained involved in medical research for the rest of his life; at the time of his death at age eighty, he was working on a vaccine for AIDS at the Salk Institute.

ADDITIONAL FACTS

1. *In 1970, after divorcing his first wife, Salk married Françoise Gilot (1921–)—who was already famous as the former mistress of painter Pablo Picasso (1881–1973).*

2. *In a sign of the urgent nature of the race to develop a polio vaccine, Salk was featured on the cover of* Time *magazine in 1954 under the headline "Is This the Year?"*

3. *Salk was so confident in his work that he inoculated himself and his three sons with the vaccine in 1952—three years before it had been proven effective in scientific studies.*

✦✦✦

The Unabomber

More than 500 FBI agents spent seventeen years searching for the Unabomber, the man responsible for sending a series of mail bombs between 1978 and 1995. But in the end, it was the bomber's brother who turned him in to authorities, ending one of the agency's most fascinating, and frustrating, investigations.

The bomber's name, it turned out, was Theodore Kaczynski (1942–), a brilliant but troubled mathematician who lived by himself in a tiny shack in the Montana woods. He had sent his bombs, addressed to university professors and airline executives, to protest computers and other forms of modern technology.

Kaczynski was born in Chicago, finished high school at age fifteen, and entered Harvard in 1958. After graduating with a degree in math, he got his doctoral degree from the University of Michigan, where he was hailed as a budding math genius. He taught for two years at the University of California at Berkeley before abruptly resigning. He built a tiny cabin near Lincoln, Montana, and moved there in 1971.

Over the next twenty years, Kaczynski sent more than a dozen bombs to science professors, airlines, and computer company employees. Three people—a computer store owner, an advertising executive, and a timber industry lobbyist—were killed. Other victims lost fingers or suffered other permanent injuries. The bombs were made from handcrafted parts that proved impossible for the FBI to trace; Kaczynski also had traveled by bus to distant cities to mail the bombs, further confusing investigators.

In 1995, Kaczynski mailed a lengthy article to authorities and demanded that it be printed in a major newspaper—or else he would continue to kill. The so-called Unabomber manifesto, a screed against modern technology, was published in the *New York Times* and the *Washington Post* in September of that year. Giving in to the bomber's demands was controversial, but authorities hoped that if they published the article, someone might recognize the Unabomber's writing style.

Someone did: Kaczynski's younger brother, David (1949–), a social worker in New York, contacted the FBI in 1996. The older Kaczynski was arrested with bomb-making materials at his shack on April 3, 1996, pleaded guilty in 1998 to avoid the death penalty, and is currently serving a life sentence.

ADDITIONAL FACTS

1. *Now a resident of the federal government's most secure prison, in Florence, Colorado, Kaczynski shares a cell block with Zacarias Moussaoui (1968–), a 9/11 conspirator; Terry Nichols (1955–), the Oklahoma City bombing accomplice; and former KGB spy Robert Hanssen (1944–).*

2. *One of Kaczynski's victims, Yale computer science professor David Gelernter (1955–), wrote a book about his experiences titled* Drawing Life: Surviving the Unabomber *in 1997. He has also been a columnist for the* Los Angeles Times.

3. *The Unabomber's shack was put on display at the Newseum in Washington, DC, for an exhibit on the 100th anniversary of the FBI in 2008. Kaczynski wrote to a US appeals court objecting to the display, but the museum declined to cancel the exhibit.*

◆◆◆

Susan Sontag

One of the leading figures in American intellectual life in the late twentieth century, Susan Sontag (1933–2004) wrote plays, novels, short fiction, and literary criticism. In her voluminous works, she sought to bridge the worlds of pop culture and high culture—and became a famous figure in both.

Sontag was born in Manhattan and graduated from the University of Chicago. At age seventeen, she married a sociology lecturer at the school, Philip Rieff (1922–2006), with whom she had her only child. The family later moved to Boston, where Sontag earned master's degrees in English and philosophy from Harvard.

The couple divorced in 1958, and Sontag returned to New York, where she taught and wrote essays for small intellectual journals such as *Partisan Review, Commentary,* and the *New York Review of Books.* The article that propelled her to fame, "Notes on 'Camp,'" was published in *Partisan Review* in 1964.

"Notes on 'Camp,'" which caused a sensation in the New York intellectual world, was a defense of so-called low culture, or *camp.* Sontag praised camp—frivolous art, sometimes purposely done in bad taste and often associated with the gay community—for its "comic vision of the world." "The whole point of Camp," she wrote, "is to dethrone the serious." Justifying popular culture to high culture, and vice versa, would be a recurring theme in Sontag's criticism.

Sontag also wrote three novels, *Death Kit* (1967), *The Volcano Lover* (1992), and *In America* (2000), which won the National Book Award. Her short story "The Way We Live Now," published in 1986, is regarded as one of the best pieces of fiction about the AIDS epidemic. Outspoken in her political views, Sontag was an opponent of the Vietnam War, a supporter of Western intervention in Bosnia in the 1990s, and a critic of US foreign policy after the September 11, 2001, terrorist attacks in New York.

Sontag's last essay criticized American mistreatment of prisoners at the Abu Ghraib prison in Iraq. She died in New York at age seventy-one.

ADDITIONAL FACTS

1. *Sontag was born Susan Rosenblatt. She changed her name after her father died and her mother remarried an army officer, Nathan Sontag.*

2. *Before her death from a rare blood cancer, Sontag survived cancer twice and wrote a book,* Illness as Metaphor *(1978), inspired by her struggle against breast cancer in the 1970s.*

3. *Sontag attracted international attention by directing a production of* Waiting for Godot *in war-torn Sarajevo in 1993. The choice of the absurdist play, which revolves around the expected arrival of a man named Godot, was seen as an allusion to the city's desperate wait for Western intervention in the Bosnian war of the mid-1990s.*

❖❖❖

Mikhail Gorbachev

Mikhail Gorbachev (1931–), the last leader of the Soviet Union, tried to save the USSR by reforming its moribund economy, militaristic foreign policy, and repressive civil society. Instead, the changes Gorbachev unleashed overwhelmed the Communist superpower, which collapsed in chaos and formally dissolved on Christmas Day of 1991.

Gorbachev was born in southwestern Russia, worked on collective farms during his youth, and became a member of the Communist Party in 1952. He held a number of administrative positions before joining the ruling Politburo in 1980.

The death of Soviet leader Leonid Brezhnev (1906–1982) set off a period of instability and drift in Soviet politics. The next two premiers, Yuri Andropov (1914–1984) and Konstantin Chernenko (1911–1985), both died after less than two years in office. Seeking more-youthful leadership, party leaders selected Gorbachev in 1985.

Gorbachev encountered enormous problems, both foreign and domestic, upon taking office. The Soviet army was bogged down in a war in Afghanistan, the economy was in shambles, and growing independence movements in the Eastern bloc countries threatened Soviet hegemony. The United States, under president Ronald Reagan (1911–2004), was pursuing a more aggressive policy to counter Soviet power.

In response, Gorbachev announced two reform programs, perestroika ("restructuring") and glasnost ("openness"). By liberalizing the economy, legalizing free enterprise, and easing restrictions on political speech, Gorbachev hoped to modernize the Soviet Union. He also withdrew troops from Afghanistan and pursued arms control agreements with Reagan. When revolution swept Eastern European countries in 1989, Gorbachev did not try to stop the tide.

Within the Soviet Union, however, perestroika and glasnost were creating food shortages, separatist violence, and widespread unrest. Gorbachev was briefly deposed in a 1991 coup, and he found his powers greatly reduced when he returned to power. Sensing the inevitable, Gorbachev lowered the hammer-and-sickle flag over the Kremlin for the last time on December 25, 1991.

Gorbachev remained active in Russian politics and ran for president in 1996. Since then, he has toured the world as a global statesman, celebrity endorser for Pizza Hut, and founder of a foundation devoted to political reform.

ADDITIONAL FACTS

1. *Gorbachev, affectionately nicknamed Gorby in the United States, is famous for the birthmark on his forehead. The port-wine-colored blotch is the result of a relatively common medical condition.*

2. *In 2003, Gorbachev won a Grammy award for Best Spoken Word Album for Children for a version of* Peter and the Wolf, *by the Russian composer Sergei Prokofiev (1891–1953).*

3. *Gorbachev met his wife, Raisa Maximovna Titarenko (1932–1999), while studying at Moscow State University. They married in 1953.*

◆◆◆

Mother Teresa

Born in Macedonia as Agnes Gonxha Bojaxhiu, the nun known to the world as Mother Teresa (1910–1997) became one of the twentieth century's most celebrated religious figures by devoting her life to the sick and dying in Calcutta, India. An inspiration to millions, she frequently topped opinion polls as the world's most respected woman.

Of ethnic Albanian descent—her birth name means "rosebud" in Albanian—Teresa decided as a twelve-year-old to become a Roman Catholic missionary. She joined an Irish religious order at age eighteen and traveled to Dublin to learn English. She sailed next to Calcutta, where she spent the next seventeen years teaching history and geography.

The turning point in Teresa's life came in September 1946, during a 400-mile train ride. During the trip, she later recounted, Jesus appeared to her and told her to give up teaching and work instead in the Calcutta slums, helping the sick and destitute. With the permission of the pope, she founded a religious group, the Missionaries of Charity, in 1950 to carry out her newfound calling. The group would grow rapidly, from 62 nuns in 1957 to roughly 4,000 in 1992. She won the Nobel Peace Prize in 1979.

Teresa attracted some criticism, however, for her conservative views on abortion and contraception, both of which she opposed. In keeping with Catholic teaching, she also campaigned against an Irish referendum to legalize divorce in 1995. Near the end of her life, Teresa's reputation was further called into question by journalist Christopher Hitchens (1949–), whose 1995 book *The Missionary Position* detailed the often-mysterious finances of the Missionaries of Charity. A subsequent investigation found that despite the millions raised for her organization, some patients in India were treated with reused hypodermic needles. Nevertheless, Pope John Paul II (1920–2005) nominated Teresa for sainthood shortly after her death, and she is widely expected to be canonized.

ADDITIONAL FACTS

1. *When she was awarded the Nobel Prize, Teresa devoted a lengthy portion of her Oslo lecture to attacking abortion, which she called "the greatest destroyer of peace today . . . because it is a direct war, a direct killing—direct murder by the mother herself."*

2. *Teresa became an Indian citizen in 1948, after the country gained its independence from Britain.*

3. *Under Vatican regulations, Teresa must cause two miracles after her death to be considered for sainthood. The first purported miracle came in 1998, when an Indian woman claimed that she had been cured of a cancerous tumor after praying to the nun. (The woman's doctors, however, insisted that the tumor had never been cancerous and that it had been healed using conventional treatments.)*

✦✦✦

Margaret Thatcher

Nicknamed the Iron Lady, Margaret Thatcher (1925–) was the first woman prime minister of the United Kingdom and an icon of conservative politics in the late twentieth century. An ideological ally of US president Ronald Reagan (1911–2004), she urged a hard-line stance against the Soviet Union, privatized government-owned industries in the United Kingdom, and waged a long battle with trade unions over the fundamental economic direction of her country.

Thatcher was born into a middle-class family in Grantham, Lincolnshire, where her father was a grocer. She graduated from Oxford with a degree in chemistry, then briefly worked for a plastics firm. In 1951, she married Denis Thatcher (1915–2003), a businessman and World War II artillery veteran; the couple had two children.

She ran for Parliament as a Conservative in 1950. Thatcher lost her first two campaigns by wide margins. She was finally elected in 1959 and quickly rose through the party's ranks. She became the party's leader in 1975, putting her in line for the premiership in the 1979 general election.

The election took place against a backdrop of high inflation, high interest rates, and high unemployment. Blaming the nation's woes on the socialist policies of the Labour Party, Thatcher promised to make sweeping changes in Britain's economic system by lowering taxes, promoting entrepreneurship, and breaking unions.

While in office, Thatcher acquired a reputation for an uncompromising, sometimes imperious style of governing. But she was reelected by a landslide in 1983 and again in 1987 by a comfortable margin. In addition to her economic reforms, Thatcher won a brief war against Argentina in 1982 to reclaim the Falkland Islands, a tiny, British-owned archipelago in the South Atlantic.

Thatcher was deposed by the Conservatives in 1990 over differences about leadership style and European policy. The Labour Party won control of Parliament in 1997, but retained many of Thatcher's reforms. Opinion polls show she ranks as one of the most respected British leaders of the twentieth century.

ADDITIONAL FACTS

1. *Thatcher's term as prime minister—eleven years and 209 days—was the longest since the Earl of Liverpool (1770–1828), who held the office from 1812 to 1827.*

2. *Queen Elizabeth II (1926–) is reputed to have had a frosty personal relationship with Thatcher. However, after Thatcher left office, the queen elevated her to the House of Lords.*

3. *Thatcher's son, Mark, was arrested in South Africa in 2004 and charged with funding a coup to overthrow the government of the oil-rich African nation of the Republic of Equatorial Guinea. He pleaded guilty, was given a suspended sentence, and returned to the United Kingdom.*

✦✦✦

John Rawls

Imagine yourself in the place of an unborn child, not knowing whether you would be born a billionaire or a beggar. What sort of society would you want to be born into? Unaware of your fate, what rules and laws would you want to govern your world?

Philosopher John Rawls (1921–2002) called this scenario the "veil of ignorance" in his celebrated 1971 book *A Theory of Justice*. Under the veil of ignorance, Rawls theorized, we would want a society that does everything it can to ensure fairness and help the most unfortunate.

In practice, Rawls used the concept of the veil of ignorance to advocate policies protecting the rights of minorities and the disadvantaged. For instance, under the veil of ignorance, it's impossible to know whether one will be born with a physical handicap. Therefore, under Rawls's logic, it makes sense for the government to help the disabled—for instance, by building wheelchair ramps at post offices.

A Theory of Justice was hailed upon its publication as a groundbreaking work that offered a sharp challenge to utilitarianism. Utilitarianism, articulated by Jeremy Bentham (1748–1832), holds that society should maximize the overall happiness of its citizens, even if it is at the expense of individuals. A utilitarian might argue that the cost of wheelchair ramps outweighs their benefit, since everyone would suffer by paying higher taxes to build the ramps that only a small number of people would use.

After the publication of *A Theory of Justice,* Rawls was regarded as one of the leading political philosophers in the United States. His chief opponent was another Harvard professor, the conservative-leaning libertarian Robert Nozick (1938–2002), who critiqued Rawls's work at length and argued that Rawls placed too much emphasis on the government's role in ensuring fairness.

Still, Rawls was a hero to many, especially on the political left. He published a follow-up work, *Political Liberalism* (1993), that confronted many of the criticisms of his early work.

Shortly before Rawls's death at age eighty-one, President Bill Clinton (1946–) offered him an encomium: "Almost single-handedly John Rawls revived the disciplines of political and ethical philosophy with his argument that a society in which the most fortunate help the least fortunate is not only a moral society but a logical one."

ADDITIONAL FACTS

1. *A detail-oriented writer, Rawls reportedly compiled the index to* A Theory of Justice *by himself.*

2. *The randomness of fate—the notion that anyone could be born poor, disabled, or a member of a minority group—forms a major theme in Rawls's philosophy. Some commentators point to the early deaths of Rawls's two brothers as key events in forming this view. Both brothers died from infections they had contracted from Rawls, the first from diphtheria and the other from pneumonia.*

3. A Theory of Justice *sold more than 200,000 copies, an astonishing figure for a book of academic philosophy, and was nominated for the National Book Award in 1971.*

◆ ◆ ◆

Barbara McClintock

During decades of study on maize plants, American geneticist and botanist Barbara McClintock (1902–1992) was able to discover many of the basic properties of genes and heredity. For her trailblazing work, she was awarded the Nobel Prize in Physiology or Medicine in 1983.

In her work, McClintock contributed to one of the greatest scientific revolutions of the twentieth century. When she first started studying genetics as an undergraduate at Cornell University in Ithaca, New York, in 1919, it was a poorly understood field. By the time she died, however, work had begun on the Human Genome Project to decode the genetic makeup of the entire human body.

McClintock was born in Hartford, Connecticut, and enrolled at Cornell in 1919 against the wishes of her mother, who felt a college education was inappropriate for a girl. As McClintock later described, only one genetics class at Cornell was open to undergraduates, but a professor spotted her potential and allowed her to enroll in a more advanced seminar in the field. She obtained her doctorate in 1927.

McClintock's most famous achievement—the one she won the Nobel Prize for—was her discovery of genetic transposition in the late 1940s. By studying corn plants, McClintock had realized that traits were not always passed down in a completely predictable, Mendelian fashion. She theorized that strands of genetic material—later identified as DNA—move around within cells, producing different color patterns and other traits in the corn.

Although initially rejected by most geneticists, her findings came to be accepted by the late 1960s. She was awarded the National Medal of Science in 1970, a prelude to her Nobel Prize the next decade.

In the male-dominated profession of genetics, McClintock also compiled a list of milestones: She was the first woman president of the Genetics Society, among the first women to win a MacArthur grant (in 1981), and only the third woman elected to the National Academy of Sciences. She died on Long Island at age ninety.

ADDITIONAL FACTS

1. *According to her obituary in the* New York Times, *McClintock did not own a telephone until 1986, preferring instead that her friends and associates contact her by mail. Appropriately, she was featured on a US Postal Service commemorative stamp in 2005.*

2. *McClintock attended Erasmus High School in Brooklyn, the same school as future Three Stooges leader Moe Howard (1897–1975).*

3. *When she won the Nobel Prize in 1983, McClintock was the first American woman and only the third woman ever to win an unshared Nobel in any scientific category. Marie Curie (1867–1934) won the award in chemistry in 1911, and Dorothy C. Hodgkin (1910–1994) won in 1964, also for chemistry.*

◆ ◆ ◆

Radovan Karadzic

Until his arrest on a city bus in Serbia in 2008, Radovan Karadzic (1945–) was the most-wanted man in Europe. The former leader of the Bosnian Serbs, Karadzic is alleged to have masterminded the killings of thousands of Bosnian Muslims during the Balkan conflict of the mid-1990s. After evading justice for more than a decade, Karadzic is currently awaiting trial on charges of war crimes and genocide at an international tribunal in The Hague.

Karadzic, prosecutors allege, ordered the shelling of Sarajevo during the Bosnian War, an action that resulted in thousands of civilian deaths. He also allegedly organized the killing of more than 8,000 unarmed Muslim men and boys in the town of Srebrenica in 1995—the worst mass murder in Europe since World War II.

Born in what was then Yugoslavia, Karadzic was trained as a psychologist with a specialty in paranoia. He spent a year at Columbia University in New York City and practiced at psychiatric hospitals in Yugoslavia in the 1970s and 1980s. Karadzic is also a novelist and a poet who has published several books of verse.

He entered politics in the late 1980s as a Serbian nationalist and was elected leader of the Bosnian Serbs when Yugoslavia disintegrated in the early 1990s. Aided by neighboring Serbia, the Bosnian Serbs embarked on a campaign of "ethnic cleansing" against Bosnian Croats and Muslims, culminating in the Srebrenica massacre.

After the Dayton Peace Accords ended the war, Karadzic was indicted for war crimes and went into hiding. He moved to Belgrade, the capital of Serbia, adopted the name Dragan David Dabic, and grew a long, bushy beard. He went into business as an alternative-medicine practitioner and expert in "human quantum energy" and was a writer for Serbia's *Healthy Life* magazine. An international manhunt failed to locate him for twelve years; Karadzic even supposedly traveled to Austria and attended soccer matches without being noticed.

His arrest, on July 21, 2008, provoked protests by many Serbians, who considered him a hero. Nonetheless, he was extradited to The Hague a few days later.

ADDITIONAL FACTS

1. *A genocide memorial to the victims of Srebrenica was opened by former US president Bill Clinton (1946–) in 2003.*

2. *With Karadzic behind bars, the most-wanted Serbian war criminal still at large is now Ratko Mladic (1942–), Karadzic's former top general. The US government has offered a bounty of $5 million for information leading to Mladic's arrest.*

3. *Karadzic wrote several books of poetry and managed to smuggle a manuscript for a novel to a Serbian publisher while he was living in hiding; it was published in 2004.*

◆◆◆

Günter Grass

For six decades, novelist Günter Grass (1927–) kept a secret. The prestigious German writer, a winner of the Nobel Prize in Literature, had become famous for his dark, unsparing narratives of postwar Germany—and his frequent criticism of his fellow Germans for failing to acknowledge the full extent of their World War II guilt.

So the revelation in 2006 that Grass himself had once been a member of the Waffen-SS caused an enormous uproar in the German press. Critics accused Grass, the self-styled moral authority of postwar Germany, of rank hypocrisy. His defenders argued that Grass was seventeen at the time he was forced to join the elite Nazi military unit and that the revelation could not diminish a lifetime of literary achievement.

Grass was born in Danzig, a city on the Baltic Sea with a predominantly German-speaking population. (It is now the Polish city of Gdańsk.) The city was annexed to Germany in 1939 after Nazi leader Adolf Hitler (1889–1945) invaded Poland. It was in Danzig that the teenage Grass was drafted into the Waffen-SS in 1944.

In a memoir, Grass described his wartime service as brief and undistinguished. He saw some combat against US troops in the spring of 1945, but never fired his weapon. He was eventually captured by the Americans and sent to a prisoner-of-war camp.

Wartime Danzig would be the setting for his first and perhaps most influential novel, *The Tin Drum* (1959). Darkly humorous, the book tells the story of Oskar Matzerath, a child in Danzig who decides, at the age of three, that he will not grow up. Set before, during, and after World War II, the book explores themes of the moral power of art, German war guilt, and lost childhood during war. One of its most poignant scenes takes place after the war in a bar called the Onion Cellar, where Germans go to peel onions, making it easier for them to cry and release their sadness.

Other novels by Grass include *Cat and Mouse* (1961), *Dog Years* (1963), and *Crabwalk* (2002). Grass has also been active in left-wing German politics and was an opponent of reunification in 1990 on the grounds that Germans had not yet fully accepted their wartime guilt. His political stances contributed to the backlash against Grass in 2006, when he was accused of smugly criticizing others for not coming to terms with the Nazi period while at the same time concealing his own past.

ADDITIONAL FACTS

1. The Tin Drum *inspired the main character in* A Prayer for Owen Meany *(1989), a novel by American author John Irving (1942–). The character's initials, O. M., are an homage to Grass's main character, Oskar Matzerath.*

2. *A former art student, Grass has provided his own drawings for the covers of his books.*

3. *Grass was a speechwriter for leftist politician Willy Brandt (1913–1992) in the 1969 West German elections. Brandt was elected chancellor and won the Nobel Peace Prize two years later for his efforts to promote reconciliation between East and West Germany.*

◆ ◆ ◆

Václav Havel

The first president of post-Communist Czechoslovakia, playwright and dissident Václav Havel (1936–) was the consensus choice to lead his country after the nonviolent revolution of 1989 that overthrew the old regime. As the Communists fled, joyous crowds in the streets of Prague chanted, "Havel to the castle"— reflecting the enormous popularity Havel had earned during years of struggle.

For the next thirteen years, Havel would be one of the most unusual leaders in world politics. A chain-smoking rock-and-roll fan, he wore jeans to work, invited the Rolling Stones to his palace, and prank-called the Kremlin, among his other exploits.

But he was also respected worldwide for his stand against Communism and is often mentioned in the same breath as South African antiapartheid leader Nelson Mandela (1918–) for the personal hardships he endured to bring freedom to his country.

Havel was born into a wealthy family in Prague. His family's property was seized when the Communists took power in Czechoslovakia in 1948 and the family was officially branded bourgeois; the designation barred Havel from completing his education. He turned to theater instead, and gravitated to the smoky cafes and underground theaters of Prague's bohemian intellectual scene.

In 1976, the Czechoslovakian government arrested the members of a rock band, the Plastic People of the Universe, deeming it counterrevolutionary. To support the band, Havel organized an illegal movement known as Charter 77, which would later form the leadership of the 1989 revolution. Havel spent the years between 1979 and 1983 in prison, the longest of his several jail stints. He continued to write plays and participate in the underground after his release.

Despite his heroic stature, Havel failed to prevent the split of Czechoslovakia into the Czech Republic and Slovakia in 1993, a move that he opposed. He was more successful in winning Czech membership in NATO, the North Atlantic Treaty Organization, and in the European Union, two of his biggest foreign policy goals. Havel retired from the presidency in 2003 and has resumed writing plays and essays.

ADDITIONAL FACTS

1. *After retiring Havel wrote his first new play in more than eighteen years,* Leaving. *The play, about a retired head of state grappling with his loss of power, premiered in Prague in June 2008.*

2. *Havel's first wife, Olga (1933–1996), died in 1996. He was criticized for remarrying the next year to Dagmar Veskrnová (1953–), an actress known in the Czech Republic for playing a topless vampire.*

3. *Even after becoming president, Havel retained his theatrical sense. One of his first acts was to hire the costume designer for the movie* Amadeus *(1984) to redesign the uniforms of the guards at his castle, replacing the Communist-era khaki with red, white, and blue costumes.*

◆◆◆

Jerry Falwell

Scourge of gays, pornographers, and Teletubbies, Reverend Jerry Falwell (1933–2007) reshaped American politics in the 1970s and 1980s by forming a powerful coalition of conservative, religious voters. From his headquarters in Lynchburg, Virginia, Falwell became one of the nation's most powerful clergymen, building an empire that eventually included books, television broadcasts, and a Christian university that he founded in 1971.

In the process, Falwell became a deeply polarizing cultural figure, denounced by critics as an "agent of intolerance" but celebrated as a moral leader by millions of evangelical Protestants.

After graduating from a Bible college in Missouri, Falwell returned to Lynchburg to found his Thomas Road Baptist Church in 1956. The church, which held its first meetings in an abandoned bottling plant, was Falwell's launchpad to national fame.

To increase the church's membership, Falwell started broadcasting his sermons on radio and television in presentations he called the *Old-Time Gospel Hour*. The shows were enormously successful, and membership in his church skyrocketed.

Initially, Falwell insisted that ministers should stay out of politics, and unlike many pastors, he did not participate in the civil rights movement. But his reluctance to enter the fray ended in the 1970s, when Falwell became alarmed by the *Roe v. Wade* Supreme Court decision that legalized abortion and by what he saw as increasingly permissive social attitudes about homosexuality, pornography, and moral values.

To critics, Falwell's aggressive rhetoric—he told his followers not to vote for any candidate who didn't "stand by" the Bible—blurred the traditional American values of religious pluralism and separation of church and state. He also provoked ridicule for attacking a character in the BBC children's series *Teletubbies* (Falwell claimed that the character Tinky Winky was a secret homosexual because he was purple and used a handbag).

Six years before his death, Falwell was embroiled in another round of controversy after claiming that the United States had brought the September 11, 2001, terrorist attacks upon itself by allowing abortion and gay rights. Falwell later apologized.

ADDITIONAL FACTS

1. *When Falwell started his Thomas Road Baptist Church in 1956, he had thirty-five congregants. By the time he died, the church had grown to 22,000 members.*

2. *Among the many groups that Falwell antagonized were Jewish groups, especially after he proclaimed that the Antichrist was probably a living, male Jew.*

3. *In 1983, Falwell sued pornographer Larry Flynt (1942–) for publishing a satirical advertisement in* Hustler *magazine that suggested the minister had committed incest with his mother in an outhouse. The Supreme Court eventually sided with Flynt in a landmark 1988 decision, ruling that the ad was protected free speech. The case was made into a 1996 movie,* The People vs. Larry Flynt, *in which Falwell was played by actor Richard Paul (1940–1998).*

✦✦✦

Benazir Bhutto

Before her assassination, Benazir Bhutto (1953–2007) was one of the best-known politicians in Pakistan, as well as a symbol of democracy in a country with a history of military rule. She served two terms as prime minister, was removed by the army both times, and was in the process of seeking a third term at the time of her killing.

Shortly before her death, in an interview with a reporter, Bhutto explained her motivations for staying in politics despite setbacks and personal tragedies. Her campaign for democracy, she said, was "a battle for the heart and soul of Pakistan. . . . It is also a battle for the rest of the Muslim world and the world at large."

Bhutto was the daughter of a former Pakistani prime minister, Zulfikar Ali Bhutto (1928–1979). She was educated at Harvard and Oxford, but was back in Pakistan in 1977, when her father was overthrown in a military coup. He was hanged two years later, a formative event in Bhutto's life that convinced her to enter politics.

In 1988, in the first free elections since her father's ouster, Bhutto was elected prime minister. At only thirty-five years old, she was the first woman elected to lead an Islamic country. Her premiership lasted less than two years before the military removed her on charges of corruption. She was elected again in 1993 and overthrown again three years later. Bhutto's critics point out that it was during her second term that the Taliban took control of Afghanistan—with support from Pakistan.

The corruption charges followed Bhutto and her husband, Asif Ali Zardari (1955–), into exile. Between 1999 and 2007, she lived in London and Dubai and faced arrest if she returned to Pakistan. Bhutto blamed her political opponents for the corruption allegations.

In 2007, Bhutto announced her intention to return to Pakistan to challenge the military dictator, Pervez Musharraf (1943–), who had seized power in a coup in 1999. She was met at the airport by an ecstatic crowd—and an assassination attempt, a bomb that missed Bhutto but killed more than 100 people. She was killed two months later by terrorists allegedly affiliated with al Qaeda; her husband succeeded her as leader of her political party and became president of Pakistan in 2008.

ADDITIONAL FACTS

1. *In Pakistan, Bhutto's husband (now president) was nicknamed Mr. Ten Percent, a reference to the kickbacks the family was alleged to have accepted.*

2. *Less than two months after her assassination, investigators from Scotland Yard determined that Bhutto had died after hitting her head on her vehicle's sunroof—not from a bullet wound, as originally reported.*

3. *In 2003, a Swiss court convicted Bhutto and her husband of laundering $10 million and sentenced them to a fine and six-month suspended jail terms. An appeal was pending at the time of her death.*

✦✦✦

Index

✦✦✦

❖❖❖

◆◆◆

✦✦✦

✦✦✦

✦✦✦

❖❖❖

Image Credits

Courtesy of the Library of Congress (image numbers follow in parenthesis): pages 142 (LC-USZ62-61365); 174 (LC-USZC4-2542); 176 (LC-USZ62-124397); 194 (LC-USZ62-87246); 211 (LC-DIG-pga-02908); 228 (LC-DIG-npcc-19612); 232 (LC-USZ62-14976); 237 (LC-DIG-ppmsca-08351); 239 (LC-USZ62-7334); 240 (LC-USZ62-47039); 241 (LC-USZ62-5877); 242 (LC-USZ62-3854); 250 (LC-USZ62-5513); 251 (LC-USZ62-124560); 262 (LC-USZ62-104276); 271 (LC-DIG-ppmsca-07757); 277 (LC-DIG-ggbain-25495); 281 (LC-DIG-ggbain-30124); 283 (LC-DIG-ggbain-06493); 290 (LC-J601-302); 294 (LC-USZ62-96275); 297 (LC-USZ62-60242); 302 (LC-USW33-019093-C); 330 (LC-USZ62-117122); 344 (LC-DIG-ppmsc-03265)

© Adoc-photos/Art Resource, NY: page 274

© akg-images: pages 300, 316, 321, 328

© akg-images/ullstein bild: pages 301, 310

© Alan King engraving/Alamy: page 102

© Alinari/The Bridgeman Art Library: page 85

© Araldo de Luca/CORBIS: page 78

© The Art Archive/Bibliothèque des Arts Décoratifs Paris/Alfredo Dagli Orti: page 48

© The Art Archive/Chopin Foundation Warsaw / Alfredo Dagli Orti: page 222

© The Art Archive/Culver Pictures: page 255

© The Art Archive/Karl Marx Museum Trier / Gianni Dagli Orti: page 254

© The Art Archive/Museo di Capodimonte, Naples/Gianni Dagli Orti: page 161

© The Art Archive/Musée du Château de Versailles/Gianni Dagli Orti: page 127

© The Art Archive/Museo de Arte Antiga Lisbon/Gianni Dagli Orti: page 134

© The Art Archive/Museum of London: page 138

© The Art Archive/National Archives Washington DC: page 193

© The Art Archive/Palazzo Barberini Rome/ Alfredo Dagli Orti: page 147

© Avico Ltd/Alamy: page 343

© Bettmann/CORBIS: pages 58, 64, 110, 153, 202, 205, 208, 217, 235, 268, 284, 289, 308, 315, 323, 326, 348, 349

© Bildarchiv Preussischer Kulturbesitz/Art Resource, NY: pages 128, 159

© British Library, London, UK/The Bridgeman Art Library: page 97

© Chinese School/National Palace Museum, Taipei, Taiwan/The Bridgeman Art Library: page 109

© Chuck Nacke/Alamy: page 350

© Classic Image/Alamy: pages 25, 43, 103, 131, 190, 210

© Collection Kharbine-Tapabor, Paris, France/ The Bridgeman Art Library: page 278

© Diego Goldberg/Sygma/Corbis: page 360

© Galleria Palatina, Palazzo Pitti, Florence, Italy/ The Bridgeman Art Library: page 125

© Getty Images: page 11

© The Granger Collection: pages 27, 55, 73, 148, 150, 155, 158, 162, 172, 186

© Harvard University/The Bridgeman Art Library: page 182

© Hulton Archive/Getty Images: page 336

© Hulton-Deutsch Collection/CORBIS: pages 152, 335

© Interfoto/Alamy: pages 32, 60, 81, 196

© Istockphoto: pages 6, 10, 30, 37, 42, 57, 104, 173, 197, 199

© Karen Kasmauski/Science Faction/Corbis: page 353

© Ken Welsh/The Bridgeman Art Library: page 246

© Liba Taylor/CORBIS: page 363

© Louise Gubb/The Image Works: page 357

© Marion Kalter/AKG-Images/The Image Works: page 355

© Mary Evans Picture Library: pages 5, 21, 46, 51, 75, 95, 115, 116, 201, 256, 260, 276, 358

© Mary Evans Picture Library/EDWIN WALLACE: page 59

© Mimmo Jodice/Corbis: page 12

© Musee Denon, Chalon-sur-Saone, France/ Roger-Viollet, Paris/The Bridgeman Art Library: page 53

© North Wind Picture Archives: pages 8, 52, 70, 106, 169, 179, 181, 192, 223

© Photo Researchers/Alamy: page 17

✦✦✦

✦✦✦